Yale Studies in English

Yale Studies in English publishes books on English, American, and Anglophone literature developed in and by the Yale University community. Founded in 1898 by Albert Stanburrough Cook, the original series continued into the 1970s, producing such titles as *The Poetry of Meditation* by Louis Martz, *Shelley's Mythmaking* by Harold Bloom, *The Cankered Muse* by Alvin Kernan, *The Hero of the Waverley Novels* by Alexander Welsh, *John Skelton's Poetry* by Stanley Fish, and *Sir Walter Raleigh: The Renaissance Man and His Roles* by Stephen Greenblatt. With the goal of encouraging publications by emerging scholars alongside the work of established colleagues, the series has been revived for the twenty-first century with the support of a grant from the Andrew W. Mellon Foundation and in partnership with Yale University Press.

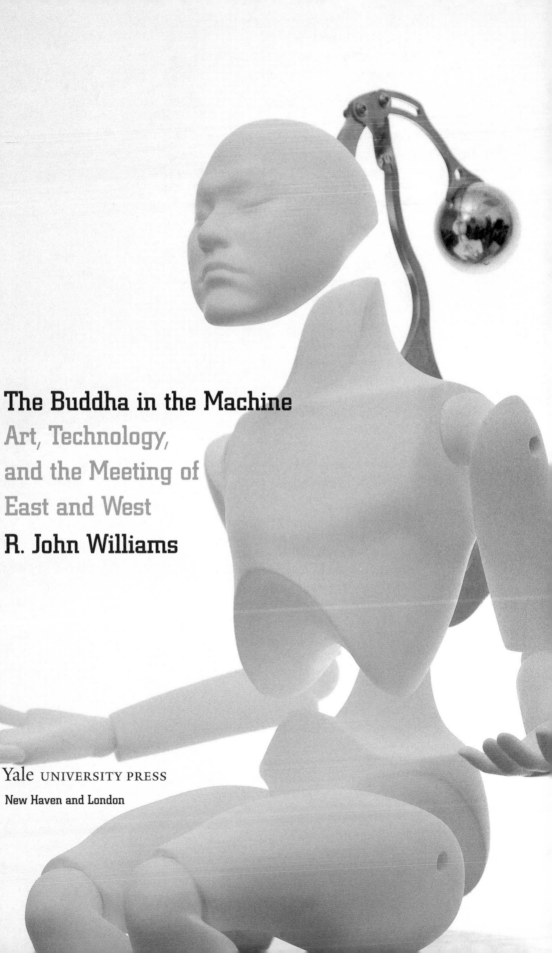

The Buddha in the Machine
Art, Technology, and the Meeting of East and West

R. John Williams

Yale UNIVERSITY PRESS
New Haven and London

Published with the assistance of the Frederick W. Hilles
Publication Fund of Yale University.

Yale University Press books may be purchased in quantity
for educational, business, or promotional use. For informa-
tion, please e-mail sales.press@yale.edu (U.S. office) or
sales@yaleup.co.uk (U.K. office).

Designed by Lindsey Voskowsky.
Set in Scala type by Westchester Publishing Services.
Printed in the United States of America.

Library of Congress Cataloging-in-Publication Data

Williams, R. John.
 The Buddha in the machine : art, technology, and the
meeting of East and West / R. John Williams.
 pages cm. — (Yale studies in English)
 Includes bibliographical references and index.
 ISBN 978-0-300-19447-0 (cloth : alk. paper)
 1. East and West. 2. Arts and society. 3. Aesthetics,
Oriental. 4. Technology—Psychological aspects.
5. Technology—Social aspects—Western countries.
I. Title.
 CB251.W47 2014
 306—dc23
 2013044488

A catalogue record for this book is available from the
British Library.

This paper meets the requirements of
ANSI/NISO Z39.48-1992 (Permanence of Paper).

10 9 8 7 6 5 4 3 2 1

Frontispiece: Wang Zi Won, *Mechanical Xanadu* (2011)
(image courtesy of Wang Zi Won).

For Brooke

Contents

Acknowledgments

I assume there is no statute of limitations on the appropriateness of thanking someone for their help in writing a book—or, at least, I hope there isn't, since this book took so long to finish that I imagine there are people I am thanking here who have long since forgotten they offered me such valuable assistance. I find the decision about where exactly to mark the borders of my intellectual debts similarly confounding. There were of course people who intervened in critical ways with specific advice and support (whom I'll thank more specifically in a moment), but there were similarly hundreds of good souls who, in the course of simply doing their job, also made this book possible in ways I could never repay. I received enormously generous help from the brilliant staff at the Beinecke Rare Book and Manuscript Library (particularly Anne Marie Menta, Naomi Saito, Moira Fitzgerald, Meredith Miller, and Chris Edwards). Similarly helpful assistance came from the staff at the Sterling Memorial and Haas Family Art Libraries, also at Yale University, the Huntington Library in Pasadena, the Utah State Special Collections and Archives, the Boston Public Library, the New York Public Library, the Langson Library at the University of California, Irvine, the East Asia Library at Stanford, the Yale Art Gallery, the Boston Museum of Fine Arts, the Guggenheim Museum in New York City, the Oakland Library, the Bancroft Library at Berkeley, the Margaret Herrick Library at the Academy of Motion Picture Arts and Science, the William Reese Company in New Haven, the University of Albert Museum, the Philadelphia Museum of Art, the New York Society Library, and the Frank Lloyd Wright Foundation in Scottsdale, Arizona. Indeed, I have a stack of request forms, receipts, CDs, emails, and file transfers as tangible proof of their generosity.

But inasmuch as these institutions left me with a paper trail to mark their assistance, I should mention that there were also people moving behind the scenes in bringing this book to life—many of whom I never had the chance to meet, to see their faces, or learn their names, even if I did sometimes see their hands. The image included here is a composite picture, made from a dozen or so screenshots I took during the course of my online research. The blurry forms you see in the bottom half of these layered images are the hands of workers who, in the course of scanning books and uploading them for Google and Archive.org, accidentally became part of the texts (all of the images, in this case, are from books by Lafcadio Hearn, whose ghostly stories seemed rather apt in this context). I've seen hundreds of these hands, and feel enormous gratitude to them for having made possible my immediate access to the thousands of volumes that would have otherwise required significant travel and time to visit. I doubt they got paid much for it, and they no doubt found the task tedious, flipping page by page in quick, linear fashion—it must be not all that different, in the end, from working on industrial assembly lines. But the amount of information they made possible in my research for this book is staggering. Certainly, this book would not

Composite image of book scanners' hands (as captured in online scans of volumes by Lafcadio Hearn).

exist in the form it does without them, and I am continually reminded that an enormous amount of labor—not my own—contributed to the "knowledge work" that is this book. The same could be said for those who made the machines I'm typing on, the paper, the buildings . . . but I digress.

The final, intellectual product of this book is evidence of a similarly scandalous debt I owe to my many wonderful colleagues, students, and readers at Yale University. Michael Warner and Caleb Smith deserve special thanks for taking apart my arguments with care and precision, and then sticking around to help put them back together. Specific and brilliant advice came at various moments from my colleagues Joseph Roach, Cathy Nicholson, Jessica Pressman, Amy Hungerford, Wai Chee Dimock, Paul Grimstad, Katie Trumpener, Justin Neuman, David Kastan, Paul Fry, David Quint, Langdon Hammer, Ian Cornelius, Jackie Goldsby, David Bromwich, and Pericles Lewis. Some of my smartest readers were graduate students, and I owe special thanks to Matt Rager, Jordan Brower, Aaron Pratt, and Ryan Carr. Outside the English department, I benefited from the dazzling conversations made possible by the Theory and Media Studies, Americanist, and Twentieth-Century Colloquia, and was encouraged at various moments by Charles Musser, J. D. Connor, Jing Tsu, Haun Saussy, and Alexander Nemerov. Financial assistance—never to be forgotten— came in the form of the Samuel and Ronnie Heyman Prize, the Hilles Publication Grant, the A. Whitney Griswold Research Grant, and the Norman Foerster Prize. I am similarly indebted to the editorial expertise of Eric Brandt and Erica Hanson at Yale University Press, who never wavered in their enthusiasm, even when tempering my desire to include more images than were practical. Mary Pasti, Paul Vincent, and Lyndee Stalter were wonderfully meticulous in their attention to my final drafts. If

this book fails in any way, in other words, it will be an intensely personal failure, since I could not imagine a better environment in which to write it.

I was also lucky enough to have spent eight years at the University of California, Irvine, where my advisors and colleagues were as warm and encouraging as the Irvine weather. My closest reader was Jerome Christensen, who treated me as a colleague long before I deserved it, and continues to serve as a model for brilliant scholarship and unwavering support. Jane Newman responded with far more energy and generosity than any institutional obligation might have required of her. John Carlos Rowe, Mark Goble, and Dorothy Fujita-Rony stuck with me through the long haul and exercised enormous patience when I abandoned an early dissertation path that was not going where I wanted. I was also continually amazed at Irvine to have been placed within the orbit of so many luminaries—Jacques Derrida, Wolfgang Iser, J. Hillis Miller, and Ngũgĩ wa Thiong'o, among others—and was astonished to find them so generous with their time and energy. Many others offered assistance at crucial times: Rei Terada, Eyal Amiran, Andrea Henderson, Elisa Tamarkin, Michael Szalay, Laura O'Connor, and Susan Jarratt. I shudder to think what my earliest drafts would have become without the line-by-line, thoughtful comments by my colleagues Eric Rangno, Peter Leman, and Matt Ancell. My time in Irvine was also a period of ideological transition for me, and I could not have navigated the rapids without a special group of infinitely supportive friends: Armand and Ruth Mauss, Mike McBride, Caroline Kline, John Manchak, Jesse and Rebekah Palmer, Amy Parkin, Jana Christine Remy, John Remy, Charlie Morgan, Nate and Alise Westbrook, Matt Nguyen, Sandra Lee, Rob Colson, and Jeff and Martha Barrett.

Along the way, a number of stunningly intelligent readers and interlocutors also offered a chance to hash out ideas and rework conclusions. Portions of chapters 5, 6, and 7 appeared previously in the journals *American Literature*, *Modernism/modernity*, and *Critical Inquiry*, respectively, and I am deeply grateful for their readers' careful attention, and for their editors' permission to republish those revised passages here. More personally, Eric Hayot served as a kind of shadow advisor for several years, without any reward that I know of other than his genuine passion for the profession. Colleen Lye, Richard Jean So, Jonathan Stalling, David Palumbo-Liu, Bishnupriya Ghosh, Jan Bakker, Ronald Bush, Andrew F. Jones, Yunte Huang, Philip Leventhal, Xiao-huang Yin, Eugene Eoyang, Don Pease, Bill Brown, Alan Trachtenberg, Christopher Nealon, Dean Irvine, Tony Barnstone—every one of these wonderful colleagues sat down with me at some point to discuss my work. I should also mention that my chapter on book covers in the 1890s would not have existed at all without the seemingly endless energies, capacious knowledge, and collecting power of John Lehner, whose emails were always a treasure trove of bookish beauty. Stuart Walker of the Boston Public Library showed me the library's crown jewels in book design, opening up the archives to me at a critical moment in my research. Richard Minsky was also helpful in getting started.

Everyone who writes a book knows that there are also people along the way who simply keep you sane. Instrumental in many of my recent adventures were Kael and Heather Alden, Kurt Deninger, and Sebastian Hackett. Those hours we spent together driving up and down the west coast in a van, the endless nights in the studio, and the back-and-forth turning over of ideas bicoastally—if there really is a path to *technê* in this world, it's somewhere wrapped up in those moments for me. A host of others kept me from dwelling on the routine panics of the profession: Susan Clinard and Thierry Emonet, Will Becker and Julie Parr, Janet and Victor Heinrich, and

Marc Levenson. My parents (Scott and Laurie), in-laws (Mike and Erma), and siblings are the pinnacle of compassion and support. My sons (Miles and Harry) are a never-ending source of energy, love, and good humor. But anyone who knows me will already understand that no one has had a greater impact on this text and its author than Brooke Jones—who stayed up late, got up early, cried, loved, and walked with me so that this book could get written. I dedicate it to her.

1. Asia-as-*Techné*

Somewhere on the way, in passing from the scientific facts and
distinctions to the traditional philosophical foundations of modern
Western culture, a mistake was made. We must find this mistake.
—F. S. C. Northrop, *The Meeting of East and West* (1946)

A root word of technology, techné, originally meant "art." The
ancient Greeks never separated art from manufacture in their
minds, and so never developed separate words for them . . .
The real ugliness is not the result of any objects of technology . . .
The real ugliness lies in the relationship between the people who
produce the technology and the things they produce.
—Robert Pirsig, *Zen and the Art of Motorcycle Maintenance* (1974)

The writers and artists described in this book are joined by a desire to embrace "Eastern" aesthetics as a means of redeeming "Western" technoculture.[1] The assumption they all share is that at the core of Western culture since at least the Enlightenment there lies an originary and all-encompassing philosophical error, manifested most immediately in the perils of modern technology—and that Asian art offers a way out of that awful matrix. That desire, I hope to demonstrate, has informed Anglo- and even Asian-American debates about technology and art since the late nineteenth century, and continues to skew our responses to our own technocultural environment. Although the "machine" has for over a hundred years functioned as an almost religious object of enthusiasm and veneration, American art and literature have been shaped as much by resistance to technology as by submission to it—and, with startling frequency, that resistance has taken the form of an investment in what I call Asia-as-*techné*: a compelling fantasy that would posit Eastern aesthetics as both the antidote to and the perfection of machine culture.[2]

None of the figures I examine in this book question the pervasive influence of technological developments on Western life and culture (and, as such, are largely guilty of what historians of science call "technological determinism"[3]); each of them, however, looks to the East for more organic, less oppressive ways of living *with* machines. As a way of illustrating how these two impulses—lamenting technology's corrupting power in the West and seeking remedial technologies from the East—frequently coincide, allow me to begin with a preliminary, somewhat extended example. Between 1998 and 2001 British artist David Hockney submitted the entire history of Western art to a kind of aesthetic Turing test, and, according to his analysis, a surprising number of the old masters tested positive for cyborgism. "Turing test" is not his phrase, of course, but the basic idea—determining whether or not in the art of the old masters we have been all along communing with "machines" rather than sentient, creative beings—is nonetheless at the heart of his investigation.[4] The essence

of Hockney's argument, articulated most elaborately in his volume *Secret Knowledge* (2001), is that hiding within the ghostly realism of Western art (and, as we shall see, in stark contrast to the art of the East) there is a machine—or rather a whole panoply of optical technologies and mechanical methods that were lost or perhaps purposefully hidden from the historical record.[5] As Hockney tells it, the reason so many of the old masters achieved such startlingly realistic effects was that their techniques for representation extended far beyond the powers of observational "eyeballing" (*SK*, pp. 184–185). Whereas art historians had already, if intermittently, acknowledged the occasional use of perspective machines and optical devices (pantographs, drafting grids, mirrors, camera obscuras, camera lucidas, and so on; Figs. 1.1–1.2), no one had ever claimed that these technologies were so *central* to Western artistic tradition, or that they were in use as far back as the early fifteenth century.[6]

Hockney's goal, in other words, is to demonstrate that the real culprit of artistic realism—the undercover use of optical technologies—has been hiding in plain sight all along. For Hockney, the moment of the originary crime (and, for reasons we will elaborate shortly, he really does think of it as something like a "crime") occurs very specifically in the late 1420s, when Van Eyck's starkly lit oil paintings show a dramatically "realistic" break from the flattened frescos and tempura techniques of previous artists. If we compare, for instance, the two paintings in Plates 1–2, something dramatic does seem to have happened between them, the Van Eyck suddenly "alive" with deeper color and shadows. But of course, as in any classic detective story, guilt

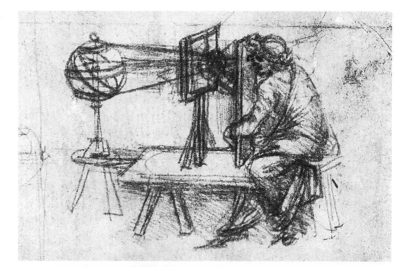

Fig. 1.1. Leonardo da Vinci, *Draftsman Drawing an Armillary Sphere Using a Perspective Machine,* Codex Atlanticus (1510). Biblioteca Ambrosiana, Milan.

Fig. 1.2. Albrecht Dürer, woodcut showing perspective machine from *Underweysung der Messung* (Treatise on Perspective) (Nuremberg, 1527); photo credit: Foto Marburg / Art Resource, NY.

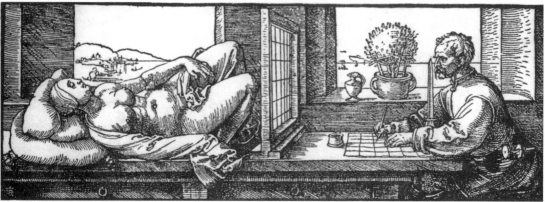

has to be isolated, hypostatized, and disciplined by way of a presiding, restoration narrative (it never turns out, that is, that the murder was "society's fault"), and *Secret Knowledge* is no different. It simply will not do for Hockney to characterize this artistic transformation as the complex, cumulative result of new developments in oil painting, the burgeoning study of human cadavers, the invention of linear perspective, changes in patronage and apprenticeship, Van Eyck's own artistic brilliance, and the growing availability of eyeglasses (another type of "optics" that Hockney seems to ignore, even though it would have certainly allowed artists to see more clearly their work and models). No, for Hockney, "something else is in play"—a singular "else."[7]

What follows in *Secret Knowledge* is a stunning re-creation of the scene of the "crime." Enlisting the help of University of Arizona physicist Charles Falco (who plays a mustachioed Watson to the artist's Sherlock), Hockney makes the "scientific" case that since there is a convex mirror in the background of Van Eyck's 1434 masterpiece *The Arnolfini Portrait* (Plates 3–4), it stands to reason that he must have had a *concave* mirror, and concave mirrors, it turns out, are not only good for burning Roman ships (as Archimedes is supposed to have done) but also for projecting images inside a camera. Indeed, if one bothers trying it out (a normal shaving mirror will do), it works surprisingly well.[8] We are suddenly reminded, then, that the "camera" existed centuries before photography, the latter being a chemical invention, not a fundamentally structural one. The word "camera" is the Latin equivalent of the English "chamber," and the curious visual effect of a pinhole projection into a dark chamber or room, due to the fact that light rays passing through the pinhole are crossed and so appear upside down on the opposite wall or screen, was known already to Aristotle and Euclid.[9] To stand in one of these dark rooms, in other words, is to be inside a camera. Specifically, then, Hockney argues that Van Eyck must have used a concave mirror to project the most visually stunning elements of the *Arnolfini Portrait* onto a screen inside a camera (that is, his darkened art studio), which would have not only allowed him to see the scene in two-dimensional form (something any regular mirror would have done), but also to set up a kind of beautiful, ghostly image that could then be painted over—*fixed*, as it were, by a paintbrush rather than, as would come centuries later, chemicals or digital code.

Suddenly, for Hockney, the entire history of Western art becomes a story of covert technologies. The montage-like discontinuities and depth-of-field distortions seen in so many classic works (heretofore explained as the mere piecemeal staging of an artist's subjects over time) become evidences of a secret lens-and-mirror apparatus, influencing everything from Filippo Brunelleschi's invention of linear perspective to the stark chiaroscurism of Caravaggio and the rapid and painterly precision of Diego Velasquez. Whether or not one accepts Hockney's thesis, there can be no denying that it offers a provocative means of reexamining the history of Western art.[10] Seeing *through* the paintings into the skeletal secrets of their mechanical origins, we "begin to look at paintings in a new way" (*SK*, p. 131). Indeed, when one considers the possibility that artists were cleverly (masterfully? secretively?) arresting a projected, analog image, doing the work, that is, that chemicals and digital sensors would later do, the figures in the paintings somehow become even more ghostly and present.[11]

The most provocative aspect of Hockney's thesis, however, is not that it overturns sacred assumptions about the almost supernaturally mimetic powers of the Western old masters. On the contrary, Hockney goes out of his way to argue that "optics don't make marks" (even sporting a garish T-shirt with that phrase boldly printed on it in the BBC documentary on his work), which is to say, even with the

assistance of optical technologies, the artist's hand was still inside the machine, still in control, setting up the scene, applying paint, positioning lenses, making all sorts of artistic decisions about composition, color, lighting, and so on.[12] Hockney's overarching argument, in other words, is not that the old masters "cheated," but rather that this development introduced a "crime" of a different magnitude. The real scandal for Hockney has something more to do with the very ideological assumptions regarding the portrayal of "reality" by means of linear, geometrically fixed perspective and the modeled, shadowy forms of chiaroscurism. According to Hockney, it is this increasingly calculative, enframing, and *mechanistic* approach to portraying the world that is the real crime:

> In a perspective picture, your viewpoint is fixed because the space is drawn from a single spot. . . . Histories of perspective generally suggest that anything that came before was "primitive" or that there had been a struggle to achieve perspective—and that once mastered it conquered the world. It was the "correct" way of depicting the world, whereas other graphic conventions were not. (*SK*, p. 204)

The supposedly linear "progress" of the invention of linear perspective, in other words, is a deception. The ideology of the perspectival window is less a reflection than it is an *alienation* of our natural experience, a "prison" wherein the "tyranny of the lens" has "pushed the world away," and "separated us" from "our environment" (*SK*, pp. 230–231).

What leads Hockney to these conclusions—the real motivation, that is, behind his exposé of the machine at the heart of Western art—is a particular vision of Asian aesthetics, which enters his argument as a means of providing a series of alternative, nonalienating techniques for depicting the world and our experience of it. A full decade before taking up these arguments in *Secret Knowledge*, Hockney produced an hour-long documentary film titled *A Day on the Grand Canal with the Emperor of China; or, Surface Is Illusion but So Is Depth* (1988) detailing the striking differences in artistic strategies between a highly perspectival scene by Canaletto during the Renaissance (Plates 5–6) and a seventy-two-foot-long Chinese landscape scroll from the seventeenth century (Plates 7–8).[13] In *Secret Knowledge*, Hockney returns to the results of this comparative analysis: "Eastern cultures," he explains, developed methods of artistic representation that were "anything but primitive." Indeed, such methods allowed for "very sophisticated representations of space, closer in fact to our physical experience of moving through the world" (*SK*, p. 204). Observing, for instance, the "principle of moving focus" found in the Chinese landscape scroll, Hockney argues (in a subtle jab at the window-like linearity of the Western codex) that the only "limitation" of such an art form is that "it cannot be shown properly in a book" (*SK*, p. 230). Unfettered by the fixed positioning of "Alberti's window," however, the Chinese scroll allows one to "take a stroll through a landscape with which you are quite connected," to "meander" and "move down to the water's edge," to "look down on the lake . . . descend onto a plain, then up into mountains again" (*SK*, p. 230). Throughout the art of Japan, China, and India (at least until very recently), Hockney contends, the deceptive and constraining optics of shadows and fixed perspectivism were never allowed to visually dictate one's experience with art and nature. By contrast, the West, in its obsession with "windows," "geometry," and "machines," has become trapped by its own mechanistic ideologies of disenchantment; hence, the need for someone like Hockney to articulate the original sin at the heart of the dilemma, to refocus our attention on the great art of the East so as to redeem us from our cor-

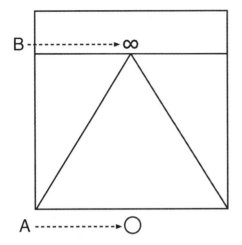

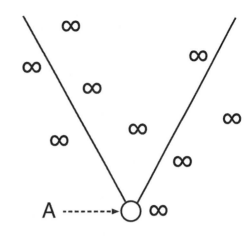

Fig. 1.3. Diagram of the "theology" of perspective in David Hockney, *A Day on the Grand Canal* (1988) (adapted by the author from Hockney's chalkboard illustration in the film).

Fig. 1.4. Diagram of the "theology" of Chinese spatial representation in Hockney, *A Day on the Grand Canal* (1988) (adapted by the author from Hockney's chalkboard illustration in the film).

rupt, mechanical inheritance. As Hockney explains in *A Day in the Grand Canal* (illustrating the following principle with a piece of chalk on a blackboard), in Western mechanical perspective, the principle of the vanishing point "places the viewer in an immobile point outside the picture" (see point A in Fig. 1.3). "Theoretically," he explains, the vanishing point (point B) "represents infinity," which is to say, if the viewer moves forward, so does the vanishing point; and (only half-joking now) "if the infinite is god," then we are left with a proposition in which "god" and the "immobile viewer" will never meet. It's "bad theology." But in the Chinese scroll, the viewer is "in movement," and "infinity is now everywhere, including the viewer" (Fig. 1.4). Thus, "god is everywhere, including within you."

One is reminded, however, that Hockney's own art—indeed, the art for which he has become most famous—is hardly antitechnological. Beginning with his work in the United States in the early 1980s, Hockney began exploring precisely this principle of "moving" perspective (echoing the modernist innovations of the cubists and vorticists) through various experiments in photo-collage. In works like *Ian with Self-Portrait* (1982) and *Henry Moore* (1982) and *Still Life, Blue Guitar* (1982, Plate 9), the Polaroid camera's white-frame images are placed together in a flat, ordered grid, while the scenes depicted offer not a single "window," but multiple shots of the same scene, with shifting focus and slightly skewed continuities. Hockney's most famous collage, *Pearblossom Hwy., 11–18th April 1986* (Plate 10), creates an even more multifocalizing effect, with almost all traces of receding perspective flattened onto a choppy plane of multiple points of view. Here the so-called vanishing point in traditional perspective refuses to vanish, seemingly jutting out from the bottom of the collage into the viewer's space. In *Walking in the Zen Garden at the Ryonji Temple, Feb. 21st 1983* (Plate 11) the traditional contracting lines of perspective are even reversed, coming closer together as they come toward the viewer. However, the point in all of these works for Hockney is not to celebrate or return to some "primitive" aesthetic culture. On the contrary, his is a Polaroid solution to the machine/art dilemma of Western art, relying directly on

what were then new and cutting-edge technologies (as would his later efforts in fax and computer art) to bring us to that supposedly more authentic, Eastern ideal.[14] The implicit idea, in other words, is that there is something already highly civilizational and modern and yet somehow more organic and healthy about Eastern aesthetics, something that must be embraced so as to counter the very dilemma created by that most modern of Western creations, the machine.

Asia-as-*Technê*

As the technological singularity (the "Polaroid-ness" if you like) of Hockney's Polaroid solution already indicates, the key term for the figures described in this book is not Luddism but *technê*—a word which to the ancient Greeks meant both "art" and "technology."[15] Martin Heidegger's particular use of the term hovers constantly in the background of this book, not so much because he developed his concept of *technê* while dabbling in Orientalism (as interesting as that is), but rather because it reflects a general, therapeutic effort to explore alternatives to the overtechnologization (what he called the *Gestell* or "enframing") of Western modernity.[16] Specifically, in "The Question Concerning Technology," Heidegger returns to the etymological roots of "technology" in an effort to rescue forms of thinking and handicraft from the systemic metaphysics of modern machine culture—in short, to distinguish between what we might call the modern "techno" and the originary *technê*. As he explains, "There was a time when it was not technology alone that bore the name *technê*. Once, the revealing that brings forth truth into the splendor of radiant appearance was also called *technê*. Once there was a time when the bringing-forth of the true into the beautiful was called *technê*. And the poïesis of the fine arts was also called *technê*."[17] Not simply a return to Nature, then, the move toward *technê* was for Heidegger (or at least "late Heidegger") an attempt to resurrect some ancient skill or craftsmanship, and to identify—against the efficient and inhumane technologies of modernity—an ontological aesthetic more conducive to a more romantic concept of organic wholeness.[18] Put another way, to argue for the value of Asia's *technê*, as the figures in this book do, is not (or not only) an ethnographic effort to account for difference but a kind of moral aspiration, identifying within the "other" a tradition of technological experience fundamentally untainted by the mechanical enframings of the Anglo-American disenchantment of nature. Unlike the more typical protocols of Orientalist discourse (in which the East is either characterized as stagnantly "tech-less" or else dangerously imitating Western technoculture[19]), the advocates of Asia-as-*technê* described in this book asserted that the technologically superior West had too aggressively espoused the dictates of industrial life, and that it was necessary to turn to the culture and tradition of the East in order to recover the essence of some misplaced or as-yet-unfulfilled modern identity.

The fantasy of Asia-as-*technê* has become so ingrained in Western cultural discourse, it is often taken to be as commonsensical as it is important to "our" need to be rescued from technological oppression. Take, for instance, Hubert Dreyfus's nuanced and very careful elaboration of Heidegger's notion of *technê*. In a rigorous reading of "The Question Concerning Technology," Dreyfus explains that the principal objection to the modern experience of "being" offered in Heidegger's essay has to do with what Dreyfus identifies as the "technological paradigm" that dominates our current ontological condition: "the technological paradigm embodies and furthers our technological understanding of being according to what does not fit in with our current paradigm—that is, that which is not yet at our disposal to use efficiently (e.g. the wil-

derness, friendship, the stars)—will finally be brought under our control, and turned into a resource."[20] Dreyfus then explains that while Heidegger attempts "to point out to us the peculiar and dangerous aspects of our technological understanding of being," this warning should not be read as opposition to technology as such: "he is not announcing one more reactionary rebellion against technology, although many take him to be doing just that. Nor is he doing what progressive thinkers would like to do: proposing a way to get technology under control so that it can serve our rationally chosen ends" ("HC," p. 359). Heidegger's is no antimodernist philosophy, in other words. The threat posed by the technological paradigm is an *"ontological condition"* requiring an entire *"transformation of our understanding of being,"* rather than a mere reaction against the modern devastation of nature caused by modern technology ("HC," p. 361; emphasis in original). What Heidegger says we need is, in Dreyfus's words, "a way we can keep our technological devices and yet remain true to ourselves" ("HC," p. 362). It might help, he continues, if we had some "illustration of Heidegger's important distinction between technology and the technological understanding of being" ("HC," p. 363). Here, Dreyfus argues, "we can turn to Japan":

> In contemporary Japan traditional, non-technological practices still exist alongside the most advanced high-tech production and consumption. The TV set and the household gods share the same shelf—the styrofoam cup co-exists with the porcelain tea cup. We thus see that the Japanese at least, can enjoy technology without taking over the technological understanding of being. ("HC," p. 363)

The point here, according to Dreyfus, is that the "Japanese understanding of what it is to be human" (so different from "us" in the West "who are active, independent, and aggressive—constantly striving to cultivate and satisfy our desires") is somehow both highly technological *and* organic, mechanical *and* holistic ("HC," p. 351). The "Japanese, at least," got it right. If it seems that a number of stereotypes have gone unexamined here (and this in an essay remarkable for its rigorous thought otherwise), it is worth pointing out that Dreyfus may not have felt the need to stop and ponder the historical context of these assumptions precisely because they seem so obvious and necessary. Perhaps Dreyfus was already familiar with, among others, Arnold Pacey's attempt to philosophize an "ethical view of how technology should be used" in *The Meaning in Technology* (1999). "Daoist sentiment," Pacey writes, "which is not against technology, but which avoids the attempt to conquer nature by means of massive forms of construction, may be a philosophy that can be adapted to address some of our present dilemmas."[21] It is the civilizational (and especially aesthetic) alterity of the East held up again as the last remaining path to an organic modern life—a path that that will lead us to salvation, as Pacey's title suggests, *in* technology, not *from* it.

As I hope to demonstrate in this volume, to tell the story of Asia-as-*technê* alters the entire landscape of Anglo-American modernism and its global continuities in postmodern culture. Concerns that had appeared primarily local, national, or otherwise overdetermined by transatlantic discourse are suddenly, intensely trans*pacific* as well, thrown into the much more complicated, tangled mesh of global modernisms.[22] As such, the chapters in this book are in constant dialogue with transpacific studies of Asian-American cultural production and with the burgeoning fields of technoculture, media theory, and communication studies, searching for more engaged modes of hybrid disciplinarity throughout.[23] Much of what made this interdisciplinary reading necessary was the simple fact that all of the writers and artists

depicted here were hyperaware of both the ethnic and technological conditions of their work. Put another way, to read these authors and artists responsibly required taking into consideration both the highly self-reflexive attention they gave to technique—in every sense of the word—and the resulting racial and cultural identities they associated with that technique.[24] In chapter 2, for example, I show how the attention given to new technologies of bookbinding during the late nineteenth and early twentieth centuries caused designers and even many authors to begin questioning the aesthetic demands of mass production and to turn to Eastern modes of design as a way of restoring the "fallen" art of the book. In chapter 3, I argue that the career of the most popular American author of the 1910s, Jack London, was powerfully shaped by an incessant "machine" anxiety, influencing not only his socialist writings on Western industrialism and literary production, but also his highly influential and contradictory responses to Japanese and Asian-Pacific "others." Chapter 4 turns to one of the most canonical texts of Anglo-American modernism, Ernest Fenollosa's *The Chinese Written Character as a Medium for Poetry* as edited by Ezra Pound, demonstrating that whereas the ideograph had for Fenollosa served as a corrective to the aesthetic dilemmas initiated by Western machinism, Pound read precisely the opposite into Fenollosa's essay, offering the Chinese character as a correlative to modern machine energies, thereby shaping much of Anglo-American modernist art according to the contradictory vortices (and political dilemmas) of a retrospective futurism. In chapter 5, I argue that the efforts of the most widely read Asian-American author of the 1930s and 1940s, Lin Yutang, to design and build a Chinese typewriter both informed his own literary production and harnessed several decades of Asian/American thinking about the role of technology in international discourse. The internationally popular "Oriental detective" film genre I analyze in chapter 6 has to be understood against the backdrop of not only presumptions about the inherently aesthetic qualities of Asian culture (portrayed in contrast, constantly, to the overmechanized wasteland of the Anglo-American metropolis), but also the Hollywood studios' cinematic techniques of corporate "authorship." Chapter 7 introduces the notion of *technê*-zen, which, I argue, serves as the overarching ethos of global capitalism, shaping everything from theories of corporate management to the digital products we have come to rely on in our everyday experience—much of which can be traced back to the questions of East–West *technê* raised in Robert Pirsig's *Zen and the Art of Motorcycle Maintenance*. My final chapter, "The Meeting of East and West," summarizes the longer trajectory of Asia-as-*technê*, detecting its influence in a series of movements in early twentieth-century architecture (in Frank Lloyd Wright's Japan), postwar philosophy (F. S. C. Northrop's cybernetic comparativism), and contemporary art and electronic culture (the "Buddha Machines" of FM3 and Wang Zi Won). The scope here is expansive, but my objective is not to provide a complete taxonomy of Asia-as-*technê* in all its modes throughout the twentieth century. Indeed, readers familiar with these intersecting discourses may wonder why some authors or works of art are not more thoroughly analyzed (much more could be made, for instance, of Asia-as-*technê* in the work of Joseph Needham, Pearl Buck, Marshall McLuhan, Gary Snyder, and so on). Put simply, rather than attempting a thorough analysis of every moment of Asia-as-*technê*—an impossible task, in any case—this book attempts to identify and read closely moments of critical convergence, wherein concerns over modern technology, Anglo-American rationalism, and Asian aesthetics are concentrated in particular periods and texts, which may then open up spaces for the elucidation of these intersecting concerns in corresponding figures.

Mechanical Methods and the Art of the East

Having acknowledged as much, I hasten to add that there are important reasons for examining the specific moments and figures represented in this book. As we shall see in several chapters, for instance, one extremely important event in the development of this discourse occurred with the World's Columbian Exposition in Chicago, 1893, an event I turned to initially with some trepidation. Surely, I thought, there could be nothing so shopworn and overdetermined as to posit 1893 as the de facto birth of the twentieth century, that moment when American exuberance over corporate and technological progress reached fever pitch.[25] In delving into these archives, however, what I found in Chicago 1893 was evidence of something quite different from the typical story of wholesale enthusiasm over the new machines of modern life. Consider, for example, this famous passage from Robert Herrick's early twentieth-century novel, *Memoirs of an American Citizen*, quoted frequently in histories of the Chicago Exposition to illustrate just how overwhelmingly positive the experience was for its visitors:

> The long lines of white buildings were ablaze with countless lights; the music from the bands scattered over the grounds floated softly out upon the water; all else was silent and dark. In that lovely hour, soft and gentle as was ever a summer night, the toil and trouble of men, the fear that was gripping men's hearts in the markets, fell away from me and in its place came Faith.[26]

There are hints here already that not all is as it should be ("toil and trouble," "fear gripping men's hearts"). But observe what Herrick's protagonist says next: "Nevertheless, in spite of hopeful thoughts like these, none knew better than I the skeletons that lay at the feast." What, I wondered, were these skeletons?

The problem was not just that the mechanical world of the fair was sometimes dangerous—as, for example, when a young woman got stuck in between the doors of an elevator as it began rising in the Home Insurance Building; or when some exhibitors in Electric Hall thought it would be funny to wet the ground in front of their dynamo and shock passersby with hundreds of volts of electricity (including, apparently, a crying baby and an elderly woman whose "form grew rigid" as the volts shook her body).[27] Nor was it just that the machines themselves were so screechingly loud and unpleasant that viewers could rarely stay for long in Machinery Hall.[28] The real problem (the real "devil" in the White City) was that the machine had become so vast and systemic that no one could fully understand, much less control, its relentless advance. In the 1880s and 1890s Americans saw the rapid mechanization of the agricultural, packing, and mining industries, a dramatic acceleration of railroads and speculative finance (including the Panic of 1893), the widespread use of new technologies of communication (telegraphs, typewriters, telephones, and so on), and a massive increase in factory machinery, worker exploitation, and urban poverty. All of it seemed to indicate that these new advances in mechanization were causing their own brand of gilded turmoil. Even rural American areas seemed to be in danger of being swept up in the coming wave of machine culture.[29] As Herrick would write regarding another of his protagonists in Chicago,

> He took the cable car, which connected with lines of electric cars that radiated far out into the distant prairie. Along the interminable avenue the cable train slowly jerked its way, grinding, jarring, lurching, grating, shrieking—an

infernal public chariot. [He] wondered what influence years of using this hideous machine would have upon the nerves of the people.[30]

Here Herrick's protagonist betrays a striking familiarity with Max Nordau's *Degeneration*, a trenchant critique of urban life that would appear in English in 1895, citing a host of new diseases attributable to "the present conditions of civilized life," including conditions known as "railway-spine" and "railway brain," which supposedly developed as a consequence of "the constant vibrations undergone in railway traveling."[31] These thoughts reflect, in any case, a vision of Chicago that, as we shall see in chapter 3 especially, gave lie to the glories at Jackson Park: "The saloons, the shops, the sidewalks, were coated with soot and ancient grime. From the cross streets savage gusts of fierce west wind dashed down the avenue and swirled the accumulated refuse into the car, choking the passengers, and covering every object with a cloud of filth. . . . It was *the machine* that maddened him."[32] For many middle-class Americans, this growing anxiety about the machine and the "industrial traffic" of American urban centers even manifested itself in depressions known as "neurasthenia," with symptoms including everything from headaches and "wretchedness," to "morning depression" and intestinal discomfort.[33] As one Arts and Crafts activist put it, "the introduction of machinery with its train of attendant evils has so complicated and befuddled our standards of living that we have less and less time for enjoyment and for growth, and nervous prostration is the disease of the age."[34]

In terms of the effects of these new mechanical wonders on the arts, there were apparently even more immediate dangers. Indeed, if there was one thing that everyone at the Congress of Art Instruction at the World's Fair in Chicago in 1893 could agree on it was that the machine had done something horrible to art. All of the speakers invited to address the artists and educators who had gathered at the event to discuss art instruction had something to say about it.[35] L. W. Miller, the principal at the School of Industrial Art in Philadelphia, for example, spoke on the need for "artistic as distinguished from mechanical methods," by which he meant not only methods of copying and mimetic representation but also a whole "habit of mind . . . mechanical because, like the work of a machine—however accurate and even delicate it may be—it is not self-directed, and its product is not the embodiment of an original conception."[36] In Western art and culture, Miller continued, we have been far too eager to "pin our faith to the mechanical," which "cramps the mind instead of expanding it."[37] J. M. Hoppin, professor of art history at Yale, similarly argued that the "present tendency in our country is decidedly scientific, to the exclusion of art and to the benefit of trade," and that new methods of mechanical reproduction had endangered the status of art: "when art loses the sense of beauty [it] loses its vocation, and it might as well be science at once . . . till it sink into the material, into, say, the literalism of photography."[38] Mary Dana Hicks, the director of art instruction at the Prang Educational Company in Boston, agreed, contending that drawing should not be an "external and mechanical thing," but rather a "means of broadening the horizon of the pupil and leading him onward and upward by contact with a broader and higher mind."[39] Professor J. Ward Stimson, head of the Institute of Artist-Artisans in New York, noted, "art must be vital, not mechanical or imitative," and so we must move "away from present mechanical, materialistic, and imitative processes" of art instruction.[40] In short, the general consensus was that to talk at all about art and the machine was to raise the specter of mass reproduction and a whole series of associated industrial dilemmas.

The one exception to this argument against "mechanical methods" at the meeting was the British artist Aimee Osborne Moore, who, embarrassingly enough, had brought a machine with her to the conference. "I may as well say at once," she confessed after taking the podium, "that mechanical help is to come in somewhere."[41] Holding up her apparatus (a wooden frame with an open space on its left side covered by a transparent gelatin to which was attached an elastic string, and under which a wooden arm extended forward and then angled up toward an eyepiece; Figs. 1.5–1.6), Moore began detailing what she called the "philographic method" of teaching art. This particular device, she explained, combined the perspective machines employed by Leonardo, Albrecht Dürer, and others, and the principle of the pantograph artists and drafters had been using for centuries to create scaled copies of their subjects. Even Moore, however, felt compelled to defend her mechanical device in terms that underscored the other participants' wholesale insistence on the seemingly intractable dichotomy between art and modern machine culture:

> We use these instruments chiefly as tests of freely done drawings because it is not reasonable to expect the hand and eye which did a certain work to have the further accuracy necessary for immediately judging and testing that work; and we maintain that the use of such helps, by enabling the beginner to attack much more difficult subjects than he could do otherwise— namely, the drawing of irregular organic forms—*prevents his being himself a machine,* as he is apt to be when tied down to the constant repetition of inorganic geometrical forms.[42]

What this effort to avoid "becoming a machine" had to do with Asian aesthetics will become obvious in the chapters that follow (as we shall see in chapter 4, Ernest Fenollosa was himself a participant at the conference). But it is worth pointing out here that both Hockney's dilemma and his implied solution were already on the ground, running, when this Congress of Art Instruction met in 1893. As Professor

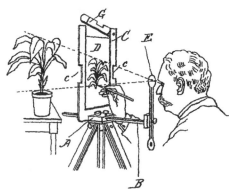

Fig. 1.5. (Left) Illustration of Aimee Osborne Moore's "philographic" apparatus in John Forbes-Robertson, "The Philographic Method of Drawing," *The Magazine of Art* (London: Cassell & Co. Ltd., 1893), p. 319.

Fig. 1.6. (Above) Illustration from the patent for Moore's device "Apparatus for Sketching," U.S. Patent # 544,642.

Stimson concluded, in stark contrast to the Western, mechanical "demon of cheap affectation and imitation," instructors might now turn to the "modest but magnificent art among [the] Japanese" represented at the fair. The Japanese, he explained, are "in complete sympathy with themselves and nature," creating an art that is "more organic and instinctive," generated in "the village schools, which during recess send the children to the river banks or carp pools, that on return they may draw *from memory* the fresh impressions of form, color, motion, and setting." It is precisely this Japanese mode of "essential art," Stimson argues, that "must be ever the directest as it is the sincerest method."[43] The implicit suggestion, already, was that only the inherently aesthetic tradition of the East could rescue us from the inherently mechanical demons of the West. How this idea came to be so central to our contemporary techno-cultural landscape, shaping everything from corporate management theories to the design of one's digital devices, is the larger story of *The Buddha in the Machine*.

2. The Teahouse of the American Book

Boston Bindings and Asia-as-*Technê*, 1890–1920

Amid all the hustle and jam on the grounds and in the buildings
at the World's Fair there is one quiet spot in which the tired
sight-seer may rest. Here the tired mortal may get away from the
great crowds, the glare of the light, the endless array of exhib-
its. . . . Nowhere on the Fair grounds can an hour's respite be more
pleasantly employed.
— *World's Columbian Exposition Illustrated* (1893)

The largest steamer that crosses the Pacific could not contain what
you wish to purchase.
—Lafcadio Hearn (1894)

When at the Columbian Exposition in Chicago, 1893, Japan's exhibits were characterized as a "quiet retreat" and "an hour's respite" from the hyper-mechanized world of the fair (and, by extension, as a therapeutic alternative to the neurasthenia-inducing industrialism that afflicted so many Anglo-Americans in the late nine-teenth century), such sentiments rather neatly coincided with those of two generations of American travelers in Japan.[1] The stark contrast, for instance, between the gargantuan, clanking dynamos in Machinery Hall (to say nothing of the overwhelming mechanical exhibits in Electricity Hall and the Manufacturers Building) and Japan's peaceful garden complex, teahouse, and Ho-o-den pavilion on the Wooded Island seemed to confirm everything travelers such as James Jackson Jarves, Edward S. Morse, and Lafcadio Hearn had been saying for over a decade (Figs. 2.1–2.3).[2] As Jarves wrote in 1876, whereas American art and manufacturing seemed "mechanical and soulless," Japanese artists showed "absolute technical perfection, aesthetic and material."[3] According to Morse (who taught evolution at Tokyo Imperial University in the late 1870s), Japanese modes of production were so "clean and neat," their products so inherently "beautiful," "exquisite," and "marvelous," that "Ruskin would have thought he was in the seventh heaven."[4] For Hearn (who as a reporter in the 1880s had already been decrying the arrival of machine culture in New Orleans when he traveled to Japan in 1890), the "exotic streets" of Yokohama offered appealing visions of a more therapeutic modern experience—one that did not exclude technology as such, but seemed to have successfully reframed it by privileging the aesthetic:

The old and the new mingle so well that one seems to set off the other. The
line of tiny white telegraph poles carrying the world's news to papers printed
in a mixture of Chinese and Japanese characters; an electric bell in some

tea-house with an Oriental riddle of text pasted beside the ivory button; a shop of American sewing-machines next to the shop of a maker of Buddhist images; the establishment of a photographer beside the establishment of a manufacturer of straw sandals: all these present no striking incongruities, for each sample of Occidental innovation is set into an Oriental frame that seems adaptable to any picture.[5]

For Hearn everything in Japan seemed "limpid," "lucid," and "elfish."[6] It was a "land of infinite hand-made variety [where] machinery has not yet been able to introduce sameness and utilitarian ugliness in cheap production."[7] Unlike the factories and manufacturers in the West, in other words, Asian craftsmen and artists had apparently refrained from committing "the serious blunder of confounding mechanical with ethical progress."[8]

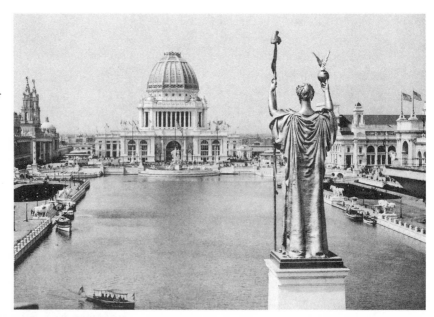

Fig. 2.1. "Grand Basin and Court of Honor" at World's Columbian Exposition, Chicago, 1893, in Hubert Howe Bancroft, *The Book of the Fair* (Chicago: The Bancroft Company, 1893), p. 370.

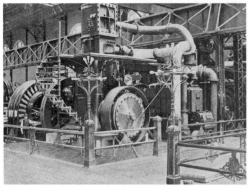

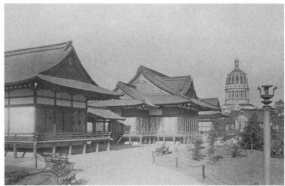

Fig. 2.2. "Westinghouse Engine" at World's Columbian Exposition, Chicago, 1893, in Hubert Howe Bancroft, *The Book of the Fair* (Chicago: The Bancroft Company, 1893), p. 309.

Fig. 2.3. "Ho-o-den, the Wooded Isle" at the World's Columbian Exposition, Chicago, 1893, in William Walton, *World's Columbian Exposition, MDCCCXCII: Art and Architecture* (Philadelphia: George Barrie, 1893), p. xli.

The World's Fair in Chicago, then, offered many Anglo-Americans their first opportunity to experience the modern value of Asia's *technê*—and the Japanese exhibits did not disappoint. The official *Report of the Committee on Awards of the World's Columbian Commission*, for example, has Japan receiving numerous accolades and prizes for its cotton goods, its bronze sculpture and cloisonné, its wood arts, paintings, and calligraphy, its kiln-fired charcoal, turpentine oil, and vegetable wax, its publications of statistics in trade and commerce, its 590 different species of herbaceous plants, its culinary arts (especially its oysters and cured shellfish), its ingenious architecture, and its offerings in dozens of other categories.[9] The judges' reports were filled with comments like "No other country has shown [such] artistic aptitude" and "Space fails in describing the really wonderful exhibition that the Japanese have sent."[10] One popular novel written to capitalize on the excitement of the fair, Charles Stevens's *The Adventures of Uncle Jeremiah and Family at the Great Fair*, aptly characterizes many of these feelings. In one scene halfway into the narrative an elderly woman sits down to rest with a friend in the Japanese section of the Manufacturers Building. Fascinated with the pottery display, one of the women says, "I don't see the use of sending missionaries to Japan," to which the other replies, "I don't believe they are so very bad after all. I can't believe that anyone who could make such things could be a very wicked heathen. I should think the Japanese would almost feel like sending missionaries over here."[11]

But the world's fair was not the last, or even only, means of experiencing Asia's *technê* as an alternative to (and, as we shall see, an increasingly fundamental part of) modern American culture. As a number of scholars have shown, the technological sublimities, methods of display, and modes of consumption associated with the world fairs of the late nineteenth century found local and distributed expression in the rise of the American department store.[12] Just as the Columbian Exposition overwhelmed spectators with incandescent bulbs, arc lights, electric fountains, white neoclassical facades, dynamos, and a host of new information technologies (telephones, telautographs, type-wheel typewriters), transportation technologies (moving sidewalks, escalators, elevators, the Ferris wheel), and products for mass consumption (Juicy Fruit gum, Quaker oats, Cream of Wheat, Shredded Wheat, Cracker Jacks, Hershey's chocolate)—American department stores quickly followed suit, capitalizing on the fairs' methods, and, in some cases, even preceded fairs in introducing consumers to these new forms of modern life. Made up of largely autonomous and modular units (each "department" was run by its own unique "buyer"), department stores were even organized and internally networked like world fairs (Figs. 2.4–2.5). By the mid-1890s, for instance, nearly every department store in the United States had installed a system of pneumatic tubes in its building as a means of circulating money and credit transactions, turning each store into a kind of throbbing organism with a central nervous system located in what was called the "tube room" (Fig. 2.6).[13] Department stores were typically located at the hubs of America's growing public transportation networks, and led the charge in transforming American retail methods away from modes of slow stock turnaround and toward economies of rapid product obsolescence and stockturn velocity—putting hundreds of smaller retail establishments out of business in the process.[14] And just as a visit to the Japanese exhibits had become such a valued part of the Anglo-American experience of the world's fair, Japanese wares very quickly became an integral component in American department store organization as well. Consider, for example, the curious mode of presenting Japanese wares in department store advertisements of the mid-1890s (Figs. 2.7–2.9). In

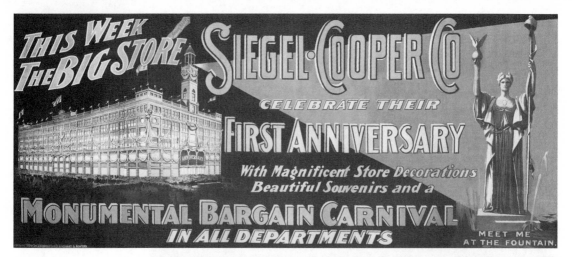

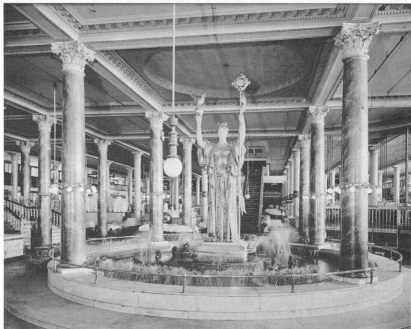

Fig. 2.4. Poster for Siegel-Cooper Department Store sale, New York City, 1897, Library of Congress, pictures, item 99472757.

Fig. 2.5. Fountain at the Siegel-Cooper Department Store in New York City, ca. 1903, Library of Congress, pictures, item 1994009614. Notice the replica of the liberty statue from the Court of Honor at the Columbian Exposition shown in Fig. 2.1. The Siegel-Cooper occupied an entire city block on Sixth Avenue, with direct access to and from the city's elevated train trestle.

what was then a new and highly attention-grabbing technique, department stores purchased entire pages of newspaper space, listing their various bargains in categories such as "Picture Dept.," "Book Dept.," "Jewelry Dept.," "Kitchen Dept.," "Bedding Dept.," and—nearly always—"Japanese Dept."[15] If, as Alan Trachtenberg has argued, in the department store the "citizen met a new world of goods; not goods alone, but a *world* of goods," what did it mean that "Japanese" had become so important (and trivially commodifiable) to that "world" that it required its own department? How did the "Japanese Dept." become such a fundamental part of what Trachtenberg calls the department store's "pedagogy of modernity"?[16]

In attempting to answer those questions it is worth noting that the growing middle-class desire to gain access to Asia's *technê* through the purchase of Oriental art objects was something Hearn understood well, even if he was sometimes troubled

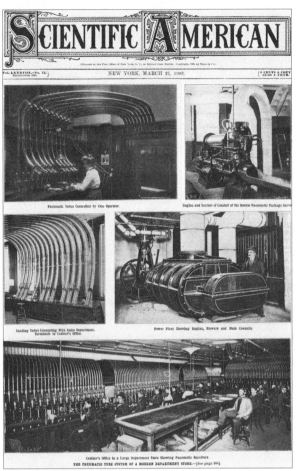

Fig. 2.6. (*Top left*) Cover story on "The Pneumatic Tube System in a Modern Department Store," *Scientific American* (March 21, 1903), p. 206.

Fig. 2.7. (*Middle*) Advertisement for J. H. Walker Co. Department Store (*Boston Daily Globe*, February 14, 1894).

Fig. 2.8. (*Top right*) Advertisement for Siegel-Cooper Department Store, *Chicago Tribune* (March 4, 1894).

Fig. 2.9. (*Bottom left*) Advertisement for Wm. H. Zinn Department Store, *Boston Daily Globe* (September 25, 1892).

by its implications. Notice, for example, the curious ambivalence with which Hearn reports on his first experience shopping in Japan. After explaining that seemingly everything he encounters is "delicate," "exquisite," and "admirable" (from paper bags to chopsticks, bank bills to sweat towels, even the "plaited colored string used by the shopkeeper in tying up your last purchase"), Hearn warns:

> But it is perilous to look at them. Every time you dare to look, something obliges you to buy it—unless, as may often happen, the smiling vendor invites your inspection of so many varieties of one article, each specially and all unspeakably desirable, that you flee away out of mere terror at your own impulses. The shopkeeper never asks you to buy; but his wares are enchanted, and if you once begin buying you are lost. Cheapness means only a temptation to commit bankruptcy; for the resources of irresistible artistic cheapness are inexhaustible. The largest steamer that crosses the Pacific could not contain what you wish to purchase. For, although you may not, perhaps, confess the fact to yourself, what you really want to buy is not the contents of the shop; you want the shop and the shopkeeper, and streets of shops with their draperies and their habitants, the whole city and the bay and the mountains begirdling it, and Fujiyama's white witchery overhanging it in the speck-less sky, all Japan, in very truth, with its magical trees and luminous atmosphere, with all its cities and towns and temples, and forty millions of the most lovable people in the universe.[17]

As Hearn tells it, the moment one "dares to look," some object of Asian artistry—some *thing* with a kind of enchanted, inexhaustible power—"obliges you to buy it." It is a passage of luminous and almost frightening desire ("enchanted," certainly, but also one of "terror," "temptation," and "witchery") that could have come straight from Theodore Dreiser. Notice, for example, that the protagonist of Dreiser's later novel *Sister Carrie* (1900) experiences almost precisely these tensions as she visits a Chicago department store (called, not coincidentally, "The Fair"): "Each separate counter was a show place of dazzling interest and attraction. She could not help feeling the claim of each trinket and valuable upon her personally and yet she did not stop. There was nothing there which she could not have used—nothing which she did not long to own. The dainty slippers and stockings, the delicately frilled skirts and petticoats, the laces, ribbons, hair-combs, purses, all touched her with individual desire."[18] Later in the same novel, when Dreiser reflects on Carrie's desires in these stores, he notes that the objects even "spoke tenderly and Jesuitically for themselves. When she came within earshot of their pleading, desire in her bent a willing ear . . . 'My dear,' said the lace collar she secured from Pardrige's, 'I fit you beautifully; don't give me up.' 'Ah such little feet,' said the leather of the soft new shoes.'"[19] Bill Brown has noted that these scenes reveal how "the new retail establishments energized the potent paradox of mass consumption, which is the singularity, the *difference*, that every commodity promises, however standardized it is," and that all of Dreiser's fiction illustrates the "extent to which the energized possessor is hardly satisfied by any mark of success; for the 'drama of desire,' . . . is a play without end, a performance where no curtain falls."[20] But if, as Brown argues, Dreiser stands out among American writers as the "most devoted to *things*" and the quasi-metaphysical desire initiated by their presence (and, paradoxically, distance, if viewed longingly through a department store's plate-glass windows), it is worth pointing out that there is clear evidence Dreiser was channeling, or at least very carefully reading, Hearn. It is not simply that Dreiser's attitude

toward Carrie's desires ("Be it known that this is not fine feeling, it is not wisdom") seems to directly coincide with Hearn's ("if you once begin buying you are lost"). Dreiser's culling from Hearn is even easier to pinpoint. Although he was apparently never called out on it, at precisely the same time Dreiser was writing *Sister Carrie* during the spring of 1899, he also wrote an article titled "Japanese Home Life," directly plagiarizing several pages from Hearn.[21] In fact, it is tempting to argue that Dreiser may even have thought there was something inherently "Oriental" in Carrie's experience of the department store, given, that is, her later success in the novel performing as one of a "group of oriental beauties" at a theater "notable for its rich, oriental appearance." But there is perhaps an even more salient reading that Dreiser's tendency toward acquisitive plagiarism offers, gathering, as he did, so many passages from Hearn into his own article—repackaging, rebranding, and then reselling them with an almost department-store-like smoothness. Both Dreiser and Hearn go out of their way to tell us that there is something spiritually problematic about this conspicuously modern desire to collect goods as a means of regenerating some therapeutic, other-than-modern experience, but they both want—and had clear financial reasons for wanting—the game to work. Indeed, what Hearn's books (like so many other Oriental books circulating at the time) supposedly offered readers back in the United States was a means of accessing not only an object of the Orient but also all the otherworldly and inaccessible aspects of Asia's *technê* that Hearn's imagination could convey— much more, that is, than was offered by any Oriental doily or silk fan. As his publishers in Boston and the various department stores carrying his volumes clearly understood, to buy and read one of Hearn's highly aestheticized books was to put oneself in his place as he shopped in Japan, coming into vivid contact with all those things that even "the largest steamer that crosses the Pacific could not contain."

It would be a mistake, however, to assume that Anglo-American travelers in Japan and white middle-class consumers were the sole proprietors of Asia-as-*technê*'s circulation in the West. If, as Thomas W. Kim argues, the Orient was "conceived as masses of objects awaiting discovery by Western collectors," and that it was "rendered abstract, static, and graspable as an aesthetic whole in the realm of consumption," it was not *only* conceived as such under the conditions of this discourse.[22] Just as Hearn was not the only agent in the scene above wanting the lure of Asia's ancient aesthetic to work (certainly the "smiling vendor" was only too happy to see Hearn's anxious desire for his wares), a number of Asian and Asian-American artists and intellectuals living in the United States in the late 1890s and early 1900s were similarly eager to take advantage of the turn to Oriental *technê* as a palliative against the mechanization of modern life. Indeed, the burgeoning discourse of Asia-as-*technê* in this era was as important for Boston Orientalists as it was for Orientals in Boston, as much a medium of modernity for Anglo-American consumers as it was for Japanese nationalists concerned with Japan's international standing. As we shall see, it also transformed the way Americans experienced books in general—and not only those dealing with the Orient. Thus, in an effort to understand how these complex effects of Asia-as-*technê* worked together to transform the entire field of book production in the 1890s and early 1900s, this chapter turns to two interrelated phenomena: first, the rise of a new Oriental mode of design in book publishing (particularly in the work of Sarah Wyman Whitman and her circle), which flourished in Boston as a means of cultivating a new, supposedly more organic culture less determined by the machines of modern industrialism; and second, the promotion of Asia-as-*technê* among Japanese artists and intellectuals in New England book culture (and particularly in

the work of Genjiro Yeto and Okakura Kakuzo) as a means of constructing a modern Japanese nationalism supposedly capable of both adapting to and transcending the machines of Western modernity.

Asia-as-*Technê* and the Boston Book Movement

What would consumers have encountered walking into Boston's Old Corner Bookstore at the corner of Washington and School streets in the late 1890s? The Old Corner Bookstore had been an important venue for many of the most famous literary minds of the nineteenth century (Hawthorne, Emerson, Thoreau, Stowe, Dickens), but according to Van Wyck Brooks, New England in the 1890s was in the midst of an "Indian Summer," by which he meant both an increased attention to the Orient (hence the labeling of those in the Boston aristocracy as "Brahmins"), and, more critically, a general loss of cultural vigor and intellectual energy.[23] But if Boston's literary culture in the 1890s was, as Brooks argues, "indolent and flaccid," it certainly did not seem that way to book publishers. On the contrary, publishing by that time had become the largest business in Boston city limits, moving hundreds of thousands of books into circulation across the United States and generating a "golden age" in the art of bookbinding.[24] In short, by the late 1890s the notion of the book as an art object, present since the beginning, had suddenly become an integral part of consumer culture, something the masses understood that they might also cultivate. Artists from around the country were suddenly coming to Boston to learn and practice the new and commercially rewarding art of book design.[25]

What would consumers have seen and felt as they handled one of these new books in the late nineteenth century? Bookmakers had by then long since perfected the mechanized process of decorative gold-stamping (introduced with the invention of the "arming press" in the 1830s as a way of providing machine-bound books with the look and feel of handcrafted volumes), and these new cloth-bound books, less expensive than leather or "de Luxe"editions but allowing for more vibrant color, were dazzlingly decorated.[26] If books had dust jackets at all during this time they were much less elaborate and artistic than the bindings themselves, and were usually discarded after purchase—if not beforehand by booksellers who knew that an elegant binding was a book's best advertisement (in the 1910s this process would reverse, with less expensive dust jackets becoming more prevalent, gradually decreasing the number of gold-stamped editions).[27] Since the 1870s, publishers had been lavishing special attention on books dealing with the Far East, creating elaborate Orientalized designs that were then stamped onto cloth bindings in radiant gold leaf and other colorful foils. Most of these designs in the 1870s and 1880s reflected (à la *horror vacui*) fairly typical Western visions of an ornate, quasi-baroque Orient, with cluttered illustrations of "Oriental life" set alongside exaggerated faux-Eastern script, busy designs, garish colors, and gaudy ornamentation (Plates 12–17).

The convergence of an American fascination with Japanese aesthetics and the Arts and Crafts movement of the 1890s, however—due in large part to the "Japanism" of French and British art communities and the massive influx of Japanese woodblock prints to the United States—brought with it a new aesthetic sensibility for the art of the book.[28] Members of the Boston book movement, as the group of designers eventually came to be known (this despite the fact that New York figured prominently as well as a site of design and production), began citing the more subtle colors, bold lines, flat, geometric simplicity, and strategic use of negative space they found in Japanese *ukiyo-e* prints.[29] The most influential figure to do so in the realm

of book design was Sarah Wyman Whitman, a well-established stained-glass artist from Lowell, Massachusetts, who had done her initial art training under William Morris Hunt before studying under Thomas Couture in Paris in the late 1870s and John La Farge in Boston in the 1880s.[30] All three of these teachers were fascinated with Asian aesthetics, and especially La Farge—who even before he visited Edward Morse and Ernest Fenollosa in Japan had published an influential essay on Japanese art in 1870 arguing that Japan's woodblock prints, "contrasted with our own brutal chromo-lithographs," cause one to feel as if one were "in the presence of a distinct civilization, where art is happily married to industry."[31]

Inheriting and adapting her various mentors' fascination with Oriental design, Whitman had by the mid-1880s already formulated a coherent philosophy on how Asia's aesthetic forms could help redeem the fallen "art of the book," and thereby counter what she understood to be the inherent dangers of machine culture. A charming socialite and enthusiastic speaker, Whitman held several prominent positions in Boston in the 1880s and 1890s and frequently gave talks explaining her aesthetic theories to aspiring artists.[32] In 1886, for example, she delivered a talk to a group of young artists on "The Making of Pictures," addressing the subject of illustration, or "pictures as such."[33] Clearly concerned with new technologies of reproduction and the cultural impact of aesthetic form, Whitman argued, "in the period in which we live, when mechanical adjustments and scientific processes have varied the methods of obtaining pictures, and multiplied their numbers almost infinitely, a very large part of the education of our country is carried on by means of pictures . . . we live in a world of pictures, and consciously or unconsciously, we are receiving numberless impressions from them."[34] But if "mechanical adjustments" were making pictures more ubiquitous, they were not necessarily making them better. Reiterating La Farge's distaste for chromolithography, Whitman argued, "Producing pictures in color by mechanical means can never be greatly developed so far as its artistic value is concerned, color as it is used in art being far too varied and subtle, far too dependent upon spontaneous expression for any other than human handling."[35] Thus, while "chromo-lithography has its place," Whitman insisted, "all the cleverness of mechanical contrivance and perfection of adjustment cannot bestow that intrinsic thing—the artist's feeling—which in original work is revealed in every tint; and without which, there is not art as such."[36] Whereas new technologies such as the heliotype and the photograph might be useful in replacing work of a "wholly mechanical nature" (as in the process of hand-copying an artist's original onto engravings or other previously labor-intensive methods of postproduction), a disappointing "want of sentiment" had "allowed machinery to attempt to produce what only the human hand, as expressing the human love of beauty, could produce."[37] There was too much "bad ornament," she explained, created by the machine's ability to reproduce whatever extravagant illustrations a publisher wanted. Against this development, Whitman advocated what she called a process of "conventionalization," or an "abstract expression," similar, she explained, to "Japanese decoration which is largely expressed by the omission of modeling, everything being done in a flat surface, or perhaps without light and shade."[38] Adhering to the eliminative, geometric style of Japanese prints, Whitman argued, would allow designers to overcome what had happened to book aesthetics in this era of "mechanical contrivance."

By the mid-1890s Whitman had successfully pioneered the role of "decorative designer," working as a mediator between authors and publishers, and the results showed a remarkable contrast from the Oriental books of the 1870s and 1880s. As

seen in covers for books by Hearn and Percival Lowell (Plates 18–21), for example, Whitman dramatically eliminated the busy, chintzy illustrations of Oriental life, the garish colors, and exaggerated type. Instead, Whitman's designs signaled a new and much more modern (and distinctly Oriental) form of composition: muted colors, bold, uncluttered designs, highly stylized objects from nature, and a marked emphasis on negative space.[39] It was a strategy specifically designed to invoke both the handcrafted traditions of the past and more efficient and stylized forms of modernity, creating in a number of her cover designs what historians of technology call *skeuomorphs*: reproductions of (or allusions to) earlier design elements that no longer serve any functional purpose except to serve as a reminder of those earlier designs.[40] In several of Hearn's volumes, for instance, Whitman had gold lines stamped along the spine, hearkening back to the exposed stitches of handcrafted Japanese book bindings, and pushed the title over onto the right-hand portion of the cover to recall the older aesthetic of European book clasps—a meeting of East and West, as it were, in complementary skeuomorphs.

At this point in her career Whitman was designing a majority of all new bindings for Boston's largest publisher, Houghton Mifflin and Company, and had even exhibited some of her book designs (to wide acclaim) in the Woman's Building at the Columbian Exposition in Chicago.[41] Visitors to the exhibit were so impressed with hers and other book designs at the fair that an exhibition was planned that same year at the prestigious Grolier Club for bibliophiles in New York, the very place where Japanese prints had been first exhibited in the United States just a few years before (and where another, even larger exhibition of Japanese prints would be held a few years later).[42] It was a venue where visitors throughout the 1890s were frequently encouraged to imagine a convergence of Oriental art and a new aesthetic in biblio-connoisseurship. The man in charge of organizing the Grolier Club's Japanese print exhibitions, Shugio Hiromichi, was an early member of the club and one of the first Japanese merchants to sell Oriental objects on Broadway in New York. In his catalog descriptions of the Japanese prints on exhibition Shugio paid special attention to the role of woodblock printing in Japanese book design, noting that it was the "artistic book illustrations" of print artists such as Moronobu and Hokusai that, more than anything else, allowed the woodblock print "to be regarded as one of the fine arts of Japan."[43] Members of the club, in short, would have already understood that a turn to Asia's *technê* was entirely consistent with the development of a new aesthetic in book design.[44]

The same year as the Grolier Club exhibition in New York Whitman was invited to give a presentation on book illustration to the Boston Art Students' Association, wherein she explained some of the specific theories behind her designs.[45] Just as she had theorized "pictures as such" for students in 1886, here Whitman turns to "the whole idea of the book," noting that the machine had once again done some damage: "In these days we have lost much in the way of bookmaking from the time when man gave their whole lives and time and thought to the making a book a beautiful work of art, the art of the craftsman. Many things which were done on the highest artistic principles have been lost."[46] Whitman is perhaps conveniently forgetting here that the book trade, even in the era of incunabula, had long since coalesced around methods of rationalization and mass production (including, in some of its earliest known manifestations, wage labor), but she is correct in noticing that something in book design had changed.[47] Notice, for example, what Whitman argues regarding the garishly designed Oriental books of the 1870s and 1880s: "Ten years ago you

would have found book covers, hundreds of them, which represented a combination of bad French art mixed with Japanese art scrolls and arabesques, which had to do with some debased form of book cover mixed with a bit of a Japanese fan, the suggestion of a sun, a stork, or strange diagonal lines." In these covers, Whitman explained, publishers had taken something "so beautiful in pure Japanese art," and rendered it "fatal and terrible" (*NIT*, p. 1).

The problem as Whitman saw it was that the market-driven modern publisher, flush with the suddenly endless possibilities of colorful chromolithography, seemed to think "that if the book is on mountains, for example, there should be a representation of a line of mountains on the outside," whereas in older books, "we see none of the coarse, familiar, and most inarticulate renderings of the inside of a book on the outside" (*NIT*, p. 4). In those older times, Whitman explained, there was a very good reason why bookbinders did not fall prey to the "almost insane desire on the part of publishers" to "put the whole contents on the cover." The difference, it turns out, was the machine. Whitman's argument relied on the fact that although the printing press had mechanized bookmaking in the fifteenth century, it was not until the early nineteenth century that the process of "case making" (securing a cloth or leather cover onto printed pages that had been folded and gathered into volumes) had become fully mechanized, finally allowing publishers to mass-produce books with uniform edition bindings.[48] While there is evidence that a small number of books were sold "pre-bound" in the sixteenth and seventeenth centuries, prior to the early 1800s if one wanted a cover for a given volume, one almost always had to take it (or arrange to purchase it after it had been taken) to a bookbinder, whereupon one would have to make all sorts of aesthetic decisions about what kind of leather (tanned calf, sheepskin, pigskin, etc.), what type of design (patterns tooled with gold leaf, fillets, roulettes, motifs with animals, monographs, etc.), whether or not to cut the pages, and so on.[49] What this meant in practical terms was that prior to the early nineteenth century, a book's binding was designed to say more about the book's *owner* than it was the book's *content*.

It is worth pausing here to note that this centuries-long differentiation between binding and printing offers yet another complication to one of the West's most precious myths about the democratic essence of print technology.[50] The traditional notion of print as a quasi-autonomous agent of Enlightenment and American republicanism, for example, generally assumes that printed objects rather consistently convey the following three interrelated messages, regardless of their cultural specificity: First, and most obviously, a printed object is assumed to say something like *I mean what I say*—that is, an encoded linguistic act on the page properly decoded by the reader allows for semantic content to be ascertained. Second, the printed object implicitly says, *I could do this again*—that is, its material existence indicates to the reader that it will be around later on to convey more or less what it said in the first place. Finally, the mechanically printed object says to the reader, *I am most likely doing this right now elsewhere with other people like you*; that is, what you have decoded and understood in the first place (and have assumed would be reproducible under the temporal conditions of the second) is being simultaneously decoded and understood by other people enough like you to have produced the same assumptions; hence, the emergence of something like a "public sphere."[51] But as Michael Warner argues in *The Letters of the Republic*, the "cultural meaning of printedness" was in fact a much more complicated process, one that did not necessarily lend itself to these specific political assumptions of enlightened democracy, and certainly not one that would

justify any characterization of mechanized print as existing prior to or outside cultural experience.[52] The history of bookbinding, in other words, provides further confirmation of how wrong it would be to assume that print technologies "caused" these political conditions. In the first place, the differentiating binding process already complicated the potential messages conveyed by a printed object. The text as held by the reader may have indicated *I am worth preserving*, but also (and even more frequently), *I am not worth preserving*.[53] It may have said, *I could do this again hundreds of times*, or it might have said, *I am so flimsy and ephemeral, I may be available for only a moment*.[54] It also disrupted and further differentiated print's relationship to its imagined communities. It said not—or, at least, not only—*I am potentially doing this right now elsewhere with people like you*, but rather, *I exist under the special material conditions you created for me to be here, and those conditions may not apply to me elsewhere at all*. Contrary to the assumption that printed objects were necessarily universalizing, democratizing, precultural agents, then, the centuries-long binding process actually allowed texts to say the opposite: *I exist for you individually and may not exist this way for anyone else—or if I do, I exist as a means of further codifying your (and their) membership in an exclusive or privileged community*.

Whitman, like many of her late nineteenth-century colleagues, accepted the notion of mechanically reproducible print as a democratizing agent, but she also valued the differentiating status of the book as an art object.[55] How were these twin commitments supposed to work together? The problem, as she understood it, was that inasmuch as more sophisticated forms of mechanization had allowed publishers to begin issuing uniform bindings, the natural impulse (insofar as the publisher wanted to market the book so that it stood out among others) was to create a cover that reflected what was *inside* the book, thereby forgetting, Whitman explained, that "it is the reader who owns it, who cares for it, who is going to have a certain feeling about the book, to whom the cover will have significance" (*NIT*, p. 4). But unlike the "private press" movement in England, which had been operating under many of the same assumptions about the aesthetic sins of industrialism while advocating a return to hand-run presses, Whitman wanted to restore the art of the book by way of mechanically *mass-produced* designs.[56] She wanted the "first idea of books, their form, their style of decoration, and those traditions [to] still regulate us," even though, she conceded, "we must take account of change, and one change has been in the enormous increase of books. Instead of having a few precious volumes we have now multitudes, myriads, published every year and sold cheap. That is one of the chief factors that you have to consider in making book covers. They are going to sell the book perhaps at sixty cents, wholesale. That makes a point in your whole scheme" (*NIT*, p. 5). The task for designers, then, was "to think how to apply elements of design to these cheaply sold books; to put the touch of art on this thing that is going to be produced at a level price, which allows for no hand work, the decoration to be cut with a die, the books to go out by the thousand, and to be sold at a low price" (*NIT*, p. 5). For Whitman, then, the value of the Oriental aesthetic of elimination was that it allowed the cover design to function not as a window or portal onto the book's contents but as a work of art in its own right. Something of the book's original distinction between cover and content could be restored: "Do not be led away by the people who want you to put the whole contents on the cover," Whitman explained. "Know the difference between a book done in an elegant and literary style or convention and one done in a florid and inconsequent mode of decoration."[57] Properly designed, the book could function as an "aesthetic tract," educating readers in the tradition of the book as an

art object as well as mirroring the reader's aesthetic experience with it rather than slavishly reproducing the contents of the book itself. "This is to be remembered," she concluded, "that the book shall be delicate, elegant, sensitive to the associations which the book has always had, and it must be done at the same time on the basis of cheapness, [and] of machine work."[58]

That a specifically Oriental aesthetic was at the center of Whitman's new design theories is also evident in what she chose not to reveal about many of her sources. Indeed, Whitman often quietly borrowed designs and images from Japanese paintings and prints in ways that were perhaps more than skeuomorphic. Notice, for example, the similarities between the crane in Whitman's cover for *The Soul of the Far East* and the woodblock print by the eighteenth-century Japanese artist Isoda Koryûsai, "Crane, Waves, and Rising Sun" (Plates 22–23). Or notice the precise similarities between the geese-in-flight seen on Whitman's cover for Longfellow's *The Song of Hiawatha* (1891) and the same geese-in-flight in one of Hokusai's woodblock print illustrations *The Hundred Views of Fuji* (1834) (Plates 24–25).[59] Or consider the striking similarities between Whitman's unique lettering design for the capital "A" and the ubiquitous portrayal of the Shinto *tori* gate seen in hundreds of Japanese prints (Plates 26–27).[60] Or observe the little roundels in one of Whitman's very first designs, usually described as an early attempt to merely mimic Dante Gabriel Rossetti's own Orientalized designs; here both Rossetti and Whitman have clearly borrowed from a handful of Japanese *mon* (traditional heraldic and family crests that were frequently printed in English and American reports on Asia at the time), but notice how much closer Whitman's roundels are to the actual Japanese *mon* (Plates 28–37).[61] In fact, Whitman seems to have been particularly fond of Japanese *mon*, placing them on dozens of books throughout the 1890s and early 1900s, and even working them into her designs for gravestones and stained-glass windows (Plates 38–43).[62]

The Dow of American Book Design

A few months after Whitman gave her lecture to the Boston Art Students' Association, the young painter, book designer, and art instructor Arthur Wesley Dow gave a talk to the same group arguing that, "Japanese art is the expression of a people's devotion to the beautiful. It is an art which exists for beauty only, in lofty isolation from science and mechanics, from realism and commercialism, from all that has befogged and debased other arts."[63] By this time Dow had already studied in Paris, returned to Boston, and experienced something of an epiphany while studying the collection of Japanese prints at the Museum of Fine Arts (developing, along the way, a close relationship with the curator Ernest Fenollosa).[64] In 1896, Dow began learning the process of Japanese woodcuts, exhibiting some of his own work at the Grolier Club in New York.[65] Three years later, he published an art and design textbook titled *Composition* that would change the way art education was conducted in the United States and bring Dow worldwide attention.[66] Indeed, whereas Sarah Whitman's influence in the book movement was felt primarily by way of visual reference (many saw and copied her designs, but very few would actually hear or read her theories on why she was designing the way she was), Dow's *Composition*, and especially its chapter on book design, exercised an enormous influence in the areas of pedagogy and aesthetic theory—even to the point that, as Joseph Masheck has recently argued, "probably no other book has influenced more people, especially Americans, to think in a modern way about art."[67] Quickly and enthusiastically adopted by design schools and universities in the United States and throughout the world, Dow's text became required

reading for virtually every student entering the art profession in the early 1900s. The editor of the journal *School Arts*, for example, wrote in 1904, "books of reference are to the teacher what dollars in the bank are to the merchant," but if a school could only afford "to make a beginning" of a reference library, it should choose first (of course) the *School Arts* journal, and then, a close second, Dow's *Composition*.[68]

The lessons of Dow's textbook (including its section on the proper design of books) were clear: "Avoid hard mechanical lines," he wrote, "and all that savors of rule and compass."[69] With frequent printed examples from Japanese artists including Sesshu, Hiroshige, and Hokusai, Dow argued that asymmetrical, patterned compositions and flat, abstracted forms of nature (one should "rigorously exclude detail") represented "the opposite of monotony," providing designers with an "artistic guidance" that reflected a more pristine, Orientalized *technê*.[70] The Japanese principle of *notan* (the eschewing of shadow in the arrangement of dark and light masses), for example, gets several pages of attention, and is put forward as evidence of a more directly aesthetic practice than the mimetic, "mechanical," and all-too-Western attempt to portray mass in "light and shade," which, since it is concerned with "merely the accurate rendering of certain facts of nature," was better understood as "a scientific rather than an artistic exercise" (Figs. 2.10–2.11).[71] In 1903 Dow even traveled to Japan and gave several lectures there, encouraging Japanese artists not to ignore their more traditional aesthetics, and to avoid repeating the mistakes of the West, where, he explained, "machines [have] hastened the decline of handicraft."[72]

Significantly, however, none of this meant completely abandoning new methods of technological reproduction. Dow himself was an avid photographer, believing that the medium—if placed in the hands of an artist—was capable of allowing for great works of art.[73] The problem was not so much the mechanical apparatus, Dow insisted, but the desire to "tell too much."[74] The goal for photographers, in other words, should be the same as the goal for painters and book designers: follow the lead of Japanese prints by abandoning the mechanical impulse to mimetically reproduce the world, and instead choose to expressively abstract it. "To the artist, a photograph that is perfect in every detail, that renders bare facts just as they are, is interesting as a scientific record and a value for scientific study, but it has no fine art in it. It is the work of light and chemicals, and produced by an operator, not an artist."[75] The genuine artist-photographer, then, was one who "takes the scientific process and makes it obey the will of the artist."[76]

True to this vision of Asia-as-*technê*, many of the most remarkable covers to emerge from the Boston book movement utilized sophisticated new technologies to produce a host of new and explicitly Oriental designs, all elegantly styled with abstracted forms from nature, colorful cloth bindings, Japanese stenciled patterns, asymmetrical compositions, and a striking emphasis on negative space.[77] Emma Lee Thayer, for example, one of many young artists influenced by both Whitman and Dow, created the design for Hearn's *Shadowings* (1900) and *In Ghostly Japan* (1903), with geometrically stylized images of lily pads and cherry blossoms photomechanically printed (following, again, the Japanese print's tendency to extend beyond the borders of the pictorial space) so as to wrap around the spines and back covers, forming a continuous image interrupted only by the paneled sections of the bindings (Plates 44–45). Thayer, along with her husband, Henry, established a professional art firm (Decorative Designers) devoted exclusively, to book design, creating hundreds of designs for Boston and New York publishers.[78] In their designs, and in the work of dozens of other book designers during the 1890s and early 1900s, one can clearly see

Fig. 2.10. (*Left*) Examples of the principle of *notan*, from Arthur Wesley Dow's *Composition* (Boston: J. M. Bowles, 1899), pp. 33, 47.

Fig. 2.11. (*Above*) Japanese woodcut illustrations reproduced in Thomas Cutler's *A Grammar of Japanese Ornament* (London: B. T. Batsford, 1880), plates 26 and 32; notice the strong diagonal lines and purposeful extension beyond the borders of the pictorial space.

the influence of this new Oriental aesthetic—countering, it was assumed, the banalities of machine culture by restoring the status of "art" to mass-produced book bindings (Plates 46–53).[79] Indeed, hundreds of traditional Japanese works of art were suddenly appearing on Boston and New York book covers. American designers went crazy over Japanese *mon*, for instance, stamping them alone on the center of covers, weaving them into floral patterns, even adapting them to look like publishers' logos—even though none of these books ever discussed or reproduced any of these *mon* in their pages (Plates 54–65). Seemingly every book or exhibition on Asian art had suddenly become a kind of stock image library for book design in the United States.[80] Birds from Japanese prints were traced onto books that had nothing to do with the Orient (Plates 66–69). Hokusai's waves were everywhere (Plates 70–71). Hundreds of book covers began to mimic the Japanese print's emphasis on vertical composition, its use of negative space, its abstracted and geometrized forms of nature, its extension beyond the pictorial border, and its use of foreground objects as framing devices (Plates 72–85). Publishers even began advertising that they were releasing "Japanese Editions" of American and British volumes—which meant not Japanese-language editions, but rather editions published on "Japanese paper," bound in "Japanese vellum," or illustrated in "the Japanese style" (see Appendix A for a representative sampling). Holiday "gift books" were frequently done up as Japanese editions—which helped to keep books, as Stephen Nissenbaum has argued, "on the cutting edge of a commercial Christmas, making up more than half of the earliest items advertised as Christmas gifts."[81] The 1891 holiday gift-book binding for John

G. Whittier's *Snow Bound*, for example, was issued as a "Japanese Edition," with "photogravure illustrations" printed on "Japanese paper," and "daintily bound from designs by Mrs. [Sarah] Whitman."[82] The holiday edition for William Dean Howell's *Venetian Life* that same year boasted, "text beautifully printed on Japanese paper."[83] In 1894 Charles Scribner's Sons issued a series of "Portraits of Favorite Authors" (Robert Louis Stevenson, Mark Twain, Richard Harding Davis, etc.), each "handsomely engraved" on "Japan paper."[84] Put simply, by the mid-1890s the American book seemed to want desperately to become a *Japanese* object.

(Para)textual *Technê* and the Oriental Books of "Onoto Watanna"

One way of tracking what I have been calling the Oriental transformation of the American book is to say that we have so far been analyzing what Gérard Genette has called the *paratext*: those "liminal devices and conventions" that surround, package, or otherwise determine the complex mediation between authors, publishers, and readers (titles, forewords, epigraphs, covers, typeface, reviews, and so on).[85] But to attempt to isolate the impact of the paratext on a reader's experience is, as Genette very well knows, not as easy as it sounds. In the first place, Genette's definition assumes that "in all its forms," the paratext is "fundamentally heteronomous, auxiliary, and dedicated to the service of something other than itself that constitutes its *raison d'être*. This something is the text . . . the paratextual element is always subordinate to 'its' text."[86] However, one need only point to the emergent practice of book cover *exhibition* (where, as at the Grolier Club in the 1890s, what was valued was not the text, but its paratextual packaging) to begin questioning that subordination. What of Whitman's conscious effort to detach the aesthetic of the binding from any illustrative or mimetic association with the text itself? Were there not moments when what mattered for consumers was not so much the text as the *way* the text appeared to them? Were there not authors who, in taking advantage of the Boston book movement in the 1890s and early 1900s (and particularly regarding the assumptions of Asia-as-*technê*), began writing paratext *into* text?

Consider the case of the young Canadian, Anglo-Asian author, Winnifred Eaton. Born in Montreal in 1875 to a Chinese mother and a British father, Eaton was already publishing stories in the local newspaper at age fourteen, and by the late 1890s had moved to the United States and published her first novel, *Miss Numé of Japan* (1899), the immediate success of which placed her in the hearts and homes of Boston's emerging middle class. For most of her writing, Eaton adopted the "Japanese" pen-name Onoto Watanna, claiming (in one of the more trickster-like moves of the authors we are examining) that she was half-Japanese and half-English.[87] Because of this decision to trade on her ethnic identity, Eaton's sentimental romances have not won many critics' hearts in contemporary academic discussions. As Jean Lee Cole has argued, Eaton "spoke from a multiplicity of apparently mutually exclusive perspectives. Canadian, American, Japanese, Chinese, Irish, mongrel, white," and so it is "difficult for critics to read her work as anything but a failure, since she did not voice her 'true' identity as half-Chinese."[88] For our purposes here, however, whether or not Eaton's ethnic passing (or, if you like, the "facade" she wore on the outside) was politically correct or not is perhaps not as interesting as the fact that what ended up mattering most about her books as they were experienced in the 1890s and early 1900s was not so much what they conveyed textually as what they conveyed paratextually (or, if you like, the facade her texts wore on the outside).[89] Indeed, reading an Onoto Watanna text it becomes increasingly difficult to distinguish text from

paratext—the aesthetic assumptions of the former constantly becoming *subordinate* to those of the latter.

In *Daughters of Nijo* (1904), for example, Watanna's text tells the story of two daughters of a royal prince from the house of Nijo, one of the sisters, Sado-ko, growing up in the palace, and the other, Masago, growing up with a middle-class father who owns a store selling European goods and gadgets. Sado-ko is portrayed as warm, beautiful, stately, and traditional, with an innate love of children and nature. She also refuses to adopt Western styles of dress and behavior that had become popular among the Japanese Meiji aristocracy. As Watanna's narrator explains, "In a robe of ancient style, soft flowing, Sado-ko had never appeared to better advantage among the ladies of the court, all of whom affected the European style of gown, which ill became them."[90] Masago, by contrast, is described as cold, impersonal, and selfish, "a girl of weak and vain ambitions."[91] Unlike her more elegant and cultured sister, Masago exhibits a fierce desire to emulate Western styles of dress and behavior, and is described repeatedly as having a "mechanical" persona.[92]

The central, unifying theme that emerges from *Daughters of Nijo* is that the modernizing "progress" that Japan has made recently—and "progress" is actually referred to in scare quotes—is in fact a tragic, Western-influenced usurpation of an ancient, chivalric, and more aesthetic Japanese culture.[93] The chapter titled "A Mirror and a Photograph" is especially illustrative. Here Sado-ko sits down one night with a photograph of her very similar-looking sister Masago in one hand, and an "ancient rounded mirror" in the other. Sado-ko looks first into the mirror and then at the photograph, which is described as "a piece of modern cardboard, such as foreign photographers use":

> The face which had looked at her from the mirror now stared up at her with cold, inscrutable eyes from the photograph in her hand. Yet there was a subtle difference in the expression of the face of the mirror, and that of the card, for the one was wistful, soul-eyed, and appealing, while the other was of that perfect waxen type of woman whose soul one dreams of but seldom sees. The one was the face of the statue, the other that of the statue come to life.[94]

Here Masago is portrayed as a soulless, foreign, mechanical simulacrum of royalty (the mimetic cheapness of the cardboard photograph), while Sado-ko is characterized as the soulful, living embodiment of royalty (the mirror being one of the objects in the imperial regalia of Japan).[95] The implicit argument of the chapter, of course, involves a privileging of Japan's originary *techné* against the mass production of mechanical culture—the former very clearly identified as a therapeutic site of organic experience and aesthetic form.

Two years after the publication of *Daughters of Nijo*, Eaton wrote both a short story and a novel set in Japan during the 1904–1905 war with Russia, specifically continuing these themes. Both of these narratives portray interracial marriage (a theme that Eaton would explore quite often), and both narratives similarly underscore the dangers of an impending Western mechanization. In "The Wrench of Chance" an Irishman hoping to escape the law goes to Japan, where he gets married and abuses his Japanese wife, turning her into a slavish, "mechanical" toy. At one point in the story, for example, the terrified wife enters the room, sees her husband on the couch, and then "like a puppet, made a mechanical obeisance to him." The husband berates her for not being more cheerful, and then "The smile she brought

Fig. 2.12. Page from Onoto Watanna's *A Japanese Blossom* (New York: Harper & Brothers, 1906), with marginal illustrations by Genjiro Yeto that seep into the text.

to her lips was that of a mechanical doll."[96] In *A Japanese Blossom* (1906), a novel also set in Japan, Watanna portrays a Japanese man married to an American woman, who selflessly consents to her husband's desire to join the army. But the narration never makes it to the battlefield, and the war serves only as a means of legitimating the husband's noble patriotism. What we do get are florid, aestheticized descriptions such as "The room was sweet with the odor of some faint perfume. Perhaps it was only the sandalwood of the toilet-boxes, or the odor of sweet-smelling incense, which had recently been burned to purify the house. There was not a speck of dust on the floor."[97] Clean, fragrant, pure, aesthetic—everything about Eaton's Japan exudes the increasingly, or at least aspirationally, modern flavor of Asia-as-*technê*, an aesthetic seemingly (but not actually) far from the dirty machines of the West.

It was also an aesthetic that precisely mirrored the paratextual elements of Watanna's books. As with so many of the texts of the Boston book movement, the irony of Watanna's implied critique of mass production and mechanical modernity was that, as she clearly knew, the success of her books relied necessarily on many of these same modes of production, even though (and to a large degree *because*) they could be packaged to appear otherwise. Marketed by her publishers as "exceedingly dainty" objects, Watanna's books—several of which were designed by Thayer and her colleagues at the Decorative Designers firm—were manufactured with highly sophisticated photomechanical technologies: colorful foils were stamped onto elegantly embossed pastel cloth, pages were gilded or deckled, and the overall design used clean, floral patterns, with vertical Oriental-style script (Plates 86–87). Opening an Onoto Watanna novel, one finds on every page decorative illustrations literally seeping *into* the text between lines and words (Fig. 2.12). But it is important to note that no one (neither Watanna, her publishers, nor her readers) considered these paratex-

tual elements "subordinate" to the text. Indeed, not only has Watanna internalized into her narrative these aesthetic considerations, her publishers were clearly foregrounding them *as text*. In an advertisement for Watanna's *Heart of Hyacinth* (1903), for example, her publishers, Harper & Brothers, give more attention to the book's aesthetic materiality than its narrative content: "A love story of Japan which comes to us beautifully bound in lavender cloth with elaborate illustrations by Kiyokichi Sano."[98] In another advertisement for the same novel, the narrative seems to have disappeared entirely: "lavender cloth with gold and colored decorations; pictures in color, and marginal drawings in tint by Japanese artists on every page. Deckle edges and gilt top."[99] Harper's advertisements for the release of Watanna's *A Japanese Nightingale* (1906) were no different: "One of the daintiest and most attractive books of the Holiday season. A Japanese love story. There are decorative page borders in color on every page by Genjiro Yeto, the Japanese artist, together with a number of full-page pictures by the same artist. A unique and artistic gift."[100] To read an Onoto Watanna novel, in other words, is to always be reading paratext—her paratext *is* her text.

One way of understanding this marketed foregrounding of the paratext is to say that buying one of the Oriental books of the Boston book movement merely signaled participation in what Thomas W. Kim has identified as "an appreciation for what were supposed to be the deepest principles of art, as well as a measure of cosmopolitanism."[101] Oriental-themed books in the 1890s, in other words, circulated as tokens of a new form of modernity, one engaged in through purchasable and collectable objects of an exotic "other" that conveyed, in surrogate fashion, a more aestheticized, cultivated, and cosmopolitan *technê*. Hence, Kim's observation that, "if the deployment of Oriental themes in advertising and of Oriental objects in store windows and homes suggests a desire to escape from modernity, it also indicates that the quest for an 'outside' to modernity actually invigorates consumer culture and forms a crucial aspect of the modern itself."[102] Or, put another way, inasmuch as "modernity" demanded a new kind of textual experience, Asia effectively became the West's paratext.

Genjiro Yeto and the Paratextual Dynamos of Asia-as-*Technê*

Such considerations are perhaps all too easy to identify in an author such as Winnifred Eaton who (as Onoto Watanna) had so self-consciously developed a paratextual authorial identity. But as I indicated at the start of this chapter, the Oriental transformation of the American book was also the product of a number of Japanese nationals living in Boston who similarly capitalized on the new demand for Asia's *technê*. Consider, for example, the paratextual contributions by the young Japanese artist, Genjiro Yeto, who had come to the United States in 1893 to market his family's pottery business at the Chicago Exposition. Inspired by much of the new art he saw there, and having earned enough at the fair that he would not need to work for some time, Yeto decided to enroll at the New York Art Students League in 1895.[103] There he studied under American impressionist painters Robert Blum and John H. Twachtman, both of whom were already deeply invested in Oriental aesthetics (Blum, for example, had gone to Japan in 1891 for *Scribner's Magazine* to create illustrations for Edwin Arnold's *Japonica*, and Twachtman had developed an impressive collection of *ukiyo-e* prints; both, of course, were experimenting with new Oriental forms). Delighted to have an opportunity to teach and learn from the young Yeto, Blum and Twachtman persuaded him to join the summer school at the Cos Cob art colony along the Connecticut coast in 1896.

Fig. 2.13. Genjiro Yeto and fellow kimono-clad art students at Cos Cob, ca. 1897 (image courtesy of the Greenwich Historical Society).

For the next six years Yeto was a frequent resident at the Holley House in Cos Cob, where dozens of artists spent their days painting the countryside and quaint New England buildings—often erasing signs of impending industrialization in their landscapes.[104] Yeto's fellow artists were clearly smitten with the idea of a representative of the new Oriental aesthetic working among them, and Yeto was apparently happy to oblige. On those summer evenings at the Holley House everyone dressed up in kimonos, sketched under the light of paper lanterns, and held forth on the virtues of Oriental aesthetics. Dozens of paintings from the Cos Cob art colony show sultry female models in loose-fitting kimonos (clearly an American eroticization of what was a rather tightly bound garment in Japan), and the daily tea ceremonies at the Holley House became elaborate affairs, with Oriental costumes, fans, floral arrangements, wall hangings, and decorations galore (Fig. 2.13).[105]

Many of the Cos Cob colony artists, including Yeto, made important contributions to the Boston book movement, often working with Sarah Whitman as the designs were ushered toward publication.[106] Clearly the name "Genjiro Yeto" lent an aura of native authenticity to the paratextual devices of the Boston book movement, and he seems to have been happy to play along (although one wonders how he felt when he was described as Onoto Watanna's "compatriot," when he was clearly aware of the ruse).[107] In his designs and illustrations for books by Lafcadio Hearn, Onoto Watanna, John Luther Long, and others, Yeto consistently portrayed Japan as a land of nonmechanical softness, aesthetic refinement, and idyllic mystery.[108]

Take, for example, Yeto's book illustrations for Hearn's *Kottō* (1902), and particularly the chapter "Fireflies." In this essay, Hearn offers a glimpse into the romantic culture that had emerged in Japan surrounding the "tiny dynamo" of the light of the firefly.[109] Hearn is naturally interested in the science of it (the possibility, for instance, that the firefly's light exists for "phototelegraphic" purposes of communication within the species, its speech being "the language of lights"), but ultimately

what most fascinates Hearn is "the romantic quality" of it (*K*, pp. 138–139). And regarding the mythology and folklore of the firefly in Japan, Hearn seems to have uncovered a literary goldmine. Fireflies are thought to be "the ghosts of old Minamoto and Taira warriors," or even those of lost ancestors: "Any firefly may be a ghost—who can tell?" (*K*, p. 140). Japanese families frequently go on outings to catch fireflies, and "occasionally, on a summer night, you may see a drooping willow so covered and illuminated with fireflies that all its branches appear to be budding fire" (*K*, p. 152). Firefly catching has even become a kind of cottage industry, with restaurants and ceremony organizers paying top dollar for the very brightest insects. The professional firefly catcher, Hearn explains, heads out at night with a bamboo pole and a brown mosquito net tied around his waist. After a tree has begun to "twinkle satisfactorily," the firefly catcher shakes a branch, whereupon the insects fall to the ground, stunned. Because the fireflies might soon fly away, the catcher must use both hands to snatch them up, and so "deftly tosses them *into his mouth*—because he cannot lose the time required to put them, one by one, into the bag. Only when his mouth can hold no more does he drop the fireflies, unharmed, into the netting" (*K*, p. 146 emphasis in original). The glowing, diaphanous mouth of the firefly catcher is especially symbolic for Hearn, since "Japanese poets have been making verses about fireflies during more than a thousand years" (*K*, p. 155). For a full ten pages, then, Hearn includes translations of what he has identified as an entire genre of Japanese verse, unified by its crisp, laconic imagism, its sense of the uncanny, and its romantic fascination with the luminous: "Here and there the night-grass appears green, because of the light of the fireflies!" (*K*, p. 159). "It is enough to make one afraid! See! The light of this firefly shows through my hand!" (*K*, p. 160). "With the coming of the dawn, they change into insects again—these fireflies!" (*K*, p. 165).

For Hearn, even the modern evolutionary questions raised by the firefly seem to demand a kind of poetic reflection. On the one hand, he argues, the biological evolution of "radiance or electricity is not really more extraordinary than [the] power to evolve color," and so we shouldn't really be led to wonder more about the one than we are the other: "that a noctiluca, or luminous centipede, or a firefly, should produce light, ought not to seem more wonderful than that a plant should produce blue or purple flowers" (*K*, p. 167). And yet, there is something in the allure of the light that "leaves me wondering . . . at the particular miracle of the machinery by which the light is made." There in the sparkling light of the firefly Hearn finds a kind of *technê* more perfect and wonderful than that of any modern machine: "a microscopic working-model of everything comprised under the technical designation of an 'electric plant' . . . a luminiferous mechanism at once so elaborate and so effective that our greatest physiologists and chemists are still unable to understand the operation of it, and our best electricians impotent to conceive the possibility of imitating it."[110] Evolution may "explain" it, he acknowledges, but even here the dazzling aesthetic of the firefly seems to demand an almost metaphysical extension of Herbert Spencer's notion of inherited memory: "I cannot rid myself of the notion that Matter, in some blind, infallible way, *remembers*; and that in every unit of living substance there slumber infinite potentialities, simply because to every ultimate atom belongs the infinite and indestructible experience of billions of billions of vanished universes."[111] The flickering *technê* of the firefly, in other words, gives rise to not only the aesthetics of Japanese poetry and folklore, but also an uncanny, lyrical trace of those billions of other universes.

been produced by accumulated effects of function on structure, yet it is conceivable that successive selections of favourable variations might have produced it." And no follower of Herbert Spencer is really justified in wandering further. But I cannot rid myself of the notion that Matter, in some blind infallible way, *remembers*; and that in every unit of living sub- stance there slumber infi- nite potential- ities, simply because to every ultimate atom belongs the infinite and indestruc- tible experi- ence of bill- ions of bill- ions of van- ished uni- verses.

Figs. 2.14–2.15. Illustrations by Genjiro Yeto for the chapter "Fireflies" in Lafcadio Hearn's *Kotto* (New York: Macmillan & Co., 1902).

It is worth reflecting, then, on the artistic (ostensibly paratextual) challenge posed by this essay to an illustrator like Yeto.[112] Unlike the decorative gold stamping available for the cover art, Yeto's illustrations inside the book would have to be done in monochromatic red. How then to illustrate this highly mysterious, aesthetic, and metaphysical phenomenon? How to convey Hearn's lyrical move from Japanese firefly poetry to the metaphysical implication that matter itself has its own mnemonics? How—on an even more basic level—to portray the light of the firefly without the advantage of colorful chromolithography? Given these rather difficult restrictions, Yeto's illustration for the chapter is quite stunning (Fig. 2.14). Set from a perspective low in the grass, the viewer sees what an insect sees, with flowers and leaves towering in the foreground like trees, all strikingly outlined in negative space.[113] The darkness of the night is conveyed in a vibrant matrix of lines, pulsing in Van Gogh-like patterns of varying length and thickness. The dark atmosphere seems dense and alive, while the flickering lights of the fireflies appear as constellations, again conveyed by allowing tiny circles of unprinted space to poke through the darkness of Yeto's lively mesh of sketched lines. What one sees in the light of the firefly, in other words, is *space*—the blank possibility of the bookleaf. Like the other stories and essays in *Kottō*, "Fireflies" opens with Yeto's illustration, but, like a bookend, a smaller version of the same illustration is again included at the end of the chapter, embedded in the text. In its second, smaller iteration, however, one cannot help but notice what Yeto's illustration does to Hearn's text (Fig. 2.15). Here Yeto's illustration sits right in the middle of the page, slowing down the reader and rendering the text into poetry-like columns. In fact, Yeto's fireflies illustration sits right in the middle of the "universe," literally between "uni" and "verse," such that what gets emphasized textually is the *poetry* of the thing (the "unity" of the "verses," as it were). Yeto's paratext,

in other words, seems to make Hearn's literature even more *literary* than it would be without it.

Thus, if Yeto's illustrations constitute a paratext for Hearn, it is useful to remember that in Genette's theorization the prefix "para-" was never intended to imply the presence of some isolatable and univocally transmissible "text" that could somehow exist without its paratext.[114] Genette was writing *Paratext* in the wake of a radical poststructuralist reconsideration of how texts were assumed to present themselves to readers, but one need not rehearse the entire antimetaphysical unraveling of deconstructive discourse to see that what makes Genette's concept so intriguing still today is the degree to which it continually disappears upon closer inspection. Here, for example, is the passage from J. Hillis Miller's "The Critic as Host" that Genette quotes from in laying out his definition of paratext:

> "Para" is a double antithetical prefix signifying at once proximity and distance, similarity and difference, interiority and exteriority, . . . something simultaneously this side of a boundary line, threshold or margin, and also beyond it, equivalent in status and also secondary or subsidiary, submissive, as of guest to host, slave to master. A thing "para," moreover, is not only simultaneously on both sides of the boundary line between inside and out. It is also the boundary itself, the screen which is a permeable membrane connecting inside and outside. It confuses them with one another, allowing the outside in, making the inside out, dividing them and joining them.[115]

Miller's text is a defense of deconstruction (under attack from critics who saw these new theoretical reading practices as "parasitical" on a text's clearly intended meaning), and the point was to demonstrate that neither the deconstructive nor the supposedly "obvious and univocal" meaning of a text can ever claim anything other than a parasitical relationship to their "host" (every reading is a "guest" as it were).[116] However, when applied to the transcultural development of what I have been referring to as the Oriental transformation of the American book, one cannot help but notice just how much the condition of the "para" might also apply to not only Yeto's paratextual illustrations but also his cultural identity. Sadakichi Hartmann, for example, an early twentieth-century poet and critic of Japanese and German descent, argued that Yeto was one of those international artists who "will always be considered aliens, no matter whether they have their studios in Tokyo or New York." Yeto was "a very talented artist," but had "deliberately abandoned all the ideals of his countrymen in regard to art. . . . It is impossible to classify him as a Japanese artist, as he has nothing in common with his country, and I fear that he will never be regarded as an American artist, as he has remained thoroughly Oriental in everything else but his art."[117] But if Yeto was an artist at the paratextual threshold of cultural identity, Hartmann is perhaps overstating the situation when he argues that Yeto had "nothing in common" with his compatriots. Although Yeto learned and borrowed from Western artists like Twachtman and others at the Cos Cob art colony, those same Western artists were also clearly learning from Japanese sources. And in fact Yeto did quite a bit to adapt the discourse of Asia-as-*technê* to promote the national aspirations of his home country. When Yeto returned briefly to Japan in 1904, for instance, his illustrations of the Russo-Japanese War for *Collier's Magazine* portray the war effort as a highly noble affair, perhaps even something tender and bucolic. In "Off to the War!" a jaunty Japanese community, in parade-like fashion, escorts some young soldiers off to battle, kites flying, banners waving, children playing, and the people

are sketched in soft lines and gentle tones (Fig. 2.16). The atmosphere is less exuberant in "Annual Review of the Tokio Garrison by the Mikado," but here again a kind of quiet nobility permeates as spectators and a young child look on in elegant traditional robes and proud postures—and of course, none of Japan's new military technologies are found intruding into the scene (Fig. 2.17).

Okakura Kakuzo: The White Disaster and *The Book of Tea*

As much as Genjiro Yeto's images may have done for positively interpreting and adapting Japanese aesthetics and national ambitions for American audiences, the most influential Japanese figure to take advantage of the Oriental transformation of the American book as a means of justifying Japanese nationalism was the educator, art critic, and curator Okakura Kakuzo. Hailed frequently in the United States as the "William Morris of his country," Okakura did more than any other Japanese figure in the 1890s to promote (and reintroduce into the university curriculum) the traditional arts and crafts of Japan, and would go on to publish one of the most influential

Figs. 2.16–2.17. Illustrations by Genjiro Yeto of the Russo-Japanese War for *Collier's Magazine* in 1904; reprinted in *Japan and Her Beauty* (New York: P. F. Collier & Son, 1904). (*Top*) "Off to the War!" The caption reads: "This sketch from life, drawn by Genjiro Yeto . . . shows the young Japanese soldiers answering the recent call to arms. They are being escorted to the railway station by their relatives and other villagers, whose patriotism and joy are expressed with gay poles and banners and shouts of '*Teikokui banzai!*'—'Long live the Empire!'" (*Bottom*) "Annual Review of the Tokio Garrison by the Mikado, January 8, 1904." Yeto wrote the caption himself, noting, "The ceremony occurred at the drill ground in Arroyama, this city (Tokio). The Emperor himself reviewed the troops."

tracts on Asia-as-*techné* in the twentieth century, *The Book of Tea* (1906)—a book that, as we shall see, is as much about books as it is about tea.[118] Indeed, Okakura's *Book of Tea* more than any other text illustrates just how much the discourse of Asia-as-*techné* had transformed (and was experienced as a product of) American book culture.

Born in 1862 in the growing metropolis of Yokahama, Okakura experienced a childhood that offered few clues that he would go on to lead a national defense of traditional Japanese aesthetics. As written by his parents, Okakura's given name "Kakuzo" meant simply "warehouse at the corner," indicating rather blandly the location where he was born.[119] Early on, Okakura changed the characters in his name to the homophonous spelling for "awakened boy," marking, at least symbolically, a journey away from a repository of industrial glut to a state of thriving young Buddhahood. Still, his childhood was not exactly filled with the cultivated aesthetics of traditional Japanese learning. His father wanted him to be educated in the changing world of the New Japan, and so sent him to a missionary school where he learned mathematics, history, and English, but—much to his father's dismay—not Japanese writing.[120] After a move to Tokyo, Okakura enrolled in Japanese classes and by 1878 he had been accepted at the newly established Tokyo Imperial University, the very school—still in its earliest phases of development—that Edward Morse had been commissioned to help establish. His association with the school happened at the very moment that Morse, Bigelow, and Fenollosa had begun their campaign to collect and preserve the ancient arts of Japan while much of the rest of the country was still eagerly embracing Western art and industry. Okakura became a frequent companion of Fenollosa, Morse, and others as they scoured the countryside for priceless ancient relics that had been either set aside or else preserved in dark rooms for centuries. Their finds became the stuff of legend, and did a great deal to alert the Japanese government to the value of these ancient works (even as many of them were being quickly snatched up by Western collectors).[121]

As exhilarating as it must have been for Okakura's American mentors to help uncover these national treasures, one rather obvious problem for Western intellectuals insisting that Japan not turn to the overly mechanized West for its artistic training was that many of them ended up talking themselves out of a job. Such was the case with many of Okakura's teachers (including Fenollosa), and by the early 1890s Okakura had begun to take on a number of responsibilities himself, becoming head of the newly established Tokyo Fine Arts School and curator of the Imperial Museum of Tokyo.[122] In fact, it was under Okakura's leadership that the Tokyo Fine Arts School won the commission to design and curate the Ho-o-den pavilion at the 1893 Chicago World's Columbian Exposition.[123] Consistent with the views of his mentors, then, Okakura's message throughout the 1880s and 1890s was that for Japan to adopt Western styles of artistic expression constituted a fundamental violation of its cultural and national identity—a message that, as we have already seen, became an important part of the discourse of Asia-as-*techné* in Boston books.[124]

A defiant and often flamboyant figure, Okakura had a personality and taste for alcohol that quite often got him into trouble, as for instance when he slept with the wife of the Japanese ambassador to the United States (fathering, incidentally, the famous Japanese philosopher and interlocutor of Sartre and Heidegger, Shuzo Kuki).[125] In 1901, no doubt motivated by some of these personal complications, Okakura decided that he needed to leave the country. It was the beginning of what would become twelve years of wandering for Okakura, spending much of that time in the

United States.[126] His first destination, however, was India, where he lived for some time with the Calcutta poet Rabindranath Tagore. It was in India that Okakura wrote his first book, *The Ideals of the East* (1903), attempting to process philosophically what Asia's seemingly inevitable Westernization meant for him and the artists of his country. Already in the now famous first line of this first book, Okakura accepts one of the main ideals of Asia-as-*technê*: the fundamental alterity of the East: "Asia is One," he wrote. And by "One," he meant that differences among the Asian nations were merely "shining points of distinctness in an ocean of approximation," and that the "Asiatic races" formed a "single mighty web."[127] But if Asia was "One" for Okakura, Japan was a rather special "one" within that "One." It has been the "great privilege of Japan," he explains, "to realize this unity-in-complexity with a special clearness" (*IE*, p. 5). This distinction may have been due to geographical advantage or cultural openness, but regardless, he wrote, "Japan is a museum of Asiatic civilization," such that even "Chinese scholars of the present day" look to Japan as "the fountainhead of their own ancient knowledge" (*IE*, p. 7). But this was not to say that Japan had merely "copied" other Asian cultures. On the contrary (and one senses here an implicit stab at Percival Lowell's insult that the Japanese are merely "imitative"), "The national genius [of Japan] has never been overwhelmed. Imitation has never taken the place of free creativeness. There has always been abundant energy for the acceptance and re-application of the influence received, however massive."[128] Yet with the recent influx of Western culture and industry, Japan's openness had begun to complicate that special talent: "There are today two mighty chains of forces which enthrall the Japanese mind, entwining dragon-like upon their own coils, each struggling to become sole master of the jewel of life, both lost now and again in an ocean of ferment. One is the Asiatic ideal, replete with grand visions of the universal sweeping through the concrete and particular, and the other European science, with her organized culture, armed in all its array of differentiated knowledge, and keen with the edge of competitive energy" (*IE*, pp. 206–207). Here the West gets some credit for waking Japan from a relative "torpor," and reigniting the "fire of patriotism" seen in the Meiji era. Indeed, Okakura even suggests that this West-inspired reawakening of Japanese military power might have allowed it (as it had already demonstrated in the Sino-Japanese War of 1895, humiliating China) to not only "return to our own past, but also to feel and revivify the dormant life of the old Asiatic unity" (*IE*, p. 223). China and Korea should perhaps even formally thank Japan, in other words, for its Western march toward imperialism.

For Okakura, however, whatever the virtues of this new, West-inspired motivation, it should not be allowed to overshadow Japan's ancient, artistic *technê*. "The old art of Asia," he wrote, "is more valid than that of any modern school, inasmuch as the process of idealism, and not of imitation is the *raison d'être* of the art-impulse" (*IE*, p. 228). To lose that *technê* was to lose something extremely valuable: "Only at a great loss can Asia permit its spirit to die, since the whole of that industrial and decorative art which is the heirloom of ages has been in its keeping, and she must lose with it not only the beauty of things, but the joy of the worker." Asia might know "nothing of the fierce joys of a time-devouring locomotion," Okakura insisted, "but she has still the far deeper travel-culture of the pilgrimage and the wandering monk" (*IE*, p. 237).

In 1904, when Japan was already deeply engaged in yet another imperial venture, this time in competition with Russia for the ports of northern Manchuria, Okakura was on his way to the United States where he would take over the position

(from Fenollosa) of curator of Eastern art at the Boston Museum of Fine Art. There he wrote *The Awakening of Japan* (1904), an even more strident and critical adaptation of Asia-as-*technê*, reproducing some of the same arguments from *The Ideals of the East* but laced with a much stronger undercurrent of Japanese nationalism. Inasmuch as Japan has "gratitude to the West for what she taught us," he wrote, "we must still regard Asia as the true source of our inspirations."[129] But it was not just that Asia (and here he means largely China) had bequeathed an ancient culture of aesthetics much greater than anything the West had recently imported. Japan's "joy must be in the fact that, of all [Asia's] children, we have been permitted to prove ourselves worthy of the inheritance" (*AJ*, p. 6). In a fascinating twist on what he knew to be the racist discourse of the "Yellow Peril," Okakura argued that the Russo-Japanese War was only evidence that Japan had begun to "awake," and thereby redeem the rest of Asia with its cultural energies: "Until the moment when we shook it off, the same lethargy lay upon us which now lies on China and India."[130] It was a historical argument reaching back all the way to Genghis Kahn, whose conquering of Asia only "rent asunder" the wide lands of the Buddha, to the point that "today the Celestial Empire is so divided against itself that it is powerless to repel outside attack" (*AJ*, pp. 17–18).

The white, racist promulgators of the yellow-peril discourse (as Jack London will demonstrate more fully in the next chapter) feared precisely what Okakura was describing: a united, pan-Asian front, led by a modern, militarized Japan unafraid of Western imperialism, eager to explore its own imperial opportunities. But in a fascinating turn of phrase, Okakura suddenly points to the disastrous "machine" as precisely the reason he and his fellow Asians were justified in imagining the need for such a defense: "If the guilty conscience of some European has conjured up the specter of a Yellow Peril, may not the suffering soul of Asia wail over the realities of the White Disaster?" (*AJ*, p. 95). What exactly is the White Disaster? It is that moment, at once cataclysmic and banal, when "organization has made of society a huge machine ministering its own necessities. It is the rapid development of mechanical invention which has created the present era of locomotion and speculation, a development which is working itself out into various expressions, as commercialism and industrialism" (*AJ*, p. 96). It is that moment when "the individuals who go to the making up of the great machine of so-called modern civilization become the slaves of mechanical habit and are ruthlessly dominated by the monster they have created" (*AJ*, p. 98). The White Disaster, in other words, was the *machine* incarnate, something the East must resist at all costs.[131] If in mounting its defense against the White Disaster Japan has had to engage in some imperial (and highly mechanical) practices, this was all the more reason for Japan to "remain true to our former ideals."[132]

For Okakura, then, the defense of traditional Japanese art was not merely some fascination with older, idyllic times. Indeed, it was Japan's gift to the rest of Asia, something that might even redeem the West from its own "disastrous" mechanical culture. In an article the next year in *International Quarterly*, Okakura would continue his attack on the White Disaster:

Disastrous as have been the consequences of the sweeping inundations of Western ideals, its ravages on Japanese painting might have been comparatively slight had it not been accompanied with modern Industrialism. It may be that Western art is also suffering from the effects of Industrialism, but to Japan its menace is more direful as we hear it beating against the bulwarks

of the old economic life. To us it seems that Industrialism is making a hand-maiden of Art. . . . In place of the handworks where we feel the warmth of the human touch of even the humblest worker we are confronted with the cold-blooded hand of the machine. The mechanical habit of the age seized the artist and makes him forget that the only reason for existence is to the one, not the many. He is impelled not to create but to multiply.[133]

But what chance did any artist have against the "cold-blooded hand of the machine"? What could anyone in the East or the West do to combat this "mechanical habit of the age"?

It might seem odd at first that Okakura would turn to the tea ceremony as the principal means of countering all the dehumanizing effects of global mechanization, but, according to him, embedded in its philosophy and aesthetic practices were all the signposts of a more perfect, modern *technê*. In his wildly popular *Book of Tea*, for example, Okakura argues for a specific antidote to the White Disaster—something he called "Teaism."[134] Teaism, Okakura explains, is "not mere aestheticism in the ordinary acceptance of the term," but rather "expresses conjointly with ethics and religion our whole point of view about man and nature" (*BOT*, p. 4). It was the fountainhead for all of Asia's most valuable *technê* culture: "Our home and habits, costume and cuisine, lacquer painting—our very literature—all have been subject to its influence" (*BOT*, pp. 4–5). The "our" in question here might be understood as referring to all of Asia (Okakura acknowledges that tea "began as a medicine and grew into a beverage" in ancient China), but it is clearly Japan that alone carries the torch of contemporary Teaism: "To the latter-day Chinese, tea is a delicious beverage, but not an ideal. The long woes of his country have robbed him of the zest for meaning of life."[135] Only in Japan, where one finds an ongoing culture of aesthetic refinement and "resistance" to foreign invasion (note the implicit justification for Japan's role in the recent Russo-Japanese War), had Teaism become "a religion of the art of life," a kind of perfect blend of Daoism, Zen, and Asian art.[136]

Okakura insists further that the *technê* of the Japanese tea ceremony has both global and political implications. "It is the only Asiatic ceremonial which commands universal esteem. The white man has scoffed at our religion and our morals, but has accepted the brown beverage without hesitation" (*BOT*, p. 13). Only in the tea ceremony, Okakura argued, could East and West finally "meet to drink from the common spring of art-appreciation" (*BOT*, p. 42). It was important enough that, as Americans knew, it had become "a taxable matter," and had therefore already played an important role in U.S. independence, which he reminds his readers "dates from the throwing of tea-chests into Boston Harbor" (*BOT*, p. 16). Clearly, Okakura knows his audience—laying out as he does a culture of aesthetic refinement with a unique history in Boston, citing both a growing disenchantment with machine culture and its global implications: "Nowadays industrialism is making true refinement more and more difficult all the world over," he writes. "Do we not need the tea-room more than ever?"[137]

But then, how many of Okakura's American readers (and keep in mind that the book was not published in Japanese until the 1930s) would ever have access to a genuine Japanese tearoom, where the "principles of construction and decoration," as Okakura explains, are "entirely different from those of the West"? (*BOT*, pp. 73–74). If, as Okakura indicates, "it was the ritual instituted by the Zen monks of successively drinking tea out of a bowl before the image of the Bodhi Dharma which laid

the foundations of the tea-ceremony," how many of his readers could ever hope for the privilege of experiencing any such ceremony? (*BOT*, pp. 80–81). Why should a book become so enormously popular—in fact, it has never gone out of print— among readers who would never experience the precise conditions he is advocating? The answer, I would argue, is tied up in *The Book of Tea*'s status as both a literary text and an art object. When Okakura argues, for instance, that the tearoom provides a "sanctuary from the vexations of the outer world," and that "there alone can one consecrate himself to undisturbed adoration of the beautiful," he knows that the closest experience most of his readers would have to this type of "sanctuary" was reading (*BOT*, p. 98). The tearoom in *The Book of Tea*, in other words, stands in as a symbol for the intellectual space created by reading *The Book of Tea* itself. The tearoom, Okakura writes, is "an Abode of Fancy," a "structure built to house a poetic impulse" (*BOT*, p. 74). It is something that requires workmanship of "immense care and precision," and allows for moments of transcendent imagination: "One may be in the midst of a city, and yet feel as if he were in the forest far away from the dust and din of civilization."[138] In the final pages of *The Book of Tea* Okakura tells of the famous poet Riuku's last tea ceremony, with readers leaving the page just as the ceremony participants leave the room: "The ceremony is over; the guests with difficulty restraining their tears, take their last farewell and leave the room. One only, the nearest and dearest, is requested to remain and witness the end" (*BOT*, pp. 159–160). As many of Okakura's readers would have known, of course, the symbolic association of tea and "reading"— principally through the process of tasseography (divination based on the interpretation of tea leaves)—has a long and venerable history in Asia.[139] Put simply, Okakura clearly knew that what was so valuable about the *Book of Tea* for his American readers was that—as a *book*—it was already a prime vehicle for the evocation of Asia's *technê*, already an invitation to experience that Oriental aesthetic. Small, portable, elegant, familiar-yet-exotic, *The Book of Tea* not only provided a means of imparting to a custom already well established in the United States (tea drinking) a measure of cultivated, aesthetic refinement; it also, even more directly than the beverage itself, *created* that experience for its American readers. That is, even if one never drank tea, the *technê* of Okakura's book was as important for its readers as the tea itself. Or, put another way, if Teaism is for Okakura a pristine form of Asia's *technê*, what his readers experienced was not only *The Book of Tea*, but also the "tea" of the *book*: leaves meticulously prepared and housed in an "abode of fancy."[140]

The bindings of Okakura's earlier books had already been carefully crafted to evoke the larger Bostonian adaptation of Asia-as-*technê*. *The Ideals of the East* (1903), for example, features three flowery *mon*-like roundels that clearly mimic Sarah Whitman's designs for earlier Oriental books (Plate 88). *The Awakening of Japan* (1904) features two imperial Japanese *mon*, with lettering and small triangular fleurons designed by the Thayers at the Decorative Design firm in New York. Perhaps in an effort to live up to its call for greater "Purity and Simplicity," *The Book of Tea* as published in 1906 by Fox Duffield (a company started by two Harvard undergraduates in the 1890s with already deep connections to the *Japonisme* of the French Art Nouveau movement) eliminates the *mon*, conveying an even simpler use of Emma Lee Thayer's lettering and fleurons (Plate 89).[141] However, for a book designed to evoke so much of Asia's *technê*, it is perhaps no surprise that after Okakura's death *The Book of Tea* would go on to become one of the most elaborately and frequently decorated books of the twentieth century. In hundreds of editions with slipcases, color plates and *sumi-e* paintings, a photograph of Okakura smoking, scholarly footnotes, even

(as is often the case nowadays) packaged with tea bowls, whisks, and instructional DVDs, *The Book of Tea* has for over a hundred years been a constant source of Asia-as-*technê* for readers.

The E-Book of Tea

Consider, as a final example of Asia-as-*technê*'s curious place in the history of the book, the role of *The Book of Tea* in one of the most frequently cited discussions of early digital e-readers in the late 1990s.[142] Here, in a review of several new e-book gadgets, *Wired* magazine contributor Steve Silberman muses over the fascinating development of the book as an information technology. The very word "book," Silberman explains, is ancient, with theories that it "descended from names for the beech tree—from the bark, beechen tablets, and sticks used in monasteries for writing and binding of early books."[143] An "icon of permanence," made to preserve "thoughts deemed worthy enough to be fixed in form designed to endure," the book seems curiously out of place in an era when "we've come to think of texts as fluid resources, circulating through the watercourse of the Net and pouring themselves into convenient forms in our browsers" (*EL*, p. 100). What does it mean, Silberman asks, "to take the beech tree out of the book?" (*EL*, p. 100). For the cyberlibertarian gurus of the e-book, Silberman explains, such considerations are irrelevant since what really matters about a book is not so much "matter" as information. "There's a fundamental discontinuity in the publishing industry," one e-reader manufacturer tells him: "the product is intellectual content, but you have an entire industry based on paper distribution, with hundreds of years of momentum that is not based on the actual product" (*EL*, p. 100). Such notions of immaterial, disembodied information are of course axiomatic for the cyberlibertarian advocates of the digital revolution, but Silberman knows better.[144] Books not only "offer journeys," he argues, they are "destinations in themselves":

> Opening the cover of a large hardbound tome is like stepping into the entry hall of some great edifice, a cathedral of reason or temple of the muse. Smaller books are enclosed spaces, rooms taken by fugitive travelers whose histories bleed into our own. The paper—is it rough or smooth? Is the ink completely absorbed into the paper, or does it seem to sit just above the surface? A well-loved volume has a tactile personality, and a certain quiet dwells among its pages. (*EL*, p. 101)

To become one of these sacred "rooms," Silberman argues, "digital books will have to learn our secrets as thoroughly as their beech-born predecessors" (*EL*, p. 101). For an e-book to really catch on, in other words, "it will not only have to function properly, it will have to possess that ineffable magnetism." The design of the device, then, will be extremely important, which is why Silberman is impressed that so many recent e-readers have learned (as we shall see more fully in chapter 7), the "Zen" lesson conveyed by the widespread acceptance of the PalmPilot, whose "way to simplicity in design" and mantra of "limited functionality" offered an implicit "rebuke against the Swiss-Army-knife school of design," which dictated that a handheld device needed to be as crowded and cluttered with as many tools as possible (*EL*, p. 101). The best e-readers will be those who, in classic skeuomorphic fashion, "inherit their proportions from the domain of the printed word," and give off "the primordial odor of bookishness" even as they promise to revolutionize the experience of the book (*EL*, p. 101).

RocketBook

NuvoMedia

Weight:	1.25 pounds
Size:	7 1/8 x 4 7/8 x 7/8"
Features:	Fits in your palm; stylus
Partners:	Bertelsmann, Barnes & Noble
Price:	Undisclosed
Release:	Fall

SIMULATED SCREEN

Fig. 2.18. Okakura Kakuzo's *The Book of Tea* as portrayed on the RocketBook in *Wired* (July 1998), p. 102.

So how well did the e-readers of 1998 measure up to the task? Silberman reports that "one night" the director of marketing for one of the new companies, "hands me his own RocketBook," on which Silberman finds Okakura Kakuzo's *The Book of Tea* (*EL*, p. 104) (Fig. 2.18). Sitting down to give the book a try, he begins by noting the heft and look of the device: "I notice how easily the RocketBook finds purchase in my hand." He is "impressed by the presence of the letters on the screen, an LCD hybrid . . . as if there were real ink trapped under the glass" (*EL*, p. 104). But he is not immediately sold on it: "It's hard to think of *The Book of Tea* pried loose from its atoms, a book—with its flax-colored paper, muted *sumi-e* landscapes, and slightly surprising portrait of the author holding a cigarette—that is an especially happy marriage of form and content. At first, Okakura's meditation on the cultivation of grace in a universe of imperfect things seems a little marooned in its plastic box, the author's voice sounding fainter in my mind's ear than when I'm reading the book on paper" (*EL*, p. 104). Silberman has no idea, it would appear, that none of the material attributes he is so enamored with in *The Book of Tea* (flax paper, *sumi-e* landscapes, the illustration of Okakura) were included in the original "atoms" of Okakura's text in 1906. But inasmuch as these later editions of *The Book of Tea* are for Silberman such a happy "marriage of form and content," he is also not willing to cut off the possibility that an e-reader might accomplish something similar. Indeed, after noting his initial reservations, Silberman's tone suddenly begins to change: "after a few pages, the subtle scorings of Okakura's tone—the erudite sentimentality, the ache for transcendence tempered by self-deprecation—again come forth to me. It's like learning to hear a familiar passage of music transposed for a new instrument" (*EL*, p. 104). Then, as if illustrating his change of heart, Silberman quotes a passage from *The Book of Tea* itself: "When we consider how small after all the cup of human enjoyment is, how soon overflowed with tears, how easily drained to the dregs in our quenchless thirst for infinity, we shall not blame ourselves for making so much of

the tea-cup." At this point in Silberman's essay we begin to see why he chose specifically to write about *The Book of Tea* in testing the *technê* of the new e-books. Indeed, the aesthetic of *The Book of Tea* has become extremely important to the aspirations of the digital culture he is analyzing. He knows the book loses something when the "beech tree" goes, but there are new things to read in the tea leaves of the Rocket-Book too: "I won't be returning this *Book of Tea* to its little slip-case on my shelf. I miss the way the printed book's type, with its tiny irregularities, is a Western equivalent of the wayward bristles that make a brush stroke more living than a line. But through the text—the bits—alone, Okakura's mind speaks. I find myself wanting to be alone with the RocketBook, to slip out the door and click through its pages under the night sky, where the incandescence of its screen would permit me a self-contained communion with the author that a book on paper couldn't allow. . . . Suddenly, I want a RocketBook right away" (*EL*, p. 104). After some initial reluctance, then, not only has the *technê* of the e-book passed the test of Okakura's *Book of Tea*, it suddenly seems like an evolutionary leap forward. Silberman is even persuaded that something transcendent and immaterial—"the bits"—has found a new home on the device. Like the "tiny dynamos" of Lafcadio Hearn's fireflies, the suddenly mystical light of the e-reader has allowed for something different yet sacred and beautiful, something connected to the cosmos in ways that Silberman can barely understand. But he knows he wants one.

3. Mastering the Machine

Technology and the Racial Logic of Jack London's Asia

There had never been a time when he had not been in intimate
relationship with machines.
—Jack London (1906)

America does not see that it is in any danger. It does not understand
that it is facing its most tragic moment: a moment in which it must
make a choice to master its machines or to be devoured by them.
—Carl Jung (1912)

At 7:00 a.m. on May 29, 1894, an exhausted and penniless Jack London
arrived in Chicago. He was eighteen years old, on the road, and without any clear
idea of how he would get home to Oakland, California. He had just abandoned a
ragtag army of protestors on their way to Washington, sensing, he would later ex-
plain, that their effort to convince the government to adopt a "Good Roads" bill
(providing temporary work, they hoped, for the growing masses of unemployed Amer-
icans) was perhaps doomed from the start.[1] He had learned to ride the rails without
paying, ducking into boxcars when "John Law" was not watching, and had jumped
off the train in Chicago after a long trip up from Missouri to find it cloudy and
drizzling rain. His mother had sent word that a few dollars would be waiting for him
there in general delivery, and he was relieved to find that she had indeed sent the
money. He found a room at the Salvation Army (the first bed he had slept in since
he left Oakland), woke up the next morning, paid for a good breakfast, a shave,
some new clothes, and began making his way out to Jackson Park to see what he
had heard so much about all the way back in Oakland: the World's Columbian
Exposition.

But the World's Fair of spring 1894 was not the World's Fair that London had
heard so much about. The official fair had ended in October 1893, and what remained
seven months later was (while perhaps still somewhat impressive architecturally) a
mere empty shell. He could wander the grounds for free now, but all of the fair's ex-
hibitions were closed, its reveling crowds gone, its dazzling electric lights doused, its
awe-inspiring Ferris wheel (with its necklace of flickering incandescent bulbs) dis-
mantled and removed.[2] The Columbian fountains had ceased flowing, the enormous
dynamos and Allis engines in Electricity Hall had been carted off, and the deafening
din of the electric turbines in Machinery Hall had been replaced by a reverberating
silence. What in the spring of 1893 had looked like gleaming marble (actually a plas-
ter mixture called "staff" that had been simply spread over frames of wood and iron)
was now starting to crack and crumble. The world's great works of art had been

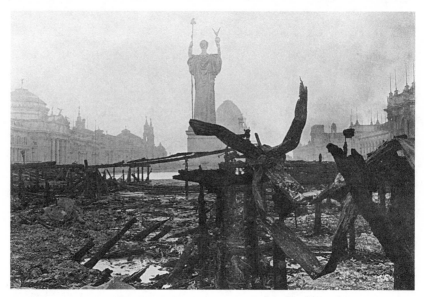

Fig. 3.1. Fire and looting reduced the "White City" to rubble in spring 1894; photographer unknown, image courtesy of the Chicago History Museum, ICHi-25106.

packed back into crates and taken away. Fires in February had already damaged a number of buildings, and many more had been torn down, looted, or vandalized (Fig. 3.1).[3]

Across the lagoon on the Wooded Island, Jack would have seen the more durable Japanese Pavilion, its curved roofs angling elegantly above the trees, and it may have brought to mind the week he spent at a Japanese port as a young sailor aboard a seal-hunting expedition only a year before. But none of the Ho-o-den's lavish art and décor remained. No one was there to explain the virtues of Zen Buddhism; there were no Japanese textiles, ceramics, printed screens, or woodcuts to bring home as souvenirs. Indeed, the aesthetic mythology of Japan's *technê*—that Orientalized dream of a unified, more organic world of art and technology—was no nearer then for Jack London than it had been the previous year when he spent a drunken night in a waterfront village on a small Japanese island—one of the stops made by his ship, the *Sophia Sutherland* (after getting thoroughly sloshed at one of the island's entertainment houses, London had passed out and woken up on the steps of the harbor pilot's house, his money and watch gone, as well as his shoes, belt, and coat; it was his first time on "foreign soil").[4]

Nor was he anywhere nearer the "glorious" and "breathtaking" displays of machine civilization he had heard about back home. But this emptiness may have felt right for London. Unlike the quasi-religious impulses directed at the new dynamos and electric motors by many visitors to the fair, the young Jack London had never had—and, indeed, would never have—any unqualifiedly romantic feelings for large machines.[5] Part of why he had left home in the first place was to escape what had become a life of oppressive and physically demoralizing machine work. As a young boy he had earned the standard, exploitative wage of ten cents an hour tending the dangerous canning machines at Hickmott's Cannery in Oakland, where ten-hour days were the required minimum (Fig. 3.2). More recently, he had walked away with stress fractures in his wrists after working twelve-hour days at the Haywards Electric Company, also in Oakland, where his boss had promised him a steady climb to

Fig. 3.2. Photograph of the interior of Hickmott's Cannery, where London worked as a boy (taken in 1902, some years after London worked there). Notice the dangerously exposed machine belts (image courtesy of the Oakland Public Library, Oakland History Room, CA).

the top if he worked hard—with Jack only realizing months later that he had been conned into doing the work of two men who were fired after he was brought on, both of whom had made more than he was promised.

If, as many contemporary accounts suggest, visitors to the World's Fair in 1893 came away shedding "tears of joy" at the sight of so sublime a civilizational spectacle, the world of Chicago in May 1894 could not have been more different. The political and economic trauma of the 1893 depression, delayed (or at least suppressed) temporarily during the fair, arrived that spring in Chicago with terrifying and revolutionary force. As Chicago historian Finnis Farr explains, the unemployed were everywhere: "abandoned children filled the orphanages beyond capacity, and every day the police gathered babies left in the streets, some of them dead."[6] British journalist William Thomas Stead's volume *If Christ Came to Chicago!* was published that spring, and had already sold two hundred thousand copies when Jack London arrived. For Stead, the temples of machine civilization during the fair seemed to mock the horrifying machine reality of Chicago life in 1894: "I have never seen so many mutilated fragments of humanity as one finds in Chicago. . . . The railroads which cross the city at the street level in every direction, although limited by statute and ordinance as to speed, constantly mow down unoffending citizens at the crossings."[7] As we shall see, Jack London had by 1894 learned to use the locomotive system to his advantage, but he knew the large machines could be dangerous. His own stepfather, John London, already a disabled Civil War veteran, had suffered a serious railroad yard accident a few months before Jack left Oakland, which fractured several ribs and kept him in bed for weeks.[8] Years later, Jack reported that as a child he suffered from a recurring nightmare in which a locomotive seemed to be endlessly pursuing him: "I could not get out of its way. . . . night after night I was run down. . . . I always rose up again after suffering the pangs of a horrible death, [only] to go over it all again. The

torture those nightmares gave me none can understand except those who have gone through a similar experience."[9]

Chicago in May 1894 also saw the first volleys of the Pullman Strike, when the luxury railroad car manufacturer George Pullman ignominiously denied the pleas of labor activist Eugene V. Debs's American Railway Union.[10] If Jack had gone to Chicago with any patriotic optimism, his experiences in the weeks following his visit would have completely destroyed it. For it was only a few weeks later, after visiting his mother's sister in Michigan and riding the rails out to see Niagara Falls before heading home, that young Jack was arrested for vagrancy and sentenced to thirty days in the Erie County Penitentiary. His request for a lawyer was met with howls of laughter, and he soon found himself alongside hundreds of other prisoners, who "formed the lock-step and marched out into the prison yard to go to work," supervised by vigilant guards on the prison walls, "armed with repeating rifles, and . . . machine-guns in the sentry-towers."[11] For the young Jack London making his way across the nation in 1894, it was not a world of fairs, mechanical glories, and patriotic progress, but one of apocalyptic crisis, injustice, and inequality, marked by the specter of dangerous and oppressive machines.

It may seem odd, at first, to begin a discussion of Jack London's Asian/Pacific writing by focusing so deeply on the historical picture of his life a full ten years before he would serve as a war correspondent for the Russo-Japanese War in 1904, and twelve years before he would visit Hawai'i in 1906; and perhaps odder still to point to what he didn't see (in the form of Asia's *technê* and the "glories" of the massive machines at the Columbian Exposition), but it is one of the central theses of this chapter that what Jack London saw and did not see of "the machine"—as well as what he saw and didn't see of Japanese and, later, Hawai'ian, culture—radically inflected his contradictory portrayals of Asian/Pacific peoples throughout his career. Put simply, the framework I am proposing in this chapter involves treating London as a representative figure of a larger discourse of "machine" anxiety, one that took as its overarching goal the drive for a nonalienated and therapeutic relationship with modern technology—the search, that is, for *technê*.

As this chapter will demonstrate, one of Jack London's most consistent concerns throughout his career was the place of the machine in modern life, and his engagements with the discourses of racial formation and socialism (and his complicated attempts to both reproduce and transcend them) are consistent with this technologically deterministic concern. London's vision of Asia/Pacific, in other words, was as much a product of his hopes and fears about modern technology as it was of any rigid, biological theories of racial difference. Indeed, when viewed through the prism of his concerns about the role of technology in late nineteenth- and early twentieth-century capitalism, London's seemingly contradictory characterizations of various Asian/Pacific people become much more coherent (if still firmly rooted in a racialized, Eurocentric worldview). One cannot legitimately claim, as some apologetic London scholars have attempted to, that London gradually "outgrew" his racism, or that his racism was less evident in his fiction than in his nonfiction, or even that London modified his racial views according to what he thought his various audiences wanted to hear. Indeed, there are too many examples of blatant racism in London's writing running across all of these possibilities. And yet, one cannot simply argue that London was only ever racist, or that he never modified his racial ideas, or that he subscribed uncomplicatedly and consistently to white supremacy and Anglo-American hegemony. Perhaps it is precisely this dense matrix of racial logic that makes London

so fascinating and relevant today. If, in other words, we hope to make sense of how modern loyalties to racial ideology can be challenged and transcended—and of how they can return at any moment as powerful and dangerous as ever—then a careful examination of Jack London's racialized search for a way of overcoming the machine is long overdue.

So Many Jack Londons

Just how contradictory were Jack London's views of Asian and Pacific Island peoples? As Jeanne Campbell Reesman has recently noted, his views were, at the very least, "complicated." London was "capable of uttering abhorrent crudities in support of white superiority," even while many of his stories "are rich in imaginative insight into the lives of racial Others."[12] And it is certainly not yet clear in London scholarship how these complicated views coexisted in the same person. In 2005, for example, both Colleen Lye and John Eperjesi published impressive studies of Jack London's orientalism, with distinct although ostensibly compatible areas of emphasis and argument.[13] Lye's comprehensively researched examination of London's East Asia and his production of "Asiatic" racial form focuses primarily on the naturalist convergence of his socialism and racism, arguing that London's vision of socialist revolution presupposes an apocalyptic confrontation between the white races and the "Yellow Peril." Eperjesi's study bypasses a discussion of London's socialism and argues primarily for a cohesive reading of London's anti-Japanese racism and his deceptively positive picture of Pacific Islanders—an image that Eperjesi argues is evidence of an American "imperialist imaginary" bent on global capitalist domination. Many reviewers have characterized these two studies as companion volumes in an overall indictment of London's orientalist worldview—with Lye accounting for (and identifying the racist logic of) London's socialism and Eperjesi accounting for (and identifying the imperialist motivation of) London's positive image of Asians in the Pacific.[14]

But if London's socialism was consistently racist, and his vision of the Pacific reflected an enthusiastic endorsement of patriotic American capitalism, it is not entirely clear how these two visions fit together. Consider, for example, the day Jack London visited Yale University in 1906. Already a highly successful writer, with *The Call of the Wild* (1903), *The Sea Wolf* (1904), and *White Fang* (1906) in wide circulation, London had begun touring the United States, preaching the cause of radical socialism in dozens of cities. When the state secretary of the Socialist Party of Connecticut, Alexander Irvine, heard him speak in New York, he was impressed and invited him to visit New Haven on January 26. Finding a place for him to speak, however, was not exactly easy. All the local theaters were booked; the Young Men's Christian Association and local Christian organizations wanted nothing to do with him; and Yale was not exactly an ideal location for a lecture on the virtues of radical socialism. Indeed, to become a "Yale Man" in 1906 meant, almost without exception, to be instructed in the virtues of white privilege and free-market liberalism.[15] Irvine nonetheless made an appeal to the Yale Union, a debating society, on the grounds that his speech would encourage debate among the students. The officers of the Yale Union agreed to host the event in Woolsey Hall, not fully realizing what they were committing to, and when posters advertising a speech by "Comrade London" on "The Coming Crisis" began to appear on campus, the panicking Union officers contacted Secretary Irvine again about the event, suggesting that "everything with a socialistic tendency was to be cut out."[16] As one student wrote to Secretary Irvine,

"Yale Union and many of the faculty are sweating under the collar for fear London *might* say something socialistic."[17] When London arrived at Woolsey Hall for his lecture, the place was packed. Standing up to the platform, London spoke in a clear, low voice:

> The comradeship of the revolutionists is alive and warm. It passes over geographical lines, *transcends race prejudice*, and has even proved mightier than the Fourth of July, spread-eagle Americanism of our forefathers. The French socialist workingmen and the German socialist workingmen forget Alsace and Lorraine, and, when war threatens, pass resolutions declaring that as workingmen and comrades they have no quarrel with each other. Only the other day, when Japan and Russia sprang at each other's throats, the revolutionists of Japan addressed the following message to the revolutionists of Russia: "Dear Comrades—Your government and ours have recently plunged us into war to carry out their imperialistic tendencies, but for us socialists there are *no boundaries, race, country, or nationality*. We are comrades, brothers and sisters, and have no reason to fight. Your enemies are not the Japanese people, but our militarism and so-called patriotism. Patriotism and militarism are our mutual enemies."[18]

It was the same speech he gave that year in San Francisco, Illinois, Iowa, Missouri, Ohio, Pennsylvania, New Jersey, New York, Massachusetts, Minnesota, Wisconsin, North Dakota, and even, one year later, to groups of white elites in Hawai'i.[19] It is not clear how such a statement, repeated with evangelical fervor and reported on in dozens of newspapers as he traveled across the nation, makes sense in the context of Lye's and Eperjesi's studies. They do not quote the passage; nor do they quote from a letter that London later wrote to a Japanese friend about the need to educate "the people of the United States and the people of Japan so that they will be too intelligently tolerant to respond to any call to race prejudice."[20] Perhaps one way of understanding statements like these might be to argue that London was simply (or pathologically) hypocritical, and that what he really thought was what he reportedly told a group of fellow white comrades at a meeting of the Oakland chapter of the Socialist Party: "I am first of all a white man and only then a socialist."[21] The fact that throughout the tour London brought along his Korean servant to help him with his travel and meals would seem to suggest as much.[22] But if so, why go on to expound the need to transcend "race, country, or nationality" in the fight against global capitalism? If, as Eperjesi maintains, London was, in his heart, a patriotic American imperialist, why does he argue for an international, multiracial uprising that would "destroy bourgeois society with most of its sweet ideals and dear moralities, and chiefest among these . . . private ownership of capital, survival of the fittest, and patriotism—even patriotism"?[23]

Problems like this only appear, of course, when one examines the entire corpus of London's writing—not just what he said about China and Japan in 1904, or socialism, or Darwinism, or capitalism, or writing, or dog adventures, or the Pacific, or Carl Jung, or machines. One has to remember that London wrote at a furious pace, keeping his goal of a thousand words a day with an almost religious regularity (even when sickness had swollen his hands to double their normal size), and that he churned out all sorts of material: novels, short stories, nonfictional essays, reviews, letters, plays, reportage, and even photojournalism. Taking stock of this entire corpus, it becomes clear just how futile it is to defend Jack London against accusations of rac-

ism, how futile to characterize him as a consistent champion of international Marxism, and how futile to characterize him as only ever racist. The real task for the critical discourse on Jack London (and for those interested in modernist naturalism more generally) is to develop a framework that can account for not only the stridency of his critique of global capitalism, and not only his racialized fears about Japanese modernity, but also his relatively antiracist views of Hawai'ian (and at times even Japanese) culture, his occasional calls for an international socialist utopia, and his unfortunate moments of regressive racial animosity—right down to the final years of his life. The first step in doing so, I would argue, is to ask what "the machine" meant for Jack London.

Jack London, Socialism, and "the Machine"

Jack London was not alone in missing or otherwise questioning the highly incorporated technological enthusiasm conveyed by the Columbian Exposition. As several scholars have shown, a burgeoning antitechnological impulse among many Anglo-Americans provided a stark counternarrative to the technocratic and increasingly corporate religion of American progress.[24] In its "antimodernist" guise, this sentiment appeared in tales depicting the ennui-stricken sufferers of overcivilized modernity (whose neurasthenia was identified as distinctly "feminine") and placed them in the more primitive surroundings of extreme climates or primordial contests with various "others"—thereby reinvigorating the protagonists with an Anglo-Saxon and "masculine" sense of purpose and direction. Less optimistic literary responses (what we now call modernist naturalism) described more severe stories of degeneration wherein the optimism and energies of an innocent and usually rural people are destroyed by the uncompromising austerity of technocratic urban life.

For a smaller group of American workers and political radicals, however, these technocratic dilemmas not only cast doubt on the role of mechanization in American life; they also signaled the inevitability of another type of American—and quintessentially modern—progress: socialism. Karl Marx had initially theorized that the most industrially developed capitalist nation would naturally lead the world into socialist transformation, and most Marxists at the turn of the century saw America's rapid mechanization (and the various antimodernist dissatisfactions with it) as an inevitable fulfillment of that prophesy.[25] The leader of the American Socialist Party, Daniel De Leon, for example, argued in 1904, "the conclusion cannot be escaped that America is the theatre where the crest of capitalism would first be shorn by the falchion of socialism."[26] And again in 1906: "If my reading of history is correct, the prophesy of Marx will be fulfilled and America will ring the downfall of capitalism the world over."[27] But Marxist theories of immanent industrial revolution did not exactly mean "back to the land" agrarianism or a rejection of complex technologies as such. On the contrary, radical socialism in late nineteenth-century America involved a complex mix of populist antimechanization and modernist praise for technological efficiency—qualified, that is, by frequent calls for the eradication of private ownership of large machine systems. Machines were dangerous and oppressive— the socialist message seemed to be—but perhaps not *so* dangerous and oppressive that a good socialist revolution couldn't transform them into mechanisms of collective, utopian efficiency. Thus, on the one hand, there were narratives like that of Roy O. Ackley, published in the socialist monthly *Wilshire's Magazine* in 1906 (and republished widely as a pamphlet during the next few years), titled "My Master, the Machine." Detailing his experience as a factory machinist, Ackley wrote of being a

mere "appendage to a machine" for ten hours a day: "I and my companions who operated these machines were chained to them by a chain of wages that we could not break," Ackley explains. "And, over all, the Machine Lord, who did not use the machine, was a Tsar—he dictated the lives of the machine serfs who toiled—he took the product!"[28] By contrast, there were also dozens of socialist tracts throughout the Gilded Age arguing for the intrinsic value of machines, provided that they could be properly (that is, collectively) managed. As Richard T. Ely, a professor of political economy at Johns Hopkins, argued in 1891, the most compelling virtue of socialism is that it would "render possible the full utilization of inventions and discoveries without the immense amount of pain and suffering which they now cause."[29] Under socialism, he argued, "Every mechanical invention and all technical progress would be the good fortune of all members of the social organism."[30] What socialism signaled for many Americans, in other words, was the possibility of a more perfect technological experience, a way of mastering (rather than abandoning or being mastered by) the increasingly efficient machines of modernity.

A number of London scholars have already demonstrated that much of his authorial self-branding was consistent with the technological anxieties of these social movements and generic forms.[31] Two very useful studies by Mark Seltzer and Jonathan Auerbach, for instance, have identified a productive tension in the "relays" between London's use of "market culture" and "machine culture."[32] Seltzer is especially persuasive in arguing that American naturalism (and London's fiction specifically) relies on a persistent coupling of bodies and machines—and particularly in the literary mechanics of typed and mechanically mass-produced literary production. Auerbach extends Seltzer's arguments by demonstrating London's tendency to characterize the literary field itself as a kind of "impersonal machine"—as though writing were a species of industrial "labor" that could be systematized and streamlined through a kind of "literary Taylorism."[33] According to Auerbach, London participated in the common practice of treating "publishing primarily as manufacture, a largely mechanical process to be studied, broken down into its component parts (paper, stamps, typewriters) and component skills, and then duplicated."[34] As we shall see, the implied connection here between London's authorial procedures and F. W. Taylor's scientific management is important precisely because London—as a highly self-conscious product of this qualified vision of modernity—so often targeted these latter mechanized systems of urban exploitation. London's search for and successful marketing of an authorial *techné*, in other words, had everything to do with the public experience of his learning to master the machine.

Consider, for example, London's short story, "The Apostate" (1906), which, as Seltzer has argued, reflects common naturalist anxieties regarding "the radical and intimate coupling of bodies and machines."[35] Originally subtitled "A Parable of Child Labor," London's quasi-autobiographical story details the horrors of a young boy's experience in the jute mills and his sudden decision to abandon the intense work (and the mother and siblings he had been supporting)—hence, his "apostasy" involves his abandoning his role in the "religion" of American technocratic industry. The story opens with young Johnny's mother waking him, feeding him a meager breakfast, and sending him on his way to the local factory where he "took his place in one of the many long rows of machines."[36] London's narrator is emphatic on the overwhelming presence of the machine in Johnny's work: "He worked mechanically. . . . From the perfect worker he had evolved into the perfect machine. When his work went wrong, it was with him as with the machine, due to faulty material. It would have been as

possible for a perfect nail die to cut imperfect nails as for him to make a mistake" ("TA," p. 326). Such precision was "small wonder," since, as London's narrator explains,

> There had never been a time when he had not been in intimate relationship with machines. Machinery had almost been bred into him, and at any rate he had been brought up on it. Twelve years before, there had been a small flutter of excitement in the loom room of this very mill. Johnny's mother had fainted. They had stretched her out on the floor in the midst of the shrieking machines. A couple of elderly women were called from their looms. The foreman assisted. And in a few minutes there was one more soul in the loom room than had entered by the doors. It was Johnny, born with the pounding, crashing roar of the looms in his ears, drawing with his first breath the warm, moist air that was thick with flying lint. ("TA," p. 327)

Born amidst the roar of machine culture, London's Johnny eventually goes to work at the factory, sitting "always in the one place, beyond the reach of daylight, a gas jet flaring over him, himself part of the mechanism" ("TA," p. 332). His work becomes the biological embodiment of F. W. Taylor's scientific management: "he had attained machinelike perfection. All waste movements were eliminated" ("TA," p. 322). His "consciousness was machine consciousness" ("TA," p. 335). Machine efficiency, in other words, did not equal progress for young Johnny: "Time did not march. It stood always still. It was only the whirling machines that moved, and they moved nowhere—in spite of the fact that they moved faster" ("TA," p. 335). Johnny's "apostasy" is an open rejection of the quasi-religious machine culture that had determined his life since birth: "I ain't never goin' to work again," he tells his mother. "My *God*, Johnny!" his mother replies, "Don't say that!"[37]

In *People of the Abyss* (1902), a serialized report on the horrific working conditions in England's East End slums, London similarly describes the working-class "Abyss" in metaphors of "the machine." After detailing the various diseases and physical ailments that afflict factory workers, London argues, "one is forced to conclude that the Abyss is literally a huge man-killing machine."[38] The workers themselves begin to resemble their machines. In a particularly vivid chapter titled "A Vision of the Night," London narrates a walk he took along Commercial Street down toward the docks. What he sees along the way is a "nightmare," a "fearful slime" of "unmentionable obscenity," "twisted monstrosities," "perambulating carcasses" that shamble along "like apes" in a "perpetual writhe of pain" (*PA*, pp. 284, 287). London closes the chapter with this very typical antimodernist sentiment: "If this is the best that civilization can do for the human, then give us howling and naked savagery. Far better to be a people of the wilderness and the desert, of the cave and the squatting-place, than to be a people of the machine" (*PA*, p. 288). Far better, perhaps, but abandoning civilization in favor of the tech-less "cave and squatting-place" was hardly London's ultimate goal. Like much of the radical socialism he identified with, London was forever in search of that more therapeutic and aesthetic relationship *with* technology, rather than without it, even if that relationship could not be completely defined in advance. It is not clear, for example, at the end of "The Apostate," where exactly young Johnny is headed after his final renunciation of machine civilization. We learn only that Johnny's resignation has brought on an "inordinate hunger for rest," and that he eventually makes his way to the railroad station, where he "lay down in the grass under a tree":

All afternoon he lay there. Sometimes he dozed, with muscles that twitched in his sleep. When awake, he lay without movement, watching the birds or looking up at the sky through the branches of the tree above him. Once or twice he laughed aloud, but without relevance to anything he had seen or felt.

After twilight had gone, in the first darkness of the night, a freight train rumbled into the station. When the engine was switching cars onto the side-track, Johnny crept along the side of the train. He pulled open the side door of an empty boxcar and awkwardly and laboriously climbed in. He closed the door. The engine whistled. Johnny was lying down, and in the darkness he smiled. ("TA," p. 341)

It may seem strange at first that young Johnny's "apostasy" from machine culture has simply taken him from one machine to another (in the factory, a machine whistle blows and Johnny moves; at the train station, a machine whistle blows and Johnny moves). But what has really changed for Johnny is neither the proximity of machines nor their precision of operation; rather, in the wake of his neurasthenic "twitching" and cathartic laughter, it is Johnny's *relationship* with the machine that has been dramatically altered by his "apostasy."

Almost as a sequel to "The Apostate," London's autobiographical memoir published a year later, *The Road* (1907), recounts his own experiences "tramping" during the economic crisis of the 1890s. For London (and especially for the "Jack London" persona constructed in *The Road*), covertly riding the rails offered a means of romantically altering one's relationship with machine culture—a measure of *technê*-freedom in a technocratic world of oppressive industry. In *The Road* London argues, "The successful hobo must be an artist. He must create spontaneously and instantaneously."[39] What this "artistry" entailed for London was a combination of two proclivities: storytelling and an insurgent stance regarding machine culture. As he explains, "I have often thought that to this training of my tramp days is due much of my success as a story writer. In order to get the food whereby I lived, I was compelled to tell tales that rang true. At the back door, out of inexorable necessity, is developed the convincingness and sincerity laid down by all authorities on the art of the short-story" (*TR*, pp. 193–194). The stories that London tells his readers in *The Road* have him besting the machine in a number of ways—and sometimes in ways that suggest striking parallels with London's characterization of print capitalism. Take, for example, the numerous moments in *The Road* where London relates his efforts to ride the rails without being caught by the various "shacks" employed to cast off freeloaders. Again and again, London describes himself working his way in, through, and around the various machinations of a moving railcar:

The train pulls out. There is a lantern on the first blind. I lie low, and see the peering shack go by. I turn and run back in the opposite direction to what the train is going . . . I sprint. Half the train has gone by, and it is going quite fast, when I spring aboard. I know that the two shacks and the conductor will arrive like ravening wolves in about two seconds. I spring upon the wheel of the hand-brake, get my hands on the curved ends of the roofs, and muscle up to the decks. (*TR*, p. 211)

The shacks cluster on the nearby platform cursing at London, but "what does it matter? It is five to one, including the engineer and fireman, and the majesty of the

Figs. 3.3–3.6. Illustrations for Jack London, *The Road* (New York: Macmillan & Co., 1907), pp. 24, 35, 37, 39.

law and the might of a great corporation are behind them, and I am beating them out" (*TR*, p. 211). In the original Macmillan edition of the story, a number of photographs and paintings were included to help illustrate these techniques—all of which convey a figure moving ingeniously between, around, under, over, and inside the roaring movement of modern machinery (Figs. 3.3–3.6). In a later memoir, London would explain his tramping days with the following: "As a tramp, I was behind the scenes of society—ay, and down in the cellar. *I could watch the machinery work.* I saw the wheels of the social machine go around."[40]

Naturally, what is being portrayed here was not a feasible option for the vast majority of London's readers. Such images, however, were crucial to London's efforts to market himself and his writing as a source of revitalized modernity; that is, as someone who could portray the evils of machines (both industrial and literary), even while

demonstrating a more therapeutic means of living with them. As Auerbach has observed, one of London's most consistent metaphorical images is "the impersonal machine of the literary field itself, the mysterious process of sending out into the world and receiving back (mostly stereotyped rejection slips)."[41] In several essays on the process of writing and getting into print, London portrays the need for developing a "self" in terms that very clearly coincide with the function of a corporate brand or trademark. More specifically, the "Jack London" that London describes in these essays is one clearly invested in portraying the need—especially in the beginning—for an insurgent relationship with the machine. As he writes in "Getting into Print," an essay published in *The Editor* in 1903:

> All my manuscripts came back. They continued to come back. The process seemed like the workings of a soulless machine. I dropped the manuscript into the mail box. After the lapse of a certain approximate length of time, the manuscript was brought back to me by the postman. Accompanying it was a stereotyped rejection slip. A part of the machine, some cunning arrangement of cogs and cranks at the other end (it could not have been a living breathing man with blood in his veins) had transferred the manuscript to another envelope, taken the stamps from the inside and pasted them outside, and added the rejection slip.[42]

In London's 1909 novel *Martin Eden*—the title character's initials signaling already the novel's autobiographical nature—several of the events from London's life address these same themes. Martin's work in a laundry has him operating like "a feverish machine," learning the "elimination of waste motion," his attempts to stay sober described as "super-machinelike."[43] More specifically, Martin's efforts to get into print exactly mirror London's mechanistic description above: "He began to doubt that editors were real men. They seemed cogs in a machine. That was what it was, a machine. He poured his soul into stories, articles, and poems, and entrusted them to the machine. . . . There was no human editor at the other end, but a mere cunning arrangement of cogs . . . well-oiled and running beautifully in the machine."[44] There is even a moment, as Andrew Sinclair has noted, when Martin "confuses the laundry and the literary machine, so that [Martin's co-worker] starches manuscripts while he mangles checks in the wringer."[45] It comes as no surprise, then, that in London's later reflections on his early writing efforts, he would describe the composition process as one of a heroic struggle with a machine:

> And then there was the matter of typewriting. My brother-in-law owned a machine which he used in the daytime. In the night I was free to use it. That machine was a wonder. I could weep now as I recollect my wrestlings with it. It must have been a first model in the year one of the typewriter era. Its alphabet was all capitals. It was informed with an evil spirit. . . . The worst of it was that I was actually typing my manuscripts at the same time I was trying to *master that machine.*[46]

If London's descriptions of both the railroad and the publishing industry portrayed his eventual success in mastering the machine (a machine that, as he is likely punning, can produce only "capital" script[47]), his ultimate sense of literary authority was based on the idea that naturalist authors must nonetheless be willing to portray the corporate machine as a hegemonic and terrifying force.

It would not be hard to argue, in fact, that virtually all the themes traditionally discussed in Jack London's writing throughout his career (masculinity, violence, authorship, racism, adventure, and so on) coincide with his constant portrayal of the machine as a target of analysis, as something that must be accounted for and transcended.[48] In one of his earliest socialist essays, "The Question of the Maximum" (1898), for example, London addresses the common 1890s concern over the "congestion" and "surplus" of Western capitalist markets, which, he argues, has emerged as a consequence of new global technologies like the telegraph, the steam engine, and the factory, causing the planet to have "undergone a unique shrinkage."[49] In his reportage on the Jeffries–Ruhlin boxing match in 1901, for example, he portrays the fighters as "Gladiators of the Machine Age."[50] In London's early collaborative novel, *The Kempton-Wace Letters* (1903), the brash young scientist Herbert Wace chastises the elderly poet Dane Kempton: "This is the day of the machine. When have you sung of the machine? The crusades are here again, not the Crusades of Christ, but the Crusades of the machine—have you found motive in them for your song?"[51] When the pampered St. Bernard/Scotch Collie dog, Buck, in *The Call of the Wild* (1903) is kidnapped from an idyllic ranch in Sonoma and taken to the brutal Klondike, he is strapped to a sled, and learns to work a "monotonous life, operating with machine-like regularity."[52] In *The Sea Wolf* (1904) Captain Wolf Larsen's brutal efficiency and systematic exploitation of his crew is described in terms that point directly to the machine logic of industrial capitalism.[53] When the wolf-dog in the novel *White Fang* (1906) arrives in urban San Francisco he is overawed by the "monstrous cable and electric cars hooting and clanging through the midst," by the "towering buildings," by the "colossal, stunning . . . thunder of the streets."[54] London's later novel *The Valley of the Moon* (1913) portrays a classic divide between the virtues of American agrarianism and the "industrial strife" of the nation's metropolitan centers.[55] In several of his short stories London portrays the "machine life" of the modern-day prison (what he calls that "iron world of bolt and bar" in *The Road*) as a nightmarish corollary to the "machinery" of the capitalist state.[56] Perhaps most fascinating of all, when some unknown antiwar socialist wrote an article pretending to be Jack London, he would do so in precisely this language: The "good soldier," the pseudo-London claims, "is a blind, heartless, soulless, murderous machine."[57] As even pseudo-Jack Londons seemed to understand, to be "Jack London" was to attempt to reframe one's relationship with the machine.

Again and again in London's writing it is modern civilization's harmful relationship with technology that has created the crises that seem to demand an aggressive socialist response. In the aforementioned speech on "Revolution," for example, London argues, "As fast as a country becomes civilized, the revolution fastens upon it. With the introduction of the machine into Japan, socialism was introduced. Socialism marched into the Philippines shoulder to shoulder with the American soldiers. The echoes of the last gun had scarcely died away when socialist locals were forming in Cuba and Porto Rico [sic]."[58] But if the machine arriving in Japan and other countries has necessarily fomented socialist responses, London is careful not to condemn technology as such: "in this day, by machinery, the efficiency of the hand-worker of three generations ago has in turn been increased many times" ("R," p. 1158). Whereas it takes 211 hand-hours to produce 100 bushels of barley, London notes that the same amount requires only nine machine-hours; 50 bushels of corn requires 228 hand-hours, but only 34 machine-hours; 50 bushels of wheat requires 160 hand-hours, but only 7 machine-hours (and so on). The point here, according

to London, is that with a more efficient and humane method of production and distribution, technology could in fact make it possible to "feed everybody, clothe everybody, house everybody, educate everybody" ("R," p. 1159). Put simply, London's radical socialism was, like his tramping, a search for *technê*: "There would be no more material want and wretchedness, no more children toiling out their lives, no more men and women and babes living like beasts and dying like beasts. Not only would matter be mastered, but *the machine would be mastered*" ("R," p. 1160; emphasis added).

This need to master the machine is underscored in several of London's socialist fictions, many of which depict machines literally severing the limbs of working-class people. Take, for example, the opening of London's short story, "A Curious Fragment": "Listen, my brothers, and I will tell you a tale of an arm. It was the arm of Tom Dixon, and Tom Dixon was a weaver of the first class in a factory," a factory called "Hell's Bottom" by those who work there.[59] Eventually Tom has his "arm torn off by a belt" in one of the machines in Hell's Bottom.[60] Framed with an "editor's note" hundreds of years in the future, London's narrator in "A Curious Fragment" describes the horrors of an industrial oligarchy not yet conquered by socialist revolution (although the "editor" of the future implies that such a revolution has at some point taken place). London's most famous socialist fiction, *The Iron Heel* (1907), is also caught up with events following the severing of a worker's arm. Similarly framed by an "editor" seven centuries in the future who frequently inserts extra-diegetic commentary and clarification in footnotes, the narrator of *The Iron Heel* is a young revolutionary woman named Avis, who one day in 1908 meets the hypermasculine Ernest Everhard. Having grown up in an upper-middle-class family, Avis is shocked to hear Everhard's indictment of capitalism, and particularly his story of a man named Jackson whose arm was severed while working in the Sierra Mills (where her father has invested a great deal of money). As Everhard explains,

> The toothed drum of the picker caught his arm. He might have let the small flint that he saw in the teeth go through. It would have smashed out a double row of spikes. But he reached for the flint, and his arm was picked and clawed to shreds from the finger tips to the shoulder. It was at night. The mills were working overtime. They paid a flat dividend that quarter. Jackson had been working many hours, and his muscles had lost their resiliency and snap. They made his movements a bit slow. That was why the machine caught him. He had a wife and three children.[61]

In this passage the machine catches and claws Jackson's arm to shreds only because he was attempting to save the machine—and yet, the capitalist machine offers no compensation to the disabled Jackson. Unable to believe that the corporations that employed Jackson would fail to compensate him for his arm, Avis begins an investigation into the incident, and it is what she discovers in the process that becomes the basis for her political awakening. After meeting with some of the supervisors at the Mills, Avis reports her disturbing findings to Everhard, who replies: "And not one of [the supervisors] was a free agent. . . . They were all tied to the merciless industrial machine" (*TIH*, p. 38). Everhard's own father, he confesses, "was a slave to the industrial machine, and it stamped his life out, worked him to death" (*TIH*, p. 38). No one in the system, Everhard insists, is a free agent: "We are all caught up in the wheels and cogs of the industrial machine. You found that you were, and that the men you talked with were. Talk with more of them. Go and see Colonel Ingram. Look up the reporters that kept Jackson's case out of the papers, and the editors that run the papers.

You will find them all slaves of the machine" (*TIH*, p. 39). Indeed, *The Iron Heel* could have been aptly subtitled "A Tale of the Machine."[62]

As in London's essay "Revolution," however, the protagonists of London's novel are careful to distinguish between technology as such, and the capitalist machine (dubbed the "Iron Heel" by Everhard) that perpetuates these social crises. In the chapter titled "The Machine Breakers," Everhard is quick to point out that there is a difference between the mechanical apparatus and the industrial machine. As he argues to a group of workers,

> You are machine-breakers. Do you know what a machine-breaker is? . . . In the eighteenth century, in England, men and women wove cloth on hand-looms. . . . Along came the steam engine and labor-saving machinery. . . . The men and women who had worked the hand-looms for themselves now went into the factories and worked the machine-looms, not for themselves, but for the capitalist owners. . . . Their standard of living fell. They starved. And they said it was all the fault of the machines. Therefore they proceeded to break the machines. They did not succeed and they were very stupid. (*TIH*, pp. 82–83)

Once again, the problem is not technology as such, but society's relationship with technology: "Let us not destroy those wonderful machines that produce efficiently and cheaply. Let us control them. Let us profit by their efficiency and cheapness. Let us run them for ourselves. Let us oust the present owners of the wonderful machines, and let us own the wonderful machines ourselves" (*TIH*, p. 86). This is the essence of Everhard's socialist dream: "Instead of being crushed by the machines, life will be made fairer, and happier, and nobler by them. . . . And we, all of us, will make new and more wonderful machines" (*TIH*, pp. 97–98).

The most often criticized element of *The Iron Heel* is that the path to this *technê-utopian* future goes missing from the narrative. That is, the future editorial commentary (written by one "Anthony Meredith" in the year 419 B.O.M., which stands for "Brotherhood of Man") makes clear that although Everhard's and various subsequent revolutions are quashed violently, eventually—somehow—the oligarchy is stamped out and an era of socialist peace triumphs. As Alessandro Portelli has argued, *The Iron Heel* is simply "Jack London's Missing Revolution."[63] That is, London fails to show us the revolution that finally transforms the nightmares of Everhard's narrative into the utopian and socialist comfort of the ostensibly paratextual narrator seven centuries in the future. For Colleen Lye, the various clues that London's narrator offers about that missing revolution are evidence of London's deeply felt racism against Asians. According to her, the missing conflict between global capitalism and international socialism in *The Iron Heel* already implies the necessity of a confrontation between "a united Asia and the world"—a conflict that must be resolved before any socialist utopia can appear. One passage in *The Iron Heel* is particularly revealing in this context. In describing the international oligarchy that arises during her narrative, Avis Everhard claims that the Japanese oligarchy was "most savage of all" in its treatment of the Japanese "coolie socialists," and that the English oligarchy "had succeeded only in retaining India. But this was no more than temporary. The struggle with Japan and the rest of Asia for India was merely delayed. England was destined shortly to lose India, while behind that event loomed the struggle between a united Asia and the world" (*TIH*, pp. 147–148). As Lye explains regarding this passage, "London does not further unfold the outcome of this East-West struggle, but

since the presumption of his narrative is that the events being recounted constitute the prehistory of an already achieved socialist utopia, we can only assume that this menace is some time safely put to rest."[64] Here, then, the missing revolution in *The Iron Heel* becomes a point of departure for Lye's argument that London saw his racism and his socialism as correlative endeavors: "The absent revolution is further reflected in the formal disjuncture between the text and its annotations. The dystopian narrative breaks off without portraying the events that result in utopia, whose eventual achievement is the foregone conclusion of the meta-commentary. . . . the world's victory over a 'united Asia' is not directly represented, only foretold and then assumed, much like the revolution itself."[65] But is it the case that London's socialism presupposed the need for a confrontation between the white races and a united Asia? And, if so, did these views ever change? What can the questions of technological culture in London's writing—marked, as it is, by constant metaphorical and metonymic references to "the machine"—tell us about London's racial worldview? In order to answer these questions, we must turn to another highly formative moment in London's career, the Russo-Japanese War in 1904.

Seeing Machines in Jack London's Yellow Peril

On February 1, 1904, a lone white man stepped off the steamer from Nagasaki and walked into the newly fortified city of Moji at the southern point of Japan closest to Korea.[66] There on the busy street the white man unfolded his camera (a portable Kodak 3A), held it down near his waist, and began snapping photographs, gazing intently into the small viewfinder on top of the machine. It was an alarming site for the observant Japanese officials in Moji; Russians were white, and here was a white man with a camera apparently documenting the city's armed installations. No word of permission or announcement had reached the officials that anyone would be arriving for such a purpose, and when they confronted the man, his brusque protestations that he was an "American journalist" and the "famous writer Jack London" were not exactly conclusive. No foreign journalists had been granted permission to be this close to the fighting in Korea, and he had no documentation to prove otherwise. Telling him politely that they were "very sorry," they dutifully arrested the man, confiscated his camera, and threw him in jail, where he would wait until their supervisors could decide what to do with him.[67]

It was the second time Jack London had landed in jail, and if the first time had inspired a litany of antimechanistic metaphors, this Japanese prison meant more of the same—if not worse—since a number of reporters had already been paying special attention to the "machines" of the Japanese army. Indeed, as Greg Waller has recently argued, the most "expansive discourse" surrounding American characterizations of Japanese military developments involved the ubiquitous portrayal of this foreign army as a "military machine."[68] All of London's fellow correspondents in Korea, including Richard Harding Davis, B. L. Putnam Weale, George Kennan, and Sidney Tyler, would characterize the Japanese army as inherently "mechanical." Tyler, for instance, reported that the Japanese military was a "splendid machine [operating] with an almost machine-like regularity and precision."[69] Kennan's reportage continually detailed the technological sophistication and accuracy of the Japanese war machine, their "machine shops," their "electric lights," and "coils of insulated telegraph wire," their inventive "hyposcope" (used to "enable an observer to look through the slit without exposing his head to the rifle fire"), their "500-pound shells"

for their massive "siege guns," their highly inventive use of "locomotive mines" and "body armor," and on and on.[70]

It was a discourse with origins already in Japan's technologically sophisticated victory over China nine years earlier during the Sino-Japanese War in 1895, an event commented on widely in the American press at the time.[71] If Japan's *technê* had been hailed for its therapeutic, more "aesthetic" version of modernity at the 1893 Columbian Exposition, by 1903 a more suspicious characterization of Japan's (dangerously mimetic) penchant for technological development had taken center stage in the Western press. One of several books London took with him to Korea, for example, was Senator Albert Beveridge's *The Russian Advance* (1903). "The Japanese army is a perfect machine," Beveridge argued, "built on the German model, but perfected at minute points and in exquisite detail with the peculiar ability of the Japanese for diminutive accuracy and completeness. The Japanese army, regiment, company, is built like a watch, and each Japanese soldier is part of this machine, like a screw or spring or disk, with this exception—every soldier is capable of being transformed into another part of this complex yet simple mechanism."[72] Japan's modern ascendancy, in other words, was marked by a kind of "techno-orientalism," in which nearly every account of the war included breathless and vaguely paranoid discussions of Japan's technological prowess.[73] Perhaps as a result of failing to see this techno-orientalist discourse as an immediate context for London's reportage, a number of scholars have attempted recently to characterize London's photojournalism during the Russo-Japanese war as culturally "progressive." As the editors of *Jack London: Photographer* (2010) put it, the "self-assured" London took a "humanistic approach" while in Korea, and had an ethnographically "discerning eye" (*JLP*, p. xiii). London's photographs are "full of feeling," such that his "instinctive response" to the war was to "open his heart as well as his camera's shutter" (*JLP*, p. xiv). Indeed, according to *Jack London: Photographer*, London's reportage was positively antiracist: "London was one of the few photographers of his day to portray nonwhite people as individualized members of humanity rather than as specimens. These were 'human documents' in London's sense of the term—subjects photographed for no other purpose than the photograph itself" (*JLP*, p. 11). London, "rarely diminishes his subjects; their individual selfhood predominates," which is evidence of his "compassionate view of humanity" (*JLP*, pp. 21, 65). Jeanne Campbell Reesman's *Jack London's Racial Lives* (2009) takes a similar approach, arguing that London's photographs of refugees in Korea reveal a "sense of their dignity and their endurance in the face of war." Reesman gives London's photographs captions like, "a portrait of the human cost of war," and argues that London's photography shows he had "compassion" for his subjects.[74]

While there may be scattered moments of such sensitivity in London's reportage, flattering portrayals of this sort are nonetheless misleading. It isn't just that it is not easy to tell whether or not the subjects of London's photographs are comfortable with being photographed (how can one tell, really, whether a photographic snapshot is "compassionate"?); and it isn't just that these scholars strategically omit several less-than-humanistic (even pornographic) images from their studies—a fact that, as I hope to demonstrate, perhaps only those who have actually seen the entire photographic archive in the London archives at the Huntington Library could understand; and it isn't just that what London actually says about his photography while in Korea is as racially and culturally *in*sensitive as any of his worst writing. All of these points are important, but the most critical element in understanding London's photo-reportage

in Korea (and the racist writing he produced there, curiously punctuated, as it is at times, with moments of humanity) is to understand the degree to which London portrayed these experiences as yet another *technê*-authorial contest over machines—and, in this case in particular, over machines of visual reproduction.

London was not alone, of course, in understanding his Russo-Japanese reportage in terms of its techno-visual significance. Indeed, one need only point to editorial cartoons such as the *Brooklyn Daily Eagle*'s "Sensations Every Minute," the *Cleveland Leader*'s "Turn on the Biograph," the *Los Angeles Times*'s "In the Orient," and, perhaps most suggestive of all, the *Des Moines Register*'s "In the World's Eye" to see how the Russo-Japanese War entered the American imagination as an event that needed to be processed visually (Figs. 3.7–3.10).[75] Frederick Palmer, one of London's fellow correspondents, put it rather cogently, arguing that the Russo-Japanese War was "the most picturesque of modern wars."[76] Certainly, London's editors at William Randolph Hearst's *San Francisco Examiner* were eager to capitalize on London's visual access to the war. In several cartoon illustrations accompanying London's stories, for example, London is portrayed, camera in hand, as not only documenting, but also directing the action itself (Figs. 3.11–3.12). Here the characterization of the war as a "show" coincides with London's role as potential director of the "theater" of war.

Sitting in jail in Japan in February 1904, however, Jack London wasn't seeing anything. He was not even sure when and how he would get out, or, if he did, whether he would ever get back his camera and make it to the front lines. He was taken a few miles north to Kokura, and after a few days of seemingly endless interrogation, was released with only a fine, but was also told his camera would not be returned. After making his way to a hotel in Shimonoseki, just north of Kokura, London was surprised to receive a visit from a Japanese reporter, a "slender, spectacled, silk-gowned man, who knew not one word of English." With the hotel manager acting as translator, the reporter explained to London that on behalf of himself and twenty other Japanese reporters in the area, he wanted to express his regret over the arrest; that "he and his fellow correspondents would petition the Kokura judges to auction off the camera"; that he and his associates would attend and collectively bid for the camera; and that "it would give them the greatest pleasure to present [his] camera . . . to [him] with their compliments."[77] London's response seems to show him in one of his most culturally sensitive moments: "I could have thrown my arms about him then and there—not for the camera, but for *brotherhood*, as he himself expressed it the next moment, because we were brothers in the craft. Then we had tea together and talked over the prospects of war."[78] It was a moment of solidarity in "craft," that sense of *technê*-culture that London saw as capable of not only countering oppressive systems of machine culture, but even, on occasion, transcending racial and national boundaries.

But it wouldn't last long. When confronted in the following months with the refusal of the seemingly intractable Japanese army to allow him anywhere near the fighting, London began conjuring up narratives of mechanized, racial terror. The Japanese are "thorough masters of the machinery of modern warfare," he wrote.

> Every division, every battery [of the Japanese army] was connected with headquarters by field telephone. When the divisions moved forward they dragged their wires after them like spiders drag the silk of their webs. Even the tiny navy at the mouth of Yalu was in instant communication with headquarters.

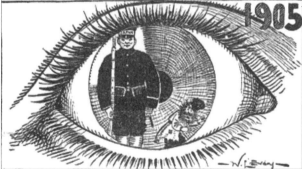

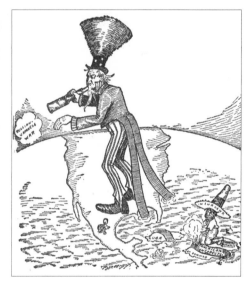

Fig. 3.7. "Sensations Every Minute," *Brooklyn Daily Eagle* (February 1904).

Fig. 3.8. "The Audience—'Turn on the Biograph,'" *Cleveland Leader* (April 12, 1905).

Fig. 3.9. "In the World's Eye," *Des Moines Register* (April 2, 1905).

Fig. 3.10. Uncle Sam looking through a telescope at the action in Korea, in Marshall Everett, *Exciting Experiences in the Japanese-Russian War* (New York: Henry Neil, 1904), p. 115.

Thus, on a wide-stretching and largely invisible field, the commander-in-chief was in immediate control of everything. Inventions, weapons, methods, systems (the navy modeled after the English, the army after the German), everything utilized by the Japanese has been supplied by the Western world; but the Japanese have shown themselves the only Eastern people capable of utilizing them.[79]

Figs. 3.11–3.12. E. Johnston, illustrations for Jack London's reportage in the *San Francisco Examiner* (April 4, 1904), p. 1.

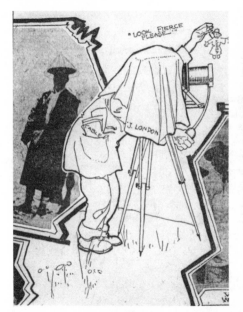

If London's portrayal of the Japanese army's communication technologies as advancing "like spiders drag the silk of their webs" seems rather ominous, his techno-orientalist fears did not stop there. The culminating essay of London's reportage in Korea (something he never bothered wiring back to the United States while in Korea as he knew it would not have made it past the Japanese censors) was a report written in June 1904 titled, tellingly, "The Yellow Peril." In this essay, published a few months after his return, London spells out a technological hierarchy beginning with the Koreans (or "mud" people, he says, who are shiftless, lazy), the Chinese (or "stone" or "brick" people, who are hardworking, industrious, and energetic, but still using "rude implements"), and the Japanese (or "steel" or "machine" people who are not only industrious, energetic, and hardworking, but are also highly industrialized and have fully adopted Western technology).[80] These technological distinctions are im-

portant for London because his notion of the "Yellow Peril" is based primarily on the possibility of a *technological* Asian collusion. After suggesting that perhaps the only thing keeping the Chinese from rapid industrialization thus far has been the jealously guarded watchfulness of the Chinese ruling class, London asks his readers to imagine the following "familiar scene":

> One is hurrying home through the dark of the unlighted streets when he comes upon a paper lantern resting on the ground. On one side squats a Chinese civilian on his hams, on the other side squats a Japanese soldier. One dips his forefinger in the dust and writes strange monstrous characters. The other nods understanding, sweeps the dust slate level with his hand, and with his forefinger inscribes similar characters. They are talking. They cannot speak to each other, but they can write. Long ago one borrowed the other's written language, and long before that, untold generations ago, they diverged from a common root, the ancient Mongol stock. ("YP," p. 279)

In the exotic shadows of London's Manchuria, the biotechnological roots of Asian orthography makes possible the collusive perils of "Asiatic" sameness: "one" dips his finger in the dust while the "other" nods in understanding—his readers suddenly unclear about which is which. But for London, this ancient orthographic technology is only the surface form of a deeper, biotechnological connection between "Asiatics," something "down at the bottom of their being, twisted into the fibers of them," a crucial "sameness in kind which time has not obliterated" ("YP," p. 279). Superficial differences between these races may have developed over several generations, as when, long ago, a sprinkling of "Malay" blood infused with the Japanese to make it a race of "mastery and power," but the more significant danger posed here is that "Today, equipped with the finest machines and systems of destruction the Caucasian mind has devised, handling machines and systems with remarkable and deadly accuracy, this rejuvenescent Japanese race has embarked on a course of conquest, the goal of which no man knows" ("YP," p. 279). There is no "Brown Peril," in other words, according to London. The real menace "lies not in the little brown man, but in the four hundred millions of yellow men should the little brown man undertake their management" ("YP," p. 281). The technological flexibility of the Chinese (who are "not dead to new ideas," who are "efficient workers," make "good soldiers," and whose earth is "wealthy in the essential materials of the machine age") constitutes the most dangerous possibility of the East. "Under a capable management [the Chinese] will go far. The Japanese is prepared and fit to undertake this management" ("YP," p. 281). It would be a mistake, perhaps, to draw too deterministic a line between London's theories about "management," "wealth," "efficiency," and "the machine" and his racial anxieties in Korea, but there can be little doubt that these forces fed off each other to an astonishing degree in London's writing. Indeed, it was precisely in moments where London felt most frustrated in his ability to practice his "craft" (the antimechanistic *technê*-culture he sought in both socialism and authorial production) that his racial anxieties became most pronounced and virulent.

If London had followed the advice of the Japanese army to stay in Tokyo when he first arrived in Japan he would not have been arrested, but he also would not have been able to file his reports in Korea where the fighting was. Determined to find his way to the front, London (his camera newly restored to him) again boarded a steamer toward Chemulpo (present-day Inchon), near Seoul.[81] Halfway there, just off the southern coast of Korea, the steamer was brought to shore and appropriated by the Japanese

Fig. 3.13. Jack London with one of his "string of permits" in Korea, surrounded by Japanese soldiers (reproduced by permission of The Huntington Library, San Marino, CA).

army. Undaunted, London hired a Korean junk to sail him up to Chemulpo, and by February 24, 1904, only twenty days after his arrest, he had hiked inland to Seoul. There he found a few British correspondents who had been in Korea since before the war. They joined up and began making their way even further north along "Pekin Road," determined to find a way into Manchuria and witness the battle firsthand. On March 9, 1904, they arrived in the half-deserted village of Sunan, about sixteen miles north of "Ping Yang" (present-day Pyongyang), and although London felt particularly proud that he had not stayed in Tokyo with the other American correspondents, the obstacles to moving on or gaining further information about the front were becoming even greater. After almost a week in Sunan, London's frustration was palpable: "Here at the village of Sunan . . . on the main Pekin Road which leads straight to the Russians, I wait and wait for permission to go onward. East I may ride, and west and south, as far as I please; to the north I may ride a hundred yards, and then a Japanese guard turns out and warns me back."[82] The need to secure an endless "string of permits" before proceeding meant, "There is no war, so far as I am concerned, to write about."[83] He would not see anything, he complained, "until the permit of permits, the final permit, is given me"(Fig. 3.13).[84]

The most frustrating irony for London there in Sunan was that after traveling so far and working so hard to see something he could report on, he had himself suddenly become the object of visual fascination:

> I live on the main street in a deserted house of which I have taken possession, and all day long there is a rapt and admiring audience before my door. It is like a Japanese play, because it lasts all day. . . . I am certain if I charged a penny a "look see," that I should more than clear expenses. . . . Each doing of mine is duly noted and before nightfall is spread to the remotest recesses of the hills. Some of my actions are greeted with shouts and exclamations. There is a constant discussion going on as to why I do this or that; but my star performance is shaving. ("HK," p. 74)

Feeling uncomfortably put on stage for an audience of supposedly "rapt and admiring" Asians, it was at this point in London's journey that his inability to engage in his "craft," his heightened racial anxieties, his underlying impulse to "master the machine," and a growing hyperawareness that he was constantly being seen rather than seeing what he had come to see—all of this came together in a virulent fusion of mean-spirited prankishness and cultural insensitivity. Completely oblivious to the fact that at least a few of his spectators (refugees who had fled into the hills and were tentatively returning to the village) were most likely owners of the home where he had taken up residence, London explains that in the afternoons, when all of the "seething life" of Asia passed by his door, he would set up his camera and begin shooting. At this, his Asian audience would become alternately "perturbed, excited, and delighted" ("HK," p. 76). The "perturbed" were usually the victims that London would choose to photograph, while the "excited and delighted" crowds were those watching the drama unfold: "The poor wight I pitch upon for my victim comes in fear and trembling to the gleeful shouts of the crowd, and each selection is hailed with a shout from all save the one selected" ("HK," p. 76). What follows in London's account certainly puts into question recent attempts to characterize London's photography as "compassionate," or to portray him as too culturally sensitive to view his photographic subjects as "specimens":

> One married man I was compelled to hold while the camera was snapped by proxy. He squirmed and twisted, the tears washing white channels through the coating dirt on his face and thereby making his expression of fear the more ghastly.... Manyoungi [London's translator and assistant] has quite entered into the spirit of my photography and fares forth enthusiastically to capture any specimen I desire. Yesterday a Korean refugee, with a child and household goods on his back, drifted into Sunan, bound south. Manyoungi seized upon him forthwith, and man and boy howled and cried for very life. Between sobs the man assured me that he had done no wrong, that he was a mere nobody, a poor man who had no money, nothing. But his howls and tears redoubled when I put the camera on him, for he took the glittering mechanism for some terrible instrument of death. ("HK," p. 77)

London seems rather amused by the Korean refugee's tearful and emotional response in assuming that the "glittering mechanism" of camera technology might be "some terrible instrument of death." Reading this scenario certainly alters one's experience of viewing the photograph in Fig. 3.14 (the photograph to which London is apparently referring, one of 315 surviving photographs archived in the Huntington Library). What might otherwise seem like a fairly innocuous—even "compassionate"—snapshot becomes something potentially much more problematic. Seeing this Korean refugee (is he clenching a stick in his right hand?), it becomes easier to see how London's attempts to master the machine were at times tinged with racial animosity.

In another set of photographs London fixates on moments of Asian nakedness: several shots of a woman with exposed breasts (Fig. 3.15); a little boy shows his penis to London (not shown here); an old cart-pushing peasant leans forward in a G-string, his rear end exposed (also not shown), while in other photographs a worker's backside becomes the principal subject of the image (Fig. 3.16). Certainly, London would have known that many of these photographs were unpublishable. But given what he (if not some of his biographers) characterized as the "spirit" of his photography, it is not surprising he would attempt as another strategy in this techno-ocular contest to

Figs. 3.14–3.16. Korean refugees photographed by Jack London (images reproduced by permission of The Huntington Library, San Marino, CA).

delve into the more intimate places of Asian bodies, expose them, exoticize them, and counter their gazes with his own hypermasculine, mechano-visual phallus.[85] Put another way, at the very moment that London is sounding an alarm that the "Asiatic" threatens to become a mimetic techno-subject, he employs his own ocular technologies to relegate that subject to the realm of a new, virgin field, ready for his writerly colonization. The machine has once again been mastered.

It is in this techno-orientalist spirit that one of the most often cited passages from London's reportage reveals a concern with not only racial difference but scopic technologies and systems of representation as well. As several scholars have noted, London's emotional identification with a group of Russian prisoners (rather than his Japanese hosts) in Korea is extremely visceral, and no doubt evidence of a deeply

imbedded racial ideology.[86] But what is perhaps most fascinating about the passage is that it occurs at a moment when London is himself engaged in a contest over technologies of visual representation. Having secured permission, finally, to go as far north as Manchuria (but still nowhere near any fighting), London sees a group of Japanese soldiers "curiously peering" into the windows of a large Chinese house:

> I too, curiously peered. And the sight I saw was a blow in the face to me. On my mind it had all the stunning effect of the sharp impact of a man's fist. There was a man, a white man, with blue eyes, looking at me. He was dirty and unkempt. He had been through a fierce battle. But his eyes were bluer than mine and his skin was as white. And there were other white men in there with him—many white men. I caught myself gasping. A choking sensation was in my throat. These men were my kind. I found myself suddenly and sharply aware that I was an alien amongst these brown men who peered through the window with me.[87]

In this passage all of London's anxiety is concentrated in his sense of the visual. He looks through a window into a kind of peep show of horrors, focusing deeply on the prisoners' eyes, suddenly hyperaware of the somatic colors all around him ("white man," "blue eyes," "brown men"), the entire experience apparently threatening his masculinity (the view striking him like "a man's fist"). London has suddenly become, in other words, something like the Korean refugee he had photographed earlier: horrified by the "glittering mechanism" of the Japanese war machine that has briefly opened its aperture to his gaze. But it is not the gaze of the Russians that terrifies London; rather, it is the effect of the camera-obscura-like prison that seems to be projecting *onto him*, such that London comes to feel alien and disoriented, almost as though he had become part of the machine itself.

That any of the Asian cultures he encountered could have been a source of *technê* was not (yet) something London was willing to consider in 1904, but the fact that his more universalist sentiments were expressed in moments where he portrays the machine as universally antihumanistic goes a long way toward explaining how his racial views could shift and transform according to the possibilities for *technê* he imagined in moments of cross-cultural interaction.[88] There are passages in London's writing where it is tempting to think that his vision of a utopian future presupposed the necessity of a racial conflict between a unified Asia and the rest of the world. However, notice that in a short story like "Goliah" (1910) what finally emerges is not so much a conflict between East and West as it is a conflict between the global forces of machine culture and an all-powerful (even totalitarian) demand for *technê*. In this story, London's narrator details the actions of an elderly German-American who has taken refuge on a Pacific island where he develops a devastatingly powerful weapon. Assuming the name "Goliah," the man begins a campaign to forcefully revolutionize the world. Targeting those in power in the United States first, Goliah threatens to kill American officials until his demands (a shorter work day, better standard of living, the abolition of child labor, and so on) are met. When the U.S. government tries to respond militarily, attacking the Pacific island where Goliah is stationed, all of the American battleships are quickly destroyed before they can even fire a shot (only one ship survives, it turns out, by sheer luck, to tell the story to the rest of the world).[89] London's narrator explains that "nearly" the entire world was stunned by these events. The burgeoning empire of Japan, however, uses the demise of the U.S. fleet to its own advantage:

But all the world was not stunned. There was the invariable exception—the Island Empire of Japan. Drunken with the wine of success deep-quaffed, without superstition and without faith in aught but its own ascendant star, laughing at the wreckage of science and mad with pride of race, it went forth upon the way of war. From the battlements of heaven the multitudinous ancestral shades of Japan leaned down. The opportunity, God-given, had come. The Mikado was in truth a brother to the gods. ("G," pp. 90–91)

Not fully aware of the extent of Goliah's power and global agenda, the Japanese "war machine" attempts to invade the West Coast of the United States, only to be destroyed in exactly the same manner the American military had near Goliah's Pacific island— efficiently and completely. What Goliah imposes on Japan afterward is a renewed culture of *technê* among the Japanese people:

And meekly [Japan] obeyed when Goliah commanded her to dismantle her war vessels and to turn the metal into useful appliances for the arts of peace. In all the ports, navy-yards, machine-shops, and foundries of Japan tens of thousands of brown-skinned artisans converted the war-monsters into myriads of useful things, such as ploughshares (Goliah insisted on ploughshares), gasoline engines, bridge-trusses, telephone and telegraph wires, steel rails, locomotives, and rolling stock for railways. It was a world-penance for a world to see. ("G," p. 94)

The lesson that Japan is forced to learn here is precisely the lesson Goliah had imposed on the United States, that the current uses of "the machine," everywhere, had to be reconsidered and transformed. But Goliah does not stop there. On the very next page, after Japan has been forced into *technê*, "Germany and France were preparing to fly at each other's throats. Goliah commanded peace. They ignored the command, tacitly agreeing to fight it out on land where it seemed safer for the belligerently inclined" ("G," p. 95). When the German and French war machines ignore Goliah's commands, he strikes again:

All generals, war-secretaries, and jingo-leaders in the two countries died on that day; and that day two vast armies, undirected, like strayed sheep, walked over each other's frontiers and fraternized. But the great German war lord had escaped—it was learned, afterward, by hiding in the huge safe where were stored the secret archives of his empire. And when he emerged he was a very penitent war lord, and like the Mikado of Japan he was set to work beating his sword-blades into ploughshares and pruning-hooks. ("G," p. 95)

Put simply, in London's "Goliah" the leaders of Japan's war machine are forced to learn the same thing that all other national leaders with machines have to learn; that is, how to live with their technology in a way that does not exploit or oppress others. Once the entire world learns this, Goliah explains, he will "make a present to the world of a new mechanical energy" ("G," p. 105). But first, he says, the nations of the world "must demonstrate that the intelligence of mankind today, with the mechanical energy now at its disposal, is capable of organizing society so that food and shelter be made automatic, labor be reduced to a three-hour day, and joy and laughter be made universal" ("G," p. 105). Of course, there are a number of ethical problems with London's "Goliah" as a model for a utopian future (most glaringly: its implicit call for an authoritarian, crypto-fascist revolution from above), but the fact that a global fight against the machine has finally transcended petty international and racial difference

in the story points to London's more overarching concern—that is, the need to initiate, somehow, a global culture of nonexploitative, organic *technê*.

The point here, again, is not to argue that London did not produce racist writings; nor is it to argue that London's socialism was unproblematic or genuinely egalitarian. Rather, the more complex picture of London that I am proposing here is one in which his efforts to battle what he saw as a global machine not only accentuated his racist visions of a rapidly technologizing Asia, but also allowed for a vision of *technê* that was sometimes more powerful than the racial prejudice he exploited in his writings. Such a perspective, I argue, allows for a more comprehensive picture of London's erratic global vision—one that shows a Jack London constantly attempting to work out how his deterministic theories of cultural evolution coincided with his dreams for an international anticapitalist utopia. This is not to say that London actually succeeded in any ideological or philosophical sense in resolving this tension. However, to fail to see this larger perspective on London's writing, I argue, is to ignore some of his most interesting (and problematic) work. It is a striking experience, for example, to read some of London's reportage during the Russo-Japanese War in 1904, and then open his 1905 volume, *War of the Classes*. In the preface to this volume of essays, London argues that socialism "presents a new spectacle to the astonished world—that of an *organized, international, revolutionary movement*."[90] In another essay in the same volume London argues, "The capitalist enforces his profits because he is the legal owner of all the means of production. He is the legal owner because he controls the political machinery of society. The Socialist sets to work to capture the political machinery, so that he may make illegal the capitalist's ownership of the means of production. And it is this struggle, between these two classes, upon which the world has entered."[91] In an effort to underscore the international nature of this struggle, London lists the growing number of socialists in Belgium, Germany, Austria, France, and Cuba. Regarding Japan, however, London is especially enthusiastic, quoting at length (more than two full pages) from the Japanese socialist Murai Tomoyoshi, an early Japanese social activist and the first translator of William Morris into Japanese, who details the rise of the socialist movement in Japan.[92]

To be sure, such passages (especially when taken in isolation) do not necessarily ameliorate the difficulty in ascertaining what Jack London really thought. He would often admit, for example, to having written sensationalistic material simply as "hackwork."[93] But which was the hackwork and which was the real? Is the "real" Jack London the Jack London of his letters to friends? Is it the Jack London of his socialist essays and lectures? Is it the Jack London of his fiction or reportage? Certainly, the oddly imbalanced racial ideology in London's writing opens itself up to these questions. But, as I have been arguing, if there is a unifying thread in the tangled and complicated fabric of London's writing, it is this search for *technê*. Sometimes this search coincided with and reinforced the kind of racism one finds in London's reportage in Korea (where Japan is portrayed as a biotechnologizing threat); sometimes it allowed for grand visions of international revolution and reform (with the Japanese citizenry as only one among several populations involved in this struggle against a global machine); and sometimes, as we shall see in the next section, it even allowed his racism to dissolve into a romantic vision of the Pacific-as-*technê*.

Jack London's *Technê*-Pacific

On the morning of May 22, 1907, Jack London lay in a hammock between two algarroba trees in Hawai'i. Dressed in a blue kimono and white obi, London was relaxing

after having written his daily one thousand words. In her memoir *Our Hawaii* (1917), London's wife, Charmian, reports the following from their conversation that morning:

> "Do you know what you are?" I quizzed Jack, having outrun him by a word or two in the race for knowledge.
>
> "No, I don't. And I don't care. But do *you* know *where* you are?" he countered.
>
> "No, *I* don't. *You* are a *malihini*—did you know that?"
>
> "No, and I don't know it now. What is it?"
>
> "It's a newcomer, a tenderfoot, a wayfarer on the shores of chance, a—"
>
> "I like it—it's a beautiful word," Jack curbed my literary output. "And I can't help being it anyway. But what shall I be if I stay here long enough?"
>
> Recourse to a scratch-pad in my pocket divulged the fascinating sobriquet that even an outlander, be he the right kind of outlander, might come in time—a long time—to deserve. It is *kamaaina*, and its significance is that of old-timer, and more, much more. It means one who *belongs*, who has come to belong in the heart and life and soil of Hawaii; as one might say, a subtropical "sourdough."[94]

After asking about its pronunciation, London's response to the notion of *kamaaina* is immediately positive: "I'd rather be called '*Kamaaina*' than any name in the world . . . I love the land and I love the people."[95] Charmian's narrative then briefly recounts London's previous visits to Hawai'i and then returns to her conversation with Jack:

> "Here's something I didn't show you in the mail," Jack said presently, picking up a thick envelope addressed in his California agent's hand. It contained a sheaf of rejections of his novel "The Iron Heel" which has proved too radical for the editors, or at least for their owners' policies. "It's been turned down now by every big magazine in the United States," he went on, a trifle wistfully. "I had hoped it was *timely*, and would prove a ten-strike; but it seems I was wrong."[96]

Part of the lament here was that London had not anticipated the degree to which the backlash against his talk at Yale would have not only affected the sales of his previous work, but also the socialist narratives he was currently writing. One of the most striking elements of Charmian's narrative, however, is that London makes such a quick transition between expressing his desire for *kamaaina* status and his disappointment that *The Iron Heel* had not resonated with American editors. Indeed, as I hope to argue in this section, for London the desire to become *kamaaina* and the need to indict machine culture in works like *The Iron Heel* were interwoven parts of the same *technê*-dream (as Charmian depicts them, literally part of the same conversation).

Accused by some socialists of having abandoned the cause so as to pursue a South Seas "vacation," London took great pains to make sure his political views were known during his voyages throughout the Pacific. He delivered his lecture "Revolution" in Honolulu, Holualoa, and Hilo, Hawai'i. In Papeete, Tahiti, when London attempted to rent a hall to deliver his lecture, property owners working with local authorities prevented him from scheduling the venue, forcing him to speak at the Folies Bergère where the chief of the gendarmes kept him under close surveillance. He spoke at a German beer garden in Apia, Samoa, and at the Central Hotel as well.[97] Before a debilitating illness cut his trip short, London had even planned to speak to three thousand miners in Central Australia. Indeed, given this extensive

proselytizing for "global revolution" throughout the Pacific (and the fact that he would continue to write socialist essays and fiction throughout this time), it is difficult not to conclude that London, at least, thought of his voyages in the Pacific and his indictment of industrial capitalism as entirely correlative endeavors.

From the very beginning of London's career as a writer, the *technê*-craft of boats and the primitive, idyllic setting of the Pacific offered dramatic alternatives (almost an "apostasy") to the oppressive systems of technocratic machine culture. After his demoralizing experience as a young laborer in the cannery, London took a job onboard the *Sophie Sutherland*, a sealing schooner traveling to Japan. After his return in 1893, when he found himself once again working in a factory (this time at the jute mills, with the same ten-hour days at ten cents an hour), London entered a writing contest in a local paper, winning twenty-five dollars (almost an entire month's salary working at the machine) for "Story of a Typhoon off the Coast of Japan." In a companion piece published shortly afterward, "The Run Across," London describes the aesthetic experience of sailing on a ship on the Pacific in terms that directly oppose the cacophonous mechanics of factory life:

> Nothing is harsh or discordant; everything harmonizes. The creaking of a block is music. The groan of the towering canvas; the dash of water from the dancing stern; the occasional splutter of adventurous flying-fish against the sails; the dull, indistinguishable mumble of unseen conversation, and the peculiar, almost inaudible, voice of every straining rope, stay, pin and block, form a sleepy symphony that lulls and soothes, and causes one to become dreamy and to sink into reverie.[98]

Contrasting this passage with young Johnny's life in "The Apostate," who, we recall, was "born with the pounding crashing roar of the looms in his ears" (his mother stretched out on the floor "in the midst of the shrieking machines"), it becomes clear that, for London, life on a ship meant something entirely different than life in a factory. To be on a ship on the Pacific—as well as to write the experience of being on a ship on the Pacific—was from the very beginning of London's adult life a therapeutic escape from the machine. It was not simply that, as Earle Labor has pointed out, "the South Seas held forth the promise of warmth, life, and new symbolic vistas."[99] Being able to write about these experiences, and get paid for it, also held forth the promise of a life outside mechanized labor.

Consequently, London's decision in 1906 to build a ship that he would then sail around the world and write about the experience throughout was, to his mind, entirely consistent with his aesthetic/political views. For London, the ship was a vehicle of *technê* (a "craft"—in both senses—that evidenced an organic and therapeutic relationship with nature), and his affectionately named *Snark* would be no different: "The *Snark* is to be sailed," he explained in his published report on the trip, emphasizing its inherently nonmechanical nature: "There will be a gasoline engine on board, but it will be used only in case of emergency, such as in bad water among reefs and shoals."[100] In detailing the necessary technologies of his ship's engine, London describes himself as an uncomfortable alien in a strange land: "What is the best kind of engine—the two cycle? three cycle? four cycle? My lips are mutilated with all kinds of strange jargon, my mind is mutilated with still stranger ideas and is foot-sore and weary from traveling in new and rocky realms of thought" (*CS*, p. 12). Perplexed by questions of ignition method, dry cell or storage batteries, dynamos, and searchlights, London's portrayal of the boat's bulky accumulation of technologies is

rather humorous and self-critical: "That engine! While we've got it, and the dynamo and the storage battery, why not have an ice machine? Ice in the tropics! It is more necessary than bread. Here goes for the ice-machine! Now I am plunged into chemistry, and my lips hurt, and my mind hurts, and how am I ever to find the time to study navigation?" (*CS*, p. 15).

Unlike the mind-numbing questions dealing with the boat's engine and ice machine, the art of navigation is one of several "non-machine" technologies in *The Cruise of the Snark* that London portrays as a particularly organic and aesthetic manifestation of *technê*. Whereas all of the engine- and machine-gadgetry that London had installed at great expense fails miserably after only a few days at sea, London's forays into navigation provide some of his proudest moments: "One whole afternoon I sat in the cockpit, steering with one hand and studying logarithms with the other. Two afternoons, two hours each, I studied the general theory of navigation and the particular process of taking a meridian altitude. Then I took the sextant, worked out the index error, and shot the sun" (*CS*, p. 53). Here was a technology that did not enslave or systematize. For London, navigation involved coming into a more organic relationship with the earth and heavens—a priestly craft of *technê*-artistry. London would even label the photograph of him using the sextant, "The Dark Secrets of Navigation" (Fig. 3.19).

The Brown Gods of Surfing

For London, the "Royal Sport" of surfing was a technology that, like navigation (and unlike the machine), was nonmechanistic and organic, and the Hawai'ian natives who had invented and mastered the art were truly men outside the machine. It was a sport "for the natural kings of the earth" (*CS*, p. 75). In one particularly vivid passage London describes himself sitting on the beach at Waikiki, feeling "tiny and fragile" before the massive waves full of "fury and foam and sound" (*CS*, p. 75). These "white battalions of the infinite army of the sea" march in toward the beach "a mile long, these bull-mouthed monsters, and they weigh a thousand tons, and they charge in to shore faster than a man can run" (*CS*, p. 75). What chance is there, London asks, for a mere man to "master" this massive force?

> No chance at all, is the verdict of the shrinking ego; and one sits, and looks, and listens, and thinks the grass and the shade are a pretty good place in which to be.
>
> And suddenly, out there where a big smoker lifts skyward, rising like a sea-god from out of the welter of spume and churning white, on the giddy, toppling overhanging and downfalling, precarious crest appears the dark head of a man. Swiftly he rises through the rushing white. His black shoulders, his chest, his loins, his limbs—all is abruptly projected on one's vision. Where but the moment before was only the wide desolation and invincible roar, is now a man, erect, full-statured, not struggling frantically in that wild movement, not buried and crushed and buffeted by those mighty monsters, but standing above them all, calm and superb, poised on the giddy summit, his feet buried in the churning foam, the salt smoke rising to his knees, and all the rest of him in the free air and flashing sunlight, and he is flying through the air, flying forward, flying fast as the surge on which he stands. He is a Mercury—a brown Mercury. . . . He is riding the sea that roars and bellows and cannot shake him from its back. (*CS*, p. 77)

Figs. 3.17–3.20. Illustrations for Jack London, *The Cruise of the Snark* (New York: Macmillan & Co., 1911), pp. 84, 81, 53, 76–77.

overhanging and downfalling, precarious crest appears the dark head of a man. Swiftly he rises through the rushing white. His black shoulders, his chest, his loins, his limbs — all is abruptly projected on one's vision. Where but the moment before was only the wide desolation and invincible roar, is now a man, erect, full-statured, not struggling frantically in that wild

Coming in on a Wave.

movement, not buried and crushed and buffeted by those mighty monsters, but standing above them all, calm and superb, poised on the giddy summit, his feet buried in the churning foam, the salt smoke rising to his knees, and all the rest of him in the free air and flashing sunlight, and he is flying through the air, flying forward, flying fast as the surge on which he stands. He is a Mercury — a brown Mercury. His heels are winged, and in them is the swiftness of the sea. In truth, from out of the sea he has leaped upon the back of the sea, and he is riding the sea that roars

and bellows and cannot shake him from its back. But no frantic outreaching and balancing is his. He is impassive, motionless as a statue carved suddenly by some miracle out of the sea's depth from which he rose. And straight on toward shore he flies on his winged heels

Leviathan and the Snark.

and the white crest of the breaker. There is a wild burst of foam, a long tumultuous rushing sound as the breaker falls futile and spent on the beach at your feet; and there, at your feet steps calmly ashore a Kanaka, burnt golden and brown by the tropic sun. Several minutes ago he was a speck a quarter of a mile away. He has "bitted the bull-mouthed breaker" and ridden it in, and the pride in the feat shows in the carriage of his magnificent body as he glances for a moment carelessly

London is clearly impressed. And given the descriptions he offers of himself in *The Road* in which he seems to be "surfing" the trains that also weigh a "thousand tons," riding the rails that "roar and bellow," perhaps this excitement should come as no surprise (notice, for example, the rather striking similarities between the photographs of surfers in Figs. 3.18–3.19 and the photographs of "Jack" riding the rails in Figs. 3.3–3.6, with both sets depicting silhouetted figures standing above or riding within their relative technologies, "mastering" their environments). London is fascinated with surfing precisely because it offers a type of human–technology interface that rejects the grid-like machine life of industrial capitalism. It is an ideal manifestation of *technê*. That London thinks of surfing in explicitly technological terms becomes even more obvious in his attempt to "explain the physics of it" (*CS*, p. 78). After his fairly idealized language in portraying the surfers, London's language quickly shifts to the "mechanics" of the sport:

> A wave is a communicated agitation. The water that composes the body does not move. . . . The water that composes the body of a wave is stationary. Thus, you may watch a particular portion of the ocean's surface and you will see the same water rise and fall a thousand times to the agitation communicated by a thousand successive waves. Now imagine this communicated agitation moving shoreward. As the bottom shoals, the lower portion of the wave strikes land first and is stopped. But water is fluid, and the upper portion has not struck anything, wherefore it keeps on communicating its agitation, keeps on going. . . . But the transformation from a smooth undulation to a breaker is not abrupt except where the bottom shoals abruptly. . . . The face of that wave may be only six feet, yet you can slide down it a quarter of a mile, or half a mile, and not reach the bottom. For, see, since a wave is only a communicated agitation or impetus, and since the water that composes a wave is changing every instant, new water is rising into the wave as fast as the wave travels. (*CS*, p. 78)

What London's scientific jargon is attempting to convey here is not simply the mechanics of surfing. Rather, London wants his narrative to be understood as, again, a detailed source of *technê*. London is excited about surfing because he sees it as an organic, beautiful technology, something that the West (despite its great advances in machine culture) has failed to cultivate.

London's photographs in his chapter on surfing seem to make precisely this point. On pages 76–77 of the first edition of *The Cruise of the Snark*, for instance, in the midst of London's idealized portrait of the surfing "sea-god," one finds two interesting images juxtaposed (Fig. 3.20). In the image on the left we see an illustration that makes perfect sense in the narrative (the "sea-god" discussed in the text). On the opposite page, however, London has included an image of the Snark and a massive American ship, without any explanation in the chapter as to what connection this photograph is supposed to have to surfing, if any. One impression gleaned from this visual non sequitur, however, might be that London is portraying two entirely different types of "mastering" the sea: the organic, beautiful, technology of surfing, and the massive, ironclad technology of American ships (with the *Snark* situated somewhere between).

In one of his final short stories, "On the Makaloa Mat" (1916), London vividly dramatizes his ongoing dissatisfaction with Western technoculture, memorializing instead the beautiful "color" and "warmth" of native Hawai'ian people. The main

protagonist of the story, Bella, is one-fourth Hawaiʻian, and we find her at the beginning meeting with her sister, Martha, who also has one-fourth of "the sun-warm, love-warm heart of Hawaii" in her.[101] During their conversation, Bella reminisces on her disastrous arranged marriage to an all-white colonizer by the name of George Castner. Leaving her warm and colorful home to live on the island of Nahala with Castner, Bella describes their time together as so many episodes of a gray factory life:

> But that house of his . . . was gray. All the color of it was gray and cool, and chill, while I was bright with all colors of the sun, and earth, and blood, and birth. It was very cold, gray cold, with that cold gray husband of mine. . . . You know he was gray, Martha. Gray like those portraits of Emerson we used to see at school. His skin was gray. Sun and weather and all hours in the saddle could never tan it. And he was as gray inside as out. (*OMM*, p. 9)

London uses the word "gray" twenty-one times in the story to describe Castner and his mechanical habits ("he went to bed always the same way, winding up his watch") (*OMM*, p. 18). According to Bella's narrative, life would have gone on in its uninterrupted grayness had not her husband's business trip to Honolulu for a few weeks coincided with her meeting the young Hawaiʻian Prince Lilolilo, whom she describes as "all man, man, man" (*OMM*, p. 28). Unlike the gray, "mechanical" severity of her life with Castner, Prince Lilolilo is described as an athletic and romantic lover who adorns her with leis "dewy fresh as the moment they were plucked, in their jewel-cases of banana bark; yard-long they were, the tiny pink buds like threaded beads of Neapolitan coral" (*OMM*, p. 32). When the prince has to leave and their brief romance comes to an end, Bella is forced to return to Castner, whom she greets upon his return from Honolulu:

> And solemnly he embraced me, perfunctorily kissed my lips, gravely examined my tongue, decried my looks and state of health, and sent me to bed with hot stove-lids and a dosage of castor oil. Like entering into the machinery of a clock and becoming one of the cogs or wheels, inevitably and remorselessly turning around and around, so I entered back into the gray life of Nahala. (*OMM*, p. 38)

The Castner machine, it turns out, runs on castor oil, and Bella once again returns to a life devoid of warmth and color. For two more years until Castner's death, Bella lives with the "machine," their nightly routine one of economizing and rigid, mechanical repetition: "I sat across the table from him until eight o'clock, mending his cheap socks. . . . And then it was bed-time—kerosene must be economized—and he wound his watch, entered the weather in his diary, and took off his shoes" (*OMM*, p. 38).

London's most dramatic indictment of Western technocracy and its imperialist ventures in the Pacific is a short story titled "Koolau the Leper" (1912), which is based loosely on an actual Hawaiʻian named Kalauaikoʻolau (Koolau) who led a band of leprosy-stricken rebels that refused to be taken from their homes when Western officials attempted to forcibly relocate them to a leper colony. A great deal of criticism has been leveled against "Koolau the Leper," much of it not so much a response to the story itself as to the fact that it was written by Jack London, who, the assumption goes, was inevitably complicit with a racialized capitalist imperialism. Kuʻualoha Meyer Hoʻomanawanui, for example, argues, "what is most disconcerting [about "Koolau the Leper"] is that London is writing as an outsider."[102] Strangely, however, whereas

Hoʻomanawanui argues that London's portrayal of Koolau is so negative that it is "downright inhuman," John Eperjesi's take on the story is that London "idealizes Koolau out of existence."[103] According to Eperjesi, while London portrays Koolau as a "noble rebel," the story is nonetheless evidence of "an imperialist imaginary that takes pride in memorializing the strength and independent spirit of indigenous peoples as they are taking their last breath."[104] Rob Wilson argues simply that "Koolau the Leper" is a "confused story" which, he asserts (rather quickly and without any qualifying language), "Hawaiians hate to this day."[105]

What all critiques of "Koolau the Leper" have failed to point out, however, is the degree to which Koolau embodies the same fight against the machine that Ernest Everhard attempts in *The Iron Heel*. From the very first page of the story, we learn that Koolau and his people have suffered two devastating blows: first, the white man's seizure of their lands, and second, the introduction of leprosy (brought on, Koolau explains, by the capitalist ventures of the white man who imported Chinese labor to work the plantations). Regarding the former, Koolau speaks bravely, exhorting his people to resist the white men who wish to "take away our liberty":

> And who are these white men? We know. We have it from our fathers and our fathers' fathers. They came like lambs, speaking softly. Well might they speak softly, for we were many and strong, and all the islands were ours. As I say, they spoke softly. They were of two kinds. The one kind asked our permission, our gracious permission, to preach to us the word of God. The other kind asked our permission, our gracious permission, to trade with us. That was the beginning. Today all the islands are theirs, all the land, all the cattle—everything is theirs. They that preached the word of God and they that preached the word of Rum . . . live like kings in houses of many rooms, with multitudes of servants to care for them. . . . and if you, or I, or any Kanaka be hungry, they sneer and say, "Well, why don't you work? There are the plantations."[106]

Afflicted with leprosy, Koolau and his people experience further forms of dehumanization, their faces "misfits and slips, crushed and bruised by some mad god at play in the machinery of life" ("KL," p. 50). They become "grotesque caricatures of everything human . . . hideously maimed and distorted" ("KL," p. 50).

But where in London's work have we seen these maimed bodies before? These are precisely the kind of dehumanizing effects that London describes as the product of the capitalist machine: In *People of the Abyss*, we recall, London's trip into the East End reveals that these "people of the machine" have been reduced to a "fearful slime" of "unmentionable obscenity," and to "twisted monstrosities" and "perambulating carcasses" that shamble along "like apes" in a "perpetual writhe of pain."[107] In *The Iron Heel* the machine-oligarchy brutalizes people to the point where they resemble "great hairy beasts of burden . . . bloated forms swollen with physical grossness . . . crooked, twisted, misshapen monsters blasted with the ravages of disease."[108] In "The Apostate" little Johnny "did not look like a man. He was a travesty of the human. It was a twisted and stunted and nameless piece of life that shambled like a sickly ape, arms loose-hanging, stoop-shouldered, narrow-chested, grotesque and terrible."[109] For London, in other words, the effects of the machine have always been leprous. With this in mind, it is difficult to view "Koolau the Leper" as merely a racist eulogy for a dying native people. On the contrary, it may very be, as James Slagel optimistically argues, that in "Koolau the Leper" "Leprosy . . . becomes an appropriate and

powerful backdrop for the struggle against imperialism London apparently was beginning to appreciate in the later years of a short life."[110] But, I would argue, it was never simply imperialism that bothered London.[111] Consistent with his ongoing polemic against technological entrenchment, what London finds so troubling about the white incursion into Hawai'ian lands and culture was that they brought with them the machine. As another of London's Hawai'ian characters explains, lamenting the "modernization" of native culture, "This is the twentieth century, and we stink of gasoline."[112]

London's Red One

By 1916 Jack London had become one of the highest paid writers in the world. But all was not well with Jack. During his time in the Pacific, London had suffered a litany of diseases: malaria, yaws (a bone and skin infection creating painful lesions all over his arms and legs), rotting gums, and an equally painful rectal ulcer. The skin of his hands had begun to swell and peel off in layers, causing him to fear he had contracted leprosy.[113] His recovery was not helped by his ongoing alcoholism, and by 1916 he was also suffering chronic uremia, kidney stones, and rheumatism. Unfortunately for London, Western medical science was hardly much help at the time, prescribing "cures" like corrosive sublimate of mercury and a dangerous regimen of Salvarsan (an arsenic-based medicine used to treat venereal and other diseases).[114] As he wrote in *The Cruise of the Snark*, if his disease was like "an organic and corroding poison," the logic of conventional, Western medical technology seemed to be "fight fire with fire!" using other, equally "corrosive poisons," the effects of which were often as dangerous as the disease.[115]

There were other tragedies too. In 1913, London's back-to-the-land search for an agricultural *technê* by way of his ranch in Glen Ellen, California, suffered a major setback when the magnificent new home he had spent all of his money on suddenly burned to the ground the day after it was completed. The redwood beams of the structure had been coated in turpentine, and it burned easily (although no one ever found out how exactly the fire started), leaving nothing behind but a pile of ashes, a stone chimney, and a few walls. He was devastated. He had also apparently lost faith in the Socialist Party's ability to fight the machine, resigning officially in a letter on March 17, 1916, from Honolulu. It was, he claimed, "because of its lack of fire and fight, and its loss of emphasis on the class struggle." Recent trends in the socialist movement in the United States had been toward "peaceableness and compromise," and these were apparently unacceptable for London.[116]

It was in the final years of his life as he suffered these personal frustrations that he encountered Carl Jung's *Psychology of the Unconscious*, published in English in early 1916. London seems to have been remarkably moved by the volume. As he wrote to one friend at the time, "I have quite a few books on psychoanalysis. . . . Doctor Jung's book is a very remarkable book to me. . . . It is big stuff."[117] To Charmian he said, "I tell you I am standing on the edge of a world so new, so terrible, so wonderful, that I am almost afraid to look over into it."[118] For London scholars, this move toward a radically new Jungian worldview helps explain the more racially sensitive fictions London wrote in 1916 (such as "On the Makaloa Mat," discussed above). Jeanne Reesman, for example, argues, "falling under the influence of Jung" allowed London to develop a "creative self who could finally conceive of 'race' as encompassing the entire human race."[119] Unlike the "racialist" stories London had written earlier in his career, Jung offered London a "renewed vision of universal kinship" that paid

greater "attention to the unity of mankind rather than its differences."[120] Key to this characterization of London's suddenly new, more racially sensitive worldview are Jung's notions of the "collective unconscious" and the mythological "archetype" that provided for London, in Reesman's terms, a "universal identity" and "spiritual home."[121]

The problem with this theory, however, is not just that the terms "collective unconscious" and "archetype" never actually appear in London's copy of Jung's *Psychology of the Unconscious* in 1916 (they are, rather, terms and concepts Jung developed much later, and then reinserted in a new edition of the volume published in 1956); nor is it that there simply isn't much evidence that London saw this new Jungian worldview as necessarily contradicting his earlier ideas about race and civilization (in fact, Jung's 1916 volume reproduces a fairly standard "racialist" view of "the lower races like the negro"—phrases that in the 1956 edition are altered to read "ancient man" and "primitives").[122] On the contrary, the reason London was so fascinated and inspired by Jung's volume was not that it contradicted his earlier views on race and "technics" but that it radically confirmed those views, providing a psychological justification in the search for *technê* to which London had so long been dedicated.[123] In the end, the turn to Jung did not signal a sudden break from London's previous worldview, but rather a deep fulfillment of it.

Consider, for example, Jung's visit to the United States in 1912, when he had already begun to attract enough attention that the *New York Times* published an interview with him titled, "America Facing Its Most Tragic Moment." Why "most tragic moment"? According to Jung, "America does not see that it is in any danger. It does not understand that it is facing its most tragic moment: a moment in which it must make a choice to *master its machines* or to be devoured by them."[124] This was the same year Jung published *Psychology of the Unconscious* in its original form (the English translation would not appear for another four years), and in this interview he expounds on what he means by many of the ideas that he develops in that volume, arguing, "There is no question but that you [Americans] have sacrificed many beautiful things to achieve your great cities and the domination of your wildernesses. To build so great a mechanism you must have smothered many growing things, but there must be somewhere a cause, and when you have discovered that, your mechanism will not have its danger for you that it has today."[125]

Certainly these calls to finally "master the machine" would have resonated deeply with London. In *Psychology of the Unconscious* more specifically, Jung is directly invested in attempting to understand (and remedy) what he calls "modern empiricism and technic" (*PU*, p. 20). There are, Jung explains, "two kinds of thinking": First, there is "thinking with directed attention," which, he argues, leads to "science and the technic fostered by it," and is the "mother of the modern scientific attitude" (*PU*, pp. 23–25). And second, there is "dream or phantasy thinking," which is that of the dream, the child, and "the lower races" and "sets free subjective wishes" (*PU*, pp. 26–31). Modern man, Jung argues, must learn to come back into more immediate contact with this "phantasy thinking." Jung's psychological theory, in other words, is a creative, therapeutic attempt to counter the evils of modern society by returning to a way of thinking that did not produce the "coldness and disillusion" of modern technologies but rather something more primitive and vital (*PU*, p. 25). To point to a passage in the introduction to London's own copy of *Psychology of the Unconscious* that he himself marked: "The value of self-consciousness" was that man "need no longer be unconscious of the motives underlying his actions or hide himself behind a

changed exterior, in other words, be merely a series of reactions to stimuli as the mechanists have it but he may to a certain extent become a self-creating and self-determining being" (*PU*, p. xliii).

There are compelling reasons, in other words, for seeing London's later works as consistent with both his ongoing racialized aporia *and* his apparent conversion to Jungian psychology, the most tempting example being London's 1916 story "The Red One."[126] From the very first line of the story, London's language resonates with seemingly archetypal impulses: "*There* it was! The abrupt liberation of sound! As he timed it with his watch, Bassett likened it to the trump of an archangel. Walls of cities he meditated, might well fall down before so vast and compelling a summons" (*TRO*, p. 1). Bassett, the character hearing this "enormous peal," is a Western scientist who has come into the jungles of the South Pacific island of Guadalcanal to find a rare butterfly. But in the process of hunting the species, he and his assistant begin to hear this unusual sound off in the distance, with a "totality" so "sonorous" and "mellow," it was "as a golden bell" (*TRO*, p. 2). Their attempt to locate the source of the sound, however, is met with tragedy, and the tribes protecting it kill Bassett's assistant, and wound him in his escape, sending him deeper into the jungle where he is bitten by mosquitoes and enters a "long sickness." As he fades in and out of consciousness, the sound continues to haunt Bassett with "troubled mutterings and babblings and colossal whisperings," "whispers of wrath," and "whispers of delight, striving still to be heard, to convey some cosmic secret, some understanding of infinite import and value" (*TRO*, p. 2). In this sick and helpless state Bassett is found by some of the headhunters and tribesmen protecting the mysterious sound, and it is only by the power of his shotgun that he manages to avoid being killed by them.

Persuaded that he is not to be trifled with, the tribe eventually brings Bassett into their conversations (he apparently masters their language without much difficulty), and he begins looking for some way he can convince them to take him to the source of the mysterious sound. It is no easy task, however, and Bassett eventually resorts to winning the affections of a woman in the tribe, promising to marry her if she will only lead him to the forbidden area. But playing along with those emotions is culturally difficult for Bassett, first because his supposed lover "Balatta" is racially hideous (with "apish features," a "retreating chin," "eyes that blinked as blink the eyes of denizens of monkey cages," "rancid-oily and kinky hair" and general "female awfulness"), but also because Bassett's own sexuality is somewhat in play: "Back in England, even at best the charm of woman, to him, had never been robust" (*TRO*, p. 14). Still, committed as he is to uncovering the mystery of that sound, Bassett soldiers on into persuading Balatta to reveal it to him, and eventually she does.

Heading deep into the "forbidden quadrant" of the island, they journey upward and onto a "mesa or tableland" made of "black volcanic sand," with a "tremendous pit, obviously artificial, in the heart of the plateau" (*TRO*, p. 31). There Bassett finally encounters the Red One, a massive, glowing sphere, "with the depth of iridescence of a pearl; but of a size all pearls of earth and time, welded into one, could not have totaled." He recognized it instantly:

A perfect sphere, full two hundred feet in diameter. . . . He likened the color quality of it to lacquer. . . . Brighter than bright cherry-red, its richness and color was as if it were red builded upon red. It glowed and iridesced in the sunlight as if gleaming up from underlay under underlay of red. (*TRO*, pp. 31–32)

Climbing up over a mass of sacrificial bones and tribal remains, Bassett moves in for a closer look and discovers something even more amazing:

> it was corrugated and pitted with here and there patches that showed signs of heat and fusing. Also, the substance of it was metal, though unlike any metal or combination of metals, he had ever known. As for the color itself, he decided it to be no application. It was intrinsic color of the metal itself. He moved his finger-tips, which up to that had merely rested, along the surface, and felt the whole gigantic sphere quicken and live and respond. It was incredible! So light a touch on so vast a mass! . . . Only from the stars could it have come, and no thing of chance it was. It was a creation of artifice and mind. Such perfection of form, such hollowness that it certainly possessed, could not be the result of mere fortuitousness. (*TRO*, p. 33)

Bassett thus decides that the object is some kind of interstellar creation of nonearthly "intelligences" who must have had extra-terrestrial abilities in "working corporally in metals," and that the Red One must have "adventured the night of space, threaded the stars, and now rose before him" (*TRO*, p. 35). It was "of design, not chance," and evoked "engines and elements and mastered forces" (*TRO*, p. 41). It was, in short, the work of some kind of cosmic, heavenly *technê*.

But before Bassett can return to the West, and reveal his "discovery," he falls ill once again, and very soon realizes that he is going to die. Hoping to gaze once more upon the Red One before he loses final consciousness, Bassett makes an agreement with the tribal "devil-doctor," who wants nothing more than to "cure" Bassett's head over a smoking flame. If he will take him to the Red One for one last, tribally sanctioned look at it, Bassett promises to bend low his neck and allow the devil-doctor to chop off his head and let him have it. The story ends with Bassett's last, nirvanic encounter with the Red One and his almost serene decapitation:

> the everlasting miracle of that interstellar metal! Bassett, with his own eyes, saw color and color transform into sound till the whole visible surface of the vast sphere was a-crawl and titillant and vaporous with what he could not tell was color or was sound. In that moment the interstices of matter were his, and the interfusings and intermating transfusings of matter and force. . . . He knew, without seeing, when the razor-edged hatchet rose in the air behind him. And for that instant, ere the end, there fell upon Bassett the shadows of the Unknown, a sense of impending marvel of the rending of walls before the imaginable. Almost, when he knew the blow had started and just ere the edge of steel bit the flesh and nerves it seemed that he gazed upon the serene face of the Medusa, Truth. (*TRO*, p. 49)

It is a story full of ambiguity and strange symbolism, with an epiphanic conclusion that sounds (as we shall see in the next chapter) like it could have come directly from Esoteric Buddhism, with its "interfusings and intermating transfusings of matter"—and the temptation to read it in explicitly Jungian terms is compelling. Is there perhaps a connection between Jack London's "Red One," and Carl Jung's *Red Book*—that cryptic, autobiographical, illuminated manuscript Jung filled with fantasies and elaborate mandalas?[127] Certainly, there is an uncanny resemblance between the "sacred geography" described in London's "Red One" (note the "sacred" and "forbidden quadrant" in which a red, glowing sphere of pulsing, corrugated metal evokes a perfected, cosmic *technê*) and the mandalas Jung spent decades drawing

Fig. 3.21. Lamaist Vajry-Mandala analyzed by C. G. Jung in a lecture in Berlin in 1930, and published in Richard Wilhelm's *The Secret of the Golden Flower* (New York: Harcourt Brace, 1931), and later in Jung's *The Archetypes of the Unconscious* (Princeton: Princeton University Press, 1959).

and analyzing. Indeed, the images that accompanied Jung's first lectures on mandalas could almost serve as cartographic illustrations for London's story (Fig. 3.21). Even more astonishing, the mandala Jung himself painted (Plate 90) he described as being the product of a "dream," wherein he saw himself with a group of people as they "walked through dark streets," climbing upward toward a city on a cliff, and finally onto a "plateau," where they found a "broad square dimly illuminated by street lights," in the center of which they found a "round pool, and in the middle of it a small island, [which] blazed with sunlight"—and on the small island, a tree, "a magnolia" that was "made of ruby-colored glass."[128] Reflecting on the structure of the dreamscape, Jung later commented on how the "individual quarters of the city were themselves arranged radially around a central point," which he speculated must have symbolized a "window opening on to eternity."[129] The mandala created from the dream (and many of the dream details) are enough to make one wonder whether Jung had himself read London's story—since, I hasten to point out, Jung painted it several years *after* London's "Red One" was published.

To think of Jung's mandalas as source material for London's story (and not the other way around) would be inadvisably fanciful, a potentially irresponsible herme-neutic strategy based more on anachronistic terminology and extravagant parallel-ism than on any hard evidence (Jung himself would be proud).[130] A more historically grounded reading might point to the fact that what Bassett encounters is a cosmic, Red *One* rather than a socialist, collective group of Red *Ones*, as London was officially abandoning his commitment to communism at the time. Still, it is useful pointing to the extravagant parallel, if only because London was clearly turned on by Jung, and there are strains of thought that would have resonated with both figures in 1916. As such, it is worth remembering what Jung later described as the point of his obses-sion with mandalas, and especially Buddhist ones. In the process of leading his pa-tients through exercises in what he called "active imagination" (a kind of directed fantasizing through stories and pictures), Jung would often steer them toward the creation of personal mandalas—not because he was particularly impressed that East-ern aesthetics were superior to Western science; indeed, he continued to describe the "Eastern intellect" as "childish," and as desperately in need of "our technology, sci-ence, and industry."[131] But inasmuch as Western science and technology tended to "usurp a throne," it was only in the holistic circularity of the mandala that one could find a performative representation of "psychic totality," and "individuation"—the process of becoming an "un-divided self."[132] The case of one "Miss X" for Jung is espe-cially telling. In her gradual tendency toward mandala-creation, Jung observes that Miss X's psychic dilemmas were the result of a fractured self due to a too-rapid ad-vance of the conscious mind over the unconscious: "It is a task that today faces not only individuals but whole civilizations. . . . The tempo of the development of conscious-ness through science and technology was too rapid and left the unconscious, which could no longer keep up with it, far behind."[133] Hence, the need for the mandala, which, Jung argues, is an "antidote for chaotic states of mind," a kind of "*ideogram* of unconscious contents."[134] The glowing red sphere at the center of Jung's mandala was, in other words, a kind of cosmic *technê* with real head-curing properties.

The *Technê* of the Tribe

In the end, it would be a mistake to believe that London's views on race became nec-essarily more sensitive and egalitarian during the course of his short life.[135] Racist language punctuates both his earliest and his latest writing, and scholars of U.S. imperialism are no doubt correct in arguing that London could have done much more to critique the imperial culture that afforded him the privilege of escaping "the machine" as he saw it. His more positive views of Hawai'ian natives can also be seen as consistent with a larger discourse of white Hawai'ian internationalism that be-came part of the U.S. drive for annexation.[136] However, it would be just as wrong to see London's racial worldview as a blanket endorsement of American technocratic capitalism. London's ongoing rage against "the machine" created occasional tensions and slippages within his theories of racial supremacy, enormously complicating what would have been an otherwise very straightforward and consistently racist social Dar-winism.

As a final illustration, I want to turn to a lecture that London gave repeatedly during his second visit to Hawai'i in 1915. At the time, surfing enthusiast Alexander Hume Ford had asked London to join his Outrigger Canoe Club, an informal asso-ciation devoted to the preservation of native water sports at a time when the vast privatization of Hawai'ian beaches had almost caused surfing to disappear from the

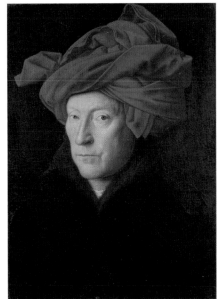

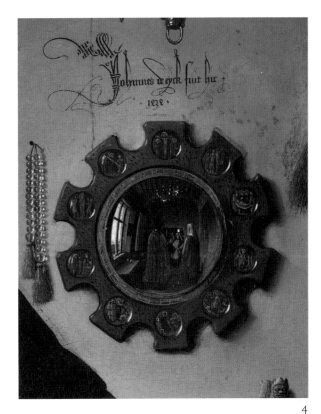

1

2

3

4

Plate 1. Detail from Gentile da Fabriano, *Adoration of the Magi* (1423), Uffizi, Florence, Italy (photo credit: Erich Lessing/Art Resource, NY).

Plate 2. Jan Van Eyck, *Portrait of a Man (Self Portrait?)* (1433) (image © National Gallery, London, Great Britain).

Plate 3. Jan Van Eyck, *The Arnolfini Portrait* (1434) (image © National Gallery, London, Great Britain/Art Resource, NY).

Plate 4. Detail from the convex mirror in Van Eyck, *The Arnolfini Portrait* (image © National Gallery, London, Great Britain/Art Resource, NY).

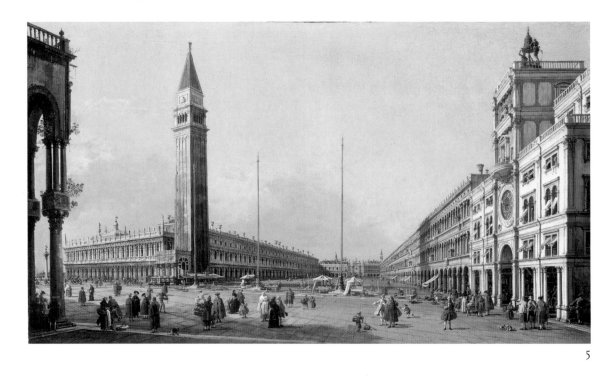

5

6

Plate 5. Giovanni Antonio Canaletto, *Piazza San Marco Looking South and West* (1763) (image © 2014 Museum Associates/LACMA. Licensed by Art Resource, NY).

Plate 6. Screenshot from *A Day on the Grand Canal with the Emperor of China; or, Surface Is Illusion but So Is Depth* (Milestone Films, 1988): David Hockney with a Canaletto on the wall and Chinese scroll on the table.

7

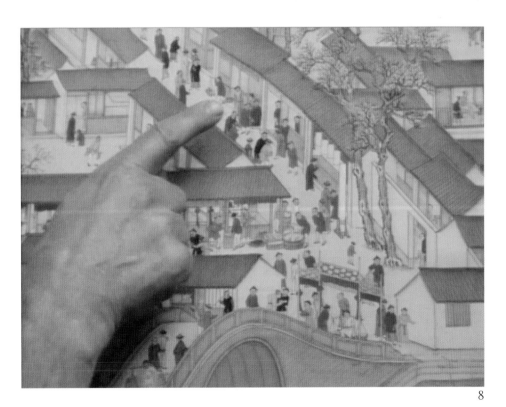

8

Plate 7. Portion of Wang Hui, *The Kangxi Emperor's Southern Inspection Tour* (1698), a seventy-two-foot-long hand scroll; ink and color on silk (image courtesy of the Mactaggart Art Collection, © 2008 University of Alberta Museums, Edmonton, Canada).

Plate 8. Screenshot from *A Day on the Grand Canal*: Hockney's hand drawing attention to nonperspectival strategies for portraying space in the Chinese scroll.

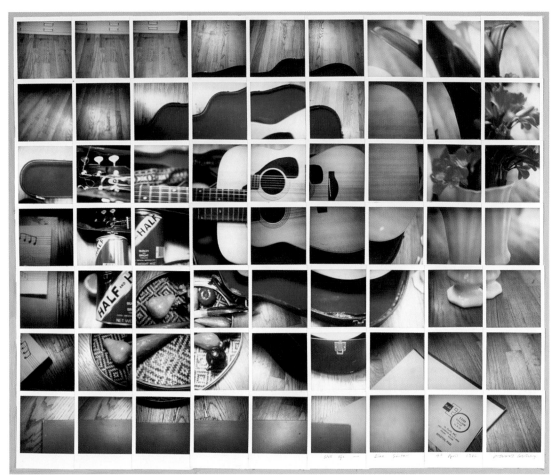

Plate 9. David Hockney, *Still Life Blue Guitar 4th April 1982*, composite Polaroid (image ©
David Hockney; photo credit: Richard Schmidt).

Plate 10. David Hockney, *Pearblossom Hwy., 11–18th April 1986 (Second Version)*, photographic collage
(image © David Hockney; J. Paul Getty Museum, Los Angeles; photo credit: Richard Schmidt).

Plate 11. David Hockney, *Walking in the Zen Garden at the Ryoanji Temple, Kyoto, Feb. 1983*, photographic collage
(image © David Hockney).

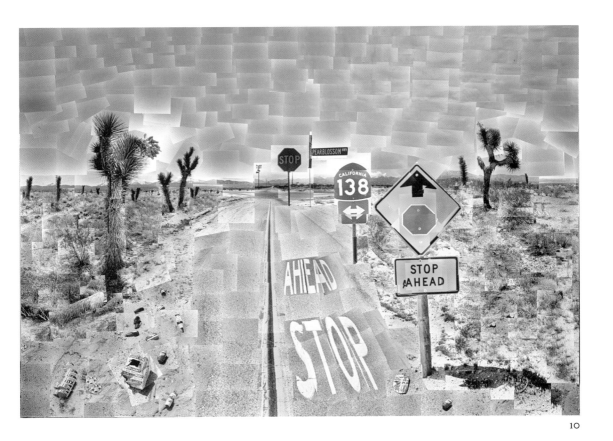

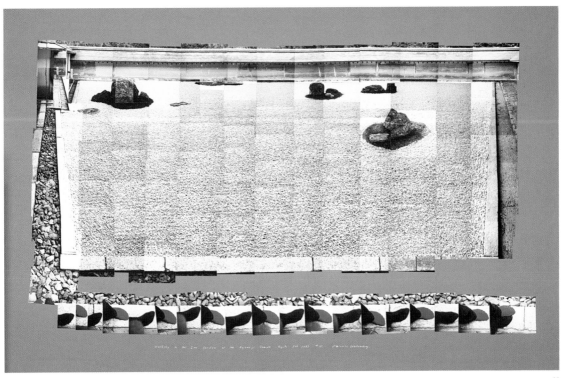

12 13 14

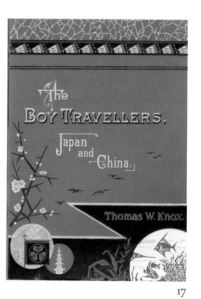

15 16 17

Plates 12–17. Typical 1870s and 1880s cover designs for Anglo-American books on the Far East. Notice the exaggerated and garish type, frequently gaudy colors, and the effort to fill the entire space with cluttered, stereotypical objects of the Orient (pagodas, peasants, dragons, rickshaws, cherry blossoms, fans, etc.). *Plate 12.* B. C. Henry, *Ling-Nam: Travels in the Interior of China* (London: S. W. Partridge & Co., 1886).

Plate 13. I. W. Wiley, *China and Japan: A Record of Observations* (Cincinnati: Cranston and Stowe, 1879).

Plate 14. E. J. Dukes, *Everyday Life in China* (London: Religious Tract Society, 1885).

Plate 15. Jules Verne, *The Tribulations of a Chinaman* (New York: E. P. Dutton & Co., 1881).

Plate 16. Walter Henry Medhurst, *The Foreigner in Far Cathay* (New York: Scribner, Armstrong, 1873) (image courtesy of the New York Society Library).

Plate 17. Thomas W. Knox, *The Boy Travellers in the Far East: Adventures of Two Youths in a Journey to Japan and China* (New York: Harper & Bros., 1879).

18

19

20

21

Plate 18. Cover design by Sarah Wyman Whitman for Lafcadio Hearn, *Gleanings in Buddha Fields* (Boston: Houghton, Mifflin & Co., 1897).

Plate 19. Cover design by Whitman for Lafcadio Hearn, *Out of the East* (Boston: Houghton, Mifflin & Co., 1895).

Plate 20. Cover design by Whitman for Lafcadio Hearn, *Glimpses of Unfamiliar Japan* (Boston: Houghton, Mifflin & Co., 1894).

Plate 21. Cover design by Whitman for Percival Lowell, *Occult Japan; or, The Way of the Gods* (Boston: Houghton, Mifflin & Co., 1894) (image courtesy of the Trustees of the Boston Public Library).

Plate 22. Cover design by Whitman for Percival Lowell, *The Soul of the Far East* (Boston: Houghton, Mifflin & Co., 1888) (image courtesy of the Trustees of the Boston Public Library).

Plate 23. Detail of Whitman's cover design for Lowell's *The Soul of the Far East* (1888) and Isoda Koryūsai's (1735–1790), *Crane, Waves, and Rising Sun* (cover image courtesy of the Trustees of the Boston Public Library; Koryūsai print courtesy of the Museum of Fine Arts, Boston; photograph © 2014).

24

25

27

Plate 24. Cover design by Whitman for Henry Wadsworth Longfellow, *The Song of Hiawatha* (Boston: Houghton, Mifflin & Co., 1891) (image courtesy of the Trustees of the Boston Public Library).

Plate 25. Sketch by Hokusai, "Fuji on Rice-Paddy," from *The Hundred Views of Fuji* (1834), as reproduced in W. Henry Winslow's "Japanese Popular Art and Sketch-Books," *New England Magazine* 3.3 (November 1890), p. 351.

Plate 26. Examples of Whitman's distinctive lettering, with the wide-serif "A" (mirroring the Torii gate seen in Plate 27), as seen on covers for her own volume *The Making of Pictures* (Chicago: Interstate Publishing Co., 1886); Clara Louise Burnham's *Miss Bagg's Secretary* (Boston: Houghton, Mifflin & Co., 1892); Kate Douglas Wiggin's *Timothy's Quest* (Boston: Houghton, Mifflin & Co., 1891); and A. D. T. Whitney's *Daffodils* (Boston: Houghton, Mifflin & Co., 1888).

Plate 27. Torii gate as represented in Japanese *mon* (see Plate 26).

26

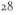

28

Plate 28. Examples of Japanese *mon* (heraldic or family crests) as published in dozens of books on Japanese art in the United States during the 1880s and 1890s. All *mon* reproduced in this book are from a 1913 collection published by the Matsuya Piece-Goods Store in Tokyo; issued as *Japanese Design Motifs*, trans. Fumie Adachi (New York: Dover, 1972).

Plate 29. Dante Gabriel Rossetti's design for Bayard Taylor's *Prince Deukalion* (Boston: Houghton, Osgood & Co., 1878).

Plate 30. Detail of Rossetti's design for Taylor's *Prince Deukalion*.

29 30

31

32

Plate 31. Whitman's design for a series of Susan Coolidge books of poetry: *Verses* (Boston: Roberts Brothers, 1880), *A Few More Verses* (Boston: Roberts Brothers, 1889), and *Last Verses* (Boston: Little, Brown & Co., 1906) (images courtesy of the Trustees of the Boston Public Library).

Plate 32. Detail of the Japanese *mon*-style design Whitman did for the covers in Plate 31; this close-up is from *Last Verses* (image courtesy of the Trustees of the Boston Public Library).

33

34

35

36

37

Plates 33–37. Whitman's Houghton, Mifflin & Co. designs with Japanese *mon*: Kate Douglas Wiggin, *A Cathedral Worship* (1898); William Elliot Griffis, *The Pilgrims in Their Three Homes* (1898); Nathaniel Hawthorne, *Our Old Home* (1891); Nathaniel Hawthorne, *The House of the Seven Gables* (1899); Bret Harte, *A First Family of Tasajara* (1892) (all images courtesy of the Trustees of the Boston Public Library).

38

40

39

Plate 39. One of several circular flower *mon* that Whitman could have used for her design, alongside the same cover design used in a series of Clara Louise Burnham books published by Houghton, Mifflin & Co. in the 1890s.

41

Plate 41. The Japanese *mon* Whitman copied for the design for *Noto* (Plate 40).

42

43

Plate 43. Japanese *mon* Whitman adapted for *Tiverton Tales* (Plate 42).

Plate 38. Whitman's cover design for Clara Louise Burnham, *Sweet Clover: A Romance of the White City* (Boston: Houghton, Mifflin & Co., 1894) (image courtesy of John Lehner).

Plate 40. Whitman's cover design for Percival Lowell, *Noto: An Unexplored Corner of Japan* (Boston: Houghton, Mifflin & Co., 1891) (image courtesy of the Trustees of the Boston Public Library).

Plate 42. In her design for Alice Brown's *Tiverton Tales* (Boston: Houghton, Mifflin & Co., 1899), Whitman appears to have culled from a few separate Japanese *mon* (Plate 43), creating a sort of hybrid symbol (image courtesy of John Lehner).

44

45

Plate 44. Cover design by Emma Lee Thayer (of the Decorative Designers firm) for Lafcadio Hearn, *Shadowings* (New York: Little, Brown & Co., 1900) (image courtesy of John Lehner).

Plate 45. Cover design by Lee Thayer for Lafcadio Hearn, *In Ghostly Japan* (New York: Little, Brown & Co., 1903) (image courtesy of University of Rochester Libraries, Rare Books and Special Collections).

46

47

48

Plates 46–53. Books published between 1890 and 1915 illustrating the general Oriental aesthetic in book design advocated in Sarah Wyman Whitman, *Notes of an Informal Talk on Book Illustration, Inside and Out* (Boston: Art Students Association, 1894), and in Arthur Wesley Dow, *Composition* (New York: J. M. Bowles, 1899). Titles identified individually. *Plate 46.* Lafcadio Hearn, *A Japanese Miscellany* (Boston: Little, Brown & Co., 1901), cover by Decorative Designers (image courtesy of John Lehner).

Plate 47. Charles Dudley Warner, *Being a Boy* (Boston: Houghton, Mifflin & Co., 1897), cover by Whitman (image courtesy of John Lehner).

Plate 48. John Gifford, *Practical Forestry* (New York: D. Appleton Co., 1902), cover by Decorative Designers (image courtesy of John Lehner).

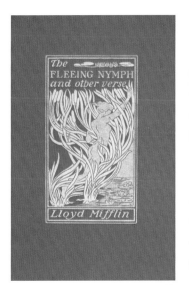
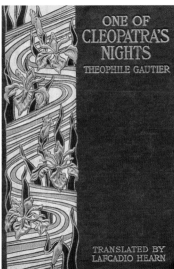
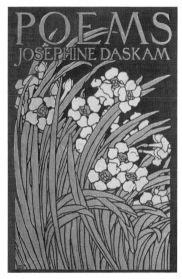

49 50 51

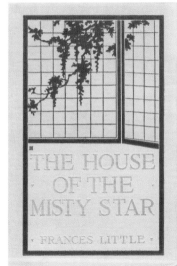
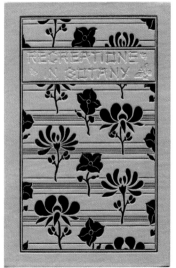

52 53

Plate 49. Lloyd Mifflin, *The Fleeing Nymph and Other Verse* (Boston: Small, Maynard & Co., 1905), cover by Marion L. Peabody (image courtesy of Charles M. Adams American Trade Binding Collection, Martha Blakeney Hodges Special Collections and University Archives, University Libraries, The University of North Carolina at Greensboro).

Plate 50. Theophile Gautier, *One of Cleopatra's Nights*, trans. Lafcadio Hearn (New York: Brentano's, 1900), cover by Decorative Designers (image courtesy of John Lehner).

Plate 51. Josephine Daskam, *Poems* (New York: Charles Scribner's Sons, 1903), cover by Lee Thayer of Decorative Designers.

Plate 52. Frances Little, *The House of the Misty Star* (New York: Century Co., 1915), cover by Decorative Designers.

Plate 53. Caroline A. Creevey, *Recreations in Botany* (New York: Harper & Brothers, 1893), cover artist unknown (image courtesy of John Lehner).

Plate 57. Japanese *mon* found in Plates 54–56.

54

55

56

57

Plate 61. Japanese *mon* found in Plates 58–60.

58

59

60

61

Plate 65. Japanese *mon* found in Plates 62–64.

62

63

64

65

Plate 54. Yin-yang and chrysanthemum *mon* in Robert Barr's *A Chicago Princess* (New York: Frederick A. Stokes Publishers, 1903), cover artist unknown.

Plate 55. A large chrysanthemum *mon* on the cover of Francis Little's *The Lady of the Decoration* (New York: Century Co., 1906), cover artist unknown.

Plate 56. Here Whitman's cover design for Bret Harte, *Openings in the Old Trail* (Boston: Houghton, Mifflin & Co., 1902), transforms a Japanese *mon* into the first letter of the title (as a kind of illuminated initial), once again mixing Japanese aesthetic forms with medieval manuscript tradition.

Plate 58. Howard Seely, *A Nymph of the West* (New York: D. Appleton & Co., 1888), cover artist unknown.

Plate 59. Laura E. Richards, *Geoffrey Strong* (Boston: D. Estes & Co., 1901), cover art by Julia Ward Richards (image courtesy of the Beinecke Rare Book and Manuscript Library, Yale University).

Plate 60. Lafcadio Hearn, *Kwaidan* (Boston: Houghton, Mifflin & Co., 1904), cover artist unknown.

Plate 62. James O'Neill, *Garrison Tales from Tonquin* (Boston: Copeland and Day, 1895), cover artist unknown (image courtesy of John Lehner).

Plate 63. Anthony Hope, *Sophy of Kravonia* (New York: Harper & Brothers, 1906), cover artist unknown (image courtesy of John Lehner).

Plate 64. Susan Coolidge, *Rhymes and Ballads for Girls and Boys* (Boston: Houghton, Mifflin & Co., 1892), cover art by Whitman (image courtesy of the Beinecke Rare Book and Manuscript Library, Yale University).

islands. An eager and sometimes quixotic internationalist, Ford would later (in perhaps a bit of overstatement) credit London as being the catalyst for his creation of the "Pan-Pacific Union," a larger civic organization devoted to improving race relations in Hawai'i.[137] In his lecture to Ford's club, titled "The Language of the Tribe," London argues that there is a universal communicative power in humanity, something that makes all humans part of a "world tribe."[138] This "world" or "cosmic language," he explains, is what separates us from animals, and what allows us to transcend even traditional linguistic and racial barriers ("LT," p. 125). London recalls an earlier time when he was in Manchuria, and inquired through his translator as to the health of a Chinese gentleman: "I asked 'How is your health today?' a very simple question, but it meant a lot. It made that Chinese gentleman feel that I really wanted to know how his health was. It was a question from one man to another" ("LT," p. 125). What was communicated here, London argues, was a kind of universal concern, something that affects every human. After describing this moment of "world language," London turns his attention to the following:

> Last night I read that for the first time the secret of fixing [mechanically extracting through high pressure] nitrogen had been discovered, and that by a Japanese. Now nitrogen is one of the most valuable things that farmers possess, and I am a farmer. The nitrate mines of Chile are being exhausted, and new nitrate deposits have not as yet been discovered. We need nitrogen for our land. We plant crops like beans and peas which gather from the air the nitrogen that is in the air and take it down through their roots into the ground. We have experimented with physics and chemistry and all the fine mechanical methods to take nitrogen from the air. . . . That Japanese did not speak the Japanese language, or the English language, or the Russian language, or the German language. He spoke the world language! When that man discovered how to fix nitrogen, he spoke the world language. It was something good for all of us. ("LT," pp. 125–126)

It is not clear which Japanese inventor London may have been referring to here (the true inventor of the process was German). But what is important for our vision of London's Asia/Pacific is not finally who developed the process, but that as part of his ongoing quest for *technê*, London was apparently willing to contradict even his most virulent racial animosities. Having made a "return to the land" in his final years to his ranch in Glen Ellen (where he spent a great deal of time and money hoping to develop more efficient and productive methods of farming), London's search for *technê* was simply entering a new phase. What the world really needed, London argued, was a forum where future possibilities of *technê* like this might be discovered. A place "where all men of all races can come, where they can eat together and smoke together and talk together" ("LT," p. 126). This, finally, was what it meant to speak the "world language"—to find a way of experiencing modernity that would allow human beings to "get down deep under the surface and know one another" ("LT," p. 128)—something, perhaps, like the "interfusings" conjured up by London's "Red One," but without all the racialized headhunting.

4. Machine/Art

Ernest Fenollosa, Ezra Pound, and the Chinese Written Character

And from the ancient pagodas, the madmen seized the blue robes that were worn to the glory of the Buddhas, to build their flying machines.

—F. T. Marinetti, *Second Futurist Proclamation* (1909)

When Ernest Francisco Fenollosa stood up to address the Congress of Art Instruction at the Chicago World's Fair (a description of which is provided in chapter one), he did so as an unrivaled expert in the study of Chinese and Japanese art. And, given the other participants' suspicions regarding the "machine" and "mechanical methods," he was very much in his element. Instructors must remember, he told the other participants, "that art is individual and type an abomination."[1] An artist could learn more by being "trained in an atmosphere of art" than by attempting supposedly "perfect," "materialistic," or "photographic" representations of nature.[2] Thus, instructors ought to provide students not with "mechanical" techniques for representational accuracy, but rather with expansive access to great works of art. And by "great works of art" Fenollosa meant primarily those of China and Japan. Indeed, Fenollosa had come to the Columbian Exposition after teaching for several years in Tokyo and was eager to promote traditional Asian art, which, as he saw it, had only barely (and with his own courageous assistance) escaped the mechanistic perils of Western culture. Consider, for example, the long poem titled *East and West* he wrote to commemorate the Columbian Exposition, the cover art for which Sarah Wyman Whitman provided her unique lettering and floral Oriental design (Plates 91–92). Calling for a "future union of East and West," Fenollosa insists that before any such synthesis can occur the West will have to radically scale back its march toward mechanization. Whereas the "virginal" East had for centuries dwelt in the "cooling floods of the real," the West's "self-centered zeal" and "steel-bound leap of trade" had suddenly "poison[ed] the crimson life-tide" of Japan's arteries, convening a "dread tribunal of our doom."[3] The imperial ambitions of Western industrialism have created only ecological catastrophe and cultural death:

> The smoke of chimneys taints this verdant world.
> See'st thou the fuse of thine own dynamite?
> Self-law, self-science, self-greed, self-wealth, self-sworn
> To blast the stanchest stronghold of thy pride! (*E/W*, p. 34)

For Fenollosa, the "blast" created here by modern machine culture was not something to celebrate. When in the poem he tells the story of Japan's Meiji-era embrace of machine culture and modern civilization, it is portrayed as a kind of cancerous disease:

O you West in the East like the slime of a beast,
Why must you devour that exquisite flower?
Why poison the peace of the far Japanese?
Is there no one to tell of the birthright they sell?
Must they sweat at machines like a slave to the means?
By the curse of your fire, and the glare of your selfish desire!
A fig for their artists and scholars!
We crave the dry-rot of their dollars.
We teach them to live in dark palaces.
We lend them the sting of our malices.
We preach them the practical Buddha of Self,
And civilization the deification of pelf. (*E/W*, pp. 39–40)

If, however, the West were to countermand its march toward mechanization and turn to the more "organic" arts of the East, the possibilities for epochal redemption were immediate and glorious. As Fenollosa explains in the preface to the poem, "within the coming century," if only Western tendencies toward "conquest, science, and industry" could be tempered by the "profounder integration" of Eastern "fertile tranquility" and its "grace of aesthetic synthesis," mankind might finally achieve the "sublime purpose of uniting the East and West." Even today, he explains, the nations of the earth have come together to commemorate the "steadfast idealism of Columbus" at the World's Fair in Chicago, where "his triumphant caravels have met the ambassadors of Xipangu on the shores of Lake Michigan" (*E/W*, pp. vi–vii). As he writes in the final section of the poem, it was the beginning of a potential "marriage" of East and West:

> Petals of infolded plan
> Model of millennial man
> Thine the vows of bride and spouse
> Plighted since the world began

Since he considered himself to be a critical part of that "infolded plan," Fenollosa would go on to promote Eastern art as an alternative to Western mechanical culture in hundreds of lectures and publications during the 1890s and early 1900s. It was a mission that would not only directly inform the theories developed by his assistant Arthur Wesley Dow (thereby underlying much of the Boston book movement examined in chapter 2), but would also become the guiding assumption for his articulation of what the Chinese written character had to offer American art and poetry.[4]

As I hope to illustrate in this chapter, Fenollosa's anxieties over the aesthetic tragedy of machine culture and the role of Asia's *technê* as an antidote to that dilemma point directly to an important complication in the traditional story about how his theories were interpreted and disseminated by his literary executor, Ezra Pound. The typical account of Fenollosa/Pound—and there are many—operates under the commonsensical notion that since Pound edited, published, and continually championed Fenollosa's manuscripts, the two figures were more or less of the same mind regarding the operative dynamics of the Chinese ideograph.[5] Hence, most discussions of Fenollosa's famous essay on *The Chinese Written Character as a Medium for Poetry* (hereafter cited as *CWC*), edited and published by Pound in 1918, have tended to focus on either the degree to which both Fenollosa and Pound "misunderstood"

the precise nature of Chinese orthography or whether such misunderstandings are of any real consequence in literary translation.[6] However, when we consider the role of the machine in—and as—art, striking discontinuities and tensions between Fenollosa and Pound begin to emerge. While Pound, for instance, argued that his promotion of vorticist "machine art" in the 1910s and 1920s constituted a logical extension of Fenollosa's theories on the synthetic structure of the Chinese ideograph, such an extension would have certainly startled, if not horrified, Fenollosa. What are we to make of Fenollosa/Pound's essay on the Chinese character if what Fenollosa offered as a *corrective* to Western mechanization became for Pound a philosophical *correlative* to the "machine art" of engineers and modern industry?[7] Was the ideograph described in Fenollosa's essay offered as an antidote to machine culture or as the perfect embodiment of concentrated machine energy? What difference did these radically divergent worldviews make in Pound's use of Fenollosa's manuscripts? As we shall see, the historical ideograph of "Fenollosa/Pound" is in fact a complicated nexus of competing energies; a point of dynamic transformation from an 1890s aesthetics of antimechanical Western Buddhism to an avant-garde aesthetics of protofascist Futurism and machine precision. In this sense, Fenollosa/Pound's essay on the Chinese character must be seen as the odd palimpsestuous text that it is—one in which the tangled, contradictory strands of both machine anxiety and technological enthusiasm are woven together and play off one another. To arrive at that point, however, we must first turn to Fenollosa's adventures in Japan and the ongoing emergence of Asia-as-*technê* to which his contributions were so central.

Fenollosa's Asia-as-*Technê*

No one who knew Fenollosa when he graduated from Harvard in 1874 would have guessed that in just ten years he would become one of the most influential men in Asia. Soon after he began graduate studies in art history under Charles Eliot Norton, Fenollosa left the university to enter art school in Boston where he studied oil painting, without much success.[8] By 1878, Fenollosa had little going for him. He was in love with an upper-middle-class woman from Salem, but without any legitimate career prospects it was difficult to propose, and his father (for reasons that were never determined) committed suicide in January that same year. When the opportunity to teach political philosophy and economics at the University of Tokyo arrived two months later, there was no question that he would accept. He married in June, arrived in Yokohama in August, and was already teaching in September, rehearsing for his new Japanese students the basics of Hegel, Spencer, and Emerson on questions of political economy, social evolution, and American transcendentalism. No one expected him to delve so enthusiastically into the traditional art of Japan. Indeed, he had come, presumably, not to learn about Japanese art but to teach what was most valuable about modernity to a cadre of young Japanese intellectuals, many of whom, it seemed, were eager to abandon the traditions and methods of the past for the slick promises of Western industrialism.

Within a few years, however, Fenollosa's sense of his mission in Japan had changed. Although he never lost his Spencerian optimism regarding social progress, the more Fenollosa learned of traditional Japanese art, the more he worried that a superior *technê* was getting swept aside in Japan's Meiji-era rush to adopt Western art forms (pencil and charcoal shading, mechanical perspective, receding landscapes, "scientific" anatomical form, and so on).[9] In 1882 Fenollosa and some of his Japanese colleagues (including his protégé, Okakura Kakuzo) started a club at the university

called the Ryūchikai (Dragon Pond Society), devoted to the preservation of Japanese "non-mechanical" art. In a highly influential speech at one of the club's first meetings, Fenollosa argued aggressively for the superiority of traditional Japanese aesthetics:

> Painting is an art that expresses Idea by means of lines, colors, and shading done in perfect harmony. . . . Japanese art is really far superior to modern cheap western art that describes any object at hand mechanically, forgetting the most important point, expression of Idea. Despite such superiority the Japanese despise their classical paintings, and, with adoration for Western civilization, admire its artistically worthless modern paintings and imitate them for nothing. What a sad sight it is! The Japanese should return to their nature and its old racial traditions, and then take, if there are any, the good points of western paintings.[10]

Offered as a strident corrective to Japan's wholesale embracing of Western modernity, Fenollosa's dismissal of Western artistic forms (which, as he says, describe their objects "mechanically") anticipated an official recuperation of traditional art in Japan. Several important Japanese men were in the audience listening that day, including the minister of education, who subsequently ordered that all prefectural governments begin a survey of art in Japanese regional temples. Shortly thereafter Fenollosa and Okakura began an official tour of Japanese temples throughout Kyoto and Nara, and by the late 1880s Fenollosa's Ryūchikai speech had become official government policy.[11]

For the next two years Fenollosa would be one of the most powerful men in Japan.[12] Appointed by Japan's Department of Education to a special committee charged with the task of forming a national art school, Fenollosa and some of his students and colleagues began a "world tour," assessing several art programs in the United States and Europe, none of which convinced Fenollosa that Japan had anything to learn from the "mechanistic" West.[13] He had also officially converted to a new form of esoteric Buddhism known as Tendai Buddhism (also known as New Buddhism), becoming a lay-ordained minister and studying traditional Japanese art and sacred texts. Heavily influenced by imported theories of Hegelian "organic wholeness" and Spencerian evolution, Tendai Buddhism supplemented traditional Daoist notions of natural flux and nirvanic consciousness with nationalistic dreams of social evolution and scientific progress.[14] It was a heady moment of spiritual discovery and political power for Fenollosa, feeding his conviction that he had come to save Japanese—and later Anglo-American—culture from the linear and mechanically mimetic (and therefore fallen) art of the West.

But if 1889 saw the auspicious opening of the Tokyo Academy of Fine Arts and the institutional acceptance of New Buddhist theories of art in Japan, it also signaled the end of the Japanese government's feeling that it needed Westerners to advise them in matters of national culture.[15] Sensing that his services were no longer in demand, when Fenollosa was offered a position as curator of Asian art at the Boston Museum of Fine Arts, he knew it was time to go. It was a prestigious job, but after having risen so dramatically as self-appointed savior of traditional Japanese art, the return to Boston (where he was once again only one of so many white New England intellectuals) caused him to reflect once more on his purpose in life. Shortly after arriving in the United States in 1890, he made the following personal notes in his notebook:

I must take a broad view of my position in America. First, I must remember that, however much I may sympathize with the past civilizations of the East, I am in this incarnation a man of Western race, and bound to do my part toward the development of Western civilization. . . . In this broad way of working, there must be no attempt to ignore the first theoretical groundwork. I must demonstrate my right to be a power in the world of philosophical opinion. I must go back to my work on Hegel. I must inform myself on present psychological progress, and I must bring them together on the basis of Buddhist mysticism.[16]

It is important to note that while couched in the typically racialized language of his time, Fenollosa's argument is both an affirmation of his Tendai Buddhist religion ("in this incarnation") and a renewed conviction that while he may have eventually worn out his welcome in Japan, he still had a great mission to accomplish in revitalizing the arts of Western civilization—a revitalization that he now saw as consistent with a much larger goal of *universal* synthesis. For the rest of his life after his return to the United States in 1890, Fenollosa would be consumed with the notion that by rescuing Western culture from its mechanistic tendencies in art he could initiate a grand meeting of East and West.

It did not take long for Fenollosa to establish his reputation as the leading expert on Asian art in the United States. Within a year he hosted one of the first exhibitions of Katsushika Hokusai's woodblock prints in North America featuring several pieces from his own collection, which, despite his constant lobbying for Japan's preservation of its own artistic heritage, had grown considerably during his time in Asia. He also gave frequent lectures at the museum, citing what he saw as the inherent differences between Asian art and Western "mechanical copying." In one early lecture given during 1891, for instance (anticipating precisely his argument at the Congress of Art Instruction during the Chicago World's Fair), Fenollosa argues, "The mere representation of an external fact, the mechanical copying of nature, has nothing whatever to do with art. This proposition is asserted by all oriental critics, and is a fundamental canon with all Japanese painters."[17] The next year, amid growing excitement over the coming Columbian Exposition in Chicago, Fenollosa published an article on "Chinese and Japanese Traits" in the *Atlantic Monthly*, arguing that Japan's rapid industrialization was merely a defensive gesture designed to keep Western military power from overwhelming Asia's aesthetic culture. Such a defense was necessary, Fenollosa explained, since the preservation of Japanese art was "a solemn service which [Japan] owes to humanity." Japan had become "the last custodian of the sacred fire. She alone has the unspeakable advantage of seeing through the materialistic shams with which Western civilizations delude themselves, while she appropriates their sounder materials to rekindle her flame."[18] As we saw earlier, the Columbian Exposition in Chicago offered yet another opportunity for Fenollosa to attack the West's "materialistic shams." Indeed, he was at the center of much of the East–West comparative dialogue in Chicago during 1893, speaking at the Congress of Art Instruction, assisting several of his former Japanese students and colleagues in developing their exhibitions at the fair (including Okakura, who had taken up many of Fenollosa's former duties after his departure), serving as a member of the fine arts jury, and publishing glowing accounts of Japan's various exhibitions.[19]

Spurred on by Japan's success at the World's Fair, Fenollosa's refutation of mechanistic realism at the Congress of Art Instruction was only the beginning of an

extended campaign for Asia-as-*technê* that would continue until his death in 1908 and take him to cities all over the United States and Europe. In a speech given the next year at the Boston Art Students Association (just months after Sarah Whitman addressed the same audience), and no doubt thinking of the recent discussion of machine culture and art instruction at the fair, Fenollosa suggested that only "debilitating minds crave a perfected machinery for learning art," and that artistic talent was not something one could "digest" through some "intractable formula." To "copy or imitate is an analytical act," a dismal breaking down of something that had been "fused in a single creative act."[20] It was a philosophy that spoke to the transcendental tradition in Boston (as well as the growing market for Japanese goods examined in chapter 2), and Fenollosa was suddenly in demand.

Fenollosa after Boston

Selling out Boston lecture halls on Friday-evening presentations throughout 1894 and 1895 (supplementing an already substantial income from his museum salary), Fenollosa might have gone on to become one of the most persuasive figures in Boston politics. However, late in 1895, a major break occurred when he began an affair with a young and beautiful assistant at the museum, Mary McNeill. The divorce and new marriage caused an enormous scandal among some of Fenollosa's most supportive museum donors, and he was forced to step down (replaced eventually by his former student Okakura).[21] But if the scandal forced Fenollosa to move his center of operations from Boston to New York, his commitment to the development of Asia-as-*technê* as a means of redeeming the fallen art of the West barely skipped a beat. Less offended by the new marriage, the New York-based feminist editors of the women's club publication *New Cycle* offered Fenollosa a job as coeditor, and he promptly set about refashioning the journal to address his more ambitious "synthetic" goals. Renaming the journal *The Lotos* as means of signaling his ongoing commitment to Buddhist ideals (the lotus flower, he writes, is the "banner symbol" of the "fragrant East," a kind of "jeweled mirror to reflect [man's] first consciousness of individuality"), Fenollosa employed Arthur Wesley Dow to provide woodblock prints for the covers and illustrations inside (Fig. 4.1).[22] Placing his own articles at the front of each issue, Fenollosa wasted no time in getting right to the questions of art and the machine.

In an essay on "Art Museums and Their Relations to the People," for instance, Fenollosa laments that "Here in America we are clever at machinery, but poor in design," decrying the "modern craze for realism, for detached facts, for cunningly-mirrored incidents."[23] Against this tendency, however, Fenollosa praises the recent attention given to collection development in U.S. museums, noting that while the West has all along recognized the "importance of science and the scientific habit," it is only now coming to understand that "beauty is as much a necessity of healthy human life as fresh air and wholesome food."[24] In finally recognizing the value of museums, he argues, the West is sensing that it need not be "condemned" to a "desert of utter sterility, a laboratory whose machines shall produce nothing of intrinsic worth before the far-off day of salvation."[25] The "law of art," he explains, will always "find its type rather in man's soul than in mechanical forces."[26] The museum should therefore be both an "outlet for individual talent which no machinery can ever supplant," and a space for learning that differed from traditional pedagogical methods: "If we suppose . . . going through certain mechanical exercises will make us poets, we are mistaken. Individuality is the one thing unteachable, if teaching means, as

usual, the applying of a formula. Here is the supreme difference between Art and Science."[27]

Another important reason for Fenollosa's insistence on the pedagogical value of the museum, as well as his increased emphasis on pedagogy more generally, was his recognition that without the steady employment he had enjoyed at the Boston Museum of Art he was going to need a reliable income soon (he was also paying alimony now), and teaching offered one possible solution. His closest ally at the museum, Arthur Wesley Dow (who, as we saw in chapter 2, experienced something of an epiphany in 1891 when Fenollosa introduced him to the Asian collection in Boston), had been offered a position directing the art program at the Pratt Institute in New York City in 1896, and he hoped Fenollosa would join him. The two had been close collaborators at the *Lotos*, and Dow's artistic theories were heavily influenced by Fenollosa's synthetic global vision.[28] Dow had not given a speech at the Congress of Art Instruction at the World's Fair in Chicago in 1892 but he was in attendance and shared Fenollosa's disdain for mechanical methods.[29] Fenollosa and Dow were so close personally and philosophically in fact that much of what appeared in the *Lotos* during 1896–1897 would find its way into Dow's groundbreaking *Composition* (1899)—including many of the same design elements and illustrations (Figs. 4.1–4.2).

But if the Pratt Institute offered the possibility of a modest but steady income, Fenollosa was more persuaded by the lucrative possibilities of another trip to Japan, where he hoped to continue collecting art to sell in the United States and perhaps even land another job at a university or as an advisor to the Japanese government. Dow was deeply disappointed by Fenollosa's decision not to join him at Pratt, but Fenollosa continued sending articles to the *Lotos* as he and Mary made their way across Europe en route to Japan. In two essays on the "Nature of Fine Art" he offered a philosophical explanation for his ongoing attack on mimetic representation, arguing that "the nature of fine art, *even in the art of painting*, is not in the least constituted by realistic representation, has primarily nothing to do with the studying or copying the mere facts of external nature."[30] The whole notion of "mechanistic" and "servile" imitation was therefore a "waste of time," a "piteous mistake" ("NFA," p. 667). Fenollosa's reasoning here is that since both painting and music are fine arts, and since music has nothing to do with mimetic representation, something else must serve as an underlying feature of the fine arts. The true nature of fine arts, he concludes, has more to do with "their power to express a pure, individual, non-ratiocinative idea in peculiar combinations of sensuous terms" ("NFA," p. 672). And if the mechanistic West has thus far failed to recognize and employ this "sensuous" and "synthetic" essence it is because "as a race, we are more ignorant of the nature of good painting. We are ignorant of the very language of art. We have debauched our aesthetic faculty by intemperate draughts at the bar of realism" ("NFA," p. 669). Trapped at the mimetic saloon, then, Western artists had become drunk on the "mechanical formulae," taught to ignore the "synthetic consciousness" of the Oriental mind, focusing instead on the "analytic elements" of "chiaroscuro and perspective" which articulate only "the external fact of sunlight and shadow" and the geometric "literalness of nature" rather than the "sparkling synthesis . . . of beautiful line and color."[31]

Unfortunately for Fenollosa, after arriving in Japan he quickly discovered that his services were even less in demand than they had been when he had left seven years earlier. He did, however, establish a business connection with a Japanese art

February, 1896

Number 8

THE SYMBOLISM OF THE LOTOS.

HE lotos is the most universal of flower symbols. It furnishes one of the main themes for the world's decorative design. A native of every continent, it has impressed the imagination of the most diverse races with the significance of its beauty, and, like the cross, it has been consecrated the talisman of a great religion. So many shades of suggested meanings, so many essences of the souls of nations float faintly in its fragrant aura, that it is as if the very Spirit of Humanity rose pure before us, incarnate in the most perfect of Nature's forms and colors. It lulls us with no vague dream of a paradise abstracted far from the soil of earth. Though it blossom in the ether of heaven, it is rooted in the marshes of matter. The thought of it awakens no vain and passing sentiment, but emotions as real as love, as vital as life, as practical as all human aspiration. It may thus be taken, in sober truth, for the symbol of the soul.

In the hazeland of early myth, primitive imagination, peering awestruck through the dim light of dawn at things not comprehended in the categories of family, food and shelter, found its first vision of God in the rising sun, read fairy tales from the hieroglyphics of the stars, sailed over infinite seas, the original argonaut, on ships of cloud, and lured the coy nymph, fire, to its shrine. That wondering shepherd could seize, from the infinite cosmic symbol, only a

DEDICATED TO MUSIC.

MUSIC IN NATURE, AND ITS RELATION TO MUSIC IN ART.

T is scientifically comprehensible that, as vibration is invariably manifest wherever there is life, the universe is one vast musical instrument, ceaselessly emitting sound. What its harmonies, discords and progressions are, must obviously remain beyond our ken, as long as human organisms retain their present narrow limitations. But that the same laws govern the septenates of tone beneath and above our auric sense of musical sound is a scientific probability, if not a demonstrable fact. Whether instruments can be devised to augment our fragmentary sense of musical sound, is a matter for imaginative conjecture, but it is a lamentable fact that the most highly endowed of human beings can recognize, by physical sense only, a limited area of musical tone. Above and below, there are realms of noise, sound, and indescribable effects of vibration which affect the mental and emotional nature of man, but are no longer tonal. They depress, elevate, soothe or madden him; but they are vague uncertainties, so far out of his range of knowledge that he is at their mercy. He stands to them in the position of the mortal to the Greek gods—like the Greek mortal, knowing none of the causes which bring one fate or another upon him, and unable to recognize that their nature is his

nature, that his faults are theirs. To apply the simile: the noise and clatter of inter-moving human beings, the sound of the wind, the roll and roar of surf, the voices of insects and animals, the song of the forest are all incomprehensible, except as emotional effects of irritation, fear, or pleasure. We are no better than victims; we neither control nor understand; our nerve-centres are at the mercy of nature's currents, tides, and eccentricities of sound. We do not even know that the evident harmoniousness of nature, when left to herself, follows laws that are identical with the tonal laws which have been discovered and developed by the civilization of the West during the past five hundred years.

A slight line of research has been extended into that vast realm of musical values, but it has been halting and desultory, and affords the merest glimmering of disconnected possibilities. From the determination of the musical tones of bird-calls to the discovery of the tonic of the roaring chord of Niagara Falls, there is a vast, unexplored space. Is it to be presumed that the space is void of rhythmical vibration? Through the air the bird sings in, the unheard voice of the wind is sweeping, spray of green; beneath and within the element we know as air, the impalpable ether passes, on currents of its own, swift, unseen, a voice within a voice. The law-controlled vibration of any medium results in musical sound,

Fig. 4.1. Cover and sample page from the *Lotos,* design by Arthur Wesley Dow during Ernest Fenollosa's time as editor (notice the initial "I" in the third column).

COMPOSITION

A SERIES OF EXERCISES SELECTED FROM A NEW SYSTEM OF ART EDUCATION

BY

ARTHUR W DOW

Instructor in Art at Pratt Institute and at the Art Students' League of New York

ΣΥΝΘΕΣΙΣ

PART I

FIFTH EDITION

NEW YORK

THE BAKER AND TAYLOR COMPANY

33 East Seventeenth Street

1903

BOOK COVERS, TITLE PAGES AND LETTERS

XVII.—LINE AND NOTAN OF TWO TONES

BOOK cover is a problem in rectangular arrangement. Whatever be the design placed upon it, the first question is the division into beautiful proportions. See Sections I, II, III, etc. Lettering may be considered as a tracery of Line or a pattern of Dark-and-Light; in fact it is itself a design, and the dignified beauty of simple lettering is often a sufficient ornament for a book cover. In any case the letters occupy a certain space, which must be well-proportioned. Above all, they must be clear and intelligible. Extravagance in lettering should be avoided, but variation is possible. Each letter may be reduced to its elements (as A to a set of three lines), and these varied like any line design. The title page, for our purpose here, is essentially the same problem as the cover.

INITIALS are a part of the Notan-scheme of a book-page. Considering the text as a gray tone, combined with a white margin, the initial comes between the two as a sort of focal point or accent, like the sharp touches of black in ancient Japanese ink-painting (see pages 11 and 39.) The initial itself is usually a composition in a somewhat square-shaped space — a useful subject for students if the scale be large.

EXERCISE

STUDENTS should make many small preliminary sketches for book covers, not attempting a large drawing till a definite and satisfactory plan of arrangement has been reached. Let them study good examples in the libraries. Reproductions or photographs of the fine old bindings will be valuable illustrations of dignity of style.

62

Fig. 4.2. Cover and page on title page design from Arthur Wesley Dow's *Composition* (1899 and 1903), recycling (compare 4.1) the initial "I" from his time at the *Lotos* (one of several images he recycled from that journal for *Composition*).

merchant who agreed to have Fenollosa act as agent for the sale of a large collection of Japanese goods in New York. If the partnership had been successful, Fenollosa might have made enough money to live in Japan without having to teach or serve in a government post, and could have continued writing and collecting. But after he returned to New York his former wife brought a lawsuit against him for failing to pay appropriate alimony, and his business associate in New York (an unsavory character by the name of William H. Ketcham) stole many of the imported goods, reportedly as a means of staving off his own bankruptcy.[32] The Fenollosas would spend the next few years shuttling back and forth between New York and Japan, dogged by lawsuits and the tangled collapse of his business venture. But as turbulent as his legal and financial situation was during these years, his commitment to the educational value of Asia-as-*technê* never wavered, although it did occasionally reflect his frustrating situation. In an article he wrote in Japan (published in both English and Japanese), for example, Fenollosa argues, "A universal conclusion is irresistible, that a craze for realism has always helped to destroy great art." The "mechanical imitation" of realism has "deluded men into forgetting these fundamental principles," such that they "become hungry for facts only," and "lose the taste for that more refined sort of emotion called art. They become utilitarian, practical, selfish; good business machines, perhaps, but stunted souls."[33] With the words "utilitarian, practical, selfish," and "business machines," Fenollosa may be offering an implicit jab at his business partner Ketcham, or perhaps even an expression of regret that he had gotten involved in such a scheme in the first place. In any case, he remained very proud of his own role in Dow's new curriculum at the Pratt Institute: "It may interest your readers to know that, in America, the beginnings of a . . . new system of art education, whose principles and exercises are primarily concerned, not with fact, but with pictorial structure already exists" ("WPV," p. 200). This new method, "now being carried on in the Pratt Institute of Brooklyn," Fenollosa writes, is based upon "the procedure of old Oriental masters," and "allows no mechanical copying of facts, insisting that an artistic feeling shall be the justification for every line drawn" ("WPV," p. 200).

After returning to the United States in 1901, Fenollosa spent the next four years on the lecture circuit as part of the "Winona Assembly," a Chautauqua-style series of traveling educational events, preaching the gospel of Asia-as-*technê*.[34] It is difficult to measure precisely the reach of Fenollosa's ideas during this time, but by any standard it was substantial. He spoke to hundreds of thousands at the Winona Assembly lectures, was regularly invited to give presentations to faculty and studies at universities (Chicago, Philadelphia, Boston, New York, and so on), spoke to the National Education Association in Milwaukee, presented at annual meetings of the American Oriental Society, published in mainstream venues like *Harper's* and in smaller educational journals such as the *Elementary School Teacher*, and even lectured to President Roosevelt in the White House.[35] He was frequently cited in art journals such as *Brush and Pencil* and *Modern Art*, and was glowingly praised by Dow in the opening pages of *Composition* (1899) as the main inspiration for the book's emphasis on Oriental forms. Throughout it all Fenollosa's message, as he wrote in one of his notebooks in 1900, was that while modern America's "industrial monsters . . . threaten the very individuality that produced them,"[36] the unfortunate response to this disaster by most art educators and historians, as he wrote in the *Elementary School Teacher*, has been to "assert that it is the development of more and more perspective, more and more elements of realistic impression that constitutes the arts in our time."[37] For Fenollosa, only artists and philosophers familiar with Oriental forms (like himself,

Dow, John La Farge, Sarah Whitman, and others he occasionally praised) saw this mechanistic culture for the catastrophic mistake it was.

Buddha vs. the Machine

In 1906, Fenollosa consolidated a number of his notes and previous lectures into a larger essay that he titled *The Chinese Written Language as a Medium for Poetry*, which Ezra Pound would later edit and promote as *the* treatise on modernist poetics.[38] Before addressing Pound's strategic use of it, however, it will be necessary to understand that at the precise moment Fenollosa was putting together this larger essay, he was also engaged as editor of a short-lived journal titled *The Golden Age* in New York, where he had the opportunity to expand on the essay's underlying philosophical ideas. It is an odd twist of authorial fate that among all the writings Fenollosa produced in 1906, the essays he felt most ready for publication (those that appeared in the *Golden Age*) would be consigned to historical obscurity, while the scribbled— sometimes illegible—notes he left behind on Chinese ideography and poetry would go on to become one of the most famous essays of the twentieth century.[39] The imbalance here is even more striking since Fenollosa's essays in *Golden Age* (placed in the context of his ongoing campaign for Asia-as-*technê*) shed a great deal of light on the underlying impulses for the essay Pound would later publish and adapt for his own uses.

Fenollosa's *Golden Age* essays posit a fundamental distinction between "analytic" and "synthetic" ways of thinking, arguing for the latter in terms that reveal both a continued commitment to Esoteric Buddhism and an increased uneasiness with Western machine culture. Like the American transcendentalists (and Hegel) before him, Fenollosa does not abandon the idea that an "essence of order" and "reason" underlies both Nature's complicated mysteries and human thought processes, but he insists there is a critical difference between analytic reason and synthetic reason:

> Take ordinary industry, for instance; it reasons along a thin straight line from effect to cause. . . . Mechanical motions follow lines of space; *here* moves to *there*, and so on forever. Numbers pile themselves up in a series that never turns round and goes backward. It is on, on, on; and that is why I call it a straight line. You feel the pull only one way. The place where you stop is defined by the object at the end; the value of the series is relative to a specific want.[40]

Here Fenollosa places an illustration in the text, a series of linear arrows and circles, as a way of visualizing the "graphic type" of analytic reason (Figs. 4.3–4.4). "Such is the logic of analysis," he argues, and "of *all machinery*."[41] That arrows and circles are part of his graphic illustration for mechanistic analysis will become important to our analysis of *CWC* below, but it is enough here to notice that they are left-to-right, linear, sequential, successive—almost like the mechanized staccato of an assembly line.

By contrast, Fenollosa continues, "the structure of a work of art differs absolutely from this," operating by way of mutually constitutive elements that constantly "irradiate" one another:

> Here I lay a spot of red paint down on my canvas. Next I choose a green which I dab near it. The red is immediately changed, and so is the green. In contrast to the green the red has taken fire, and the green now glows inwardly like an emerald. The reaction is mutual. Now let me go on to add a

Figs. 4.3–4.4. Passage with illustration of "analysis" and "all machinery" in Ernest Fenollosa, "The Roots of Art," *Golden Age* (May 1906), p. 232. (*Below*) Expanded detail (re-created by author).

single key. Mechanical motions follow lines of space; *here* moves to *there,* and so on forever. Numbers pile themselves up in a series that never turns round and goes backward. It is on, on, on; and that is why I call it a straight line. You feel the pull only one way. The place where you stop is defined by the object at the end; the value of the series is relative to a specific want. Its graphic type is:

Such is the logic of analysis; of all classification, of all labeling, of all machinery,

ation is clear a color-wonder relations of c no longer ana specific combi one, unheard c ment.

So I might added colors,

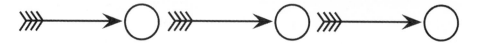

patch of yellow;—presto! The green-red combination is itself all changed; the green looks bluer than before, the red more purple, and the very yellow has become brighter. It has become a triangular system of mutuality. (*GA*, p. 232)

Once the "magic" of the work of art has been accomplished, the colors "have been mutually juxtaposed so that their multiple cross relations have only clarified and ir-radiated each other, then no one is cause and no one effect, for all is cause and all effect" (*GA*, pp. 232–233). Fundamentally different from the logic of "mechanistic" analysis, then, the work of art is portrayed here as a *synthetic* process in a manner that, as Jonathan Stalling and Haun Saussy have recently pointed out, reveals something of Fenollosa's implicit fascination with the Esoteric Buddhist notion of "Indra's net."[42] Certainly the image most frequently associated today with the Hua-yen school of Buddhism and its *Avatamsaka Sutra* (or "Flower Ornament Scripture"), Indra's net is typically described as a metaphor for the metaphysical structure of the cosmos: a vast heavenly matrix or net wherein at each "eye" of the net a small, glittering jewel has been hung (the net is infinite, and thus so are the jewels), and if one were to look into one of these jewels one would see a vivid reflection of all the other jewels in the net—each jewel its own universe of infinite reflection, interconnected and mutually constitutive in a dynamic, luminous totality.[43] While it would be over-reaching to claim that many Western Buddhists would have known of the metaphor of Indra's net in 1906 (its presence in English-language discourse, as we shall see in chapter 7, accelerated dramatically during the 1950s with the recognition that its implied doctrine of interdependent totality corresponded neatly with cybernetic theories of networked consciousness[44]), it is nonetheless significant that the first articulation of this metaphor in English occurs in Okakura Kakuzo's *Ideals of the East* (1903), in which he claims that "art, like the diamond net of Indra reflects the whole chain in every link. It exists in no period in any final mould. It is always a growth, defying the dissecting knife of the chronologist. To discourse on a particular phase of its development means to deal with infinite causes and effects throughout its past and present."[45] As if invoking precisely the description offered here by his former student, Fenollosa offers the following graphic illustration of artistic "synthesis" (Figs. 4.5–4.6). In this diagram, he writes, eight separate points are "ranged about in a circle with their mutual lines of influence crossing about a common center" (*GA*,

all effect. The color effect may be called a color individual which has no definition, no possible existence, except in that one stable equation. There it lies, created or discovered, whichever you like, out of ordinary dead pigments. When Nature plays this game for us, as in some sunset pageant, we cry "How beautiful!"—admitting that the reason of it, the wonderful cross harmony, is in things too.

Here, I urge, we find a new species of structure, whether in nature or in art, which is not to be found in our list of logical categories. It does not lessen the mystery that we give it the familiar name, Beauty. It is a very real method of grouping, yet unproducable by any ordinary analytical reasoning from whole to part, from end to means, from 1 to 10, or by any other linear path. The parts of it may be symbolized as ranged about in a circle, with their mutual lines of influence crossing about a common centre. In truth, the complexity is far greater than the number and directions of the lines shown in this figure, because there should be a line between each unit and each combination of two or more units.

The same kind of phenomenon is true of lines as of colors. Lay down a single line, say on a rectangular sheet of paper; and it may have in that space a certain vague value. Add a second line with sufficient cunning, and you will see that the two help to give each other value. So do, if well chosen, a third and a fourth, a specific new line-feeling coming out into clearer relief. The test of right choosing is that no unit in the obtained combination can be changed without loss to the whole. Each

demands all the others in just that place, length, and direction. If one single line-quality is altered in the smallest degree, the whole individual line-impression becomes blurred. It is something like a chemical reaction in which each element has to be present in exactly the right proportion. And it suggests chemistry in that the production is often unlike any of its constituents. Here is a kind of being where the whole is more than the sum of all its parts; it is the sum plus all the mutual modifications and the new integration. The truth about great poetry and great music is similar; not a word or one tone can be dropped or added without marring the unique impression. Of course in practice it is impossible to achieve such unity and harmony by beginning any tentative series at random. It is all, though perhaps dimly, perceived together before the artist begins, in a creative flash or trial vision wherein all the parts rise up to condition each other.

That anybody should hope to build up such out marring the unique impression. Of course in practice it is impossible to achieve such unity and harmony by beginning any tentative series at random. It is all, though perhaps dimly, perceived together before the artist begins, in a creative flash or trial vision wherein all the parts rise up to condition each other.

That anybody should hope to build up such æsthetic wholes,—such color impressions say, —by any ordinary analytical methods of experiment, is readily proved absurd. Let us suppose that we have only ten spots of color in our design, and that each color would have been capable of ten variations between which

Figs. 4.5–4.6. Passage with illustration of "synthesis" and the "irradiating" structure of a work of art in Fenollosa, "Roots of Art," p. 233. (*Above*) Expanded detail (re-created by author).

Fig. 4.7. Diagrammatic illustration (by author) of Fenollosa's expanded point: "the complexity is far greater than the number and directions of the lines shown in [Fig. 4.6], because there should be a line between each unit and each combination of two or more units [with potentially infinitely proliferating connections]" ("Roots of Art," p. 233).

p. 233). However, lest we misunderstand what the diagram is intended to illustrate, Fenollosa writes that even in this more dynamic illustration, the potential lines of juxtapositional relation have only been delineated to one degree: "In truth, the complexity is far greater than the number and directions of the lines shown in this figure, because there should be a line between each unit and each combination of two or more units" (*GA*, p. 233). And since each new point of connection creates several more points of connection, the potential interactions become infinite (to illustrate Fenollosa's point, one need only see how delineating the implied additional cross points in Fig. 4.6 would create, among several others, the new cross points in Fig. 4.7, and so on ad infinitum). "Here is a kind of being," he writes, "where the whole is more than the sum of all its parts; it is the sum plus all the mutual modifications and the new integration" (*GA*, p. 233). Put simply, Fenollosa provides this illustration as a kind of diagrammatic snapshot of processes that he believes are continually unfolding before us—a visual arresting of what is actually an endless series of mutual interactions. True art is therefore not a visual "representation" of reality (as modeled

in the linear, mechanical process of Fig. 4.4), but rather a "saturated solution of all the involved elements in terms of each other" (as modeled in the complex mutual interactions of Fig. 4.6) (*GA*, p. 235). It is a vision of processual, synthetic dynamism that Fenollosa had actually described years earlier in a lecture in Tokyo as being consistent with the complex spiritual systems of all of Nature:

> If we take an instantaneous photograph of the sea in motion, we may fix the momentary form of a wave, and call it a thing; yet it was only an incessant vibration of water. So other things, apparently more stable, are only large vibrations of living substance; and when we trace them to their origin and decay, they are seen to be only parts of something else. And these essential processes of nature are not simple; there are waves upon waves, processes below processes, systems within systems—and apparently so on forever.[46]

Here the vision offered by the machine (an "instantaneous photograph of the sea in motion") deceptively urges us to consider "systems within systems" as a "thing." For Fenollosa, however, Asia's *technê* offered a whole series of forms that radically subverted any such mechanistically arresting—or, as Okakura would have it, "dissecting"—impulse. In fact, as geometrized and "modern" as Fenollosa's diagrammatic illustration of synthesis might appear, it too is grounded in Asian aesthetic and religious forms. Notice, for example, the basic square-and-circle design of the hundreds of mandalas that Fenollosa had access to in Japan and as curator of Asian art at the Boston Museum of Fine Art.[47] Commonly known as "representations of sacred geography," the Sanskrit term *mandala* stems from a circle or disk or "sacred center" (*la*) that has been illuminated or "set apart" (*mand*).[48] As Elizabeth Grotenhuis explains, the mandala was used frequently as an aid to meditation, providing "a kind of cosmic ground plan or map" that "lays out a sacred territory or realm in microcosm, showing the relations among the various powers active in that realm and offering devotees a sacred precinct where enlightenment takes place."[49] If Fenollosa had Indra's net in mind when illustrating the infinitely "irradiating" processes of artistic synthesis, it makes sense that his diagram would perfectly model the underlying points of connection in many Buddhist mandalas, including some in his personal collection (Plates 93–95). But it is not only that the matrix of associative lines between the characters in the mandala mirror Fenollosa's diagram for synthesis; floating between these characters one also finds representations of the *dharmachakra* or "wheel of the law," with their eight spokes signaling the Eightfold Noble Paths of the Buddha—echoing, again, the proliferating "synthetic" complexity Fenollosa had identified in the implied delineations of his diagram.[50] Indeed, it is quite astonishing how many dozens of *dharmachakra* appear in Fenollosa's personal art collection at the Boston Museum of Fine Arts (Plate 96).[51]

We also know that during Fenollosa's final visits to Japan he began studying the *Yijing* (or, as it was alternately spelled in English then, the *Yih-King*, *Yi-King*, or *I-Ching*) with the Japanese scholars of Chinese philosophy Kainan Mori and Michiaki Nemoto.[52] In the *Yijing* the universe is understood to function according to the mutually interacting powers of heaven ("Yang") and earth ("Yin"), with the former symbolically represented by three Yang sticks (☰) and the latter by three Yin sticks (☷). Eight combinations of these trigrams (called the *Bagua* and typically arranged in a circle; Fig. 4.8) symbolize the essential elements of nature (the trigram *zhen* ☳, for example, means "thunder," while *kan* ☵ means "water").[53] The sixty-four possible combinations between any two trigrams in the circle thus form the basis for the

Fig. 4.8. The eight trigrams of the *Yijing* and the sixty-four hexagrams created by their potential combinations. Notice how the implicit lines drawn between the trigrams precisely mirror the networked pattern created by Fenollosa's "synthesis" diagram. This layout appears in *The Sacred Books of China: The Yi-King* [*Yijing*], trans. James Legge (Oxford: Clarendon Press, 1882), plates 2–3.

Yijing's cosmic scheme and geomantic powers. It is no coincidence, I would argue, that if one were to actually draw out the lines of relation between the eight trigrams in the *Bagua* (and thus produce the sixty-four hexagrams), the resulting diagram would look exactly like Fenollosa's graphic illustration for synthesis.

What Fenollosa's Buddhism-inspired diagrammatic illustrations of synthesis vs. analysis are designed to convey, in other words, is a fundamental difference between Eastern aesthetics and Western machinism and thus critical information for our methods of education.[54] The synthetic processes of art (and of Buddhist religious expression) lead to flashes of "perfect reaction" between "mutually irradiating" elements, while the analytical processes of the machine (and of a Western "bigotry for *barbara-celarent* logic") lead to mental and spiritual "atrophy."[55] As he writes in his conclusion:

> And indeed God might have made us all machines, which cut the same undeviating groove into the metallic substance of things. But fortunately He didn't! The very quality that distinguishes man from things, and even from brutes, is an infinite adaptability to conditions. In war, in politics, in society, in daily life a thousand new situations arise; that is part of the fun. The problem never repeats itself. A machine can do only one thing, but man can do a million things, and things which he has never tried before.[56]

Thus, Fenollosa concludes, since we are not machines that can do only one thing (Fig. 4.4), but rather spiritual beings that can do a million things (Fig. 4.6), we must actively avoid the "specific poison" of overemphasizing analytical thinking, especially since "this poison may even lurk in the fangs of our educational methods."[57] We must teach students to cast off the "mental stiffness" with which "the mechanical or the savage mind clings to its narrow traditions."[58]

From the vantage of today's networked computer culture, it is perhaps difficult to imagine a time when the machine could not (even metaphorically) signal the kind of synthesis that Fenollosa's Buddhist philosophy imagined. Indeed, it is worth asking

whether there were not traces in Fenollosa's writing of an incipient fascination with more cutting-edge technologies, or moments where something less massive and ominous than industrial factories, brickyards, and chimneys—and yet no less technological—could serve as a model, or even medium, for the aesthetic culture he sought to create. I address this possibility more fully below. For now, however, it is enough to note that by the time of his death in 1908, the machine had for Fenollosa become an overarching metaphor for any system or formula designed to induce dissective, analytical thinking—East or West. Western "bigotry" for the machine, he argued in his *Golden Age* articles, was "an obsession quite as fatal as Confucian classics."[59] Indeed, he was especially hard on structured attempts to codify Confucianism in Ming-era China, finding such endeavors unfortunately close to those of imported Christian theology:

> It is strange that both Mongols and Manchus should have lent ready ear to the repressive propaganda of both Confucian atheists and Christian scholars, but should have thrown down between them all that poetic Taoist and Buddhist idealism which has been the core of Chinese imaginative life. *Of the more honest of those Confucians, it was no doubt a definite desire to make China into a moral machine*, where every rite, ceremony, industry, and even thought should be conducted along pre-established formulae.[60]

For Fenollosa, then, the only means of defense against the machine (whatever its form) were the synthetic, "artistic" ideals of Daoism and Buddhism, the very "core" of Eastern imaginative life. It was a message he not only delivered in hundreds of lectures and publications, but in a massive trove of unpublished manuscript material as well.

Fenollosa's Posthumous Image

Mary Fenollosa cared deeply about her husband's legacy, and was committed to continuing his efforts to preach the gospel of Asia-as-*technê*.[61] With thousands of pages of unpublished material, Mary hoped to find someone she could trust to help organize and publish her husband's unfinished work. Traveling to London in 1912, she had arranged for the publication of Fenollosa's two-volume *Epochs of Chinese and Japanese Art*, but had not enjoyed working with the academic "experts" she encountered in the process.[62] After hearing that a young American poet named Ezra Pound was interested in Oriental art and literature she agreed to meet with him, and on September 29, 1913, they had dinner together in London. During their first meeting, Pound was uncharacteristically quiet, listening intently as Mary discussed her husband's work in Japan, not telling him at first about the hundreds of pages of copious notes her husband had left unpublished back in the United States. She may have been attempting to gauge his interest, or perhaps determine just how closely she could trust him with her husband's legacy. In any case, nothing Pound had published by then would have scared her away. His earliest volumes (*A Lume Spento* in 1908, *A Quizaine for This Yule* in 1908, and *Personae* in 1909) were nothing if not consistent with the antimodernist "spirit of the 1890s" full of Yeatsian "Celtic Twilights" and Pre-Raphaelite medievalism.[63] Indeed, while Pound's fascination with Provençal lyrical dramas and medieval lore may have reflected the esoteric studies he had taken up in graduate school, the honeyed language and shopworn meter of his early poems did little to set him apart from the saccharine sentimentalism of previous decades (so much so that Pound himself would later refer to these early

poems as "stale creampuffs").[64] Put simply, Pound's early poetic forms were not all that different from those Fenollosa had produced in *East and West* more than a decade earlier. Indeed, there were even hints in the early Pound of a Fenollosian positing of Oriental form as an antidote to Western mechanization. In 1912, for instance, Pound had praised the Bengali poet Rabindranath Tagore, whose work, he argued, "brings to us the pledge of a calm which we need overmuch in an age of steel and mechanics."[65] By the time he met with Mary in September 1913 Pound was already deep into "Imagism" (the March and April editions of *Poetry* that year, which Mary had read with interest, mark the arrival of the Imagist movement, including Pound's haiku-style poem, "In a Station of the Metro"), but these relatively innovative forms would have also seemed consistent with Fenollosa's vision of Oriental *technê*. The man who had introduced Pound to Mary, Laurence Binyon, was curator of new Asian acquisitions at the British Museum and author of *The Flight of the Dragon: An Essay on the Theory and Practice of Art in China and Japan* (1911), a text Pound read closely during 1911–1912.[66] As several scholars have shown, Binyon's *Flight of the Dragon* profoundly influenced the first theoretical articulations of Poundian Imagism.[67] In the March issue of *Poetry*, for instance, the three "rules" for the new movement are as follows:

1. Direct treatment of the "thing," whether subjective or objective.
2. To use absolutely no word that did not contribute to the presentation.
3. As regarding rhythm: to compose in sequence of the musical phrase, not in sequence of a metronome.[68]

To which Pound adds a few points of clarification such as, "use no superfluous word," and "go in fear of abstractions."[69] In *Flight of the Dragon*, three of the Chinese "canons" or "tests of a painting" are presented in very similar terms:

1. Rhythmic Vitality, or Spiritual Rhythm expressed in the movement of life.
2. The art of rendering the bones or anatomical structure by means of the brush.
3. The drawing of forms which answer to natural forms.[70]

It is not hard to spot the similarities ("rendering the bones," "natural forms," "rhythmic vitality"), but inasmuch as the articulations or "tests" of good poetry in *Flight of the Dragon* offered a model for the development of Imagism in London, it is worth noting that the entire volume already owed an enormous debt to Ernest Fenollosa. Fenollosa actually met Binyon on September 12, 1908, after his arrival in London, and had immediately requested that he take him to the museum's Print Room.[71] The two became fast friends, but it was not to last, as only nine days later Fenollosa died of a heart attack having spent most of his time in London going through Binyon's curated collection at the British Museum (how fascinating, in fact, to realize that Pound, although he had not yet met Binyon, was also in London—frequenting the British Museum no less—when Fenollosa died there in 1908).[72] Binyon was intimately familiar with Fenollosa's work, citing it frequently in his earlier volume, *Painting in the Far East* (1908), and assisting Mary with the posthumous publication of her husband's *Epochs of Chinese and Japanese Art* (1912).[73] Although Binyon never cites him directly in *Flight of the Dragon*, Fenollosa is everywhere in the text. Oriental art is described as having a "*fusion* of the rhythm and of the spirit," and a "strong *synthetic* power," in contrast to Western art which is "mechanically" rooted in the "idea that art

is, in some sense or another, an imitation of nature, a consequence of the imitative instinct of mankind."[74] The lines and colors of Oriental art are juxtaposed in "rhythmic vitality," rather than in "mechanical" attempts at mimetic representation, such that "the meanings associated with them become different, take on a new life, or rather yield up their full potentiality of life, fused into radiance and warmth as if by an inner fire" (*FD*, p. 19). Western art, by contrast, is characterized as falling "more and more to mechanical routine and to unintelligent attempts at realism" (*FD*, p. 50). Binyon even refers several times to the specifically Fenollosian term *notan*, and praises as a "masterpiece" a Japanese scroll that was part of Fenollosa's personal collection.[75] If, as Zhaoming Qian has argued, Binyon's influence on Poundian Imagism shows the young poet "felt the spell of China before his encounter with the widow of Ernest Fenollosa," one could certainly argue that what Pound was feeling was, already, the spell of Fenollosa.[76]

In many ways, then, the development of Imagism during 1912–1913 offered innovations in Western poetics that Fenollosa, although he had never been as daring in his own poetry, would have most likely found exhilarating. Indeed, Fenollosa had himself argued in 1894 that the use of "imagination" in art required the "clear and exact" rendering of "concrete" images:

> I suppose the majority of people think that the imagination is a sort of faculty of dreaming, that it is identical with reverie, a vague enthusiasm of the mind; something weak, loose, and visionary; the very opposite of exactness and sharp focusing. Now I do not mean any such thing as this by imagination . . . I should say that, in art, imagination is the faculty of thinking and feeling in terms of a single *image*. It implies the integrity, the wholeness and purity of the image. Imagination comes from the word "image"; not a fancy, not a dream, not a vague blur of consciousness, but a clear unbroken image. It is a visible integer . . . an image is concrete and individual, full of particulars and individual relations.[77]

Given Pound's new goals of embracing the "clear unbroken image," of avoiding mechanistic, "metronomic" rhythm, his seemingly undogmatic openness to Oriental *technê*, and his apparently critical stance toward Western modernity, it was no wonder that after their third meeting Mary decided to deliver the bulk of Fenollosa's unpublished materials to the young poet. It seemed like a safe bet.

The Chinese Written Character as a Medium for Poetry

In the Fenollosa papers Pound found hundreds of pages of Noh plays, rough translations of Chinese poetry, and a theoretical essay on *The Chinese Written Character as a Medium for Poetry* (*CWC*). Eventually, Pound would take advantage of nearly all of the material (creating "translations" of the plays and poems), but in terms of theorizing his own goals in modern poetry, Fenollosa's essay on the Chinese written character would prove the most compelling and transformative. Actually, it would be more accurate to refer to Fenollosa's *essays* on the Chinese written character since there were at least four notebook versions in which Fenollosa laid out his theory on Chinese ideography and poetic form (Fig. 4.9). The differences between these manuscript sources will be discussed below, but for now it is sufficient to observe that once Pound noticed that the 1906 notebook was a fairly complete consolidation of Fenollosa's earlier notes and lectures from 1903 he seems to have focused his attention primarily on that version.[78] What then is the argument Pound encountered in Fenollosa's 1906 essay?

Given what we have seen of Fenollosa's decades-long battle against the ideologies of representational art, it is critical to remember that what he finds so important about Chinese characters is not that he believes they are "pictures of *things*" (he never says this), but that they are "vivid short-hand picture[s] of the *operations of nature*" (*CWC*, p. 80; emphasis added). And by "operations of nature," Fenollosa means precisely the nonmechanistic, constantly synthesizing flux of all reality as described by Esoteric Buddhism (something, as we saw, like Indra's net). Consider Fenollosa's example of the difference between how one would convey the sentence "man sees horse" in alphabetic vs. ideographic script. In English, Fenollosa explains, the "rapid continuity of this action" is reduced to "three phonetic symbols" that form the "parts or joints" of a sentence (Fig. 4.10). However, he explains, this grammatical reduction is entirely "arbitrary"; so much so that "as easily we might denote these stages of our thought by equally arbitrary symbols that had no basis in sound—as, for example, by these three visible forms. If everyone knew what division of this mental horse-picture each of these signs stood for, [one] could communicate his thoughts to another as easily by drawing them as by speaking words."[79] By contrast, Chinese orthography "is something very much more than any of these arbitrary symbols," and proceeds upon "natural suggestion." Here Fenollosa includes Chinese characters for the same phrase and explains, "First, there stands the man upon his two legs. Second, his eye moves through space—a bold figure—represented by moving legs drawn under the modified picture of an eye. Third, at the end of the eye's journey, stands the horse upon his four legs" (*CWC*, p. 80). Legs everywhere! The phrase suddenly evokes the "quality of a continuous moving picture," and we seem to be "watching things work out their own fate."

Well, but isn't a picture of a man with legs still a picture of a *thing*? Not exactly, Fenollosa says: a "deeper view" of Chinese orthography reveals that, "a large number of primitive Chinese characters, even of the so-called [pictographic] radicals, are really short-hand pictures of *actions or processes*."[80] Of course, this "deeper view" of Chinese orthography, as many scholars have pointed out, is rather fanciful (only a small number of characters actually reflect this idea), but the upshot of this characterization is that for Fenollosa every word of written Chinese ends up being a verb of some sort, and is therefore closer to the "Nature" of Esoteric Buddhism: "After all, a true noun, an isolated thing in Nature[,] does not exist. Things are only terminal points, or rather, the meeting points of action, cross-sections, so to speak, cut through actions, photographic snapshots taken of them." When we observe a "thing" in Nature, what we really see are "noun and verb as one—things in motion, motion in things—and so the Chinese conception tends to represent them" (*CWC*, p. 82). There is no such thing as a noun, in other words, because there is no such thing as a *thing* in the static sense of objective reality: "Like nature, the Chinese words are alive and plastic, because *thing* and *action* are not formally separated"—the implication being that all Chinese ideographs, in a way, have "legs" (*CWC*, p. 90).

For Fenollosa, then, the real weakness with English writing is that we have somehow come to believe that our nouns, intransitive verbs, and "pure copulas" (that is, the multiple forms of "to be") accurately convey the reality before us. But even in English what we really mean when we say, "he runs," is, "he runs (a race)." We mean, "the sky reddens (itself)," and "we breathe (air)." And when we say, "the tree *is* green," what we really mean is "the tree greens itself." And because these primitive, elemental processes are supposedly still visible in the characters, Chinese writing offers a

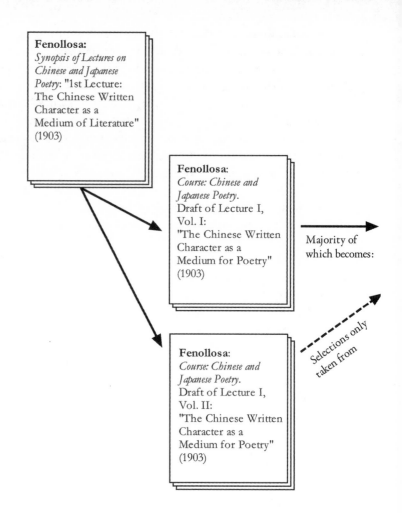

more direct account of the most fundamental and constant operations of nature, the ever-flowing "transference of power." Thus, Fenollosa explains, even the most basic sentence form in language ("agent — act — object") should not be thought of as a "kind of brickyard, where the living soil of truth is dug up in lumps, squeezed out, and baked into little hard units called 'concepts,' we then pile away in rows labeled for future use." It is, rather, a "flash of lightning," which "passes between two terms, a cloud and earth. . . . All natural processes whatever, are, in their units, as much as this: light, heat, gravity, chemical affinity, human will, have this in common, that they redistribute force; and their unit of process can be represented by the following diagram [Fig. 4.11]" (*CWC*, pp. 85–86). Here Fenollosa's diagram of the basic sentence form—a fascinating play on the diagrams he included in his *Golden Age* articles that same year—suggests that at each point in the grammatical representation of power-transference we observe a kind of synthetic flux happening before us (a kind of Zen and the Art of Grammatical Archery, if you like). Indeed, examining Fenollosa's marginal illustration of this ideographic flux from a similar passage in the 1903 manuscript version of the essay (Vol. I, Lecture I), the link to his *Golden Age* notion of synthesis becomes even more obvious (Fig. 4.12).[81] What in English writing seems like a mechanical process (something like the diagram in Fig. 4.4) becomes in Chinese a dynamic, fluid process of interdependence and mutual connectivity (something like the diagram in Fig. 4.6):

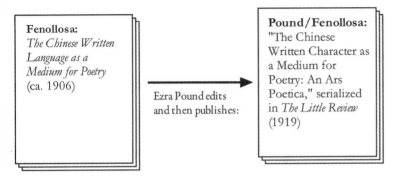

Fig. 4.9. Diagram (by author) of the sources Pound received from Fenollosa's widow regarding the essay that later became *The Chinese Written Character as a Medium for Poetry*.

> Nature has become for us [in English] less and less like a Paradise, and more and more like a Factory. We are content to accept the vulgar misuse of the moment. A late stage of decay is arrested, and embalmed in the dictionary. Only our scholars and poets feel painfully back along the thread of our etymologies, and piece together our diction, as best they may, out of forgotten fragments, the broken coral that strews our sand.[82]

Given this factory-like aspect of our lexical and syntactical inheritance (remember: "machines can only do one thing"), Fenollosa concludes that writing poetry in English is, perhaps, "a more difficult art than painting or music." In painting, "great color beauty" can be achieved by "the refined modifications or overtones which each [color] throws into the other, just as tints are etherealized in a flower by reflection from petal to petal." But the English-language poet must somehow achieve these "overtones" and "halos of secondary meaning" without the benefit of the visually transparent etymologies that Chinese writing naturally conveys. How, then, to create poetry in which the "manifold suggestions shall blend into an ethereal fabric clear as crystal?" (*CWC*, pp. 102–103).

As we have already seen, one answer to that question might have been Imagism. Perhaps Pound's "In a Station of the Metro," for instance, with its stark, haiku-like imagery, was evidence that Pound had already fulfilled Fenollosa's synthetic Buddhist

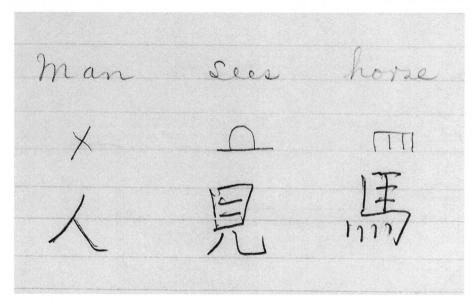

Fig. 4.10. Ernest Fenollosa, *The Chinese Written Language as a Medium for Poetry* (ca. 1906), Ezra Pound Papers, YCAL, Beinecke Library, Yale University, MSS 43; box 101, folder 4248, p. 9A.

vision of "halos of secondary meaning," of "overtones," and of the blended "ethereal fabric" of art. If so, Pound had a curious way of showing it. Indeed, one of the most stunning insights to emerge from the recent publication of Haun Saussy, Jonathan Stalling, and Lucas Klein's critical edition of *CWC* is how little of Fenollosa's Buddhism-inflected vocabulary found its way into Pound's 1919 edited version of Fenollosa's essay. In the 1906 manuscript, for example, most of the phrases above (along with dozens of references throughout the essay to synthetic "impressions" whereby "a thousand flowers intermingle in a meadow, or the notes of orchestral chords flow into one," creating a "warm wealth of human feeling," and "permeating tone") are slashed through by Pound's editorial pencil, and completely omitted from the published version in 1919 (Fig. 4.13). It is as though Pound had cut a Buddha-shaped hole in the manuscript before championing it in public.[83]

But why would Pound have cut Fenollosa's Buddhist imagery when going through his notebooks in 1914–1915? Years later, of course, Pound would develop an almost delirious antipathy for Buddhism, portraying it as "decadent" and "muzzy," as opposed to the "hard and sane" spirit of Confucius. In his *Pisan Cantos* (1940), for instance, he would refer to "goddam bhuddists," "Bhudmess," "hochangs," "Bhudrot," and "Bhud-foés" who "use muzzy language the more to mislead folk."[84] In 1940 he would complain to *Japan Times Weekly* that "Occidental Buddhists are nearly always a bore, at any rate . . . they have been invariably so in my personal experience of them."[85] Akiko Miyake has argued that due to the selective nature of what Mary delivered to Pound (withholding, for some reason, any of the materials that would have indicated Fenollosa had converted to Tendai Buddhism), the poet would have had no idea that the aesthetic theories outlined in *CWC* were grounded in Buddhist imagery.[86] It is a compelling argument, given that Pound would have never referred to Fenollosa, the most influential "Occidental Buddhist" of his generation, as a "bore," but it does not explain why in 1914–1915, when Pound began editing *CWC*, he would so aggressively delete language and ideas that had been central to Fenollosa's aesthetic

term *from which* | transference of force | *term* <u>to</u> which

agent act object

Fig. 4.11. (*Above*) Fenollosa, *Chinese Written Language*, p. 19A.

Fig. 4.12. (*Left*) Ernest Fenollosa, Lecture I, Vol. I, "The Chinese Written Character as a Medium for Poetry" (1903), Ezra Pound Papers, YCAL, Beinecke Library, Yale University, MSS 43; box 99, folder 4218, p. 38A.

Fig. 4.13. (*Below*) Fenollosa, *Chinese Written Language*, p. 55B.

55

overtones of its words, the halos of secondary meanings which cling to them, are struck among the infinite terms of things, vibrating with physical life and the ~~same~~ wealth of human feeling. How is it possible that such heterogeneous material shall suffer no jar, how that its manifold suggestions shall blend into ~~an ethereal~~ fabric ~~clear as crystal~~?

No philosopher has ever analyzed this; but one device is clear in all three arts, namely the dominance of a single permeating tone. In music we get this by the unity of key. Painting achieves it by mixing a suspicion of one tone color through all tints. In poetry it requires that the metaphorical overtones of neighboring words shall belong in the same general sphere of na- ture or of feeling. It is almost impossible to

theories. In fact, none of the later hard-and-fast distinctions Pound would make so much of between Buddhism and Confucianism were present anywhere in his writing when he first encountered Fenollosa's manuscripts. He most likely had no idea in 1914–1915, in other words, that he was cutting a *Buddha*-shaped hole in *CWC*. Why, then, if the metaphorical language of Fenollosa's synthesizing Buddhism so neatly confirmed what Pound had already been doing with Imagism, did he turn so sharply against it? Why not *embrace* Fenollosa's Buddhist imagery as an Oriental confirmation of Poundian Imagism?

Ezra Pound: Demon Pantechnicon Driver

On or about December 1913, the Chinese character changed. I am not saying that one went over, as one might, to a Chinese dictionary on the shelf, and there saw that Chinese characters had shed some of their superfluous strokes, or that they reorganized themselves from left to right. The change was not sudden and definite like that. But it was a change nonetheless.[87] A new metaphorics of Chinese ideography had been invented for the modern era. Those, anyway, were T. S. Eliot's words. "Pound," he wrote in his 1928 introduction to Pound's *Selected Poems*, was "the *inventor* of Chinese poetry for our time."[88] But what did he mean? Edison, Tesla, Ford—Pound? Eliot goes on to suggest that the very concept of translation is, to a certain extent, an "illusion," something that "each generation" must work out for itself; and so Pound, as translator of Chinese ideograms, was necessarily "inventor" as well, if a very talented one.[89] Fair enough. But I think it just as likely that after the Vorticist agitations of 1914–1915 Pound increasingly thought of himself as an inventor of Chinese poetry in the more traditional, industrial sense; one like Edison or Ford, constantly experimenting with mechanical forms and efficiencies, jealously guarding his "discoveries" with carefully worded patents, risky business ventures, and an iconographic brand. What would such a possibility offer for our understanding of Fenollosa/Pound? Put simply, I believe it is time to account (and not in a manner that simply takes Pound at his word) for the striking simultaneity of Pound's embrace of machine-loving Vorticism and his championing of Fenollosa's manuscripts. We cannot assume, as so many scholars have, following Pound, that Fenollosa's aesthetic theories were a direct inspiration for Pound's Vorticism and subsequent fascination with machine art and industrial efficiencies.[90] The fact is that when Pound took control of Fenollosa's manuscripts, he did so in the context of a movement that, had Fenollosa been alive to respond to it, would have spurned—no, *blasted* him. How, then, did Fenollosa's concept of the ideograph end up on the front lines of Pound's battle with the "spirit of the 1890s"? How was it that in Pound's hands the Chinese character began to take on the properties of the machine itself when Fenollosa had so specifically offered it as an antidote to the brutalities of machine culture?

Between 1910 and 1912 Pound came into close contact with a number of people and works of art that would eventually pull him out of his romantic orbit. It was a gradual transformation, of course, but one we can track with relative precision. No one at the time, for instance, could ignore the somewhat belated, but no less controversial, arrival of Postimpressionism and Cubism in London as exhibited in Roger Fry's curated series at the Grafton Galleries during 1910–1912. The furor over the exhibition may seem odd now, given that most of the art exhibited (Van Gogh, Gauguin, Cézanne, Manet, and so on) was produced in France nearly a quarter of a century earlier and was still tame compared to what was coming, but that the "new" art was both compelling and scandalous would not have been lost on Pound. Accord-

ing to Fry's associate Desmond MacCarthy, who had helped organized the exhibition, the show aimed at "no gradual infiltration, but—*bang*! an assault along the whole academic front of art."[91] After nearly four years in London, a failed attempt at finding academic work again in the United States, and having introduced himself to every important writer he could find, Pound had seen no comparable "bang" for poetics. He had joined the Poet's Club organized by T. E. Hulme, whose arguments for a more "concrete visual" poetry in 1909–1910 had a significant impact on Poundian Imagism, but these innovations sparked nothing like the public excitement over painting and sculpture at the time.[92] At one of Hulme's evening discussions, for instance, Pound met A. R. Orage, the editor of the highly influential *New Age* magazine, and was invited to begin contributing regularly; but whereas the pages of *New Age* during 1910–1912 were alive with a sense that something new was happening in painting and sculpture, nothing that revolutionary seemed to be going on in poetry. Even at home in the United States painting seemed to have arrived with a bang. Within months of Pound's lament that American poets "fill pages with nice domestic sentiments inoffensively versified,"[93] the Armory Show in New York arrived on the scene exhibiting Postimpressionist and early cubist paintings in all their controversial glory. The scandalized press described them as "brutal," "electrifying," "pathological," and "rude."[94] Comparatively speaking, poetry just wasn't getting much press. As Reed Way Dasenbrock explains, "For anyone interested as Pound in how to win a hearing for his art, the dramatic success of these exhibitions must have been both exciting and a little frustrating. How could poetry get in on the action?"[95]

In 1913 a series of interrelated developments offered Pound a sense of how he might begin to align his literary efforts with those of the growing international art scene. The first involved the artist and author Wyndham Lewis, whose friendship with Pound, although cautious at first (as one might expect of two such agonistic figures) quickly became an alliance based on a mutual desire for radical transformations in art and literature. Born in Canada to a wealthy American father and a Scots-Irish mother, Lewis received his art education in Paris and other European cities during 1904–1908, and by 1911 had become part of the Camden Town group of English painters, whose focus on Postimpressionism and Cubism placed them at the vanguard of the more experimental art scene in London. One of London's "two bohemias," Camden Town did not have the cultural capital of the more respected, establishment group of artists and writers in Bloomsbury, where Roger Fry exercised his enormous influence and where writers like Virginia Woolf, E. M. Forster, and Lytton Strachey advocated a kind of literary impressionism.[96] But in 1912–1913, Fry had taken an interest in Lewis's work and invited him to become part of his proposed Omega Workshops, a design and art organization that would operate in conjunction with both Bloomsbury and the still-active Arts and Crafts movement in London. The Omega group was a Morris-like (one could even say Fenollosian) organization that reflected ongoing conversations in *New Age* and other publications that remained committed to the antimachine discourse of the 1890s. Between 1910–1912, for instance, *New Age* ran a series of articles lamenting the "poisonous doctrines of machine-made minds" that had tied art to "the apron strings of the mechanical."[97] The machine had become "a devouring monster, always attempting the destruction of handicraft," something that "has not resulted in much good artistic work" and "will in time lower the whole tone of the working population."[98] Readers were encouraged to "dispel the idea that the machine can even equal the man in quality or beauty of workmanship."[99] The temptation for "cheap products" and "mechanical perfection" had led

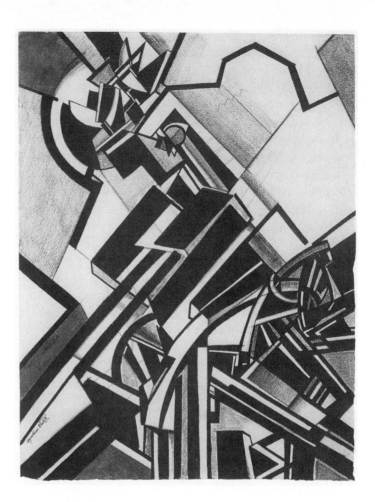

Fig. 4.14. Wyndham Lewis, *Timon of Athens* (1912), in *BLAST1* (1914), p. v.

only to a degradation of the "human quality" in art and crafts: "We want the best race of men (not machines) we can get together," wrote one critic, "and I would sooner clothe myself in good Harris or Kerry tweeds, mechanically imperfect, perhaps, but much more humanly interesting than [the machine's] smooth perfections."[100] Fry, whose "vehement" dislike of machine-made products nearly matched that of William Morris, crafted his prospectus for the Omega Workshops in precisely these terms, decrying the "humbug of the machine-made," and striving to "keep the spontaneous freshness of primitive or peasant work while satisfying the needs and expressing the feelings of modern cultivated man."[101] The Omega Workshops would foster a communal, gentle form of craftsmanship, "substituting wherever possible the directly expressive quality of the artist's handling for the deadness of mechanical reproduction."[102] Participants in the Omega group would not even sign their work, donating their egos, as it were, to the cooperative goals of Fry's aesthetic vision.

Increasingly fascinated by the harder, more geometric lines he saw in contemporary art movements in Europe, Lewis felt that the Omega prospectus was a step backward. His works from 1912 (Fig. 4.14), for example, like those of the Cubists, uncoupled the Fenollosian pairing of machine form and mimetic representation, positing a both counter-mimetic and "mechanical" approach to portraying objects, reducing human figures (when there were figures at all) to the abstract geometries of sharp edges, shapes, and lines. Still, he needed the money, and Fry had been one of the few influential figures to praise his work. So in the late summer of 1913 Lewis

joined the Omega Workshops, half-heartedly conforming to Fry's more conservative aesthetics. In October 1913, however, when he learned that Fry had secretly cut him out of what was supposed to be a joint commission from the *Daily Mail*, Lewis's dissatisfaction with the Omega Workshops quickly boiled over.[103] Staging a dramatic walkout from the group, Lewis persuaded several of the Omega's more radically inclined artists (and future Vorticists) to join him in creating a rival art center, one that could finally cast off, as he wrote in an angry letter to his now former colleagues, the "prettiness" and "pleasant tea-party" timidities of Bloomsbury conservativism.[104]

Pound was watching all of these events very closely. He knew already that the tightly knit group at Bloomsbury had no interest in listening to any young American upstart, and he found himself increasingly drawn to Lewis and the agonistic spirit of London's "underworld" art scene at Camden Town (they often met, literally, underground at the notorious Madame Frida Strindberg's Cave of the Golden Calf nightclub, which was situated below street level). But Pound's support for Lewis's new "Rebel Arts Center" was not simply a reaction to the stuffy traditionalism and (crypto-Fenollosian) antimachinism of Bloomsbury and the Omega Workshops. Both he and Lewis were also deeply impressed by the boisterous, provocative clamor of F. T. Marinetti's Italian Futurism and its tendency to pull together the disparate realms of modern art under the carnival tents of war and revolution. Marinetti, dubbed the "caffeine of Europe," had been making frequent appearances in London following an initial lecture given to the Lyceum Club in 1910, and over the next two years a steady stream of Futurist manifestos appeared in English translation.[105] In stark contrast to the Arts-and-Crafts antimachinism of London's most successful artists and writers in the Bloomsbury crowd, Marinetti and his disciples offered the dazzling, fiery vision of a new "Kingdom of the Machine." "We shall sing," Marinetti wrote in his earliest manifesto, of "the pulsating nightly ardor of arsenals and shipyards, ablaze with their violent electric moons; of railway stations, voraciously devouring smoke-belching serpents; of workshops hanging from the clouds by their twisted threads of smoke."[106] Marinetti's Futurism offered a "love of the machine," in tones both joyous and erotic: "Have you ever watched an engine driver lovingly washing the great powerful body of his engine? He uses the same little acts of tenderness and close familiarity as the lover when caressing his beloved . . . his beautiful engine of steel that had so often glistened sensuously beneath the lubricating caress of his hand."[107] Not surprisingly, then, at the Lyceum Club, Marinetti aimed his hypermasculinized, machine-gun discourse at London's Ruskin-and-Morris-style antimachinism:

> You [English] are victims of your own traditionalism, which takes on something of a medieval hue. . . . When, oh when, will you rid yourselves of the sluggish ideology of that deplorable man, Ruskin, who—I should like to convince you, once and for all—is utterly ridiculous. With his morbid dream of the primitive, agrarian life, with his nostalgia for Homeric cheeses and age-old "whirling spindles," and his hatred of machines, of steam and electricity, with his mania for ancient simplicity, he resembles a man who, after attaining complete physical maturity, still wants to sleep in a cradle and be suckled at his decrepit nurse's breast, so as to regain the mindlessness of his infancy.[108]

Unlike this "sluggish" ideological fear of the machine, then, Marinetti's Futurism promised a united artistic program that would "overcome the seeming hostility that separates our human flesh from the metal of engines," and prepare mankind for "the creation of mechanical man."[109]

But while Marinetti's Futurism had been stalking the land in London since 1910, and "Futurism" had already entered circulation as a term used to describe the cubist (and even some of the Postimpressionist) works of art at the Sackville Gallery exhibitions in late 1912, the movement had not received much attention in the English press until around September 1913, when the popular magazine *Poetry and Drama* devoted an entire issue to it. In an opening statement to the special issue, the editors explain, "It may surprise, it may even shock some of our readers that we devote the principal space of a whole number of *Poetry and Drama* to the publication of matter in a certain degree representative of a term at present closely, in fact almost exclusively, associated with that group of young Italian rebels led by the famous Marinetti."[110] They defend the move by stating that they too believe in a form of "futurism" (with a small "f"), even if they did not arrive at it by way of Marinetti. But notice already the key words that would have set Pound and Lewis on fire: "surprise," "shock," "space," "young," "rebels led by the famous." This was everything Pound and Lewis wanted. The Futurist spell was so compelling, in fact, that in November 1913, before he decided to found the Rebel Arts Centre on his own, Lewis was tentatively exploring the possibility of declaring Marinetti the leader of his group of Omega secessionists, hosting a special dinner in his honor and tentatively adopting "Futurism" as a term for his own art.

Adding to the lure of these Futurist provocations, the theorist most important to Pound's early development in London, T. E. Hulme, had begun suggesting that "the machine" would overwhelmingly determine the future of modern aesthetics. In a lecture to the Quest Society of London on January 22, 1914, Hulme argued that there were historically "two kinds of art," the "vital" and the "geometrical."[111] The former were those arts that, as one sees in later Greek art and in Western art since the Renaissance, sought to portray the world "realistically" and with "naturalism," and did so with lines both "soft and vital." Here one found gradations of atmospheric shadow, wiggly paths and lines, and a general "feeling of liking for, and pleasure in, the forms and movements to be found in nature" ("MP," p. 273). Geometrical art, by contrast, conveyed a "tendency to abstraction," with "stiff" forms that reflected a desire to counter the excess of flux and messy complexities of nature. It evidenced an "attempt to purify" objects and make them "immovable . . . fixed and necessary." These more "rigid lines" were not evidence that artists during these eras were incapable of more "vitalist" representation, but that they sought "something absolutely distinct from the messiness, the confusion, and the accidental details of existing things" ("MP," p. 274). In the "new art" that he saw coming from Lewis and his fellow Omega secessionists, Hulme saw a definite impulse toward the geometrical: a "desire to avoid those lines and surfaces which look pleasing and organic," and a use of lines that were "clean, clear-cut, and mechanical. You will find artists expressing admiration for engineer's drawings, where the lines are clean, the curves all geometrical, and the color, laid on to show the shape of a cylinder for example, gradated absolutely mechanically" ("MP," p. 279). Indeed, this sense of the "mechanical" was precisely what most distinguished this new art from earlier epochs of "geometrical" style: "As far as one can see, the new tendency toward abstraction will culminate, not so much in the simple geometrical forms found in archaic art, but in the more complicated ones associated in our minds with the idea of machinery" ("MP," p. 282). But this would not be simply an "interest in machinery itself." It was an "attempt to create in art structures whose organization, such as it is, is very like that of machinery" ("MP," p. 283). This sense of "mechanical," Hulme concludes "whether you like it or not, is the character of the art that is coming."[112]

Both Pound and Lewis were in attendance at Hulme's lecture, and immediately recognized not only his prescience in turning to "the machine" as model for the new art but also the branding value of Hulme's efforts to distinguish between the machine-form arts of Italian Futurism and those of their Camden Town collective.[113] Indeed, it was also in this lecture that Hulme gave Lewis and Pound the gift of articulating just how their movement supposedly differed from Marinetti's: "I am not thinking of the whole movement," Hulme explained, "I am speaking of one element which seems to be gradually hardening out, and separating itself from the others. I don't want anyone to suppose, for example, that I am speaking of futurism, which is, in its logical form the exact opposite of the art I am describing, being the deification of flux, the last efflorescence of impressionism" ("MP," p. 279). It was a somewhat specious move, aligning Marinetti's Futurism with the London impressionism from which a certain "element" had "separated itself," but its immediate effect was to validate Lewis's self-exile from the Omega Workshops and his subsequent efforts to start the Rebel Arts Centre.

Hulme's creative assertion also came at an extremely opportune moment, since Lewis and Pound had been planning their own intervention in the London art scene. In the April 15, 1914, issue of the *Egoist* Pound wrote the first advertisement for a new periodical titled *BLAST*, announcing a "Discussion of Cubism, Futurism, and Imagism," but no word yet of Vorticism. He and Lewis had not yet decided on exactly what to call their mechanical/geometric "innovations" in art, and in fact more than half of the first issue would be printed before they finally settled on the new name (hence, the weird statement on p. 143 of *BLAST* that "we may hope before long to find a new word" for the movement they had already spent dozens of pages naming and describing in the first sections—pages that were printed after the movement's June christening). But if in April they were content to allow their work to fall, however tentatively, under the expansive umbrella of Futurism, by June they had realized that if they did not immediately seize the opportunity to declare some kind of branded movement of their own, they would be forever known as mere Marinetti disciples. They were horrified to learn, for example, that before they could get the first issue of *BLAST* into print, Marinetti and one of his English followers, Christopher Nevinson, hailed the arrival of "Futurism and English Art" in a manifesto printed in the *Observer*, railing against the "passéist filth" of "Maypole Morris dances," "Aestheticism," "Pre-Raphaelites," "sentimentality" (in short, everything Lewis and Pound were hoping to rail against in *their* publication), and even identifying Lewis's Rebel Art Centre as a locus of Marinetti-inspired Futurist activity.[114]

Thus, when *BLAST* finally appeared in early July 1914, Pound's term "Vorticism" had become a rallying cry for the new movement—in all its unfortunate belatedness—mainly in an attempt to distance themselves from the Futurists they were so obviously inspired by. But in addition to providing a name for their supposedly unique brand of modern art, the concept of the vortex offered Pound a way of engaging with the group literarily without completely abandoning everything he had been doing up until that moment in poetry. Most importantly, the term implied swirling, violent, and *spatial* energies rather than, as in Futurism, the *temporal* specifics of accelerated modernity. Until 1913, all of Pound's poetics smacked of an antimodernist dialogue with some lost and more idyllic aesthetics, a therapeutic ethos more in line with a Fenollosian disregard for modern sensibilities. How could Pound possibly embrace what Hulme had declared ("whether you like it or not") would be the basis for the great art of the new era—the mechanical—and not feel that everything he had done

up to that point was some monumental waste of time?[115] Pound's concept of the vortex solved the dilemma in two interrelated ways: first, it emphasized the aspects of the machine that were most abstract and kinetic (that is, energy, movement, power, efficiency) over those aspects connected to the specifics of modern technological life (that is, the automobiles, airplanes, and ocean liners that had fascinated the Futurists); and second, this abstracting emphasis on the formal properties of aestheticized mechanics meant that all art was, in a sense, a kind of perfect machine, something that depended less on the specific uses of 1914-era technology than on the kinetic energies and efficiencies that machines so captivatingly embodied. With one proprietary slash of the pen, then, Pound's manifesto in *BLAST* declared that at the heart of every great work of art there was a machine diligently at work:

> The vortex is the point of maximum energy,
> It represents, in mechanics, the greatest efficiency.
> We use the words "greatest efficiency" in the precise sense—as they would be used in a text book of MECHANICS . . .
> THE TURBINE.
> All experience rushes into this vortex. All the energized past, all the past that is living and worthy to live.[116]

It was a stroke of genius for Pound, a clever rescuing of his earlier training from an almost immediate obsolescence when placed alongside the more provocative avant-gardism of Futurist mechanics. Suddenly terms like "maximum energy" and "greatest efficiency" could be employed to refer to both "mechanics" "turbines," *and* "the energized past." Pound had become, as Lewis would dub him in the second and final issue of *BLAST*, a "demon Pantechnicon driver, busy with removal of old world into new quarters."[117]

For all Pound's pious protestations against the recycled "impressionism" and "disgorging spray" of Marinetti's Futurism, however, there can be little doubt that the "new quarters" he was moving the old world into were replete with the very same exuberance over machinism, engineers, massive industry, and technological innovation that had set apart Marinetti's movement.[118] Take, for example, this statement in the first Vorticist manifesto in *BLAST* signed by the entire group: "It cannot be said that the complication of the Jungle, dramatic tropic of growths, the vastness of American trees, is not for us. For, in the forms of machinery, Factories, new and vaster buildings, bridges and works, we have all that, naturally, around us."[119] The visual art in both issues of *BLAST* offered a kind of abstract architecture for an energized, kaleidoscopic machine world, with dozens of geometric and gear-like shapes printed in stark black and white (Figs. 4.15–4.17). The second issue of *BLAST*, published in the midst of World War I, insisted, "A machine is in a greater or less degree, a living thing. Its lines and masses imply force and action" (*BLAST*2, p. 44). Jacob Epstein, Vorticist sculptor, was praised for his *Rock Drill*, which had already appeared as a drawing in *New Age*, and, as a sculpture, seemed to embody all the hypermasculine energies of Vorticist/Futurist machinism: "Mr. Jacob Esptein's 'Rock Drill' is one of the best things he has done," Lewis argued, "The nerve-like figure perched on the machinery, with its straining to one purpose, is a vivid illustration of the greatest function of life" (Fig. 4.18 and Plate 97) (*BLAST*2, p. 78). Such a depiction of machine erotics made sense, Lewis insisted, since "in any heroic, that is, energetic representations of men today, this reflection of the immense power of machines will be reflected" (*BLAST*2, p. 44). Even the definition of "artist" seemed to have changed:

Fig. 4.15. (Top left)
Vorticist drawing by
Edward Wadsworth (1914),
in *BLAST1* (1914), p. 29.

Fig. 4.16. (Top right) Helen
Saunders, *Atlantic City*
(1915), in *BLAST2* (1915),
p. 57.

Fig. 4.17. (Bottom left)
William Roberts, *Drawing*
(1915), in *BLAST2* (1915),
p. 87.

Fig. 4.18. (Bottom right)
Jacob Epstein, *Study for
the Rock Drill* (1913), in
New Age (December 25,
1913).

"Engineer or artist might conceivably become transposable terms, or one, at least, imply the other" (*BLAST2*, p. 135).

For Pound, accordingly, the "best artist is the man whose machinery can stand the highest voltage. The better the machinery, the more precise, the stronger; the more exact will be the record of the voltage."[120] In Pound's memoir for another Vorticist sculptor, Gaudier Brzeska, the artist's "combinations of abstract forms" are described as embodying "machinery itself," an argument that Pound knew some would find offensive:

> Needless to say the forms of automobiles and engines, where they follow the lines of force, where they are truly expressive of various modes of efficiency, can be and often are very beautiful in themselves and in their combinations, though the fact of this beauty is in itself offensive to the school of sentimental aesthetics.[121]

And later in the same volume:

> We all know the small boy's delight in machines. It is a natural delight in a beauty that ha[s] not been pointed out by professional aesthetes. . . . This enjoyment of machinery is just as natural and just as significant a phase of this age as was the Renaissance "enjoyment of nature for its own sake," and not merely as an illustration of dogmatic ideas. (*GB*, p. 116)

In short, what Pound is performing in these and other passages in 1914–1915 is a radical rupture, disguised as fulfillment and continuity. He knew very well that Fenollosa himself belonged to this "school of sentimental aesthetics" that took offense at machine forms, and yet would go on to claim that it was precisely Brzeska's mastery of machine forms that allowed him, after "what could not have been more than a few days studying the subject at the museum," to intuitively "understand the primitive Chinese ideographs." Indeed, it is into this new machine world that "Fenollosa's finds in China and Japan, his intimate personal knowledge . . . are pouring into the vortex of London."[122]

To understand just how intertwined Pound's delving into the Fenollosa manuscripts and his engagement with the machine enthusiasm of Futurism/Vorticism had become, it will be useful to consider the overlapping chronologies of these various events as outlined in Appendix B. The consequences of this simultaneity cannot be overstated. If Mary Fenollosa had delivered her husband's manuscripts to Pound in 1909 rather than late 1913, they would have ended up in very different hands. Consider, for example, the stunning reversals in Appendix C. Pound, of course, would never admit to any such radical transformation in his thought, but a number of observers were quick to point out the crypto-Futurist change. The most outspoken and influential critic to do so was Pound's editor at the *New Age*, A. R. Orage.[123] In a biting editorial in September 1914, just two months after the publication of *BLAST*, Orage scoffs at Pound's attempts "to establish some connection between 'Vorticism' in painting and design and 'Imagism' in verse. As usual, [Pound] is very obscure and the more so for the pains he takes to disguise the real relations."[124] The only connection between Vorticism and Pound's earlier work, Orage argues, was the "accident of friendliness": "Mr. Pound happened to like Mr. Wyndham Lewis, and there you are!"[125] Several other writers also noted the odd transformation for Pound, as well as the ridiculousness of his Vorticist claims of "not Futurism" (Fig. 4.29).[126] In a hilarious satire of Pound's Vorticist enthusiasm, for example, John Triboulet related an account of a fictitious barroom conversation with a Pound disciple by the name of "Obadiah Pence" (the name itself a pun on a kind of junior version of "Ezra Pound": minor biblical prophet, less valuable monetary coin). Triboulet asks "what are you arguments for Vorticism?" to which Obadiah replies,

> "*Euphemisme*, you mean. Certainly, we are all related, but what gulfs separate us are signified by the final 'es.' Jack, I've had my eyes opened. . . . You see, it's this way. Energy creates everything. How it does it is no matter. . . . Have you ever seen a steam punch push through a plate of cold steel, or a lathe tool pare a half-inch layer off a twenty-foot gun tube? If you have not, don't talk of Drake and Shakespeare."
>
> "But Obadiah, I am sure neither Mr. Pound nor any other Futurist ever suggested such a comparison. You confuse mechanical energy with spiritual and human energy . . ."

"What confusion am I guilty of? The only difference between a man and a machine is that man is a self-starter. Even Mr. Pound says that."[127]

What this overarching reversal of Pound's aesthetic meant for his use of Fenollosa's manuscripts was that something that had been central to Fenollosa's entire mission—the antimodern, Orientalized desire for an ideographic antidote to machine culture—would be turned in on itself and become its opposite. It was as though Marinetti's "Second Futurist Proclamation" in 1909 had finally come true: "And from the ancient pagodas, the madmen seized the blue robes that were worn to the glory of the Buddhas to build their flying machines."[128] Pound's seizure of Fenollosa's "Buddhist robes" not only allowed him to praise the mechano-Vorticist art of his era as embodying the energies of the ancient Orient;[129] it also determined the way Pound would explain and utilize Fenollosa's *CWC* and play an important role in the form and content of Pound's aesthetics deep into the twentieth century.[130]

So how exactly did Pound's crypto-Futurist machinism transform his writing and theories during 1914–1915? First, as Marjorie Perloff has shown, for all Pound's championing of the transitive verb phrase and belittling of the "pure copula" via Fenollosa's *CWC*, the writing that most anticipates his *Cantos* during this time consists of suspended noun phrases, fragmented and dispersed with plenty of "is" copulas—writing, in other words, that more closely resembles Marinetti's "words-in-freedom." Consider, for instance, the following passage from *BLAST1*, as lineated by Perloff:

> All experience rushes into this vortex.
> All the energized past.
> All the past that is living and worthy to live
> All MOMENTUM, which is the past bearing upon us
> All the past that is vital
> All the past that is capable of living into the future[131]

If, as Perloff suggests, what we are seeing here is closer to Marinetti than to Pound's supposed allegiance to Fenollosa, I would argue that it should come as no surprise. Indeed, the moment Pound removed *CWC* from its original context of Fenollosian/Buddhist flux and antimachine discourse, the abstract, dynamic energies Fenollosa attributed to the always-in-motion ideograph (and transitive verb) were suddenly "mechanical" in a way that Marinetti had already claimed. Indeed, something overlooked far too long in the discourse of Fenollosa/Pound is that at precisely the moment when Pound was turning his attention more specifically to Fenollosa's *CWC* (April–July, 1914; see Appendix B), Marinetti published two manifestos in the *New Age* advocating, in essence, the use of both infinitive verbs and ideography as a means of creating a new poetry of "Mechanical and Geometric Splendor."[132] In the first of these manifestos, Marinetti calls for a poetics of "power and control," citing the need for a literature of "speed," "engines," the "precision of well-oiled cogs," "diverse rhythms," the elimination of "decadent adjectives," "expressive orthography and typography," and a more sustained attention to the "infinitive tense of the verb" for its implicit "motion."[133] As a means of executing this new literary "efficiency," Marinetti suggests that the mathematical ideographs "$+ - \times =$" are "useful to obtain marvelous synthesis . . . by their abstract simplicity of anonymous cogwheels." As in Pound's own ideographic speculations, the supposed semantic payoff is somewhat overdetermined, but the structural (if not ethnographic) similarities are striking. According to

Marinetti, for example, "The arrangement $+ - + - + \times$ renders . . . the changes and the increase of speed of a motor car. The arrangement $+ + + + +$ renders the sum of similar sensations."[134]

Ezra Pound would of course never acknowledge the similarities between his later "ideogrammatic method" and Marinetti's suggestion that mathematical ideographs could function like "machines" in poetry, precisely because his turn to the spatial, as a vindication of the "energized past," supposedly offered a means of distinguishing his literary Vorticism from Marinetti's Futurist poetics. But rather than understanding this turn as a preservation or extension of some Fenollosian ideal, I would argue that the rest of Pound's career shows him projecting the machine back onto that past, dramatically countering Fenollosa's most fundamental premise. In short, by the mid-1920s Pound had consolidated an entire literary (and increasingly political) theory based on what he saw as the correlative aesthetics of machine energy and Chinese ideography—each of these increasingly defined in terms of the other.[135] In 1927, for example, Pound published a defense of American avant-garde composer George Antheil's *Ballet Mécanique*.[136] Although originally conceived as an accompaniment to an experimental film of the same name by Pound cohorts Ferdinand Leger, Dudley Murphy, and Man Ray (see chapter 6), it is not difficult to see why the musical composition eventually took on a life of its own. Calling for the synchronization of over sixteen mechanized player-pianos, a battery of percussionists, and two aircraft engines with propellers pointed at the audience, *Ballet Mécanique* was, as Antheil described it, "the first piece of music that has been composed OUT OF and FOR machines."[137] Pound's investment in the "machine aesthetic" of the project is reflected in his praise for Antheil as "the first artist to use machines. I mean actual modern machines without bathos" (by some accounts, Pound himself even served as a percussionist for the premier of *Ballet Mécanique*).[138] And the reason for turning to "actual modern machines," Pound insists, was that their concentrated energy and form paralleled that of the Chinese ideograph:

> The lesson of machines is precision, valuable to the plastic artist, and to the literati. . . . I take it that music is the art most fit to express the fine quality of machines. Machines are now a part of life, it is proper that men should feel something about them; there would be something weak about art if it couldn't deal with this new content. . . . Antheil has used them effectively. That is a *fait accompli* and the academicians can worry over it if they like. . . . The thorough artist is constantly trying to form the *ideograph* of 'the good' in his art; I mean the ideograph of admirable compound-of-qualities that make any work of art permanent.[139]

In praising Antheil's machine compositions as a noble "attempt to form the ideograph," Pound's "ideogrammatic method" starts to take on the properties of the machine (and vice versa).[140] Antheil's machine compositions were "ideographic" precisely because "all the joints are close knit."[141]

What this meant for Pound's poetics was that the machine's clean, hard lines, and concentrated movement and energy, its component parts, juxtaposed and interrelated with precision and efficiency—all of this had become simply the modern instantiation of the Chinese ideograph, and therefore a model for the type of poetry (and eventually politics) Pound hoped to create.[142] The very same year he published the *Antheil* treatise Pound began work on an ambitious theoretical and educational project titled *Machine Art*.[143] As several scholars have already noted, the date of

Machine Art's composition (1927–1930) coincides precisely with Pound's consolidation of his ideogrammatic method, particularly in his famous "How to Read" essay (1930) and its extended version in *ABC of Reading* (1934). In *Machine Art* Pound argues, "The beauty of machines (A.D. 1930) is now chiefly to be found in those parts of machines where energy is most concentrated," and that "it is here that the inventor's thought, or more probably the thought of a whole series of inventors has been most concentrated."[144] The reason the "aesthetic of machines" is in such a "healthy state," Pound suggests, is that it most directly relies on the combination of formal "components" (*MA*, p. 58). In order to illustrate this aesthetic quality of the machine, Pound enlisted his father to begin contacting a number of American machine manufacturers, requesting photographs "representing good shapes in machinery," and specifically "photos with HARD edge, not muzzy arty."[145] The sheer number of photographs in Pound's collection is stunning, and his letters to his parents show him growing increasingly enthusiastic about the machines that seemed to concentrate energy in the nexus of their component parts.[146] There are photographs of hundreds of machine parts (Figs. 4.19–4.20), specialized mechanical instruments (Figs. 4.21–4.23), scenes of massive industry and assembly-line production (Figs. 4.24–4.26), and a whole series of cranes (Fig. 4.27).[147]

That Pound is in an entirely different frame of mind than Fenollosa here is perhaps obvious enough, but it is worth drawing out Pound's specific attention to the Bliss press machines, which he says are "particularly good for purpose of [aesthetic] study because each press seems intent on its *one* particular job." Whereas Fenollosa's argument for the Chinese ideograph had called specific attention to its fundamental difference from the "machine," which "can do only one thing," here Pound is collecting photographs of and celebrating machines that literally *perform* that logic. Note, for instance, the uncanny resemblance between Fenollosa's graphic type for machine logic in Fig. 4.4 and the many machines in Pound's image collection that repetitively pound, cut, and die-cast thousands of identical round objects from metal (Fig. 4.28). Throughout *Machine Art*, Pound ridicules the "sob-sisters" who "maintain an antipathy to machines," arguing that "the best engineers are possibly in our times the engineers of machinery," and that "the engineering mind is about the most satisfactory mind of our time."[148] From this development, there was no turning back: "You can no more take machines out of the modern mind, than you can take the shield of Achilles out of the Iliad" (*MA*, p. 77). Whereas Fenollosa had argued that, "debilitating minds crave a perfected machinery for learning art," in *Machine Art* Pound maintains, "Objection to machines has probably disappeared from all, save a few belated crania (Fig. 4.29).[149]

In the consolidation of his ideogrammatic method during this time, Pound continually ignores Fenollosa's emphasis in *CWC* on transitive verbs and the implicitly Buddhist and metaphysical flux within every "thing," and turns almost obsessively to the process by which component images within an ideograph come together to perform a specific "function."[150] In his essays "How to Write" (1930), "How to Read" (1930), and *ABC of Reading* (1934) Pound identifies this emphasis on function as central to the "precision" and "maximum efficiency" of what he calls "Phanopoeia" (the "casting of images upon the visual imagination").[151] For decades after this development, Pound will continually draw attention to examples in Fenollosa's essay wherein, for instance, the character "east" is created by the combination of component parts "man," "tree," and "sun" (Fig. 4.30), or wherein the character "red" is created by the combination of "rose," "cherry," "iron rust," and "flamingo."[152] What for Fenollosa

Figs. 4.19–4.28. (*This page and next three pages*) Photographs from Ezra Pound's *Machine Art* project, Ezra Pound Papers, YCAL, Beinecke Library, Yale University, MSS 186, box 1, folders 35–42; grouped here (by the author) in rows according to the type of machine.

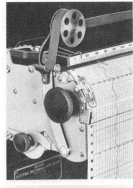

Simply reversing these gears changes the speed of the chart

Either Electric

or Hand-
wound
Clocks

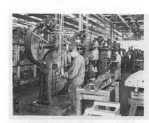

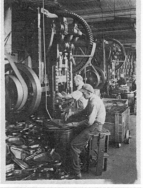

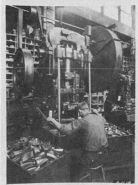

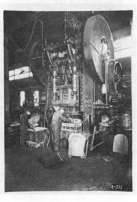

Fig. 4.28. (*Above*) Notice the similarity between this image in Ezra Pound's machine art collection and Fenollosa's graphic type for "machine logic" in Figs. 4.3–4.4.

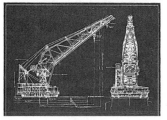

Fig. 4.29. In this drafted passage for *Machine Art*, Ezra Pound is once again wrestling with the question of Futurism and his own claims to original machinism. Here Pound revises "I don't happen to agree . . ." to the stronger "I *disagree* . . ." before striking the entire passage. Ezra Pound Papers, YCAL, Beinecke Library, Yale University, MSS 186, box 111, folder 4705.

Fig. 4.30. Illustration of Chinese ideograph for "East" in Ezra Pound, *ABC of Reading* (New York: New Directions, 1934), p. 21. © 1934 by Ezra Pound. Reprinted by permission of New Directions Publishing Corp.

Fig. 4.31. Page from Ezra Pound, *Guide to Kulchur* (New York: New Directions, 1938), p. 16. © 1970 by Ezra Pound. Reprinted by permission of New Directions Publishing Corp.

Fig. 4.32. Page from *The Cantos of Ezra Pound* (New York: New Directions, 1970), p. 382. © 1970 by Ezra Pound. Reprinted by permission of New Directions Publishing Corp.

had served as a model for the underlying, infinite flux of a deeply Buddhist reality became for Pound an instrumental aesthetics of precision, Confucian governance, and "maximum efficiency." The "golden wheel" of universal interconnectivity and Buddhism had become the Fordist wheels of the assembly line (notice how many mechanical wheels appear in Pound's photographs). Fenollosa's ever-expanding matrix, reaching out eternally in all directions (Fig. 4.6) became, as Pound explains in *Guide to Kulchur* (1938), a finely tuned, literary-fascist method of "exact terminology,"

The ching ming text includes a meaning that functionaries shd/ be called by their proper titles, that is to say a man should not be called controller of curency unless he really controls it. The ching is used continually against ambiguity.

The dominant element in the sign for learning, in the love of learning chapter, is a mortar. That is the knowledge must be ground into fine powder.

正名

E. P.

Fig. 4.33. Ezra Pound's characteristic signature "E. P." with more than a passing resemblance to the characters for *ching ming*, which he cites frequently. Ezra Pound Papers, YCAL, Beinecke Library, Yale University, MSS 186, box 89, folder 3839.

"precise definition," and the "rectification of names"—the Chinese characters for which (*ching ming*) Pound began inserting into the Middle Cantos (Figs. 4.31–4.32). These are in fact the first Chinese characters to be included in *The Cantos* (on the final page of the *Fifth Decad*), the first of which, according to Pound, represents "governor" (the combination of "hitching post" with levels of ground and sky), and the second a waning moon over a mouth (one's terms float adrift and must be brought into line with facts and laws).[153] The careful observer might notice that hidden inside this little ideographic machine are Pound's own initials (an almost Xu Bing-style "EP"—his signature just below *ching ming* in an early draft of his Confucian analects implies as much; Fig. 4.33), which effectively became the logo for Pound's new poetics, hearkening back to that earlier Vorticist, completely non-Fenollosian ideal, "the best artist is the man whose machinery can stand the highest voltage. The better the machinery, the more precise, the stronger; the more exact will be the record of the voltage."[154] Near the end of his career, Pound even began alluding to Epstein's classic vorticist sculpture "Rock Drill" as an embodiment of the way Chinese characters—now ideographic machines—pierce through the "muzziness" of Western decadence and political corruption. The "Rock Drill Cantos" (Cantos 85–95), for instance, are frequently cited for their "interesting visual appearance," with Chinese characters

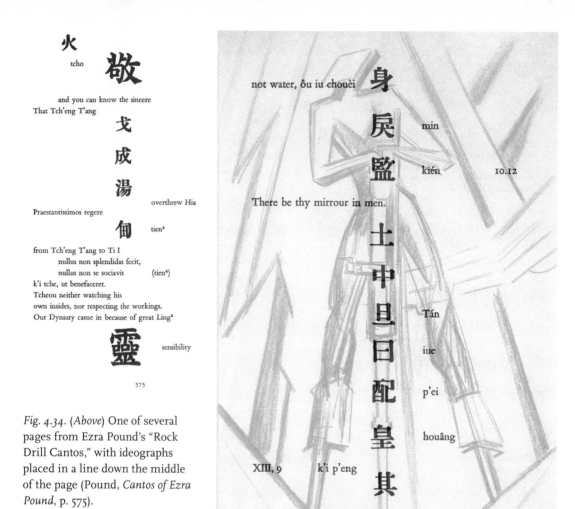

Fig. 4.34. (*Above*) One of several pages from Ezra Pound's "Rock Drill Cantos," with ideographs placed in a line down the middle of the page (Pound, *Cantos of Ezra Pound*, p. 575).

Fig. 4.35. (*Right*) Page from Pound's "Rock Drill Cantos" superimposed (by author) over Jacob Epstein's "Rock Drill" drawing (see Fig. 4.18).

drilling down the page in a form that, I would argue, resembles nothing so much as Epstein's famous sculpture (Figs. 4.34–4.35).[155]

Fenollosa's Son and Heir

As a final thought, one should not conclude that despite this important tension between Fenollosa and Pound what *CWC* truly advocates is some kind of Luddite back-to-the-landism or an elimination of all technological experience as such. Indeed, there are moments in *CWC* and its various drafts where Fenollosa seems to be toying with the possibility that some new form of less restrictive technological experience—something almost mystical, luminous, and quasi-Buddhist—might be yet on the horizon, something mediated by way of small and cutting-edge forms of scientific devices. For instance, even as Fenollosa laments in *CWC* the tendency for Western grammar to function like machines in a "factory," he also hints several times at the potentially cinematic qualities of the Chinese ideograph: "the Chinese word is more

than a symbol. . . . It is as near as possible to a shorthand Kinetoscope picture of the process [of Nature] itself."[156] In one of Fenollosa's marginal notes in his 1903 draft, he even comments that he "ought to have a Kinetoscope picture" to accompany the lecture.[157] The Chinese ideograph is also described as being so full of "motion" that it "leaks everywhere, like electricity from an exposed wire." It has a "kind of energy in itself like an electric bulb."[158] There is even the suggestion in an earlier draft (penciled out in a later version—almost as though he were unsure of how accurately he thought the metaphor reflected the situation) that the metaphorics of the Chinese ideograph could be compared to a "Roentgen ray, which pierces through bone and tissue."[159] However, what separates these metaphorical speculations from Pound's focus on the "clean," "hard," and "sane" machinery of the Chinese ideograph was that for Fenollosa these scientific instruments only confirm something deeply metaphysical and Buddhist about the nature of reality itself, a transcendent "leaking everywhere" for which Pound had no patience. *CWC*, as delivered to us over the years, must therefore be understood as more than a single text—and not only in the sense that Fenollosa himself moved through several versions. It reflects, on the one hand, Fenollosa's lament over modern machine culture and the spiritual, Buddhist reality of Asia's *technê* that was its remedy; but it also reflects Pound's efforts to drive the pantechnicon back into the past, moving the old world, as it were, into new quarters. In short, "Fenollosa/Pound" is itself a complicated ideograph, alive with the tensions of divergent worldviews, juxtaposed without the usual connecting links.

In gauging the poetic legacy of Fenollosa/Pound, one could argue that the writer who most effectively understood and capitalized on this tension was Charles Olson. A second-generation American modernist, Olson felt torn between admiration for Pound's formal innovations and loathing for his intractable fascism. At the end of World War II, when Pound had been indicted for treason (only to be found "insane and mentally unfit for trial"), Olson read Pound's published version of Fenollosa's *CWC*, and was deeply moved by it. Indeed, I think we can be even more precise in its effect: Olson's great work on Melville, *Call Me Ishmael*, was two books written between 1940 and 1947; the first did not contain Fenollosa. It may not, except incidentally, have contained Pound.[160] The purpose of *Call Me Ishmael* (to lay claim to and offer evidence for the "two *Moby-Dicks*" theory) remained the same throughout, but what *CWC* offered Olson when he read it in June 1945 was a means of rethinking the dense, academic approach he had taken in his earlier version.[161] The resulting volume is slim and oblique, and, at times, reads more like a modernist poem than it does a scholarly treatise. But Fenollosa is undoubtedly present, both in direct quotation and in the general sense of informing Olson's reading of *Moby-Dick*: "Americans still fancy themselves such democrats. But their triumphs are of the machine. . . . I am interested in a Melville who decided sometime in 1850 to write a book about . . . one of the most successful machines Americans had perfected up to that time—the whaleship."[162]

When Olson began developing his own poetics more directly a few years later, Fenollosa's *CWC* had become even more central. But whereas Olson's famous theoretical essay "Projective Verse" is typically understood as reproducing a Poundian poetics (minus the fascism) via Fenollosa, I would argue that what finally emerges in Olson's essay is a modernist Fenollosian poetics *in spite of* Pound. In 1951, for instance, Robert Creeley wrote to Olson, noting that "old Ez" had not been "as direct" in his use of Fenollosa's ideas as had Olson: "I wd now say, if anyone's you are F[enollosa]'s son, i.e. this is the man behind you, the one who lights up yr own

word."[163] Olson responded with some enthusiasm: "my interest in Fenollosa is, as you have pointed out, to some clear degree at root a different interest than Ez's."[164] In later letters, Olson becomes even more direct. Writing from the experimental Black Mountain College where Buddhism had become the new ethos of poetic instruction, Olson explains that Pound's "misuse" of Fenollosa and his notion of ideographs "rankles," such that by "using them . . . improperly, he has harmed them. And harms them more in such late peddling of the proper noun."[165] Olson was not, of course, a Sinologist, and his sense that Pound had "harmed" Fenollosa's notion of the ideograph had little to do with any attempt to understand the "true" nature of Chinese orthography; rather, what he meant was that Pound's ideogrammatic method had gone far afield from Fenollosa's protocybernetic vision of intrinsic "motion" caught up in the energies of the transitive verb. Hence, in "Projective Verse" Olson returns to Fenollosa's critique of the "pure copula," arguing that "is" simply "comes from the Aryan root, *as*, to breathe," and that "be" comes from the Sanscrit "*bhu*, to grow."[166] And further, the machine in the form of the printing press, has placed us "by two removes" away from the immediacy of "breath" and *spiritus*. But perhaps the machine could yet be harnessed to achieve what Fenollosa had observed in the Chinese ideograph:

> The irony is, from the machine has come one gain not yet sufficiently observed or used, but which leads directly on toward projective verse and its consequences. It is the advantage of the typewriter that, due to its rigidity and its space precisions, it can, for a poet, indicate exactly the breath, the pauses, the suspensions even of syllables, the juxtapositions even of parts of phrases, which he intends. For the first time the poet has the stave and the bar a musician has had. For the first time he can, without the convention of rime and meter, record the listening he has done to his own speech and by that one act indicate how he would want any reader, silently or otherwise, to voice his work.[167]

For Olson, what the typewriter—that most *personal* of machines—offers here is the possibility of an ideographic poetics composed not as a series of juxtaposed nouns, but as a scored measuring of the "breath," or "what Fenollosa is so right about, in syntax, the sentence as first act of nature, as lightning." Perhaps the typewriter, then, could be that perfect means of reproducing Asia's *technê* in the West. Now, if only there were an ideographic typewriter, perhaps Fenollosa's dream might really come to life.

5. The *Technê* Whim

Lin Yutang and the Invention of the Chinese Typewriter

China is there, a great mystical Dasein.
—Lin Yutang (1935)

A state—is. By virtue of the fact that the state police arrest a
suspect, or that so-and-so many typewriters are clattering in a
government building, taking down the words of ministers and
state secretaries? Or "is" the state in a conversation between the
chancellor and the British foreign minister? The state is. But
where is it being situated? Is it situated anywhere at all?
—Martin Heidegger (1935)

One rainy morning in 1947, Chinese-American writer Lin Yutang and his
daughter arrived at the door of the Remington Typewriter Company in New York
City. After being shown into a solemn, rectangular conference room where a dozen
Remington executives sat at a table, Lin lifted a plastic-covered wooden box onto one
end of the table, and opened it to reveal the product of over thirty years of work and
over $120,000 (much of which he had borrowed): a prototype of an electric Chinese
typewriter.[1] Launching into his presentation, Lin detailed many of the arguments he
had stated in an article in the magazine *Asia* just one year before. The word "amanu-
ensis," he explained, "seems almost a forgotten English word today, while in China,
the amanuensis, or the man who copies by hand all correspondence in neat, ortho-
dox, professional-looking calligraphy, is still an indispensable part of any office staff."[2]
Producing all of its official discourse "by hand," the Chinese nation-state was there-
fore at a severe disadvantage in a rapidly technologizing global order: "When the Ex-
ecutive Yuan wants to issue an order of three thousand words to the provincial
governments, and twenty to thirty copies have to be made in writing because they may
not be mimeographed, an army of amanuenses have to be set to work till midnight
to get the order out by the next day" ("ICT," p. 58). But, Lin argues, if one had a Chi-
nese typewriter, "the same work could be done by two expert typists in an hour. . . .
The whole office atmosphere would be changed, the drowsy tempo quickened, and a
Chinese office would start to click and come to life" ("ICT," p. 58).

Lin's rather deterministic faith in the power of his new technology was not with-
out historical precedent. During the late nineteenth and early twentieth centuries
the rapid ascendance of the typewriter as a central mechanism of Western moder-
nity paralleled a dramatic proliferation in bureaucratic inscription (consolidating vari-
ous modes of official discourse and accelerating colonial and international channels
of communication), even as it signaled the final dominance of alpha-mechanical
orthography over more "tribal" or "primitive" modes of inscription. Regarding the

typewriter and Chinese characters more specifically, the general consensus in the United States for many years was not that Asia would someday solve the mechanical problem of producing a typewriter, but rather that the typewriter would eventually solve Asia's orthographic dilemma by simply convincing Asians that it made more sense to more fully "modernize" by learning English. *The Story of the Typewriter*, published in 1923 by the Herkimer County (New York) Historical Society to commemorate the fiftieth anniversary of the invention, explains that there are two "ideographic" languages, Japanese and Chinese, that "lie outside the pale of the writing machine," and while nothing was mechanically impossible it would be some time before one could expect an ideographic typewriter to appear. "Meanwhile, the Chinese and Japanese buy typewriters—thousands of them; not to write their own languages, of course, but other languages, usually English. . . . Thus it may be said that the typewriter has not only facilitated the use of language but has been no mean influence in determining the spread of language itself."[3] As the triumphant "of course" implies, to "lie outside the pale of the writing machine" was to exist beyond the borders of progress. What the typewriter signaled throughout the twentieth century—whether for the philosophical antimodernism of Martin Heidegger or the exultant media theatrics of Marshall McLuhan—was the inscriptive authority of an exclusively Western modernity.

Given the centrality of the typewriter in critical studies of Euro-American modernity (such that nearly every major commentator on technology in the twentieth century had something to say about it), it is rather odd that Lin Yutang and his widely publicized efforts to invent and mass-produce an electric Chinese typewriter during the 1930s and 1940s have received so little attention in scholarly discourse.[4] In terms of his status as a native interpreter of Chinese culture for Western readers, Lin's influence and authority was unmatched during the first half of the twentieth century. His first book in English, *My Country and My People* (1935), was reprinted seven times in just four months, and was translated into a number of European languages. Just a few years later, Lin's *The Importance of Living* (1937) became the best-selling nonfiction book in the United States during 1938, topping the *New York Times* bestseller list for over fifty weeks. Nominated twice for the Nobel Prize (in 1940 and again in 1950), Lin's career, and particularly his work on the Chinese typewriter, would seem like the perfect topic for analysis in the new transnational American studies. Strangely, however, Lin's work has been largely ignored in American studies, deliberately disregarded—at least until very recently—in Asian-American studies, and only selectively attended to in Asian studies. Much of this inattention and misreading, I argue, has been the result of failing to see how Lin's engagement with the discourse on technology (and especially his decades-long attempt to invent an electric Chinese typewriter) was central to both his literary work and its transnational circulation. Whereas some scholars have argued that Lin Yutang simply internalized the basic tenets of Euro-American Orientalism, I contend that his typewriter provides evidence of an aggressive attempt to modify and subvert those discursive practices for Asia's benefit.

Before turning to the events surrounding Lin Yutang's Chinese typewriter, however, it will be useful to map out some of the critical misprisions of his work over the last few decades. The varied reactions to Lin's 1948 novel *Chinatown Family* offer a particularly telling example of the erratic reception of his work across various scholarly disciplines. On the one hand, there have been some recent attempts to recuperate Lin's writing in the field of Asian-American studies.[5] The blurb on the recent

republication of *Chinatown Family* by Rutgers University Press, for example, aims to promote the text within that discipline: "Lin Yutang, author of more than thirty-five books, was arguably the most distinguished Chinese American writer of the twentieth century." It cites the book's "engrossing" treatment of "issues of culture, race, and religion," noting that the novel addresses interracial marriage and family life at a time when such marriages were "frowned upon and it was forbidden for working-class Chinese men to bring their families to America."[6] Such a characterization of Lin, however, is a much more engaging and positive picture of him than had initially emerged in Asian-American studies. Scholars such as Elaine Kim, on the other hand, can barely contain their disdain for Lin. In her groundbreaking volume, *Asian American Literature*, Kim condemns Lin's writing as "superficial, pithy pieces about China that are in perfect keeping with the American popular view."[7] He was a "bourgeois anti-Communist" whose descriptions of the Chinese "as backward, childlike, superstitious people, loveable but incapable of taking care of themselves, [are] in perfect keeping with the Western colonial view of them." *Chinatown Family* is an "uncomplicated" novel whose characters are simply "modeled after familiar stereotypes." According to Kim, Lin does not even take Chinese-American life seriously, and writes with "apparent boredom with [his] subject."[8]

In contrast to his initial reception of Lin's work in Asian-American studies as self-Orientalizing and blatantly stereotypical, responses have been more positive in studies by scholars in Taiwan (where Lin spent the last years of his life, and where his home has been turned into a museum) and in English-language Asian studies more generally. In these studies, careful attention is paid to Lin's satirical style, particularly its significance to Chinese politics during the 1920s and 1930s.[9] However, by focusing primarily on Lin's early political career, and his later time in Taiwan, many of these scholars overlook crucial developments in the decades Lin spent in the United States writing in English. Diran John Sohigian's 719-page study on *The Life and Times of Lin Yutang* (1991), for instance, never once mentions *Chinatown Family*, and Sohigian even fails to include it in his extensive twelve-page bibliography of Lin's writings.[10] A recent introduction of Lin's work as part of a Metropolitan Museum of Art exhibit similarly fails to mention the novel, even while referring to every other work Lin produced during the late 1940s and early 1950s.[11] In Asian studies, then, a work like *Chinatown Family* is seen as hardly relevant, whereas in Asian-American studies the same book becomes the target of a great deal of animosity.[12] As I will demonstrate, however, recasting Lin's career (and particularly his efforts to invent an electric Chinese typewriter) in the context of Asia-as-*technê* not only provides a more accurate picture of Lin's transnational literary development; it also opens a space for a reading of *Chinatown Family* that dramatically alters the typical Asian-American understanding of his work, and offers an important contribution to the larger critical discourse on the place of technology in American studies.

Such a reading is especially critical since, from one perspective, the Anglo-American versions of Asia-as-*technê* we have examined so far in this book could be thought of as reinforcing the classic Orientalist denial of coevalness. That is, the "masculine" and "modern" techno-West turns momentarily to the "feminine" and "premodern" *technê*-East as a means of resolving its own problems within a certain form of knowledge (specifically technology) precisely in order to maintain its global superiority.[13] However, from a more transnational perspective Asia-as-*technê* offered legitimate opportunities to subvert the classical Orientalist characterizations of Asia as either tech-less or techno. That is, the discourse of Asia-as-*technê* could be adopted

as a means of developing more positive and organic forms of modernity outside the racialized hierarchies of traditional Western technics. Karen Leong has argued, for example, that a distinct transformation in American Orientalism during the 1930s produced "a romanticized, progressive, and highly gendered image of China" that allowed figures like Pearl Buck, Anna May Wong, and Mayling Soong to more actively influence civic and consumer life in both the United States and China—and this precisely in the context of "the modernization wrought by technology, increasingly complex relations, and a population shift toward urban areas."[14]

Lin Yutang's Asia-as-*Technê*

Even a cursory reading of Lin Yutang's major works demonstrates how important the discourse of Asia-as-*technê* was to his thinking. In *The Importance of Living* (1937), for instance, Lin repeatedly warns against what he calls the dangers of the "mechanistic mind."[15] The problem with "modern industrial life," he argues, is that it forbids a kind of "glorious and magnificent idling" (*IOL*, p. 162). Worse than that, "it imposes upon us a different conception of time as measured by the clock, and eventually turns the human being into a clock himself" (*IOL*, p. 162). People in the West have begun to "degenerate into automatons" (*IOL*, p. 58), such that the "gloriously scamp-like qualities of reacting freely and incalculably to [one's] external surroundings" have suddenly been replaced with "the model of the ants" (*IOL*, p. 84). What has happened in the United States is that a "mechanistic view of man came about at a time when mechanistic science was proud of its achievements and its conquests over nature" (*IOL*, p. 85). But Lin does not leave his readers without hope. "It is foolish to assume that man must be swamped by the machine in a uniform, helpless manner, when we realize there is such room for variety in life" (*IOL*, p. 88). There was no reason, he argued, to go on living like "a worm, a machine, an automaton" (*IOL*, p. 100). The answer to these perils of machine culture, he suggests, is that the West must begin to emulate the Chinese in their "sense of freedom" and their "love of vagabondage" (*IOL*, p. 2). For Lin, these were inherently (and positively) gendered distinctions. As he explains earlier in the same volume, "It would not be at all far-fetched to say that Oriental civilization represents the female principle, while Occidental civilization represents the male principle."[16] Throughout his writings, these gendered characterizations are drawn very clearly along the lines of techno and *technê*.[17]

In his 1943 collection of essays titled *Between Tears and Laughter*, Lin Yutang accelerates this gendered critique of machine culture, claiming that unless the West turns to the wisdom of the East for cultural redemption, the world will continue to spiral into chaos and war.[18] Indeed, he says, Western culture has become "incorrigibly mechanical" (*BTL*, p. 80). The "development of the machine" (in addition to the evils of "nationalism, racial prejudice, [and] militarism") has caused the world to begin to "fall apart" (*BTL*, p. 87). Again and again, Lin argues that Western culture has become overtechnologized. Even "the words of the modern tongue are getting increasingly mechanical. Both a political party and a motor-car are a 'machine.' Public sentiments are a 'response' or 'reactions' . . . bravado is a 'defense mechanism,' criticism is an 'outlet,' and something or other is a 'safety valve'" (*BTL*, p. 168). Man has been substituted by a machine to such a degree that "the human mind itself is being changed and . . . a kind of scientific formalin is taking the place of human blood in our blood vessels" (*BTL*, p. 169). All of these developments are only evidence that "man had in Europe's mind become a mechanistic animal" (*BTL*, p. 182). For Lin, then, the only legitimate "challenge to this mechanical age" was traditional Chinese

philosophy, and specifically figures such as Laotse, Chuang-tzu, and Mencius.[19] For example, it was Mencius who,

> in recovering for us a spiritual concept of man, has provided us with a doctrine of equality of all men, a basis for world co-operation among the races of mankind, and the possibility of freedom. He has given us a more flattering view of man than that of mechanical robots which the thousand scientific idiots of the past century have been trying to tell us that we are. (*BTL*, p. 213)

Given Lin's arguments that the cultural and aesthetic "handicraft" of China (an entity he once referred to as that "great mystical *Dasein*"[20]) held the answers to the perils of the "mechanistic mind," it might seem logical to assume that his views on the "mechanized" writing of the typewriter would have paralleled those of other anti-modernist figures. Heidegger, for example, (whose flirtations with Orientalism were most likely unknown to Lin[21]) proposes that the typewriter specifically inhibits philosophical reflection: "when writing was withdrawn from the origin of its essence, i.e. from the hand, and was transferred to the machine [by means of the typewriter], a transformation occurred in the relation of Being to man."[22] For Heidegger, the typewriter simply underscores his larger claim that modern technology has only further entrenched humanity's metaphysical blindness to Being: "the typewriter veils the essence of writing and of the script. It withdraws from man the essential rank of the hand, without man's experiencing this withdrawal appropriately and recognizing that it has transformed the relation of Being to his essence."[23] The typewriter "tears writing from the essential realm of the hand, i.e., the realm of the word. The word itself turns into something 'typed.' "[24] So while Nietzsche clearly understood that the typewriter was having an effect on his writing (as he would say, "Our writing tools are also working on our thoughts"), Heidegger would respond that Nietzsche was simply "the last victim of a long process of error and neglect" who had "long fallen out of being, without knowing it."[25] That is, Nietzsche failed to see precisely *how* the typewriter was working on his thoughts, further veiling his metaphysical relationship to Being. Thus, to remove the hand from this realm is to further conceal one's access to Being: "In the typewriter the machine appears, i.e. technology appears, in an almost quotidian and hence unnoticed and hence signless relation to writing, i.e. to the word, i.e. to the distinguishing essence of man."[26]

Isn't the typewriter, then, the very essence of what Lin Yutang had condemned as the "steady hum of . . . clicking and clanking machines"? Isn't the typewriter merely evidence that people in the West had begun to, in Lin's words, "degenerate into automatons"? How, then, can we reconcile Lin's decades-long obsession with creating a Chinese typewriter with his simultaneous polemic against Western machine culture? How does his role as one of the most popular architects of the discourse of Asia-as-*technê* in America in the 1930s and 1940s work against (or along with) his effort to engineer this fundamental move in the production of Asia-as-*techno*?

The *Technê* Whim

In turning to a discussion of Lin's typewriter, it will be useful to understand how his fascination with machine culture emerged at the crossroads of a series of transnational movements and imperial–cultural interactions. Lin's father was a Presbyterian minister from a rural town in Fujian Province, very much committed to the idea that his sons would receive an education in English with particular attention to Western science. As a young student at a Christian missionary school in Xiamen in 1905,

Lin was entranced by the steam-engine paddleboats he would see floating along a nearby river. He became fascinated by the technocultural forms described in his physics and engineering textbooks, and would sometimes copy out the diagrams of engines in his journals. When he attended St. John's University in Shanghai in 1915, he enrolled in a number of humanities courses, primarily because he had become so proficient in English and was looking forward to studying literature in the United States. But his fascination with science and technology continued. "Don't be surprised," he told his friends at the time, "if when I'm fifty years old, I suddenly enroll at MIT and switch to engineering."[27]

At about this time, however, Lin arrived in Beijing, where (given his Western education) he experienced a kind of culture shock that ran counter to that experienced by most other Chinese intellectuals during this period. As he explained later,

> Imagine my shame when plunged into Peking, the center of China. It was not only my studies, but the Christian background. I had been forbidden to see Chinese theaters, from which all Chinese learned about Chinese famous men and women. I knew all about the trumpets of Joshua which brought about the fall of Jericho, but I did not know how Meng Jiangnü's tears washed away a section of the Great Wall. And yet I was a college graduate and therefore considered an *intelligentsia*.[28]

As several scholars have shown, the intellectual atmosphere in urban China during the late 1910s was marked by excited calls for China to abandon the traditional strictures of Confucianism and Daoism, and to turn more directly to Western models of democracy, science, and technology.[29] Lin's position during all of these upheavals can best be described as ambivalent. On the one hand, his fascination and expertise in Western thought and technology made him quite comfortable with these new ideas.[30] But on the other hand, his growing interest in traditional Chinese culture during his time in Beijing convinced him that while Western machine culture offered an important means of advancing Chinese modernity, something of China's past must be preserved—not only because such a past was inherently valuable, but also because the imperialist context of China's modernization seemed to equate such a process with Westernization.[31] As Shi-yee Liu has shown, "At a time when the

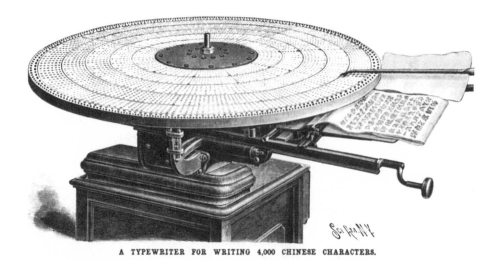

A TYPEWRITER FOR WRITING 4,000 CHINESE CHARACTERS.

Fig. 5.1. D. Z. Sheffield's Chinese typewriter in *Scientific American* (June 3, 1899), p. 359.

majority of the educated elite immersed itself in Western learning, Lin turned to China's past."[32]

During his studies in China, Lin came across a number of previous attempts to invent a Chinese typewriter.[33] Large and unwieldy, these "typewriters" were more often simply massive trays or rotating drums with individual character blocks inside them. One attempt, for example, by Reverend D. Z. Sheffield, head of the American Board Mission and President of Tung Chow College in 1897, was hailed by the American press as potentially "revolutionizing" writing in Chinese "for foreigners, who have in most cases turned their whole attention to the speaking and reading of the language, and have avoided the great difficulty in learning to write it" (Fig. 5.1).[34] Like the very first alphabetic typewriters (which were marketed initially as a tool for the blind[35]), the first Chinese typewriter was invented as a means of overcoming a particular disability, in this case, the difficulty of Americans to learn Chinese writing. As a missionary tool, then, this early typewriter was seen more as a means for foreigners to convey information to the Chinese rather than as a way for the Chinese to modernize their means of textual production. As *Scientific American* would explain, "Dr. Sheffield's typewriter is a triumph of *American* inventive skill."[36] Unfortunately, however, without an efficient system for organizing and accessing the characters on the gigantic drums, typists often had to spend months learning where the characters were, and even then the machines were not as fast as simply handwriting individual characters. Such typewriters, Lin knew, could hardly be used on a "whim." But as Darren Wershler-Henry reminds us, Marshall McLuhan's famous description of the typewriter as an "Iron Whim" is a complex Joycean pun: the word "whim" can refer to not only "a capricious notion or fancy" but also "a pun or play on words; a double meaning" and, even more surprising, "A machine . . . consisting of a vertical shaft containing a large drum with one or more radiating arms or beams."[37] Thus, the real problem with previous Chinese typewriters—if one can characterize the problem by extending Wershler-Henry's particular "whim" (or pun)—was that they required the use of a "whim" (rotating drum) but did not allow for textual production on a "whim" (or capricious fancy).[38] As Lin would comment years later while reflecting on these early attempts, the "principal problem in inventing a Chinese typewriter" was not one of making a machine that could produce Chinese characters, but rather one of inventing a "quick and sure-fire index keyboard" ("ICT," p. 58). The task was not simply to mechanize China's orthography, but rather to discover some hidden, inner systematic logic to the Chinese characters that was already there, a kind of *technê*-essence that could then be transferred onto a mechanical grid.[39] He could not accept the idea, as some had argued in early discussions on the (im)possibility of a Chinese typewriter, that there was no underlying system already coded into Chinese writing.[40]

Building the Machine of Asia's *Technê*

By the mid-1920s, Lin Yutang felt he had discovered the answer. By dividing Chinese characters into their top-left and bottom right components, a system he called 上下形 (*shang xia xing*, he found that he could organize tens of thousands of characters according to a kind of Chinese "alphabet," which disregarded a character's pronunciation and focused instead on a combination of relative stroke positions (Fig. 5.2).[41] His solution, then, was to ignore the phonetic and sequential qualities of the characters (the alphabetic sound and stroke order), and focus instead on their spatial structure. It was as if the relative slowness of Chinese writing in an era of mechanization could

THE CHINESE ALPHABET

Fig 5.2. Dictionary Index System using Lin Yutang's *shangxiaxing* or "up-and-down" classification method, in Lin Yutang, *Chinese-English Dictionary of Modern Usage* (Hong Kong: Hong Kong Chinese University Press, 1973).

be solved by ignoring the temporal elements of the orthography and focusing instead on their spatial aesthetics—a vivid corollary to Lin's turn toward *technê* as a means of appropriating the classic Orientalist denial of coevalness and recasting it as an aesthetic advantage in the search for a way out of (and into) modern technics.

In 1931 Lin traveled to England as a representative of Academica Sinica for a conference, taking with him a blueprint for a potential Chinese typewriter. In England he hired an engineer to help develop a prototype of his machine, spending all of his savings on the project. Perhaps not realizing how expensive and complicated the actual mechanical production of the typewriter would be, Lin quickly ran out of money and returned to China with an unfinished prototype. In 1934, at the urging of Pearl Buck (and with the help of her future husband, Richard Walsh, who owned the John Day Publishing Company), Lin began writing what would become his first international bestseller, *My Country and My People*. By October 1935, the book was on the *New York Times* bestseller list and was widely praised in the United States as an accurate picture of China.[42] The basic, gendered distinction between the techno-West and the *technê*-East that Lin would develop as evidence of the East's superior culture in later publications appears in this collection of essays as well, but with one important distinction: in *My Country and My People*, Lin sets up this dichotomy as a way of illustrating not only the relative virtues of China's *technê*-culture, but also some of its shortcomings in the modern era.[43] Here Lin argues that while traditional Chinese culture has been invaluable to China's development, it has become entrenched, preventing the country from adapting the modernizing power of technology needed in order to progress as a nation.

It is in this 1935 volume, for example, that Lin Yutang notes the tendency of Chinese *technê*-inventiveness to reflect "the handicraft stage," but then goes on to argue that "Because of the failure to develop a scientific method, and because of peculiar qualities of Chinese thinking, China has been backward in natural science" (*MC*, p. 78). Lin notes that the Western techno-world has led to a degeneration of the "art of living," but he simultaneously suggests that the Eastern *technê*-world has been too content with this same art of living: "The Chinese as a race, are unable to have any faith in a system. For a system, a machine, is always inhuman, and the Chinese hate anything inhuman. The hatred of any mechanistic view of the law and government is so great that it has made government by law impossible" (*MC*, p. 111). He praises

the Chinese penchant for "the rural life" and "reasonableness" and "humor." But while humor is a generally a good thing, he argues, it is also "ruining China." It is possible, to "have too much of that silvery laughter" (*MC*, p. 71). Put simply, Lin thought that the "feminine" *technê*-culture of traditional China was both a potential liability in China's rapid push towards modernization and its most valuable asset in counteracting the global perils of "masculine" Western technologies. As he explains in *Between Tears and Laughter*, "This weakness of ancient China [is] also her greatest strength" (*BTL*, p. 74). Western "mechanical thinking," he writes later in the same volume, had failed in every effort to "create or devise a world peace" (*BTL*, p. 167). By contrast, Lin insists, the approaching modernization of Asia offered revolutionary possibilities: "The emergence of Asia simply means this: the end of the era of imperialism" (*BTL*, p. 20). China's legitimate entrance into the "masculine" realm of machine culture would not only benefit the "feminine" China, but also assist in the "liquidation" of a "whole imperialist system of a world half free and half slave" (*BTL*, p. 36).

It may seem like something of a stretch, at first, that the invention Lin introduced in order to assist in China's "feminine" modernization (and the world's salvation) was a Chinese typewriter. However, as Lin also makes very clear in *My Country*, Chinese characters were in his mind one of China's most valuable assets, connected as they were to the Chinese art of calligraphy: "So fundamental is the place of calligraphy in Chinese art as a study of form and rhythm in the abstract that we may say it has provided the Chinese people with a basic aesthetics, and it is through calligraphy that the Chinese have learned their basic notions of line and form" (*MC*, p. 284). To simply alphabetize Chinese orthography would be to allow the machine to eliminate all traces of this vital and originary art form. Indeed, it is through calligraphy that "the Chinese scholar is trained to appreciate, as regards line, qualities like force, suppleness, reserved strength, exquisite tenderness, swiftness, neatness, massiveness, ruggedness, and restraint or freedom; and as regards form, he is taught to appreciate harmony, proportion, contrast, balance, lengthiness, compactness, and sometimes even beauty in slouchiness and irregularity" (*MC*, p. 285). Outside of China, Lin argues, "Modern art is in search of rhythms and experimenting on new forms of structure and patterns" (*MC*, p. 289). But "it has not found them yet. It has succeeded only in giving us the impression of trying to escape from reality. . . . For this reason, a study of Chinese calligraphy and its animistic principle, and ultimately a restudy of the rhythms of the natural world in the light of this animistic principle or rhythmic vitality, gives promise of great possibilities."[44]

Much of what Lin Yutang would have read in English-language discourse on the inherent qualities of Chinese ideography would have confirmed this assumption. He would have no doubt been familiar, for instance, with the illustrated survey of post–World War I typography, *Printing of Today*, published in both the United States and Europe in 1928. In an introduction to the volume, Aldous Huxley reflects on the nature of mechanization, typography, and the "spiritual state" of reading. "The state of mind produced by the sight of beautiful letters," he argues, "is in harmony with that created by the reading of good literature. Their beauty can even compensate us, in some degree, for what we suffer from bad literature."[45] Then, as if to demonstrate the potential for typographic form to transcend even the most banal content, Huxley turns to the example of Chinese ideography:

> Beautiful letters . . . can give us intense pleasure, as I discovered in China, even when we do not understand what they signify. For what astounding

elegances and subtleties of form stare out in gold or lampblack from the shop-fronts and the hanging scarlet signs of a Chinese street! What does it matter if the literary spirit expressed by these strange symbols is only "Fried Fish and Chips," or "A Five Guinea Suit for Thirty Shillings"? The letters have a value of their own apart from what they signify, a private inwardness of graphic beauty. The Chinese themselves, for whom the Fish-and-Chips significance is no secret, are the most ardent admirers of this graphic beauty. Fine writing is valued by them as highly as fine painting. The writer is as much respected as the sculptor or the potter. (*PT*, p. 2)

Lin might not have agreed that what words "signify" could be so entirely subordinate to their "literary spirit" and "graphic beauty."[46] But he would no doubt have sympathized with the argument that these "astounding elegances and subtleties of form" were not the product of some backward, premodern culture, but were actually a valuable means of maintaining nonmechanical variety and aesthetic priority. The Chinese have never fallen into the "monotony" of alphabetic writing, Huxley continues:

Writing is dead in Europe; and even when it flourished, it was never such a finely subtle art as among the Chinese. Our alphabet has only six and twenty letters, and when we write, the same forms must constantly be repeated. The result is, inevitably, a certain monotonousness in the aspect of the page—a monotonousness enhanced by the fact that the forms themselves are, fundamentally, extremely simple. In Chinese writing, on the other hand, ideographs are numbered by the thousands and have none of the rigid, geometrical simplicity that characterizes European letters. The rich flowing brushwork is built up into elaborate form the symbol of a word, distinct and different. Chinese writing is almost the artistic image of thought itself, free, various, unmonotonous. (*PT*, p. 2)

Even in moments where the Chinese use machines to print, Huxley insists, the inherently beautiful qualities of the Chinese characters (their very number being an important facet of that "unmonotonous" beauty) keep them from falling prey to the "soulless ugliness" of the machine, as occurred too often in England and America during the nineteenth century when "Machines were producing beastliness" (*PT*, p. 3). One can almost imagine Lin's thoughts here: if the Chinese had managed to transcend the machine during these long centuries of mechanical printing, surely they could not abandon Chinese orthography during this next stage of Chinese modernity.

But beyond the special role of Chinese characters themselves, everything Lin would have read about Western typewriters at the time seemed to agree that the invention of the writing machine had destabilized an entire system of gender differentiation.[47] Reports from the U.S. Bureau of the Census in 1943, for example, show an exponential rise of women working as stenographers and typists. In 1870, only 4.5 percent of typists and stenographers were women, whereas by 1930, 95.6 percent were women.[48] There can be little doubt Lin Yutang would have been aware of the highly gendered (and technologically deterministic) discourse surrounding the typewriter. Wilfred A. Beeching's *Century of the Typewriter* notes that as early as 1881 the Young Women's Christian Association had introduced typing classes for girls, and it was not long before typewriter manufacturers instituted typing programs in order to train young women "and then more or less 'sell' them to business houses with their

machines."[49] The Herkimer County Historical Society's *The Story of the Typewriter* even characterizes Christopher Latham Sholes (the man credited with its invention) as "symbolizing" the feminist movement.[50] A frontispiece illustration for *The Story of the Typewriter* shows a montage image of a Moses-like Sholes sitting at a typewriter with a line of women in the air above him, floating angelically as they gradually file away from an almost Egyptian (or Chinese?) fortress and into the light near Sholes's typewriter. A leaf of translucent vellum paper at the front of the book covers the frontispiece with an epigraph that reads "EMANCIPATION" and then a small quotation from Sholes: "I feel that I have done something for the women who have always had to work so hard. This will enable them more easily to earn a living"[51] (Fig. 5.3). The cover to the volume offers a similarly redemptive image, with a goddess-like woman rising up into the clean air above the grimy industrialism of the masculine city—towering over a crowded panoply of phallic buildings, cranes, trains, and sweaty men (Plate 98). Holding out the typewriter before her, the serenity of her expression betrays no hint that these early writing machines were rather heavy objects. The message is clear: it is dignified, important work for the woman in the urban setting, offering her a place where she previously had none.

Thus, at the time Lin Yutang was contemplating his typewriter the general (and technologically deterministic) consensus was that typewriting had dramatically "femi-

Fig. 5.3. Frontispiece depicting Christopher Latham Sholes, artist unknown, in Herkimer County Historical Society, *The Story of the Typewriter* (New York: Herkimer County Historical Society, 1923).

nized" the modern field of bureaucratic inscription—a consensus that more accurately contextualizes Lin's efforts to "liberate" Chinese orthography so that it might participate in the technological and material basis of international discourse without losing what he perceived as the value of an essentially feminized Asian *technê* culture. For Lin, to have simply alphabetized Chinese writing (thereby rendering his invention unnecessary) would have been to betray the vital *technê*-essence of the Chinese people.[52] To lose the ideograph into the technological world of the alphabet would be to not only masculinize China, but also jeopardize China's role in saving the world from the West's global overmechanization.[53]

In 1945 Lin completely set aside his literary endeavors to devote his time to solving the final problems of his typewriter. Not bothering to secure outside funding, he tried to tackle the problem entirely on his own, getting up every morning at 5:00 a.m. and working in his office, smoking his pipe, drawing diagrams, lining up or arranging characters, working on the keyboard, and retiring only late at night. In the words of Shi Jianwei, "he was like a man possessed."[54] While the outline of Lin's invention was relatively simple, its mechanical translation proved to be much more complicated than he had anticipated. In fact, the closer he came to success, the more difficulties he encountered, and the more expensive the project became. Lin's daughter remembers her mother getting very nervous as she watched their savings drain away.[55] Perhaps inevitably, before Lin had finished his prototype he ran out of money and requested a loan from Richard Walsh. Despite the fact that Walsh had benefited enormously from Lin's success, he was not convinced that Lin's typewriter was a wise investment. Disgruntled at this rejection, Lin called on some wealthy Chinese friends and eventually took out a large loan from the bank to finish his prototype.

Lin Yutang's patent application for the "Chinese Typewriter," submitted on April 17, 1946, reveals a great deal about the type of work he thought it could accomplish. Because of the "great number of characters" in Chinese writing, Lin explains, it had been impossible heretofore "to provide practical devices for printing or transmitting correspondence or news in the Chinese language."[56] The question of "transmitting correspondence" had become crucial by the time Lin was submitting his patent application. As Michael MacDonald has argued, the popular media in the United States (particularly in movies such as *Destination Tokyo*) had characterized the Second World War as, at least secondarily, a "battle of typewriters."[57] Accordingly, before he had even finished the prototype, Lin was attempting to market his Chinese typewriter as much more than simply a bureaucratic lubricant for the acceleration of official government business. As he explains in his patent, "The selector keys may easily be applied to establishing circuits in a Teletype or radio typewriter. Therefore, the invention should not be considered as restricted to typewriters only, but instead should be considered as being directed to all forms of typewriting."[58] But as he would contend in *Asia*, what "all forms of typewriting" meant for Lin was not only the mechanical realms of war, science, and bureaucratic inscription. He also saw it as an opportunity for Chinese literary artists to "return to ultimate simplicity" ("ICT," p. 60). Rejecting "archaic words" found only in "flamboyantly bad prose," Lin built his typewriter to eliminate these less valuable ideographic elements, and to reproduce more effectively the "artistic variants" indulged in by China's great poets ("ICT," p. 61). Thus, Lin saw his machine as making possible the ascendance of his own sense of China's *technê*-culture to the global status of what had previously been an exclusively Western technological form. What the rotating cylinders of his new machine were designed to inscribe was a graceful fusion of the *technê* and the techno—

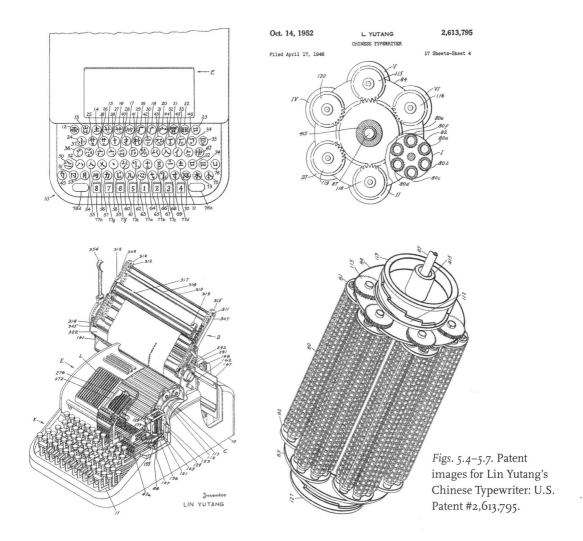

Oct. 14, 1952 L. YUTANG 2,613,795
CHINESE TYPEWRITER
Filed April 17, 1946 17 Sheets-Sheet 4

Inventor
LIN YUTANG

Figs. 5.4–5.7. Patent images for Lin Yutang's Chinese Typewriter: U.S. Patent #2,613,795.

not a slavish mimetic type of "modernity" and not a resistance to it, but a form of perfect cultural balance between art and technics[59] (Figs. 5.4–5.7).

Chinatown Family

Having invested so much work and money into his invention, one can only imagine the anguish Lin must have felt that morning in 1947 when, standing before a dozen Remington executives at their Manhattan office, he directed his daughter to begin the demonstration and the machine did not respond. Walking over to the typewriter, Lin tapped on the keys himself, but again nothing happened. After several uncomfortable minutes, he quietly put his invention back in its wooden case and awkwardly left the room. In the taxi on the way home, he did not say anything. He was no doubt very nervous, as he had arranged for a press conference the next day to announce his invention. When he got home he called the factory engineer who came over and, with just some minor tweaking, was able to get the machine working again. Unfortunately, however, this incident only foreshadowed the ultimate demise of Lin's dreams for the typewriter. In May 1948, Lin signed a contract with the Mergenthaler Linotype Company to investigate the possibility of mass-producing his invention. While the contract provided Lin with some hope, Mergenthaler would soon discover that the

enormous complexity of the machine meant that even after mass-production the type-writer would have had to retail at over $1,000, which made it much more expensive than any other typewriter for sale at the time. With China in the throes of a violent civil war (and then communist isolation), there was never any realistic market for it.[60]

Despite Lin's embarrassing visit with the executives at Remington, news reporting on his achievement was very enthusiastic. Articles on the invention appeared in most of the major papers, usually with a large photograph of the strange new machine. The *New York Times* reported that the invention was "expected to revolutionize Chinese office work and publishing." In a change that reveals something of the trouble Lin would have marketing his typewriter, the *Times* would not use the word "revolutionize" in a second article on Lin's invention when the patent finally cleared in 1952, noting that Lin "applied for the patents before the current unpleasantness in the Orient began."[61] The *San Francisco Chronicle* quoted Lin as stating that the typewriter would "move the clock of progress in China forward by 10 to 20 years."[62] Lin must have been especially pleased with an article in the Chinese-language newspaper *Chung SaiYat Po*, based in San Francisco, which had asserted that if Lin's typewriter were mass produced, "his contribution to cultural progress [would] be no less than that of Gutenberg."[63]

Lin no doubt had similar visions. His daughter writes that some time later, as he fidgeted with a cardboard mockup of his keyboard, he thoughtfully noted, "The crux of the invention is here. The mechanical problems were not hard." Lin Taiyi continues:

> "Then, could you have just used this mockup to sell your invention? Was there any need to build the model?" I asked.
>
> He looked at me for a few seconds. "I suppose I could have," he whispered, "but I couldn't help myself. I had to make a real typewriter. I never dreamed it would cost so much."[64]

Such an admission illustrates the degree to which Lin might have agreed with Wershler-Henry's contention that "typewriting itself was *always* haunted."[65] According to accounts by several authors, the rhythmic "clicking" of the machine itself seems to exert some powerful, almost supernatural pull over the typist, such that a kind of fetishized fascination with the mechanization itself becomes a source of inspiration, rather than simply the possibilities created by mechanized textual production. Henry James's typist, Theodora Bosanquet, for example, wrote that his Remington typewriter had become a central part of his creative power:

> When I began to work for [James], he had reached a stage at which the click of the Remington machine acted as a positive spur. He found it more difficult to compose to the music of any other make. During a fortnight when the Remington was out of order he dictated to an Oliver typewriter with evident discomfort, and he found it almost impossibly disconcerting to speak to something that made no responsive sound at all.[66]

Most of Lin Yutang's writings in English were also written on a typewriter or dictated to a typist, so it is rather easy to see how this fascination with a kind of material or mechanical-audio feedback might have been central to Lin's desire for a Chinese typewriter.[67]

All these possibilities of popular (and metaphysical) vindication notwithstanding, Lin's most pressing task after finishing the typewriter in 1948 was to get back

out of debt, and for that he turned to a more reliable source of income: novel writing on his English-language typewriter. It was during this year that Lin wrote *Chinatown Family*, which follows the triumphs and heartbreaks of an immigrant family during the 1930s, including their work in a basement laundry, the father's tragic death in a car accident, the son Tom's marriage to another Chinese immigrant, and the family's success in opening a Chinese restaurant. Although *Chinatown Family* has been by turns praised, panned, and more often ignored, I argue that it has never really been understood in critical discourse, primarily because its true source of inspiration—Lin's invention of a Chinese typewriter—is never actually mentioned in the text. Indeed, no study of the novel has noticed the degree to which Lin's work on his typewriter became a part of *Chinatown Family*.[68]

The book opens with two young Chinese siblings, Tom (the protagonist) and Eva, who with their mother have just arrived in New York from China. Their father and two older brothers have already been in America for some time working at a laundry. Tom is lying in bed on his first night in New York, and his mother has just "clicked off the switch" of the electric light, "leaving for a second a streak of liver red that danced across his eyes" (*CF*, p. 3). Tom's sister Eva tiptoes back over to the switch, "Click, click! Click, click! The light over his head went on and off three times" (*CF*, p. 4). Tom gently scolds his younger sister for playing with the light, but then thinks to himself,

> It was electricity! Momentous word in Tom's mind, symbolic of all that was new and marvelous in this new world of miracles. Tom had scrutinized the crisscross pattern of the filaments; . . . He knew that he was going to explore that incomprehensible marvel someday; just now he only wanted to understand that nice, neat infallible click. . . . Electricity was lightning, and he had lightning over his bed. (*CF*, p. 4)

As Tom sits pondering these wonders, a "mad rushing sound" approaches his window, and the Third Avenue El train roars by. Machines, Tom suddenly realizes, are everywhere: "America was a country made all of machines, and machines were of course noisy, and, Tom reasoned, America should be noisy and full of that rushing motion, speeding motion, going somewhere—click—stopping—click—progress—click, click!" (*CF*, p. 5). Here Lin's text itself starts to perform like a machine, and one can only imagine how this sentence must have sounded to Lin as he composed it on a typewriter—click, click!

But these opening passages are only the beginning of a recurring motif in the novel that could be most aptly described by what David Nye has called a discourse of the "technological sublime."[69] Tom is constantly pondering over the mechanical mysteries of this new land: escalators, vending machines, skyscrapers, bridges, and so on:

> The first thing that had impressed him on his second day in America was an electric orange squeezer at a lunch counter. Americans squeeze oranges by machines, mix chocolate drinks by machines, shovel earth by machines, haul cargo by machines, sweep snow by machines. He went all the way to Pennsylvania Station to see the electronic door. It was ghostly. All these things he did not understand. Would he be an engineer one day when he was a man? (*CF*, p. 98)

At one point in the story, Tom visits a Catholic cathedral and is quite taken with the majesty of the arches and columns, but then thinks that it is only "almost" as

beautiful as the light of the sunset over the skyscrapers of Manhattan (*CF*, p. 96). Even more than the skyscrapers, the two most powerful symbols of machine architecture for Tom are the El train and the bridge: "Sometimes Tom walked alone to the head of the Queensboro Bridge, drawn by a mysterious power like his early fascination with the El. . . . The bridge contained a mystery, a secret of human knowledge in a vast realm that he did not understand. . . . The bridge itself became a symbol of the power of the age of machines" (*CF*, p. 97). Like the bridge, the El appears in *Chinatown Family* almost as a recurring character, or a distant observing God; for example, when an Italian-American marries Tom's older brother and sets out to convert the family to Catholicism (which is why Tom eventually visits a cathedral), she finds the family accepting but rather indifferent: "The family accepted the existence of God. It was like accepting the existence of the father and the mother and the Third Avenue El" (*CF*, p. 82). With a Christian minister for a father, Lin was no doubt familiar with "El" as another name for "God," and it is fitting that in *Chinatown Family* the El is described as "the artery of this great cluster of life," breaking the occasional silence of city life with a breath-like "intermittent rumble."[70] It is portrayed as the very tissue of Tom's mental and physical life in the United States: "Only thirty feet away on the avenue loomed the dark steel trusses and bars of the Interborough Rapid Transit Elevated Railroad, with its lurching trains moving swiftly past his corner, carrying passengers seated at their windows. Tom was satisfied" (*CF*, p. 19).

But the El is central to the narrative in two more ways that provide important clues as to how Lin is writing his typewriter into the novel. First, *Chinatown Family* is a story about not only machine culture, but also language and its effects and means of production. For Tom, there is an unmistakable interweaving of the mechanical technologies of the El and the alphabetic technologies of the "L."[71] When Tom's teacher uses the word "smuggle" at school, he is fascinated by it and asks her to explain it:

> Miss Cartwright tried to explain what the word *smuggle* meant.
> "I know what it means from the Chinese dictionary."
> "Why do you like the word?"
> "I like the sound of it. We have no sounds like *gle* in Chinese. I like all the words like *giggle, juggle, jumble, scramble.* (*CF*, p. 51)

Hearing the "intermittent rumble" of the "El," and the intermittent "gle" or "ble" created by the "L," Tom is assimilating the vital technologies of America. Being able to pronounce the "L" at the appropriate times is of course central to the stereotypical characterization of linguistic assimilation. After the earlier passage when the El roars by and "Tom was satisfied," we read that the family is sitting down for the evening, enjoying the light of a new electric lamp purchased that day: " 'Well, Tom and Eva . . . You are now in America. How do you like it?' The father could trill the *r* after more than thirty years' stay in this country. It was his pride that he could say 'America' " (*CF*, p. 22). Tom's brother, Freddie, however, never quite understands how to be an American, can't manage his money, and is constantly talking about "Amelica" and "Amelicans."[72] In *Chinatown Family*, there is a distinct corollary between knowing how to use the technologies of the "El" and those of the "L."

Tom's grasp of the cultural logic of both the "El" and the "L" also becomes important when he falls in love with the recently immigrated Chinese girl *Elsie* (El-see?). Whereas Tom comes to embody the drive for techno, Elsie very clearly embodies the virtues of *technê*. Given that Tom's heroes are "Newton. And Watt and Edison and Singer" it comes as no surprise that for his first date with Elsie he takes her to a

bridge, telling her, "Perhaps I shall take engineering. Look at those bridges, aren't they the most inspiring things in the world?"[73] He even pulls out a copy of Walt Whitman's *Leaves of Grass* (that great hymn of American techno-romanticism), and reads to her, "You flagg'd walks of the cities! You strong curbs at the edges! You ferries! You planks and posts of wharves! You timberlined sides! You distant ships!" (*CF*, p. 149). But Elsie does not share Tom's enthusiasm for American technoculture. Elsie is from a scholar's family in China, and "her background had given her a knowledge of ancient Chinese that even the most modern Chinese college students lacked" (*CF*, p. 128). Thus, when Tom first meets Elsie, it is appropriate that she emerges in the act of reproducing Chinese *technê*-culture: "He saw a beautiful young Chinese girl come out of the narrow door, gingerly holding in her two hands a paste pot and a poster, the characters on which were freshly written and not quite dry yet" (*CF*, p. 128). When the techno-acculturated Tom meets the *technê*-embodied Elsie, "It was like hearing exotic music that he had known and forgotten, had hidden somewhere deep in his being, and now he heard it and recognized it as something belonging to other lands, other times" (*CF*, p. 129). Everything about Elsie suggests the ancient *technê*-culture of China:

> Tom stood near and looked on, fascinated by the way she wrote, the way she drew, and by her whole figure. He watched beneath her dark tresses the soft contours of her small face. . . . To see a modern Chinese girl holding a Chinese brush, her hand bent at the wrist at a steep angle, writing such Chinese characters, was like entering a world unknown to him. Not only her writing, but all her movements and gestures had something of the old China about them. (*CF*, p. 130)

As Tom's infatuation for Elsie grows, he begins to sense that he needs to know something more about this ancient *technê*-culture that he has forgotten or perhaps never learned: "It appeared more and more important to him that he should know Mandarin and Chinese literature. He formed a new equation—Chinese literature was Elsie Tsai, and Elsie Tsai was Chinese literature" (*CF*, p. 138). Their courtship becomes a kind of romance between techno and *technê*. Tom begins practicing Chinese calligraphy and reading Laotse, who is described as a "dazzling light . . . so blinding that it took some time for Tom's mind to adjust itself to him"; in time, however, this reading "helped him to understand Elsie better" (*CF*, p. 189). Meanwhile, Elsie becomes more acquainted with American technoculture, visiting the 1939 New York World's Fair with Tom's family, where they encounter "chromium-plated machines, miniature models, giant motors, and the humming, flashing, flickering signs of the progress of science and industry" (*CF*, p. 215). It is fitting in the end that Tom and Elsie's first date was a visit to a New York bridge: the final result of this courtship is that they begin to bridge the cultural gap between the techno and the *technê*, which brings us even closer to an allegorical representation of Lin's Chinese typewriter.

There is even a moment when the precise mechanical structure of Lin's typewriter is represented in the novel. After the family opens its ground-level Chinese restaurant, the young Tom sets out to invent a number of gadgets and systems that will help make their work more efficient. For one of these systems, Tom strings two long wires along the floor of the restaurant against the wall: "This was for signals between Tom and [his sister] Eva. A red light over the sink blinked when Tom or the mother was needed outside. A green light meant that a handsome customer had walked in" (*CF*, p. 181). His mother tells him it's a silly invention, but Tom insists,

"You see, with three lights, red, green, and blue, I can have seven kinds of signals."

"What do you want seven signals for?"

"I will write it down for you." Tom showed his mother a pad of paper, on which he had written down:

A—red
B—green
C—blue
A Loy wanted
B Mother wanted
C Tom wanted
AB Something exciting in the street
AC A handsome customer
BC A beautiful girl
ABC Something *very* exciting. (*CF*, p. 182)

With this schema, we see the operating logic of Lin Yutang's Chinese typewriter. To illustrate the symbolic significance of Lin's textual device here, it is useful to know that Lin's typewriter utilized a process involving what he called a "magic eye" (Fig. 5.8): "By pressing one top and one bottom key, a unit of characters with the same tops and bottoms is shown in the 'magic eye' in the center of the machine, with a maximum of eight characters. This 'magic eye' is an important feature of the machine."[74] After seeing the eight most common characters created by pressing two of the typewriter's keys, the typist visually selects which of the eight characters is desired, and then presses one of the corresponding eight white keys at the bottom of the keyboard—a process that allowed the typist to produce over seven thousand different characters (and theoretically, up to ninety thousand rarely used characters). In short, one presses *three* buttons to produce something "very exciting": the *technê*-cultural orthography of Chinese characters. In *Chinatown Family*, the narrator explains what that special "ABC" code transmitted: "So it turned out that when Elsie was seen passing in the street, Eva at the front of the restaurant flashed AB. But when Elsie walked into the restaurant, Eva flashed all three lights" (*CF*, p. 182). The information about Elsie's arrival is thus transmitted via three buttons—literally via the technology of "ABC"—and an exciting fusion of *technê*-China and the techno West begins to emerge.[75]

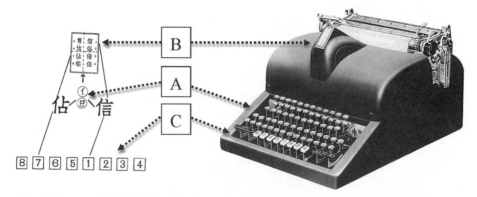

Fig. 5.8. Prototype and diagram for the "magic eye" process in Lin Yutang's Chinese typewriter, in Lin Taiyi, *Yutang Zhang* (Taipei, Taiwan: Linking Publishing, 1993), pp. 233–234 (images courtesy of Linking Publishing, Taiwan).

Ultimately, Tom and Elsie get married, and the novel ends in chiastic form with another "click." The family has come to visit their father's grave, and they decide to take a picture. "When the camera was focused and the exposure set, Freddie set the self-timer and dashed back to his place. The camera clicked. A spring breeze blew softly across the grass, and it seemed at that moment that the spirit of their father was with them" (*CF*, p. 248). Here Lin associates the mechanical "click" of the camera (the sound of yet another "magic eye") with the spiritual presence of the father. Before Tom and his sister and mother immigrated to the United States, his father had seemed like "a dream, a legend, a reality so remote that it was unreal" (*CF*, p. 6). He had been more like a "mystical entity" than a real person (*CF*, p. 7). Arriving in the United States, Tom finds his father and older brothers working in the laundry, moving about "under the glow of hundred-watt lamps like silent robots" (*CF*, p. 11). When Tom's father dies, it is because he is "struck by a motor car near the ramp of the Manhattan Bridge," crushed by a machine on this symbol of the machine age, "dying a typically American death" (*CF*, pp. 166–167). In essence, Tom's father (like "El" the Father) paves a spiritual and sacrificial path for Tom to gain access to this machine culture and, by extension, redemption in Elsie; thus, in the final scene of the book, the spirit of the father appears with the mechanical "click" of an American "magic eye"—making possible the union of the *technê*-Elsie and the techno-Tom that provides this journey with its happy ending.

Lin Yutang wanted to become the transnational embodiment of this marriage. He saw his straddling of world cultures as a means of transcending the entrenchment of China's *technê*-culture and the overmechanization of the techno-Western world. As I have been arguing, Lin's obsession with the creation of a Chinese typewriter did not just inform his own aesthetic production; it also reflected a general discursive move to secure and advance what he understood to be Asia's most valuable assets in a perilous age of globalizing Western technologies.

Such a moment has important implications on the place of technology in American studies. Consider, for instance, the degree to which Lin Yutang's search for *technê* helps clarify the theoretical interventions of his friend and fellow antimodernist Lewis Mumford. Often identified as one of the "Intellectual Founders of American Studies" and "the last of the great humanists," no one did more during the 1930s through the 1960s to question the place of technology in American life than Lewis Mumford.[76] In 1952, the same year Lin would finally secure the patent for his Chinese typewriter, Mumford published *Art and Technics*, a collection of lectures he had given at Columbia University. "The great problem of our time," Mumford argues, "is to restore modern man's *balance and wholeness*: to give him the capacity to command the machines he has created instead of becoming their helpless accomplice and passive victim."[77] In words that would have resonated with Lin, Mumford focuses on the dangers and miraculous advantages made possible by typography and mechanical printing. On the one hand, he claims, typography offers all the benefits of "the repeatable, the standardizable, the uniform—which is to say, again, the typical—that is the essential field of technics" (*AT*, p. 79). Whereas handwriting, and particularly Chinese calligraphy (which Mumford posits as the ultimate instance of individualized human expression), tells "so much at every stroke, about the individuality of the writer, about his tone and his temper and his general habits of life," such a form can nonetheless become "a handicap to the widest kind of communication" without some form of typographic uniformity and rational impersonality (*AT*, p. 68). However, the danger with "mechanized" writing, Mumford continues, is that "man's relation to

the machine must be symbiotic, not parasitic" (*AT*, p. 73). While the creation of typographic fonts without "serifs or shading may make letters look a little more mechanical," such development "does not in the least make them more legible" (*AT*, pp. 74–75). In short, to lose sight of "man's" originary forms of "handicraft" and "symbolism" would be to allow the machine to "wantonly trespass on areas that do not belong to it" (*AT*, p. 81). The principal task illustrated in the example of typography involved completely transforming the "world of technics": "salvation lies, not in the pragmatic adaptation of the human personality to the machine, but in the readaptation of the machine, itself a product of life's needs for order and organization, to the human personality."[78]

What Mumford points to here, I would suggest, is exactly the type of quest Lin Yutang had undertaken (only more dramatically and at a greater personal cost) in his efforts to invent a Chinese typewriter: the possibility of imagining therapeutic and alternative forms of modernity outside the Euro-American myths of progress and white, Western superiority. Of course, this is not to say that these efforts were entirely successful. Mumford's typically unironic insistence that "man's" relationship with the machine should be symbiotic rather than parasitic, much like Lin's constant positioning of the "feminine" as the repository of ethnic tradition, shows how entrenched and pervasive the authoritarian discourse of modern technics has been, how much further toward a truly radical questioning of patriarchal modern technics these figures might have gone.[79] As Michel Foucault explains, the effort to produce "other" modernisms has appeared, at various moments, almost "unthinkable." In his famous passage regarding Borges's "Chinese encyclopedia," an apparently anxious Foucault asks, "what kind of *impossibility* are we faced with here?"[80] The dynamic that produces such an anxious "shattering" laughter in Foucault is precisely the transgression of boundaries that occurs between a series of disconnected categories and the strict implications of an "alphabetical series" (*OT*, p. xvi). It is that "vanishing trick that is masked, or, rather, laughably indicated by our alphabetical order, which is to be taken as the clue (the only visible one) to the enumerations of a Chinese encyclopedia" (*OT*, p. xvii). I think Lin would have very much liked to present his typewriter to Foucault, despite its obvious shortcomings, as an instantiation of that "unthinkable space" Foucault finds in Borges—a romantic attempt to inscribe the Chinese ideograph into "the blank spaces of this grid" in which "order manifests itself in depth as though already there" (*OT*, p. xx). And perhaps Foucault would have agreed that Lin's attempts to bring together gendered stereotyping and mechanical linguistic typing—in both his invention and his literary work—provide us with a dynamic opportunity to rethink the technocultural divisions that have been central to our discursive constructions of East–West epistemes.

6. The Chinese Parrot

Technê-Pop Culture and the Oriental
Detective Genre

It seems we have been swooning mainly over copies.
—Walter Benjamin (1938)

And that Chan never dies, never. That Pop waits in the darkness of
every theater, in every TV, ever ready to come to light again at the
flick of a switch.
—Frank Chin (1994)

In the first full-length Charlie Chan novel by Earl Derr Biggers, *The Chinese Parrot*, published in 1926, Charlie Chan goes undercover as a pidgin-speaking Chinese houseboy named Ah Kim in order to get access to a Chinese-speaking parrot that has witnessed (assuming that "witnessing" is possible for a parrot) a terrible murder.[1] "You understand," Charlie Chan explains, "parrot does not invent talk. Merely repeats what others have remarked."[2] The value of the parrot's speech as "testimony" in the novel, we discover, lies in its reproductive, mechanical nature—its *lack* of invention and thought. The parrot's speech is not "language," but rather a mere "type" of indiscriminate mimetic duplication—important in the story precisely because of the bird's apparent incapacity for duplicity (duplicability, yes, duplicity, no). Descartes, one is reminded, thought of the parrot as something like a ghostless machine.[3] As he explains in his *Discourse on Method*, "One sees that magpies and parrots can utter words as we do, and yet cannot speak as we do . . . it is nature which acts in them according to the disposition of their organs, as one sees that a clock, which is made up of only wheels and springs, can count the hours and measure time."[4] Ernest Fenollosa (as we saw in chapter 4) echoed these sentiments, arguing,

> Let us remember when we sit down to paint a picture, that we are not parrots, about to screech, but consecrated beings, who have been admitted to the laboratory of creation, privileged to see the depth of some forest made gay by the unfolding spirals of stems, the soft song that bursts the prison of buds, and the prismatic tintings of a thousand shy petals.[5]

But whereas Fenollosa felt obligated to point out that "we" are not parrots (about to utter a quasi-mechanical "screech"), the truth is parrots are philosophically interesting (Freud would no doubt have said "uncanny") because they reproduce as other-than-human the technology most basic to us as humans: language.[6] Parrots speak, and some of them remarkably well, but only as heteronomous creatures—we assume, that is, although no one knows for sure.[7]

Perhaps as a result of this weird categorical liminality, parrots have often haunted machine aesthetics and form. Two years before Biggers's novel appeared, the quintessential artist of the machine age, Fernand Léger (who frequently confessed a fascination with parrots) produced an experimental nonnarrative film, *Ballet Mécanique*, in which dancing machine pistons, items of kitchenware, typewriters, and mechanically blinking eyes are juxtaposed with the jerky, similarly repetitive movements of one of Léger's cockatoos (Figs. 6.1–6.2).[8] As Paul Carter has recently noted, Léger's bird is presented in the film as a media image: "The pathos of Léger's cockatoo is technological," reflecting a collective cultural sense of the parrot as a "memory system, which the inventions of Edison, Bell, and Lumiére superseded. Parrots contrive to imitate telephone bells; they cheerily catch the hiss and click of the phonograph needle; they learn to double the look of the mirror."[9] Pointing to a more recent example (to say nothing of rapidly proliferating YouTube videos featuring talking parrots), online retailers now offer a USB Parrot, which, according to its creators, learns to "speak random phrases which are picked up in passing when a phrase is repeated enough" and comes complete with "mechanical wings." As the advertisement explains,

Figs. 6.1–6.2. (Right) Screenshots from Fernand Léger's *Ballet Mécanique* (1924).

Fig. 6.3. (Below) USB Parrot (image courtesy of www.thumbsupuk.com).

"Now you can feel like a real pirate while making your illegal downloads with this USB parrot as your sidekick."[10] It is a striking image: the online pirate's USB parrot presiding over endless online iterations of mechanical, and now digital reproducibility (Fig. 6.3).[11]

Even before the advent of moving pictures, the exotic connotations of this speaking animal allowed it to play a rather curious role in the development of "talking" pictures. Spanning the entire history of Western art, the hundreds (probably thousands) of "woman and parrot" paintings that appeared throughout Europe and America are interesting for not only what they communicated about an artist's mastery of form, but also for the artistic conversations they articulated above and beyond their subject matter.[12] When, for example, the French Realist Gustave Courbet painted *Woman with a Parrot* in 1866 (Plate 99), it was widely understood to be a critique of Édouard Manet's famous nude prostitute, *Olympia* (1863), which Courbet had already criticized as rather too realistic, reportedly describing it as "the Queen of Spades stepping out of her bath."[13] Art historian Arden Reed's explanation of Courbet's use of the parrot as a way of "talking" to Manet through his painting might seem a bit tenuous at first, but when we notice Manet's own response to Courbet in his *Young Lady in 1866*, Reed's take is difficult to dispute (Plate 100). In his painted response, Manet reproduces the woman-and-parrot genre, but conspicuously refuses to reproduce the marketable sensuousness of the traditional female nude, thereby sending the message to Courbet (by way of a mute parrot next to a much less exotic and fully clothed young woman) that Courbet had too spinelessly abandoned the artistic principles of French realism in favor of a more bureaucratic and bourgeois Orientalism.[14] Manet's parrot, in other words, signals a kind of parodic polyglossia—and the pun here on "polly," as Paul Carter has argued, is neither trivial nor rare.[15]

These moments of polyphonic speaking-through-genre only scratch the surface of the role of the parrot in literary and visual culture. As Manet's critique of Courbet implies, for centuries parrots have figured prominently in Western aesthetics as an iconic emblem of exotic imperial gathering. Bruce Boehrer, author of one of several studies on "parrot culture," notes that, "parrots have the distinction—or misfortune, depending on how you look at it—of being the first animal to be exported from the New World to the Old."[16] Collected and displayed as part of an "ongoing process of [colonial] acquisition," parrots became a decorative reflection of Western imperialism.[17] Those interested in the circulation of Japanese prints in the United States during the late nineteenth and early twentieth centuries would have seen a great number of parrots, which was a favorite subject of the Shin-hanga art movement in Japan (a revitalization of the *ukiyo-e* print tradition).[18] Indeed, in addition to Boehrer, Paul Cater, Julia Courtney, and Paula James have all recently published studies detailing the cultural role of the parrot in selected texts from Ovid to Jean Rhys—arguing, in short, that this "talking" animal has functioned throughout history as an important figure in aesthetic explorations of the delineations and slippages between West and East, machine and human, self and other.[19]

The idea of an "Oriental detective" when it first appeared in the 1920s conjured up many of these psittacine fantasies, and corporations and individuals involved in film production were savvy to its potential marketability. It is hardly surprising, in fact, when at one point in Biggers's *The Chinese Parrot* (Fig. 6.4), as Charlie Chan visits Hollywood to observe a film production team at work, the director of the film— literally between takes—glances over at Chan and says, "By gad, here's a type . . . Say, John—how'd you like to act in the pictures?" Chan laughs off the suggestion, but he

Fig. 6.4. Promotional photo of Earl Derr Biggers with parrot cage and stand-in "Charlie Chan" (1927) (photo courtesy of Lilly Library, Indiana University, Bloomington, IN).

is clearly intrigued. "Warmest thanks for permitting close inspection of picture factory," Chan says about the experience afterwards, "Always a glowing item on the scroll of memory."[20] Biggers knew already that he was writing this novel to be made almost immediately into a film, and the obvious self-reflexivity in the phrase "here's a type," I will argue, relies on all the correlative associations of the parrot: Charlie Chan is exotic; his speech is strangely both halting and elegant, he is ripe for mechanical reproduction—he is already, in other words, sleuthing toward Hollywood. And when he finally entered film culture, his appearance was certainly grand. Between 1927 and 1949, and not counting his appearance in Mexican, Chinese, and other international versions, Hollywood studios alone produced over sixty full-production films featuring either Charlie Chan or one of his Oriental detective spin-offs.[21]

For perhaps obvious reasons, most discussions of the Oriental detective genre have tended to focus on whether or not the character reflects a positive or negative stereotype for Asian-America. Defenders of the genre have been, until recently, mostly nonacademic, arguing that the Oriental detective is very consistently portrayed as smart and heroic. Keye Luke, the Asian-American actor who played both the voice of Charlie Chan in the 1970s animated series and Charlie Chan's "Number One Son" in the original films, argued, "They think [the character] demeans the race. I said, 'Demeans! My God! You've got a Chinese hero!' "[22] Ken Hanke, the author of *Charlie Chan at the Movies*, insists that "anyone familiar with the films knows that if anyone comes off badly in most Charlie Chan movies, it is invariably Charlie's white counterparts—those dimwitted, cigar chewing Hollywoodized upholders of law and order who get nothing right until Charlie solves things for them."[23] Jon L. Breen, writing for *Mystery Scene* magazine, recently declared it "baffling" that Charlie Chan has been "branded as perniciously racist when, in print and on the screen, he was a consistently admirable character."[24] Breen even goes so far as to claim that "Asian Americans who protest Charlie Chan are making themselves

look foolish, mainly because they show no evidence of having seen the products they want to suppress."[25]

For Charlie Chan's detractors, however, the Oriental detective narrative is practically a crime scene. The most caustic of Chan's critics continues to be Frank Chin, who in the preface to his 1973 interview with Roland Winters (at the time the sole surviving white actor to have played Charlie Chan in the original films), argued that "the 47 Charlie Chan serials and features have had more influence on the mass perception of Chinese America than all of Chinese America in or out of all her Chinatowns."[26] Chin argues that the Chinese detective character "directly influenced" the "form and content" of nearly every book on Chinese America (including, curiously enough, Lin Yutang's *Chinatown Family*), which, in Chin's mind, is not a good thing. Referring to the early 1970s animated cartoon series *The Amazing Chan and the Chan Clan* that briefly brought the detective to Sunday morning television screens, Chin argues that these attempts to rehabilitate the character are "as questionable and in as questionable taste as making children's heroes of Lee Harvey Oswald, Adolf Eichmann, [and] Richard Speck." Chan "emerged as a racist sex joke in the period characterized by mass anti-Chinese sentiment."[27]

Until very recently, the academic discourse on Charlie Chan has overwhelmingly followed an argument that, while avoiding Frank Chin's more hyperbolic assertions, more or less follows the logic offered by the National Asian American Telecommunication Association and the National Asian Pacific American Legal Consortium, who (when pressuring the Fox Movie Channel to cancel its recent plan to showcase the early Chan films) argued that the Chinese-American sleuth represents "an offensive stereotype who revives sentiments and social dynamics that should be relegated to the past."[28] William Wu, for example, concedes that as an alternative to the Fu Manchu narratives that had preceded the Chinese detective, "Charlie Chan was drawn in lines that no one could mistake as a threat," but quickly notes that in this "overcompensation" Biggers nonetheless insults Chinese Americans by implying that this chubby, soft-boiled detective is "the best Chinese Americans have to offer."[29] According to Wu, even the fact that Chan is a hero is tinged with racism: "That Charlie Chan has been tamed, however, implies that he conceivably could have been wild, or uncontrolled, and so he is a reflection of the Yellow Peril though not a part of it."[30] Shengmei Ma echoes Wu's arguments, noting, "As spotty as Charlie Chan's two goatees were, he nevertheless had them, just like Fu Manchu."[31]

Against this tendency, detective fiction scholar Charles Rzepka offers a stunning defense of the Charlie Chan novels. Carefully avoiding any criticism of Asian-American responses to the Chan character (and particularly the derogatory "Ching Chong Chinaman" stereotypes that have accompanied its circulation), Rzepka argues, "Asian Americans' hostility toward this parade-balloon version of Charlie Chan is entirely justified, given the enormous racial shadow it has cast."[32] However, Rzepka continues, this cultural "parade-balloon version" of Charlie Chan is not in fact the Charlie Chan of Biggers's novels. What the ongoing Asian-American "animus" against Chan fails to point out is that against "formidable" odds, "Biggers created what is arguably the first nonwhite popular detective hero in literary history" (*RRR*, p. 1465). Rzepka explains that through the generic technique of "rule subversion" Biggers dramatically subverted the discursive saturation of regionalist stereotypes, thereby enlisting the detective formula's "very tendencies toward racism to question racial stereotyping, even as he played the game of detection according to the genre's own rules" (*RRR*, p. 1464). That the original Chan character works in the more

idyllic, racially diverse setting of Hawaii, rather than in the Fu Manchu-ish and noir-like setting of Chinatown, provides one point of subversive departure for Biggers; merely allowing a "Chinaman" to be the detective hero of the stories provides another. Accordingly, one of Rzepka's most fascinating insights about the historical reception of the Charlie Chan character is that both detractors and defenders have tended to avoid addressing the crucial question of genre:

> In general, Charlie Chan's defenders focus on authorial good intentions as conveyed by formal effects, while his Asian American detractors focus on the deleterious impact of his reception by the larger white as well as non-white population, especially on-screen. Neither group addresses genre, the historical bridge between intention and reception. (*RRR*, p. 1466)

The phrase "especially on-screen" foreshadows an implicit argument that continues throughout Rzepka's essay: that is, that perhaps the reason Biggers's Chan character has been so dramatically misunderstood in the critical discourse is that he did not fair as well on *screen* (that is, that the "parade-balloon version" is Hollywood's fault, rather than Biggers's). At one point, for example, Rzepka cites Chinese-American scholar Xiao-huang Yin's defense of the Chan character as a trickster. According to Yin, his "African American students and colleagues [enjoy] the Charlie Chan films because they are pleased to see how a Chinese, albeit played by a Caucasian, fools and ridicules white police officers on screen."[33] In response, Rzepka notes,

> Yin does not report on the reaction of his Asian American students, but I suspect they are not as enthusiastic as their black counterparts. While Twentieth Century-Fox incorporated many of the rule-subversive devices first deployed by Biggers, there is no denying that the cinematic Chan popularized in the 1930s by Warner Oland, first of the three white actors to play the detective on-screen, is a diminished figure. (*RRR*, p. 1476)

However, Rzepka's suspicion here that African Americans might more readily enjoy the Chan films, while Asian-Americans would be less enthusiastic, is difficult to substantiate when watching the films themselves.[34] Indeed, if there are any generic characters in the Chan films that come across as consistently cowardly, inept, and generally silly, they are the token comic-relief figures played by African Americans in many of these films. Watching the antics written into Chan films for actors like Stepin Fetchit or Mantan Moreland, one is much more immediately struck by the racist cultures of Hollywood cinema.[35] What is really surprising about Yin's statement, I would argue, is not that he fails to mention whether or not his Asian-American students are similarly enthusiastic about Chan; rather, it is that any African Americans today would be enthusiastic about the Chan films in the first place—and that if African Americans are enjoying these films (and actually *did* in large numbers when they were originally produced[36]), there must have been something more complicated happening in them than the seemingly straightforward offenses of stereotypical form.

Without dismissing these concerns—and, indeed, as a way of more fully understanding them—this chapter attempts to reframe the discussion around which scholars have typically investigated the Oriental detective genre. More specifically, rather than focusing on the question of whether or not Charlie Chan and his various spin-offs are deplorably racist caricatures or else heroic defenders of justice, I want to follow the trail of the "Chinese parrot" as it makes its way through a discursive convergence of machine culture, corporate aesthetics, and ethnic and racial stereo-

typing, pausing to notice not only what the Oriental detective genre says about American racial attitudes during the 1930s and 1940s, but also what it says about the corporate production of film and film culture (and, in proper sleuth fashion, all will be revealed in the end).[37] The first clue in such an investigation will be found in the mechanized world of the Oriental detective.

The Technological World of the Oriental Detective

The golden age of the Oriental detective genre (from the early 1930s to the mid-1940s) coincided with an era of deep technological anxiety in Euro-American culture. Oswald Spengler's *Man and Technics* (1931), for example, lamented an ongoing Western exultation in mechanization, predicting a massive ecological crisis as machines came to dominate the landscape. Lewis Mumford's highly influential *Technics and Civilization* (1934) decried the unrestrained imposition of a mechanized modernity over the organic, anticipating many of Siegfried Gideon's later arguments in the 1940s in his similarly influential volume *Mechanization Takes Command* (1948). In the early 1940s, reflecting what would eventually become a common theme in Frankfurt School criticism, Max Horkheimer and Theodor Adorno characterized technology as the "essence" of Enlightenment knowledge, arguing that the question of whether or not technology can be brought under control is "*The supreme question* which confronts our generation today—the question to which all other problems are mere corollaries."[38] Herbert Marcuse would make the connection between enlightenment rationality and the technological exploitation of man and the environment even more explicit: "The more reason triumphed in technology and natural science, the more reluctantly did it call for freedom in man's social life."[39] For these critics, the arrival of the "mechanical" meant only a "distorting [of] the world in such a way that it seems to fit into pre-established pigeonholes," thereby facilitating the ominous hegemony of the "culture industry."[40]

It is important to remember that these anxieties were not unique to Western intellectuals and radical Marxists. In the 1930s, in addition to the general sense that an acceleration of mechanical reproduction had contributed to the euphoric surplus of the 1920s, and, therefore, the massive depression, many Americans were also highly skeptical that the mechanization of cultural production necessarily constituted a step forward in the arts.[41] The Federal Radio Commission in the early 1930s, for example, legally required as a service to listeners that radio stations describe on air whether the program being broadcast was an actual performance or a mere "mechanical reproduction."[42] Some of the earliest television broadcasters even (however shortsightedly) boasted that they were not simply training the lens on reel-to-reel prerecorded production, but were delivering "live" and therefore less mechanically tainted programming.[43] Stories in the 1930s of robots rising up against their masters circulated with surprising frequency.[44] "Is Man Doomed by the Machine Age?" asked an article published in *Modern Mechanics and Inventions*.[45] Ohio's *Sandusky Star Journal* carried an editorial noting that

> A psychologist could probably make a good deal of this fascinating dread of ours for mechanical monsters. Machinery has created a revolution in our life. The wage-earner, the farmer, the soldier, the merchant, the politicians, the schoolmaster, the printer—all of us, in every moment of our lives, live differently than our ancestors lived because of the constant increase in the mechanizaton of society.[46]

Against this 1930s backdrop of American mechanophobia, the following two characteristics of the Oriental detective genre (both of which are consistent with the development of the discourse of Asia-as-*technê*) become extremely important: first that Charlie Chan and his spin-offs were, by way of their supposedly Oriental philosophical outlook, constantly involved in reframing and even undoing the dangerous intrusion of technology into modern life, and second, that the Oriental detective genre was itself a happily self-reflexive (and self-consciously "parodic") product of mechanical reproduction. In developing this argument, I want to point to something in the Charlie Chan films that, to my knowledge, has never been articulated in the critical discourse (including those in both academic and nonacademic venues): in addition to the novelty of having a Chinese detective hero, technology is a central, perhaps even *the* central, concern of the film series. Consider, for instance, how many of the Charlie Chan films feature some kind of techno-trick at the center of the narrative (Figs. 6.5–6.8 and Table 6.1).

Figs. 6.5–6.6. (*Top*) Screenshots of some of Charlie Chan's myriad interactions with modern technology in *Charlie Chan's Secret* (Twentieth Century-Fox, 1936).

Fig. 6.7. (*Bottom left*) Screenshot of *Charlie Chan at the Race Track* (Twentieth Century-Fox, 1936).

Fig. 6.8. (*Bottom right*) In this image from *Charlie Chan at the Opera* (Twentieth Century-Fox, 1936), Chan takes advantage of a primitive kind of fax machine, which (as part of the plot) transmits Boris Karloff's face via electric wire.

Table 6.1 Techno-tricks used in Charlie Chan films from the 1930s and 1940s

The Black Camel (1931)	Typewriter identification test solves the case, while a secret mechanical button on the floor is revealed in part of the home where the murder takes place.
Charlie Chan in Egypt (1932)	X-ray machine provides a radiograph of ancient Egyptian sarcophagus, a typewriter identification test is used again, and Chan's work in the laboratory reveals the technology to create a small glass capsule that breaks when exposed to high sound frequencies.
Charlie Chan in London (1934)	Plans are made for a high-tech noiseless propeller that the German government wants to steal, and Chan discovers a mechanical dart gun that shoots out tiny missiles.
Charlie Chan in Shanghai (1935)	A switchboard and telephone figure centrally in the plot, while a special paper, when held to the light, reveals a secret message.
Charlie Chan at the Circus (1936)	Chan uses a microscope to enlarge images of some fake ape hair, and a phonograph is used to charm a deadly snake.
Charlie Chan's Secret (1936)	A loudspeaker is hidden in a chandelier while an ultraviolet camera projects images from across the room. Chan does more work in the laboratory and discovers both a radio transmitter and a mechanical contraption used to fire a gun from a great distance.
Charlie Chan at the Opera (1936)	Chan is again in a makeshift laboratory, mixing chemicals (giving an impromptu lesson in techno-science for his son), and Boris Karloff's picture is transmitted mechanically, via AP wire.
Charlie Chan at the Race Track (1936)	Yet another typewriter identification test, while photoelectric cells are placed every ¼ mile on the track, and later developed with a high-speed film developer—Chan uses these to capture the criminals.
Charlie Chan at the Olympics (1937)	A robot device is created that can fly a plane from remote radio control. Chan even takes a ride on the *Hindenburg* zeppelin (filmed in late 1936 before the famous airship exploded in New Jersey).
Charlie Chan on Broadway (1937)	"Candid Camera Night" at a club reveals photographic clues for Chan ("Camera remember many things human eye forget"). Also when one of the suspect's fingerprints are found on the murder weapon, he submits to a "paraffin test," which is explained in elaborate technical detail.
Charlie Chan in Honolulu (1938)	A human brain is kept alive mechanically in a glass case, and a high-tech camera automatically takes photographs when lights go out.

(continued)

Table 6.1 (continued)

Charlie Chan at Treasure Island (1939)	Mechanical "spirits" emerge when a button concealed in floor is pressed, used to manipulate the victims.
Charlie Chan in Reno (1939)	Chan solves the case through his scientific experiments with nitric acid.
Charlie Chan at the Wax Museum (1940)	Features a wax automaton/robot (an obvious play on the famous "Turk" chess-playing automaton hoax in the late eighteenth century), plastic surgery to alter the criminal's face, and an electric current (running through a radio) is attached to a chair, to deadly effect.
Charlie Chan in Panama (1940)	Chan is dispatched to help protect the Panama Canal (the great marvel of early twentieth-century engineering) from the threat of wartime espionage and discovers an attempt to destroy the American fleet with biological weapons.
Charlie Chan's Murder Cruise (1940)	Chan uses trick photography to determine who committed the murder.
Murder over New York (1940)	The culprit's face and voice have been changed by plastic surgery, but Chan uses fingerprint-recognition technology to identify him. Also a glass vial with a dangerous chemical is designed for use as a bio-weapon.
Charlie Chan in Rio (1941)	Chan discovers a cigarette drugged with a kind of truth serum, used to produce a "semi-comatose" state, forcing the victims to reveal their secrets.
Castle in the Desert (1942)	When Chan discovers that there are no telephones in a mysterious castle, he uses one of his son's carrier pigeons as an emergency mode of communication ("United States Army carrier pigeon number 15376—prefer briefer name, Ming Toy, daughter of happiness"). Chan then discovers a modern chemist shop hidden in the castle.
Charlie Chan in the Secret Service (1944)	Chan discovers a closet fitted with a mechanical electrocution device. In another scene, Chan visits a scientist's laboratory and takes obvious delight in all of the various gadgets.
Charlie Chan in Black Magic (1944)	A cigar case conceals a mechanical gun, which shoots bullets made of frozen blood. Chan also discovers a drug that causes its victims to abandon all "mental or physical resistance."
Charlie Chan and the Jade Mask (1945)	Using voice-recognition technology, only a certain person is allowed into an elaborate passageway where the treasure is hidden. Also, a special gas is invented that hardens wood to the toughness and durability of metal (solving the steel shortage of the war at the time). Chan also uses a recording Dictaphone.

Table 6.1 (continued)

Red Dragon (1945)	The title refers to a type of special Chinese ink, which an atomic engineer uses to hide his secret equations on a typewriter ribbon. Also, a thermostat in a room is actually a radio-remote control mechanism for triggering a double-bullet device planted on the victims (one of these almost killing Chan).
The Scarlet Clue (1945)	Chan is employed to protect government secrets in radar technology, which happen to be located in the same building as a radio broadcast network. Small gelatin capsules filled with poison are placed in a microphone, and designed to break at a certain frequency (and the poison then reacts only with tobacco smoke).
The Shanghai Cobra (1945)	A jukebox in a diner turns out to have a kind of television camera embedded in it, through which the customers are viewed on a monitor by a woman in a dark room. The jukebox is equipped with a small mechanically run needle that shoots out and delivers poison to its victims. Chan also inspects the government's radium supply in the local bank's large vault.
Shadows over Chinatown (1946)	Chan's watch stops a bullet, and later in the film Chan again uses AP wire technology to send a picture through phone lines.
Dark Alibi (1946)	Another typewriter test sets Chan on the trail of the killer. Later, in the laboratory, he eventually discovers that another suspect's fingerprints have been forged when fingerprint cards are copied and dabbed with a mix of animal oils to duplicate the effect of real human skin.
The Chinese Ring (1947)	The victims are shot with a "European air rifle," which delivers poisonous darts, and Chan even brings out one of these guns from his own collection. Through various experiments in his newly acquired private laboratory (complete with film and slide projectors), Chan discovers that the bank drafts are forgeries.
Docks of New Orleans (1948)	Chan determines that a vacuum tube in a radio will break at a certain frequency, and that this was filled with poisonous gas by the murderer.

As the accumulation of evidence here clearly suggests, throughout the entire Charlie Chan film series one finds a constant return to the problems and solutions posed by modern technology, such that Chan's solving of the mystery in film after film depends on his ability to utilize (or else uncover the criminal use of) technological devices: microscopes, phonographs, picture wires, photoelectric cells, radiographs,

laboratory experiments, ultraviolet film projection, and so on. It is important to note here that these moments of gadgetry are not peripheral to the narratives; indeed, they routinely constitute the most distinctive parts of each film. While it is often difficult, for example, to keep track of the various characters in the Oriental detective films (such that until the revelation of who the criminal is, it is rather complicated sometimes to distinguish who is who), it is very easy to mark where and how the techno-trick enters the plot.[47]

It is perhaps not surprising that this particular species of detective genre should be preoccupied with the potential problems and solutions of modern technology. Ronald Thomas has recently shown that the "history of detective fiction is deeply implicated with the history of forensic technology."[48] Arthur Conan Doyle's Watson, for example, refers to Holmes as "the most perfect reasoning and observing machine the world has seen."[49] Edgar Allan Poe began writing his detective stories just as he was becoming fascinated by the "cryptographic writing" of telegraphy.[50] Indeed, technologies such as photography, telegraphy, cinematography, radiography, lie detectors (and dozens of others) appear with striking regularity in detective fictions from the first moments of the genre. As such, Thomas argues that the genre has sometimes functioned to provide reassurances regarding the place of modern science in Western culture, even as it also sometimes "exposed, and in so doing . . . challenged the emerging culture of surveillance and the explanations of individual and collective identity it promulgated"—in short, that detective fiction at various times "both reinforces and resists the disciplinary regime it represents."[51]

What is so unique about the Oriental detective character, however, is that his stereotypical "Asianness" is consistently portrayed as a cultural asset in solving the problems created by modern technology. In all of the films he is portrayed as understanding and yet crucially standing apart from the dangerous Western technological systems he is called in to remedy. Unlike the hard-boiled and frequently violent lonerism of characters like Sam Spade or Philip Marlowe, Chan helps to solve the problems of mechanical culture without becoming corrupted by them. He is infinitely polite and gracious (his most famous catchphrase was "thank you so much"). He is a family man (he's portrayed as having thirteen children). He is a far cry from the haughty bohemianism one finds in Sherlock Holmes. And he's portrayed as having a kind of limitless supply of Oriental wisdom. For example, one of the most memorable and often parodied character traits that audiences remember about Chan is his trademark penchant for quasi-Confucian aphorisms, known as "Chanograms" in Hollywood circles, where he says things like, "only foolish dog pursue flying bird" or "truth, like football, receive many kicks before reaching goal," or "murder case like revolving door; when one side close, other side open."[52] Audiences would often "parrot" these sayings after the show, and no doubt came to Chan films expecting these rhetorical flourishes (one large advertisement for a Charlie Chan film even promises, in large lettering, "Chinese Wisecracks of Laughter").[53] Clearly, none of these particular aphorisms have any currency in Chinese culture, but of course that was never really the point. What mattered was that this highly "Oriental" figure seemed to have both an authoritative grasp of modern technology and a sagacious ability to transcend the dangerous and systematic mechanicity of American culture, even as he confirmed the fundamental place of technology within that culture. Take, for example, Twentieth Century-Fox's *Charlie Chan in Egypt* (1935). In this film, set in an exotic locale (and capitalizing, no doubt, on the ongoing public fascination with the discovery of Tutankhamen's tomb), an archaeologist's son dies suddenly while playing the violin. Chan suspects foul play, and in a

scene that offers a number of important clues in our investigation, he discovers that a small tube made of extremely fragile glass and filled with poisonous gas had been placed inside the violin and designed to explode when exposed to the violin's sound vibrations (Figs. 6.9–6.13). Chan's demonstration of this techno-trick before the other inspectors functions as a narrative turning point in the film, and, combined with a series of memorable Chanograms (for example, "Hasty conclusion easy to make, like hole in water"), the film develops what would become a familiar pattern in the Oriental detective genre: the wisdom of the East resolving the techno-perils of the West, and doing so in a way that did not reject technology, but rather seemed to demonstrate a wise and more organic way of living with it.

But beyond this rather obvious instance of Asia-as-*technê*, I want to argue further that a closer inspection of the larger Oriental detective genre reveals a surprising degree of metacinematic self-reflexivity, such that one can readily imagine both the filmmakers and their audiences detecting that the posited *technê* in these films is a parodic, technological construction—a mechanically reproducible stereotype that continually acknowledges the limits of its own authenticity. In short, that the ethnic or even racial identity of the Oriental detective becomes itself a kind of generic technology, exposing that at the heart of the genre lies a composite picture of celebrated reproducibility. In developing this argument, I will be relying on a particular discourse in film studies that focuses on the presence of what might be called extra-diegetic managerial signals that allow the films to speak as products of "corporate art."

The Cinematic Corporation and the Chinese Parrot

Characterizations of Hollywood cinema as the work of corporate "industries" devoted to the mass-production of visual products (rather than as the unified, self-contained work of a single "auteur") have been useful in drawing attention to the critical economic processes of film production and distribution.[54] Seen in this light, the Oriental detective genre fulfilled, usually, a very specific role in the economic structure of the Hollywood studio system. As primarily "B" films, or else "programmers" (those occupying an in-between position "straddling the A-B boundary"), the films of the Oriental detective genre are part of that massive "other half" of Hollywood that has often been neglected in critical discourse.[55] This despite the fact that, as Brian Taves argues, since the Depression-era advent of the "double bill," the B film was essentially "*the* basis of production, the underlying commercial and artistic means by which the industry survived—as well as the vast quantity and range of films offered to spectators during the studio era."[56] Indeed, B films were what "fueled the engines of production, distribution, and exhibition" in the 1930s.[57] For example, when asked what he thought of B film productions in 1938, John Stone (the assistant to Twentieth Century-Fox's producer Sol Wurtzel, who made most of the Chan films) noted that these films "are really the products which count in the long, steady pull," and then adding, with a smile, "They don't lose money."[58]

Two crucial pieces of evidence, however, begin to complicate the effort to characterize the Oriental detective films as the slavish products of generic industries. First, as a number of scholars have shown, what the financial stability of the B film process meant in practical terms was that (provided the filmmakers finished on time and within their allocated budget) the cheap genre films we typically think of as adhering most faithfully to the reproduction of inherited form were in fact allowed a greater degree of artistic freedom than were their more carefully regulated A-list counterparts.[59] As B film director Robert Florey once explained, "As long as I remained on

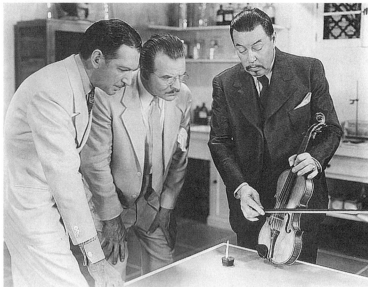

Figs. 6.9–6.13. Screenshots from Charlie Chan's techno-trick in *Charlie Chan in Egypt* (Twentieth Century-Fox, 1935).

schedule, I could shoot all the angles and set-ups I wanted, and move the camera whenever and wherever I wanted to, in the limited time I had."[60] Second, as Jerome Christensen has recently noted, "looking at Hollywood as a generic industry has the considerable disadvantage of erasing the strategies of individual studios, each of which—oligopolistic agreements notwithstanding—had a distinctive corporate in-

tention that informed the meanings its films communicated to their various audiences."[61] Christensen's point here is that corporate authorship quite often played a much larger role in film production than has previously been understood—often shaping a film's final content above and beyond even economic considerations. As he succinctly puts it, "When Jolson sang, Warner Bros. performed. When the lion roars, MGM speaks."[62] What would it mean, then, in our investigation of the Oriental detective films to take seriously Christensen's argument that "numerous Hollywood films could only have been made by the studios that released them"?[63]

To answer that question it will be useful to look at a few of the many attempts to capitalize on the success of the Charlie Chan series from Twentieth Century-Fox (the two studios merged in 1935, at the peak of the series' success). When Fox realized that audiences were enjoying the Charlie Chan films faster than they could make them, the studio quickly set up another film crew and introduced the "Mr. Moto" series starring Peter Lorre, which was yet another box office success.[64] Indeed, the Mr. Moto films followed the familiar pattern of techno-gadgetry and Oriental wisdom, interestingly tinged, however, with an occasionally violent unpredictability that, coupled with America's entry into World War II, clearly spelt the end of Moto as a moment of Asia-as-*technê* (when Japan could only be seen as a techno-threat). In 1938, the Monogram Pictures Corporation, one of the leading small studios in what is referred to as "Poverty Row" (typically characterized as the "dregs" of the Hollywood studio system), seeing Twentieth Century-Fox's success with not only Charlie Chan but now Mr. Moto as well, introduced yet another Oriental detective, Mr. James Lee Wong, played by Boris Karloff.[65] In fact, there were so many Oriental detective films circulating at the time that one reviewer at the *New York Times* only half-jokingly noted, "This subtle discrediting of the West, this constant insistence on the superior finesse of the yellow races in the presence of homicide, is something which every red-blooded American should resent."[66]

Hiring Boris Karloff to play Mr. Wong meant that Monogram's budget for these films would be tight, but with the generic Asia-as-*technê* forms already clearly established by Fox, most of Monogram's work was done before they had even begun filming.[67] The first installment in the Mr. Wong series, William Nigh's *Mr. Wong Detective*, (1938), is perhaps one of the most fascinating, metacinematic films of B Hollywood, though it has certainly never been recognized as such (there's a legitimate reason, I would argue, that Jean-Luc Godard was being only partly ironic when he dedicated *Breathless* to Monogram pictures). In the opening shots we encounter one Mr. Dayton, a businessman who suspects that his life is in danger, and so we see him rushing to Mr. Wong's residence. Let into the study by Wong's Chinese servant (played by Lee Tung Foo), Mr. Dayton enters the screen on the right, just as a parrot resting on a small perch in the center of the room squawks, "What do you want?" Mr. Dayton then glances nervously about the room, as though he is not sure from where the voice has come, "I . . . I am looking for Mr. Wong" (the effect is, of course, comically unbelievable; Fig. 6.14). The camera cuts to another angle, and Mr. Wong has appeared suddenly, startling Mr. Dayton and greeting him with "Good evening Mr. Dayton. I am James Lee Wong. I beg you to forgive my feathered friend. He delights in his own voice, but like so many humans, the words don't seem to matter."

Karloff's wardrobe is not immediately Chan-like. With a shimmering silk robe, Chinese slippers, his exotic furniture, and the delicately feminine way he holds his cigarette (between his thumb and index finger), Karloff seems more Fu Manchu than Chan in these opening shots. But when Wong arrives the next day at Mr. Dayton's

Figs. 6.14–6.19. Screenshots from *Mr. Wong, Detective* (Monogram, 1938). Mr. Wong's parrot speaks to Mr. Dayton. Mr. Wong notes that he has discovered shards of broken glass at the scene of the crime, reproduces the glass sphere in his laboratory, takes the glass back to his home, and experiments with sound frequencies and their impact on the glass sphere.

office, he is dressed in a Western suit, and has become much more of the Chinese detective that Monogram is attempting to parrot. Unfortunately, however, Wong arrives just a few minutes too late, and discovers that Mr. Dayton has been murdered, the only clue being a few small shards of very fragile glass lying near the body (Fig. 6.15). Taking the glass to a laboratory, Wong reconstructs the original unbroken glass object, a small, spherical orb that fits into the palm of his hand (Figs. 6.16–6.17). When the

autopsy on Mr. Dayton's body reveals that he died of a poisonous gas, Mr. Wong is convinced that the small glass sphere is somehow involved. But how could the glass break and release its deadly gas when Mr. Dayton had been alone in his office?

One is reminded here that Fox's Charlie Chan had rather smoothly solved this problem in *Charlie Chan in Egypt* (1935). And the filmmakers at Monogram clearly know that they are directly parroting not only the Chan character, but also the techno-trick at the center of the Chan genre. As a "parrot," then, Monogram's Mr. Wong is both parodying and speaking to the original Chinese parrot. Back in his study, Mr. Wong carefully places the fragile glass sphere on a tiny pedestal on his desk (Fig. 6.18). Behind him on the left-hand portion of the screen is his parrot. On his desk, a variety of Chinese musical instruments—the exotic accoutrements of Wong's supposed *technê*-culture—have been laid out in preparation for the experiment. Wong reaches for a *suona* (a kind of Chinese oboe), points it directly at the glass orb, and begins to play (Fig. 6.19).

The resulting noise is terrible, a kind of screechingly dissonant, atonal whine, and Mr. Wong's servant turns toward Wong with a painful grimace on his face (Fig. 6.20). However, the glass orb remains intact. Puzzled, but deep in concentration, Wong sets down the *suona* and picks up a *zhongruan* (a kind of miniature Chinese guitar). Plucking the strings awkwardly, the sound is again dissonant and clumsy, and Wong's servant seems even more annoyed, perhaps even embarrassed. The glass orb still undamaged, Wong picks up an *erhu* (a kind of Chinese violin with only two strings), and begins to play it in precisely the same way that Charlie Chan had played the violin in the *Egypt* film (compare Figs. 6.12–13 and Fig. 6.21). However, unlike Chan's smooth, methodical demonstration in that film, Wong's *erhu* playing is so cacophonous and jarring that his servant scowls and puts his fingers in his ears. Wong's *technê*-powers would seem to be lacking in this particular case. Mystified by the glass orb's resistance to his experiments, Wong stops playing and looks down (Fig. 6.22). And then suddenly his parrot squawks, loudly, and the shrillness of the sound—wait for it!—causes the glass orb to shatter into tiny pieces on his desk (Fig. 6.23). Startled by the parrot's "speech act," Wong looks back at his parrot, down again at the shattered glass, and then walks back over to his parrot, and bows deeply in prostration, as if to say "Thank you so much," Charlie Chan's famous catchphrase (Fig. 6.24).

But of course what we are witnessing here is not simply Mr. Wong thanking his parrot. This scene is Monogram's way of speaking to Twentieth Century-Fox, as if to say, we know we are pirating and parroting the Chan genre (good pirates always have a parrot on their shoulder), and "Thank you so much!" Monogram knows that Mr. Wong is not their invention, and so his homage to the parrot (the Chinese parrot) is explicitly metonymic. Wong's uncovering of the techno-trick is clumsier and more primitive, and lacks the high-budget polish of Chan's demonstration with the violin, but this is again Monogram's highly self-reflexive way of communicating its debt to Twentieth Century-Fox, as if to say, yes, we know that without Chan, Mr. Wong's techno-tricks would have never existed, and this is our way of playing with the piracy, riffing on it as one might a musical variation.

Mr. Wong's more-Chinese servant is not entirely impressed with Mr. Wong's parroted mimicry. As Lee Tung Foo's grimace (and his subsequent fury at having to clean up the glass shards) seems to indicate, Wong's piracy is only making a mess of Chinese culture (Fig. 6.20). But Monogram had an interesting reason for casting Lee Tung Foo as well. As Krystyn R. Moon has shown, Lee Tung Foo, beginning with his career in vaudeville, was for quite a time the most famous Chinese American in the

Figs. 6.20–6.23. Mr. Wong attempts to shatter the glass sphere as Charlie Chan had in *Charlie Chan in Egypt* (Figs. 6.9–6.13); screenshots from *Mr. Wong, Detective* (Monogram, 1938).

Fig. 6.24. After the (Chinese) parrot's squawk shatters the glass sphere, Mr. Wong thanks him and bows deeply, signaling Monogram's "parroting" of the Chan genre and the same techno-trick demonstrated in the Twentieth Century-Fox film.

entertainment industry.[68] In 1906 Lee's act became a smash hit when, after singing a Cantonese song or two in traditional Chinese dress, he would return to the stage in a tuxedo, and sing popular ballads like "My Irish Molly O," and other Tin Pan Alley favorites in English with a flawless Irish accent. After touring Europe in 1909, Lee returned to the United States with a Scottish number, having learned to perfectly

Fig. 6.25. Lee Tung Foo in Scottish dress, 1909 (image courtesy of the California History Room, California State Library, Sacramento, CA).

mimic a Scottish accent, wearing an authentic Scottish costume (Fig. 6.25). Audiences at the time described it as "screamingly funny," and Lee was widely credited with having debunked the popular assumption that Chinese people could not reproduce Western accents and musical sounds.[69] Lee had already demonstrated, in other words, the fascinating (and highly marketable) affect made possible by the "other" faithfully "parroting" speech back to the "self."

In 1941, Twentieth Century-Fox responded with a Charlie Chan film titled *Dead Men Tell*. In this film, a terrified elderly woman claims to have seen the ghost of a pirate on a ship recently at harbor, and so Charlie Chan (now played by Sidney Toler, following Warner Oland's death) is brought in to investigate. Going below deck, Chan is inspecting some high-tech sea-diving equipment when he hears a strangely distressed voice: "Look out, it's the cops! Beat it, it's the cops!" Chan looks over in the direction of the voice, and the camera zooms in slowly onto the face of a plastic pirate mask, propped up in the corner. The voice continues, "murder, murder, murder!" As Chan walks over to the corner, the mask suddenly lifts and a parrot flies up into Chan's face (Fig. 6.26). Thus, Chan learns that the source of the phantasm is really just someone dressing up and imitating a pirate (parroting a pirate, as it were). Chan's investigation soon focuses on the captain of the ship, a strangely Karloff-ish looking

character who is rarely seen without a parrot on his shoulder. And perhaps not surprisingly, the piratical captain's chief assistant and coconspirator in *Dead Men Tell* is none other than Mr. Wong's (the Monogram pirate) servant, Lee Tung Foo.

In 1942 Twentieth Century-Fox, like most other major studios, was facing pressure from antitrust suits to reduce its B film units, and so allowed Sidney Toler to secure the rights to the Charlie Chan character, which he took with him to Monogram Pictures for the remainder of the Chan series. As a full-fledged Monogram product, Charlie Chan was now a part of the very studio that had so self-reflexively parroted and paid homage to him in the form of Mr. Wong just a few years previously. And in these increasingly low-budget Chan films, Monogram seems to revel in its playful cribbing of the same old techno-tricks and *technê*-forms from previous intercorporate conversations. Fifteen minutes into *The Scarlet Clue* (1945), for example, we learn that Chan's suspect is one "Mr. Horace Karlos" (pronounced so as to rhyme with Boris Karloff). Accentuating this playful allusion, Chan actually meets Karlos when he bumps into him in the hall. With grand gestures and a distinctly Karloffian trilling of the tongue, the man (played by Leonard Mudie) exclaims, "Sir! To meet a gentleman who apologizes for *bumping* you in these days is a rare thing indeed. He is either a coward or a gentleman," and then, with a flourish, "I give you credit for the latter" (Figs. 6.27–6.28). In an over-the-top melodramatic voice, Karlos gives a brief monologue about his great days on the stage, before turning to radio, film, and television; but unfortunately he now plays "only the mad monster." "Still," he adds, "it *is* a living." To get the in-joke here, it is useful to know that the word "bumping," according to the *Oxford English Dictionary*, was widely used in the 1940s to mean "dismiss[ing] someone from a position, or tak[ing] the position of another, especially by exercising the right to displace a less senior member of an organization." Given the fact that Monogram studios had already given up on the Mr. Wong series, and that Twentieth Century-Fox had given up on the Charlie Chan films, Chan had clearly "bumped" his way over to Monogram in a way that would prevent Karloff's Mr. Wong from ever making it back on the screen. And we are hardly surprised to discover that the murderer (who we suspect for much of the film is Horace Karlos) has planted a small glass capsule filled with poisonous gas into a studio microphone, which shatters when exposed to, again, a concentrated sound frequency (Fig. 6.29).

In *Docks of New Orleans* (1948) we find Roland Winters playing Charlie Chan, back at home in his study, holding a small radio tube in his hand, and pondering the now very familiar mystery of how the tube's glass could shatter on cue. Chan's chauffeur (Mantan Moreland) and "Number Two Son" Tommy (Victor Sen Young) are, much to Chan's annoyance, in the next room playing jazzy music (Fig. 6.30). When the music causes the familiar breakage, Chan picks up another radio tube and walks into the next room where the comic duo had been playing: "Excuse interruption of music festival, please," Chan says, "but would mind repeating excruciating sound made with assistance of cat intestines?" Tommy jauntily picks up the violin again and plays, causing the second radio tube to explode with a loud "pop" (Figs. 6.31–6.33). "Ah ha!" Chan exclaims, to which Tommy responds—in what can only be described as a parodic twist on what he calls his parent (parrot?)—"Discover something new, *pop*?"

As many in the audience would have certainly known, there was nothing new about Tommy's "pop" at this point, and, indeed, nothing new about the acoustic "pop" of this particular techno-trick. Indeed, one could posit here an ongoing metonymic parity between the representation of a given technology (that is, the "pop" caused by a given frequency within acoustic space), the "pop" (or father/predecessor)

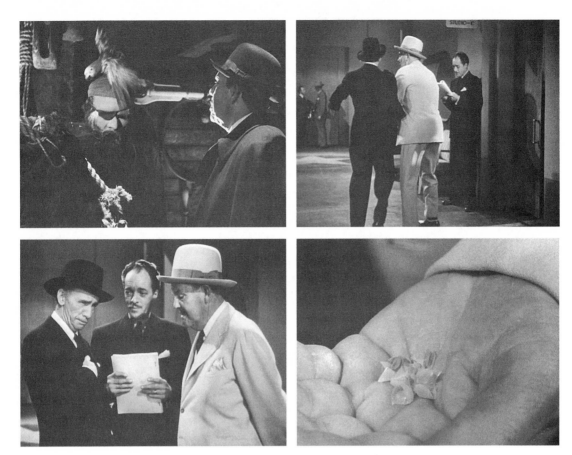

Fig. 6.26. (*Top left*) Screenshot from *Dead Men Tell* (Twentieth Century-Fox, 1941); note the parrot and the pirate are here metonymically brought together.

Figs. 6.27–6.29. Screenshots from *The Scarlet Clue* (Monogram, 1945); "Mr. Horace Karlos" bumps into Chan and then becomes a suspect in the crime of the mysteriously shattering glass.

of these films brought to life by the "frequency" with which these mechanisms were recycled through the Hollywood studio system (reflecting here the *generational* nature of genre—the genre film operating always by way of refamiliarization rather than artistic defamiliarization), and, finally, the attempt to characterize this endless reproducibility not as a product of industrial mass culture, but as a simultaneously organic, exotic, *pop* culture.

Cinematic *Technê*

Here, then, is the mystery exposed: what really pops out from within the glass encasing of Asia-as-*technê* is the not-so-subtle characterization of cinema-as-*technê*. Inasmuch as the wonders of Oriental aesthetics and exoticism are supposedly transmitted by means of the mechanical reproducibility of film, the realm of the cinematic apparatus is portrayed as taking on its own mysterious, exotic splendor. To put it very simply, the cinema wants nothing so much as to become the Chinese parrot. Indeed, from the very beginnings of film theory and production, one finds an ongoing effort to amplify the aura of the cinematic apparatus with the *technê*-cultural equipment of the Orient. Metaphors for the cinema as a kind of universal orthography went hand

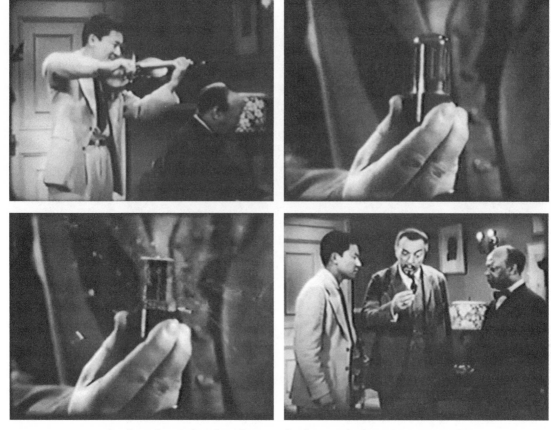

Figs. 6.30–6.33. Screenshots from *Docks of New Orleans* (Monogram, 1948).

in hand with ideographic characterizations of Oriental script.[70] The juxtapositional processes of montage, according to early film theorists like Vachel Lindsay, Sergei Eisenstein, and Jean Mitry, are precisely those of the Chinese ideograph.[71] And certainly nothing better evokes what might be called the Architectural School of the Chinese Parrot than the dozens of polychromatic Oriental theater palaces built across America in the 1920s and early 1930s. There were Oriental-styled theaters in Chicago, New York, Denver, Milwaukee, Portland, Seattle, Detroit, Boston, and, of course, the most famous and iconic of the Oriental movie palaces, Grauman's Chinese Theatre in Hollywood—which, I would argue, looks like nothing so much as a massive parrot (Fig. 6.34).[72] In one of the publicity photos for the opening of the theater, usherettes stand beside the massive black projection machines, dressed in ornate Chinese costumes and headdresses (Fig. 6.35). The middle projector is turned on, and the camera seems ready to burst with light from within, mirroring in microcosm the bursting spectacle of light from the theater itself on film premier nights—events that at least one spectator described as "a veritable furnace of energy" (Fig. 6.36).[73]

The frequent and self-reflexive turn to Asia in the process of constructing a discourse of the cinema-as-*technê*, in other words, reflects an ongoing and highly self-conscious response to charges that the reproducibility of cinema be understood solely as a product of capitalist, machine culture. Whereas Adorno would rather unforgivingly characterize the "culture industry" as a means of inducing—in "*parrot-fashion*"—a kind of social resignation and impotency, the Oriental detective emerges

Fig. 6.34. Street view of Grauman's Chinese Theatre, 1927 (image courtesy of the Margaret Herrick Library, Academy of Motion Picture Arts and Sciences, Los Angeles, CA).

as a means of evoking the pleasures and self-reflexive artistry of generic reproducibility.[74] Thus, the Chinese parrot flies closer to Walter Benjamin's realm in the second version of his magisterial essay "The Work of Art in the Age of Its Technological Reproducibility."[75] Written in 1935, the same year that *Charlie Chan in Egypt* appeared in theaters, Benjamin admits that the inherent "political advantage" of the cinematic apparatus will remain latent "until film has liberated itself from the fetters [feathers?] of capitalist exploitation."[76] Just a few paragraphs later, however, Benjamin argues that the "pol[l]ytechnic training" of technological reproducibility has the power to induce a "progressive attitude . . . characterized by an immediate, intimate fusion of pleasure—pleasure in seeing and experiencing—with an attitude of expert appraisal."[77] If then, for Benjamin, the "shattering of tradition" in the loss of artistic aura coincides with an "emancipation" of the work of art "from its parasitic subservience to ritual,"[78] we might argue that the Chinese parrot's refamiliarization of technology (by way of the frequent "shatterings" of glass tubes in film after film) was presented as the celebrated, iterative broadcasting of a new kind of ritual—a tradition of pleasurable "frequencies." In 1938 (coincidentally, again, the very year Mr. Wong would be bowing to Twentieth Century-Fox's Chinese parrot), Benjamin turned his attention to an exhibit of Chinese paintings at the Bibliothéque Nationale, pointing specifically to the recent revelation that very few of the paintings on display had actually come from the earlier, and more celebrated Yuan period (most of the paintings being Ming- or Qing-era hand reproductions): "It seems," he wrote, "that we have been swooning mainly over copies."[79] But this swooning over simulacra did not disappoint Benjamin. Rather, the implication is that there is something delicious in this irony, something that allows him to draw a metaphorical line between traditional Chinese art and the liberatory power he found in technological reproduction: "It is from this blending of the fixed and mutable that Chinese painting derives all its meaning. It goes in search of the thought-image."[80] If we are going to be

Fig. 6.35. Usherettes at Grauman's Chinese Theatre, 1927 (image courtesy of the Margaret Herrick Library, Academy of Motion Picture Arts and Sciences, Los Angeles, CA).

Fig. 6.36. Grauman's Chinese Theatre illuminated for the premier of *Hell's Angeles*, ca. 1929 (image courtesy of the University of Southern California, on behalf of USC Libraries).

parrots, the logic of both Charlie Chan and Walter Benjamin seems to be, then let us be *Chinese* parrots.

But what I have been arguing here is not simply that the Oriental detective film is really only "about" cinema. Nor has it been my intention to redirect attention away from the sociopolitical consequences of these stereotypical representations of Asians

and Asian-Americans. On the contrary, Frank Chin's lament that the Chan figure has so oppressively overshadowed Asian-American self-representation (as he writes, like an unwanted father figure that "never dies, never. That Pop waits in the darkness of every theater, in every TV, ever ready to come to light again at the flick of a switch") reminds us that the talkative "parrot" as it appears in the West has only ever been a creature of captivity.[81] As Paul Carter points out, "parrots do not imitate other birds in the wild."[82] It is time for us to notice, he argues, "not the parrot but the cage through which we look at it."[83] Thus, in cultural discourse surrounding the Chinese parrot, the striking disparity between those who celebrate and those who despise him says less about the specific traits of the Oriental detective than it does the contradictory aesthetics and sociopolitical inequalities of the cinematic cage. From a rather straightforward historical perspective, for example, we are reminded that Hollywood studios restricted roles and production control in highly racist ways. Lee Tung Foo might have been a fine Charlie Chan, but was not allowed to be an "Oriental detective" because he was not white. But of course the problem has never been one of simply controlling one's own stereotypes. The more puzzling dilemma of this simulation cage (or, as Plato would have it, "cave") is that the perceived dangers of mechanical duplicability—stereotype, erasure of individuality, the possibility of forgery—directly coincide with the mimetic faculties that make us human. As one of the detective's many Chanograms reminds us in *Charlie Chan at the Circus*, "Even if name signed one million times, no two signatures ever exactly alike." My signature speaks only for me, in other words, when it is something I can repeat a million times, and yet I am supposed to find it reassuring that I can never reproduce it in *exactly* the same way (even though, in the end, this hardly makes it more difficult to forge a signature).[84] Perhaps this is why the parrot so fascinates us: it becomes a kind of auto-graph, reproducing—with exotic flourish—our most basic *technê*, and yet never fully collapsing the boundaries of the self and the other.

7. *Techné*-Zen and the Spiritual Quality of Global Capitalism

> The Buddha, the Godhead, resides quite as comfortably in the
> circuits of a digital computer or the gears of a cycle transmission as
> he does at the top of a mountain or in the petals of a flower. To think
> otherwise is to demean the Buddha—which is to demean oneself.
> —Robert Pirsig, *Zen and the Art of Motorcycle Maintenance* (1974)

> I believe robots have the Buddha-nature within them.
> —Masahiro Mori, *The Buddha in the Robot* (1974)

The publication in 1974 of Robert Pirsig's philosophical novel *Zen and the Art of Motorcycle Maintenance* coincided with—and seemed to speak to—a number of transformative global crises. Amidst the ongoing U.S. military invasion of Vietnam, the collapse of the Bretton Woods gold standard, the 1973–1974 oil crisis, the stock market crash, and the ensuing 1973–1975 recession, Pirsig's novel was immediately hailed as a trenchant diagnosis of contemporary failures to realize the aesthetic and therapeutic potential of modern technological systems.[1] W. T. Lhamon, Jr., for example, praised Pirsig's efforts to put "the garden back into the machine—art back into artifice, romantic back into classical," pointing specifically to Pirsig's rebuke of Luddites like Henry David Thoreau for "talking to another situation, another time, just discovering the evils of technology rather than discovering the solution."[2] George Steiner penned a glowing review in the *New Yorker*, suggesting that Pirsig's novel be canonized as the *Moby-Dick* of our time: "a book about the diverse orders of relation—wasteful, obtuse, amateurish, peremptory, utilitarian, insightful—which connect modern man to his mechanical environment."[3] It would be difficult, in fact, to overstate just how much Pirsig's novel resonated with readers in the 1970s. It went quickly through six printings within the first year of its release, eventually selling more than five million copies. The London *Telegraph* was perhaps only slightly exaggerating when it described it as "the most widely read philosophy book, ever."[4]

Much of the book's popularity when it first appeared was due to the perception that it was a self-consciously postcountercultural text, periodizing already (as were many other authors at the time) a version of countercultural dissent that Pirsig thought was misplaced, however well-intentioned. The agonistic "spirit of the sixties," Morris Dickstein argued in his 1977 summary of the counterculture, "was surely Luddite. It saw machines everywhere, and was determined to break them or shut them down: the war was a machine, society was a machine, even the university was a machine producing cogs for society." Pirsig's narrator, by contrast, offered the natural flux and holism of Zen Buddhism as a more technology-friendly "post-sixties perspective," arguing for "systems-analysis rather than dropping out of the system."[5] Indeed, Pirsig's book is in

many ways as much about the supposedly technophobic counterculture as it is either Zen or motorcycle maintenance. As Pirsig's narrator argues near the beginning of the book, the countercultural dissidents of the sixties thought "technology has . . . a lot to do with the forces that are trying to turn them into mass people and they don't like it," even though, he continues, "their flight from and hatred of technology is self-defeating" (*ZMM*, p. 17). The narrator later reminds his readers that

> a root word of technology, *technê*, originally *meant* "art." The ancient Greeks never separated art from manufacture in their minds, and so never developed separate words for them. . . . The real ugliness is not the result of any objects of technology. . . . The real ugliness lies in the relationship between the people who produce the technology and the things they produce. (*ZMM*, pp. 296–297)

For Pirsig, it was time for the failed Luddism of the sixties to give way to a new "Zen" effort to live with (rather than rage against) machines, and *Zen and the Art of Motorcycle Maintenance* was a manifesto for this new, more cybernetic relationship with technological systems. The central argument of Pirsig's novel, in other words, relies on a notion of what I call *technê*-Zen: a discourse premised on the supposed commensurability and mutual determination of Zen Buddhism (including all of its related Taoist notions and techniques of spiritual and aestheticized practice—in short its *technê*) and the possibilities of an organic and holistic form of rationalist technocracy.

In analyzing the discourse of *technê*-Zen in Pirsig's novel, its historical origins, and its ongoing role in the networked, global capitalist systems we live with today, this chapter advances two main arguments, one a rather straightforward historical claim, the other a perhaps more controversial assertion. First, building on a number of recent studies on technology and the counterculture, I argue that whereas Pirsig posits *technê*-Zen as a discursive rupture from the dissident "spirit of the sixties," *Zen and the Art of Motorcycle Maintenance* can be more correctly understood as both a continuation and acceleration of a discourse of "cybernetic Zen" already well underway in the 1950s and 1960s; second, the forms of *technê*-Zen developed in *Zen and the Art of Motorcycle Maintenance* have come to occupy an especially privileged space in the technologically saturated realms of network capitalism and particularly the corporate management theories that currently dominate international business practice. As I intend to illustrate, the discourse of *technê*-Zen picked up on and accelerated by Pirsig continues to exercise enormous power in our current era, when technological innovation (computational, organizational, pharmacological, and so on) is offered by multinational corporations as yet another path toward enlightenment—provided, that is, that these innovations are mediated by the supposedly more organic thinking of Eastern philosophy.

Technê-Zen and the Counterculture

In a summary of the sixties published at the height of American anxieties about Vietnam and the military-industrial-university complex, Theodore Roszak argued that the "paramount struggle of our day" was against something he called the "technocracy."[6] Echoing Jacques Ellul's notion of an all-encompassing "technique"[7] (as well as Herbert Marcuse's notion of "technological rationality"),[8] Roszak argued that the technocracy was not simply the introduction of technology into society but a much more comprehensive regime of hyperrationality and organizational integration: "By the technocracy, I mean that social form in which an industrial society

reaches the peak of its organizational integration. It is the ideal men usually have in mind when they speak of modernizing, up-dating, rationalizing, planning" (*MCC*, p. 5). The real enemy, then, was not so much a specific political or economic structure (not, that is, something like capitalism or communism) but the entire "mad rationality" (*MCC*, p. 78) of what Lewis Mumford had called the "Mega-Machine," a systematic tyranny of rationalism, grid-like regimentation, and ecocidal industrialism.[9]

Naturally, then, if one is overturning the "mad rationality" of the technocratic machine one has to have something to offer in its place, and so a number of counterculturalists promoted various forms of Eastern mysticism as an antidote to Western technocracy. It may be, Roszak argued, that some less mature youth have taken off "in the direction of strenuous frenzy and simulated mindlessness," but there were nonetheless many who espoused, "a very different and much more mature conception of what it means to investigate the non-intellective consciousness. This emerges primarily from the strong influence upon the young of Eastern religion, with its heritage of gentle, tranquil, and thoroughly civilized contemplativeness." In the mystical East one finds "a tradition that calls radically into question the validity of the scientific world view, the supremacy of cerebral cognition, the value of technological prowess; but does so in the most quiet and measured of tones, with humor, with tenderness, even with a deal of cunning argumentation" (*MCC*, p. 82). And in positing Eastern mysticism as an answer to the overmechanization of the West, Roszak was hardly alone. To point to only some of the most famous examples: D. T. Suzuki's *Zen Buddhism* (1956), Alan Watts's *The Way of Zen* (1958), Alan Ginsberg's "Sunflower Sutra" (1955), Jack Kerouac's *Dharma Bums* (1958), Philip Whalen's "Vision of the Bodhisattvas" (1960), Gary Snyder's "Buddhist Anarchism" (1961), Aldous Huxley's Zen Buddhist *Island* (1962), John Cage's *Yijing*-inspired *Music of Changes* (1951) and *Variations I–VII* (1958–1966), and the widespread 1950s and 1960s circulation of Paul Reps's *Zen Flesh, Zen Bones*, Richard Wilhelm's translation of the *Yijing*, P. D. Ouspensky's *In Search of the Miraculous*, and G. I. Gurdjieff's *All and Everything*.

It was, by all accounts, as Van Meter Ames put it, a "Zen 'boom.'"[10] "The impact of science and technology upon traditional ways of living, thinking, and feeling has made people seek for some guiding wisdom," and so, he explained, "the Zen 'boom' is on."[11] As Stephen Mahoney put it in a 1958 article on "The Prevalence of Zen" in the *Nation*, "Zen is a nature religion. It is booming at a time when Western man's celebrated victory over nature is less convincing than ever—but when his alienation from nature, including his own nature, seems to be an accomplished fact."[12] And it would keep on booming. In the 1970s, hundreds of Zen centers cropped up all over the United States, accompanied by antitechnocratic treatises from Buddhists like Philip Kapleau Roshi, Chögyam Trungpa, and Thich Nhat Hanh—all of whom advocated the virtues of Zen Buddhism as an antidote to the dehumanizing effects of Western technology.[13] As Charles Prebish's 1979 historical summary of *American Buddhism* noted, "In the 1970s the problems resulting from the monumental advances in all aspects of technology have become strategic concerns for American Buddhists."[14]

However, by the mid-1980s, and particularly amid the mounting excitement of the impending "PC revolution," the periodizing notion of the counterculture as uniformly antitechnocratic had begun to seem problematic. Take, for example, Roszak's startling revision to his earlier thesis offered at a San Francisco State University lecture in 1985. Whereas Roszak had in 1969 seen a coherent and unified "sensibility" of "mystic tendencies and principled funkiness" in the counterculture, he was now noticing a "deep ambiguity" in the movement. It would not be doing justice to our

understanding of the counterculture, he now asserted, to overlook, "the allegiance it maintained—for all its vigorous dissent—to a certain irrepressible Yankee ingenuity, a certain world-beating American fascination with making and doing. For along one important line of descent, it is within this same population of rebels and dropouts that we can find the inventors and entrepreneurs who helped lay the foundations of the California computer industry." What had seemed in the late 1960s like a consistently antimodernist group of neo-Luddites now seemed much more complicated: "The truth is, if one probes just beneath the surface of the bucolic hippy image, one finds this puzzling infatuation with certain forms of outré technology reaching well back into the early sixties."[15] Indeed, a great deal of recent scholarship on the role of technology in the counterculture (especially those areas focusing on Stewart Brand's countercultural *Whole Earth Catalog*) has shown persuasively that the path from counterculturalism to the digital networks of "California capitalism" was marked by a deep structural continuity.[16]

For many counterculturalists, in other words, not all forms of Western technoculture were equally "technocratic," and, indeed, most Zen advocates (in fact, *all* of those listed on the previous page) were convinced that Eastern mysticism shared certain affinities with what Watts, in *The Way of Zen* (1958), called the "growing edge" of Western scientific thought. As Watts explains,

> The egocentric attempt to dominate the world, to bring as much of the world as possible under the control of the ego, has only to proceed for a little while before it raises the difficulty of the ego's controlling itself.
>
> This is really a simple problem of what we now call cybernetics . . . [which] exemplifies the whole problem of action in vicious circles and its resolution, and in this respect Buddhist philosophy should have a special interest for students of communication theory, cybernetics, logical philosophy, and similar matters.[17]

For Watts, however, the reason Zen Buddhism had a "special interest" for students of cybernetics was not only that the two philosophies shared interests in questions of nonduality, natural flux, and the virtual spaces of networked consciousness. More importantly, Zen Buddhism offered a way for cybernetics to transcend its own tendencies toward technocratic computationalism.[18] In his regular KQED television series, *Eastern Wisdom and Modern Life*, for example, Watts would often extol the therapeutic value of Zen in discussions of cybernetics and technological regimentation. In the second episode, for instance, Watts continues with a theme he had begun in the first presentation regarding "the extraordinary conflict between man and nature that exists among almost all highly civilized peoples, and especially here in the Western world where we talk so much about our conquest of nature, our mastery of space, our subjection of the physical world." Walking over to a large canvas to his left, Watts pulls out a paintbrush and begins to explain the Sanskrit term *māyā*, which he says comes from the root *mā*, a word that is

> at the basis of all kinds of words that we use in our own tongue: at the basis of "matter" . . . of "matrix," or "metric," because the fundamental meaning of the root *mā* is to "measure," and so it works in this sort of way. I was talking about our world being wiggly. You know, something like this [Watts draws a wiggly line; Fig. 7.1]. That is the typical sort of shape we are having to deal with all the time.[19]

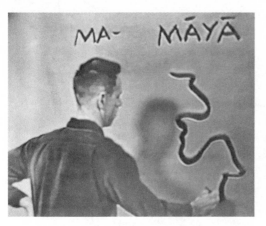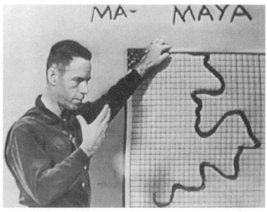

Figs. 7.1–7.2. Alan Watts draws a "wiggly line" (*left*) and illustrates the grids of "māyā" (*right*). Screenshots from TV series, *Eastern Wisdom and Modern Life* (1959–1960).

The problem with such shapes, Watts explains, is that they are extraordinarily difficult to talk about. To describe such a line over the phone or on the radio so that the person on the other end could reproduce it would require enormous effort. "But here," he says, "you can *see* it, and you can understand it at once." But the problem is, Watts continues, "We want to be able to describe [the wiggles] exactly so that we can control them and deal with them. I mean, supposing this were the outline of a piece of territory on a map. Then you might want to tell someone an exact spot to which he should go, and then you would have to be far more precise about it than you can be when you just get the general idea by looking at it." Thus, Watts explains, we turn to the concept of *māyā* by introducing a "matrix." Holding up a wooden frame with a transparent glass on which a pattern of graph lines has been printed (Fig. 7.2), Watts continues, "the moment we do this, it becomes very easy to talk about this wiggly line, because we could, for example, number all these squares across and down-wards . . . and then we can indicate the exact points on this grid which cross the wig-gly line. And by numbering those points one after another, we can give an accurate description of the way that line moves." The powers of *māyā*, in other words, allow for an amazingly efficient means of communicating complicated patterns and move-ments. But that is not all, Watts continues,

> supposing it was wiggling, in *motion*, supposing it was a flea or something dipped in ink, and was crawling across the paper, and we wanted to know where he was going to go? All we would have to do would be to plot out the positions which he has covered, and then we could calculate statistically a trend, which would indicate where he would be likely to go next. And if he went there next, we should say, "By Jove! Isn't that incredible. This little flea crawling across the paper is obeying the laws of statistics." Well, as a matter of fact he isn't. . . . what we are doing is we are making a very abstract model of the way in which that line is shaped, or in which that flea is crawling. We are breaking it up into little bits, whereas in fact it is not a lot of little bits. It is a continuous sweep, but by treating it in this way as if it were broken up into bits, we are measuring it, we are making a *māyā* . . . a way of *projecting*. You see, this thing [Watts picks up the frame with the graph lines] comes out of our minds, and we *project* it upon nature, like this, and break nature into bits, so that it can be easily talked about and handled.

Watts's point, in the end, is that the projected grids of *māyā* are useful and compelling, but one needs the holistic awareness of Zen in order to carefully balance those grids against the organic wiggles of our ecological experience.[20]

However, to see just how close Watts's *māyā* is here to the questions of cybernetics one need only suppose that the wiggling object in question were not a flea but an airplane. During World War II, for example, this was precisely the task laid out for Norbert Wiener and his associates at Massachusetts Institute of Technology. Wiener later described the situation in his 1948 volume *Cybernetics*: "At the beginning of the war, the German prestige in aviation and the defensive position of England turned the attention of many scientists to the improvement of antiaircraft artillery." As Wiener understood his task, the mechanized speed of the airplane or weapon had to be matched by the mechanized speed of an even more powerful, computational counterweapon. If calculations of the "curvilinear" path of the airplane could be built into an automated, antiaircraft "control apparatus,"[21] all the mystery and danger of the object's curvilinear movements—its "wiggles"—could be made sense of, bit by bit.[22]

In the end, the U.S. Army never actually made Wiener's apparatus (the war ended before his insights could be built into any actual antiaircraft weaponry), but the role of these projected feedback mechanisms between the pilot and his machine, or antiaircraft operator and his intended target, became an integral part of Wiener and his colleagues' postwar efforts to employ theories of statistical mechanics and information transmission in developing new machines and understandings of the human nervous system. In 1946, along with a number of other scientists, Wiener made arrangements with the Josiah Macy Foundation in New York to host the first of a series of meetings "devoted to the problems of feed back."[23] The idea was to bring together twenty or so leading scientists, psychologists, sociologists, and anthropologists to establish a common vocabulary with which scholars could develop a greater understanding of thinking machines—including, most centrally, the human nervous system, which was understood and characterized in explicitly informational and mechanical terms.[24]

The idea that Zen not only shared certain interests with this new cybernetic thinking but—more importantly—also offered a therapeutic means of developing and integrating it became a central underlying assumption for the entire countercultural fascination with Eastern mysticism. Consider, for example, Zen devotee Richard Brautigan's famous 1967 poem, "All Watched Over by Machines of Loving Grace," reprinted in several issues of Stewart Brand's countercultural *Whole Earth Catalog*:

I like to think (and
the sooner the better!)
of a cybernetic meadow
where mammals and computers
live together in mutually
programming harmony
like pure water
touching clear sky.

I like to think
 (right now, please!)
of a cybernetic forest
filled with pines and electronics
where deer stroll peacefully

past computers
as if they were flowers
with spinning blossoms.
I like to think
 (it has to be!)
of a cybernetic ecology
where we are free of our labors
and joined back to nature,
returned to our mammal
brothers and sisters,
and all watched over
by machines of loving grace.[25]

For Brautigan, this vivid interweaving of the organic ("meadows," "pure water," "flowers," and so on) and the cybernetic ("computers," "machines," "electronics," and so on) reflected an explicitly Zen philosophy, and as such it mirrored the techno-philic visions of many counterculturalists fascinated with both Eastern mysticism and the burgeoning field of cybernetic computationalism. Consider, for example, Gary Snyder's ecological treatise *Earth House Hold* (1969), which reports (in consistent, log-keeping detail) on the mountain-to-mountain radio transmissions over his SX areal antennae between him and fellow Zen-devotees Jack Kerouac and Philip Whalen during two summers of fire lookout on Crater Mountain—including thoughts on adjusting his "mechanism of perception" by way of seeing the world as "a vast inter-related network."[26] Or notice Ken Kesey's Merry Pranksters, who were not only fascinated by far-out pharmacological technologies, but also utilized as part of their "Acid Test" celebrations all kinds of high-tech equipment: synthesizers, soundboards, electric guitars, reel-to-reel tape players, film projectors, amplifiers, and spectacles of electronic, neon light. Or consider the sophisticated "cybernetic" experimentation of Cage's Zen-inspired *Variations VII* (performed in collaboration with the Bell Telephone Labs in 1966), with his use of radios, electric juicers, fans, blenders, telephones, magnetic pickups, audio mixers, and contact microphones—all connected and activated in a massive control room by a series of wires and electric photocells (Figs. 7.3–7.4). Cage's close colleague, Nam June Paik, was no less interested in blurring the line between technological innovation and Eastern mysticism, as seen, for example, in *Zen for Film* (1964) and *TV-Buddha* (1974) (Plate 101). There was also the highly influential *technê*-Zen promoted at Esalen, California, in the late 1960s, where figures like Fritjof Capra offered seminars on the commensurability of quantum mechanics and Eastern mysticism (Capra eventually published *The Tao of Physics* in 1975), and where former Macy Conference participant Gregory Bateson gave seminars on the dynamic convergence of technological experimentation, cybernetic theory, and Zen Buddhism.[27] Countercultural Zen, in other words, was an already highly techno-philic endeavor, but, as I hope to show in the next section, it was Robert Pirsig's vivid articulation of *technê*-Zen that refined and amplified the discourse, providing it with the mainstream authority it exercises today.

Zen and the Art of Motorcycle Maintenance

The opening lines of Pirsig's *Zen and the Art of Motorcycle Maintenance* are immediately cybernetic, weaving together feedback loops of man, machine, and ecological environment: "I can see by my watch, without taking my hand from the left grip of

66

67

69

68

70

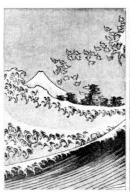

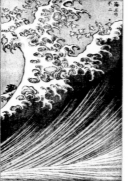

71

Plate 66. Two variants of the cover design, possibly by Charles Livingston Bull, for Charles G. D. Roberts's *Earth's Enigmas: A Book of Animal and Nature Life* (Boston: Lamson, Wolffe & Co., 1903) (images courtesy of John Lehner and the Beinecke Rare Book and Manuscript Library, Yale University).

Plate 67. Ando Hiroshige (1797–1858), *Eagle Flying over Fukagama District* (1857) (Library of Congress, pictures, item 2008660617).

Plate 68. Cover art by Jay Chambers (working for Decorative Designers) for Julia Darrow Cowles, *Jim Crow's Language Lessons and Other Stories of Birds and Animals* (New York: Thomas Y. Crowell & Co., 1903).

Plate 69. Shibata Zeshin, *Crows in Flight at Sunrise* (1888) (image courtesy of Dieter Wanczura, Artelino).

Plate 70. Copies of this London-published edition of Robert Louis Stevenson and Lloyd Osbourne, *The Ebb-Tide: A Trio and Quartette* (London: W. Heinemann, 1894), also circulated in the United States during the 1890s (image courtesy of the Beinecke Rare Book and Manuscript Library, Yale University).

Plate 71. "Kaijo no Fuji" (The Great Wave) from the second volume of Hokusai's *Hundred Views of Fuji* (1834), as reprinted in Friedrich Perzenski, *Hokusai* (Germany: Velhagen & Klasing, 1904), p. 83.

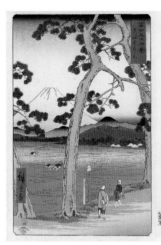
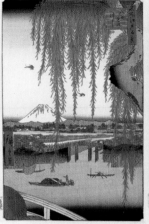

72

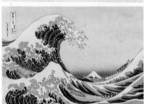

73 74 75

Plate 72. Three prints by Hiroshige: *Fuji on the Left Side of the Tokaido* (1858), *Yatsumi Bridge* (1856), and *Kinryuzan Temple* (1856) (Library of Congress, pictures, items 2008660394, 2009631868, and 2008660649).

Plate 73. Notice the top of Mt. Fuji extending beyond the pictorial border in Hiroshige's *Hara* (ca. 1836) and the large wave as a framing device in Katsushika Hokusai's most famous image, *The Great Wave* (ca. 1830).

Plates 74–85. A collection of covers published between 1890 and 1917 that engage in the new Oriental aesthetic, mimicking various techniques of Japanese prints: frequent vertical emphasis, strategic use of negative space, geometrized and abstracted forms from nature, the use of foreground objects as framing devices, paneled continuity, and the occasional extension beyond the pictorial frame. *Plate 74*: Alice Brown, *Country Neighbors* (Boston: Houghton, Mifflin & Co., 1910), cover artist unknown.

Plate 75. Detail of Brown, *Country Neighbors*.

Plate 76. Amelia E. Barr, *Prisoners of Conscience* (New York: Century Co., 1897), cover art by William Snelling Hadaway.

Plate 77. Detail of Barr, *Prisoners of Conscience*.

Plate 78. George Cabot Lodge, *The Song of the Wave* (New York: Scribner's, 1898), cover art likely by Lee Thayer of Decorative Designers (image courtesy of John Lehner).

Plate 79. Grant Showerman, *A Country Child* (New York: Century Co., 1917), cover art by Decorative Designers (image courtesy of John Lehner).

Plate 80. Robert W. Service, *The Spell of the Yukon and Other Verses* (New York: Barse & Hopkins, 1915), cover art by Decorative Designers (image courtesy of John Lehner).

Plate 81. Josiah Flynt, *The Little Brother* (New York: Century Co., 1902), cover art by Evelyn W. Clark (compare to Fig. 2.10).

Plate 82. Hamlin Garland, *Hesper* (New York: Harper & Brothers, 1903), cover artist unknown.

Plate 83. Norman Duncan, *The Cruise of the Shining Light* (New York: Harper & Brothers, 1907), cover art possibly by Thomas W. Ball.

76

77

78

79

80

81

82

83

84

85

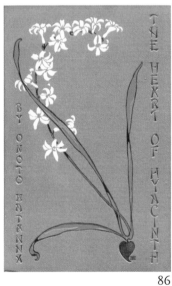

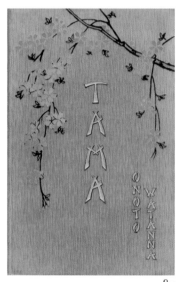

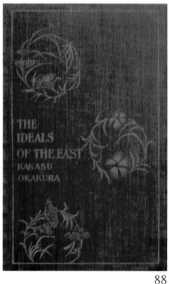

86

87

88

Plate 84. Robert Louis Stevenson and Lloyd Osbourne, *The Ebb-Tide: A Trio and Quartette* (Chicago: Stone & Kimball, 1894), cover art by Thomas Buford Meteyard (image courtesy of the Beinecke Rare Book and Manuscript Library, Yale University).

Plate 85. Stewart Edward White, *The Magic Forest* (New York: Macmillan & Co., 1903), cover artist unknown.

Plate 86. Cover design by Lee Thayer for Onoto Watanna's *The Heart of Hyacinth* (New York: Harper & Brothers, 1903) (image courtesy of John Lehner).

Plate 87. Cover design by Genjiro Yeto for Onoto Watanna, *Tama* (New York: Harper & Brothers, 1910).

Plate 88. Kakasu Okakura [Okakura Kakuzo], *The Ideals of the East with Special Reference to the Art of Japan* (London: John Murray, Albemarle Street, 1903); cover artist unknown.

89

90

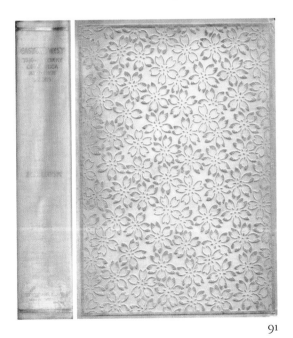

91

92

Plate 89. Okakura Kakuzo, *The Book of Tea*, as published in 1906 (New York: Duffield & Co.), cover lettering by Decorative Designers.

Plate 90. Mandala, from C. G. Jung, *The Red Book: A Reader's Edition* (New York: W. W. Norton & Co., 2009), p. 159 (image © 2009 The Foundation of the Works of C. G. Jung. Used by permission of W. W. Norton & Co., Inc.).

Plate 91. Sarah Wyman Whitman's design (undocumented) for Ernest Fenollosa's *East and West: The Discovery of America and Other Poems* (Boston: Thomas Y. Crowell & Co., 1893). Notice the characteristic "Torii gate" lettering on the "A," and the very similar flower pattern Whitman used in her design for Alice Bacon's *A Japanese Interior* (Plate 92).

Plate 92. Alice Mabel Bacon, *A Japanese Interior* (Boston: Houghton, Mifflin & Co., 1894), cover design by Whitman (image courtesy of the Trustees of the Boston Public Library).

93

94

95

96

Plate 97. Jacob Epstein, *The Rock Drill* (1913–1914), as reconstructed from its original form (image © Tate, London 2013).

Plate 93. Sonsho Mandala (Japanese, Kamakura period, first half of the thirteenth century), part of Ernest Fenollosa's personal collection (image courtesy of the Museum of Fine Arts, Boston, Fenollosa-Weld Collection, 11.4033; photograph © 2014).

Plate 94. The *dharmachakra* shows up with startling frequency in Fenollosa's art collection, here in the hand of a goddess, in "Benzaiten, the Goddess of Music and Good Fortune, and Fifteen Attendants" (Japanese, Muromachi period, fourteenth century; image courtesy of the Museum of Fine Arts, Boston, Fenollosa-Weld Collection, 11.4077; photograph © 2014).

Plate 95. A *dharmachakra* around the neck of the Buddha, in "Ichi Kinrin, the Cosmic Buddha of the Golden Wheel" (Japanese, Kamakura period, beginning of the thirteenth century; image courtesy of the Museum of Fine Arts, Boston, Fenollosa-Weld Collection, 11.4039; photograph © 2014).

Plate 96. Details of Plates 93–95 showing the *dharmachakra* or "wheel of the law," a ritual object associated with Esoteric Buddhism and used in conjunction with mandalas of the Kamakura period in Japan, and a standardized illustration of the *dharmachakra* from Ernst Lehner, *Symbols, Signs & Signets* (New York: Dover Publications, 1969), p. 22.

Plate 98. Cover art for *The Story of the Typewriter, 1873–1923* (New York: Herkimer County Historical Society, 1923), cover artist unknown.

Plate 99. Gustave Courbet, *Woman with a Parrot* (1866), oil on canvas. H. O. Havemeyer Collection, Bequest of Mrs. H. O. Havemeyer, 1929. The Metropolitan Museum of Art, New York, NY (image © The Metropolitan Museum of Art. Image source: Art Resource, NY).

Plate 100. Édouard Manet, *Young Lady in 1866* (1866), oil on canvas. Gift of Erwin Davis, 1889. The Metropolitan Museum of Art, New York, NY (image © The Metropolitan Museum of Art. Image source: Art Resource, NY).

Plate 101. Nam June Paik, *TV-Buddha* (1974), closed circuit video installation with bronze statue of Buddha (image courtesy Nam June Paik Estate).

FIGURE 4 Different shape arrangements based on a grid.

The Grid

A grid is an important layout tool, but it is often overlooked due to its rigidity. As in mathematics, a layout grid is simply a series of evenly spaced, crossing lines that create a set of logical, proportionately consistent boxes. These lines and boxes help set the stage for the design elements that will be added later. When a grid is closely followed, proportions and spacing may be more consistent, though perhaps at the expense of being overly ordered and creatively dry (**FIGURE 4**).

Classic table-based design demonstrates the unintentionally confining nature of an overly structured grid—an element placed within a table cell has no recourse but to stay within that cell. If an overlapping effect is desired, the adjoining cells need to play a part in the effect. Often the only way to accomplish any form of breaking out of the grid involves slicing images into tiny pieces and joining them back together by building grids within grids, or complex nested tables.

CSS, on the other hand, allows much more refined control over non-grid elements. A layout may be based on a grid structure, with many elements that spill outside the boundaries in a more fluid and spontaneous manner. The CSS positioning model gives much more freedom to elements. It allows you to nudge elements outside of their containers or reposition them anywhere else on the page.

Plate 102. Dave Shea and Milly E. Holzschlag, *The Zen of CSS Design: Visual Enlightenment for the Web* (Berkeley: Peachpit Press, 2005), p. 112. Notice that here the "Zen" method of CSS design is portrayed as allowing designers to transcend the "grid" of HTML (image courtesy of Dave Shea at CSS Zen Garden).

Plates 103–106. Designs from www.csszengarden.com using the same HTML code but different layers of CSS design (images courtesy of Dave Shea at CSS Zen Garden).

103

104

105

106

107

108

109

Plates 107–108. Screenshots from *Tron* (Walt Disney Productions, 1982) showing Jeff Bridges's character Kevin Flynn hacking into ENCOM's Master Control Program (MCP) wearing a karate-style Japanese robe.

Plate 109. Screenshot from *Tron* showing the austere Oriental décor at ENCOM headquarters.

Plate 110. Screenshot from *Tron* showing the chairman at ENCOM telling the defeated "Walt" that "ENCOM isn't the business you started in your garage anymore."

Plate 111. Screenshot from *Tron* showing a large Mickey Mouse head in the "Sea of Simulation."

Plate 112. Screenshot from *Tron* showing "light cycle" battles on the game grid.

Plate 113. Screenshot from *Tron Legacy* (Walt Disney Pictures, 2010) showing Kevin Flynn (Jeff Bridges) in one of his several moments of *zazen* meditation.

Plate 114. Screenshot from *Tron Legacy* showing the now curvilinear paths of the light cycles on the game grid (compare with Plate 112).

Plate 115. Screenshot from the final scene of *Tron Legacy* showing Kevin's son and his program-become-human motorcycling into the sunlight.

116

117

118

Plate 116. Frank Lloyd Wright, *Weeds and Wildflowers*, insert in William C. Gannett, *The House Beautiful* (River Forrest, IL: Auvergne Press, 1896), photogravure prints on Japanese (*mitsumata*) paper (image courtesy of the Frank Lloyd Wright Foundation [1028.021]).

Plate 117. Cover design by Wright for his *The Japanese Print: An Interpretation* (Chicago: Ralph Fletcher Seymour, 1912) (image courtesy of William Reese Co., Rare Books and Manuscripts, New Haven, Connecticut).

Plate 118. Two Japanese *mon* Wright drew inspiration from for his cover design for *The Japanese Print* (thereby participating in a very popular trend in American book design).

119

120

121

Plate 119. Georgia O'Keefe, *Abstraction No. 11, 1916*, inserted as frontispiece to F.S.C., Northrop, *The Meeting of East and West: An Inquiry concerning World Understanding* (New York: Macmillan & Co., 1946) (image courtesy of the Yale University Art Gallery, Katharine Ordway Fund).

Plate 120. Georgia O'Keefe, *From the Lake No. 3*, oil on canvas (1924) (image © Philadelphia Museum of Art: Bequest of Georgia O'Keefe for the Alfred Stieglitz Collection, 1987).

Plate 121. Wang Zi Won, *Buddha_Z in the Steel Lotus* (2011) (image courtesy of Wang Zi Won).

Figs. 7.3–7.4. Screenshots from John Cage's *Variation VII* (1966).

the cycle, that it is eight-thirty in the morning. The wind, even at sixty miles an hour, is warm and humid" (*ZMM*, p. 3). For the narrator (a mostly autobiographical version of Pirsig himself [28]), the cybernetic experience of riding his motorcycle on small, out-of-the-way rural roads is highly therapeutic: "Tensions disappear along old roads like this" (*ZMM*, p. 3). But it isn't just the natural scenery afforded by avoiding the traffic of the "four-laner." The motorcycle itself, we learn on the next page, is critical to this experience:

> You see things vacationing on a motorcycle in a way that is completely dif-
> ferent from any other. In a car you're always in a compartment, and because
> you're used to it you don't realize that through that car window everything
> you see is just more TV. You're a passive observer and it is all moving by you
> boringly in a frame. On a cycle the frame is gone. You're completely in con-
> tact with it all. You're *in* the scene, not just watching it anymore, and the
> sense of presence is overwhelming. (*ZMM*, p. 4)

The vision offered here is explicitly therapeutic; the motorcycle enables one to get outside the (*māyā*-projected?) "frame" and back into an overwhelming sense of "contact" and "presence." Indeed, Pirsig seems to be taking a page right out of Watts's doctrine of the wiggly. "Twisting hilly roads," he writes, are "much more enjoyable on a cycle where you bank into turns and don't get swung from side to side in any compartment. . . . We have learned how to spot the good ones on a map, for example. If the line *wiggles*, that's good" (*ZMM*, pp. 5–6; emphasis added).

The motorcycle is also important because even when traveling with others it demands a certain noncommunicative meditation of its operators: "Unless you're fond of hollering you don't make great conversations on a running cycle. Instead you spend your time being aware of things and meditating on them" (*ZMM*, p. 7). The motorcycle, in other words, makes for some great *zazen* (the Zen practice of extended meditation), and this inner contemplativeness plays into the narrative in important ways as well. The plot of the novel basically involves a man (the narrator) who takes his son (Chris) on a motorcycle vacation from Minnesota to San Francisco and along the way records his philosophical musings in the form of what he calls (after the late nineteenth-century traveling lecture and entertainment assemblies) "Chautauquas" (*ZMM*, p. 7). The major difference, however, is that the narrator's chautauquas are all interior, reflective musings and not at all the public experience of those earlier traveling assemblies.[29] It is central to my argument, in fact, that this intense interiority is important to the discourse of *technê*-Zen in *Zen and the Art of Motorcycle Maintenance* both because it provides a vehicle for Pirsig's own fantasies of self-justification and philosophical eminence and because it lays the groundwork for the ideological agenda of the novel—which will, in turn, make it enormously useful to the corporate culturalism and postindustrial capitalism of the 1980s and 1990s.

A number of biographical and historical events provided the motivation for Pirsig to write this deeply autobiographical narrative, most of which are described in *Zen and the Art of Motorcycle Maintenance* in roughly chronological order: the author's precocious intelligence during his early days as a student in Minnesota; his stint in Korea during his time in the army; his study at Banaras Hindu University in India; his frustrated efforts to teach composition at Montana State University in Bozeman; and his similarly aborted progress toward a degree in philosophy at the University of Chicago. The most important event in the narrative, however, is Pirsig's nervous breakdown during these later events and his subsequent time in psychiatric hospitals during the early 1960s. Having been diagnosed with clinical depression and paranoid schizophrenia, Pirsig was subjected to multiple doses of electroshock therapy. As his narrator in *Zen and the Art of Motorcycle Maintenance* explains, "Approximately 800 mills of amperage at durations of 0.5 to 1.5 seconds had been applied on twenty-eight consecutive occasions" (*ZMM*, p. 88)—a highly transformative event, to be sure, and one that plays a central role in both the novel and Pirsig's own life. All of these experiences are processed philosophically in the story by way of the narrator's inner chautauquas, but like any good psychoanalytic session (or novel) they do not all come out at once.

The first of several conflicts to emerge in *Zen and the Art of Motorcycle Maintenance* happens between Pirsig's narrator and two friends, a husband and wife by the name of John and Sylvia Sutherland, who have joined him on the first leg of their motorcycle journey. The point of contention between Pirsig's narrator and the Sutherlands has to do, at least initially, with the question of how much one should engage in one's own motorcycle maintenance. Pirsig's narrator argues, "it seems natural

and normal to me to make use of the small tool kits and instruction booklets supplied with each machine, and keep it tuned and adjusted myself." John and Sylvia, on the other hand, prefer to "let a competent mechanic take care of these things" (*ZMM*, p. 10). Neither view, of course, is necessarily extreme or unusual, but as the narrator contemplates this difference he begins to see it as symptomatic of a much deeper conflict:

> It's all of technology they can't take. And then all sorts of things started tumbling into place and I knew that was it. Sylvia's irritation at a friend who thought computer programming was "creative." All their drawings and paintings without a technological thing in them. . . . Of course John signs off every time the subject of cycle repair comes up, even when it is obvious he is suffering for it. That's technology. (*ZMM*, p. 23)

The Sutherlands, in other words, are neo-Luddites, and, as such, they come to serve as important cultural types for Pirsig's more pointedly ideological arguments. Consider, for example, the most famous passage in *Zen and the Art of Motorcycle Maintenance*, which offers *techné*-Zen as an aesthetic and deeply natural way of living *with* technology rather than fighting against it:

> Their flight from and hatred of technology is self-defeating. The Buddha, the Godhead, resides quite as comfortably in the circuits of a digital computer or the gears of a cycle transmission as he does at the top of a mountain or in the petals of a flower. To think otherwise is to demean the Buddha—which is to demean oneself. (*ZMM*, p. 26)

For Pirsig, to say that the Buddha "resides" in a mechanical object is not to say that some spiritual, otherworldly essence is haunting these gears and circuits. To demean technology is to demean the Buddha and oneself because technology is merely a material manifestation of an "underlying form" of analytic thought. And, for Pirsig, there are ways of understanding and employing analytic thought (and technology) that are consistent with the aestheticized practices of Zen. Even heavy industrial systems are only extensions of human thought and, as such, not the real source of evil. The root of the problem has to do with our all-too-rational patterns of thought: "to tear down a factory or to revolt against a government or to avoid repair of a motorcycle because it is a system is to attack effects rather than causes; and as long as the attack is upon effects only, no change is possible. The true system, the real system, is our present construction of systematic thought itself, rationality itself" (*ZMM*, p. 98). The problem arises, he explains, when people portray "romantic" (that is, wiggly, hip, aesthetic, experiential, Eastern) and "classic" (that is, *māyā*-projected, square, scientific, theoretical, Western) forms of thinking as necessarily antagonistic: "in recent times we have seen a huge split develop between a classic culture and a romantic counterculture—two worlds growing alienated and hateful toward each other with everyone wondering if it will always be this way" (*ZMM*, p. 71).[30] This is why motorcycles are so useful to Pirsig as an ongoing point of discussion. They may be mass-produced, technological products, created by means of "classic" thinking, but they are also wonderfully "romantic" vehicles that allow for free and wiggly traveling across the grids of America (a notion already firmly established by the "rebellious motorbiker" film genre of the 1960s). As Pirsig's narrator puts it, "although motorcycle riding is romantic, motorcycle maintenance is purely classic" (*ZMM*, p. 70). The motorcycle as a conceptual, philosophical object, then, reveals Pirsig's more synthetic

purpose: "What has become an urgent necessity is a way of looking at the world that does violence to neither of these two kinds of understanding and unites them into one" (*ZMM*, p. 80). Thus, even heavy industries and the digital circuits of a computer could become the products of a much lighter, more aesthetic process, given the proper philosophical outlook; and, as we shall see, Pirsig will claim to have discovered, by way of *techné*-Zen, *the* philosophical answer to such a challenge.

But before we can see how this answer plays out in the novel and its reception, it will be necessary to note that the manner in which Pirsig arrives at these insights is a very important part of his narrative. What makes *Zen and the Art of Motorcycle Maintenance* such an intriguing novel and, indeed, what makes it literary rather than strictly biographical or philosophical is that the narrative develops by way of a complex mystery—a ghost story of sorts. One night, after traveling through a storm, Pirsig confesses to his son that he has seen a ghost, and he knows who it is. The ghost's name, he tells Chris, is Phaedrus, but who exactly this Phaedrus is will remain a mystery until the sixth chapter, when the narrator decides that it is time, finally, to "reopen his case" (*ZMM*, p. 69). Here Pirsig's narrator confesses he has actually been getting all of his ideas about technology, Zen, and the romantic/classic split from Phaedrus, and he wants to explain how Phaedrus developed these ideas and where they eventually took him: "what Phaedrus thought and said is significant. But *no* one was listening at that time and they only thought him eccentric at first, then undesirable, then slightly mad, and then genuinely insane. There seems little doubt that he was insane, but much of his writing at the time indicates that what was driving him insane was this hostile opinion of him" (*ZMM*, p. 72).[31] Phaedrus, the narrator explains, was a "knower of logic" (*ZMM*, p. 84). He was so intelligent that "his Stanford-Binet IQ, which is essentially a record of skill at analytic manipulation, was recorded at 170, a figure that occurs in only one person in fifty thousand" (*ZMM*, p. 84)—a real child prodigy. But his intelligence also produced isolation: "In proportion to his intelligence he was extremely isolated. . . . He traveled alone. Always. Even in the presence of others he was completely alone. . . . His wife and family seem to have suffered the most" (*ZMM*, pp. 84–85). Eventually, we learn that Phaedrus is in fact the pre-electroshock-therapy narrator himself. That previous lone-wolf self, which he has come to call Phaedrus (because Pirsig thought, mistakenly, that the ancient Greek name meant "wolf"[32]), was "destroyed by order of the court, enforced by the transmission of high-voltage alternating current through the lobes of his brain" (*ZMM*, p. 91). Thus, in what remains of the narrative, Pirsig tells of Phaedrus's grand discovery, his persecution by the academy, his insanity, and his reunion with the narrator in the final scenes of the book.

Phaedrus's initial move toward his grand discovery comes as he is stationed in Korea while serving in the army. While there, Phaedrus encounters a particular wall, "seen from a prow of a ship, shining radiantly, like a gate of heaven, across a misty harbor." The memory of that wall must be valuable to Phaedrus, the narrator explains, because it sticks in his mind as "symboliz[ing] something very important, a turning point" (*ZMM*, p. 122). What exactly that wall symbolizes is detailed more fully later in the narrative:

That wall in Korea that Phaedrus saw was an act of technology. It was beautiful, but not because of any masterful intellectual planning or any scientific supervision of the job, or any added expenditures to "stylize" it. It was beautiful because the people who worked on it had a way of looking at

things that made them do it right unselfconsciously. They didn't separate themselves from the work in such a way as to do it wrong. There is the center of the whole situation.

The way to solve the conflict between human values and technological needs is not to run away from technology. That's impossible. The way to resolve the conflict is to break down the barriers of dualistic thought that prevent a real understanding of what technology is—not an exploitation of nature, but a fusion of nature and the human spirit into a new kind of creation that transcends both. (*ZMM*, p. 298)

But, for Phaedrus, the East is not the final destination in his new metaphysics. Indeed, after traveling to India to study "Oriental Philosophy" at Benaras Hindu University, Phaedrus grows dissatisfied with the "Oriental" teachers' refusal to engage in analytic rigor. In the end, he decides that an exclusively Eastern approach remains "hopelessly inadequate," and so he leaves India and gives up studying for a while, eventually taking a job teaching composition at Montana State University in Bozeman (*ZMM*, p. 142). There, however, he becomes equally unimpressed by the all-too-Western thinking he encounters (the Western academy comes to be referred to at this point in *Zen and the Art of Motorcycle Maintenance*, rather disdainfully, as the "Church of Reason" [*ZMM*, p. 145]). Unsatisfied as he is with teaching composition something happens to Phaedrus one day on campus that will eventually change his entire philosophical outlook. One of his colleagues, an elderly woman,

came trotting by with her watering pot . . . going from the corridor to her office, and she said, "I hope you are teaching Quality to your students." This in a la-de-da singsong voice of a lady in her final year before retirement about to water her plants. That was the moment it all started. That was the seed crystal. . . . That one sentence . . . and within a matter of a few months, growing so fast you could almost *see* it grow, came an enormous, intricate, highly structured mass of thought, formed as if by magic. (*ZMM*, pp. 180–181)

What follows in *Zen and the Art of Motorcycle Maintenance* is Phaedrus's rather obsessive pursuit of this elusive concept. He becomes listless and despondent, sensing that he *knows* what Quality is, and yet he can't quite grasp the best way to teach it to his students: "Most people would have forgotten about Quality at this point, or just left it hanging suspended because they were getting nowhere and had other things to do" (*ZMM*, p. 183). But Phaedrus is relentless: "when he woke up the next morning there was Quality staring him in the face. Three hours of sleep and he was so tired he knew he wouldn't be up to giving a lecture that day . . . so he wrote on the blackboard: 'Write a 350-word essay answering the question, What is *quality* in thought and statement?' Then he sat by the radiator while they wrote and thought about quality himself" (*ZMM*, p. 184). What seems to be missing in both the East and the West, according to Phaedrus, is a unified field vision of "Quality." And so ends the fifteenth chapter of *ZMM*, with Phaedrus wondering "What the hell is Quality? What *is* it?" (*ZMM*, p. 184). Does it inhere in an object? Or is it merely a subjective act of judgment? Could Quality serve as a "point of common understanding between the classic and romantic worlds"? (*ZMM*, p. 224). That Quality seems to exist in both the romantic and classic worlds—that it is both "within" and "beyond" both forms of thinking (*ZMM*, p. 237)—leads Phaedrus to the notion that it "wasn't subjective or

objective either, it was beyond both of *those* categories" (*ZMM*, p. 237). Quality, then, becomes a kind of cosmic, third entity prior to any subjectivity or objectivity. This is the grand epiphanic insight: "And finally: Phaedrus, following a path that to his knowledge had never been taken before in the history of Western thought, went straight between the horns of the subjectivity-objectivity dilemma and said Quality is neither a part of mind, nor is it a part of matter. It is a *third* entity which is independent of the two" (*ZMM*, p. 238). Quality becomes not a *"thing"* but an *"event"* (*ZMM*, p. 242), something that, according to Phaedrus, "is the *cause* of the subjects and objects, which are then mistakenly presumed to be the cause of the Quality!" (*ZMM*, p. 242). Quality is revealed as embodying a kind of absolute priority. At last, "he had broken the code" (*ZMM*, p. 258).

The remainder of *Zen and the Art of Motorcycle Maintenance* is devoted to testing out the consequences and implications of Pirsig's great discovery. At one point, for example, Phaedrus picks up a copy of the *Tao Te Ching* and notices that if one substitutes the word *Tao* with the word *Quality*, something like the same metaphysical doctrine emerges: *"The Quality that can be defined is not the Absolute Quality. . . . Quality is all-pervading. And its use is inexhaustible!"* (*ZMM*, pp. 256–257). It becomes "the answer to the whole problem of technological hopelessness" (*ZMM*, p. 276). The most devastating consequence of this new insight, however, involves his attempt to bring it with him to the University of Chicago. Phaedrus, it turned out, had the apparent misfortune of pursuing his PhD under the direction of Richard McKeon, known in the novel only and rather derisively as "The Chairman." The real life McKeon already had a reputation in academia for, as one of his former students put it, "a surpassing sharpness for his dialectical assaults and defenses"—a man "remorseless in the drive of his logic."[33] He prided himself on teaching the classic texts with what he termed a "sympathetic literalness" that defended, somewhat fanatically, the original as if the author were present in the classroom. For someone as convinced as Phaedrus was that he had discovered *the* final nondualism to end all dyads and that "it was time Aristotle got his" (*ZMM*, p. 354), the coming clash with a sympathetic literalist like McKeon was perhaps inevitable. The more detached narrator of *Zen and the Art of Motorcycle Maintenance*, looking over Phaedrus's hubris, admits that he lacked the "ability to understand the effect of what he was saying on others," and that he had become "caught up in his own world" (*ZMM*, p. 354). But these are portrayed as understandable offenses for one on his way to "a major breakthrough between Eastern and Western philosophy, between religious mysticism and scientific positivism" (*ZMM*, p. 354). In the final showdown, the narrator depicts Phaedrus humiliating "The Chairman" in the classroom for failing to see just how radically Socrates had mischaracterized the Sophists.[34] It is probably not a very fair characterization of McKeon (who comes across as petty, arrogant, and insecure), but Phaedrus's rereading of the pre-Socratics as espousing a form of *arête* closer to the dynamic notions of "Quality" and "excellence" rather than to fixed, Truth-bound notions of "virtue" is actually quite remarkable. It is a philosophical holism with echoes in the phenomenological and postmodern philosophies of Martin Heidegger, Maurice Merleau-Ponty, Jacques Derrida, Stanley Fish, and even—in a final, painful twist of irony—in two of Richard McKeon's less wounded students, Richard Rorty and Wayne Booth.[35] Indeed, if Phaedrus had pursued his insights with a bit more patience and less megalomaniacal fervor, he might have gone on to a fine career in academia. (That he would go on to write one of the best-selling novels of the twentieth century is its own consolation, no doubt.)

In any case, the possibility of such a career is treated only with disdain in Pirsig's novel. Phaedrus recoils from his interaction with "The Chairman," feeling only "disgusted" (*ZMM*, p. 400). Suffering under the weight of this insight and its rejection by the academy, Phaedrus eventually goes insane, staring at his bedroom wall for days on end, urinating in bed, his cigarettes burning down into his fingers. Phaedrus isn't far, at this point, from undergoing the "liquidation" of his personality by electroshock therapy; he isn't far, that is, from becoming the narrator. But the search for a nondualistic philosophy in *Zen and the Art of Motorcycle Maintenance* is also the search for a nondualistic self in Pirsig.[36] Indeed, what is often quoted from the novel as a kind of banal self-help cliché is actually a rather sophisticated metanarrative moment: "The real cycle you're working on is a cycle called yourself. The machine that appears to be 'out there' and the person that appears to be 'in here' are not two separate things. They grow toward Quality or fall away from Quality together" (*ZMM*, p. 332). Cycle-as-self here means both the metaphorical engine or vehicle *and* the cyclical returning to a former self, as the narrator of *Zen and the Art of Motorcycle Maintenance* experiences with Phaedrus. For Pirsig, Quality—like the letter "Q"—is a metaphysical circle with a kickstand.

It seems clear, in other words, that Pirsig wants both to redeem Phaedrus and reunite him with the narrator, but one casualty of that originary rupture has also been haunting the book like a ghost: Pirsig's son, Chris. The narrator constantly struggles with the tension created between his recognition that he failed in some crucial (which is to say *qualitative*) way as a father and his conviction that the philosophical insights he developed demanded precisely this sacrifice. The various moments when Chris enters the narrative he appears generally unhappy, perhaps even unstable, and it is not hard to see why. Chris seems more like a hostage to his father's unrelenting inwardness than he does a young kid on a vacation. The narrator routinely insults Chris (at one point calling him a "complete bastard"), refuses to console him, and on at least a few occasions seems to physically intimidate him (see *ZMM*, pp. 59, 64, 67). For Pirsig's narrator to be fully redeemed, then, he not only has to revisit and confirm the philosophical insights developed by his former self but also reveal that in the process of discovering these ideas he committed a number of what seem to be rather low-Quality acts. He cannot, however, allow that lack of Quality to cancel out the truth-value of his "Metaphysics of Quality." To put the matter in what are the obviously intended symbolic terms, God must be all good at the same time that he tortures his Son. Thus, for Chris to become a metaphorical stand-in for Christ, he has to have at least a glimpse of the divine plan, which occurs in the final scenes of the novel:

> Now the fog suddenly lifts and I see the sun on his face makes his expression open in a way I've never seen it before. He puts on his helmet, tightens his strap, then looks up.
>
> "Were you really insane?"
> Why should he ask that?
> "*No!*"
> Astonishment hits. But Chris's eyes sparkle.
> "I knew it," he says.
>
> Then he climbs on the cycle and we are off. (*ZMM*, p. 419)

With Chris now "sparkling" over this revelation, the last chapter finds Father and Son emotionally reunited, driving together along the "wiggly" path: "The road continues

to twist and wind through the trees. It upswings around hairpins and glides into new scenes one after another around and through brush and then out into open spaces where we can see canyons stretch away below" (*ZMM*, p. 421). And then, as the pair take off their helmets (with hints toward casting off their mortal selves), we see, finally, Chris(t)'s ascension:

> More trees and shrubs and groves. It's getting warmer. Chris hangs onto my shoulders now and I turn a little and see that he stands up on the foot pegs. . . . After a while when we cut sharp into a hairpin under some over-hanging trees he says, "Oh," and then later on, "Ah," and then, "Wow." . . .
>
> > "What's the matter?" I ask.
> > "It's so different."
> > "What?"
> > "Everything. I never could see over your shoulders before."
>
> The sunlight makes strange and beautiful designs through the tree branches on the road. It flits light and dark into my eyes. We swing into a curve and then up into the open sunlight. (*ZMM*, p. 410)

Suddenly convinced of his Father's sanity, standing up on the foot pegs (thus suspended by the nail-like bars installed on the sides of the sacred machine), Chris transcends his Father's torture and ascends—in curvilinear, wiggly fashion—"up into the open sunlight."

Whether or not one finds the implied sacrifice and ascension of Chris persuasive goes a long way to determining how one feels, finally, about the novel.[37] Some critics see this abrupt, cathartic transformation as evidence that the narrator has "come home to a Quality that was never really lost by reaching a vastly fuller union with his son, within himself, and with the whole world."[38] Others argue that after hundreds of pages of noncommunicative rudeness bordering on abuse, this sudden reconciliation feels a bit empty without any apology or promise of renewed sensitivity.[39] But for every critic, *Zen and the Art of Motorcycle Maintenance* has a whole group of devotees, with a growing number of readers debating online the book's philosophical assertions.[40] It is my contention, however, that the most powerful and influential legacy of the novel can be found not in the academy (where Pirsig has received very little attention), and not in the archives of cultish web discussions (where Pirsig is fervently admired by a small and fairly inconsequential group of fans), but rather in the hallowed halls of today's corporate "campus." Breaking down *Zen and the Art of Motorcycle Maintenance* into its most salient themes, we see why this might have been the case. First, despite whatever ills modern technological and industrial systems have been accused of, to simply abandon them is escapist; to transform these systems, one must find a way of synthesizing "classic" and "romantic" forms of thinking. Next, the result of that synthesis, which Pirsig calls the Metaphysics of Quality, must come *prior* to any objective or subjective understanding of manufactured products. Furthermore, academia is morally bankrupt; one cannot hope to find the answers to these questions in the "Church of Reason," and so we must look to the East (but not exclusively) in our efforts at reshaping our modes of technological experience in the West. And, finally, there may be some unfortunate, but necessary personnel casualties (call them externalities) in the journey toward a greater manifestation of Quality; however, these can be remedied with a discourse of techno-transcendentalist at-one-ment.[41] As a number of scholars of global capitalism have noticed, this particular

combination of themes will eventually come to serve as a broad discursive foundation for what we know today as the corporate culture of information work.[42] Pirsig's novel would become an active participant (whether unwittingly or not) in the effort to delineate a new *technê*-Zen for the postindustrial landscape. How then did *Zen and the Art of Motorcycle Maintenance* get cast into this role?

Technê-Zen and the Art of Late Capitalism

If there was one overarching concern of corporate managers in the West during the 1980s, it was this: "Japanese manufacturers trounced American ones in the 1980s because they embraced 'quality.'"[43] It was an anxiety that seemed to show up everywhere: in films like Ron Howard's *Gung Ho* (1986), TV documentaries like NBC's *If Japan Can, Why Can't We?* (1980) and PBS's *Japan: The Electronic Tribe* (1987), in alarmist proclamations of "The Japanese Threat" in *Fortune* and *Business Week*, as well as in terrorist acts of violence against Asian-America (detailed vividly in Renee Tajima's 1987 documentary *Who Killed Vincent Chin?*).[44] The proposed solution to the apparent Japanese monopoly on quality involved two main manufacturing and corporate reconfigurations: (1) a reconsideration of quality as a product of statistical, systems-theory analysis, revealed most obviously in the sudden popularity of W. Edwards Deming and in calls for wide-scale adaptations of Japanese just-in-time production methods (sometimes known as Lean Production or Toyotism); and (2) a new approach in management studies geared toward counterintuitive "Zen" forms of leadership that embraced more flexible models of team culture and technological innovation.

By the late 1980s, most likely every CEO in America had heard of W. Edwards Deming. He was, as one book hailed him, *The American Who Taught the Japanese about Quality*.[45] Deming's expertise was in the area of statistical process control, and he had been invited to Japan at General Douglas MacArthur's request to work on the first Japanese postwar census in 1947. While there he also began to consult Japanese managers on how best to rebuild their war-torn industries, and within just a few years he had helped to completely transform the Japanese economy. Toyota, to this day, hangs a large portrait of Deming in the main lobby of their headquarters in Tokyo, and the annual Deming Prize remains the most prestigious manufacturing award in Japanese industry.[46] Deming's theories of statistical control had quite a lot in common (both in terms of terminology and philosophical premise) with cybernetics. In the 1920s Deming had interned at the Bell Laboratories and had come in contact with many of the same individuals and theories of information that would go on to influence Wiener's cybernetics and other systems theories years later.[47] As a result, his frequent use of the quality-control flowchart, among other innovations, relied explicitly on the statistical analysis of feedback mechanisms (Figs. 7.5–7.6). Indeed, Total Quality Management, as the movement adopting Deming's methods eventually came to be known, was a highly cybernetic process. It involved managing, by way of statistically monitored feedback loops, a constant flow of information and parts toward an assembly-line worker, designed to arrive "just in time" rather than to accumulate in large quantities of static storage inside the factory—all of which allowed for much greater flexibility and last-minute variation in product lines. In addition, rather than following the Fordist model of keeping the assembly line moving at all costs (and then repairing botched products later on during quality-control inspection), Deming's system allowed any worker to bring the entire line to a halt at any time upon noticing any defect in the moving product.[48] Deming's basic philosophical

Figs. 7.5–7.6. Illustrations of W. Edwards Deming's Quality Control Flowchart as modeled in *Dr. Deming: The American Who Taught the Japanese about Quality* (New York: Simon and Schuster, 1990), p. 161.

premise was that considerations of quality must come *prior* to both the (objective) manufacturing of a product and (subjective) considerations of profit. That these Total Quality processes, perfected by the Japanese using quasi-cybernetic theories of statistical control, overlap in uncanny ways with Pirsig's Metaphysics of Quality has not been lost on the authors of the Total Quality Management movement.[49] References to Pirsig and his Metaphysics of Quality appear with striking regularly in titles like *Quality and Power in the Supply Chain*; *Fundamentals of Total Quality Management*; and *Qualitative Methods in Management Research* (see Appendix D for a broader sampling of Total Quality Management studies that directly cite Pirsig's Metaphysics of Quality). Pirsig has become Deming's spiritual cousin.

A second transformation in U.S. corporations in the late 1970s and early 1980s involved a massive reconsideration of corporate management theory. According to early twentieth-century Taylorist/Fordist models of scientific management, the task of the manager was to break down a worker's job into specific procedures so that even the least intelligent could understand it and to provide incentives so that even the least motivated would be willing to perform it energetically.[50] Even relatively "decentralized" theories of management during the first half of the twentieth century (for example, the Sloanism at General Motors) generally adhered to notions of command and control that might be simply described as distributed Taylorism.[51] By the early 1960s, however, a number of "countercultural" critiques of the Taylorist model began to enter management discourse. Douglas McGregor, for example, contrasted the strictures of Taylorism, which he called "Theory X," with the more humane tenets of what he called "Theory Y," which, according to McGregor, offered integration, teamwork, and better worker–management communication as a means of allowing

a corporation to "realize the potential represented by its human resources."[52] Scattered experiments in Theory Y (or "soft") management during the 1960s made their way into a number of corporations—for example, Procter & Gamble, Shell Oil, and General Foods—by way of the National Training Laboratories (which, as Art Kleiner has argued, served as a basic template for the modern corporate training program).[53] But it was not until the "Japan Crisis" of the late 1970s that corporate managers in the United States began to question more radically the Taylorist objectives of management discourse.

In his recent study *Zen at War*, Brian Victoria has shown that what the dozens of management scholars visiting Japanese corporations in the 1970s would have encountered was not only the quality-control methods introduced by Deming in the 1950s but also an entire reconfiguration of Zen Buddhism for the Japanese corporation. Such an argument comes by way of a rather startling revelation for some American Buddhists: what had been understood in the United States as a largely peace-loving religion had actually, at least until the end of World War II, contributed rather enthusiastically to some of the most egregious moments of Japanese militarism, such that even famous Buddhists like D. T. Suzuki offered a number of hawkish speculations on the commensurability of Zen and the Bushido warrior ethic of "obedience" and "conformity."[54] After the war, when, as Brian Victoria explains, Japanese "companies realized that schools were no longer emphasizing the old virtues of obedience and conformity," a series of Zen training programs were developed for a number of Japanese corporations (Z, p. 182). Zen masters became frequent visitors of Japanese companies (and vice versa), where they gave sermons, arguing things like, "by carrying out our [assigned] tasks, we become part of the life of the entire universe; we realize our original True Self" (Z, p. 185). As Victoria argues, what Japan's defeat during World War II meant was, "not the demise of imperial-way Zen and soldier Zen but only their metamorphosis and rebirth as corporate Zen" (Z, p. 186).

That this reconfiguration of Zen Buddhism bolstered new forms of Japanese industrial automation and organizational control during the 1970s is shown most strikingly in a volume published in Japan the same year Pirsig's novel appeared in the West: Masahiro Mori's *Bukkyō Nyūmon* (1974), translated into English a few years later as *The Buddha in the Robot*.[55] As one of Japan's leading experts in automated control and robotics, Mori exercised enormous influence on a number of Japanese industries throughout the 1970s and 1980s, never hesitating to put a religious spin on his (avowedly cybernetic) notions of what he called the "man-machine system."[56] The final argument of *The Buddha in the Robot* could have come straight from Pirsig (and vice versa): "If we are to coexist with machines," Mori argues, "we must develop the spiritual strength needed to control the vast power that a man-machine system possesses. . . . My robot's call is loud and clear: 'The more mechanized our civilization becomes, the more important the Buddha's teaching will be to us all.'"[57] Mori even has a chapter titled "Seek Happiness in Quality, Not Quantity," and the "Quality" he means here is not the quaint goal of some self-help optimism, but an intrinsically Buddhist doctrine that all material and organizational entities (human bodies, robots, corporations, automated systems, and so on) are manifestations of cosmic flux, and so must be understood and administered in these terms.[58] It is in this sense that Mori will argue, "I believe robots have the Buddha-nature within them."[59] Accordingly, in 1970 Mori founded the *Jizai Kenkyujo* (typically translated in English as "Mukta Institute," with Mukta being the Sanskrit term for "spiritual liberation"),

an organization devoted to training corporate technologists and management theorists in areas of automation, roboticization, and product development.[60] One of the institute's "graduates," for instance, was Soichiro Honda, the founder of the Honda Motor company (which, interestingly enough, had manufactured Pirsig's 1964 motorcycle, the Honda Superhawk, CB77).[61] Held up as a shining example of successful management and industrial automation, Honda Motors adopted Mori's philosophy during the 1970s and reorganized their factory floor by incorporating employees into feedback systems and smaller-scale assembly operations, encouraging workers to design their own automation devices.[62]

Thus, in early studies published in the United States like Japan business expert William Ouchi's *Theory Z: How American Business Can Meet the Japanese Challenge* (1982), Japanese business culture is described, in a nod to McGregor's terms, as neither hard (Theory X) nor soft (Theory Y), but rather as a new Theory Z (clearly playing with "Zen"). Japanese Type Z organizations can be "most aptly described as clans in that they are intimate associations of people engaged in economic activity but tied together through a variety of bonds." Obedience and loyalty to the corporation becomes more intuitive and cultural, part of the "wholistic relation between employees" rather than something strictly enforced by a given hierarchical structure.[63] In *The Art of Japanese Management* (1981), two of Ouchi's collaborators, Richard Pascale and Anthony Athos, argue (in a chapter titled "Zen and the Art of Management") that the Japanese are "more means oriented, or process oriented, whereas Americans tend to focus more on the bottom line, on the ends. Americans are more Aristotelian. We feel if it is not white, by deduction it has to be black. The Japanese live comfortably with gray."[64] The Japanese are "generally suspicious of too much logic." Whereas American managers might exhibit a "drive for closure," Japanese managers, by contrast, "tend to be more savvy. . . . The Japanese are regularly encouraged to reflect on their experience. Some executives even do Zen meditation with the purpose of clearing their minds so they may reflect on their experience more deeply."[65]

Ouchi, Pascale, and Athos were highly influential in management discourse during the 1980s. With distinguished professorships at University of California, Los Angeles, Stanford University, and Harvard University, respectively, all three scholars also benefited from funding by what was then (and still is) the leading management and consulting firm in the United States, McKinsey & Company. Indeed, the meetings conducted at McKinsey headquarters in June 1978 with Pascale, Athos, Tom Peters, and Bob Waterman on the topic of "excellent companies" formed the basis for what would eventually become the best-selling management book of all time, Peters and Waterman's *In Search of Excellence* (1982). That the approach advocated by Peters draws on countercultural assumptions about Zen Buddhism has been noted by a number of scholars.[66] It is perhaps sufficient here to point out that in *In Search of Excellence* the authors cite one of their "favorite stories"; a certain Honda worker

> on his way home each evening, straightens up windshield wiper blades on all the Hondas he passes. He just can't stand to see a flaw in a Honda!
>
> Now, why is all of this important? Because so much of excellence in performance has to do with people's being motivated by compelling, simple—even beautiful—values. As Robert Pirsig laments in *Zen and the Art of Motorcycle Maintenance*: "While at work I was thinking about this lack of care in the digital computer manuals I was editing. . . . They were full of errors, ambiguities, omissions and information so completely screwed up you had

to read them six times to make any sense of them. But what struck me for the first time was the agreement of these manuals with the spectator attitude I had seen in the shop. These were spectator manuals. It was built into the format of them. Implicit in every line is the idea that, 'Here is the machine, isolated in time and space from everything else in the universe. It has no relationship to you, you have no relationship to it.' "[67]

A more detached observer might note that what Peters and Waterman are praising here seems more like evidence of an obsessive-compulsive disorder than it does a healthy practice for the average worker (the wiper blades on *all* the Hondas he passes?). But the point is that this Honda Motors worker is described as evidencing a devotional, cybernetic relationship with machine systems, a kind of enlightened awareness of Quality (Peters's word is "excellence")—and, of course, Pirsig's doctrine of *technê*-Zen is ushered in as *the* scriptural point of reference. In a follow-up volume, *A Passion for Excellence*, Peters would again cite Pirsig's *Zen and the Art of Motorcycle Maintenance*, calling it the "most constructive book on the topic [of Quality]."[68] Peters's message in subsequent decades has become increasingly antirationalist, his prose more outrageous and zany. With titles such as *Thriving on Chaos* (1987), *Crazy Times Call for Crazy Organizations* (1993), and *The Pursuit of WOW!* (1994), it is no wonder that Peters was recently dubbed the "original Zen businessman."[69]

But Peters is only one of several management "gurus" (a name that is itself rather suggestive of the discourse I am identifying) promoting *technê*-Zen as the animating principle of information-age management theory. Peter F. Drucker, the "undisputed alpha male" in management studies and author of more than twenty-six books and thousands of articles on management, also held a distinguished chair in Oriental art at the Claremont Graduate School (publishing a volume in 1982 titled *The Zen Expressionists: Painting of the Japanese Counterculture, 1600–1800*).[70] Peter Senge, author of what is perhaps the most widely cited volume on the corporate centrality of knowledge work, *The Fifth Discipline: The Art and Practice of the Learning Organization* (1990), is an active Zen Buddhist and reportedly meditates regularly.[71] It is not difficult to see why these apostles of informatics and networking would gravitate toward *technê*-Zen. The embracing of alternative rationalities in the ascetic reengineering of corporations in the 1990s; the dematerialization of cubicle work (as Alan Liu has argued, where once upon a time matter mattered, "*post*industrial corporations must de-essentialize themselves until they are nothing but information processing" [*LC*, p. 43; emphasis in original]); the celebration of flexibility, flow, chaos, virtuality, and creative destruction; the aggressive antihistoricism of the eternal corporate present— it's all so very *Zen*. As the authors of *The Corporate Mystic* explain,

> Corporations are full of mystics. Over the past 25 years we have been in many boardrooms and many cathedrals, and we have discovered that the very best kind of mystics—those who practice what they preach—can be found in the business world. We are now convinced that the qualities of these remarkable people, and the principles they live by, will be the guiding force for 21st-century enterprise.[72]

It would be difficult to overestimate just how dramatically these corporate "mystics" have gravitated toward *technê*-Zen. There are literally hundreds of books currently in print arguing for the ultimate commensurability of Zen and the healthy corporate life (see Appendix E for a representative sampling).

Silicon Grids and *Techne*-Zen

Certainly no realm of postindustrial information work has had a better relationship with Zen than the "mystical" corporate world of Silicon Valley. Take, for example, Steve Jobs, who while still employed at Atari in the mid-1970s (and already a deeply committed fruitarian, having traveled on a kind of mystical quest throughout India in the early 1970s), began frequenting the Los Altos Zen Center, meditating and studying under Zen master Kobin Chino Otogawa. Jobs studied for several years with Otogowa during his first years at Apple, employed him as the official *roshi* of his subsequent company NeXT, and even asked Otogawa to officiate at his marriage in 1991.[73] It is not irrelevant, I would argue, that the iPod, iMac, and iPad hearken back, in both aesthetic and homonymic approximation, to the *iChing*, or that the iPod stole its layout from Creative Worldwide, Inc.'s "Zen" mp3 player.[74] Following Steve Jobs's death, for instance, *Forbes* magazine hired the creative data visualization firm Jess3 to develop a graphic novel titled *The Zen of Steve Jobs* (2012), drawing very specific connections between the doctrine of Buddhist "circles" taught to Jobs by Otogawa and the designs for Apple's most innovative products (especially the iPod).[75] Indeed, marketing the Mac has, from the beginning, involved characterizations of the machine's ability to both harness and transcend the "obsessive perfection of the analytical grid"—this from the author of (what else?) *Zen and the Art of the Macintosh* (1986).[76]

Even on the PC side of the digital revolution the ubiquity of *techne*-Zen is remarkable. The IBM PC's first killer app, for example, was Mitch Kapor's provocatively named *Lotus 1-2-3*, a name Kapor decided on after teaching transcendental meditation at Cambridge. Oracle founder and noted Japanophile Larry Ellison has also commented that in starting Oracle he tried very hard to "replicate" Japanese Zen culture.[77] His palatial home in northern California was built as a kind of Zen-inspired compound. Or, to point to yet another example, take Novell's Desktop Managing Interface program ZENworks. Conceived in 1994 by one of Novell's senior software engineers, the point of ZENworks was (and still is) to allow for "policy-driven automation" and remote control of Windows- or Linux-based workstations by way of centralized IT management. As Novell's product description explains, the "ZEN" in ZENworks is an acronym for "Zero Effort Networking," which is then associated with the "enlightened" network possibilities allowed for by "configuration management."[78] (One wonders if Novell was aware that whereas typing "www.zenworks.com" into a web browser takes one to Novell's home site, typing "www.zenworks.org" takes one to a Zen Buddhist site offering "high quality meditation supplies and Jizo images.") Such references are everywhere in Silicon Valley: Facebook has a "meditation room" for employees; Google offers "Search Inside Yourself" classes; Twitter sponsors an annual "Wisdom 2.0" seminar—all promoting some form of *techne*-Zen as "not just about inner peace," but also about "getting ahead."[79]

Perhaps no example seems as appropriate as the curious popularity of Drue Kataoka, "Master Zen Sumi-e Artist" and self-proclaimed Silicon Valley Artist in Residence. Coauthor of *ValleyZen.com*, "a blog at the intersection of Zen, Modern Life, and Technology," Kataoka details her interactions with Silicon Valley's digerati, asking things like, "how is the simplicity of Zen central to your company?" to which the digerati invariably and enthusiastically explain to Kataoka just how Zen they all are. In one of her several video blogs, for example, we find Jim Barnet, founder of the online advertising company Turn, Inc., telling Kataoka that he gets up every morning to practice Zen meditation, that Zen is all about "breaking through the clutter,"

and that Zen has inspired him to "think outside the box" with greater "spontane-ity."[80] In another, Silicon Valley venture capitalist Bill Draper (who, with his son provided the initial capital for companies like Skype, Baidu, and Hotmail) comments that Zen simplicity is the "key to a breakthrough concept" and (only half-jokingly) that "my Lexus is my samurai sword."[81] Kataoka brings in a sizeable income, appar-ently, by offering seminars to various corporations on the value of Zen in "Corporate Branding through Art."[82]

As Kataoka's art implies, if there is an aesthetic inherent to network capitalism it relies rather openly on the principles of *technê*-Zen. Ask anyone in the design world today where the most innovative transcending of HTML grids can be found, and the answer will invariably be www.csszengarden.com and its accompanying volume *The Zen of CSS Design* (2005). Equal parts "manifesto and gallery," the authors of CSS Zen Garden built the site to "demonstrate what can be accomplished through CSS-based design."[83] HTML code, they argue, may offer a nice grid-like structure for web designers, but it fails to allow for the more wiggly artistic freedom that designers need. CSS (Cascading Style Sheets) are lines of code that can be superimposed over HTML code to enable a separation between document content (HTML or some other markup language) and its presentation (the various fonts, colors, and layout of the digital page). Armed with CSS, a designer has greater freedom and economy to curve certain lines, move between the margins of HTML grids, and employ more aesthetically pleasing fonts and colors (Plates 102–106). Thus, designers contribut-ing to the site "are called upon to submit their own original visions in the form of style sheets and images. The catch is that all designs must use the same base HTML file. There are no exceptions; the HTML is absolutely identical in *every single design*" (*CSS*, p. 2; emphasis in original). The default CSS Zen Garden site (the structural content of which is then reproduced in dozens of iterations by the web's top design-ers) invites designers to "relax and meditate on the important lessons of the masters. Begin to see with clarity. Learn to use the (yet to be) time-honored techniques in new and invigorating fashion. *Become one with the web*."[84] The original site designers even include some Japanese characters in the top-left corner, which roughly trans-late to "a new holistic *technê*." As the authors of the accompanying volume explain, "If you've ever *felt constrained by the grid* that a table-based layout imposes, you might be delighted to learn that CSS positioning allows you to smash out of it and place ele-ments wherever you like on a page" (*CSS*, p. 36; emphasis added). It is a point the authors make several times throughout the book: "Through clever design and place-ment of imagery, a designer can find him- or herself *transcending the grid* and think-ing in more fluid, open ways. . . . Rigidly enforced grids that impede the design process are a thing of the past" (*CSS*, p. 137; emphasis added). What this new holistic *technê* allows for, in other words, is a more organic relationship with one's machine interface. Both the gridness of *māyā* and the "wiggly" are once again brought to-gether by way of *technê*-Zen.[85]

Consider, as a final example, the fundamental role of *technê*-Zen in Disney's two *Tron* films. The first *Tron* (1982) was already a self-reflexive corporate rescue fantasy. Since Walt Disney's death in 1966, the studio's film production unit had been floun-dering under the weight of corporate bureaucracy and a failure to keep up, as it had so many times in the past, with new developments in media technologies.[86] *Tron* (1982) therefore signaled not only Disney's recommitment to branching out into new technologies of simulation, but also a recognition that it needed the assistance of out-side production teams in order to do so. In this case, the unit charged with producing

Tron (1982) included a group of non-Disney computer animators and designers (headed by Steven Lisberger and Don Kushner) deeply invested in California's *technê-*Zen-inspired "hacker" culture.[87] In *Tron* (1982) the production team directly allegorizes their own role as saviors of Disney through Jeff Bridges's character, Kevin Flynn, who, not incidentally, appears in his first computer hacking scene wearing a Karate-style Japanese robe (Plates 107–108). When Flynn gets transported "into the grid" of the fictional corporation ENCOM's rogue Master Control Program (MCP), his rescue of the MCP has important consequences for ENCOM, whose original founder, a gentle, elderly man named "Walt" (a clear stand-in for Walt Disney), has been usurped by corporate cutthroats whose offices are decorated with ancient oriental statues (Plates 109–110). "ENCOM isn't the business you started in your garage anymore," the evil corporate chairman tells him. Only the Zen, cyber-cowboy Kevin Flynn can rescue ENCOM from the crypto-feudal computationalism dictated by the MCP's corporate logic (at one point, perhaps for any skeptics who might doubt that the digital landscape of ENCOM's MCP is a simple allegory for Disney, Inc., a massive Mickey Mouse head passes under Flynn as he floats over the "Sea of Simulation"; see Plate 111), and he is rewarded in the end by rising to the head of the corporation himself.

But if *Tron* (1982) is a corporate rescue fantasy, *Tron Legacy* (2010) is an even more direct paean to Disney's corporate vision of a *technê-*Zen-inspired global capitalism. In this second film we discover that Kevin Flynn (again played by Jeff Bridges) has returned to the grid, where his involvement in Zen Buddhism has intensified, and from which he can no longer return without risking the life of his creation, and so it is up to his son, Sam, to rescue his father and the program he has built. When Sam Flynn makes his own way into the grid, he finds his father deep in *zazen* meditation (Plate 113), his dwelling a kind of iMac palace of clean, white lines and glowing LEDs (on his bookshelf—a touch of the skeuomorphic for the nostalgic Kevin—we are not surprised to find the *Yijing* and *Journey without Goal: The Tantric Wisdom of the Buddha*). Indeed, Zen Buddhism was so important to Jeff Bridges's character in *Tron Legacy* that Bernie Glassman (American Buddhist *roshi* and founder of Zen Peacemakers) was hired on as a consultant during production, sitting in on story meetings and making himself available on set for Bridges to consult during shooting. Bridges has even suggested in interviews about the film that Glassman should get a "story credit" for the film.[88]

At one point in the film Sam tells his father that he has restored his old motorcycle, a Ducati, and they reminisce for a moment about its technological brilliance. "Not a day goes by when I don't think about that bike," Kevin wistfully tells his son. But of course, during the three decades Kevin has been trapped inside the grid he was not entirely without something like a motorcycle. Indeed, the most iconic scenes of *Tron* (1982)—those most memorialized in video games and cultural memory—are the "light cycle" games wherein opponents on motorcycle-like vehicles race each over the lines of a grid, trailing uncrossable walls of colored light (Plate 112). The same light cycle games occur in *Tron Legacy* (2010) as well, but with one important difference: now the light cycles *wiggle* over the lines of the grid (Plate 114). The deeper Kevin Flynn's technologically mediated attachment to Zen, in other words, the more the light cycles' movements over the grid have become *motorcycle*-like—no longer bound by the strict lines of *māyā*. The message is clear: whereas in 1982 Disney was in need of help in understanding the grids of *māyā*, in *Tron Legacy* they can simply flex their *technê-*Zen muscles.

But inasmuch as the arrival of his son Sam has unsettled the universe of Kevin's program ("You're messing with my Zen thing, man!" he tells his son), he soon comes to the difficult realization that the only way that both his son and his computer program can survive is for Kevin to die in a battle against the program's viral element. And the program *must* survive, we learn, because Kevin has discovered in it the key to a Kurzweilian dream of biotechnological immortality—eternal life in other words. Thus, if it has been tempting to read the film as a veiled analogue of Pirsig's *Zen and the Art of Motorcycle Maintenance*, it becomes even more compelling once we realize that in *Tron Legacy* the father must give his life for the son—a new story of redemption for the father after his having abandoned the son to the Pirsigian Quality of his creation. The final scene even has Sam and a woman from his father's program (now materialized in the real world), driving his father's Ducati into the bright sunlight (Plate 115).

One of the most bizarre things about the film, however, is how insignificant we are supposed to think the last three decades in the "real world" have actually been. In one scene, for instance, Kevin asks his son for a brief history lesson of what has happened on the outside while he has been trapped in his machine. Sam looks out over the Sea of Simulation and slowly muses,

> SAM: Ice caps are melting, war in the Middle East, Lakers-Celtics back at it;
> Oh, I don't know, rich getting richer, poor getting poorer, cell phones,
> online dating, WiFi.
> KEVIN: What's WiFi?
> SAM: Wireless interlinking.
> KEVIN: Of digital devices?
> SAM: Yeah.
> KEVIN: Hah. I thought of that in '85.

It is difficult to imagine a more absurd flattening of the last thirty years in human history. Nothing has changed, Sam tells him, except that corporations have finally caught up with the technological dreams Kevin had back in 1985. Nothing else even remotely matters for Sam or his *technê*-Zen father Kevin. Theirs is a world of "groovy" code, "biodigital jazz," "creative destruction," and "digital frontiers," but hardly one of historical awareness.

Zen and the Art of Historiography

Slavoj Žižek has come under fire recently for his claim that "if Max Weber were to live today, he would definitely have written a second, supplementary, volume to his *Protestant Ethic*, titled *The Taoist Ethic and the Spirit of Global Capitalism*."[89] Žižek's argument that "Western Buddhism" has become simply "the most efficient way for us to participate fully in the capitalist dynamic," reflecting an "attitude of total immersion in the selfless 'now' of instant Enlightenment,"[90] has been described as both "incorrect" and "incoherent."[91] Setting aside attacks on Žižek's coherence, there can be little doubt, I would argue, that the assertion that a form of Eastern mysticism has become the new ethos of global capitalism is correct. As I have been arguing, the discourse of *technê*-Zen was not just some late sixties fad that lent the more technophilic counterculturalists an air of cool until they could grow up and start healthy secular corporations. It has served, rather, as a continuous ideological framework for the transition to what we have now come to identify as the informatic networks of late capitalism. As a final evidence of this continuity, it is surely one of the most lasting

legacies of Pirsig's famous novel that the phrase "Zen and the Art of" has become *the* quintessential signal for the informational quality of a given product or process.[92] When, for instance, Joseph A. Grundfest, former commissioner at the Securities and Exchange Commission (and former director of the Oracle Corporation), wanted to discuss the informatic effects of globalizing technologies on capital markets, he did so by explicitly referring to Pirsig in an article titled "Zen and the Art of Securities Regulation" (1993), noting "technology has already made possible computerized markets that instantaneously link traders without regard to their physical location or institutional affiliation," and so, he argues, the Securities Exchange Commission must take a more Zen approach to regulation.[93] "Zen and the Art of" has become, in other words, the sloganeering ethos for postindustrial capitalism, reflecting simply the ideological and historical emptiness of informational excellence or quality. One can publish on *Zen and the Art of War* just as easily as *Zen and the Art of Peace* and find an audience either way. *Zen and the Art of Knitting* sits comfortably alongside *Zen and the Art of Harley Riding*. The subject never matters, only that informational *quality* is being conveyed (see Appendix F for a sampling of "Zen and the Art of" in contemporary discourse).

For those of us in the academy and, in particular, the humanities, the fact that "Zen and the Art of" became part of our Global English vocabulary just as the university was forced to give up its special role as the primary "learning organization" of society (having adopted, as Bill Readings has shown, a "techno-bureaucratic notion of excellence"),[94] should not go unnoticed. As Alan Liu has argued, we must ask, "'What *then* is the difference?' What is the postindustrial, and not nineteenth-century, difference between the academy and the 'learning organization?'" (*LC*, p. 21; emphasis in original). I would argue that we might find some inspiration in the fact that Liu's answer—that is, history—has remained so far outside the pale of "Zen and the Art of." As we saw in *Tron Legacy*, the quality of attitudinal presentism (the "instant now") implicit in the phrase has, to my knowledge, so far precluded the possibility of "Zen and the Art of History." Thus, any effective response to the late capitalist culture of *technê*-Zen will involve a commitment to not only aesthetics and political egalitarianism (equality, we must remember, is not the same thing as e-quality) but also historiography. Even the most faithful Buddhist critiques of global capitalism today— and there are several—concede the necessity of an acute awareness of history.[95] However, we must also understand in doing so that our new global technologies of information processing are not necessarily antipathetic to the values of historical analysis (certainly they made possible, to a remarkable degree, *this* analysis). Consider, as a final example, the archival brilliance of *The Daily Show with Jon Stewart*. As a fake-news critic of contemporary culture, Stewart has been more adept and has had more influence than any other "legitimate" news organization at returning to the historical televised archive in detailing the hypocrisies and corruptions of our corporate and political landscape.[96] Indeed, I would argue that academics might learn something from Stewart's technologically and aesthetically brilliant historiography—in a word, his *technê*. When he signs off each night, he does so by bringing out from the recent cultural archive some ironic, contradictory snippet—something one can only "get" if one can also see that history is cool: "Now, here it is, your moment of Zen."

8. The Meeting of East and West

> This meeting of East and West in thought will become a mighty
> feeling only when this vicarious Force you call the Machine
> becomes, instead of your master, your expedient servant.
> Then only will you know Freedom.
> —Frank Lloyd Wright (1951)

The hubris of this book's subtitle is not my own. I was continually astonished as I wrote these chapters that so many intelligent people could be so confident that there were clear-cut, definable entities like "East" and "West," and that one could presume to know how to "synthesize" them, or even, as per Kipling's famous dictum, that one could presume to know already of their inherent incompatibility. As we have seen, however, Asia-as-*technê* played a key role in the long-standing dream of proving Kipling wrong. For so many of the writers and artists analyzed in this volume the turn to Asian aesthetics meant not only a more therapeutic means of experiencing Western modernity, but full-scale global synthesis as well. By way of conclusion then, I'd like to attempt to match that synthetic impulse with one last whirlwind tour through the visual and literary landscape informed by the Anglo-American fascination with Asia's *technê*, turning to a few more figures who, while not formally or disciplinarily related, nonetheless demonstrate the stunning continuity of Asia-as-*technê* as it made its way through early twentieth-century modernism, postwar cybernetics, and the nearly all-encompassing hegemony of global capitalism. As we shall see, each of these figures is complicated and fascinating enough, each might have been the subject of an entire chapter, but I have waited until now because the scope and interconnecting paths of their contributions to Asia-as-*technê* make them ideal subjects in summarizing the longer trajectory of this study. If there are such things as "East" and "West" (and it is difficult to imagine a time when we will no longer rely on these mythologies of global differentiation), I hope this book will have shown that their interwoven histories are as complicated as the very substance of consciousness and the way we understand the "self"—and that the consequences are every bit as problematic and tangled.

Frank Lloyd Wright and the Oriental Machines of Modernity

The night before Frank Lloyd Wright delivered what would eventually become the most famous speech of his career at Chicago's Hull House in 1901, a group of women had gathered there to discuss the industrial horrors of the city's sweatshop factories and what Chicago's young Arts and Crafts movement could do to counter them. One of the women, Eleanor Smith, head of Hull House Music School, led the women in a song titled "Sweatshop," whose child narrator lamented,

> The roaring of the wheels has filled my ears,
> The clashing and the clamor shut me in,

Myself, my soul, in chaos disappears,
I cannot think or feel amid the din.[1]

The overarching sentiment at Hull House, which for over ten years had been Chicago's leading center for social reform, was that "the machine" had cast an oppressive spell on Anglo-American culture. In hundreds of talks and events leading up to Wright's presentation, the machine was assailed as an inorganic and alienating barrier to the more organic modes of arts and crafts.

Given this sentiment, the very title of Frank Lloyd Wright's talk, "The Art and Craft of the Machine," seemed downright oxymoronic.[2] *Of* the machine? Surely he meant *versus* the machine? But Wright's message was no less provocative: "In the years which have been devoted in my own life to working out in stubborn materials a feeling for the beautiful," he began, "a gradually deepening conviction" has grown "that in the machine lies the only future of art and craft," a "glorious future," in which "the machine is, in fact, the metamorphosis of ancient art and craft" ("ACM," p. 23). Wright knew very well the heretical nature of such a statement, insisting that, "disciples of William Morris [like those in his audience] cling to an opposite view." But Morris and John Ruskin, he argued, did not have the advantage of witnessing the machine's having "advanced to the point which now so plainly indicates that it will surely and swiftly, by its own momentum, undo the mischief it has made" ("ACM," pp. 23–24). While the word "mischief" (as opposed to, say, "alienation," "oppression," "exploitation," and so on) already indicates that Wright is working from within a different historical model than that of the Hull House reformers in his audience, he goes on to admit that the machine is not without fault. If the machine had "dealt Art in the grand old sense a death blow," he argues, such a crime had more to do with the historical situation articulated in Victor Hugo's *The Hunchback of Notre Dame* than it did any inherently exploitative tendencies of machine production. In that book, after lamenting the Renaissance's eclectic "improvements" (a cluttered hodgepodge of sculptural and architectural "additions") to the Notre Dame Cathedral's early gothic brilliance, Hugo offers an extended treatise on the radical transformations effected by print technology on the fragile authority of architecture.[3] The title of the relevant chapter is typically translated as "This Will Kill That," *this* referring to "the book," and *that*, "the edifice" (*ND*, p. 230). Here is Wright's summary:

> After seeking the origin and tracing the growth of architecture in superb fashion, showing how in the Middle Ages all the intellectual forces of the people converged to one point—architecture—[Hugo] shows how, in the life of that time, "whoever was born poet became an architect. All other arts simply obeyed and placed themselves under the discipline of architecture." . . . Thus, down to the time of Gutenberg, architecture is the principal writing— the universal writing of humanity. . . . In the fifteenth century everything changes. Human thought discovers a mode of perpetuating itself, not only more resisting than architecture, but still more simple and easy. Architecture is dethroned. ("ACM," p. 24)

While both Wright and Hugo share a disdain for the Renaissance's return to classical architectural forms (what Wright variously labels the "grandomania" and "pseudo-classic" work of those "fashionable followers of Phidias"), Hugo's articulation of the conflict between print and architecture undergoes two important transformations in Wright's hands. First, whereas for Hugo the revolution supposedly initiated by print

technology was ultimately democratizing—intimately connected, that is, to the liberalizing Protestantism that access to the *book* (specifically, the Bible) offered against the concentrated authority of Catholicism (as symbolized in the stone edifice), for Wright this aesthetic reallocation of human talent becomes less religious than techno-cultural, such that the machine is described as having violated something grand and traditional:

> See how architecture now withers away, how little by little it becomes lifeless and bare. How one feels the water sinking, the sap departing, the thought of the times and people withdrawing from it. . . . The printed book, the gnawing worm of the edifice, sucks and devours it. It is petty, it is poor, it is nothing . . . architecture, as it was, is dead, irretrievably slain by the printed book. ("ACM," p. 25)

But whereas Hugo—not surprisingly, given his chosen profession—also celebrates the newly embodied powers of the printed word ("Who does not see," he writes, "that in this form she [human thought as embodied in the book] is more indelible than ever? She was solid, she is now living; she passes from duration in time to immortality"[4]), Wright sees a situation in which the "average of art is reduced," due to Man's "lust for the *letter*, the beautiful body of art made too available by the machine" ("ACM," p. 25; emphasis in original).

A second important difference between Hugo's text and Wright's description of it has to do with the aforementioned possibility that the machine might "undo the mischief it has made." To pursue this argument, Wright has to deliberately misread Hugo—a misreading that will become even more blatant in subsequent versions of this talk throughout Wright's career. Specifically, in a throwaway line designed to underscore the scale and endurance of this architecture-to-print transformation, Hugo writes, "The great accident that an architect of genius may appear, can occur in the twentieth century as the accident of Dante in the thirteenth. But architecture will no longer be the art which represents social forms or collective endeavors, and no longer be the dominant art" (*ND*, p. 248). That is, while it is *technically* possible that a great mind will find its way toward architecture hereafter, just as Dante (who, by this logic, should have been an architect) emerged in a time when architecture was the "mother Art," one should certainly not count on it, or even assume that an architectural genius of the future will have any lasting impact. Ignoring this implication, Wright seizes on what Hugo calls a potential "accident," and immediately raises it to the level of immutable "prophecy." In Wright's summary, then, the takeaway point of the novel is that architecture will "rise again, reconstruct, as Hugo *prophesies* . . . in the latter days of the nineteenth century."[5] There *will be* an architectural genius, Wright's Hugo tells us (and notice that Wright has become even more specific about Hugo's timeline), who will use the machine to restore the mother Art (architecture) to its place of dominance. The problem, in other words, is not that the "machine" is inherently evil; but rather that it has been "forced by false ideals," and handed over to unworthy stewards ("ACM," p. 26). For Wright, then, the promised genius (himself) not only has nothing to lose by embracing the machine, he *must* do so as a way of restoring the mother Art—finally allowing architecture to take back what was stolen from it by literature. This grand narrative constitutes one of two central themes that Wright will return to again and again—with stunning consistency—throughout his career.[6] Indeed, from his earliest writings in the 1890s until his death in 1959, it is difficult to find a published piece by Wright in which he does not

somewhere mention "the machine," and the desire to have his "organic architecture" be the source of its ultimate redemption—which is saying quite a bit when considering Wright published thousands of pages of writing, far more than any other architect in the twentieth century.[7]

The other central theme of Wright's career has everything to do with *how* he thought the architect could embrace the machine without falling into the "vulgarities" and "decadence" that most mechanical reproduction seemed to be creating— and here enters the critical role of Asian aesthetics.[8] Although he would never own up to specific instances of formal borrowing (even when a number of scholars were identifying them), Wright was consistently clear on the influence of Japanese aesthetics on his own work. Consider, for example, his explanation of an "Oriental Influence" in one of his final publications, *The Natural House* (1954):

> Many people have wondered about an Oriental quality they see in my work. I suppose it is true that when we speak of organic architecture, we are speaking of something that is more Oriental than Western. The answer is: my work *is*, in that deeper philosophic sense, Oriental. . . . The gospel of organic architecture has more in sympathy and in common with Oriental thought than it has with any other thing the West has ever confessed. (*CW*5, p. 126; emphasis in original)

Taking even a cursory tour through Wright's work and social circles, one is struck by the sheer number of interactions with—and formal borrowings from—Eastern aesthetics, with the Japanese print holding a special significance.[9] It was not just that Wright invested and earned enormous amounts of money by participating in their circulation (there are estimates that over 20,000 Japanese prints passed through Wright's hands during his lifetime); something more of the print's expressive qualities became especially important to Wright's grand theory of organic architecture.[10] As he wrote in a 1917 tribute to the Japanese print,

> When I first saw a fine print about twenty-five years ago, it was an intoxicating thing. At that time, Ernest Fenollosa was doing his best to persuade the Japanese people not to wantonly destroy their works of art. . . . Fenollosa, the American, did more than anyone else to stem the tide of this folly. On one of his journeys home, he brought many beautiful prints. Those I made mine were the narrow tall decorative forms—hashirakake—that I appreciate today even more than I did then. These first prints had a large share . . . in vulgarizing the Renaissance even then for me. Already Victor Hugo's prophesy—that the Renaissance was the setting sun of Art all Europe mistook for dawn—had opened my eyes. Nothing less than radical, the simplifying, clarifying light they wore like a nimbus then, has been shining for me ever since. (*CW*1, p. 149)

The special connection here between Wright's return to the "prophesy" of Hugo and the "intoxicating" influence of the Japanese print hinges on the impact of Ernest Fenollosa, who, it turns out, was the first cousin of Wright's first boss in Chicago, J. L. Silsbee.[11] However, if, as a number of scholars have conjectured, Wright attended Fenollosa's lecture on Japanese prints at the Art Institute in Chicago, 1894, it would certainly not have been his first exposure to Japanese aesthetics.[12] Wright had visited the Japanese Ho-o-den at the World's Columbian Exposition in 1893, and had come away with much more than a mere "clarifying light" from its

Fig. 8.1. (*Above left*) Logo that Frank Lloyd Wright adopted for his architectural practice in the mid-1890s (re-created by author).

Fig. 8.2. (*Above center and right*) Two Japanese *mon* Wright was inspired by in creating his logo, appearing here as published in *Japanese Design Motifs*, trans. Fumie Adachi, by the Matusya Piece-Goods Store (Tokyo, 1913), and re-issued by Dover Publications (New York, 1972).

Fig. 8.3. (*Left center*) Frank Lloyd Wright's Taliesin logo, ca. 1930s (re-created by author).

Fig. 8.4. (*Left bottom*) The Japanese *mon* that was Wright's clear inspiration for his Taliesin logo, image from *Japanese Design Motifs*.

architecture; indeed, as Kevin Nute has shown, many of Wright's designs from the late 1890s and early 1900s are transparent adaptations of the Ho-o-den's architectural layout.[13]

By the mid-1890s, Wright was already deeply familiar with the presumed value of Asian aesthetics in the attempt to redeem machine culture. When two of his early clients started a press in 1896 and invited him to design a deluxe edition of a popular tract from the Arts and Crafts movement, *The House Beautiful* by William C. Gannett, Wright demonstrated a clear understanding of Sarah Wyman Whitman and others' efforts to transform the American book into an Oriental object.[14] Eschewing first of all the Kelmscott-style prohibition against mechanical methods, Wright insisted on metal plates and a new high-tech procedure of electrotype transfer, even as a great deal of the book's design borrowed from Eastern aesthetics. In the first pages of the volume, Wright had a series of twelve photogravures he himself had taken printed on *mitsumata* (a rough-edged, coarse Japanese paper) and sewn into the text, their vertical thrust and thematic presentation echoing many of the Hiroshige *tanzaku* woodcuts Wright had in his personal collection (Plate 116).[15] At the bottom-right corner of each pair of photogravures one finds the logo Wright had adopted for his fledgling architectural business (compare Figs. 8.1–8.2), showing he had already acquired and was putting to good use one of the many collections of Japanese *mon* circulating among designers at the time—a motif he would return to again, with stylized *mon* showing up, among dozens of other places, in his design for the publication

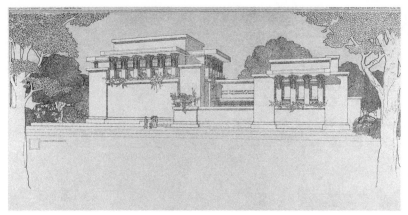

Fig. 8.5. (*Above*) Frank Lloyd Wright, House and temple for the Unity Church, Oak Park, Illinois, Plate LXIII of the Wasmuth Portfolio (*Ausgeführte Bauten und Entwürfe von Frank Lloyd Wright*, 1910).

Fig. 8.6. (*Right*) Frank Lloyd Wright, Thomas P. Hardy House, detail of a plate 15 of the Wasmuth Portfolio.

Fig. 8.7. (*Below*) Perspective of dwelling for Victor Metzger, Sault Ste. Marie, Michigan, Plate IX of the Wasmuth Portfolio.

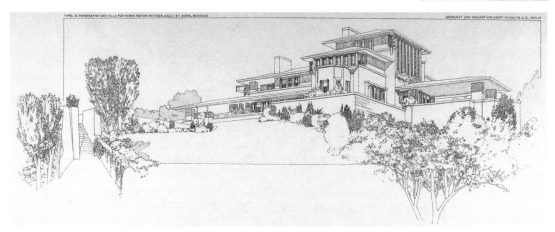

of his 1912 essay on *The Japanese Print* (Plates 117–118) and again in his logo for the Taliesin studio beginning in the 1930s (Figs. 8.3–8.4). What Sarah Wyman Whitman was doing for books and the imagined (but also real social and cultural) spaces conjured up by them Wright wanted to do for architecture and physical space—and precisely because of what the book (as an embodiment of the machine) had done to architecture. Indeed, to look at nearly any Frank Lloyd Wright architectural drawing is to witness the wholesale adaptation of the aesthetic strategies of the Japanese print: the extension of objects beyond the pictorial borders, the strategic use of negative space, the foregrounding of objects of nature as a framing device, and so on (compare Figs. 8.5–8.7 and Plates 72–73).

The point I want to stress here is that although no study on Wright has yet pointed to what he clearly saw as the correlative—even mutually *constitutive*—nature of the two endeavors, he was throughout his career as devoted to forms of Asian aes-

thetics as he was the fulfillment of the "Art and Craft of the Machine."[16] His many travels to Japan (beginning in 1905, and continuing through his design for the new Imperial Hotel in Tokyo in 1916), his sponsoring of print exhibitions in the United States (beginning in 1906, and continuing on to his "print parties" at Taliesin in the 1940s and 1950s), and his many borrowings of Asian art forms in his drawings and building designs—all of these Wright understood as directly related to his ongoing attempt to "master the machine."

But what exactly did Wright believe Asian art had to do with the redemptive possibilities of machine culture? First, Japanese aesthetics—even in their most ancient forms—were, in Wright's view, not only already "modern"; they were modern in the most organic, redemptive sense. As he explained in his talk on "The Art and Craft of the Machine," when used appropriately the machine is a "marvelous simplifier," and can "smooth away the necessity of petty structural deceits," countering the "wearisome struggle to make things seem what they are not." The machine has, for instance, "placed in artist hands the means of idealizing the true nature of wood harmoniously with man's spiritual and material needs, without waste, within reach of all" ("ACM," p. 29). It was an aesthetic principle, Wright explained, that "all peoples but the Japanese" have failed to understand ("ACM," p. 29). In his 1912 volume on *The Japanese Print*, drawing on a lecture he had given at an exhibition of Hiroshige prints in 1908, Wright specifically points to the Japanese print's geometric simplicity. Just as he had hailed the machine for its structural efficiency and capacity to reproduce geometric form, Wright argues for the print's "grammar" of geometry: "the Japanese print . . . has spread abroad the gospel of simplification as no other modern agency has preached it," an idea he repeated later in his *Autobiography*, arguing that Japanese art and architecture were "more nearly modern, as I saw it, than any European civilization alive or dead."[17]

In 1928, Wright would again discuss the interwoven values of Asian aesthetics and the proper use of the machine: "There is a life-principle expressed in geometry at the center of every Nature-form we see," he wrote, a kind of "ultimate purpose," an "essential-abstract," which is "the architect's proper concern before all else." Wright continued,

> Now what is this abstract concern? A little book I found in Japan fifteen years ago had the answer. Hokusai analyzed with his T square, triangle, and compass any and every natural object one could think of, first giving the geometrical pattern on which depended the expression of each. Then, by a few free relevant strokes, he would make it the realistic object as we commonly see it. . . . Here was integral method: true creative method that did not compose but developed, that got to the geometric heart of the object. . . . Therefore, why should an architect any longer compose? Why should he continue to be deceived by appearances? Why not now see as artists alone see the essential in abstract form as a source of form suggestion? This imaginative substance is the material to use with the machine if it is to be successful as a tool in sentient artist hands and ever greatly serve humanity. (*CW1*, p. 260)

What the "imaginative substance" of Hokusai's strikingly "modern" forms embodied, in other words, was the very "material" one needed in order to allow the machine to achieve its greatest potential for human beings (Fig. 8.8). This was only one of several moments throughout his career where Wright would refer to Hokusai's *Quick Lessons in Simplified Drawing* suggesting that in this geometrized "elimination of the

Fig. 8.8. (*Top*) Katsushika Hokusai, *Quick Lessons in Simplified Drawing* (*Ryakugahayaoshie*), vol. 1 (Edo: Kadomaruya Jinsuke, 1812).

Fig. 8.9. (*Bottom left*) Frank Lloyd Wright's mandala "peacock" design for a carpet in the Imperial Hotel, Tokyo, Japan (1916), in Hendrikus Theadorus Wijdeveld, ed., *The Life Work of the American Architect Frank Lloyd Wright* (Santpoort, Holland: C. A. Mees, 1925), p. 105.

Fig. 8.10. (*Bottom right*) Frank Lloyd Wright's design for mandala skylight. Installation view: The Art of the Motorcycle, Solomon R. Guggenheim Museum, New York, June 26–September 20, 1998. Photograph by David Heald © The Solomon R. Guggenheim Foundation, New York.

insignificant" the machine would find its redemption, but the point was always the same: to fulfill the "prophesy" of "The Art and Craft of the Machine"—to attain that state of an organic archi-*technê*—one would have to follow Wright into the East.[18]

However we must not confuse what Wright saw as the value of the "geometric heart of the object" with the kind of calculative, perspectival, window-like framing that was the "geometry" of the Renaissance (he is much closer to Hockney, that is, than

Leonardo). As such, we can turn, again, to the mandala as an ideal form in which Wright illustrated these "essential Nature-patterns" (*CW1*, p. 261). To be sure, mandala forms appear with striking consistency in Wright's drawings and architectural designs.[19] The interior décor of the Tokyo Imperial Hotel, for example, has several mandalas scattered throughout (in Fig. 8.9, for instance, we see his design for one of the hotel's carpets).[20] Staring up into Wright's famous ceiling at the Guggenheim Museum, one is struck by the mandala-like pattern radiating out from the skylight, down into the famous sloping curves of the building's continuous floors (Fig. 8.10)—it is hard not to see the influence, again, of Fenollosa's Buddhist "synthesis" (Figs. 4.5–4.6).[21] One is reminded here of something Wright published in the January 1951 issue of the *Architectural Forum*, written in the midst of the decades-long revision process that went into his design for the Guggenheim.[22] In ancient Asia, Wright explains, "the great Buddha taught his prophets," and even now that influence continues in the "drafting room at Taliesin."[23] He then reflects on the expression of a Buddha statue he keeps in his studio, an expression he says quite often "pervades our thought," and that "sometimes in his expression there seems evidence of the deep beneficent inner quiet our Art so needs and that Taliesin covets"[24] (Fig. 8.11). Dwelling on the subject a bit longer, Wright imagines the following dialogue between himself and the "Great Buddha":

> *Buddha*: Why, Son of the West, has your great nation never realized that Creative Art is implicit in faith in one's own Ideal? . . . Its vast mechanical apparatus is too busy among you raising a vast crop of weeds. Regardless of true flowers the policy of the West seems to drive this weed crop ahead to a dead end . . .
>
> *Wright*: You speak Truth, great Buddha, for my people do yet realize no other or better choice. . . . Artificially powered they now are by their own Machines and are becoming themselves more and more like machines. But in this little green valley, as in others elsewhere, a message is being prepared: a message you have helped make clear to us. . . . Someday East and West as one will waken to the honest practice of what we call a natural organic architecture . . .
>
> *Buddha*: Then you may not die as all civilizations preceding yours have died! Sharing our ancient Wisdom, you may live. . . . We will know eternal Life together. This meeting of East and West in thought will become a mighty feeling only when this vicarious Force you call the Machine becomes instead of your master, your expedient servant. Then only will you know Freedom. (*CW5*, p. 29)

Ernest Fenollosa could not have said it any better himself: the cultural vehicle of the Buddha's hoped for "meeting of East and West" is nothing other than Asia-as-*technê*. It was precisely this complex, transcultural mythology that, at least since the mid-1890s, shaped Frank Lloyd Wright's entire career.

The Mandala and the Motorcycle

Looking up into the particular photograph of the Guggenheim ceiling in Fig. 8.10, however, one is struck by a somewhat unusual sheen surrounding Wright's mandala design—a kind of chromed-out, metallic surface swirling down the museum floors from above, something not at all part of Wright's original plan. These metallic arcs were part of an installation art project held from June to September 1998 at the Guggenheim by Frank Gehry—an architect-sculptor whose entire aesthetic practice

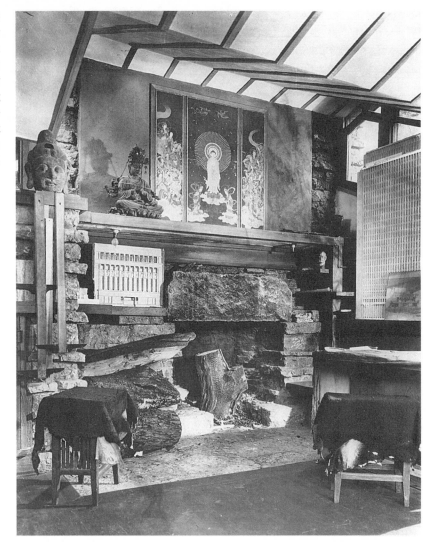

Fig. 8.11. The "Studio Buddha" and other Buddhist objects in Frank Lloyd Wright's Taliesin Studio, interior view, Taliesin III, Spring Green, Wisconsin, late 1920s. © The Frank Lloyd Wright Fdn, AZ / Art Resource, NY.

seems hell-bent on erasing Alan Watts's distinction between the "wiggles" of nature and the "grids" of *māyā* (Figs. 7.1–7.2).[25] In this installation the spiraling, opaque walls that feel calming and contemplative in Wright's original spiral design have taken on a kind of strange electricity. The lights and shadows dance and flit as if charged by some unseen mechanized energy. But whether or not one likes Gehry's chromed-wall installation (former museum guide Paul Werner called it "Terminator *Schlag*"[26]), it was certainly appropriate for its setting, since what is *not* seen in the photograph in Fig. 8.10—what Gehry's wiggly chrome installation was specifically designed to accompany—was the Guggenheim's controversial new exhibit, *The Art of the Motorcycle*, sponsored by both BMW and Delta Air Lines, Inc. It may have made a kind of perverse sense that the phrase the exhibit was constantly channeling ("Zen and the Art") never actually entered the show's catalog, since, as a number of art historians have shown, the exhibition itself was designed to both "democratize" our understanding of art "objects" and to amplify the museum's status (and financial holdings) as an institution of cultural exclusivity.[27] But "Zen and the Art" it most certainly was, as director Thomas Krens explained, with each motorcycle in the catalog photographed "in black and white against a minimal white background" in an "attempt to

neutralize the surrounding environment and present the machines in a standardized format."[28] Machines bracketed, in other words, visually, so as to become art—and done enthusiastically under the official sponsorship of a transnational corporation. It was as if what mattered the most about the exhibit (that the objects in question were motorcycles) also hardly mattered at all (since *any* object could be similarly bracketed, artified, exhibited, and sponsored by a transnational corporation). As we saw in the last chapter, such is the spiritual quality of global capitalism.

Still, given the historical trajectory we have been mapping in this book, there is something specific about the motorcycle-under-the-mandala that makes it a potential touchstone in attempting to understand the ongoing power of Asia-as-*technê* in our current era. Hundreds of thousands of visitors that year (more than the museum had ever entertained before) encountered the dizzying perspective of Wright's mandala ceiling hovering over Gehry's wiggly chrome walls and the freshly artified motorcycles—a dizzying perspective made all the more stunning by the fact that the exhibit's visiting curator was none other than David Hockney's partner-in-crime, Charles Falco, who, it turns out, not only has an insatiable passion for optical science and art history, but a long-standing interest in motorcycles as well (see chapter 1). It seems only too fitting, then, that Wright's original justification for the sloping, curvilinear movement of the Guggenheim atrium—so controversial in its abandonment of the traditional "white cube" space of exhibition—was offered in terms Robert Pirsig echoed years later in his *Zen and the Art of Motorcycle Maintenance* (1974). The circular, looping design was, Wright said, a "new freedom!" The only "framing" that a painting really needed was its "relationship to architectural environment. Painting no longer compelled by the strait jacket of the tyrannical *rectilinear*."[29] Wright's view on the "nature of our automobility" and its relationship to architecture was even more consistent: "Who designs those cars?" he asked. "No student of nature!" One must stand up and "refuse to be jammed into a box, no matter how big the hole is in front." Only through an "inspired sense of design," Wright argued, can one "put quality into quantity" (*CW5*, p. 237).

My point, however, is not to say that Pirsig necessarily drew any direct inspiration from Wright, as tempting as those resonances are. Indeed, Pirsig had yet another, even more direct source of inspiration for his novel, one we have waited to examine until now, a philosophical source that has been hovering in the historical background of this entire book. The novel's narrator (and later Pirsig himself in dozens of interviews) is very clear about its core inspiration. Not even halfway through the novel, when Phaedrus is on his way home from Korea in the early 1950s, he picks up a copy of F. S. C. Northrop's *Meeting of East and West: An Inquiry Concerning World Understanding* (1946) and reads it on the boat all the way back to Seattle.[30] Its effect is so galvanizing, Pirsig writes, that it becomes the guiding motivation for Phaedrus's decision to "return to the University to study philosophy" (*ZMM*, p. 124). It was only after reading Northrop, Phaedrus says, that his "lateral drift was ended." He was suddenly "actively in the pursuit of something" (*ZMM*, p. 124). Northrop's book "was my mentor," Pirsig later recalled in an interview about the novel, "I would not be saying what I am saying today without having read that book." If one wants to know the "real, hard Metaphysics of Quality," Pirsig argued, "read F.S.C. Northrop . . . I would never take credit away from him for my own ideas."[31] But what was it about Northrop's volume that so animated Pirsig? He was certainly not the only person influenced by it. Hailed at the time as "One of the most provocative, penetrating, and thrilling deployments of philosophical insight that has come to light in a generation,"

Northrop's study emerged in the context of what would eventually become an entire academic industry devoted to Cold War, East–West comparativism, and quickly became required reading at most American universities.[32] As we shall see in these final sections, the trajectory of Northrop's theory in the light of his contribution to Asia-as-*technê* offers a revealing last glimpse at how exactly we arrived at our present techno-cultural moment.

Epistemic Correlates

Born in 1893 (again, that critical year) in Wisconsin, Northrop was educated in the Midwest before volunteering for the Tank Corps at Washington, DC, in 1918.[33] If he had been hoping to see the world as a soldier, he must have been sorely disappointed; the war ended only five months after he enlisted, and he spent the entire time at various training camps throughout the United States. After getting married the next year, Northrop and his wife headed to Hong Kong where he had landed the more exciting post of Educational Secretary for the International Committee of the Young Men's Christian Association. His time in Asia must have been highly formative, for although he would spend the next decade studying Western philosophy (first, under Edmund Husserl at Freiburg, where his classmates included Jose Ortega y Gasset and Jean-Paul Sartre; then at Cambridge under Alfred North Whitehead and Bertrand Russell; and finally as a graduate student in the Philosophy of Science at Harvard), by the late 1930s as a professor of philosophy at Yale, he had begun to turn his attention almost exclusively to the question of just how differently Western science seemed to approach the world than did "the Far Eastern Taoists and Zen Buddhists."[34]

The motivating insight for Northrop's early articulations of East–West difference resided in what he described as the philosophical distinction between "concepts given by *intuition*" and "concepts given by *postulation*." To point to what would become his most frequently cited example, think of the color blue. In terms of something "sensed" and "immediately apprehended," as, for example, when "presented by the painter," the color "'Blue' is a concept by intuition," something grasped "purely inductively." By contrast, the color "'Blue' in the sense of the number of a wavelength in electromagnetic theory is a concept by postulation," something that can be "deduced" even prior to observation.[35] In short, it was the difference between "aesthetics" and "theory."[36]

Northrop developed this distinction initially as a means of explaining what he saw as the fundamental difference between the humanities (the proper domain of the "aesthetic" and the "intuitional") and the sciences (the proper domain of the "theoretic" and "postulational"), and their respective roles in a liberal education. Hence, as he argued in an article on the "Functions and Future of Poetry," the "primary task of poetry . . . is to convey the aesthetic component of reality in and for itself apart from all postulated doctrine and theory."[37] However, in 1939, when one of Northrop's former students, Charles A. Moore (then a professor at the University of Hawai'i), invited him to present at what would be the first of several East-West Philosophers' Conferences in Hawai'i, Northrop suddenly saw an inherent similarity between this dichotomy and traditional, Orientalist binaries, allowing for what he would call "a basic terminology for comparative philosophy."[38] As he later wrote to Junjiro Takakuso, one of his Japanese interlocutors at the conference, "The factor which greatly impresses me at a distance, about your country, is the wonderful aesthetic sense which you all possess. . . . It seems to me that it is precisely this which is at the heart of all Oriental thought—Indian, Chinese and Japanese."[39]

In *The Meeting of East and West* (1946) the articulation and potential regulation of this basic, stereotypical difference would be characterized as the underlying premise for any attempt at global synthesis. Whereas the East has historically "concerned itself with the immediately apprehended factor," developing a "doctrine built out of concepts by *intuition*," the West has, by contrast, "concentrated for the most part on the doctrinally designated factor," those concepts developed "by *postulation*" (*MEW*, p. 448; emphasis in original). Understanding that this difference is what led to such radically divergent cultures is important, Northrop insists, for at least two reasons: first, the East is no longer as "passive and receptive" as it used to be: "each part of the Orient has left its traditional, passive, receptive attitude and is coming to impress its existence and values upon the Occident"; and second, the West itself has grown increasingly turbulent for its overemphasis on the theoretic component's "technological applications."[40]

Northrop's solution to this grand dichotomy ends up being so simple one is tempted to think that if it were not couched in five hundred-plus pages of philosophical jargon and world history, he would not have been taken seriously at all. What both the East and West need to understand, Northrop suggests, is that *all* knowledge is essentially the product of both concepts by intuition and concepts by postulation. The whole "world of things and persons" as experienced in "common sense and science" involves both 1) aesthetic "data brought to the knower by means of the senses," and 2) "ordering and regulating concepts brought to the data by the knower" (*MEW*, p. 194). This intuitional–postulational simultaneity of all knowledge Northrop calls the "epistemic correlate," and he contrasts this two-part process of knowledge construction with the centuries-long adherence in the West to a Newtonian, three-part epistemology (the traditional three parts being: 1-material substance, 2-mental substance, and 3-the differentiated "sensed qualities" of "mere appearance"; *MEW*, pp. 74–83). Once we see the true nature of the "epistemic correlate," Northrop insists, we suddenly realize that to know anything at all we need both the "aesthetic" and the "theoretic," and that neither can be devalued in the march toward enlightened experience:

> The answer to the basic problem underlying the ideological issues of these times is, therefore, as follows: *the aesthetic, intuitive, purely empirically given component in man and nature is related to the theoretically designated and indirectly verified component*, not as traditional modern Western science and philosophy supposed, by a three-termed relation of appearance, but instead *by the two-termed relation of epistemic correlation*. . . . [Thus] the traditional opposition between the Orient and the Occident, as voiced by Kipling is removed. . . . The situation arose because the East in its intuition and contemplation of things in their aesthetic immediacy, and the West in its pursuit of the theoretically known component, tended to brand the knowledge other than its own as illusory and evil. When the preceding analysis reveals both factors to be ultimate and irreducible the one to the other, and related by the two-termed relation of epistemic correlation, thereby insuring that the one cannot be regarded as the mere appearance of the other, the two civilizations are shown to supplement and reinforce each other. They can meet, not because they are saying the same things, but because they are expressing different yet complimentary things, both of which are required for an adequate and true conception of man's self and his universe. Each can move into the new comprehensive world of the future, proud of its past and

preserving its self-respect. Each also needs the other. (*MEW*, pp. 443, 454–455; emphasis in original)

If Northrop's solution to the ideological conflicts of his day seems simplistic now, it is important to remember that his thesis would have appeared both intuitively and postulationally "true" to his readers precisely because he was synthesizing almost fifty years of inherited discourse on Asia-as-*techné*. The writings of Lin Yutang, for example, formed the basis for his chapter on "The Traditional Culture of the Orient," and he borrows generously throughout his study (without acknowledging, or perhaps even realizing it) from Ernest Fenollosa.[41] Indeed, the artist Northrop turns to most often in *The Meeting of East and West* to illustrate the modern potential for a work of art to embody "the aesthetic and theoretic components in their unity" is Arthur Wesley Dow's most famous student, Georgia O'Keeffe (whose debt to Fenollosa's *Epochs of Chinese and Japanese Art* has been well documented[42]). O'Keeffe's *Abstraction No. 11* serves as a frontispiece for *The Meeting of East and West* (Plate 119), valued by Northrop for its gestures toward symbolic unity: "the one blue line represents the female aesthetic component; the other, the male scientific component in things. And the common base from which they spring expresses the fact that although each is distinct and irreducible to the other, both are united" (*MEW*, p. 163). But it's O'Keeffe's *Abstraction No. 3* (known now as *From the Lake, No. 3*) that really turns him on (Plate 120). In this painting the viewer is "forced to apprehend the aesthetic component of reality by itself for its own sake" (*MEW*, p. 162). Here Northrop sees "pure fact with all its emotive quale and ineffable luminosity, before the inferences of habit and thought have added their transcendent references to the external three-dimensional objects of common sense or scientific belief, to the theological objects of traditional Western religious faith, or to the future pragmatic consequences of reflective action" (*MEW*, p. 162). It is as if Northrop were already directly theorizing what Hockney will later call "good theology," that encounter with Asian *techné* made possible by the rejection of fixed perspectivalism and mimesis.

When, in *Zen and the Art of Motorcycle Maintenance* the narrator comes to Northrop's epistemic correlate, he immediately sees this binary as central to his own cultural and personal dilemma:

The book [Northrop's *Meeting of East and West*] states that there's a theoretic component of man's existence which is primarily Western . . . and an aesthetic component of man's existence which is seen more strongly in the Orient. . . . These terms "theoretic" and "aesthetic" correspond to what Phaedrus later called classic and romantic modes of reality and probably shaped these terms in his mind more than he ever knew. (*ZMM*, pp. 123–124)

But while Pirsig's way of updating Northrop's synthesizing epistemic correlate was to suggest that "The Buddha, the Godhead, resides quite as comfortably in the circuits of a digital computer or the gears of a cycle transmission as he does at the top of a mountain or in the petals of the flower" (*ZMM*, p. 26), he most likely had no idea that Northrop was already one step ahead of him.

Reverberating Circuits

F. S. C. Northrop's role in the Macy Conferences on Cybernetics is a largely forgotten story in both East–West comparative discourse and the history and philosophy of science. Recent studies of Northrop's comparativism, for example, make no mention of

his participation in the cybernetics group, and histories of the Macy Conferences tend to either dismiss his participation as superficial and parasitic, or else ignore him entirely.[43] This neglect is unfortunate not only because Northrop shaped the Macy conversations in important ways (and influenced a number of post-Macy Conference publications), but also because the cybernetic ideas presented at the conference became an absolutely critical part of Northrop's own highly influential East–West comparativism after 1946.[44]

By the time Northrop joined the Macy Conferences in March 1946, the primary revolutions in cybernetic research had already taken place. But in at least one of those early breakthroughs, Northrop had been an important source of inspiration. In the mid-1920s he had introduced one of his brightest students at Yale, Warren McCulloch, to Russell and Whitehead's *Principia Mathematica*, and it was this work (the legacy of Northrop's own professors at Cambridge) that had inspired McCulloch to speculate that there may be precise, mappable structures among the neurons in the brain's cortex that could explain how human beings performed logic and carried out calculations.[45] In the 1930s, as a research fellow at the Yale Medical School's Laboratory of Neurophysiology, McCulloch meticulously created the first anatomical map of the human cortex. But insofar as McCulloch was searching for the brain's neurophysiological architecture (where all our ostensibly precise, logical operations are executed), what he found positively puzzled him: *circular* connections. How did they work? The whole idea of "nets with circles" seemed odd, like a purposeless mesh of irrationally wired loops.[46]

At the very first Macy Conference in May 1942, Norbert Wiener and his colleague Arturo Rosenbluth revealed something that McCulloch seized on.[47] All of the research they had been conducting on "servomechanisms" suggested that circuitous "feedback loops" may in fact constitute the underlying, operative logic of both machines and human nervous systems. With his assistant, Walter Pitts, McCulloch very quickly confirmed that the circular structures he had mapped operated according to a kind of purposeful feedback mechanism. They published their findings in an article titled "A Logical Calculus of Ideas Immanent in the Nervous System" (1943), arguing that a kind of "reverberating" activity among these "nets with circles," revealed a computational logic that coincided rather neatly with the British mathematician Alan Turing's new notion of a "universal" computer.[48] But if they were suggesting that the brain might already be a "machine," they were doing so in the context of an entirely new kind of machine. Wiener would later reflect on this initial excitement:

> Very shortly we found that people working in all these fields were beginning to talk the same language with a vocabulary containing expressions from the communications engineer, the servomechanism man, the computing-machine man, and the neurophysiologist. . . . All of them were interested in the storage of information. . . . All of them found that the term *feedback* . . . was an appropriate way of describing phenomena in the living organism as well as in the machine.[49]

The excitement over these initial collaborations led to a desire to expand the group, and so in March 1946 Northrop was invited to join a slightly larger meeting for what was then being called the "Conference on Teleological Mechanisms."

Northrop quickly brought himself up to speed with the McCulloch/Pitts research, and on the very first evening of the conference immediately connected their notion of "reverberating circuits" to his own theory on epistemic correlates. His book

The Meeting of East and West was already in press, but this new discovery seemed to lend his world-saving theories an even greater authority. He told the other conference participants that what they were discovering was the very basis for human "ideation," and so their job must be to develop a "theory of the good" based on these new insights.[50] According to McCulloch, however, the "following debate smoldered on several scores." Many of the scientists present were uncomfortable with Northrop's efforts to apply these theories of neural connectivity to, as McCulloch would write, "domains of which we were ignorant as to what the significant variables were." But it was precisely this debate that led to an entire meeting of the cybernetic group on "sociological issues," and Northrop quickly made plans for an edited volume that would attempt to account for the "ideological" implications of the new science.[51]

For the purposes of concluding this study, I want to draw attention to a rather curious moment in the article Northrop published on the McCulloch/Pitts findings in *Science* the next year. Northrop explains that whereas "traditional [neurological] theories rest upon an oversimplified notion of activity in the nervous system," assuming that neurons are "put together in the nervous system to form a path in or through the nervous system which is noncircular," the new truth of the matter was that the human mind is built according to "reverberating chains of neurons." But this was not all:

> McCulloch and Pitts, in their 1943 paper, proved one other exceedingly important theorem. This theorem is that any robot or organism constructed with regenerative loops possessing the aforementioned formal properties, and thereby being a Thuring [sic] machine, "can compute any computable number or, what is the same thing mathematically, can deduce any legitimate conclusion from a finite set of premises." It is not an accident that John Von Neumann and Norbert Wiener, in their designing of two of the most powerful contemporary machines for carrying through mathematical deductions and calculations, and McCulloch and Pitts, in their theoretical and experimental studies of the human nervous system, have influenced one another.[52]

In several of his publications during the next two decades, Northrop would return repeatedly to this theorem, diagramming the difference between the old "Linear Neural Net" theory and the new "Non-Linear Reverberating Circuits" (Figs. 8.12–8.13). But if Northrop's two diagrams together bear an uncanny resemblance to Fenollosa's graphic illustrations of the difference between "machine/analysis" and "art/synthe-

Figs. 8.12–8.13. Diagrams illustrating the difference between theories of traditional "Linear Neural Net" vs. the cybernetic "Non-Linear Neural Net" in F. S. C. Northrop, *Philosophical Anthropology and Practical Politics* (New York: Macmillan & Co., 1960), pp. 49, 52.

sis" (Figs. 4.3–4.6) it is worth pointing to what is in fact their radical difference: what Northrop offers in his diagrammatic representation of "reverberating" and "nonlinear" networks in Fig. 8.13 is now an illustration of both the mind *and* the machine. What Fenollosa had offered in his mandala-like diagram of synthesis as positively antimechanical has in Northrop become the operating logic of our most sophisticated machines, our minds.

To portray the mind as machine in this context, however, says more about how much the power of the machine had changed by the 1950s than it does any overarching transformation in the basic tenets of Asia-as-*technê*. It was not as if Northrop was comparing the mind to a pulley or some other simple machine. The seemingly unstoppable progress of machine computation in even those first room-sized computers already suggested the inevitable arrival of "thinking machines" somewhere on the horizon. Leibniz's seventeenth century assertion that binary digits could in fact communicate everything in the known universe—as well as his identification of these complexities in the hexagrams of the *Yijing*'s codes of divination—seemed to find its fulfillment in the atomic dreams of John von Neumann and his team at Princeton's Institute for Advanced Study.[53] Their machines and their offshoots—the ENIAC, the EDVAC, the UNIVAC, even Kurt Vonnegut's parody the EPICAC—all hinted at a computational horizon that posited the machine as *the* paradigmatic illustration for the type of networked complexities that Fenollosa had diagrammed as nonmechanical "synthesis."[54] Which perhaps explains something of how Asia-as-*technê* could become so easily adapted to our contemporary computational landscape. By the mid-1990s, the Internet was already being described as a computational fulfillment of what Fenollosa had intimated was that most nonmechanical of Buddhist mythologies: Indra's net. It is worth taking a closer look at Francis Cook's description of the *Flower Garland Sutra*:

> Far away in the heavenly abode of the great god Indra, there is a wonderful net which has been hung by some cunning artificer in such a manner that it stretches out infinitely in all directions. In accordance with the extravagant tastes of deities, the artificer has hung a single glittering jewel in each "eye" of the net, and since the net itself is infinite in dimension, the jewels are infinite in number. There hang the jewels, glittering like stars of the first magnitude, a wonderful sight to behold. If we now arbitrarily selected one of those jewels for inspection and look closely at it, we will discover that in its polished surface there are reflected *all* the other jewels in the net, infinite in number. Not only that, but each of the jewels reflected in this one jewel is also reflecting all the others jewels so that there is an infinite reflecting process occurring.[55]

It was most likely inevitable, then, that this description of the Hua-yen Buddhist "net" of individual "jewels," with each reflecting the "infinite" structure of the entire net, would be compared to the Internet.[56] It is only one of several instances of a larger Western mythology that would suggest we almost *need* a Buddha somewhere inside our machines.[57] Take, for example, *Fortune* magazine's annual Brainstorm TECH conferences, the official logo for which (much like its name) evokes precisely this mind/machine theory of computational intelligence—reproducing, in what is a rather uncanny coincidence, Fenollosa's exact diagram for Buddhist synthesis (compare Figs. 8.14 and 4.6). It is as though we need both the mind and the Internet to be a kind of mandala. It comes as no surprise, then, that in William Gibson's originary cyberpunk novel *Neuromancer* (1984)—credited with coining the term "cyberspace"—the

Fig. 8.14. Logo and banner for Fortune.com's "Brainstorm TECH" conference (image source: www.fortune conferences.com).

FORTUNE
BRAINSTORMTECH
July 22-24, 2013: Aspen, Colorado

constellation of networked computers is described in precisely these terms. "Cyberspace," Gibson's narrator explains, is "a consensual hallucination experienced daily by billions. . . . A graphic representation of data abstracted from the banks of every computer in the human system. Unthinkable complexity. Lines of light ranged in the nonspace of the mind, clusters and constellations of data."[58] Here the protagonist "jacks in" (a phrase that already evokes all the Orientalist aggressiveness of Jack London) to cyberspace:

> in the bloodlit dark behind his eyes, silver posphenes boiling in from the edge of space, hypnagogic images jerking past like film compiled from random frames. Symbols, figures, faces, a blurred, fragmented *mandala* of visual information. . . . And flowed, flowered for him, fluid neon origami trick, the unfolding of his distanceless home, his country, transparent 3D chessboard extending to infinity.[59]

As I indicated in chapter 3, I do not put much stock in quasi-metaphysical concepts like Carl Jung's theory of the "collective unconscious"—that supposedly phylogenetic substratum which manifests itself in the world's religious symbols and mythological stories. But I am struck by the aptness of his characterization of the mandala as a collective "ideogram of unconscious contents," and a "delineation of dimly sensed changes going on in the background."[60] If it is the case that, as Jung argues, our cultural "God-Image" continually "expresses itself in the mandala," one can certainly point to the Buddha-in-the-machine as the mandala of our epoch.[61]

In closing, then, I want to point to two clear articulations of our contemporary mandalas—each a material embodiment of Asia's *technê* as understood in the context of our increasingly computational human experience. The first is the aptly titled "Buddha Machine" created by Beijing-based music duo Christiaan Virant and Zhang Jian, known as FM3. In the original version released in 2005, the Buddha Machine (designed as a compact box with a circle speaker on the front, so as to emulate Apple's ubiquitous iPod) is a small musical "loop" player with nine digitally encoded songs (or rather meditative "drones"), all relatively short (10–40 seconds). The "user" can navigate between the drones by clicking a button, and can control their pitch with a small knob. Virant reportedly got the idea for the gadget when he walked into a Buddhist temple and saw a tape recorder playing a "prayer" that someone had left there. The online images used to promote the device are like layered mandalas, with a small Buddha figure shown at the center of each, meditating among the gears and circuits (Fig. 8.15). Of course, the actual objects themselves are rather simple machines compared to the breathtaking complexities of today's smart phones and other digital devices. But as aesthetic statements on our contemporary experience, they are quite ingenious, if only because Virant and Jian seem to realize that *all* our machines are now Buddha Machines.

A final example of the mandalas of our era can be found in a number of recent sculptures by South Korean artist Wang Zi Won, whose mechanized Buddhas offer

達麻　龕喇叭　盾状部　大老師　天然能

FM3 BUDDHA MACHINE II
exploded view by longmo.net

Fig. 8.15. (*Above*) Diagram for FM3's "Buddha Machine"; notice the small Buddha drawn in the center of the device (image source: www.fm3 buddhamachine.com).

Fig. 8.16. (*Top left*) Wang Zi Won, *Kwanon_Z* (2010) (image courtesy of Wang Zi Won).

Fig. 8.17. (*Bottom left*) Wang Zi Won, *Pensive Mechanical Bodhisattva* (2010) (image courtesy of Wang Zi Won).

a strikingly aesthetic vision of the transposition of biological and spiritual-mechanical systems. Conceived as a kind of alter ego named "Z," the polished-white mannequins that frequently appear in Wang's sculptures are modeled after himself, each one poised in a state of Buddhist meditation and embodied in the chromed, austere forms of mechanical gears, levers, and electronic circuits. The titles of the sculptures already reveal the questions posed by this juxtaposition: *Kwanon_Z* (2010; Fig. 8.16), *Pensive Mechanical Bodhisattva* (2010; Fig. 8.17), *Buddha_Z Mandala* (2010; not shown), *Buddha_Z in the Steel Lotus* (2011; Plate 121), and *Machinery Yamala Variocana* (2011; not shown). What the still images included here do not reveal, however, is that Wang's sculptures are fluidly moving, dynamic objects. As the gears turn—slowly,

relentlessly—the Steel Lotus in Plate 121, for instance, seems to breathe in and out, while the Kwanon's many hands in Fig. 8.16 gesture gracefully according to their prescribed mechanical patterns.[62] The effect is mesmerizing, and Wang's art has gone viral on the Internet in the last few years as his mechanical Buddhas have been exhibited in Korea, Tokyo, London, Chicago, New York, Beijing, and Hong Kong. Wang's sculptures are new enough that not many academics have reflected on them yet, but his blog includes a number of analyses and theoretical statements on the questions raised by his art.[63] Reading through these reflections (and for the purposes of concluding my study here) it is not at all surprising to find commentary on how Wang's art engages in a grand "fusion" of art and technology. The "ancient Greeks," Wang's blog explains, "did not have a word for what we today call art. Instead they used the word *technê*."[64] Indeed, the brilliance and aesthetic power of Wang's *technê* is his dramatization of our contemporary mythos—wherein the aesthetics of the East offer a means of transcending (and eventually *becoming*) the machine. What Wang invites us to ponder, finally, is whether the cultural dilemmas posed by the Buddha-in-the-machine can be limited to questions of informatics and communication technologies, or whether we are not actually changing what it means to be human.

A. Appendix

Japanese Edition Books Published in the 1890s

This is a sample listing of "Japanese Edition" books published in the 1890s advertised by their publishers as exhibiting one or more of the following qualities: printing on "Japanese paper," "Japanese vellum," "Japanese-style binding," or illustrations done in "the Japanese style."[1]

Alexandre, Arsene. *The Modern Poster* (New York: Charles Scribner's Sons, 1890)

Allen, Charles Dexter. *American Book-Plates: A Guide to Their Study with Examples* (New York: Grolier Club, 1894)

Barrie, James Matthew. *The Little Minister* (New York: Lovell, Coryell & Co., 1892)

Bates, Clara Doty. *From Heart's Content* (Chicago: Morrill, Higgins & Co., 1892)

Bell, Cora Hamilton. *Memoirs of Madame De Staal-de Launay* (New York: Dodd, Mead & Co., 1892)

Berkow, Paul. *Vae Victis* (New York: Rand, McNally & Co., 1892)

Beyle, Henri. *La Chartreuse de Parme* (New York: George H. Richmond & Co., 1896)

Bits of Nature (New York: Nims & Knight, 1899)

Bradford, Amory H. *The Sistine Madonna: A Christmas Meditation* (New York: Charles Scribner's Sons, 1894)

Brine, Mary D. *Grandma's Attic Treasures* (New York: Dutton & Co., 1891)

Brontë, Charlotte. *Jane Eyre* (New York: Thomas Y. Crowell & Co., 1891)

Browning, Robert. *Poems* (New York: Macmillan & Co., 1897)

Bryant, William Cullen. *A Souvenir of William Cullen Bryant* (Boston: Cassino Art Co., Souvenir Series, 1891)

Bulwer, Lord Lytton. *The Last Days of Pompeii* (Boston: Estes & Lauriat, 1891)

Bulwer, Lord Lytton. *Rienzi* (Boston: Estes & Lauriat, 1891)

Bunyan, John. *Pilgrim's Progress* (New York: Charles Scribner's Sons, 1894)

Catholic Prayer Book. *Key of Heaven* (Chicago: A. C. McClurg & Co., 1891)

Child Life (New York: Nims & Knight, 1899)

Cornish, C. J. *Wild Animals in Captivity* (New York: Macmillan & Co., 1894)

Creighton, Mandell. *Queen Elizabeth* (New York: Goupil & Co., 1896)

Cunningham, Peter. *The Story of Nell Gwyn* (New York: Francis P. Harper, 1896)

de Lafayette, Madame. *The Princess of Cleves* (Boston: Little, Brown & Co., 1891)

Delights of History (series) (New York: D. Appleton & Co., 1892)

Dickens, Charles. *Charles Dickens' Complete Works, New Edition De Luxe* (Boston: Estes & Lauriat, 1890)

Dickens, Charles. *A Souvenir of Charles Dickens* (Boston: Cassino Art Co., Souvenir Series, 1891)

Dobson, Austin. *Eighteenth Century Vignettes* (New York: Dodd, Mead & Co., 1892)

Dobson, Austin. *Four Frenchwomen* (New York: Dodd, Mead & Co., 1891)

Dobson, Austin. *Horace Walpole: A Memoir* (New York: Charles Scribner's Sons, 1894)

Dobson, Austin. *The Sundial* (New York: Dodd, Mead & Co., 1891)

Dodd, Anna Bowman. *Three Normandy Inns* (New York: Lovell, Coryell & Co., 1892)

du Camp, Maxime. *Theophile Gautier* (New York: Charles Scribner's Sons, 1894)

Dürer, Albert. *The Little Passion of Albert Dürer* (New York: Macmillan & Co., 1894)

Edwards, George Wharton. *Sundry Rhymes from the Days of Our Grandmothers* (New York: Anson D. F. Randolph, 1889)

Elliot, Frances. *Old Court Life in France* (New York: G. P. Putnam's Sons, 1893)

Eliot, George. *Adam Bede* (Boston: Estes & Lauriat, 1894)

Eliot, George. *Romola* (Boston: Estes & Lauriat, 1891)

Ellwanger, George H. *In Gold and Silver* (New York: D. Appleton & Co., 1892)

Emerson, Ralph Waldo. *A Souvenir of Ralph Waldo Emerson* (Boston: Cassino Art Co., Souvenir Series, 1891)

Episcopal Church. *Prayer and Hymnal* (Chicago: A. C. McClurg & Co., 1891)

Freeley, Mary Bellie. *Fair to Look Upon* (Chicago: Morrill, Higgins & Co., 1892)

Garnett, Richard. *A Chapter from the Greek Anthology* (New York: Frederick A. Stokes Co., 1892)

Garrett, Edmund H., ed. *Elizabethan Songs* (Boston: Little, Brown & Co., 1891)

Gibson, Charles Dana. *Drawings* (New York: R. H. Russell & Son, 1894)

Gibson, Charles Dana. *Pictures of People* (New York: R. H. Russell & Son, 1896)

Gomme, Alice B. *Children's Singing Games* (New York: Macmillan & Co., 1894)

Gowar, Lord Ronald. *Joan of Arc* (New York: Charles Scribner's Sons, 1894)

Greard, Vallery C. O. *Meissonier: His Life and His Art* (New York: A. C. Armstrong & Son, 1896)

Hamerton, Philip G. *Man in Art* (New York: Macmillan & Co., 1892)

Harrissey, Henry. *History of the Discovery of North America* (New York: H. Welter, 1898)

Hawthorne, Nathaniel. *A Souvenir of Nathaniel Hawthorne* (Boston: Cassino Art Co., Souvenir Series, 1891)

Herbert, George. *Eastern Hymn* (New York: Nims & Knight, 1899)

Howells, William Dean. *Venetian Life* (Boston: Houghton Mifflin & Co., 1891)

Hughes, Thomas. *Tom Brown's School Days* (New York: Thomas Y. Crowell & Co., 1891)

Hugo, Victor. *Notre-Dame de Paris* (New York: William R. Jenkins, 1896)

Irving, Washington. *Rip Van Winkle and the Legend of Sleepy Hollow* (New York: Macmillan & Co., 1894)

Jackson, Catherine Charlotte. *The Last of the Valois* and *The First of the Bourbons* (Boston: L. C. Page & Co., 1897)

Jeffries, Richard. *The Pageant of Summer* (Portland, Maine: Thomas B. Mosher, 1896)

Kavanagh, Julia. *Women in France during the 18th Century* (New York: G. P. Putnam's Sons, 1893)

Keats, John. *Poems* (New York: Macmillan & Co., 1897)

Lang, Andrew. *Aucassin and Nicolette* (Portland, Maine: Thomas B. Mosher, 1895)

Leslie, Amy. *Personal Sketches* (Chicago: Herbert S. Stone & Co., 1899)

Lever, Charles. *The Novels of Charles Lever* (Boston: Little, Brown & Co., 1893)

Locker-Lampson, Frederick. *Selected Prose* (Cleveland, OH: Rowfant Club, 1895)

Longfellow, Henry W. *A Souvenir of Henry W. Longfellow* (Boston: Cassino Art Co., Souvenir Series, 1891)

Lowell, James Russell. *A Souvenir of James Russell Lowell* (Boston: Cassino Art Co., Souvenir Series, 1891)

Lorrequer, Harry. *Charles O'Malley, the Irish Dragoon* (Boston: Little, Brown & Co., 1891)

Lover, Samuel. *The Low-Back'd Car* (Philadelphia: J. B. Lippincott Co., 1890)

Mack, Robert Ellice. *All Things Bright and Beautiful* (Boston: Houghton Mifflin & Co., 1891)

Maclaren, Ian. *Beside the Bonnie Brier Bush* (New York: Dodd, Mead & Co., 1896)

Matthews, Brander. *Notes of a Book Lover* (New York: Macmillan & Co., 1895)

Masson, Frederic. *Napoleon's Cavalry* (New York: Goupil & Co., 1895)

Metropolitan Museum of Art. *Gems of Art* (New York: Metropolitan Museum of Art, 1891)

Miller, Joaquin. *Songs of the Sierras* (Chicago: Morrill, Higgins & Co., 1892)

Miller, Joaquin. *Songs of Summer Lands* (Chicago: Morrill, Higgins & Co., 1892)

Molloy, J. Fitzgerald. *The Life and Adventures of Peg Woffington* (New York: Dodd, Mead & Co., 1892)

Morin, Louis. *French Illustrators* (New York: Charles Scribner's Sons, 1894)

Morris, William. *The Defense of Guinevere* (Portland, Maine: Thomas B. Mosher, 1896)

Morris, William, trans. *The Story of Amis and Amile* (Portland, Maine: Thomas B. Mosher, 1896)

Pater, Walter. *The Child in the House* (Portland, Maine: Thomas B. Mosher, 1896)

Pennel, Joseph. *Modern Book Illustration* (New York: Macmillan & Co., 1894)

Ricci, Corrado. *Antonio Allegri Da Correggio: His Life, His Works, His Time* (New York: Charles Scriber's Sons, 1895)

Robinson, Edwin Arlington. *The Children of the Night* (Boston: Richard G. Badger & Co., 1897)

Rossetti, D. G. *The House of Life* (Boston: Copeland and Day, 1894)

Rossetti, D. G. *The New Life* (Portland, Maine: Thomas B. Mosher, 1896)

Rubaiyat of Omar Khayyam (Portland, Maine: Thomas B. Mosher, 1896)

Sand, George. *Fadette* (New York: Charles Scribner's Sons, 1894)

Scott, Sir Walter. *The Betrothed* and *The Talisman* (Boston: Estes & Lauriat, 1895)

Scott, Sir Walter. *Ivanhoe* (Boston: Estes & Lauriat, 1893)

Scott, Sir Walter. *Rob Roy* (Boston: Estes & Lauriat, 1895)

Scott, Sir Walter. *Waverly Novels* (series) (Boston: Estes & Lauriat, 1898)

Shakespeare, William. *Romeo and Juliet* (New York: Duprat & Co., 1892)

Skelton, John. *Mary Stuart* (New York: Goupil & Co., 1893)

Stevenson, Robert Louis. *A Child's Garden of Verses* (New York: Longman, Green & Co., 1896)

Streamer, Volney, ed. *In Friendship's Name* (Chicago: Morrill, Higgins & Co., 1892)

Streamer, Volney, ed. *What Makes a Friend?* (Chicago: Morrill, Higgins & Co., 1892)

Stowe, Harriet Beecher. *The Writings of Harriet Beecher Stowe* (Boston: Houghton Mifflin & Co., 1896)

Tennyson, Alfred. *Enoch Arden* (New York: Macmillan & Co., 1891)

Tennyson, Alfred. *The Poems of Alfred Tennyson* (New York: Macmillan & Co., 1893)

Tennyson, Alfred. *A Souvenir of Alfred Tennyson* (Boston: Cassino Art Co., Souvenir Series, 1891)

Thackeray, William Makepeace. *Vanity Fair* (Boston: Estes & Lauriat, 1894)

Thompson, David C. *The Barbizon School of Painting* (New York: Scribner & Welford, 1891)

Walton and Cotton's Complete Angler (Boston: Little, Brown & Co., 1890)

Whittier, John G. *Snow Bound* (Boston: Houghton Mifflin & Co., 1891)

Whittier, John G. *A Souvenir of John Greenleaf Whittier* (Boston: Cassino Art Co., Souvenir Series, 1891)

Wilcox, Ella Wheeler. *Poems of Passion* and *Poems of Pleasure* (Chicago: Morrill, Higgins & Co., 1892)

Williams, Alice L., ed. *A Handful of Letters* (Chicago: Morrill, Higgins & Co., 1892)

Williams, J. L. *Bits of English Scenery* (New York: Nims & Knight, Publishers, 1891)

Williams, J. L. *By Stream and Roadside* (New York: Nims & Knight, Publishers, 1891)

Wiseman, Robert R. *The Harvard Yard* (New York: Frederick A. Stokes Co., 1890)

B. Appendix

Chronology of Futurism/Vorticism in London, 1913–1915

Ezra Pound's interactions with Ernest Fenollosa's manuscripts are marked with <<>>.

1913

April	• Futurist Gino Severini has a one-man exhibition at Marlborough Gallery in London.[1] • Horace B. Samuel publishes "The Future of Futurism" in the *Fortnightly Review*. • Publication of Pound's Imagist poems in *Poetry*.[2]
September	• <<Introduced by Laurence Binyon, Pound has first of three meetings with Mary Fenollosa.>>[3] • *Poetry and Drama* publishes an entire issue on Futurism, including F. T. Marinetti's manifesto, "Destruction of Syntax—Wireless Imagination—Words-in-Freedom," as well as a "French Chronicle" on Marinetti by F. S. Flint.[4]
November	• Wyndham Lewis organizes post-Omega group dinner for Marinetti where he begins planning for a new magazine (eventually *BLAST*).[5] • Marinetti's manifesto "The Variety Theater" published in the *Daily Mail*.[6] • Marinetti gives "Futurist evenings" at the Cabaret Club, the Poet's Club, the Poetry Bookshop, and the Doré Galleries.[7]
December	• <<Pound receives Fenollosa's manuscripts.>> • Richard Aldington publishes account of "M. Marinetti's Lectures," in *New Freewoman*.[8] • T. E. Hulme defends Jacob Epstein's *Rock Drill* against critics in the *New Age*.[9]

1914

January	• Hulme gives lecture to the Quest Society in London declaring that the "character of the art that is coming" will be that of "the machine" (with Pound and Lewis in attendance).[10] • <<Pound begins work on Fenollosa's manuscripts.>>
March	• Lewis establishes the Rebel Arts Center. • <<Pound decides to publish an edition of the Noh plays from Fenollosa's manuscripts.>>
April–June	• Advertisements written by Pound for the forthcoming *BLAST* in the *Egoist*.

	• Exhibition of Futurist painting at the Doré Galleries in London.
	• <<Pound writes to Amy Lowell that he is deeply engrossed in the Fenollosa manuscripts.>>[11]
	• *New Age* publishes Marinetti's manifestos "Geometric and Mechanical Splendor in Words at Liberty," and "Abstract Onomatopoeia and Numeric Sensibility."[12]
June	• Christopher Nevinson and Marinetti publish "Vital English Art" manifesto, after which Lewis and other future Vorticists heckle Marinetti at a public performance.[13]
July	• *BLAST1* published.
September	• A. R. Orage criticizes Pound's Vorticism and his misplaced attempt to link it to Imagism.[14]
November	• <<Pound begins final selection of which poems from Fenollosa's notes to include in *Cathay*.>>

1915

January	• Pound publishes explanation of Vorticism in *New Age* ("tangle of telegraph wires . . . sidings of railways").[15]
February	• <<Pound publishes account of both Wadsworth's "delight in machines," and Fenollosa's "personal knowledge" of China and Japan "pouring into the vortex in London.">>[16]
	• *New Age* publishes parody of attempts by Vorticists to separate themselves from Futurists.[17]
April	• <<Publication of *Cathay*.>>
June	• <<Pound laments that magazine editors have not been receptive to publication of Fenollosa's essay *The Chinese Written Character as a Medium for Poetry*.>>[18]
July	• <<*BLAST2* published, including translations from Fenollosa's notes.>>

C. Appendix

Ezra Pound 1910–1912 vs. Ezra Pound 1914–1915

1910–1912	1914–1915
Pound seeks out the advice of establishment poet Robert Bridges, whose sentimental hymns and lyrics had made him extremely popular in England.[1]	Pound curses Bridges for his "flabby" verses and poetic "drizzle."[2]
Pound vehemently criticizes the poetic theories of Hudson Maxim, a retired engineer who had been advocating a machine-like "efficiency" in poetics (decrying the "confused" author's "fathomless ignorance," "inaccuracies," and lack of "taste").[3]	Pound (without acknowledging his source) directly reproduces Maxim's notion of "maximum efficiency" in BLAST1.[4]
Pound spends countless hours with Laurence Binyon at the British Museum, enjoying his expertise in Oriental art, and deliberately borrowing from his *The Flight of the Dragon* to establish Imagism.	Pound criticizes Binyon in BLAST2 for not having "sufficiently rebelled."[5]
Pound publishes the respectable *Spirit of Romance*, engaging in normative, scholarly discourse on Provençal minstrelsy, arguing, for example, "Troubadours were melting the common tongue and fashioning it into new harmonies depending not upon the alternation of quantities but upon rhyme and accent." (All very responsible academic language, none of which tries to draw attention to itself.)[6]	Pound begins a new kind of "Pound-speak," with ALL-CAPS phrases, purposeful misspellings, snarky remarks, and an aggressive, unpredictable blending of metered lyric and free verse; for instance, "Let us deride the smugness of 'The Times': GUFFAW! So much the gagged reviewers."[7] It is much more the style of what will become *The Cantos*.
Pound praises the poetry of Rabindranath Tagore for evoking "a calm which we need overmuch in an age of steel and mechanics."[8]	Pound praises paintings by Edward Wadsworth for producing "a delight in mechanical beauty, a delight in the beauty of ships or of crocuses, or a delight in pure form."[9]

D. Appendix

Total Quality Management and Pirsig's *Zen and the Art of Motorcycle Maintenance*

This is a sampling of total quality management studies citing Robert Pirsig's Zen and the Art of Motorcycle Maintenance *and his Metaphysics of Quality.*

Baets, Walter R. *Organizational Learning and Knowledge Technologies in a Dynamic Environment* (Norwell, MA, 1998)

Barker, Tom. *Leadership for Results* (Milwaukee: American Society for Quality, Quality Press, 2006)

Bassett, Glenn. *Operations Management for Service Industries* (Westport, CT: Quorum Books, 1992)

Beckford, John. *Quality: A Critical Introduction* (New York: Routledge, 1998)

Bhimani, Alnoor. *Contemporary Issues in Management Accounting* (New York: Oxford University Press, 2006)

Brown, Steve. *Strategic Operations Management* (Woburn, MA: Butterworth-Heinemann, 2000)

Buono, Anthony F., and Flemming Poulfelt. *Challenges and Issues in Knowledge Management* (Charlotte, NC: Information Age Publishing, 2005)

Christensen, Bruno. *From Management to Leadership* (Parkland, FL: uPublish, 1999)

Collins, Philippa. "Approaches to Quality," *TQM Magazine* 6.3 (1994), pp. 39–42

Cunningham, Ian. *The Wisdom of Strategic Learning* (Brookfield, VT: Gower Publishing Limited, 1999)

Dahlgaard, Jens J. *Fundamentals of Total Quality Management* (Boca Raton, FL: Taylor & Francis, 1998)

Doherty, Tony L., and Terry Horne, eds. *Managing Public Services* (New York: Routledge, 2002)

Fink, Stephen L. *High Commitment Workplaces* (New York: Quorum Books, 1992)

Gluck, Frederick W. "Vision and Leadership," *Interfaces: Special Issue on Strategic Management* 14.1 (January–February 1984), pp. 10–18

Greisler, David, and Ronald J. Stupak. *Handbook of Technology Management in Public Administration* (Boca Raton, FL: Taylor & Francis, 2007)

Gummesson, Evert. *Qualitative Methods in Management Research* (Thousand Oaks, CA: Sage Publications, Inc., 2000)

Haring, Christina. *Total Quality Management in a Theoretical and Practical Context* (Frankfurt: Diplomarbeiten Agentur, 2002)

Khosrow-Pour, Mehdi. *Emerging Trends and Challenges in Information Technology Management* (Hershey, PA: Idea Group Publishing, 2006)

King, Jonathan B. "Ethical Encounters of the Second Kind," *Journal of Business Ethics* 5 (February 1986), pp. 1–11

Knights, David, and Hugh Willmott. *Introducing Organizational Behavior and Management* (London: Thomson Learning, 2007)

Kolbe, Kathy. *Pure Instinct: The M.O. of High Performance People and Teams* (Phoenix, AZ: Monumentus Press, 1993)

Koprowski, Eugene J. "Exploring the Meaning of 'Good' Management," *Academy of Management Review* 6 (July 1981), pp. 459–467

Lamprecht, James L. *Quality and Power in the Supply Chain* (Woburn, MA: Butterworth-Heinemann, 2000)

Lehman, Cheryl. *Accounting's Changing Role in Social Conflict* (Princeton, NJ: Markus Wiener Publishers, 1992)

Lessem, Ronnie. *Management Development through Cultural Diversity* (New York: Routledge, 1998)

Levy, Peter, and Michael Junkar. *Technosophy: Strategic Assessment and Management of Manufacturing Technology Innovation* (Norwell, MA: Kluwer Academic Publishers, 1997)

Loughlin, Michael. *Ethics, Management and Mythology* (United Kingdom: Radcliff, 2002)

Lowe, David, and Roine Leiringer, eds. *Commercial Management of Projects* (Malden, MA: Wiley-Blackwell, 2006)

Lundberg, Craig C., and Cheri A. Young, eds. *Foundations for Inquiry: Choices and Trade-Offs in the Organizational Sciences* (Stanford, CA: Stanford University Press, 2005)

Mansfield, Roger. *Frontiers of Management* (New York: Routledge, 1989)

Mintzberg, Henry. *Power in and around Organizations* (New York: Prentice Hall, 1983)

Moore, David. *Project Management* (Malden, MA: Blackwell Science, Ltd., 2002)

Nicholas, John M., and Herman Steyn. *Project Management for Business, Engineering and Technology* (Woburn, MA: Butterworth-Heinemann, 2008)

Peters, Thomas J., and Nancy Austin, *A Passion for Excellence* (New York: Warner Books, 1989)

Peters, Thomas J., and Robert H. Waterman, Jr. *In Search of Excellence* (New York: Harper & Row, 1982)

Pitagorsky, George. *The Zen Approach to Project Management* (New York: International Institute for Learning, 2007)

Robey, Daniel, and William Tagger. "Issues in Cognitive Style Measurement," *Academy of Management Review* 8.1 (1983), pp. 152–155

Sallis, Edward. *Total Quality Management in Education* (Sterling, VA: Stylus Publishing, Inc., 1993)

Sherman, Joe. "The Zen of Quality," *In the Rings of Saturn* (New York: Oxford University Press, 1994)

Stevenson, Rodney. "Corporate Power and the Scope of Economic Analysis," *Journal of Economic Issues* 19 (June 1985), pp. 333–341

Van de Ven, Andrew H., ed. *Research on the Management of Innovation* (New York: Harper & Row, 1989)

Walker, Derek, and Steve Rowlinson, eds. *Procurement Systems: A Cross-Industry Project Management Perspective* (New York: Routledge, 2008)

Westwood, Robert, and Stewart Clegg. *Debating Organization: Point-Counterpoint in Organization Studies* (Malden, MA: Blackwell, 2003)

Williams, Peter. "Total Quality Management: Some Thoughts," *Higher Education* 25.3 (1993), pp. 373–375

Wright, Susan, ed. *Anthropology of Organizations* (New York: Routledge, 1994)

E. Appendix

Zen and Management/Corporation Studies

Bing, Stanley. *Throwing the Elephant: Zen and the Art of Managing Up* (New York: Collins, 2002)

Carroll, Michael. *Awake at Work: Thirty-Five Practical Buddhist Principles for Discovering Clarity and Balance in the Midst of Work's Chaos* (Boston, MA: Shambhala Publications, 2006)

Carroll, Michael. *The Mindful Leader: Awakening Your Natural Management Skills through Mindfulness Meditation* (Boston, MA: Shambhala Publications, 2008)

Cleary, Thomas. *Zen Lessons: The Art of Leadership* (Boston, MA: Shambhala Publications, 2007)

Dreher, Diane. *The Tao of Personal Leadership* (New York: Harper, 1996)

Field, Lloyd. *Business and the Buddha* (Somerville, MA: Wisdom Publications, 2007)

Godden, Lee. *ZenWise Selling: Mindful Methods to Improve Your Sales and Your Self* (Signal Hill, CA: Telsius Publishing, 2004)

Heider, John. *The Tao of Leadership* (Lake Worth, FL: Humanics Publishing Group, 2005)

Heine, Steven. *White Collar Zen: Using Zen Principles to Overcome Obstacles and Achieve Your Career Goals* (New York: Oxford University Press, 2005)

Hendricks, Gay, and Kate Ludeman. *The Corporate Mystic: A Guidebook for Visionaries with Their Feet on the Ground* (New York: Bantam, 1997)

Holender, Allan. *Zentrepreneurism: A Twenty-First Century Guide to the New World of Business* (San Diego, CA: BookTree, 2008)

James, Geoffrey. *The Tao of Programming* (Georgetown, TX: InfoBooks, 1986)

James, Geoffrey. *The Zen of Programming* (Georgetown, TX: InfoBooks, 1988)

Kay, Les. *Zen at Work* (New York: Three Rivers Press, 1997)

Krause, Donald G. *The Book of Five Rings for Executives* (London: Nicholas Brealey Publishing, 1999)

Leeds, Regina. *The Zen of Organizing* (London: Alpha Press, 2002)

Lesser, Marc. *Z.B.A.: Zen of Business Administration—How Zen Practice Can Transform Your Work and Your Life* (Novato, CA: New World Library, 2005)

Low, Albert. *Zen and Creative Management* (North Clarendon, VT: Tuttle Publishing, 1992)

McClain, Gary, and Eve Adamson. "Buddha in Your Cubicle," in *The Complete Idiot's Guide to Zen Living* (New York: Penguin, 2001)

McDermott, Patrick. *Zen and the Art of Systems Analysis: Meditations on Computer Systems Development* (Bloomington, IN: IUniverse, 2002)

Menon, Murli. *ZeNLP: The Power to Succeed* (Thousand Oaks, CA: Sage Publications, 2005)

Metcalf, Franz. *What Would Buddha Do at Work? One Hundred and One Answers to Workplace Dilemmas* (Berkeley, CA: Ulysses Press, 2001)

Mindell, Arnold. *The Leader as Martial Artist* (San Francisco: HarperSanFrancisco, 1992)

Park, Dong J. *Management, Zen, and I: One Hundred Questions for Management Thinking* (New York: BookSurge Publishing, 2007)

Philip, Karun. *Zen and the Art of Funk Capitalism* (Bloomington, IN: IUniverse, 2001)

Pitagorsky, George. *The Zen Approach to Project Management: Working from Your Center to Balance Expectations and Performance* (New York: International Institute for Learning, 2007)

Richmond, Lewis. *Work as Spiritual Practice: A Practical Buddhist Approach to Inner Growth and Satisfaction on the Job* (New York: Broadway Press, 2000)

Schultz, Ron. *The Mindful Corporation* (Long Beach, CA: Leadership Press, 2000)

Spears, Nancy. *Buddha Nine to Five: The Eightfold Path to Enlightening Your Workplace and Improving Your Bottom Line* (Avon, MA: Adams Media, 2007)

Van de Weyer, Robert. *Zen Economics* (Berkeley, CA: O Books, 2004)

Virc, Rizwan. *Zen Entrepreneurship: Walking the Path of the Career Warrior* (Bloomington, IN: Xlibris 2004)

Witten, Dona. *Enlightened Management: Bringing Buddhist Principles to Work* (South Paris, ME: Park Street Press, 1999)

F. Appendix

"Zen and the Art of" in Contemporary Discourse

This is a sampling of "Zen and the Art of" in contemporary discourse to be read as a poem of late capital.

Published Books (Arranged Chronologically)
1948
 Zen in the Art of Archery
1958
 Zen and the Art of Tea
 Zen and the Art of Flower Arrangement
1974
 Zen and the Art of Motorcycle Maintenance
1977
 Zen and the Art of J. D. Salinger
 Zen and the Art of Reading
1981
 Zen and the Art of Management
1983
 Zen and the Art of Calligraphy
 Zen and the Art of Enlightenment
 Zen and the Art of Computing
 Zen and the Art of Medicaid
1986
 Zen and the Art of the Macintosh
1987
 Zen and the Art of Medicaid Budgeting
1988
 Zen and the Art of Windsurfing
1989
 Zen and the Art of Pottery
1992
 Zen and the Art of Therapy
 Zen and the Art of Resource Editing
1993
 Zen and the Art of the Internet
 Zen and the Art of Making a Living
 Zen and the Art of Modern Macroeconomics
1994
 Zen and the Art of Money Management
 Zen and the Art of Writing
 Zen and the Art of Merchandising

1995
Zen and the Art of Climbing Mountains
1996
Zen and the Art of Fatherhood
Zen and the Art of Street Fighting
1997
Zen and the Art of Facing Life
1998
Zen and the Art of Stand-up Comedy
Zen and the Art of Dialogue
Zen and the Art of Debugging
Zen and the Art of Snowboarding
1999
Zen and the Art of Making a Living
Zen and the Art of Poker
Zen and the Art of Circle Maintenance
Zen and the Art of Murder
Zen and the Art of Anything
Zen and the Art of Tying Shoelaces
2000
Zen and the Art of Postmodern Philosophy
Zen and the Art of the Monologue
Zen and the Art of Art
Zen and the Art of Data Pooling
2001
Zen and the Art of Piano Buying
Zen and the Art of Paradox
2002
Zen and the Art of Knitting
Zen and the Art of Course Selection
Zen and the Art of Living with Fearlessness and Grace
Zen and the Art of Diabetes Maintenance
Zen and the Art of Foosball
Zen and the Art of Systems Analysis
Zen and the Art of Whole-Home Networking
Zen and the Art of English Language Teaching
Zen and the Art of Dealing with the Difficult Patron
2003
Zen and the Art of Falling in Love
Zen and the Art of Managing Up
Zen and the Art of Fundraising
Zen and the Art of War
Zen and the Art of Fasting
Zen and the Art of Meditation
Zen and the Art of Dishwashing
Zen and the Art of Patient Placation
Zen and the Art of Not Drinking
2004
Zen and the Art of Headbutting
Zen and the Art of Creating Life
Zen and the Art of Journal Article Reviewing
Zen and the Art of Quilting

2005
Zen and the Art of Needlecraft
Zen and the Art of Water Quality
Zen and the Art of the SAT
Zen and the Art of Modern Life Maintenance
Zen and the Art of Scaling
Zen and the Art of Wholeness
Zen and the Art of Securities Regulation
2006
Zen and the Art of Trying
Zen and the Art of Harley Riding
Zen and the Art of Happiness
Zen and the Art of Performance Monitoring
Zen and the Art of Crossword Puzzles
Zen and the Art of Thinking Straight
2007
Zen and the Art of Internet Marketing
Zen and the Art of Ubuntu Networking
2008
Zen and the Art of Dying
Zen and the Art of Cylon Maintenance
Zen and the Art of Growing Older
Zen and the Art of Construction Management
2009
Zen and the Art of Staying Sane in Hollywood
Zen and the Art of Vampires
2010
Zen and the Art of Faking It

References Online (Arranged Alphabetically)

Zen and the Art of Abstraction Maintenance
Zen and the Art of Academic Motorcycling
Zen and the Art of Acquiring the Write Stuff
Zen and the Art of AHRB Maintenance
Zen and the Art of Alarm Clock Negligence
Zen and the Art of Alternative Reality
Zen and the Art of Anarchy
Zen and the Art of Appliance Repair and Finding Shit
Zen and the Art of Attendee Marketing
Zen and the Art of Attention
Zen and the Art of Autobiography Comics
Zen and the Art of Automation
Zen and the Art of Backyard Barbecue
Zen and the Art of Balancing Rocks
Zen and the Art of Baseball
Zen and the Art of Bathrooms
Zen and the Art of Being a Matzo Ball
Zen and the Art of Being Happy with Microsoft
Zen and the Art of Being Out of Work
Zen and the Art of Bicycle Riding
Zen and the Art of Biking
Zen and the Art of Blueberry Picking

Zen and the Art of Boston Driving
Zen and the Art of Bouldering
Zen and the Art of Brand Maintenance
Zen and the Art of Breaking and Entering
Zen and the Art of Briefing
Zen and the Art of Building a Program
Zen and the Art of Building the City
Zen and the Art of Bully Taming
Zen and the Art of California Dreaming
Zen and the Art of Calm Maintenance
Zen and the Art of Canine Maintenance
Zen and the Art of Car Décor
Zen and the Art of Car Design
Zen and the Art of Car Rental
Zen and the Art of Car Thievery
Zen and the Art of Carpet Beating
Zen and the Art of Casting
Zen and the Art of Castle Maintenance
Zen and the Art of CD Collection Maintenance
Zen and the Art of Ceding Control of Consumer Tech to End Users
Zen and the Art of Central Heating Maintenance
Zen and the Art of CEO Driving
Zen and the Art of Checkbook Balancing
Zen and the Art of Child Maintenance
Zen and the Art of Classified Advertising
Zen and the Art of Clay and Glass
Zen and the Art of Clubbing
Zen and the Art of Coaching
Zen and the Art of Cocktails
Zen and the Art of Coffee Roasting
Zen and the Art of Color
Zen and the Art of Combining Motorcycling with Fatherhood
Zen and the Art of Communication
Zen and the Art of Competitive Eating
Zen and the Art of Condé Nast
Zen and the Art of Connecticut Brews
Zen and the Art of Contemporary Urban Design
Zen and the Art of Cooking
Zen and the Art of Cooking up Italian Mysteries
Zen and the Art of Coping with Alzheimer's
Zen and the Art of Corncrake Surveillance
Zen and the Art of Corporate Productivity
Zen and the Art of Cramming
Zen and the Art of Creating a Taste of the Orient
Zen and the Art of Crime
Zen and the Art of Culture
Zen and the Art of Curry
Zen and the Art of Cutting Grass
Zen and the Art of Cycling around Japan
Zen and the Art of Dance
Zen and the Art of Data Center Greening
Zen and the Art of Dealing with Difficult Physicians
Zen and the Art of Debunkery

Zen and the Art of Dessert
Zen and the Art of Desktop Management
Zen and the Art of Dessert Perfection
Zen and the Art of Detective Maintenance
Zen and the Art of Digging a Hole
Zen and the Art of Dim Sum
Zen and the Art of Diplomacy
Zen and the Art of DNC Avoidance
Zen and the Art of Do-It-Yourself Decorating
Zen and the Art of Dog Park Maintenance
Zen and the Art of Doing Nothing
Zen and the Art of Drinking Beer
Zen and the Art of Drowning out the Neighbors
Zen and the Art of Drupal
Zen and the Art of Dual-Garden Maintenance
Zen and the Art of Dudeliness
Zen and the Art of Dump Truck Driving
Zen and the Art of Dumpster Diving
Zen and the Art of Eating
Zen and the Art of Economic Engine Maintenance
Zen and the Art of Economics in Blissful Bhutan
Zen and the Art of Engaging the Dragon
Zen and the Art of Enterprise Search
Zen and the Art of Erectile Dysfunction
Zen and the Art of Evolving Relationships
Zen and the Art of Face Punching
Zen and the Art of Facial Maintenance
Zen and the Art of Family Gatherings
Zen and the Art of Fine Company Maintenance
Zen and the Art of Fingerpicking
Zen and the Art of Fixing a Flat Tire
Zen and the Art of Flight
Zen and the Art of Following Newcastle United
Zen and the Art of Forgetting That Your Feet Are Cold
Zen and the Art of Fridges
Zen and the Art of Frying Tiny Drumsticks
Zen and the Art of Fuel Efficiency
Zen and the Art of Garden Design
Zen and the Art of Garden Maintenance
Zen and the Art of Gator Maintenance
Zen and the Art of Getting Around
Zen and the Art of Global Maintenance
Zen and the Art of Gloss Maintenance
Zen and the Art of Golden Temple Maintenance
Zen and the Art of Golf
Zen and the Art of Good Business
Zen and the Art of Good Mail List Maintenance
Zen and the Art of Guitar Playing
Zen and the Art of Hacking
Zen and the Art of a Harmonious Abode
Zen and the Art of Hand-to-Hand Combat
Zen and the Art of Health Care Facility Programming
Zen and the Art of Herb Gardening

Zen and the Art of Hi-Tech Sales
Zen and the Art of Hitting a Bull's-Eye
Zen and the Art of Hitting a Little Ball
Zen and the Art of Home Building
Zen and the Art of Home-Office Décor
Zen and the Art of Home Work
Zen and the Art of Humor in Bread Making
Zen and the Art of IA
Zen and the Art of Inbox Maintenance
Zen and the Art of Incubation
Zen and the Art of Index Investing
Zen and the Art of Information Security
Zen and the Art of Ink Painting
Zen and the Art of Interior Design
Zen and the Art of an Internal Penetration Program
Zen and the Art of Internet Search
Zen and the Art of Intrusion Detection
Zen and the Art of Investigation
Zen and the Art of Investing
Zen and the Art of iPod Killing
Zen and the Art of Israeli Diplomacy
Zen and the Art of Jibber-Jabber
Zen and the Art of Joint Maintenance
Zen and the Art of Kicking the Ball
Zen and the Art of Killing
Zen and the Art of Kitsch
Zen and the Art of Laptop Battery Maintenance
Zen and the Art of Law Enforcement
Zen and the Art of Lawyer Maintenance
Zen and the Art of Lawyering
Zen and the Art of Leading
Zen and the Art of Legislating
Zen and the Art of Letting Go
Zen and the Art of Living in Delhi
Zen and the Art of Lunchbox Contentment
Zen and the Art of Mail Delivery
Zen and the Art of Making Friends
Zen and the Art of Making Noodles
Zen and the Art of Managerial Maintenance
Zen and the Art of Marketing
Zen and the Art of Mashing Potato
Zen and the Art of Mazda
Zen and the Art of Meditation Gardens
Zen and the Art of Mental Maintenance
Zen and the Art of Metalworking
Zen and the Art of Mix Tapes
Zen and the Art of Mobile Phones
Zen and the Art of Monetary Mayhem
Zen and the Art of Motherhood
Zen and the Art of Motor Neuron Maintenance
Zen and the Art of Motorcycle Mania
Zen and the Art of Motorcycle Manuals
Zen and the Art of Motorcycle Muffling

Zen and the Art of Murder Mysteries
Zen and the Art of Murray Mania
Zen and the Art of Music and Video
Zen and the Art of Net Startups
Zen and the Art of a New Career
Zen and the Art of New Year's Eve
Zen and the Art of Nonprofit Technology
Zen and the Art of Oil Market Maintenance
Zen and the Art of Online Sweepstakes
Zen and the Art of Operating Systems
Zen and the Art of Pad Thai Generation
Zen and the Art of Paid Search Maintenance
Zen and the Art of Partial Mash Brewing
Zen and the Art of Patio Scraping
Zen and the Art of Peacekeeping
Zen and the Art of Perfect Pork
Zen and the Art of Physician Autonomy Maintenance
Zen and the Art of Piano Tuning
Zen and the Art of Pizza
Zen and the Art of Plane Deals
Zen and the Art of Playing MP3s
Zen and the Art of Political Campaigning
Zen and the Art of Political Maneuvering
Zen and the Art of Political Status Quo Maintenance
Zen and the Art of Portable Music
Zen and the Art of Portfolio Maintenance
Zen and the Art of Post Operative Maintenance
Zen and the Art of Press Management
Zen and the Art of Prison Reform
Zen and the Art of Programming
Zen and the Art of Propane Safety
Zen and the Art of Proper Bathroom Maintenance
Zen and the Art of Proposal Writing
Zen and the Art of Public Relations
Zen and the Art of Pumpkin Bombing
Zen and the Art of a Queer Icon
Zen and the Art of Raising Geopolitically-Savvy Kids
Zen and the Art of Rationality
Zen and the Art of Recycling
Zen and the Art of Relaxation
Zen and the Art of Remarkable Blogging
Zen and the Art of Retailing
Zen and the Art of Retirement Planning
Zen and the Art of Riding a Girl's Bicycle
Zen and the Art of Road Rage
Zen and the Art of Rock and Roll
Zen and the Art of Rockbolting
Zen and the Art of Rogue Employee Management
Zen and the Art of Running a Tea Business
Zen and the Art of Safe Holiday Driving
Zen and the Art of Sandcastles
Zen and the Art of Sarbanes-Oxley Compliance
Zen and the Art of Saving Gasoline

Zen and the Art of Savory Sushi
Zen and the Art of Saxophone Playing
Zen and the Art of Scrapbook Maintenance
Zen and the Art of Scrapyard Archeology
Zen and the Art of Search Engine Optimization
Zen and the Art of Seduction
Zen and the Art of Selling Minimalism
Zen and the Art of Service-Oriented Architectures
Zen and the Art of Serving Food
Zen and the Art of Shaving
Zen and the Art of Shears Sharpening
Zen and the Art of Sheriffing
Zen and the Art of Shockwave
Zen and the Art of Shoe Shows
Zen and the Art of Shopping
Zen and the Art of Shoveling Sierra Nevada Snow
Zen and the Art of Showbiz
Zen and the Art of Sitting in One Place
Zen and the Art of Skiing
Zen and the Art of Slam Dancing
Zen and the Art of Small Claims
Zen and the Art of Soap Studies
Zen and the Art of Social Commentary
Zen and the Art of Social Networking
Zen and the Art of Software Configuration Management
Zen and the Art of Software Quality
Zen and the Art of Solo Sailing
Zen and the Art of Songwriting
Zen and the Art of Soul SA
Zen and the Art of Spa Maintenance
Zen and the Art of Space
Zen and the Art of Speedrunning
Zen and the Art of Speedskating
Zen and the Art of Street Design
Zen and the Art of Strolling Past Bob Dole While Boarding a Plane
Zen and the Art of Stunt Riding
Zen and the Art of Summer Session
Zen and the Art of Summing Up the Year
Zen and the Art of Supermodel Maintenance
Zen and the Art of Superstar Maintenance
Zen and the Art of Supporting John McCain
Zen and the Art of Sushi Preparation
Zen and the Art of Talisman Hunting
Zen and the Art of Team Blogging
Zen and the Art of Tech Blog Maintenance
Zen and the Art of Technology
Zen and the Art of Telemarketing
Zen and the Art of Temperature Maintenance
Zen and the Art of the Alcohol Stove
Zen and the Art of the Baby Swing
Zen and the Art of the Bull's-Eye
Zen and the Art of the Burger Chain
Zen and the Art of the Climate Ride

Zen and the Art of the Deal
Zen and the Art of the Entrepreneur
Zen and the Art of the Haiku
Zen and the Art of the House Party
Zen and the Art of the Mosh Pit
Zen and the Art of the New Data Center
Zen and the Art of the Obama-McCain Debate
Zen and the Art of the Project Log
Zen and the Art of the Scam
Zen and the Art of the Six-Figure Linux Job
Zen and the Art of the Sport Cliché
Zen and the Art of the Third Wheel
Zen and the Art of the Triathlon
Zen and the Art of the Wall
Zen and the Art of Thinking Straight
Zen and the Art of Total Fitness
Zen and the Art of ToughBooks
Zen and the Art of Tourism
Zen and the Art of Traffic Engineering
Zen and the Art of Translation
Zen and the Art of Travel in China
Zen and the Art of Tree-Climbing
Zen and the Art of Troubleshooting
Zen and the Art of TV
Zen and the Art of VMware ESX Storage
Zen and the Art of Volunteering
Zen and the Art of Volvo
Zen and the Art of Walking
Zen and the Art of Warehouse Management
Zen and the Art of Washing Machine Maintenance
Zen and the Art of Watching Recorded TV on Your Weekday Commute
Zen and the Art of *Watchmen*
Zen and the Art of Wave Riding
Zen and the Art of Website Promotion
Zen and the Art of Websites
Zen and the Art of Weeding

Notes

Chapter 1: Asia-as-*Technê*

1. For the sake of readability, I will refrain hereafter from placing "East" and "West" in scare quotes, with the assumption that I am using these terms as cultural constructs rather than ontological essences. I should also mention at the outset that while "techne" (without the circumflex over the "e") is currently an acceptable way of transcribing τέχνη into English, I have chosen to use the more traditional form *technê* precisely because, as we shall see, it was the more exotic, "lost" sense of the word that captivated the authors and artists I analyze in this book.

2. For accounts of Anglo-American enthusiasm for technology, see Thomas P. Hughes, *American Genesis: A Century of Invention and Technological Enthusiasm, 1870–1970* (Chicago: University of Chicago Press, 2004); David E. Nye, *American Technological Sublime* (Cambridge, MA: MIT Press, 1996); and Michael Adas, *Machines as the Measure of Men: Science, Technology, and Ideologies of Western Dominance* (Ithaca, NY: Cornell University Press, 1990). On technology as an Anglo-American religion, see David F. Noble, *The Religion of Technology: The Divinity of Man and the Spirit of Invention* (New York: Penguin, 1999); and Siva Vaidhyanathan, "Rewiring the 'Nation': The Place of Technology in American Studies." *American Quarterly* 58.3 (2006), pp. 555–567.

3. On the question of technological determinism, see *Does Technology Drive History? The Dilemma of Technological Determinism,* ed. Merritt Roe Smith and Leo Marx (Cambridge, MA: MIT Press, 1994).

4. On the Turing test, see Ray Kurzweil and Mitchell Kapor, "A Wager on the Turing Test," *Parsing the Turing Test: Philosophical and Methodological Issues in the Quest for the Thinking Computer,* ed. Robert Epstein, Gary Roberts, and Grace Beber (New York: Springer, 2009), pp. 463–464.

5. David Hockney, *Secret Knowledge: Rediscovering the Lost Techniques of the Old Masters, New and Expanded Edition* (New York: Viking Studio, 2006). Subsequent references are to this edition, hereafter cited as *SK*. The controversy regarding Hockney's thesis began as early as December 1–2, 2001, when a special symposium on his ideas was held at NYU. Optical scientists Christopher Tyler and David G. Stork offered the most aggressive attacks, with Stork publishing, among dozens of other rebuttals, a short follow-up piece, "Optics and Realism in Renaissance Art," *Scientific American*, December 2004, pp. 76–83.

6. Most art critics prior to Hockney already had some idea that artists in the seventeenth and eighteenth centuries like Johannes Vermeer and Joshua Reynolds were at least fascinated with and perhaps even actively incorporating optic technologies into their methods of representation, but no one had ever argued that these techniques were as old as early fifteenth-century paintings by Jan Van Eyck. See, for example, Martin Kemp, *The Science of Art* (New Haven, CT: Yale University Press, 1990), and Philip Steadman, *Vermeer's Camera: Uncovering the Truth behind the Masterpieces* (New York: Oxford University Press, 2001). In the revised edition of *SK*, much of his correspondence with Kemp (who alternates between enthusiasm and caution regarding Hockney's ideas) is reprinted in the back of the book. Hockney also relies heavily on Steadman's experiments in his book and the subsequent BBC documentary on it.

7. All of these potential explanations are offered by Stork in "Optics and Realism," p. 83; it is worth noting here that oil as a medium did in fact allow for new ways of "seeing," not only because colors could be more carefully blended and nuanced, but also because oil dried more slowly than tempura, which meant that for a longer period of time what a painter might see was a potentially "unfinished" canvas, opening up the possibility of re-vision in ways that artists would have never had available to them previously.

8. Or, at least, works surprisingly well with the highly reflective modern concave mirrors available today. As Stork, Tyler, and others have pointed out, one cannot be certain as to whether or not such a crisp reflection was available by way of the concave mirrors Van Eyck would have had access to.

9. J. J. Stamnes, *Waves in Focal Regions: Propagation, Diffraction, and Focusing of Light, Sound, and Water Waves* (New York: Taylor & Francis Group, 1986), pp. 4–5.

10. That opponents like Stork have become so exercised in their responses should also not obscure the fact that their answer to Hockney is, in essence, a "probably not." It will take much more than visual evidence within the paintings themselves (something like a heretofore undiscovered document) to go much further than these positions will allow. Much of the confusion is a result of Hockney putting all his optics eggs in the one concave-mirror basket; it makes for very good cinema, but not very thick description.

11. Much of the controversy stems from the fact that Hockney's hypothesis also radically disrupts the traditional distinction between painting and photography. See Walter Benn Michaels, *The Shape of the Signifier* (Princeton: Princeton University Press, 2004), pp. 95–96; and Kendall Walton, "Transparent Pictures: On the Nature of Photographic Realism," *Critical Inquiry* 11.2 (December 1984), pp. 250–251.

12. Even given his acknowledgment of these talents, Hockney is still arguing something radically different from traditional art practice. Whereas the old masters had been praised for their ability to see and reproduce their models on a two-dimensional surface, Hockney would have us praise the old masters' abilities to bring together set designs, lighting, choreography, and even narrative; Hockney's old masters are not "artists" really, but rather Hollywood film directors (who call out "freeze!" rather than "action!").

13. Hockney's argument in the film self-reflexively addresses four distinct points of view: 1) the scene observed by viewers watching the film (made, interestingly enough, by *rolls* of celluloid that, however similar to the Chinese scroll, proceed according to a strict linearity—even when it "appears" to be going in reverse); 2) Canaletto's *Capriccio: Plaza San Marco Looking South and West*, painted in 1763, which is perspectivally correct to a fault; 3) the seventy-two-foot-long Chinese scroll by Wang Hui titled *The Kangxi Emperor's Southern Inspection Tour* (1698), which Hockney finds a brilliant synthesis of space and time; and 4) a second Chinese scroll painted some seventy-five years after Wang Hui's, titled *The Qianlong Emperor's Southern Inspection Tour* (1770) by Xu Yang, created after Western missionaries had arrived with "Western ways of seeing." Hockney sees this final scroll as a regression of Wang Hui's spatial brilliance (the perspectival machine having entered the garden of China). See *A Day on the Grand Canal with the Emperor of China; or, Surface Is Illusion but So Is Depth*, a film written by David Hockney and directed by Philip Haas (Milestone Films, 1988).

14. For more on Hockney's fax and computer art, see Paul Melia and Ulrich Luckhardt, *David Hockney* (New York: Prestel, 2011), p. 196; and Sarah Howgate, Barbara Stern Shapiro, and Mark Glazebrook, *David Hockney: Portraits* (New Haven, CT: Yale University Press, 2006), pp. 223–233, 244.

15. Throughout the twentieth century, questions about the value of machine culture were often introduced by reminding readers that the Greek word *technê* meant "art." As we shall see, this was true of poetic, critical, and philosophical figures like Ezra Pound, in his *Machine Art and Other Writings* (Durham, NC: Duke University Press, 1996), pp. 23–25;

Marshall McLuhan (see Donald F. Theall, *The Virtual Marshall McLuhan* [Montreal: McGill-Queen's University Press, 2001], pp. 13, 43, 75–76, 101, 116, 139, 172, 271); Daniel Bell, "Technology, Nature, and Society," *Technology and the Frontiers of Knowledge* (New York: Doubleday & Co., 1973), pp. 23–72; Richard McKeon, *Selected Writings of Richard McKeon, Volume 2* (Chicago: University of Chicago Press, 2005), p. 169; Robert Pirsig, *Zen and the Art of Motorcycle Maintenance* (New York: Bantam, 1974), p. 283; and, more recently, Bernard Stiegler, *Technics and Time 1* (Stanford, CA: Stanford University Press, 1998), pp. 1–18.

16. In 1946, still reeling from the embarrassment of the de-Nazification proceedings, Heidegger retreated to his mountain cabin in Todnauberg where he began translating the *Daodejing* with another visiting Chinese student, Paul Shi-yi Hsiao. Hsiao's reminiscences on the weeks spent translating show that Heidegger was fascinated by the text, and especially Chinese characters, but that he would often take liberties with the original that made his partner in translation feel anxious. See Paul Shih-yi Hsiao, "Heidegger and Our Translation of the *Tao Te Ching*," *Heidegger and Asian Thought*, ed. Graham Parkes (Honolulu: University of Hawai'i Press, 1987), pp. 93–104. We will return to Heidegger's fascination with the Orient in chapter 5.

17. Martin Heidegger, *The Question Concerning Technology, and Other Essays* (New York: Harper & Row, 1977), p. 34. This differentiation between "techno" and *technê* is, in essence, what Heidegger means when he claims (somewhat more cryptically), "technology is not equivalent to the essence of technology" (p. 4). I hasten to add that my use of Heidegger's term should not be read as unqualified admiration for his philosophical conclusions. Indeed, as has been well documented, Heidegger's refusal to philosophically consider his own role in the justification of the highly mechanized slaughter of Jews during the Holocaust makes him, perhaps, one of the least qualified philosophers to offer more therapeutic and organic models of consciousness within the realm of technological systematicity. See Berel Lang, *Heidegger's Silence* (Ithaca, NY: Cornell University Press, 1996).

18. On the question of late Heidegger, see Arnold I. Davidson, "Questions concerning Heidegger: Opening the Debate," *Critical Inquiry* 15.2 (Winter 1989), pp. 407–426.

19. The specific name for this latter discourse is "techno-Orientalism." First employed by David Morley and Kevin Robbins in their discussion of Japan's technological dominance in the 1980s, the phrase refers specifically to fears that the East will appropriate, or even improve upon, the technologies of the West, to supposedly dangerous consequences, a dynamic that informed many of America's fears of Japan in the first half of the twentieth century; see David Morley and Kevin Robins, *Spaces of Identity: Global Media, Electronic Landscapes, and Cultural Boundaries* (New York: Routledge, 1995), p. 169. It is important to note, however, that while techno-Orientalist discourse featured, at various times, some-what prominently in the Anglo-American imagination, the figures examined in this book (excepting, for reasons we shall see in chapter 3, Jack London) would have understood their arguments as, if not antipathetic, at least secondary to this idea. Asia-as-*technê*, in other words, was more *technê*-Orientalism than techno.

20. Hubert Dreyfus, "Heidegger on the Connection between Nihilism, Art, Technology, and Politics," *The Cambridge Companion to Heidegger*, ed. Charles B. Guignon (Cambridge: Cambridge University Press, 2006), p. 358; subsequent references are to this edition, hereafter cited as "HC."

21. Arnold Pacey, *Meaning in Technology* (Cambridge, MA: MIT Press, 1999), pp. 135, 217.

22. My debt to the transpacific field of Asian/American studies will be obvious in the chapters that follow, but to point to only a few of the critical works that have helped shape this study, see Colleen Lye, *America's Asia: Racial Form and American Literature, 1893–1945* (Princeton: Princeton University Press, 2004); *Pacific Rim Modernism*, ed. Mary Ann Gillies, Helen Sword, and Steven Yao (Toronto: University of Toronto Press, 2009);

Sinographies: Writing China, ed. Eric Hayot, Haun Saussy, and Steven Yao (Minneapolis: University of Minnesota Press, 2008); Christopher Bush, *Ideographic Modernism: China, Writing, Media* (New York: Oxford University Press 2010); David Palumbo-Liu, *Asian/American: Historical Crossings of a Racial Frontier* (Stanford, CA: Stanford University Press, 1999); John Eperjesi, *The Imperialist Imaginary: Visions of Asia and the Pacific in American Culture* (Lebanon, NH: Dartmouth University Press, 2005); Yunte Huang, *Transpacific Displacement* (Berkeley: University of California Press, 2002); Rob Wilson, *Reimagining the American Pacific* (Durham, NC: Duke University Press, 2000); Rey Chow, *The Protestant Ethnic and the Spirit of Capitalism* (New York: Columbia University Press, 2002); J. J. Clarke, *Oriental Enlightenment: The Encounter between Asian and Western Thought* (New York: Routledge, 1997); and Bruce Cumings, *Dominion from Sea to Sea: Pacific Ascendency and American Power* (New Haven, CT: Yale University Press, 2009).

23. This book will also continue a conversation with a number of classic works on the ambivalence with which Anglo-Americans responded to technological experience, including Lewis Mumford, *Technics and Civilization* (New York: Harcourt, Brace & World, Inc., 1934); Leo Marx, *The Machine in the Garden: Technology and the Pastoral Ideal in America* (New York: Oxford Press, 200); Alan Trachtenberg, *Brooklyn Bridge: Fact and Symbol* (Chicago: University of Chicago Press, 1965); and Cecilia Tichi, *Shifting Gears: Technology, Literature, Culture in Modernist America* (Chapel Hill, NC: University of North Carolina Press, 1987); Perhaps the most immediately relevant work is Jackson Lears, *No Place of Grace: Antimodernism and the Transformation of American Culture* (Chicago: University of Chicago Press, 1981). I should mention here that the problem I have with Lears's periodizing notion of "antimodernism" is not only that the term can sometimes be confusing (obscuring, as it often does, Lears's own thesis that these reactions to the second industrial revolution served as a catalyst for the transformation to *modern* American capitalism), but, more critically, that the sweeping nature of Lears's category tends to overemphasize the notion that these crises were understood as primarily temporal (i.e., a condition of abstract, technological "modernity") rather than as geographically and culturally specific (i.e., a philosophical dilemma unique to Anglo-American racial experience). Thus, Lears frequently overgeneralizes the "reaction" to modernity in ways that group together what are often contradictory responses, even as he limits these reactions to the bounded, local concerns of white-male elites during the Gilded Age, far removed from the commotions of popular culture. This is not to say that I intend to entirely undo Lears's notion of the antimodern (there are times, in fact, when I will use the term to refer to reactions against what was understood to be the specifically temporal crises of machine-induced "progress"); rather, my goal is to show that the turn to Asian aesthetics as a means of advancing Western technoculture is both more complicated and widespread than Lears's antimodern thesis would indicate, something that continues to shape our responses to technocultural experience today.

24. On "technique" as not only "craft" or "gadget," but also the whole post-Enlightenment question of technological experience, see Jacques Ellul, *The Technological Society* (New York: Vintage Books, 1967), pp. 3–22.

25. For accounts of technological enthusiasm at the World's Fair in Chicago, see Stanley Appelbaum, *The Chicago World's Fair of 1893: A Photographic Record* (New York: Dover Publications, 1980), p. 47; James Wilson Pierce, *Photographic History of the World's Fair and Sketch of the City of Chicago* (Baltimore: R. H. Woodward & Co., 1893), pp. 216–219; Finis Farr, *Chicago: A Personal History of America's Most American City* (New York: Arlington House, 1973), p. 186; Nye, *American Technological Sublime*, pp. 147–148; and David E. Nye, *Narratives and Spaces: Technology and the Construction of American Culture* (New York: Columbia Press, 1997), pp. 115–122; Cumings, *Dominion from Sea to Sea*, p. 131; Alan Trachtenberg, *The Incorporation of America: Culture and Society in the Gilded Age* (New York: Hill & Wang, 2007), pp. 41–42.

26. Robert Herrick, *Memoirs of an American Citizen* (New York: Macmillan & Co., 1905), p. 192.

27. "Elevators Go Wild," *Chicago Daily Tribune* (November 15, 1893), p. 8; "Shocking," *Chicago Daily Tribune* (October 22, 1893), p. 35.

28. As Bolotin and Laing explain, "The grand section of Machinery Hall assaulted fairgoers' ears with the clanking and grinding of its mechanical wonders . . . Although the displays were interesting, the noise was almost unbearable and most spectators did not linger long inside" (Norman Bolotin and Christine Laing, *The World's Columbian Exposition: The Chicago World's Fair of 1893* [Chicago: University of Illinois Press, 2002], p. 87).

29. Just eight days after the fair began the Chemical National Bank of Chicago, which had set up operations inside the administration building at the fair, suddenly failed, as did hundreds of others (and more than eight thousand businesses) all over the nation. Rumors that the secretary of the treasury might begin redeeming paper money in silver instead of gold caused widespread anxiety among investors. In early June, long lines formed outside all of Chicago's banks, with depositors waiting long past midnight for their turn to withdraw as much gold as the banks were willing to release; see Farr, *Chicago*, p. 188. Massive labor unrest had also plagued Chicago since the Haymarket riots only six years before, caused in large part by workers' fears that, as one labor group later stated, "machinery is introduced faster than new employments are founded" (*The Forum* 43 [September 1897], p. 29). See also Rosenberg, *America at the Fair*, pp. 16–17; George E. Weddle, "National Portraits: The Columbian Celebrations of 1792–3, 1892–3 and 1992 as Cultural Moments," *The Cultures of Celebrations*, ed. Michael T. Marsden (Bowling Green, OH: Bowling Green University Press, 1994), pp. 119–120; Harper Leech and John Charles Carroll, *Armour and His Times* (New York: D. Appleton & Co., 1938), pp. 229–230.

30. Robert Herrick, *The Web of Life* (New York: Macmillan & Co., 1900), p. 198.

31. Max Nordau, *Degeneration* (New York: D. Appleton & Co., 1895), p. 41.

32. Herrick, *The Web of Life*, pp. 199–201; emphasis added.

33. Adrien Proust and Gilbert Ballet, *The Treatment of Neurasthenia* (New York: Edward R. Pelton, 1903), p. 7; John Harvey Kellogg, *Neurasthenia; or Nervous Exhaustion* (Battle Creek, MI: Good Health Publishing, 1916), p. 44; Tom Lutz, *American Nervousness, 1903: An Anecdotal History* (Ithaca, NY: Cornell University Press, 1991), pp. 1–30.

34. Quoted in Lears, *No Place of Grace*, p. 69.

35. The Department of Congress of Art Instruction was held as part of the International Congress of the World's Columbian Exposition, from Wednesday July 26 to Friday July 28, 1893. All three sessions were held in Hall No. 8 of the Art Institute at 9:30 a.m. See *Proceedings of the International Congress of Education of the World's Columbian Exposition, Chicago, July 25–28 1893* (New York: National Educational Association, 1894), pp. 455–456; all talks from these proceedings are from this edition hereafter cited as *PICE*.

36. L. W. Miller, "Importance of the Aesthetic Aim in Elementary Instruction in Drawing," *PICE*, p. 465.

37. Ibid. Henry T. Bailey, the supervisor of drawing for the state of Massachusetts, similarly criticized "mechanical" methods of art and mass production. "Could anything be more deadly," he asks, than to strive for a "servile" and "mechanical" representation of nature? "Such technique is false; it robs the drawing of truth, and annihilates individuality in the artist" (Henry T. Bailey, "Drawing from the Flat to Learn the Technique of Representation," *PICE*, p. 460).

38. J. M. Hoppin, "Methods of Art Education for the Cultivation of Artistic Taste," *PICE*, pp. 483, 485.

39. Mary Dana Hicks, "Does Art Study Concern the Public Schools?" *PICE*, p. 491.

40. Professor J. Ward Stimson, "Discussion," *PICE*, pp. 462, 470.

41. In the published record of the Congress of Art Instruction Moore's first name was actually misprinted as "Annie" rather than "Aimee"; see "The Self-Correcting System of Drawing," *PICE*, p. 502. A more detailed description of Moore's apparatus can be found in

John Forbes-Robertson, "The Philographic Method of Drawing," *The Magazine of Art* (London: Cassell & Co. Ltd., 1893), pp. 317–319.

42. Emphasis added; "Whether we like and admit it or not," she goes on to argue, "it is very clear that machinery, in the shape of photography, has been doing its very best during the last fifty years, even in the so-called arts of design, to replace human handiwork—far worse, to supersede the human eye" (*PICE*, p. 502). Lamenting attempts by contemporary artists to replicate the "inhuman perspective" of the "wide-angle lens" ("most glaringly," she says, "in France"), Moore argues for a return to the originary, "enlightened machines" of the old masters, which will allow students to achieve a more "natural" representation of "organic forms," and free them from the impending dangers of modern machine culture. Moore is strategically ignoring the similarities between the fixed perspectivism of her pantograph and traditional (non-wide-angle) camera lenses, but this is precisely what allows her to maintain the conference participants' assumption that the machine had somehow damaged art.

43. *PICE*, pp. 469–470; emphasis in original.

Chapter 2: The Teahouse of the American Book

1. On the machine as a major cause of neurasthenia during the 1890s, see chapter one, p. 10.

2. See Judith Snodgrass, *Presenting Japanese Buddhism to the West: Orientalism, Occidentalism, and the Columbian Exposition* (Chapel Hill, NC: University of North Carolina Press, 2003), pp. 18–44. For more on Jarves, Morse, and Hearn, see Joseph Henning, *Outposts of Civilization: Race, Religion, and the Formative Years of American–Japanese Relations* (New York: NYU Press, 2000); Christopher Benfey, *The Great Wave: Gilded Age Misfits, Japanese Eccentrics, and the Opening of Old Japan* (New York: Random House, 2004); and David Weir, *American Orient* (Amherst, MA: University of Massachusetts Press, 2011).

3. James Jackson Jarves, *A Glimpse at the Art of Japan* (New York: Hurd and Houghton, 1876), pp. 144–145.

4. Edward Sylvester Morse, *Japan Day by Day, Volume II* (Boston: Houghton, Mifflin & Co., 1917), pp. 272–273.

5. Lafcadio Hearn, *Glimpses of Unfamiliar Japan, Volume 1* (Boston: Houghton, Mifflin & Co., 1894), p. 8; hereafter cited as *GUJ1*. The next year Hearn would reiterate this idea; see Lafcadio Hearn, *Kokoro* (Boston: Houghton, Mifflin & Co., 1896), p. 13. Hearn continually contrasts these experiences with those of Western cities; see *Kokoro*, pp. 16–17.

6. *GUJ1*, p. 2.

7. Ibid., p. 9.

8. Lafcadio Hearn, *Glimpses of Unfamiliar Japan, Volume 2* (Boston: Houghton, Mifflin & Co., 1894), p. 379; hereafter cited as *GUJ2*.

9. *Report of the Committee on Awards of the World's Columbian Commission* (Washington, DC: Government Printing Office, 1901), pp. 87, 121, 215, 307, 310, 491, 604–611, 724, 757, 764.

10. Ibid., pp. 121, 310.

11. Charles McClellan Stevens, *The Adventures of Uncle Jeremiah and Family at the Great Fair* (Chicago: Laird & Lee Publishers, 1893), p. 100.

12. On the connection between the world fairs and the rise of the department store, see Alan Trachtenberg, *The Incorporation of America* (New York: Hill and Wang, 1982), pp. 130–136, 208–234; Jan Whitaker, *The World of Department Stores* (New York: Vendome Press, 2011), pp. 11–13; Jan Whitaker, *Service and Style: How the American Department Store Fashioned the Middle Class* (New York: St. Martin's Press, 2006), p. 100; and Neil Harris, *Cultural Excursions: Marketing Appetites and Cultural Tastes in Modern America* (Chicago: University of Chicago Press. 1990), pp. 58–66.

13. On the pneumatic tubes and other sophisticated technologies of the department store, see Ralph M. Hower, *History of Macy's of New York, 1858–1919* (Cambridge, MA: Harvard University Press, 1943), pp. 324–325; Susan Porter Benson, *Counter Cultures: Saleswomen, Managers, and Customers in American Department Stores, 1890–1940* (Urbana, IL: University of Illinois Press, 1988), pp. 17–32; and Whitaker, *Service and Style*, pp. 15, 89–92, 107.

14. Robert Hendrickson, *The Grand Emporiums: The Illustrated History of America's Great Department Stores* (New York: Stein & Day, 1979), pp. 25–33.

15. On the department store as the engine of modern advertising, see Trachtenberg, *Incorporation*, p. 135; Whitaker, *Service and Style*, pp. 137–138.

16. Trachtenberg, *Incorporation*, pp. 130–131; emphasis in original.

17. *GUJ1*, p. 8.

18. Theodore Dreiser, *Sister Carrie* (New York: Oxford World's Classics, 2009), p. 20.

19. Ibid., p. 94.

20. Bill Brown, "The Matter of Dreiser's Modernity," *The Cambridge Companion to Theodore Dreiser*, ed. Leonard Cassuto and Clare Virginia Eby (New York: Cambridge University Press, 2004), pp. 86–88.

21. Dreiser's "Japanese Home Life" appeared in *Demorest's* 35 (April 1899), pp. 123–125, and is reprinted in *Theodore Dreiser's Uncollected Magazine Articles, 1897–1902*, ed. Yoshinobu Hakutani (Newark, DE: University of Delaware Press, 2003), pp. 281–290. There are several sections of the article that are plagiarized from Hearn, but the most egregious example is when four full pages of Hearn's *Out of the East* (Boston: Houghton, Mifflin & Co., 1895), pp. 95–99, are lifted word for word into Dreiser's article (pp. 283–285). The article also plagiarizes from the "Japan" entry in the *Encyclopedia Britannica* and an 1873 article titled "Inside Japan" by William Elliot Griffis. It was not, of course, the only writing Dreiser plagiarized during his career; in fact, the first edition of *Sister Carrie* borrowed several lines verbatim from George Ade's *Fables in Slang* (Chicago: Herbert S. Stone & Co., 1899).

22. Thomas W. Kim, "Being Modern: The Circulation of Oriental Objects," *American Quarterly* 58.2 (June 2006), p. 384. I am also indebted here to Kojin Karatani's brilliant essay "Uses of Aesthetics: After Orientalism," in *Boundary 2*, 25.2 (Summer 1998), pp. 145–160, which identifies a discourse (very similar to what I am calling Asia-as-*technê*) Karatani calls "aestheticentrism." Connecting Said's notion of Orientalism to the "aesthetic exceptionalization of the other" seen in Euro-American characterizations of the Far East, Karatani describes the Kantian practice of "bracketing" certain preindustrial activities as "aesthetic"—injecting them, as it were, with precisely the "aura" that Walter Benjamin argued mechanical reproduction had replaced: "It is the mechanization of production that endows handmade products with auras and changes them into art" (p. 152). For Karatani, the perniciousness of the practice emerges by way of "never unbracketing" these cultural practices as aesthetic, which is why Japanese intellectuals such as Okakura Kakuzo, as we shall see, could be so indifferent to (or at least forgiving of) their nation's own highly mechanized imperialism.

23. Van Wyck Brooks, *New England: Indian Summer, 1865–1915* (New York: E. P. Dutton & Co., 1940), pp. 330–331.

24. Nancy Finlay, *Artists of the Book in Boston, 1890–1910* (Cambridge, MA: Harvard College Library, 1985), p. ix; hereafter cited as *ABB*. On the 1890s as a golden age for book design, see Ralph Adams Cram, *My Life in Architecture* (New York: Little, Brown & Co., 1936), p. 6. The most impressive work on the 1890s revolution in book design is Richard Minsky's three-volume handcrafted catalog *American Decorated Publishers' Bindings, 1872–1929* (New York: Richard Minsky, 2006–2011); hereafter cited as *ADPB*. Minsky has also published a smaller mass-market version titled *The Art of American Book Covers, 1875–1930* (New York: George Braziller, 2010); hereafter cited as *AABC*.

25. *ABB*, p. ix. For more on book design as a part of art school curriculum in Boston during the 1890s, see Mindell Dubansky, *The Proper Decoration of Book Covers: The Life and Work of Alice C. Morse* (New York: Grolier Club, 2008), p. 23; hereafter cited as *PDBC*.

26. See Sue Allen, "Machine-Stamped Bookbindings, 1834–1860," *Antiques, the Magazine* (March 1979), pp. 564–572.

27. G. Thomas Tanselle has undertaken the significant task of attempting to track down the relatively few book jackets still remaining from the 1890s; see "Book-Jackets of the 1890s," *Studies in Bibliography* 58 (2007–2008), p. 215; see also Charles Rosner, *The Growth of the Book-Jacket* (Cambridge, MA: Harvard University Press, 1954), pp. xiv–xvi; and *AABC*, pp. 21–23.

28. Boston designers were drawing on the imported Oriental aesthetics of at least three movements: the British Arts and Crafts movement (William Morris, John Ruskin, Charles Ashbee, and T. J. Cobden-Sanderson), the British Aesthetic movement (D. G. Rossetti, Christopher Dresser, Edward Burne-Jones), and the French *Japonisme* of the Art Nouveau and Postimpressionist movements (Pierre Bonnard, Toulouse-Lautrec, Van Gogh). For more on the movements in England, see Wendy Kaplan, *The Arts and Crafts Movement in Europe and America: Design for the Modern World, 1880–1920* (London: Thames & Hudson, 2004); *Apostles of Beauty: Arts and Crafts from Britain to Chicago*, ed. Judith A. Barter (Chicago: Art Institute of Chicago, 2009); Rosalind P. Blakesley, *The Arts and Crafts Movement* (New York: Phaidon, 2009); Charles Spencer, *The Aesthetic Movement: 1869–1890* (New York: E. P. Dutton, 1972); Elizabeth Aslin, *The Aesthetic Movement: Prelude to Art Nouveau* (New York: Excalibur Books, 1981); and Lionel Lambourne, *The Aesthetic Movement* (New York: Phaidon, 1996). On France, see Gabriel P. Weisberg, *Japonisme* (Baltimore, MD: Walters Art Gallery, 1975); and Stephen Eskilson, *Graphic Design: A New History* (New Haven, CT: Yale University Press, 2007); hereafter cited as *GD*.

29. Most art historical accounts of the introduction of a Japanese print aesthetic in the United States focus on the "poster movement," which arose alongside these transformations in book design (and circulated in periodicals such as *Harper's* and *Lippincott's*), although it is certainly not clear why posters should be privileged over books in the historical account. Eskilson, for example, cites the Grolier Club exhibition in 1896 as influencing American poster design without acknowledging the club's distinct role as a gathering place for bibliophiles; see *GD*, pp. 53–54; and Ellen Mazur Thomson, *The Origins of Graphic Design in America, 1870–1920* (New Haven, CT: Yale University Press, 1997), p. 119.

30. See Erica E. Hirshler, *A Studio of Her Own: Women Artists in Boston, 1870–1940* (Boston: MFA Publications, 2001), p. 35; Martha J. Hoppin, "Women Artists in Boston, 1870–1900: The Pupils of William Morris Hunt," *American Art Journal* 13.1 (Winter 1981), pp. 17–46; *AABC*, pp. 11–13. I am also indebted to an excellent exhibit of Sarah Whitman's designs at the Drew University Library, curated by Catherine Magee, with notes online at https://uknow.drew.edu/confluence/display/Library, and an exhibit titled "Beauty for Commerce: Publishers' Bindings, 1830–1910" at the University of Rochester Rare Books and Special Collections Library curated by Andrea Reithmayr, with sample images online (with the same title) at http://www.lib.rochester.edu/index.cfm?page=3352.

31. John La Farge, "An Essay on Japanese Art," in Raphael Pumpelly, *Across America and Asia* (New York: Leypoldt & Holt), pp. 195–202. See also Julia Meech-Pekarik, "Early Collectors of Japanese Prints and the Metropolitan Museum of Art," *Metropolitan Museum Journal* 17 (1984), p. 99; and James L. Yarnall, *John La Farge: Watercolors and Drawings* (New York: Hudson River Museum, 1990), p. 28.

32. Specifically, Whitman was a member of the Radcliffe Governing Board, a leading member of the Library Committee, founding member of the Boston Society for Arts and Crafts, and, along with Ernest Fenollosa, a member of the Twentieth Century Club; see *Handcraft: Published by the Society of Arts and Crafts, Volume 1* (Boston: Society of Arts and

Crafts, 1902–1903), p. 28, and "Staff Correspondence from Boston," *Congregationalist* (May 3), 1895, p. 678.

33. Sarah Wyman Whitman, *The Making of Pictures: Twelve Short Talks with Young People* (Boston: Interstate Publishing Co., 1886), p. 9; hereafter cited as *MOP*.

34. Ibid., p. 8.

35. Ibid., p. 94. For more on the Boston school of chromolithography and its excesses, see Philip B. Meggs, *A History of Graphic Design* (New York: John Wiley & Sons, 1998), pp. 146–159; hereafter cited as *HGD*.

36. *MOP*, p. 94.

37. Ibid., pp. 98, 121.

38. Ibid., pp. 120–121.

39. See Sue Allen and Charles Gullans, *Decorated Cloth in America: Publishers' Bindings, 1840–1910* (Los Angeles: University of California Press, 1994), p. 62.

40. See N. Katherine Hayles, *How We Became Posthuman* (Chicago: University of Chicago Press, 1999), p. 17. On Japanese book binding methods, see Peter Francis Kornicki, *The Book in Japan* (Honolulu: University of Hawai'i Press, 2001), pp. 44–5.

41. Whitman was in fact responsible for the design of Houghton and Mifflin's entire exhibit at the Chicago Exposition; see "Chicago," *American Stationer* (May 18, 1893), p. 1063. See also *ABB*, p. 106; Rita K. Gollin, *Annie Adams Fields: Woman of Letters* (Amherst, MA: University of Massachusetts Press, 2002), p. 254; and *PDBC*, p. 23. A history of the various company names and organizational developments of Houghton, Mifflin and Company during the 1880s and 1890s can be found in Ellen B. Ballou's *The Building of the House: Houghton Mifflin's Formative Years* (Boston: Houghton Mifflin, 1970); for ease of reference, the books published by this company during this period are cited hereafter as "Houghton, Mifflin & Co."

42. Alice C. Morse, a younger artist following in Whitman's footsteps (although working primarily for Dodd, Mead & Co.), was also having enormous success. Her volumes for Hearn's *Chita* and *Two Years in the French West Indies*, for example, were also part of the Grolier Club exhibition and received special mention. On the Grolier Club, see Nicholas A. Basbanes, *A Gentle Madness: Bibliophiles, Bibliomanes, and the Eternal Passion for Books* (New York: Henry Holt & Co., 1999), p. 81.

43. See Shugio Hiromichi, *Catalogue of an Exhibition of Japanese Prints* (New York: Grolier Club, 1896), pp. 3, 6.

44. At the exhibit of book covers in 1894, for example, viewers would have not only seen the designs for books by Hearn and Omar Khayyám (the *Rubaiyat* was of course highly popular), but also Edwin Arnold's *Japonica* and the original watercolor sketch created for its cover; see *ADPB*, 1:3; viewers also praised Dante Gabriel Rossetti's "Oriental" design for the cover of *Goblin Market*; see Brander Matthews, *Bookbindings Old and New: Notes of a Book-Lover, with an Account of the Grolier Club of New York* (New York: Macmillan & Co., 1895), pp. 201–203, 209; and *Commercial Bookbindings: An Historical Sketch, with Some Mention of Drawings, Covers, and Books, at the Grolier Club* (New York: Grolier Club, 1894), p. 20. The cover designs for Hearn's books would also be praised in Ainsworth Rand Spofford's, *A Book for All Readers: Designed as an Aid to the Collection, Use, and Preservation of Books and the Formation of Public and Private Libraries* (New York: G. P. Putnam's Sons, 1905), p. 86. On the Orientalism in Rossetti's book designs, see Paul Spencer-Longhurst, *The Blue Bower: Rossetti in the 1860s* (New York: Scala Publishers, 2009), p. 30.

45. She would also exhibit some of her work at the Avery Galleries in New York, and the Doll and Richards galleries in Boston that year; see *PDBC*, p. 25. Also see Betty Smith, "Sarah de St. Prix Wyman Whitman," *Old-Time New England* (Spring–Summer 1999), p. 50.

46. Sarah Wyman Whitman, *Notes of an Informal Talk on Book Illustration, Inside and Out, Given before the Boston Art Students Association, February 14, 1894* (Boston: Boston Art

Students Association, 1894), p. 11; hereafter cited as *NIT*. Whitman would have agreed with Philip Meggs's assessment that at the beginning of the nineteenth century, "the quality of book design and production became a casualty of the Industrial Revolution" (*HGD*, p. 162).

47. Lucien Febvre and Henri-Jean Martin, *The Coming of the Book* (New York: Verso, 1976), pp. 128–136; hereafter cited as *COB*. It is also worth noting that Whitman's concerns were consistent with what Laura Miller has described as an ongoing mythology of the book as a "sacred product"—one whose necessary presence in the "marketable profane" produces a kind of "structural ambivalence"; see Laura J. Miller, *Reluctant Capitalists: Bookselling and the Culture of Consumption* (Chicago: University of Chicago Press, 2006), p. 19; and Ted Striphas, *The Late Age of Print* (New York: Columbia University Press, 2009), pp. 6–7.

48. See Rob Banham, "The Industrialization of the Book, 1800–1970," *A Companion to the History of the Book*, ed. Simon Eliot and Jonathan Rose (Malden, MA: Blackwell, 2007), pp. 280–281; and Edwin Wolf, *From Gothic Windows to Peacocks: American Embossed Leather Bindings* (Philadelphia: Library Company of Philadelphia, 1990), p. 12. See also the special exhibit of the Columbia University Rare Book and Manuscript Library titled "Judging a Book by Its Cover: Gold-Stamped Publishers' Bindings of the 19th Century," November 14, 1997–February 27, 1998, online at http://www.columbia.edu/cu/lweb /eresources/exhibitions/gilded/; John Espey, "Introduction," in Allen and Gullans, *Decorated Cloth in America*, pp. 11–12. For an early twentieth-century discussion of mechanized case making, see George A. Stephen, "Bookbinding: Modern Methods and Machinery," *Bindery Talk* 2.2 (March–April 1913), pp. 12–14.

49. Stewart Bennett has shown that there were a number of retail booksellers in Great Britain during the sixteenth and seventeenth centuries that were already binding books prior to selling them, but this did not eliminate the practice of consumers making specific decisions about *how* they wanted a book bound since a single manuscript could still be bound in dozens of ways—allowing for similar social differentiations in the type and quality of bound volumes; see Stewart Bennett, *Trade Bookbinding in the British Isles, 1660–1800* (London: Oak Knoll Press, British Library, 2004), pp. 11–54. The more important point is that the arrival of the printing press actually changed very little as far as bookbinding was concerned; for the first four hundred years of printed book history the same craftsmen who had bound handwritten manuscripts were employed to bind printed volumes; see *COB*, pp. 104–108, 222.

50. The most famous of these assumptions are articulated in Jürgen Habermas, *The Structural Transformation of the Public Sphere* (Cambridge, MA: MIT Press, 1962); Elizabeth Eisenstein, *The Printing Press as an Agent of Change* (Cambridge, MA: Harvard University Press, 1979); and Walter J. Ong, *Interfaces of the Word* (Ithaca, NY: Cornell University Press, 1977); for a discussion of these and the larger discourse of printedness, see Michael Warner, *Letters of the Republic: Publication and the Public Sphere in Eighteenth-Century America* (Cambridge, MA: Harvard University Press, 1990); hereafter cited as *LOR*.

51. See *LOR*, p. xiii; and Benedict Anderson, *Imagined Communities* (New York: Verso, 1983), p. 46.

52. *LOR*, pp. x–xiii.

53. See Gérard Genette, *Paratexts: Thresholds of Interpretation* (Cambridge: Cambridge University Press, 1997), pp. 17–18; hereafter cited as *PT*.

54. The "default" materiality of early binding, however, is difficult to pin down, since very important books, culturally speaking, were also sometimes flimsily bound (I am indebted to Aaron Pratt for this insight).

55. As Sue Allen has argued, "by the mid-1850s, inexpensively made books were no longer a source of embarrassment but a watchword of democracy" ("Machine-Stamped Bookbindings," p. 567).

56. On the private press movement in England, see *HGD*, pp. 171–178, and *GD*, p. 33.

57. *NIT*, p. 8.

58. Ibid., p. 6.

59. There were dozens of publications in which Whitman would have observed Hokusai's geese-in-flight, including, for example, Thomas W. Cutler's *A Grammar of Japanese Ornament and Design* (London: B. T. Batsford, 1880), plate 9. It is worth noting here that Henry Wadsworth Longfellow also had a great deal of access to Japanese art; see Christine M. E. Guth, *Longfellow's Tattoos: Tourism, Collecting, and Japan* (Seattle: University of Washington Press, 2004), pp. 101–180.

60. I am indebted to Catherine Magee for drawing attention to this similarity in her exhibit on Whitman's bindings during the summer of 2009 at Drew University, with notes online at https://uknow.drew.edu/confluence/x/rAEfAQ "East, West, and the Individual: Intersections in the Book Bindings of Sarah Wyman Whitman." Drew University Library, Curated by Catherine Magee.

61. The Japanese heraldic *mon* reproduced in Figs. 16–48 were published in hundreds of sources on Oriental art in the 1880s and 1890s in the United States, England, and France. For the sake of uniform viewing, all of the *mon* reproduced here are from the compilation originally published in 1913 by the Matsuya Piece-Goods Store in Tokyo; a more recent edition was issued as *Japanese Design Motifs*, trans. Fumie Adachi (New York: Dover, 1972). For contemporary sources where Whitman may have studied these crests, see John Leighton, "On Japanese Art," *Journal of the Society of Arts* (July 24, 1863), pp. 596–598; Albert Jacquemart, *History of the Ceramic Art* (London: Sampson Low, Marston, Low & Searle, 1873), p. 80; "Japanese Heraldic Art," published in *Transactions of the Asiatic Society of Japan* 5.1 (1876–1877), pp. 22–23; Thomas W. Cutler, *A Grammar of Japanese Ornament and Design* (London: B. T. Batsford, 1880), plate 52; *Japanese Pottery*, ed. A. W. Franks (London: Chapman & Hall, 1880), p. 18; George A. Audsley and James L. Bowes, *Keramic Art of Japan* (London: Henry Sotheran & Co., 1881), p. 30; *The Magazine of Art* (London: Cassell, Petter, Galpin & Co., 1882), pp. 522–526; Christopher Dresser, *Japan: Its Architecture, Art, and Art Manufactures* (London: Longman, Green & Co., 1882), p. 276; James L. Bowes, *Japanese Enamels* (Liverpool: D. Marples & Co., 1884), pp. 22–25; J. J. Rein, *Japan: Travels and Researches* (London: Hodder & Stoughton, 1884), p. 317; "Home-Maker Art Class," *The Home-Maker*, ed. Marion Harland (New York: Home-Maker Co. Publishers, 1889), p. 301; and Henry Balfour, *The Evolution of Decorative Art* (New York: Macmillan & Co., 1893), pp. 49–54.

62. For reference to Whitman's use of the Japanese *mon* on gravestone designs, I am indebted to Stuart Walker who shared his photographs of the gravestones with me. On Whitman's use of heraldic roundels and her mimicking of Japanese woodblock prints in her stained-glass window designs, see Smith, "Sarah de St. Prix Wyman Whitman," pp. 56–57.

63. Nancy E. Green, "Arthur Wesley Dow: His Art and Influence," in Nancy E. Green et al., *Arthur Wesley Dow, 1857–1922: His Art and His Influence* (New York: Spanierman Gallery, LLC, 1999), p. 20; book hereafter cited as *AWD*.

64. Letters by Dow held at the Smithsonian reveal that in February 1891 he spent a number of days at the Boston Public Library going through Japanese sketch books and prints by Hokusai. In June of that same year, Dow spent hours with Fenollosa going over some of the same art; see *Arthur Wesley Dow Correspondence*, February 27 and June 19, 1891, Smithsonian Archives of American Art.

65. Green, "Arthur Wesley Dow," p. 25.

66. Ibid., p. 24; Frederick C. Moffat, "Composition," in *AWD*, p. 39.

67. Joseph Masheck, "Dow's 'Way' to Modernity for Everybody," introduction to Arthur Wesley Dow, *Composition* (Berkeley: University of California Press, 1997), p. 2; hereafter cited as *DWM*.

68. "The School Library," *School Arts* 3 (1903–1904), pp. 75–77.

69. Arthur Wesley Dow, *Composition* (Boston: J. M. Bowles, 1899), p. 16.

70. Ibid., p. 34.

71. Ibid., p. 36; see also *GD*, p. 40. On Dow's use of the word *notan*, see *DWM*, p. 21.

72. See Akio Okazaki, "Arthur Wesley Dow's Address in Kyoto, Japan (1903)," *Journal of Aesthetic Education* 37.4 (Winter 2003), pp. 87–89; Richard J. Boyle, "Arthur Wesley Dow: American Sensei," in *AWD*, p. 77.

73. Dow even won a prize for his photography at the Boston Camera Club exhibition in 1892; see Barbara L. Michaels, "Arthur Wesley Dow and Photography," in *AWD*, p. 87.

74. This remark was part of a lecture he gave in 1911 to an art club, reported in a Los Angeles newspaper and referenced in James L. Enyeart, *Harmony of Reflected Light: The Photographs of Arthur Wesley Dow* (Santa Fe: Museum of New Mexico Press, 2001), p. 64.

75. Here Dow is commenting on one of his star pupils who would go on to become one of the twentieth century's most influential photographers, Gertrude Käsebier; see Arthur Wesley Dow, "Mrs. Käsebier's Photographs, from a Painter's Point of View," *Camera Notes* 3.1 (July 1899), pp. 22–23.

76. Ibid. For more on Dow's pupils in photography, see Enyeart, *Harmony of Reflected Light*, pp. 69–71.

77. See Dubansky for more on Morse and excellent descriptions of the printing technologies used (*PDBC*, pp. 33–37). Finlay also cites a debate that emerged regarding photomechanical reproduction among book designers associated with the Arts and Crafts movement in Boston after 1897, with machine methods eventually winning out (and a gradual shift from Boston to New York as the center for cover design following Whitman's death in 1904) (*ABB*, p. xii).

78. The precise number of their contributions to the movement is difficult to determine since covers were not often signed, but it is certainly in the hundreds, perhaps thousands; see *ABB*, p. 104; and *AABC*, p. 33. Eskilson points to the emergence of dedicated art firms in the 1880s and 1890s as the birth of the "graphic design" profession; see *GD*, p. 29.

79. For obvious reasons, it isn't practical to reproduce the hundreds of book covers from this period that engage in this new Oriental aesthetic. The collection of images included here is only a small sampling, and does not include entire categories of this new aesthetic (such as the frequent use of Oriental dragons and the ornamental use of Japanese and Chinese stenciled patterns); in fact, it would not be difficult to produce an entire volume charting these Oriental motifs in American book design. Any such study would also include a chapter on Whitman's very successful colleague Margaret Armstrong, whose cover designs for a series of Henry Van Dyke books borrowed heavily from Chinese and Japanese floral patterns; for more on Armstrong, see Charles Gullans and John Espey, *Margaret Armstrong and American Trade Bindings* (Los Angeles: University of California Press, 1991).

80. An American edition of Owen Jones's Orient-themed study, *The Grammar of Ornament* (New York: J.W. Bouton, 1880; originally published by Day and Son in London, 1856) circulated widely, along with other imports such as Christopher Dresser's *Japan: Its Architecture, Art, and Art Manufactures* (London: Longman, Green & Co., 1882) and T. W. Cutler's *A Grammar of Japanese Ornament and Design* (London: B. T. Batsford, 1880).

81. Stephen Nissenbaum, *The Battle for Christmas* (New York: Alfred A. Knopf, 1996), p. 140.

82. See *Retail Catalogue of Standard and Holiday Books* (Chicago: A. C. McClurg & Co., 1891), p. 48.

83. Ibid., p. 52.

84. *Book Buyer* 10 (1894), p. 607. It is worth noting that already in the early 1880s the publisher R. Worthington in New York issued an entire holiday series of "Japanese Edition" volumes of canonical poets (Milton, Wordsworth, Shelley, Pope, etc.); see "Literary Notes," *American Bookseller* (September 15, 1883), p. 690.

85. See *PT*, p. 2.

86. Ibid., p. 12.

87. In an article in *Frank Leslie's Popular Monthly* (September 1899), for example, Onoto Watanna (photographed wearing a kimono) is introduced as "the only Japanese woman writer of fiction in this country" (p. 553).

88. Jean Lee Cole, *The Literary Voices of Winifred Eaton: Redefining Ethnicity and Authenticity* (New Brunswick, NJ: Rutgers University Press, 2002), p. 6.

89. On Eaton as a trickster, see Yuko Matsukawa, "Onoto Watanna's Japanese Collaborators and Commentators," *The Japanese Journal of American Studies* 16 (2005), p. 37; Eaton was recently the subject of a conference held at Mount Allison University on March 15–16, 2007, the proceedings of which can be found at http://www.mta.ca/faculty/arts-letters/english/faculty/harris/winnifred-eaton-project/symposium.html "Winnifred Eaton Project Symposium," website organized by Jennifer Harris.

90. Onoto Watanna, *Daughters of Nijo: A Romance of Japan* (New York: Macmillan & Co., 1904), pp. 130–131; hereafter cited as *DN*.

91. Ibid., p. 251.

92. For example, "Slowly, mechanically, Masago arose" (ibid., p. 338). "Her courtesy was mechanical" (ibid., p. 341). Winnifred's sister, Edith (whose pen name was the more Chinese-sounding Sui Sin Far), although differing from Winnifred in important ways—especially in her identifying more directly with her mother's Chinese heritage—also tends to identify the West with cold, inhuman machine culture, and the Chinese-American community with warm, loving, and earthy images; see, for example, Sui Sin Far, *Mrs. Spring Fragrance and Other Writings* (Champaign, IL: University of Illinois Press, 1995), pp. 70–71, 100–102, 292, 295.

93. Ibid., p. 270.

94. Ibid., p. 167.

95. That these were the three objects of Japan's imperial regalia was fairly common discursive knowledge about Japan at the time. See, for example, Anna C. Hartshorne's *Japan and Her People* (Philadelphia: Henry T. Coates & Co., 1902), pp. 229–232, from which Eaton seems to have cribbed several passages in describing the mirror.

96. See Onoto Watanna, *Half-Caste and Other Writings* (Urbana, IL: University of Illinois Press, 2003), p. 82.

97. Onoto Watanna, *A Japanese Blossom* (New York: Harper & Brothers Publishers, 1906), p. 242.

98. *Bookman* (September 1903), p. 322.

99. *Nation* (October 1, 1903), p. xiii.

100. *Publisher's Weekly* (November 23, 1901), p. 1068.

101. Thomas W. Kim, "Being Modern," p. 383.

102. Ibid., p. 387.

103. Biographical information on Genjiro Yeto can be found in Susan Larkin, "Genjiro Yeto: Between Japan and Japanism," *Greenwich History: The Journal of the Historical Society of the Town of Greenwich* 5 (2000), pp. 8–31; Susan Larkin, *The Cos Cob Art Colony: Impressionists on the Connecticut Shore* (New Haven, CT: Yale University Press, 2001), pp. 17–25; and Marilyn Symmes, *Once Upon a Page: Illustrations by Cos Cob Artists* (Cos Cob, CT: Historical Society of the Town of Greenwich, 2007), pp. 73–75.

104. See Larkin, *Cos Cob Art Colony*, pp. 148–157.

105. The kimono had become so popular in the United States at this point that the Sears, Roebuck catalogue offered "Long Kimonas or Negligees," marketed (chastely, of course) as "very handy house garments." See Larkin, *Cos Cob Art Colony*, pp. 149–150.

106. Childe Hassam, for example, did the illustrations for Celia Thaxter's *An Island Garden* (Boston: Houghton, Mifflin & Co., 1894), the cover for which Sarah Whitman designed.

107. See "Harper & Brothers," in *The Bookseller, Volume 6* (Chicago: Rutherford & Hayes, 1901), p. 416. Another advertisement for Watanna's *A Japanese Nightingale* notes,

"Onoto Watanna infuses the witching charm of Japan into a delicate little romance. Misty decorations by Genjiro Yeto increase the Oriental illusion"; see "A Short Guide to New Books," *The World's Work, Volume III* (New York: Doubleday, Page & Co., 1901–1902), p. 1564.

108. Yeto's ability to fuse Western and Eastern art methods was widely praised in Boston and New York; see Larkin, "Genjiro Yeto," p. 15; and Symmes, *Once Upon a Page*, p. 73; and *American Art Annual, Vol. VI* (New York: American Art Annual, 1908), p. 213. Yeto also did the illustrations for one of his true compatriots, Yone Noguchi, who for *The American Diary of a Japanese Girl* (New York: Frederick A. Stokes Co., 1902) had assumed the female penname Miss Morning Glory, and who later became close friends with Yeto.

109. Lafcadio Hearn, *Kottō: Being Japanese Curios with Sundry Cobwebs* (New York: Macmillan & Co., 1902), p. 138; hereafter abbreviated as *K*.

110. Ibid., p. 168.

111. Ibid., p. 169; emphasis in original.

112. That Genette's *Paratext* completely omits any analysis of illustration as paratext is one of the book's most spectacular failures, but he is duly apologetic. To study the "immense continent . . . of illustration" Genette writes, "one would need not only the historical information I don't have but also a technical and iconological skill . . . I will never have. Clearly, that study exceeds the means of a plain 'literary person'" (*PT*, p. 406). One could take Genette at his word here, but his skills of analysis are such that one wonders what he might have produced if not for this strict disciplinary separation.

113. I am indebted here to Susan Larkin for drawing attention to the curious "bug's-eye view" of Yeto's illustration; see Larkin, "Genjiro Yeto," p. 18.

114. The moment Genette begins to describe "typeface" as a paratextual element, the cat is clearly out of the bag: "One may doubtless assert that a text without a paratext does not exist and has never existed" (*PT*, pp. 3–4).

115. Quoted in ibid., p. 1; originally in J. Hillis Miller, "The Critic as Host," in *Deconstruction and Criticism*, ed. Harold Bloom (New York: Seabury Press, 1979), p. 219.

116. Miller, "The Critic as Host," pp. 217–218.

117. Sadakichi Hartmann, *Japanese Art* (Boston: L. C. Page & Co., 1903), pp. 262–263. Hartmann was no doubt thinking of Yeto's agreeing to serve as "cultural advisor" to the racially infantilizing stage production of *Madame Butterfly* by David Belasco in 1900; see Larkin, "Genjiro Yeto," p. 19. Something of Hartmann's sad prediction did come true for Yeto when he returned to Japan in 1912, and was unable to find a mainstream audience for his work; he ended up working at the Postal Communications General Museum in Tokyo until he died in 1924; see Larkin, "Genjiro Yeto," p. 26.

118. Sister Nivedita, "Introduction," in Okakura Kakuzo, *The Ideals of the East* (London: John Murray, 1903), p. xi.

119. Yasuko Horioka, *The Life of Kakuzo* (Tokyo: Hokuseido Press, 1963), p. 3; Benfey, *Great Wave*, pp. 46–78; hereafter cited as *GW*.

120. Horioka, *Life of Kakuzo*, pp. 15–17; *GW*, pp. 83–89.

121. Benfey sees 1886 as a kind of watershed year, when Okakura and Fenollosa were joined for relic hunting by John La Farge, Henry Adams, and William Sturgis Bigelow (*GW*, pp. 78–86). Okakura was clearly well liked by all of these figures; La Farge dedicated his *An Artist's Letters from Japan* (New York: Century Co., 1890) to Okakura (who would return the favor in 1906 with *The Book of Tea*); upon Okakura's death, Bigelow wrote that regarding East and West, Okakura "completely invalidated Kipling's famous line"; see *Museum of Fine Arts Bulletin* 11 (Boston, December 1913), p. 75.

122. See *GW*, pp. 88–90.

123. For a fascinating discussion of Okakura's pedagogy and aesthetics, see Victoria Weston, *Japanese Painting and National Identity: Okakura Tenshin and His Circle* (Ann Arbor: Center for Japanese Studies, University of Michigan, 2004); on Okakura's curating the Columbian Exposition, see p. 107.

124. Weston, *Japanese Painting*, p. 161.

125. Benfey suggests that this affair was perhaps why Okakura lost his job at the Tokyo Fine Arts School, and so with the financial help of William Sturgis Bigelow founded an alternate art school known as the Japan Art Institute; see *GW*, pp. 89–90. As Weston notes, Okakura's fight against Western art forms would continue at this new school, which he presented "as the bulwark against a Westernization that was, in his representation, both insidious and officially sanctioned" (*Japanese Painting*, p. 230).

126. *GW*, p. 90.

127. Okakura Kakuzo, *The Ideals of the East, with Special Reference to the Arts of Japan* (London: John Murray, 1903), p. 3; hereafter cited as *IE*.

128. Ibid., p. 20; note also the jab at Lowell in Okakura's proud references to Japan's "Universal-Impersonal" (ibid., pp. 132–133).

129. Okakura Kakuzo, *The Awakening of Japan* (New York: Century Co., 1904), p. 6; hereafter cited as *AJ*.

130. Ibid., p. 7. For more on Okakura's nationalism, see Wakakuwa Midori, "Japanese Cultural Identity and Nineteenth-Century Asian Nationalism: Okakura Tenshin and Swami Vivekananda," in *Okakura Tenshin and Pan-Asianism*, ed. Brij Tankha (Kent, U.K.: Global Oriental, 2009), pp. 22–26.

131. For Okakura, the danger was that, "The economic life of the Orient . . . succumbs to the army of the machine and capital" (*AJ*, p. 104).

132. Ibid., p. 185. Okakura clearly understands that Japan's rapid industrialization complicates his argument, at least in the eyes of China and Korea: "our continental neighbors regard us as renegades—nay, even as an embodiment of the White Disaster itself" (ibid., p. 101).

133. Okakura Kakuzo, "Modern Art from a Japanese Point of View," *International Quarterly* (July 1905), p. 214.

134. The first chapter of *The Book of Tea* was actually published in 1905 as an article titled "The Cup of Humanity" in *The International Quarterly* 11 (1905), pp. 39–51. Addressed to Westerners in English, Okakura's article and subsequent book cited the "absurd cry of the Yellow Peril," even as the West "fails to realize that Asia may also awaken to the cruel sense of the White Disaster"; see Okakura Kakuzo, *The Book of Tea* (New York: Fox Duffield & Co., 1906), p. 42; hereafter cited as *BOT*.

135. Specifically, Okakura argues, it was Japan's resistance to the Mongol invasion in 1281 that allowed the country to become "the culmination of tea-ideals" (*BOT*, pp. 40–41).

136. Ibid., pp. 44–48. For more on the nationalist underpinnings of Okakura's argument here, see *GW*, p. 103; and Karatani Kojin, "Japan as Art Museum: Okakura Tenshin and Fenollosa," in *A History of Modern Japanese Aesthetics*, ed. Michael F. Marra (Honolulu: University of Hawai'i Press, 2001), pp. 48–52.

137. *BOT*, p. 99. Dow was impressed enough with *The Book of Tea* that he would include a discussion of its aesthetic principles in his updated edition of *Composition* (New York: Doubleday, Page & Co., 1913), p. 28. Dow's most famous student, Georgia O'Keeffe, was similarly struck by Okakura's text; see Elsa Mezvinsky Smithgall, "Georgia O'Keeffe's Life and Influences: An Illustrated Chronology," in *Georgia O'Keeffe: The Poetry of Things, Part III*, ed. Elizabeth Hutton Turner (New Haven, CT: Yale University Press, 1999), p. 98.

138. *BOT*, pp. 77, 82. One might also point out that Okakura's description of tearoom décor shows remarkable resemblance to Sarah Whitman's own aesthetic of the book; see *BOT*, p. 93.

139. To point to just one of the many contemporary reports, see "Chinese Astrologers and Fortune-Tellers," *Frank Leslie's Pleasant Hours* 30.1 (February 1881), pp. 207–208.

140. It is no coincidence that during the years of the American department store's most profound role as arbiter of middle-class values and style (1890–1930), they became the principal location for what Jan Whitaker calls the "tea room craze" in American culture. Typically characterized as eating establishments with "atmosphere" (read: Oriental décor),

hundreds of tea rooms in department stores during the 1920s began advertising fortune telling—the "teacup reading"—as a novel activity during one's meal; see Jan Whitaker, *Tea at the Blue Lantern Inn: A Social History of the Tea Room Craze in America* (New York: St. Martin's Press, 2002), pp. 142, 154–157; and Whitaker, *Service and Style*, p. 226.

141. *BOT*, p. 137. On Fox Duffield, see Hellmut Lehmann-Haupt, *The Book in America: A History of Making, the Selling, and the Collecting of Books in the United States* (New York: R. R. Bowker Co., 1939), p. 211.

142. See Striphas, *Late Age of Print*, pp. 23–24.

143. Steve Silberman, "Ex Libris: The Joys of Curling Up with a Good Digital Reading Device," *Wired* 6.7 (July 1998), p. 99; hereafter cited as *EL*.

144. Hayles, *How We Became Posthuman*, p. 54.

Chapter 3: Mastering the Machine

1. More on Jack London's joining "Kelly's Army" can be found in most London biographies; see, for example, James L. Haley, *Wolf: The Lives of Jack London* (New York: Basic Books, 2010), pp. 62–68; Richard O'Connor, *Jack London: A Biography* (Boston: Little, Brown & Co., 1964), pp. 60–64; Earle Labor, *Jack London* (New York: Twain Publishers, Inc., 1974), pp. 30–31; Russ Kingman, *A Pictorial Life of Jack London* (New York: Crown Publishers, Inc., 1979), pp. 50–52; Carolyn Johnston, *Jack London—An American Radical?* (Westport, CT: Greenwood Press, 1984), pp. 12–15; Jonah Raskin, *The Radical Jack London: Writings on War and Revolution* (Berkeley: University of California Press, 2008), pp. 24–26; and Joan London, *Jack London and His Times* (Seattle, WA: University of Washington Press, 1968), pp. 54–64.

2. As of January 1, 1894, it no longer cost money to enter the fairgrounds (see "All Gates Now Open," *Chicago Daily Tribune*, January 1, 1894, p. 3).

3. "Start More Blazes—Incendiaries Continue to Threaten World's Fair," *Chicago Daily Tribune*, February 19, 1894, p. 1. Even before the February fires, the *Tribune* reported in January, "The relic hunters were in their glory. Each separate ruin contributed to the welcome vandalism. Mosaics and ornaments, bits of plaster, and tiling, nails, wood, anything was seized as a precious trophy" ("Jackson Park Free," *Chicago Daily Tribune*, January 2, 1894, p. 2).

4. Haley, *Wolf*, pp. 50–51.

5. As Haley notes, "Although he later acquired a fondness for bicycle trips," London's "later disdain for automobiles evidenced a lifetime suspicion of technology" (*Wolf*, p. 94).

6. Finis Farr, *Chicago: A Personal History of America's Most American City* (New York: Arlington House, 1973), p. 199.

7. William Thomas Stead, *If Christ Came to Chicago! A Plea for the Union of All Who Love in the Service of All Who Suffer* (Chicago: Laird & Lee Publishers, 1894), p. 188.

8. Charmian London, *The Book of Jack London* (New York: Century Co., 1921), p. 55.

9. Quoted in George Wharton James, "A Study of Jack London in His Prime," *Overland Monthly* (May 1917), p. 393.

10. If Jack had picked up a copy of the *Chicago Daily Tribune* that day, what would he have seen? Any number of the following headlines: "Pullman Strikers in Great Want," "Scarcity of Coal Gets Serious," "Many Industries Close for Lack of Fuel," "Riot on Troy Street," "Claims to Have Pullman Blacklist." At the top of the *Tribune*'s third page, London may have seen a reprint of "Lincoln's Gettysburg Dedication Address," only to find at the bottom of the page another article titled, "Desecration of Gettysburg Field," with a report that a railroad company had won its fight against an injunction preventing it from building a path directly through the sacred battlefield. See *Chicago Daily Tribune*, May 29–30, 1894. For more on the Pullman Strike, see *The Pullman Strike and the Crisis of the 1890s: Essays on Labor and Politics,* ed. Richard Schneirov, Shelton Stromquist, and Nick Salvatore (Champaign, IL: University of Illinois Press, 2009); Almont Lindsay, *The*

Pullman Strike: The Story of a Unique Experiment and of a Great Labor Upheaval (Chicago: University of Chicago Press, 1942); Farr, *Chicago*, pp. 199–226.

11. Jack London, *The Road* (New York: Peregrine Press, 1907), p. 94.

12. Jeanne Campbell Reesman, *Jack London's Racial Lives: A Critical Biography* (Athens, GA: University of Georgia Press, 2009), p. 2.

13. Colleen Lye, *America's Asia: Racial Form and American Literature, 1893–1945* (Princeton: Princeton University Press, 2004); John Eperjesi, *The Imperialist Imaginary: Visions of Asia and the Pacific in American Culture* (Hanover, NH: Dartmouth College Press, 2004).

14. See, for example, Donna M. Campbell, "Fiction: 1900 to the 1930s," *American Literary Scholarship* (2005), p. 295; and John Streamas, "Book Review: *The Imperialist Imaginary: Visions of Asia and the Pacific in American Culture*," *MELUS* 30.4 (2005), p. 173.

15. To point to just one example of what London was up against, Yale was famously the home of classical liberalist (and darling of the robber barons) William Graham Sumner, whose volume *What Social Classes Owe to Each Other* argued that financial assistance for the poor only provided a cover for "the negligent, shiftless, inefficient, silly, and imprudent" of society (New York: Harper & Brothers, 1883, p. 20). See also "Sumnerology—The Social Philosophy of Prof. W.G. Sumner," *New York Times* (April 17, 1910), p. SM2. Many of the robber barons of the Gilded Age gave Yale millions of dollars on behalf of Sumner. When Jack London arrived in January 1906, for example, Andrew Carnegie (a devoted reader of Professor Sumner) had just donated $40,000 to Yale for a new swimming pool (see Edwin Kinmonth Smith, "The Month," *Yale Scientific Monthly*, February 1907, p. 180).

16. Socialist Party of Connecticut, *Jack London at Yale* (Westwood, MA: Connecticut State Committee & Ariel Press, 1906), pp. 7–8.

17. Ibid., 8; emphasis in original. For a fuller account of London's lectures, see Haley, *Wolf*, pp. 215–218.

18. The text of London's speech was later published as an essay titled "Revolution," included in Jack London, *Revolution and Other Essays* (New York: Macmillan & Co., 1910), p. 5; emphasis added.

19. See Johnston, *Jack London*, pp. 136–137. At one point in his lecture, London also commented on the possibility that a workingman, after being systematically denied his rights and forced to listen to a speech on the sacredness of the U.S. Constitution, might very well say, "To hell with the Constitution!" When the events at Woolsey Hall were reported in the *New Haven Register*, however, the subtleties of London's quoting a hypothetical worker were omitted, and it became simply London himself calling out, "To hell with the Constitution!" See Socialist Party of Connecticut, *Jack London at Yale*, p. 24. It was apparently inflammatory enough that one local librarian in Derby, Connecticut, began a nationwide letter-writing campaign encouraging libraries and bookstores to ban London's books. London's book sales fell dramatically, and his decision to leave the United States and travel throughout the Pacific was in many ways an effort to get away from the drama created by the report (notice, for example, that in some brief notes for a never-written socialist autobiography housed at the Utah State University special collections, London typed the phrase, "All went well until Yale and the misreport"). On the other hand, one young Yale undergraduate, Sinclair Lewis, was impressed enough with London that he dropped out of school to become a socialist and writer, later developing a relationship with London and even selling him a number of plot ideas for future stories. Another Yale undergraduate, Joseph Medill Patterson, son of the highly conservative editor of the *Chicago Daily Tribune*, also cited London's speech as a reason for becoming a socialist; see "Patterson, Jr. Believes He Has Too Much Money—Fanaticism Says Father," *New York Times* (March 4, 1906), p. 5.

20. Jack London to Mr. Nakahara, August 25, 1913 (quoted in Johnston, *Jack London*, p. 106).

21. See Alex Kershaw, *Jack London: A Life* (New York: St. Martin's Press, 1999), p. 143.

22. London's (often unkind) interactions with his Asian servants are detailed in Haley, *Wolf*, pp. 234, 248, 252, and 308.

23. Jack London, *Revolution and Other Essays*, p. 7.

24. Mark Seltzer's observation is also relevant here: "Nothing typifies the American sense of identity more than the love of nature (nature's nation) except perhaps the love of technology" (Mark Seltzer, *Bodies and Machines* [New York: Routledge, 1992], p. 3).

25. There is some debate on the degree to which Marx himself saw the United States as consistent with this development. See, for example, Bruce Cumings's analysis of Marx's essay "Bastiat and Carey" in the former's *Dominion from Sea to Sea: Pacific Ascendancy and American Power* (New Haven, CT: Yale University Press, 2009), p. 13; among American Marxists, however, there was little doubt in what these prophecies meant for the future of socialism in the United States; see Seymour Martin Lipset and Gary Marks, *It Didn't Happen Here: Why Socialism Failed in the United States* (New York: W. W. Norton, 2000), pp. 15–20.

26. Lipset and Marks, *It Didn't Happen Here*, p. 17.

27. Ibid., p. 18.

28. Roy O. Ackley, "My Master, the Machine," *Wilshire's Magazine* (October, 1906), p. 3.

29. Richard T. Ely, "The Full Utilization of Inventions and Discoveries under Socialism," *Independent* (April 26, 1891), p. 5.

30. Ibid., p. 5. Or take, for example, the popular American socialist James MacKaye, who advocated a new "technology of happiness" in which the exploitative efficiency of modern capitalist machines would be appropriated and transformed, such that society itself might become a vast "happiness-producing mechanism." See James MacKaye, *The Economy of Happiness* (Boston: Little, Brown & Co., 1906), p. 185. MacKaye's work was also in London's personal library; see David Mike Hamilton, *The Tools of My Trade: The Annotated Books in Jack London's Library* (Seattle, WA: University of Washington Press, 1986), p. 200.

31. On London's naturalism, see Jacqueline Tavernier-Courbin, "*The Call of the Wild* and *The Jungle*: Jack London's and Upton Sinclair's Animal and Human Jungles," *The Cambridge Companion to American Realism and Naturalism*, ed. Donald Pizer (Cambridge: Cambridge University Press, 1995), pp. 236–262; Jay Gurian, *Western American Writing: Tradition and Promise* (DeLand, FL: Everett/Edwards, 1975), pp. 49–60; Lee Clark Mitchell, *Determined Fictions: American Literary Naturalism* (New York: Columbia University Press, 1989), pp. 34–54; and Christophe Den Tandt, *The Urbane Sublime in American Literary Naturalism* (Chicago: University of Illinois Press, 1998), p. 97.

32. Mark Seltzer, *Bodies and Machines* (New York: Routledge, 1992); Jonathan Auerbach, *Male Call: Becoming Jack London* (Durham, NC: Duke University Press, 1996).

33. Auerbach, *Male Call*, p. 22.

34. Ibid., p. 23.

35. Seltzer, *Bodies and Machines*, p. 13.

36. Jack London, "The Apostate," *To Build a Fire and Other Stories* (New York: Reader's Digest Association, 1994), p. 326; hereafter cited as "TA."

37. Ibid., p. 338; emphasis added. Seltzer astutely connects Johnny's nervous condition to the notion of antimodernist neurasthenia (*Bodies and Machines*, p. 13), which, as Anson Rabinbach has argued, constitutes "an ethic of resistance to work or activity in all its forms" (Anson Rabinbach, *The Human Motor: Energy, Fatigue, and the Origins of Modernity* [Berkeley: University of California Press, 1990], p. 167).

38. Jack London, *People of the Abyss* (New York: Macmillan & Co., 1904), p. 47; hereafter cited as *PA*.

39. Jack London, *The Road* in London, *Novels and Social Writings* (New York: Library of America, 1982), p. 193; subsequent page references are to this edition; hereafter cited as *TR*.

40. Jack London, *John Barleycorn*, in London, *Novels and Social Writings*, p. 1039; emphasis added.

41. Auerbach, *Male Call*, p. 12.

42. Jack London, "Getting Into Print," *No Mentor but Myself: Jack London on Writing and Writers*, ed. Dale L. Walker and Jeanne Campbell (Stanford, CA: Stanford University Press, 1999), pp. 54–57.

43. Jack London, *Martin Eden* (New York: Penguin, 1984), pp. 202–203.

44. Ibid., pp. 160–161.

45. Andrew Sinclair, "Introduction" to London, *Martin Eden*, p. 15.

46. Jack London, *John Barleycorn*, p. 1049; emphasis added. In the same memoir, London describes the intoxicating camaraderie of social drinking as a means of escaping his "bestial life at the machine" (p. 965).

47. The pun is not without precedent given Auerbach's argument that the name of London's self-modeled wolf-dog "Buck" in *The Call of the Wild* is also a pun on the financial rewards of literary production. See Auerbach, *Male Call*, p. 85.

48. For more on this unifying theme in London, see Seltzer, *Bodies and Machines*, pp. 166–172.

49. Jack London, *War of the Classes* (New York: Macmillan & Co., 1905), p. 153.

50. Jack London, "Gladiators of the Machine Age," *Jack London Reports*, ed. King Hendricks and Irvine Shepard (New York: Doubleday & Co., Inc., 1970), pp. 205–252. Originally published November 19, 1901.

51. Jack London and Anna Strunsky, *The Kempton-Wace Letters* (New York: Macmillan & Co., 1903), pp. 23–24.

52. Jack London, *Call of the Wild* (New York: Macmillan & Co., 1903), p. 111. The connection between London's characterization of the process of getting into print as a "machine" in *John Barleycorn* and *Martin Eden* and Buck's machine-like work here is made explicit in Auerbach's brilliant reading of the novel, in which Buck's "toiling in the traces to deliver letters" allegorizes, in turn, "London's own labor as writer—the need to get his message out, to be recognized by others for his work and make a name for himself" (p. 98).

53. Jack London, *The Sea Wolf* (New York: Macmillan & Co., 1904), p. 69.

54. Jack London, *White Fang*, in Jack London, *Novels and Stories* (New York: Library of America, 1984), p. 255.

55. Jack London, *The Valley of the Moon* (New York: Macmillan & Co., 1913), p. 214; and Den Tandt, *Urbane Sublime*, p. 97.

56. See, for example, *The Star Rover* (New York: Grosset & Dunlap Publishers, 1915).

57. This manifesto, titled "The Good Soldier," began circulating in the Bay Area in 1911, and was reprinted dozens of times even as London made every effort to disclaim authorship.

58. Jack London, "Revolution," in London, *Novels and Social Writings*, p. 1151; hereafter cited as "R."

59. Jack London, *When God Laughs and Other Stories* (New York: International Fiction Library, 1921), p. 259.

60. Ibid., p. 268.

61. Jack London, *The Iron Heel* (Chicago: Lawrence Hill Books, 1907), p. 29; hereafter cited as *TIH*.

62. Everhard's first political speech in the novel blames the introduction of "the machine" and the factory system for the demise of rural family life (*TIH*, p. 25). One chapter is titled "Slaves of the *Machine*" (*TIH*, pp. 41–47); another "The *Machine* Breakers" (*TIH*, pp. 78–90). "No man in the industrial *machine* is a free-will agent," Everhard argues (*TIH*, p. 45); "This senator was the tool and the slave, the little puppet, of a brutal uneducated *machine* . . . the *machine* boss" (*TIH*, p. 54); "I showed him the human wrecks cast aside by the industrial *machine*" (*TIH*, p. 69); "He had a strong constitution. But he was

caught in the *machine* and worked to death for a profit" (*TIH*, p. 70); "It is for my child that I cry. It was the *machine* that killed her. . . . That is why I cannot work in the shop. The *machine* bothers my head. Always I hear it saying 'I did it, I did it'" (*TIH*, p. 125); emphases added.

63. Alessandro Portelli, *The Text and the Voice: Writing, Speaking, and Democracy in American Literature* (New York: Columbia University Press, 1994), p. 247.

64. Lye, *America's Asia*, p. 14.

65. Ibid., p. 42.

66. Michael S. Sweeney, "'Delays and Vexation': Jack London and the Russo Japanese War," *Journal of Mass Communication Quarterly* 75.3 (1998), pp. 548–559.

67. See Earle Labor, Robert C. Leitz, and Irving Milo, ed., *The Letters of Jack London* (Stanford, CA: Stanford University Press, 1988), pp. 409–410; Jeanne Campbell Reesman, Sara S. Hodson, and Philip Adam, *Jack London: Photographer* (Athens, GA: University of Georgia Press, 2010), pp. 56–61, hereafter cited as *JLP*; Sweeney, "'Delays and Vexation,'" p. 550.

68. Gregory A. Waller, "Narrating the New Japan: Biograph's *The Hero of Liao-Yang* (1904)," *Screen* 47.1 (Spring 2006), p. 58.

69. Sidney Tyler, *The Japan-Russia War: An Illustrated History of the War in the Far East* (Philadelphia: P. W. Ziegler Co., 1905), p. 203.

70. George Kennan, "The Story of Port Arthur," *Outlook* (March 4, 1905), p. 523.

71. Philo N. McGiffin, "The Battle of Yalu: Personal Recollections by the Commander of the Chinese Ironclad 'Chen Yuen,'" *Century Illustrated Magazine* (August 1895), p. 601. J. B. W., "The Lessons of the Battle of Yalu," *Scientific American* (August 31, 1895), pp. 130–131.

72. Beveridge, *The Russian Advance*, p. 144; Hamilton, *"The Tools of My Trade,"* pp. 85–86.

73. According to David Morley and Kevin Robins, the technological ascendancy of Japan in the mid-1980s added a symbolic layer to traditional American characterizations of the "inscrutable" and "impersonal" Oriental: "As the dynamism of technological innovation has appeared to move eastwards, so have these postmodern technologies become structured into the discourse of Orientalism" (David Morley and Kevin Robins, *Spaces of Identity: Global Media, Electronic Landscapes, and Cultural Boundaries* [New York: Routledge, 1993], p. 169). One of the earliest Fu-Manchu-like villains of Anglo-American literature, for instance, the "Oriental" Dr. Yen How of Matthew P. Shiel's *The Yellow Danger* (1898), emerged in precisely these terms.

74. Reesman, *Jack London's Racial Lives*, p. 96.

75. All of these cartoons were featured in a spectacular exhibit at Indiana University in 2008, "Japan in America: The Turn of the Century," directed by Greg Waller (much of which is still available online at www.indiana.edu/~jia1915/exhibit.html). See also his accompanying article, "Narrating the New Japan: Biograph's *The Hero of Liao-Yang* (1904)," *Screen* 47.1 (Spring 2006), pp. 43–65.

76. Frederick Palmer, *With Kuroki in Manchuria* (New York: Charles Scribner's Sons, 1904), p. 72.

77. Jack London, "How Jack London Got In and Out of Jail in Japan" *San Francisco Examiner* (February 3, 1904), reprinted in *Jack London Reports*, p. 32.

78. Ibid., p. 32; emphasis added.

79. Jack London, "Japs Drive Russians across Yalu River," *San Francisco Examiner* (May 5, 1904), reprinted in *Jack London Reports*, p. 111, and "The Monkey Cage," *San Francisco Examiner* (May 10, 1904), reprinted in *Jack London Reports*, p. 118.

80. "The Yellow Peril" was written originally in Feng-Wang Cheng, Manchuria, June 1904, and published four months later in the *San Francisco Examiner* (September 25, 1904). Cited here in London, *Revolution and Other Essays*, pp. 272–279; hereafter cited as "YP."

81. There is some uncertainty in the historical record on how exactly London got back his camera. In addition to the story about the generous offer of the Japanese reporters to bid for his camera, there is also evidence that fellow correspondent Richard Harding Davis intervened via the American embassy to secure both London's release and his camera. See Reesman et al., *Jack London: Photographer*, p. 65.

82. Jack London, "How the Hermit Kingdom Behaves in Time of War," *San Francisco Examiner* (March 12, 1904), reprinted in *Jack London Reports*, p. 73; hereafter cited as "HK."

83. Jack London, "*Examiner* Writer Sent Back," *San Francisco Examiner* (March 28, 1904), reprinted in *Jack London Reports*, p. 91.

84. Ibid., p. 91.

85. In fairness to the authors of *Jack London: Photographer*, it should be pointed out here that clearly not all the Asians photographed by London seem coerced or exploited by it. Of the 315 surviving photographic positives archived at the Huntington Library Jack London Collection, about a dozen show Asians posing elegantly for the camera, some clearly dressing up for the event. There are also dozens of typical touristy snapshots: an arriving ship, a busy street, a Chinese temple, a group of peasants, London posing with a group of correspondents, etc.

86. See Eperjesi, *Imperialist Imaginary*, p. 110; Lye, *America's Asia*, p. 43; Lewis H. Carlson, *In Their Place: White America Defines Her Minorities, 1850–1950* (Indianapolis, IN: John Wiley & Sons, 1972), p. 216.

87. Jack London, "Give Battle to Retard Enemy," *San Francisco Examiner* (May 1, 1904), reprinted in *Jack London Reports*, p. 106.

88. It may also explain how a short story like London's "The Unparalleled Invasion" (1907) can be read as both a highly racist, techno-Orientalist vision of a "final solution" to the "yellow peril," *and* as a work of "chilling irony" detailing (and implicitly decrying) an act of Western biotechnological genocide on Asia. For the former, see John N. Swift, "'The Unparalleled Invasion': Germ Warfare, Eugenics, and Cultural Hygiene," *American Literary Realism* 35.1 (Fall 2002), pp. 59–71. For the latter, see both Reesman, *Jack London's Racial Lives*, p. 101, and Lawrence I. Berkove, "A Parallax Correction in London's 'The Unparalleled Invasion,'" *American Literary Realism* 24.2 (Winter 1992), pp. 33–39.

89. Jack London, "Goliah," *Revolution and Other Essays*, p. 89; hereafter cited as "G."

90. Jack London, *War of the Classes* (New York: Macmillan & Co., 1905), p. xiii; emphasis in original.

91. Ibid., p. 245.

92. Ibid., p. 247. For more on Murai Tomoyoshi, see Yuko Kikuchi, *Japanese Modernization and Mingei Theory: Cultural Nationalism and Oriental Orientalism* (New York: RoutledgeCurzon, 2004), pp. 24–26. At least one Japanese scholar citing these passages has even called London a "Japanophile." See Takaharu Mori, "Jack London and Kanae Nagasawa," *Jack London Foundation Newsletter* 11.3 (July 1999), pp. 1–2.

93. For example, in a letter to Emmanuel Julius of the *Western Comrade*, London explained, "You may think that I am not telling the truth, but I hate my profession. I detest the profession I have chosen. I hate it, I tell you, I hate it! . . . I assure you that I do not write because I love the game. I loathe it. I cannot find words to express my disgust. The only reason I write is because I am well paid for my labor. . . . I always write what the editors want, not what I'd like to write. I grind out what the capitalist editors want, and the editors buy what the business and editorial departments permit. The editors are not interested in the truth." Quoted in Philip S. Foner, *The Social Writings of Jack London* (New York: Citadel, 1964), p. 122.

94. Charmian Kittredge London, *Our Hawaii* (New York: Macmillan & Co., 1917), p. 24.

95. Ibid., pp. 24–25.

96. Ibid., p. 26; emphasis in original.

97. See Johnston, *Jack London*, p. 129.

98. Jack London, *Tales of Adventure* (Garden City, NY: Hanover House, 1956), p. 58.

99. Earl Labor, "Jack London's Pacific World," *Critical Essays on Jack London*, ed. Jacqueline Tavernier-Courbin (Boston: G. K. Hall & Co., 1983), p. 209.

100. Jack London, *Cruise of the Snark* (New York: Macmillan & Co., 1911), p. 8; hereafter cited as *CS*.

101. Jack London, *On the Makaloa Mat* (New York: Macmillan & Co., 1919), p. 4; hereafter cited as *OMM*.

102. Kuʻualoha Meyer Hoʻomanawanui, "Hero or Outlaw? Two Views of Kalauaikoʻolau," *Navigating Islands and Continents: Conversations and Contestations in and around the Pacific*, ed. Cynthia Franklin, Ruth Hsu, and Suzanne Kosank (Honolulu: College of Languages, Linguistics and Literature, 2000), p. 238. According to this view, it hardly matters what London writes, since "his ethnic and cultural status as a white American constitute his political and national identity as an American colonizer who cannot help but be racist, as the two are intertwined. Thus his own racial bias flavors his writing from beginning to end" (p. 238). Notice, by contrast, that Reesman points to precisely this fact as one of London's most racially sensitive techniques: London's "cross-identification [with the "others" he writes about] sets London apart from his naturalist contemporaries; it is easy to sympathize with the racially oppressed but quite another thing to be consistent in imagining *being* them or telling a story from their point of view, from within their community, or 'house'" (*Jack London's Racial Lives*, p. 39). Slagel similarly comes to a different conclusion regarding the story's departures from the original "Koolau" narrative, seeing London's alterations from his source text as evidence of his "appreciation of the underdog, the weaker combatant pitted against the more fit in the struggle for survival, as well as a disappearance of the racism that his long-held belief in Social Darwinism helped create" (James Slagel, "Political Leprosy: Jack London the 'Kamaʻāina' and Koolau the Hawaiian," *Rereading Jack London*, ed. Leonard Cassuto and Jeanne Campbell Reesman [Stanford, CA: Stanford University Press, 1996], p. 182).

103. Hoʻomanawanui, "Hero or Outlaw," 248; Eperjesi, *Imperialist Imaginary*, p. 119.

104. Eperjesi, *Imperialist Imaginary*, p. 120.

105. Wilson, *Reimagining the American Pacific*, p. xiv. The only evidence that Wilson offers for this assertion is a reference to Hoʻomanawanui's argument against the text, which makes no claim to speaking for the views of all Hawaiʻians. Contrary to Wilson's claim, Slagel (a faculty member at the all-Hawaiʻian Kamehameha School in Honolulu) reports the following: "On a more personal level, I can speak to the enduring nature of London's relationship with the Islands. I teach at the Kamehameha Schools, a unique college-preparatory institution established more than a century ago by a descendant of the Hawaiian monarchy for the education of native Hawaiian children. Like many indigenous peoples compromised, betrayed, and eventually consumed by the Western world, Hawaiian students exhibit a certain skeptical resentment toward Western writers, especially when so much beautiful and important Hawaiian literature has been ignored in favor of these visitors. Yet Jack London, more than any other visiting *haole* writers, touches the lives of the students. In a story like "Koolau the Leper," my students see a sympathetic, somewhat indignant white writer speaking *to* a proud culture and *for* an otherwise unheard (to the ears of these students) segment of the population" (Slagel, "Political Leprosy," p. 190; emphasis in original).

106. Jack London, "Koolau the Leper," *The House of Pride and Other Tales of Hawaii* (New York: Macmillan & Co., 1915), pp. 47–48; hereafter cited as "KL."

107. London, *People of the Abyss*, pp. 163–164.

108. London, *The Iron Heel*, p. 207.

109. London, "The Apostate," p. 341.

110. Slagel, "Political Leprosy," p. 185.

111. Notice, for example, that when London (shocking almost everyone at the time) came out in favor of American imperialism during the Mexican Revolution, he did so by invoking the dangers of "modern mechanics": "I see a great rich country [Mexico], capable

of supporting in happiness a hundred million souls, being smashed to chaos by a handful of child-minded men playing with the tragic tools of death made possible by modern mechanics and chemistry" ("The Trouble Makers of Mexico," *Jack London Reports*, ed. King Hendricks and Irvine Shepard [New York: Doubleday & Co., Inc., 1970], p. 174).

112. Jack London, "Shin-Bones," *On the Makaloa Mat* (New York: Macmillan & Co., 1919), p. 291.

113. Reesman, *Jack London's Racial Lives*, p. 110.

114. Haley, *Wolf*, p. 307.

115. London, *Cruise of the Snark*, p. 317.

116. London to Members of the Glen Ellen Socialist Labor Party, March 7, 1916, in *Letters*, 3, pp. 1537–1538.

117. London, *Letters*, p. 1598.

118. Charmian Kittredge London, *Book of Jack London, Part 2* (New York: Macmillan & Co., 1921), p. 323. London's copy of *Psychology of the Unconscious* is indeed the most heavily annotated volume in his library; see Hamilton, *"Tools of My Trade,"* pp. 175–176.

119. Reesman, *Jack London's Racial Lives*, p. 54.

120. Ibid., pp. 170–171.

121. Ibid., p. 171. I am citing Reesman here, but she is certainly not alone in promoting this vision of Jung as a catalyst for a more racially sensitive Jack London. Earle Labor first introduced this idea in his 1974 biography of London, *Jack London* (Ann Arbor: University of Michigan Press, 1974), p. 128, and it has since been reproduced consistently in London biographies. See Alex Kershaw, *Jack London: A Life* (New York: Macmillan & Co., 1997), p. 286; and Rebecca Stefoff, *Jack London: An American Original* (New York: Oxford University Press, 2002), p. 98.

122. Compare, for example, the copy London owned, *Psychology of the Unconscious*, trans. Beatrice M. Hinkle (New York: Moffat, Yard & Co., 1916), pp. 21–26, hereafter cited as *PU*; and the same passages from the 1956 edition, republished in *The Basic Writings of C.G. Jung* (New York: Modern Library, 1993), pp. 31–33.

123. "Technics," as we shall see below, is Jung's term, which London then marks in his reading of the *Psychology of the Unconscious*.

124. Reprinted in *C.G. Jung Speaking: Interviews and Encounters*, ed. William McGuire and R. F. C. Hull (Princeton: Princeton University Press, 1977), pp. 17–18; emphasis added.

125. Ibid., p. 17.

126. Jack London, *The Red One* (New York: Macmillan & Co., 1918); subsequent page references are to this edition; hereafter cited as *TRO*.

127. There's even a section in *The Red Book*, called "The Red One," in which Jung relates a dream/fantasy conversation with the devil. See C. G. Jung, *The Red Book: A Reader's Edition* (New York: W. W. Norton & Co., 2009), pp. 212–219. Not surprisingly then, London scholarship is replete with connections between Jungianism and "The Red One." See, for example, James Glennon Cooper, "The Womb of Time: Archetypal Patterns in the Novels of Jack London," PhD dissertation, Texas Tech University, 1974; Ellen Brown, "A Perfect Sphere: Jack London's 'The Red One,'" *Jack London Newsletter* 11 (1978), pp. 81–85; Jeanne Campbell, "Falling Stars: Myth in 'The Red One,'" *Jack London Newsletter* 11 (1978), pp. 87–96; Jens Peter Jørgenson, "Jack London's 'The Red One': A Freudian Approach," *Jack London Newsletter* 8 (1975), pp. 101–103; Jørgen Riber, "Archetypal Patterns in 'The Red One,'" *Jack London Newsletter* 8 (1975), pp. 104–106; James Kirsch, "Jack London's Quest: 'The Red One,'" *Psychological Perspectives* 2 (Fall 1980), pp. 137–154; and Lawrence I. Berkove, "The Myth of Hope in Jack London's 'The Red One,'" *Rereading Jack London* (Palo Alto, CA: Stanford University Press, 1996), pp. 204–215.

128. Carl Jung, *Memories, Dreams, Reflections* (New York: Vintage Books, 1989), pp. 197–198.

129. Ibid., p. 198, and Jung, *The Red Book*, p. 418.

130. Anachronistic not only because while Jung was undergoing his intense fascination with mandalas as early as 1914, he would only explicitly characterize it in Buddhist terms in the late 1920s, but also because London himself would have had no notion of Jungian mandalas and even though (as Lawrence Berkove has pointed out) there are almost a dozen places where London might have encountered Jung's early philosophies before 1916, he could not actually have read *Psychology of the Unconscious* until after he had written "The Red One"; see Berkove, "Myth of Hope," pp. 205–206. For more on Jung and mandalas, see Harold Coward, *Jung and Eastern Thought* (Albany, NY: SUNY Press, 1985), pp. 49–54; and J. J. Clarke, *Jung and Eastern Thought* (New York: Routledge, 1994), pp. 134–140.

131. See Jung's "Commentary" on Richard Wilhelm's translation of *The Secret of the Golden Flower* (New York: Harcourt Brace & Co., 1931), pp. 85, 137.

132. Ibid., p. 82. Keep in mind, if ever there was a "divided Self" it was London.

133. C. G. Jung, *The Archetypes and the Collective* (Princeton: Princeton University Press, 1959), p. 349. I suspect that all of the paintings done by "Miss X" in his "Study in the Process of Individuation" were actually done by Jung himself. If so, it would not have been the only time he passed off one of his own paintings as the work of one of his "patients"; see ibid., p. 355.

134. Ibid., pp. 10, 352; emphasis added.

135. Some scholars have argued that this is the case. See, for example, Dan Wichlan's introduction to "The Language of the Tribe," *Jack London: The Unpublished and Uncollected Articles and Essays*, ed. Daniel J. Wichlan (Bloomington, IN: AuthorHouse, 2007). However, given London's racist response to the Mexican Revolution in 1915 and novels like *Adventure* (New York: Macmillan & Co., 1911), *The Mutiny of the Elsinore* (New York: Macmillan & Co., 1919), and even the unfinished novel *Cherry* (which, despite the fact that many of its more progressive aspects were edited out of the version of the story published in *Cosmopolitan* in 1924, still has a protagonist expounding passionately on the racial dangers of "mongrelization"), it seems clear London had some racist tendencies right up to the final moments of his life.

136. For a discussion of London's interaction with the internationalist movement in Hawai'i, and particularly his friendship with Alexander Hume Ford, see Paul F. Hooper, *Elusive Destiny: The Internationalist Movement in Modern Hawaii* (Honolulu: University of Hawai'i Press, 1980), p. 15.

137. See Tom Coffman, *The Island Edge of America: A Political History of Hawai'i* (Honolulu: University of Hawai'i Press, 2003), p. 33; Hooper, *Elusive Destiny*, pp. 65–104; and John Laurent, "Varieties of Social Darwinism in Australia, Japan, and Hawaii, 1883–1921," *Darwin's Laboratory: Theory and Natural History in the Pacific*, ed. Roy Macleod and Philip F. Rehbock (Honolulu: University of Hawai'i Press, 1994), p. 493.

138. Jack London, "The Language of the Tribe," *Jack London: The Unpublished and Uncollected Articles and Essays*, ed. Daniel J. Wichlan (Bloomington, IN: AuthorHouse, 2007), p. 124; hereafter cited as "LT."

Chapter 4: Machine/Art

1. Ernest Fenollosa, "Studying Art—A Discussion," *Proceedings of the International Congress of Education of the World's Columbian Exposition, Chicago, July 25–28 1893* (New York: National Educational Association, 1894), p. 472.

2. Ibid.

3. Ernest Fenollosa, *East and West: The Discovery of America and Other Poems* (New York: Thomas Y. Crowell & Co., 1893), pp. 21, 23, 33–34; hereafter cited as *E/W*.

4. Fenollosa's influence on Dow is discussed at length in Lawrence Chisolm, *Fenollosa: The Far East and American Culture* (New Haven, CT: Yale University Press, 1963), pp. 187–194; hereafter cited as *F*.

5. The language is fairly consistent on this matter: "Fenollosa *and* Pound would maintain . . ." (Anthony David Moody, *Ezra Pound: Poet. The Young Genius, 1885–1920* [New York: Oxford University Press 2007], p. 365); "Fenollosa *and* Pound's discussion of Chinese characters . . ." (Zong-qi Cai, *Configurations of Comparative Poetics* [Honolulu: University of Hawai'i Press, 2002], p. 171); "Fenollosa *and* Pound see language as . . ." (Jay Goulding, "Hwa Yol Jung's Phenomenology of Asian Philosophy," *Comparative Political Theory and Cross-Cultural Philosophy* [Lanham, MD: Lexington Books, 2009], p. 124); "In Fenollosa's *and* Pound's view, Chinese represented . . ." (Mary Ellis Gibson, *Epic Reinvented: Ezra Pound and the Victorians* [Ithaca, NY: Cornell University Press, 1995], p. 205; emphases added). The "and" works the other way just as often; see, for example, "For Pound *and* Fenollosa, the meaning of the concrete world . . ." (Cary Wolfe, *The Limits of American Ideology in Pound and Emerson* [New York: Cambridge University Press, 1993], p. 194); and so on in George Kearns, *Ezra Pound: The Cantos* (New York: Cambridge University Press, 1989), p. 64; F. Turner, "Space and Time in Chinese Verse," *Time, Science, and Society in China and the West*, ed. J. T. Fraser, N. Lawrence, and F. C. Haber (Boston: University of Massachusetts Press, 1986), p. 246; David Marriot, "Aspects of *Ousia* and Transitive Verb Form in Fenollosa's *The Chinese Written Character* and Pound's *Cantos*," *Language and the Subject*, ed. Karl Simms (Amsterdam: Rodopi, 1997), p. 67; Miguel Tamen, *Manners of Interpretation: The Ends of Argument in Literary Studies* (Albany, NY: SUNY Press, 1993), p. 122; Willard Bohn, *Modern Visual Poetry* (Cranbury, NJ: Associated University Presses, 2001), p. 35; and James McCorkle, *The Still Performance: Writing, Self, and Interconnection in Five Postmodern Poets* (Charlottesville: University of Virginia Press, 1989), p. 195.

6. I include my own earlier work on Pound as a case in point: R. John Williams, "Modernist Scandals: Ezra Pound's Translations of 'the' Chinese Poem," *Orient and Orientalisms in US-American Poetry and Poetics*, ed. Sabine Sielke and Christian Kloeckner (New York: Peter Lang, 2009), pp. 145–165. See also George Kennedy, "Fenollosa, Pound and the Chinese Character," *Selected Works of George A. Kennedy* (New Haven, CT: Far Eastern Publications, Yale University Press, 1964), pp. 443–462; Hwa Yol Jung, "Misreading the Ideogram: From Fenollosa to Derrida and McLuhan," *Paideuma* 13.2 (1984), pp. 211–227; Xiaomei Chen, "Rediscovering Ezra Pound: A Post-Postcolonial 'Misreading' of a Western Legacy," *Paideuma* 23.2–3 (1994), pp. 81–105; Ming Dong Gu, "Reconceptualizing the Linguistic Divide: Chinese and Western Theories of the Written Sign," *Comparative Literature Studies* 37.2 (2000), pp. 101–124; Zhaoming Qian, *Orientalism and Modernism: The Legacy of China in Pound and Williams* (Durham, NC: Duke University Press, 1995).

7. The excellent work of scholars Haun Saussy, Jonathan Stalling, and Lucas Klein in developing a new critical edition of *CWC* (which includes several—but, as we shall see, not all—of Fenollosa's previous drafts and Pound's annotations) makes such a question not only possible, but also, I would argue, absolutely necessary to any future understanding of the essay's most fundamental claims; see *The Chinese Written Character as a Medium for Poetry: A Critical Edition*, ed. Haun Saussy, Jonathan Stalling, and Lucas Klein (Bronx, NY: Fordham University Press, 2008); unless otherwise stated all references to *CWC* are to this edition. As this critical edition makes clear, there are aspects of Fenollosa's Buddhism that figured prominently in *CWC*, only to be cut short or entirely ignored by Pound in his (more Confucian) version of the essay.

8. Accounts of Fenollosa's biography can be found in Van Wyck Brooks, *Fenollosa and His Circle* (New York: E. P. Dutton & Co., 1962); hereafter cited as *FHC*; *F*; Christopher Benfey, *Great Wave* (New York: Random House, 2003); hereafter cited as *GW*; and David Weir, *American Orient: Imagining the East from the Colonial Era through the Twentieth Century* (Boston: University of Massachusetts Press, 2011).

9. See Felice Fischer, "Meiji Painting from the Fenollosa Collection," *Philadelphia Museum of Art Bulletin* 88.375 (1992), p. 7; Chisolm notes that Fenollosa led the charge in Japan for a return to the brush as opposed to the pencil in art instruction (*F*, p. 57).

10. Chisolm quotes this passage from Fenollosa's speech as an English translation of the published Japanese version, which circulated widely under the title "Bijutsu Shinsetsu" (Truth of Fine Arts) (as translated by Mikiso Hane in *F*, pp. 50–51; see also Fischer, "Meiji Painting," p. 8). The original English text is apparently lost. For a slightly different translation see Tarō Kotakane, "Ernest Fenollosa: His Activities and Influence on Modern Japanese Art," *Bulletin of Eastern Art* 16 (1941), p. 22.

11. Fischer, "Meiji Painting," p. 6; and *GW*, pp. 83–86.

12. Chisolm notes that in 1886, Fenollosa's star was "approaching its zenith" (*F*, p. 66); Benfey similarly argues that 1886 was an important year for Fenollosa, not only for his political powers but also because he hosted visits to Japan by Henry Adams, John La Farge, and William Sturgis Bigelow (*GW*, p. 86).

13. For more on the grand tour, see *F*, pp. 66–79.

14. For more on Fenollosa's commitments to the esoteric Tendai Buddhism, see Jonathan Stalling and Haun Saussy, "Fenollosa Compounded: A Discrimination," in *CWC*, pp. 19–20, hereafter cited as "FC"; and Jonathan Stalling, *Poetics of Emptiness: Transformations of Asian Thought in American Poetry* (Bronx, NY: Fordham University Press, 2010), pp. 26–27; hereafter cited as *PE*.

15. There were signs already in 1886 that some Japanese officials were growing impatient with Fenollosa's insistence that Japan emphasize its artistic heritage at the exclusion of other industries. After hearing that Japan was planning an Industrial Exhibition, for instance, Fenollosa wrote to the then prime minister, Hirobumi Ito, urging him to rename the event "The Asiatic Exhibition," and to scale back its planned emphasis on mechanical progress, focusing instead on the arts as the basis for "the whole subject of national learning." Ito, however, refused. See *The Ernest Fenollosa Papers: The Houghton Library, Harvard University*, ed. and trans. Akiko Murakata, 3 vols. (Tokyo: Museum-Shuppan Co., 1982), Vol. 1, pp. 144–145.

16. Ernest Fenollosa, "My Position in America; a Manifest of Mission," manuscript dated May 1, 1891, Harvard University, Houghton Library, bMS. Am. 1752.2, item 60; also in Murakata, *Ernest Fenollosa Papers*, 3:48.

17. Ernest Fenollosa, "The Lessons of Japanese Art," manuscript dated November 1891, bMS AM 1759.2 (54), pp. 5–7, Compositions by Ernest Francisco Fenollosa 1853–1908, the Ernest G. Stillman Papers, Houghton Library, Harvard.

18. Ernest Fenollosa, "Chinese and Japanese Traits," *Atlantic Monthly* 69 (1892), p. 774.

19. See *F*, pp. 92–93; *FHC*, p. 61; *PE*, pp. 38–39; and Fenollosa's "Contemporary Japanese Art with Examples from the Chicago Exhibit," *Century Illustrated Monthly Magazine* 46 (August 1893), p. 580.

20. Ernest Fenollosa, *Imagination in Art: Introductory Remarks* (Boston: Boston Art Students' Association, 1894), p. 9.

21. See *F*, pp. 118–124; and *FHC*, p. 62.

22. Ernest Fenollosa, "The Symbolism of the Lotos," *Lotos* 8 (February 1896), pp. 578, 581. As Jonathan Stalling has shown (and as we will see more clearly below), Fenollosa's frequent references to "jeweled mirrors" indicate that he was also borrowing from one of the central doctrines of the Kegon school of Japanese Buddhism (with its origins in the Chinese Huayan school), i.e., the posited existence of a vast web of interconnected points known as "Indra's net," whose defining feature is a small jewel at each connecting point that simultaneously reflects every other jewel in the net; see *PE*, pp. 15–16, 37, 50, 62.

23. Ernest Fenollosa, "Art Museums and Their Relation to the People, Part II," *Lotos* 9.12 (May 1896), pp. 931–932.

24. Ernest Fenollosa, "Art Museums and Their Relation to the People," *Lotos* 9.11 (May 1896), p. 842.

25. Ibid.

26. Fenollosa, "Art Museums, Part II," p. 930.

27. Ibid., pp. 932–933.

28. In an introduction to an exhibition to Dow's own woodblock prints in 1895, Fenollosa had argued that Dow's "application of [Japanese woodblock technique] to Western expression and use" was nothing short of an "epoch-making event"; see Fenollosa, "Introduction," *Special Exhibition of Color Prints, Designed, Engraved and Printed by Arthur W. Dow* (Boston: Museum of Fine Arts, 1895), p. 5; Fenollosa also described their meeting as "no matter of chance" in his article on "Arthur W. Dow," *Lotos* 9 (March 1896), pp. 709–710.

29. As Dow himself wrote in an article in the *Lotos*, the problem with art education in the United States was that it had for too long been "based on a system promulgated by Leonardo da Vinci and his pupils," the main tenet of which was that "representation is the most important thing in education, that the ability to represent truthfully must first be acquired by the student, after which he may turn his attention to composition—to expression." By contrast, Dow explained, "Oriental art has never felt the touch of Leonardo's system," offering a way of "learning to feel beauty and to create it in simple ways" (Dow, "The Responsibility of the Artist as an Educator," *Lotos* 8 [February 1896], pp. 610–611).

30. Ernest Fenollosa, "The Nature of Fine Art," *Lotos* 9 (March 1896), p. 667; emphasis in original; hereafter cited as "NFA."

31. Ernest Fenollosa, "The Nature of Fine Art, Part II," *Lotos* 10 (April 1896), pp. 759–760.

32. *F*, pp. 131–133.

33. Ernest Fenollosa, "Japanese Art from the World Point of View," *Far East* 2.5 (May 1897), p. 198 (the *Far East* was the English-language version of the magazine *Kokumin no Tomo*); hereafter cited as "WPV."

34. For more on Fenollosa's lectures see Chisholm, *F*, pp. 154–155.

35. Fenollosa's "The Coming Fusion of East and West" (in *Harper's Magazine* 98 [1898], pp. 115–122) argued for American expansionism in Asia, not because (as many were arguing) he thought Eastern cultures were incapable of self-government, and not because U.S. markets needed a means of alleviating the capitalist crises of underconsumption, but because modern industrialism inevitably led to global integration and that since British and European imperialisms were racist and exploitative, it would be better for the United States to broker the coming "fusion" of East and West ("It must be no conquest, but a fusion," p. 116). He was also more progressive on immigration, and argued for a more tolerant policy toward Asians in the United States. For a description of Fenollosa's visit with Roosevelt, see *F*, p. 156; see also *Modern Art* 4.4 (1896), pp. 119–120; *Brush and Pencil* 4.5 (1899), pp. 258–271; Arthur Wesley Dow, *Composition* (New York: Baker and Taylor Co., 1903), p. 5; *Journal of the American Oriental Society* 22 (1901), pp. 205–206; *Elementary School Teacher* 5.1 (September 1904), pp. 15–28; and a special article on "Fenollosa's Theory of Art Development and Its Relation to Certain Problems of Elementary Education," in *Elementary School Teacher* 5.8 (April 1905), pp. 473–481.

36. Ernest Fenollosa, *Chinese Ideals* (November 15, 1900), Ezra Pound Papers, box 98, folder 4214, Yale Collection of American Literature, Beinecke Library (hereafter cited as YCAL).

37. Ernest Fenollosa, "The Fine Arts," *Elementary School Teacher* 5 (July 1904), p. 16; this article was originally given as an invited lecture at the new School of Education established at the University of Chicago in 1904; Fenollosa also gave a similar talk to the National Education Association at Milwaukee, published as "Possibilities of Art Education in Relation to Manual Training," *Journal of the Proceedings and Addresses of the 41st Annual Meeting* (July 1902), pp. 564–570.

38. The final essay edited by Pound was called *The Chinese Written Character as a Medium for Poetry*, which was a title Fenollosa had also used in an earlier set of notes on the subject (and certainly reflects more directly Fenollosa's meaning); more on this essay specifically below.

39. Fenollosa's *Golden Age* essays are reprinted in Seiichi Yamaguchi's three-volume collection *Ernest Francisco Fenollosa: Published Writings in English* (Tokyo: Edition Synapse, 2009).

40. Fenollosa published a series of three related essays in *The Golden Age*: "The Bases of Art Education — I," "The Roots of Art, II," and "The Logic of Art, III," *Golden Age* (April, May, and June 1906), pp. 160–162, 230–235, 280–284, respectively; these essays are hereafter cited as *GA*.

41. *GA*, p. 232; emphasis added.

42. See *PE*, pp. 15, 37, 204; "FC," pp. 23, 30. I would also point out that Fenollosa's personal copy of Bunyio Nanjio's *A Short History of the Twelve Japanese Buddhist Sects* (Tokyo: Bukkyo-Sho-Ei-Yaku-Shuppan-Sha, 1886), preserved at the New York Public Library, shows that Fenollosa at least had access to information about the *Avatamsaka Sutra* and Huayan (in Japanese, "Kegon") Buddhism; see pp. xvii, 22, 38, 52, 57, 63, 71, 150.

43. See Francis H. Cook, *Hua-yen Buddhism: The Jewel Net of Indra* (University Park, PA: Penn State University Press, 1977), pp. 2–3.

44. Other than Okakura's 1903 description of Indra's net, cited below, I cannot find another reference in English to it (at least as the metaphor of networked jewels alluded to in the *Avatamsaka Sutra*) until Derk Bodde's 1937 translation of Fung Yu-Lan's *A History of Chinese Philosophy* (Peiping: Henri Vetch, 1937), p. 1, also discussed in Bodde's "Translator's Introduction" to *The Philosophy of Chu Hsi* reproduced in the *Harvard Journal of Asiatic Studies* 7.1 (1942), pp. 18–19. In the 1960s and 1970s, descriptions of Indra's net in English would proliferate rapidly; see, for example, Fritjof Capra's *The Tao of Physics* (Boston: Shambhala, 1975), p. 297, and Alan Watts's 1950s and 1960s lectures collected in *Buddhism: The Religion of No Religion* (Boston: Tuttle Publishing, 1999), pp. 28, 43, 76. For a discussion of Indra's net in the context of postmodern computationalism, see Erik Davis, *TechGnosis: Myth, Magic, and Mysticism in the Age of Information* (New York: Harmony Books, 2004), pp. 376–379.

45. Okakura Kakuzo, *The Ideals of the East* (New York: E .P. Dutton & Co., 1903), p. 9.

46. Ernest Fenollosa, "Preliminary Lectures on The Theory of Literature: A Theory of Literature—Higher Normal School, Tokio, Jan. 25th, '98," in Murakata, *Ernest Fenollosa Papers*, 3:156.

47. See, for example, Masaharu Anesaki, *Buddhist Art: Its Relation to Buddhist Ideals* (Boston: Houghton Mifflin Co., 1915), pp. 38–39.

48. See Elizabeth ten Grotenhuis, *Japanese Mandalas: Representations of Sacred Geography* (Honolulu: University of Hawai'i Press, 1999), p. 2; and Robert H. Sharf, "Visualization and Mandala in Shingon Buddhism," *Living Images: Japanese Buddhist Icons in Context* (Stanford, CA: Stanford University Press, 2002), pp. 151–197. Thomas A. Tweed also cites the American orientalist assumption during the late nineteenth century that mandalas were "symbolic representations of the Buddhist cosmos"; see Thomas A. Tweed, *The American Encounter with Buddhism, 1844–1912* (Chapel Hill, NC: University of North Carolina Press, 2000), p. 73.

49. Grotenhuis, *Japanese Mandalas*, p. 2.

50. On the *dharmachakra*, see Robert Beér, *The Handbook of Tibetan Buddhist Symbols* (Chicago: Serendia Publications, 2003), pp. 14–15, 171–172.

51. Plates 93–95 are only a representative sampling of the dozens of *dharmachakra* that show up in Fenollosa's personal collection, now held at the Boston Museum of Fine Arts. For more on the mandala as sacred text, see Martin Brauen's *Mandala: Sacred Circle in Tibetan Buddhism* (New York: Rubin Museum of Art, 2009).

52. See *F*, p. 137; *PE*, p. 72.

53. Akiko Miyake, *Ezra Pound and the Mysteries of Love* (Durham, NC: Duke University Press, 1991), pp. 54–55, 234; hereafter cited as *EPML*; several works of art with *Bagua* design were purchased for the Boston Museum of Fine Art by Okakura Kakuzo in the early 1900s; see, for example, the "Tusba with the Design of Hakke (Bagua)," in the Boston

collection. The eight-trigrams *Bagua* design was circulating in the West as early as 1801 in *Critical Review* (April 1801), pp. 361–365. Several publications during the 1890s and early 1900s reproduced the *Bagua* design in stories on Chinese geomancy; see, Stewart Culin, "Divination and Fortune-Telling among the Chinese in America," *Overland Monthly* 25 (February 1895), p. 170; Paul Carus, *Chinese Philosophy* (Chicago: Open Court Publishing, 1898), pp. 9–11; J. J. M. De Groot, *The Religious System of China* (Leiden: E. J. Brill, 1897), p. 963; and Robert Lockhart Hobson, *Porcelain, Oriental, Continental and British* (London: Constable, 1906), p. 55.

54. Fenollosa even draws a specific contrast between the "mental powers" of an artist and those of an inventor of machines like Thomas Edison: "Now, can you guess the number of possible color combinations which [an artist] would have to produce one by one in a slow trial in order to find some perfect one reaction where all should mutually irradiate? It would take some ten billion, and . . . a million years to find by sheer experiment in the Edison manner any one of the few mysterious masterful combinations that may be lurking in that group of elements. The ordinary faculties of man are absolutely incapacitated from acting in that rarefied region. An entirely new set of mental powers must be brought into play" (*GA*, p. 234).

55. Ibid., p. 235. The phrase *"barbara-celarent"* refers to the first two words of a medieval mnemonic device designed to help students remember basic syllogisms of Aristotelian logic; Fenollosa may have been thinking of the description of the device published in John Neville Keynes, *Studies and Exercises in Formal Logic, Including a Generalization of Logical Processes in Their Application to Complex Inferences* (New York: Macmillan & Co., 1906), pp. 319–320.

56. *GA*, pp. 283–284.

57. Ibid., p. 282.

58. Ibid.

59. Ibid., p. 235.

60. Ernest Fenollosa, *Epochs of Chinese and Japanese Art, Vol. II* (London: William Heinemann, 1912), p. 142; emphasis added.

61. A fairly successful writer herself, Mary had published an allegorical tribute to her husband in her 1906 novel *The Dragon Painter* (dedicated to "Kano Yeitan," her husband's Japanese name). Detailing the story of a gifted Japanese artist who "hold[s] to the traditions" of Asian aesthetic form, even as "Italian sculptors" and "degenerate French painters" come to Japan, bringing "stiff graphite pencils, making lines as hard and sharp as those in the faces of foreigners themselves," Mary's novel was extremely successful (and would be adapted for the theater and even a film in the 1910s); see Mary Fenollosa, *The Dragon Painter* (Boston: Little, Brown & Co., 1906), pp. 6–8.

62. See *GW*, pp. 271–272.

63. For an early take on the overheated "decadence" of the 1890s, see Holbrook Jackson's *The Eighteen Nineties* (New York: Mitchell Kennerly, 1914); on the "spirit of the 1890s" as parodied by later modernist authors such as Pound and Joyce, see James Eli Adams, *A History of Victorian Literature* (Malden, MA: Wiley, 2012), p. 432.

64. The description "stale creampuffs" is from Pound's "Foreword (1964)" to the 1965 reprinting of his *A Lume Spento and Other Early Poems* (New York: New Directions, 1965). By 1911, Pound was already sensing his early poetry as an embarrassing extension of the antimodernist sentimentalism of the 1890s. When, for instance, Pound visited Ford Maddox Ford (then still Heuffer) in Germany in 1911, showing him the poems he had decided to include in *Canzoni*, Ford erupted in laughter. As Alec Marsh succinctly tells it, Ford's laughter "vaporiz[ed] a good deal of Pound's merely poetical affectation. From here on Ezra would rhyme less in earnest, using it only for ironic effect. . . . From then on there was less of 'the purple fragrance of incense'" (Alec Marsh, *Ezra Pound* [London: Reaktion Books, 2011], pp. 31–32; hereafter cited as *EP*); see also John Tytell, *Ezra Pound: The Solitary Volcano* (Chicago: Ivan R. Dee, 1987), pp. 68–69; hereafter cited as *SV*.

65. Pound, "Tagore's Poems," *Poetry* 1.3 (December 1912), p. 93. There are even hints in Pound's earliest work of an Oriental mysticism that suggest an openness to the therapeutic ethos Fenollosa had been promoting. In a note on his Browningesque monologue, "Plotinus," for instance, Pound explains that the philosopher's Neoplatonic antimaterialism ("sweeping to the vortex of the cone . . . an atom on creation's throne . . . amid the void . . . my essence reconciled") is actually more "in accord" with that of "a certain Hindoo teacher," and that the "vortex of the cone" presumably refers to "the 'Vritta' whirlpool, vortex-ring of Yogi's cosmogony." See *Ezra Pound: Poems and Translations*, ed. Richard Sieburth (New York: Library of America, 2003), p. 1258; hereafter cited as *PT*. In 1906 Pound and his college girlfriend H. D. had been reading the "certain Hindoo teacher" Yogi Ramacharaka's volumes *Advanced Course in Yogi Philosophy* (1905) and *A Series of Lessons in Raja Yoga* (1906), and it is not difficult to find his influence sprinkled throughout Pound's early poetry. For more on Pound and Ramacharaka, see Timothy Materer, *Modernist Alchemy: Poetry and the Occult* (Ithaca, NY: Cornell University Press, 1995), pp. 32–33; Leon Surette, *The Birth of Modernism* (Montreal: McGill-Queens's University Press, 1993), p. 130; and *SV*, p. 57.

66. Laurence Binyon, *The Flight of the Dragon: An Essay on the Theory and Practice of Art in China and Japan* (London: John Murray, 1911); hereafter cited as *FD*.

67. Zhaoming Qian, *Orientalism and Modernism: The Legacy of China in Pound and Williams* (Durham, NC: Duke University Press, pp. 9–14; hereafter cited as *OM*; Zhaoming Qian, *The Modernist Response to Chinese Art* (Charlottesville: University of Virginia Press, 2003), pp. 141–143; hereafter cited as *MRCA*; *EP*, p. 51; Ming Xie, *Ezra Pound and the Appropriation of Chinese Poetry: Cathay, Translation, Imagism* (London: Psychology Press, 1999), pp. 8–9.

68. F. S. Flint [and Ezra Pound], "Imagisme," *Poetry* 1.6 (March 1913), pp. 198–199.

69. Ezra Pound, "A Few Don'ts by an Imagiste," *Poetry* 1.6 (March 1913), p. 201.

70. *FD*, p. 12. The technical brilliance of the Asian artists is also described in ways that resonate with Poundian Imagism. The "swiftness of execution," in Asian painting, for example is described as "not only possible, but in some cases indispensable; and the image of something fervently contemplated in the mind would be struck upon silk or paper with the glow and immediacy of a lyric poem" (*FD*, p. 57). Of course, this is not to say that Poundian Imagism was *only* influenced by Binyon's quasi-Fenollosian characterization of Asian art; there were important contributions, for instance, from French Symbolists who offered a model for the Imagists' experiments in vers libre. See Cyrena N. Pondrom, *The Road from Paris: French Influence on English Poetry, 1900–1920* (Cambridge: Cambridge University Press, 1974), pp. 4–23, 84–85.

71. John Hatcher, *Laurence Binyon: Poet, Scholar of East and West* (Oxford: Clarendon Press, 1995), p. 170.

72. Ezra Pound arrived in London on August 14, 1908, a full month before Fenollosa's visit (and death). J. J. Wilhelm has shown that it was during that September that Pound stayed at Mrs. Ann Withey's rooming house at 8 Duchess St. near Portland Place, and that she "endorsed the card that enabled him to use the British Museum Library, which was not far away"; see J. J. Wilhelm, *Ezra Pound in London and Paris* (University Park, PA: Penn State University Press, 1990), p. 3.

73. Laurence Binyon, *Painting in the Far East* (London: Edward Arnold, 1908), pp. vii, 91, 231–233, 276; *MRCA*, p. 10.

74. *FD*, p. 10; emphasis added. Binyon similarly notes, "In art it is not essential that the subject-matter should represent or be like anything in nature; only it must be alive with a rhythmic vitality of its own" (*FD*, p. 21). This idea is repeated frequently in *FD* in the Fenollosian terms of machine/science (West) vs. image/art (East); see pp. 17, 87–94.

75. On *notan*, see *FD*, pp. 60, 86. Speaking of a specific school of art in Japan during the twelfth and thirteenth centuries, Binyon writes, "It is a great misfortune that so little work of the great period of this school survives. All of its masterpieces, with the one

notable exception of the Keion scroll . . . remain in Japan." The "Keion scroll" in question was part of Fenollosa's personal collection, now at the Boston Museum of Fine Arts (accession #11.4000). Binyon also cites Fenollosa's student, Okakura Kakuzo (*FD*, pp. 13, 32).

76. *OM*, p. 25.

77. Ernest Fenollosa, *Imagination in Art: Introductory Remarks* (Boston: Boston Art Students' Association, 1894), pp. 6–8; emphasis added.

78. I am following the dating of the 1906 manuscript as determined by Stalling/Saussy in "FC," pp. 15–16. My sense that Pound focused primarily on the 1906 version is based on the fact that it is in that version where we find most of his commentary penciled into Fenollosa's notebook.

79. *CWC*, p. 80. It is a curious irony that the "arbitrary" symbols Fenollosa provides to illustrate this are not *completely* arbitrary. The "×" symbol could very well be a pictograph of a person's arms and legs; the "eye" symbol looks almost like a cartoon eye; and the "horse" symbol has four legs. The implied irony (if there is any) is perhaps intended to draw attention to the fact that any symbolic representation of a thing would be less arbitrary than phonetic script.

80. *CWC*, p. 80; emphasis added.

81. To be more specific, Fenollosa drew this mandala-like (expressly "synthetic") design in the margin of p. 38a of his Lecture I, Draft 1 (Ezra Pound Papers, MSS 43, box 99, folder 4218, YCAL). While this early version of Fenollosa's essay is not included in Saussy et al.'s *CWC*, an almost identical passage is published (without the marginal illustrations and their corresponding characters) in the 1906 Pound-edited version of Saussy et al.'s *CWC* on p. 97, beginning with the discussion on how the Chinese character's "etymology is visible," and continuing on to how all of Chinese life is "entangled with its roots" and these "manifold illustrations" that "flash upon the mind."

82. Ibid., pp. 96–97. In the 1903 *Synopsis* version of *CWC*, this image is even more striking: "Sentences analytic are like building with little hard bricks, with red mortar for *is*, black for *is not*," but "true sentences let the fringes of words interlock as the color of a thousand flowers intermingle in a meadow, or the notes of orchestral chords flow into one" (*CWC*, p. 110; emphasis in original).

83. This is the principal argument advanced by Stalling and Saussy. As Stalling argues, "Fenollosa's Buddhism has remained submerged beneath his editor Ezra Pound's 'anti-Buddhist' interpretation (and editorial decisions)" (*PE*, p. 16); and Stalling/Saussy: "Frequently occurring, frequently abbreviated or deleted, this group of metaphors—the 'blending,' 'ethereal fabric' or 'halo' group—has a history in Buddhist epistemology that Pound would almost certainly have spurned, had he been able to recognize it. Through the editing process, the 'hard and sane' language of Imagist poetics predominated. It is not simply a stylistic improvement but a basic reorientation, for those 'halos of secondary meaning' figure the very intercultural mission Fenollosa had assigned himself" ("FC," p. 19 [see also p. 40]). The other revelatory moment in the *Critical Edition* is the inclusion of the previously unpublished Lecture I, Vol. II, wherein Fenollosa readily acknowledges the phonetic elements of Chinese characters. Stalling and Saussy make much of this discussion of sound, arguing that it reinforces the Buddhist "intermingling" element that Fenollosa sees in the Chinese character and that this further removes Fenollosa from Pound (who would never even acknowledge the phonetic element in Chinese orthography). One could point out, however, that in the excluded section Fenollosa seems to acknowledge sound only to dismiss it as less fundamental to the operations of a given character: "it is incredible that such minute subdivisions of the idea could ever have existed as abstract without the concrete characters. Neither is it likely that they were made up all at once in an artificial list. Therefore we may believe that the phonetic theory is in large part unsound" (*CWC*, p. 127).

84. See Cantos 54, 55, 98, and 99; for a discussion of Pound's anti-Buddhism, see Britton Gildersleeve, "'Enigma' at the Heart of Paradise: Buddhism, Kuanon, and the Feminine Ideogram in *The Cantos*," in Zhaoming Qian, editor, *Ezra Pound and China* (Ann Arbor, MI: University of Michigan Press, 2003), pp. 193–195.

85. Ezra Pound, "From Rapallo," *Japan Times and Mail* (March 4, 1940); also in Sanehide Kodama, *Ezra Pound and Japan: Letters and Essays* (Redding Ridge, CT: Black Swan Books, 1987), pp. 162–163.

86. Pound "knew nothing about Fenollosa's Buddhism, even after he read through the notebooks Mary Fenollosa sent to him in 1913. She carefully excluded from the package everything that included her late husband's confession of Buddhism. What she kept for herself was auctioned in 1920 in New York, as Professor Yamaguchi found out (2:445), purchased by Dr. E. G. Stillman, and discovered in 1972 in the basement of Widener Library, Harvard University. This Stillman collection is the only one containing any materials indicating Fenollosa's Buddhism" (*EPML*, p. 47).

87. This, of course, in the immediate wake of Virginia Woolf's half-serious declaration that "on, or about December 1910, human character changed," and her subsequent qualifications: "I am not saying that one went out, as one might into a garden, and there saw that a rose had flowered, or that a hen had laid an egg. The change was not sudden and definite like that. But a change there was, nevertheless; and since one must be arbitrary, let us date it about the year 1910." Woolf's statement—the first part anyway—has become extremely useful for scholars of Anglo-American modernism, if only because there are so many things to point to at this precise moment: the death of Edward VII, the first Postimpressionist exhibition in London, public demonstrations for women's suffrage, new technologies of communication, travel, weaponry, and radical changes in habits of deference and class. For a fine overview of these issues, see Pericles Lewis, *The Cambridge Introduction to Modernism* (Cambridge: Cambridge University Press, 2007), pp. 86–88; and Robert Scholes and Clifford Wulfman, *Modernism in the Magazines* (New Haven, CT: Yale University Press, 2010), p. 168.

88. T.S. Eliot, "Introduction," in Ezra Pound, *Selected Poems*, ed. T.S. Eliot (New York: Faber and Faber, 1948 [orig. 1928]), pp. 14–15; emphasis added. For an excellent discussion of Eliot's discussion on Pound as inventor, see Eric Hayot, *Chinese Dreams: Pound, Brecht, Tel Quel* (Ann Arbor, MI: University of Michigan Press, 2004), pp. 4–5.

89. Eliot writes, "I suspect that every age has had, and will have, the same illusion concerning translation. . . . Each generation must translate for itself. This is as much to say that Chinese poetry, as we know it today, is something invented by Ezra Pound. It is not to say that there is a Chinese poetry-in-itself, waiting for some ideal translator who shall be only translator." See Eliot, "Introduction," p. 15.

90. See, for example, *MRCA*, p 40.

91. See Richard Cork, *Vorticism and Abstract Art in the First Machine Age, Volume 1* (Berkeley: University of California Press, 1976), pp. 16–17; hereafter cited as *VAA1*.

92. T. E. Hulme, "Romanticism and Classicism," *The Collected Writings of T.E. Hulme*, ed. Karen Csengeri (Oxford: Clarendon Press, 1994), p. 70.

93. Ezra Pound, "Patria Mia, IV," *New Age* 11.22 (September 26, 1912), pp. 515–516.

94. For these and other responses to the Armory Show, see Sam Hunter, John Jacobus, and Daniel Wheeler, *Modern Art*, rev. 3rd ed. (Upper Saddle River, NJ: Prentice Hall, 2005), p. 250; Francis K. Pohl, *Framing America: A Social History of American Art* (New York: Thames & Hudson, 2002), p. 321; and Kenyon Cox, *Documents of the 1913 Armory Show: The Electrifying Moment of Modern Art's American Debut* (Tucson, AZ: Hol Art Books, 2009).

95. Reed Way Dasenbrock, "Pound and the Visual Arts," *Cambridge Companion to Ezra Pound* (Cambridge: Cambridge University Press, 2006), p. 227; hereafter cited as "PVA."

96. On the complexities of London's various art groups, see Peter Brooker, *Bohemia in London: The Social Scene of Early Modernism* (New York: Palgrave Macmillan, 2007); and Scholes and Wulfman, *Modernism in the Magazines*, pp. 102–105.

97. Huntly Carter, "The Recovery of Art and Craft," *New Age* 8.2 (November 10, 1910), p. 44. Incidentally, Carter's article appears in the same issue as an essay on the Japanese sensitivity to the "universal in art"; see p. 30. It should also be noted that *New Age* was far from alone in this conversation. Similar arguments can be found in *Rhythm* 2.7 (August 1912), pp. 110–111; and *Freewoman*, which also published a special issue "On Machines" (September 12, 1912), arguing for an "anti-machine" syndicalism.

98. C. H. B. Quennell, "Man and the Machine," *New Age* 8.4 (November 24, 1910), p. 93. A response by a professional mechanic to Quennell's lament ("it is nonsense to speak of all things being better done by hand than by machinery. Has Mr. Quennell ever ridden a hand-made bicycle, used a hand-made typewriter, played a hand-made pianoforte with hand-drawn wires?") only led, as we shall see, to even more impassioned calls for the recovery of arts and crafts in subsequent issues; see William McFee, "Man and the Machine," *New Age* 8.6 (December 8, 1910), p. 143.

99. C. H. B. Quennell, "The Machine-Made Man," *New Age* 8.12 (January 19, 1911), p. 287.

100. C. H. B. Quennell, "Hand v. Machine," *New Age* 8.18 (March 2, 1911), p. 430. The conversation would continue for several years. See, for instance, Arthur J. Penty's "The Machine Problem," *New Age* 14.9 (January 1, 1914), which argued that "Machinery is ever the enemy of culture" (p. 269); or Jan Gordon's "Taste and the Machine," *New Age* 27.3 (May 20, 1920): "It may be that Art will disappear under the influence of the mechanical civilization, and that the age previous to the discovery of coal will be called the Art age. There are signs of it already . . . the machine has divorced the workman from his Art-craft. His task is now the guidance of a mechanism in a work of endless repetition" (p. 43).

101. Quoted in Richard Cork, *Art Beyond the Gallery in Early 20th Century England* (New Haven, CT: Yale University Press, 1985), p. 134.

102. Quoted in *VAA1*, p. 87.

103. For accounts of Lewis's walkout, see *VAA1*, pp. 92–94; Paul Edwards's "Foreword" to the reprint of *BLAST* (Berkeley: Gingko Press, 2009), p. vi; Robert Upstone, "'The Cubist Room' and the Origins of Vorticism at Brighton in 1913," *The Vorticists: Manifesto for a Modern World* (London: Tate Publishing, 2010), p. 28; Miranda Hickman, "Vorticism," *Ezra Pound in Context* ed. Ira B. Nadel (Cambridge: Cambridge University Press, 2010), p. 288.

104. *The Letters of Wyndham Lewis*, ed. W. K. Rose (London: Methuen, 1963), p. 49. See also *VAA1*, pp. 92–93.

105. On Marinetti as "the caffeine of Europe," see Reed Way Dasenbrock, *The Literary Vorticism of Pound and Lewis* (Baltimore, MD: Johns Hopkins University Press, 1985), p. 20; hereafter cited as *LV*.

106. F. T. Marinetti, "The Foundation and Manifesto of Futurism [1909]," in Marinetti, *Critical Writings*, ed. Gunter Berghaus (New York: Farrar, Straus & Giroux, 2006), p. 14; hereafter cited as *CW*. As Berghaus notes in his introduction to this volume, Marinetti's fascination with machine energy was present even before he had settled on the term "Futurism," with earlier candidates being "Elettricismo or Dinamismo" (p. xviii).

107. F. T. Marinetti, "Extended Man and the Kingdom of the Machine," in *CW*, pp. 85–86.

108. F. T. Marinetti, "Lecture to the English on Futurism," in *CW*, pp. 90, 93.

109. F. T. Marinetti, "Technical Manifesto of Futurist Literature," in *CW*, pp. 113–114.

110. "Futurism," *Poetry and Drama* No. 3 (September 1913), p. 262. In addition to some of Marinetti's poetry and manifestos, the issue also included a summary of Futurist claims by F. S. Flint in terms that closely resembled those he had articulated just a few months previously on Imagism. The Futurist "Foreword to the Book of Anrep" in the same issue

evidenced a new type of text-image typography that would also be important to Pound and Lewis's layout for *BLAST*.

111. T. E. Hulme, "Modern Art and Its Philosophy," *The Collected Writings of T.E. Hulme*, ed. Karen Csengeri (Oxford: Clarendon Press, 1994), pp. 268–285; hereafter cited as "MP." While this particular version of Hulme's lecture was not published until 1924, it appeared in pieces and various versions in volume 14 of the *New Age*, issues 11, 15, and 21. As a number of scholars have noted, Hulme's dichotomy between vital and geometric borrows directly from Wilhelm Worringer (Hulme says as much); see Wilhelm Worringer, *Abstraction and Empathy*, trans. Michael Bullock (New York: International Universities Press, 1967), p. 17. Reed Way Dasenbrock downplays Hulme's very clear emphasis on the "mechanical" in this formative lecture mainly because he wants to project a critique of the machine at the heart of Vorticism (determined, as he was, at least in 1985, to identify the real "originality" of the movement); see *LV*, pp. 42–47. There is little evidence for this claim, however, beyond Dasenbrock's own impressions of the Vorticist "doubt about the machine" (*LV*, p. 84). On this question, I find Richard Cork's massive documentation of Vorticism's quasi-Futurist fascination with machine technology more persuasive (*VAA1*); Marjorie Perloff was the first to suggest that Vorticist efforts toward differentiation from Futurism were only so much smoke and mirrors; see Marjorie Perloff, *The Futurist Moment: Avant-Garde, Avant Guerre, and the Language of Rupture* (Chicago: University of Chicago Press, 2003), pp. 171–178. Dasenbrock's later assessment of Vorticism's debt to Futurism very admirably takes these critiques into consideration; see Dasenbrock, "PVA," pp. 227–228.

112. "MP," p. 285. Hulme singles out Lewis's work as evidence of this new mechanical turn: "Take for example one of Wyndham Lewis's pictures. It is obvious that the artist's only interest in the human body was in a few abstract mechanical relations perceived in it, the arm as a lever and so on. The interest in living flesh as such, in all that detail that makes it vital, which is pleasing, and which we like to see reproduced is entirely absent" (ibid., p. 283).

113. On Pound's and Lewis's impressions of Hulme's lecture, see Miranda B. Hickman, *The Geometry of Modernism: The Vorticist Idiom in Lewis, Pound, H.D., and Yeats* (Austin: University of Texas Press, 2005), p. 15. For Pound's own snarky response to Hulme, see his "The New Sculpture," *Egoist* 1.4 (February 16, 1914), pp. 67–68: "Some nights ago Mr. T.E. Hulme delivered to the Quest Society an almost wholly unintelligible lecture on cubism and new art at large. He was followed by two other speakers equally unintelligible" (the "two other speakers" were Pound and Lewis).

114. For an excellent account of Lewis's response to the Nevinson manifesto, see Philip Rylands's "Introduction" to *The Vorticists: Manifesto for a Modern World*, ed. Mark Antliff and Vivien Greene (London: Tate Publishing, 2010), pp. 20–21.

115. Paul Edwards has suggested that Pound's reluctance to cast off his allegiance to the past was a constant source of frustration for Lewis, who considered much of Pound's Imagist and translation work "something of an embarrassment" to Vorticism; see Edwards's foreword to *BLAST* (reprint) (Berkeley: Gingko Press, 2009), p. viii.

116. *BLAST1* (1914), pp. 153–154.

117. *BLAST2* (1915), p. 82.

118. One could fairly easily track the development of a discourse of "not Futurism," in both Vorticist and other international movements during the pre-World War I era, in which all of Futurism's most distinctive features (its provocative manifestos, celebration of machines, innovations in typography, etc.) are slavishly copied, but all while actively renouncing any connection to Italian Futurism. Such a discourse saturates *BLAST1*.

119. *BLAST1*, p. 46. The keyword for Lewis here is "we," since what Pound had done in an effort to preserve his experience with the past (spatializing the Futurist fascination with machines), Lewis turned into a championing of the specifically British qualities of the new industrialism. "Once this [machine age] consciousness towards the new possibili-

ties of expression in present life has come," Lewis argued, "it will be more the legitimate property of Englishmen than of any other people in Europe" (p. 41). The point is an awkward one, since the Vorticist group was already very international, but Lewis's objective is not to fetishize Britishism so much as to draw attention to his group's access to the *real* locus of industrial modernity and thereby further discount the "Latin's" claim on it (see also p. 39).

120. Ezra Pound, "Affirmations IV," *New Age* 16.13 (January 28, 1915), p. 350.

121. Ezra Pound, *A Memoir of Gaudier-Brzeska* (1916), p. 26; hereafter cited as *GB*.

122. Ibid., p. 117.

123. For more on Orage and Pound's editorial relationship (and how Vorticism directly strained it), see Scholes and Wulfman, *Modernism in the Magazines*, p. 8.

124. A. R. Orage [under the pseudonym R. H. C.], "Readers and Writers," *New Age* 15.19 (September 10, 1914), p. 449.

125. Ibid. Following the publication of Pound's *Cathay* a year later, Orage praises the poet's translations from Fenollosa's notes, observing that the book "contains some excellent work," but also expresses annoyance at Pound's attempts to do something avant-gardish with the translations: "In these poems, however, as in all free-rhythm, the form is not a positive source of pleasure" (*New Age* 17.14 [August 5, 1915], p. 332). Free-rhythm was simply "an imperfect form of art," and marked Pound's unfortunate commitment to "the revolutionaries and charlatans" who have "no poetry in them." The most damning connection here was that "Mr. Pound also professes himself a Vorticist," a claim that Orage attempts to explain with the following: "A young American, feeling isolated by reason of his alienation from America . . . is naturally disposed to enlist under any flag that promises him the company of writers similarly situated. . . . But in his association with Vorticism I venture to say that he has got into a current that is not proper to him" (p. 333). The problem was that Vorticism, unlike everything Pound had done up to that point, "has as its ultimate object, not the perfectioning of Nature, but her frustration." Thus, Orage hopes that Pound "will discover in time" how out of place he should be with the Vorticists, concluding, "I wish him speedily out of it" (ibid.).

126. In an article in the *Little Review* 1.8 (November 1914), Eunice Tietjens argued that Pound's early work showed a clear talent for "clean-cut, sensitive," and "beautiful" poetry. Having fallen in with the Vorticists, however, his poetry had become "brutal," evidencing a "spiritual and cerebral degeneration." Pound was the "perfect example" of the "spiritual dangers of writing vers libre" (pp. 25–29).

127. John Triboulet, "Pastiche. Euphemism; or, What You Will," *New Age* 16.16 (February 1915), p. 434. Triboulet's satire is, to my mind, a clever and very accurate account of Pound's Vorticism as a euphemism for the Futurist confusion of "machine" and "spiritual energies."

128. Followers of the historical Buddha Shakyamuni traditionally wore blue robes. It is a fascinating coincidence that in Mary Fenollosa's *The Dragon Painter*, the artist protagonist modeled after her husband wears blue robes as well (see pp. 40–46). The Marinetti manifesto begins: "Hey there! You Hell-raising poets, Futurist brothers-in-arms! . . . Make haste, brothers! . . . What we need is wings! . . . So let us make ourselves some airplanes." Then "'They've got to be blue!' the madmen shouted, 'blue so the enemy can't see them and so that we merge into the blue of the sky which, whenever there's a wind, flies over the mountain tops like a huge flag'" (*CW*, p. 29).

129. Notice, for example, Pound's praise of Vorticist painter Edward Wadsworth, whose work, he says, creates "a delight in mechanical beauty, a delight in the beauty of ships or of crocuses, or a delight in pure form," and then, just a few paragraphs later, "The feeling I get from [Wadsworth's art] is very much the feeling I get from certain Eastern paintings, and I think the feeling that went into it is probably very much the same as that which moved certain Chinese painters"; see Pound, "Edward Wadsworth, Vorticist: An Authorized Appreciation by Ezra Pound," *Egoist* (August 15, 1914), pp. 306–307. Later in the same

article, Pound observes a specific shape in one of Wadsworth's works: "a signal arm or some other graceful unexplained bit of machinery, reaching out, and alone, across the picture, like a Mozart theme skipping an octave, or leaving the base for the treble" (p. 307).

130. It would also determine which parts of Fenollosa's materials Pound would spend the most time editing and promoting. As several scholars have shown, Pound's enthusiasm for the Noh plays was never more than lukewarm, and he most likely engaged that aspect of the manuscripts first so as to fulfill his duty to Mary Fenollosa and get them out of the way. "I don't really believe in *Noh*," Pound wrote to Iris Barry, "It is too fuzzy and celtic, even too '90s." Given the chronology of his reception of the Fenollosa materials, such a feeling is not very surprising; see *SV*, p. 136.

131. "Vortex. Pound," *BLAST*1, p. 153; as Perloff notes, the typographic layout of *BLAST* both borrows from Futurism and anticipates very similar strategies in Pound's *Cantos*; see Perloff, *Futurist Moment*, pp. 181–184.

132. The margins of Fenollosa's notebooks include several penciled notes by Pound on the topic's supposed closeness to Vorticism; including, "vide Vorticism" (*CWC*, p. 95) and "vide. Science of Poetry. From 1912. Vorticism" (*CWC*, p. 100).

133. F. T. Marinetti, "Geometric and Mechanical Splendor in Words at Liberty," *New Age* 15.1 (May 7, 1914), pp. 16–17. A more direct translation from the Italian (which Pound no doubt also read) is even more specific, "I see every noun as a vehicle or as a belt set in motion by the verb in the infinitive"; see *CW*, p. 137.

134. F. T. Marinetti, "Abstract Onomatopoeia and Numeric Sensibility," *New Age* 15.11 (July 16, 1914), p. 255. Notice, in the Italian version of the same manifesto, how closely Marinetti's explanations of the ideographic resemble Pound's own later discussions of Chinese ideography: "For example, it would have required at least a whole page of description to portray this vast, complex panorama of battle that I have instead conveyed through this supreme lyrical equation: 'horizon = gimlet most piercing some sun + 5 triangular shadows (1 kilometer to one side) + diamond shapes of rosy light + 5 bits of hills + 30 columns of smoke + 23 blazes.' I use the × to convey pauses for searching thoughts" (*CW*, p. 141); compare with Pound's ideographic explanation of "man + tree + sun = east" in Fig. 4.30.

135. As Ronald Bush and other scholars have shown, it was not really until the mid-1920s that Pound adapted the notion of "ideogrammatic" as the underlying premise of his poetics—a move which, as we shall see, coincided directly with his involvement in machine aesthetics; see Ronald Bush, *The Genesis of Ezra Pound's Cantos* (Princeton: Princeton University Press, 1989), pp. 10–11; hereafter cited as *GEP*; Herbert N. Schneidau, *Ezra Pound: The Image and the Real* (Baton Rouge: Louisiana State Press, 1969), pp. 58–63; hereafter cited as *EPIR*; *LV*, pp. 205–207.

136. Ezra Pound, *Antheil and the Treatise on Harmony with Supplementary Notes* (Chicago: Pascal Covici, 1927); hereafter cited as *ATH*.

137. George Antheil, "My *Ballet Mécanique*: What It Means," Ezra Pound Papers, MSS 43, box 2, folder 69 (n.d.), YCAL. Pound clearly thought of Antheil as the missing Vorticist musician; for more on the performance, see *EP*, pp. 82–83; Humphrey Carpenter, *A Serious Character: The Life of Ezra Pound* (London: Faber & Faber, 1988), pp. 431–436; hereafter cited as *ASC*.

138. *ATH*, p. 51. Throughout the volume, Pound praises Antheil's idiosyncratic tendency to refer to his compositions as "mechanisms" (see pp. 41, 49–50).

139. Ibid., pp. 52–54; emphasis added.

140. That Antheil is American makes sense for Pound, since "If America has given or is to give anything to general aesthetics," it is "an aesthetic of machinery" (*ATH*, p. 61).

141. Ibid., p. 49; Antheil thus musically fulfills the originary Vorticist mission: "Antheil gives us the first music really suggesting Lewis' 'Timon' designs" (p. 49). Antheil's machine compositions also served as inspiration for Pound's (thoroughly wacky) idea that industrial factories might use their machines to create "harmonious" sounds for their

workers: "As for the machine shop, the boiler works, Antheil has opened the way with his *Ballet Mécanique*; for the first time we have a music, or the germ and start of a music that can be applied to sound regardless of its loudness. The aesthete goes to a factory, if he ever does go, and hears *noise*, and goes away horrified . . . [but] with the grasp of *longer durations* we see the chance of time-spacing the clatter, the grind, the whang-whang, the gnnrrr, in a machine shop, so that the eight-hour day shall have its rhythm; so that the men at the machines shall be demechanized, and work not like robots, but like the members of an orchestra" (p. 138; emphasis in original).

142. While an in-depth analysis of the machine in Pound's *Cantos* is well beyond the scope of this chapter, one should point out that this turn toward the technical virtues of the machine in art during the mid-1920s coincides with Pound's own analogic characterization of himself as embodying the mechanical genius of the Renaissance figure Leon Battista Alberti who served as the architect for the patron Sigismundo (who becomes modern patron John Quinn) in the Malatesta Cantos; see especially Pound's "Paris Letter," *Dial* (January 1923), pp. 85–90; "PVA," pp. 228–234; and *EP*, pp. 87–88. One could certainly point to the curious tension between Pound's ongoing attack against mimetic art and his embracing of the father of modern perspective machines (à la "Alberti's Window").

143. Pound was editing his own short-lived journal at the time entitled *The Exile* (1927–1928), where he expressed confidence that the new project would "receive an imprimatur somewhere" soon, but he had difficulty securing a publisher for it, and so eventually published a truncated version in the *New Review* in 1931; see Pound, "Data," *Exile* 1.4 (Fall 1928), p. 109; and *New Review* 1 (Winter 1931/32), pp. 292–293. Had Pound known that the *Exile* would die off after only four issues (Spring 1927–Fall 1928), he might have gone ahead and published at least portions of *Machine Art* there. At the time, however, some publishers had expressed interest in *Machine Art*, and he had reason to believe it would be in print soon; for more on Pound's plans for *Machine Art*, see Donald Gallup, *Ezra Pound: A Bibliography* (Charlottesville: University of Virginia Press, 1983), pp. 449–450. The manuscript was eventually edited and published as Ezra Pound, *Machine Art and Other Writings: The Lost Thought of the Italian Years*, ed. Maria Luisa Ardizzone (Durham, NC: Duke University Press, 1997); hereafter cited as *MA*. Only a small sampling of Pound's photographs and manuscript revision information is included in the Ardizzone volume.

144. *MA*, p. 57. The manuscript version of *MA* actually shows the revision "A.D. 1927 30," indicating how long Pound had been working on the project; see Ezra Pound Papers, YCAL MSS 43, box 111, folder 4705. It is also worth remembering here that Pound makes this assertion in the immediate context of Eliot having dubbed him "the *inventor* of Chinese poetry for our time." See Eliot, "Introduction," pp. 14–15.

145. Pound, "To Mrs. Isabel W. Pound," *Rapallo* (June 10, 1925), in *Ezra Pound and the Visual Arts*, ed. Harriet Zinnes (New York: New Directions, 1980), p. 299; references to this volume hereafter cited as *EPVA*.

146. Pound repeatedly asks his parents to send him photos of machinery "especially at point where force is concentrated" and "energy concentrates"; see *EPVA*, pp. 299–300. The manuscript version of *Machine Art* shows that Pound planned to include at least fifty of these photographs in his final version (*MA*, p. 34).

147. It is unfortunately not practical here to include all of Pound's *Machine Art* images; those included in this chapter are a representative sampling.

148. *MA*, pp. 59, 70–71, 77.

149. Ernest Fenollosa, *Imagination in Art*, p. 9; *MA*, p. 78. Of course, as a number of biographers have shown, these comments were also offered in the context of Pound's renewed interest in Futurism and Marinetti's protofascist work in the late 1920s, but he still can't quite bring himself to admit that he is once again borrowing heavily from the Futurists. The manuscript of *Machine Art* shows him severely wrestling with the issue; see for example Fig. 4.29; and note the penciled tension over the question of whether he

"dis-agrees" with their methods (the entire passage would be eliminated from Ardizzone's edition of *MA*). Pound's *Machine Art* was also clearly influenced by other machine art exhibitions and publications, including a special edition of the *Little Review* that catalogued a "Machine Age Exhibition" in New York (May 16–28, 1927); Alec Marsh has also shown that Pound was intimately familiar with Le Corbusier's machine aesthetic; see "Ezra Pound, Leger and Le Corbusier: 'Machine Art,' Vorticism and Purism," MLA presentation, 2002 (copy in author's possession). On Pound's reconsideration of Futurism during this period, see *EP*, pp. 105–106; and Carpenter, *ASC*, pp. 489–490. This ideological difference also goes a long way toward explaining why the "Vortography" (prism-refracted, abstract photography) invented by Alvin Langdon Coburn was eventually dismissed by Pound as only "as good as the bad imitators" of Cubist art; see *EPVA*, pp. 154–155, 242–243, 281. Trained by Arthur Wesley Dow in a more Fenollosian tradition and increasingly committed to Buddhism, Coburn was far too off-brand for Pound's crypto-Futurist Vorticism; see Tom Normand, "Alvin Langdon Coburn and the Vorticists," *The Vorticists*, ed. Mark Antliff and Vivien Greene (London: UK: Tate Publishing, 2010). The most telling anecdote is Coburn's request to his publisher that he remove the photograph of Wyndham Lewis from his autobiography in order to make room for a portrait of D. T. Suzuki (pp. 85–91).

150. "Function" here becomes all-important for Pound: "we find a thing beautiful in proportion to its aptitude to a function. I suspect that the better a machine becomes AS A MACHINE, the better it will be to look at" (*MA*, p. 69). Alec Marsh has noted the connection here with Fenollosa: "The connection to Fenollosa's emphasis on [transitive verbs] is impossible to miss. If Fenollosa, following Emerson and William James, saw truth as 'the transference of power' expressed by 'the sentence form pressed upon primitive man by nature itself,' so machines operate like sentences, and sentences like machines" (MLA presentation, p. 16); however, one must carefully explain that this "connection" is explicitly—and retroactively—Pound's, not Fenollosa's. Furthermore, Dasenbrock (*LV*, p. 206), Ronald Bush (*GEP*, pp. 10–12), and Schneidau (*EPIR*, pp. 58–63) all convincingly demonstrate that Pound is in 1930 avoiding Fenollosa's main argument in *CWC*, despite his claims to be turning to the essay's most central ideas (which, as I have been arguing, had its origins in Pound's transformation during 1913–1915).

151. Unlike Pound's "How to Read" (published in three installments in the *New York Herald Tribune* in 1929 and reprinted in Pound, *The Literary Essays of Ezra Pound* [New York: New Directions, 1968], pp. 15–40) and *ABC of Reading* (New York: New Directions, 1934), "How to Write" would remain unpublished until its inclusion in Ardizzone's edition of *MA* (pp. 87–109); however, it demonstrates Pound working out much of the same material, connecting the ideograph to the machine in the same terms: "if you try to put the static image into ideograph you at once feel the void. The ideograph wants the moving image, the concrete thing plus its action" (*MA*, p. 88).

152. Chinese poets are continually referred to as paragons of Phanopoeia in Pound's *ABC of Reading* (pp. 42, 52, 63–64); unfortunately, as Hugh Kenner noted, no such Chinese character actually exists; see Hugh Kenner, *The Pound Era* (Los Angeles: University of California Press. 1971), p. 158; *LV*, p. 205.

153. See a summary of Pound's explanation of *ching ming* in Hugh Kenner, *The Poetry of Ezra Pound* (Lincoln: University of Nebraska Press, 1985), pp. 37–38.

154. Ezra Pound, "Affirmations IV," *New Age* 16.13 (January 28, 1915), p. 350. Had he lived a few decades longer, Fenollosa may have agreed with Pound's assertion in *Guide to Kulchur* that "Kung fu Tsue [Confucius] was a vorticist," but, as we have already seen, this would not have been high praise for Fenollosa; see Pound, *Guide to Kulchur* (New York: New Directions, 1938), p. 266.

155. See Dasenbrock on the "appeal to the eye" in Pound's "Rock Drill Cantos" (*LV*, pp. 231–232).

156. Some of these references to the kinetoscope (but not all) are included in the recent critical edition of *CWC*; see pp. 106, 117, 190. Fenollosa also once referred to consciousness itself in terms of the kinetoscope; see Murakata, *Ernest Fenollosa Papers*, p. 151.

157. The "ought to have" marginal note is in the *Synopsis* (1903) version of *CWC*; see Ezra Pound Papers, MSS43 box 99 folder 4218, p. 9a, YCAL; Pound's pencil marks in this version reveal, I would argue, that he did not read past p. 7, which is about where in his reading he may have realized the 1906 version was more complete.

158. *CWC*, pp. 100, 193.

159. The critical edition (*CWC*, p. 192) notes that the "Roentgen ray" passage is crossed out on p. 21b of *CWC* Lecture I, Vol. I. For some reason, however, the entire text of Lecture I, Vol. I, is not included in the critical edition, and Saussy et al. fail to note that Fenollosa returns to the metaphor later in the same draft. The entire passage notes that poetic metaphors "are Roentgen rays that play through bone and tissue and lay bare the pulsing of the heart. Nature is like a splendid pageant passing through the streets of a crowded city. Now, the method of the dictionary is like that of an old-fashioned photograph with slow plates, who calls each figure of the pageant out separately, to be stored up against an artificial screen and have his 'picture taken.' But the poet and philosopher are like modern geniuses with Kodaks, who take snap-shots upon the world with instantaneous plates. It is time that they can catch but one part of the show at a time; but that part is very much alive" (Ezra Pound Papers, MSS43 box 99 folder 4218, p. 36b, YCAL). For a fascinating discussion of X-rays in the early twentieth century that, I believe, helps explain how this new technology would have resonated with Fenollosa, see Barbara Zabel, *Assembling Art: The Machine and the American Avant-Garde* (Jackson: University Press of Mississippi, 2004), pp. 20–27.

160. An updated version of his graduate thesis of 1933, the "Call Me Ishmael" Olson drafted in 1940, was an almost entirely different book, some 400 pages and with a style Edward Dahlberg described as "too Hebraic, Biblical Old Testament"; see Merton M. Sealts, Jr., "Afterword," *Call Me Ishmael* (Baltimore, MD: Johns Hopkins University Press, 1997), pp. 127, 134; hereafter cited as *CMI*. On the question of *CWC*'s influencing the revision process for *Call Me Ishmael* beginning in June 1945 (just as Olson was reading Fenollosa), Olson's often conflicting biographers agree; see Ralph Maud, *Charles Olson at the Harbor* (Vancouver: Talonbooks, 2008), p. 64; Maud, *What Does Not Change: The Significance of Charles Olson's "The Kingfishers"* (London: Associated University Presses, 1998), pp. 50–51; Tom Clark, *Charles Olson: The Allegory of a Poet's Life* (New York: W. W. Norton & Co., 1991), pp. 103–104.

161. Olson writes, "*Moby-Dick* was two books written between February, 1850 and August, 1851. The first book did not contain Ahab. It may not, except incidentally, have contained Moby-Dick." The catalyst for the transformation, Olson argues, was Shakespeare, and specifically *King Lear* (*CMI*, p. 35).

162. Ibid., p. 12.

163. *Charles Olson and Robert Creeley: The Complete Correspondence, Vol. 7* (Boston: David R. Godine Publisher, 1987), pp. 207–208.

164. *Charles Olson and Robert Creeley: The Complete Correspondence, Vol. 8* (Boston: David R. Godine Publisher, 1987), p. 150.

165. *Charles Olson and Robert Creeley: The Complete Correspondence, Vol. 10* (Boston: David R. Godine Publisher, 1996), pp. 63–64; on Buddhism at Black Mountain College, see Joan Qiongling Tan, *Han Shan, Chan Buddhism, and Gary Snider's Ecopoetic Way* (Portland, OR: Sussex Academic Press, 2009), p. 227; and Ellen Pearlman, *Nothing and Everything: The Influence of Buddhism on the American Avant-Garde, 1942–1962* (Berkeley: North Atlantic Books, 2012), pp. 44–52. Olson often commented on how Pound's embrace of Confucius had taken him far from Fenollosa; he refers in "Projective Verse" to "what the master [Pound] says he picked up from Confusion [Confucius]" (in Olson, *Collected*

Prose, ed. Donald Allen and Benjamin Friedlander (Berkeley: University of California Press, 1997), p. 243; hereafter cited as *CP*.

166. *CP*, p. 242.

167. Ibid., p. 245.

Chapter 5: The *Technê* Whim

* Unless otherwise indicated, translations are my own. For helpful comments on previous drafts of this chapter, I would like especially to thank Jerome Christensen, Jesse Palmer, Colleen Lye, Peter Leman, Erik Rangno, Mark Goble, Dorothy Fujita-Rony, John Carlos Rowe, and the editors of *American Literature*.

1. See the biography of Lin Yutang by his daughter Lin Taiyi, *Lin Yutang Zhuan* (Taipei, Taiwan: Linking Publishing, 1993), p. 236.

2. Lin Yutang, "Invention of a Chinese Typewriter," *Asia* (February 1946), p. 58; hereafter cited as "ICT."

3. Herkimer County Historical Society, *The Story of the Typewriter 1873 to 1923* (New York: Herkimer County Historical Society, 1923), p. 130.

4. After this chapter had appeared as an essay (see *American Literature* 82.2, pp. 389–419), Jing Tsu published a fine discussion of Lin Yutang's typewriter in the context of Lin's involvement with the Basic English movement (and the involvement of his keyboard design in later postwar discussions of the possibilities for mechanized "universal language"). See Jing Tsu, *Sound and Script in Chinese Diaspora* (Cambridge, MA: Harvard University Press, 2010), pp. 49–79. The story I tell here deals more with Lin's engagement with notions of Asia's *technê* as an intervention against global systems of mechanization (and particularly how these concerns shaped Lin's aesthetic sensibilities), but Jing's account dovetails nicely with my own. Tom Mullaney at Stanford University is also at work on what will be a comprehensive history of numerous attempts to design or build a Chinese typewriter, including Lin Yutang's, during the late nineteenth and twentieth centuries. Beyond these scholars, the only other academic treatment of Lin's typewriter I have found is Micah Efram Arbisser's impressive undergraduate senior thesis "Lin Yutang and His Chinese Typewriter," Princeton University, 2001.

5. See, for example, Xiao-huang Yin, "Worlds of Difference: Lin Yutang, Lao She, and the Significance of Chinese-Language Writing in America," *Multilingual America: Transnationalism, Ethnicity, and the Languages of American Literature*, ed. Werner Sollors (New York: NYU Press. 1998), p. 181; and Yunte Huang, *Transpacific Displacement: Ethnography, Translation, and Intertextual Travel in Twentieth-Century American Literature* (Los Angeles: University of California Press, 2002), p. 128.

6. Lin Yutang, *Chinatown Family* (New Brunswick, NJ: Rutgers University Press, 2007); hereafter cited as *CF*.

7. Elaine H. Kim, *Asian American Literature: An Introduction to the Writings and Their Social Context* (Philadelphia: Temple University Press, 1984), p. 28.

8. Ibid., pp. 104–105.

9. See Diran John Sohigian, "Contagion of Laughter: The Rise of the Humor Phenomenon in Shanghai in the 1930s," *positions: east asia cultures critique* 15.1 (2007), pp. 137–163; see also studies by Ling Mingchang, Zhou Zhiping, and Qin Xianci in *Cong Lin Yutang Yan Jiu Kan Wenhua Xiangrong/Yu Xianghan Guoji Xueshu Yantao-Hui Lunwen Ji* (Proceedings of "A Stride Over/Forward—Cultural Fusion/Function in the Study of Lin Yutang" International Conference) (Taipei, Taiwan: Lin Yutang House, 2007).

10. Diran John Sohigian, "The Life and Times of Lin Yutang," PhD dissertation, Columbia University, 1991.

11. Shi-yee Liu, *Straddling East and West: Lin Yutang, A Modern Literatus* (New York: Metropolitan Museum of Art, 2007), pp. 16–17.

12. Also after this chapter had appeared as an essay, Richard Jean So published a brilliant reading of *Chinatown Family* analyzing efforts by Richard Walsh, Lin's publisher

at John Day, to require that Lin's novel adhere to the ethnographic and political "reality" of Chinese-American life (thereby making his story more marketable); see Richard Jean So, "Collaboration and Translation: Lin Yutang and the Archive of Asian American Fiction," *Modern Fiction Studies* 56.1 (Spring 2010), pp. 40–62.

13. On the "denial of coevalness," see Johannes Fabian, *Time and the Other: How Anthropology Makes Its Object* (New York: Columbia University Press, 1983), p. 31.

14. Karen J. Leong, *The China Mystique: Pearl S. Buck, Anna May Wong, Mayling Soong, and the Transformation of American Orientalism* (Los Angeles: University of California Press, 2005), pp. 1, 29. For additional transnational perspectives, see Mari Yoshihara, *Embracing the East: White Women and American Orientalism* (New York: Oxford University Press, 2003), pp. 18–20, and Sohigian "Contagion," p. 155.

15. Lin Yutang, *The Importance of Living* (New York: William Morrow, 1998), p. 162; hereafter cited as *IOL*.

16. *IOL*, p. 107; see also Lin Yutang, *With Love and Irony* (New York: John Day Co., 1940), p. 14; hereafter cited as *WLI*.

17. See especially Lin Yutang, *My Country and My People* (Beijing: Foreign Language Teaching & Research Press, 1998), pp. 78–81; hereafter cited as *MC*; *IOL*, pp. 106–110; *WLI*, pp. 175–176; and *Between Tears and Laughter* (New York: John Day Co., 1943), pp. 76–79; hereafter cited as *BTL*.

18. It is important to remember that the *technê* of East for Lin meant primarily China—*not* Japan, which he more often associated with the evils of Western machine culture. In *WLI*, for example, he argues that the Japanese "behave essentially like the humorless Germans," are more directly aligned with "the machine," and "have not got Taoist blood in them," which is why "the Japanese are supremely fitted to become a warlike Fascist nation, *moving like a machine*, and the Chinese are supremely unfit to become the same" (*WLI*, pp. 32, 35; emphasis added). Japan has "swallowed Western civilization whole, its militarism, its capitalism, its nationalism, and its belief in power, and superimposed it upon a feudalistic society with no time to think for itself," all of which has only given Japanese civilization "a machinelike humorless quality" (*WLI*, p. 39)

19. *BTL*, p. 212. For the sake of discursive consistency, I am using Lin Yutang's own traditional English-language spelling of these Chinese figures rather than their current (and arguably more accurate) Pinyin spellings.

20. *MC*, p. 4.

21. Paul Shih-yi Hsiao, "Heidegger and Our Translation of the *Tao TeChing*," *Heidegger and Asian Thought*, ed. Graham Parkes (Honolulu: University of Hawai'i Press, 1987), pp. 97–98.

22. Martin Heidegger, *Parmenides* (Bloomington: Indiana University Press, 1998), p. 85.

23. Ibid.

24. Ibid., p. 81.

25. Nietzsche quoted in Friedrich Kittler, *Gramophone, Film, Typewriter*, trans. Geoffrey Winthrop-Young and Michael Wutz (Stanford, CA: Stanford University Press, 1986), p. 200; Martin Heidegger, *An Introduction to Metaphysics*, trans. Ralph Manheim (New Haven, CT: Yale University Press, 1959), pp. 36–37; hereafter cited as *IM*.

26. Heidegger, *Parmenides*, p. 86. Long before Heidegger would develop his more specific critique of the typewriter as a central mechanism in the ongoing Western "concealedness" of Being, he was already alluding to it in his *Introduction to Metaphysics* as an example of how we can understand something to "exist" and yet fail to question its essential Being-ness: "A state—*is*," he explains, but then asks whether it "is" simply because "so-and-so-many typewriters are clattering in a government building" (p. 35). This disdain for the bureaucratic will become even more pronounced following the Second World War, when Heidegger would have much more to explain about his politics. As Jacques Derrida has shown, Heidegger's later "protest against the typewriter also

belongs . . . to an interpretation of technology [*technique*], to an interpretation of politics starting from technology"; see Jacques Derrida, "Geschlecht II: Heidegger's Hand," trans. John P. Leavey, Jr., in *Deconstruction and Philosophy: The Texts of Jacques Derrida*, ed. John Sallis (Chicago: University of Chicago Press, 1987), p. 180; hereafter cited as *GII*.

27. Quoted in Shi Jianwei, *Lin Yutang Tsai Hai wai* (Lin Yutang Abroad) (Tianjin, China: Bai Hua Wei Yi, 1992), p. 101. In 1917 Lin Yutang's proclivity for scientific inventiveness would contribute to a useful change in the method by which Chinese dictionaries organized characters, placing them in groups according to stroke number rather than in thematic groups according to radical; see "ICT," p. 60. This was also the time when Lin was involved in the arguments for the use of the vernacular (*baihua*) in Chinese writing as opposed to the older, more literary tradition of writing (*wenyan wen*). See also Lin Yutang, "Guoyu Luomazi Pinyin yu Kexue Fangfa" (Romanization of Chinese Characters and Scientific Methods), in Lin Yutang, *Yuyanxue Luncong* (Collected Essays on Linguistic Studies) (Taipei: Wenxin Shudian Gufen Youxian Gongsi, 1967).

28. Lin Yutang, *Memoirs of an Octogenarian* (Taipei: Taiwan: Mei Ya, 1975), p. 31; emphasis in original.

29. See Mark Borthwick, *Pacific Century: The Emergence of Modern Pacific Asia* (Boulder, CO: Westview Press, 2007), pp. 175–176; John King Fairbank, *China: A New History* (Cambridge, MA: Harvard University Press, 1994), pp. 266–269; Peter Gue Zarrow, *China in War and Revolution, 1895–1949* (New York: Routledge, 2005), pp. 133–137.

30. In the 1920s, for example, Lin would elaborate on his innovations in the categorization of Chinese writing in an effort to improve the Chinese Telegraph Code, which had since the late nineteenth century involved assigning numerical equivalents to individual characters according to stroke order.

31. On this question Eric Hayot has brilliantly argued, "It only makes sense to wonder about what modernization can 'do' to Chineseness if you believe that they are totally different things (that is, that Chineseness somehow lies outside of modernization, or that the latter occurs fully independent from Chineseness)"; see his "Chineseness: A Prehistory of Its Future," *Sinographies: Writing China* (Minneapolis: University of Minnesota Press, 2008), p. 25. Lin's typewriter, as I argue below, constitutes an implicit rejection of this attempt to characterize modernization and Chineseness as inherently dichotomous concepts.

32. Shi-yee Liu, *Straddling East and West*, p. 12.

33. "ICT," p. 58.

34. "A Chinese Typewriter," *Scientific American* (June 3, 1899), p. 359.

35. Kittler notes that in 1823 a physician named C. L. Muller published a treatise titled *Newly Invented Writing-Machine, with Which Everybody Can Write, without Light, in Every Language, and Regardless of One's Handwriting*. What Muller meant by "everybody" was that blind people would be able to produce text (and, he would argue, by feeling their hands over the ink on the page, be able to read as well). Kittler observes, however, that when Muller says "blind people," what he really meant was blind *men*, advertising the machine for the specific cultural needs of men. Kittler argues, "The 'writing-machine,' in that sense, only brought to light the rules regulating discourse during the age of Goethe; authority and authorship, handwriting and rereading, the narcissism of creation and reader obedience. The device for 'everybody' forgot women'" (*Gramophone*, p. 188). But of course, as Lin might have argued, it forgot the Chinese too. What Muller meant by "Every Language," was every language with a Romanized alphabetic script (and specifically the three or four languages that might be spoken by his potential customers). For a fine summary of typewriting as a prosthesis for the blind, see Darren Wershler-Henry, *The Iron Whim: A Fragmented History of Typewriting* (Cornell: Cornell University Press, 2007), pp. 45–48; hereafter cited as *IW*.

36. "Chinese Typewriter," p. 359; emphasis added. The *New York Evangelist* would also note, "Although the machine is complicated, it shows a remarkable degree of ingenuity

and skill"; see "Type-Writing in Chinese," *New York Evangelist* (June 24, 1897), p. 30. A reporter for the *Critic* implied that the need for a complicated Chinese typewriter served as evidence of a particular Chinese (as opposed to Japanese) national characteristic. After noting that Sheffield's invention had been "received with delight in China," the *Critic* reporter explains, "A gentleman interested in one of the popular American type-writers told me that he had sold hundreds of machines in Japan. 'Fitted with Japanese characters?' I asked. 'Indeed, no,' he replied. 'They wouldn't have them if they were. The Japanese are all learning English, and most of their commercial correspondence is carried on in that language.' This marks the difference in the national characteristics of the two countries"; see "The Lounger," *Critic* (July 17, 1897), p. 36. A report in the Christian publication the *Congregationalist* would make the logic behind the Chinese typewriter (and the American missionary's need for it) even more explicit: "Mr. Sheffield, a Presbyterian missionary at Tang Chow, has invented a Chinese typewriter. . . . The Japanese use typewriters having English letters, but the Chinese are not yet so far advanced"; see "Notes," *Congregationalist* (August 5, 1897), p. 193.

37. See the *Oxford English Dictionary* entry for "whim."

38. *IW*, pp. 37–38.

39. Put another way, Lin's goal was as close to becoming a Chinese Alan Turing as it was a Chinese Christopher Latham Sholes. Turing is most remembered for his preliminary equations setting up the possibility for the modern computer, but his main work in the 1940s involved the breaking of the German and Japanese military codes. He was instrumental in England's reconstructing a copy of the Germany's type-coding "Enigma Machine"; see Stephen Budiansky's *Battle of Wits: The Complete Story of Codebreaking during World War II* (New York: Touchstone, 2000), pp. 114–115. Sholes is credited with having "invented" the modern typewriter, but such a view, as many histories of the typewriter have demonstrated, only obscures the work of a long line of innovations in mechanized writing; see *IW*, pp. 61–71.

40. As one missionary doctor in China commented upon seeing Sheffield's typewriter, "the characters defy analysis in any way to make possible building them up piecemeal, so *a keyboard is out of the question*." Thus, the characters would have to be "arranged on the face of a stereotyped wheel"; see A. P. Peck, "Letter 2," *Scientific American* (January 28, 1899), p. 55; emphasis added. Lin would spend two decades trying to prove this assertion wrong.

41. Lin Taiyi, *Lin Yutang Zhuan*, pp. 228–230. This design would later become the basis for the character index system in Lin's famous *Chinese-English Dictionary* (Hong Kong: Chinese University of Hong Kong, 1972). By way of background, in 1919 Lin got married and headed off to America where he had been accepted as a student in the Department of Comparative Literature at Harvard University. When his scholarship was mysteriously canceled a short while later, Lin applied to work at the YMCA to assist teaching Chinese laborers in France. Hoping to continue his studies, Lin and his wife moved to Germany where economic deflation allowed for a lower cost of living. Through an arrangement with Harvard, Lin was allowed to continue his degree through the University of Jena and then Leipzig, focusing now on Chinese philology. When he returned to China in 1923, Lin brought home with him a number of foreign-language typewriters, which he placed in his study and began assembling and disassembling (according to some reports, his study at the time seemed to resembled a typewriter factory).

42. See "Best Sellers of the Week, Here and Elsewhere," *New York Times* (October 7, 1935), p. 13.

43. The joke among the Chinese intelligentsia who did not appreciate Lin's frankness about China's problems was that the book should have been called *Mài Country and Mài People*, with a pun on *mài*, the Chinese word for "to sell" or "to sell out"; see Elaine H. Kim, "Defining Asian American Realities through Literature," *Cultural Critique* (Spring 1987), pp. 94–95.

44. Ibid. Given this vision of Chinese ideography, it is quite remarkable that Lin mentions neither Ernest Fenollosa nor Ezra Pound anywhere in his writing. But Fenollosa's Okakura-like celebration of Japanese superiority and Pound's increasingly troublesome politics were no doubt very disturbing for Lin Yutang. Indeed, Pound's simultaneous promotion of Chinese culture and European fascism (via his appropriation of Fenollosa) may have even served as evidence against Lin's central premise that only by turning to Chinese philosophy could the West recover from the degeneracy of the "mechanistic mind."

45. Aldous Huxley, "Introduction," *Printing of Today* (New York: Harper and Brothers, 1928), p. 1; subsequent references are to this edition which will be cited parenthetically as *PT*. Huxley's essay would be reprinted the same year Lin (himself a self-confessed "typophile") completed work on his Chinese typewriter in *Books and Printing: A Treasury for Typophiles* (New York: World Publishing Co., 1951), pp. 344–349. I am indebted to Richard Jean So for bringing this essay to my attention. For similar English-language appreciations of the inherent "beauty" of Chinese writing, see James Dyer Ball, *Things Chinese; or, Notes Connected with China* (New York: Charles Scribner's Sons, 1904), pp. 769–770; John Calvin Ferguson, *Outlines of Chinese Art* (Chicago: University of Chicago Press, 1910), p. 136; "Home Life of the Chinese," *Missions* (December 1910), pp. 788–789; Lucien Alphonse Legros and John Cameron Grant, *Typographical Printing-Surfaces: The Technology and Mechanism of Their Production* (New York: Longmans, Green & Co., 1916), p. 498; Stephen W. Bushell, *Chinese Art, Vol. II* (London: His Majesty's Stationery Office, 1919), p. 107; Raphael Petrucci, *Chinese Painters: A Critical Study* (New York: Brentano's Publishers, 1920), p. 25; Owen Mortimer Green, *The Story of China's Revolution* (New York: Hutchingson & Co. Ltd., 1945), p. 10.

46. Huxley's celebration of the "inner" qualities of Chinese characters (while also playing down their individual semantic qualities) is consistent with his mystically oriented "perennial philosophy," which privileges ostensibly universal cultural forms (like aesthetics and archetypal myths) over particularities like orthography and ethnic tradition. See Aldous Huxley, *The Perennial Philosophy: An Interpretation of the Great Mystics, East and West* (New York: Harper Perennial Modern Classics, 2009).

47. The very word "typewriter" at the time could mean either the machine or the person (almost always female) assigned to run the machine.

48. Quoted in Kittler, *Gramophone*, p. 184. Kittler argues that the most unique technological effect of the typewriter had to do with an inversion of gender: "The typewriter cannot conjure up anything imaginary, as can cinema; it cannot simulate the real, as can sound recording; it only inverts the gender of writing. In doing so, however, it inverts the material basis of literature" (p. 183). According to this logic, prior to the invention of the typewriter, a series of privileged material experiences were the exclusive domain of men: specifically, the very "metaphysics" of (hand)writing (including, of course, the oppressive socioeconomic systems that generally prevented women from having the time or means to write) associated the pen or stylus with the phallus and the clean white sheet of paper with femininity and virginity. As Kittler explains, "the honor of having a manuscript appear in print under the author's proper name was barred to women, if not factually then at least media-technologically: the proper name at the head of their verse, novels, and dramas almost always has been a male pseudonym" (p. 186). Kittler argues that it was precisely because of this male-centered techno-exclusivity of textual production that this metaphorical connection between stylus/page and phallus/woman became prevalent, and hence, "No wonder that psychoanalysis discovered during its clean-up operation that in dreams, '*pencils, pen-holders,* . . . and other *instruments* are undoubtedly male sexual symbols.' It only retrieved a deeply embedded metaphysics of handwriting" (p. 186; emphasis in original). Into this masculine "monopoly of writing," then, comes the

typewriter, which, according to Kittler, caused the disappearance of the intimate, sexualized experience of one's hand on the page and the correlative association of the stylus and the phallus.

49. Wilfred A. Beeching, *Century of the Typewriter* (New York: William Heinemann, 1974), p. 35.

50. Herkimer County Historical Society, *Story of the Typewriter*, pp. 9, 140; see also *IW*, pp. 86–87.

51. As several scholars have shown, such language certainly overestimated the liberatory effect of the typewriter for women. See *IW*, p. 88; Margery W. Davies, *Woman's Place Is at the Typewriter: Office Work and Office Workers, 1870–1930* (Philadelphia: Temple University Press, 1982), p. 170; and Christopher Keep, "The Cultural Work of the Type-Writer Girl," *Victorian Studies* 40.3 (1997), p. 412.

52. As Lin argues in *My Country and My People*, it was the Chinese language's monosyllabic ideography that "determined the character of the Chinese writing, and the character of the Chinese writing brought about the continuity of the literary heritage and therefore even influenced the conservativism of Chinese thought" (*MC*, p. 211). And further: "Had the Chinese been speaking a language with words like the German *Schlact* and *Kraft* or the English *scratched* and *scalpel*, they would have, by sheer necessity, invented a phonetic script long ago" (*MC*, p. 212).

53. It is in this context, I would argue, that we can begin to examine the relationship between Orientalism and the typewriter in an American writer like Jack Kerouac (whose fascination with Zen and other Chinese philosophies we will contextualize more in chapter 7). Kerouac's creative use of the typewriter involved writing on long scrolls (in the manner of ancient Chinese writing) of paper rather than individual sheets so as not to disrupt the flow of his thought created by changing paper. Kerouac himself described his use of the scrolls and typewriting in terms that directly evoke Chinese writing, noting that a normal typing process was too restrictive, a kind of "horizontal account" that he wanted to abandon for something more "vertical, metaphysical"; see Jack Kerouac, *Visions of Cody* (New York: Penguin, 1993), p. 1.

54. Shi Jianwei, *Lin Yutang Tsai Hai Wai*, p. 103.

55. Lin Taiyi, *Lin Yutang Zhuan*, p. 235.

56. Lin Yutang, "Chinese Typewriter," US Patent #2,613,795, p. 1.

57. Michael MacDonald, "Empire and Simulation: Friedrich Kittler's War of Media," *Review of Communication* 3.1 (2003), p. 88.

58. Lin, "Chinese Typewriter," p. 7.

59. Given his esteem for Edison, the fact that Lin chose cylinders as the structural basis for his machine is telling. As Lisa Gitelman has shown, "the rotating cylinder has been described as part of Edison's 'style' "; see Lisa Gitelman, *Scripts, Grooves, and Writing Machines: Representing Technology in the Edison Era* (Stanford, CA: Stanford University Press, 1999), p. 185.

60. Lin Taiyi, *Lin Yutang Zhuan*, p. 240. Lin Taiyi also notes that in the 1980s, IBM and the Itek Corporation would adopt Lin's keyboard design for a Chinese-English translation computer, and Lin's daughters tried several times in the 1980s to market the keyboard design as a means of computerized character input. In 1985 the Mitac Automation Company of Taiwan bought Lin's keyboard system, but like many computer systems, this too would be superseded by subsequent innovations (pp. 246–248). Shi-yee Liu notes that Lin's keyboard design was also used in "machines for telecommunication and phototypesetters by the American Air Force in the 1960s, operated by Americans that did not read Chinese" (*Straddling East and West*, p. 21).

61. See "New Typewriter Will Aid Chinese: Invention of Dr. Lin Yutang Can Do a Secretary's Day's Work in an Hour," *New York Times* (August 22, 1947), p. 17; Stacy V. Jones, "New Chinese Typewriter Triumphs over Language of 43,000 Symbols," *New York*

Times (October 18, 1952), p. 30; "New Chinese Typewriter Developed," *Christian Science Monitor* (August 23, 1947), p. 3.

62. "Lin Yutang Invents Chinese Typewriter," *San Francisco Chronicle* (August, 22, 1947), p. 6.

63. "Faming HuawenDaziji," *Chung Sai Yat Po* (August 22, 1947), p. 1.

64. Lin Taiyi, "Foreword," Lin Yutang, *MC*, p. 9.

65. *IW*, p. 2; emphasis in original.

66. Theodora Bosanquet, *Henry James at Work*, ed. Lyall Powers (Ann Arbor: University of Michigan Press, 2006), p. 248. For a fascinating study of Bosanquet's conflation of typewriting and spiritualism (in which the typewriter itself becomes something like a Ouija board), see Pamela Thurschwell, "Henry James and Theodora Bosanquet: On the Typewriter, in the Cage, at the Ouija Board," *Textual Practice* 13.1 (1999), pp. 5–23. McLuhan writes that James eventually "became so attached to the sound of his typewriter operating that on his deathbed, Henry James called for his Remington to be worked near his bedside"; see *Understanding Media: The Extensions of Man* (Cambridge, MA: MIT Press, 1994), p. 100.

67. Lin's *With Love and Irony* provides several glimpses of how much his English-language typewriter was central to his writing. At one point he writes, "I hardly knew the number of things I had not done myself, until someone first asked me this question, and now I am sitting in front of my typewriter to think it out" (*WLI*, p. 73). He also includes an essay in which he discusses one of his boy servants who had "a genius . . . for all sorts of mechanical devices" and was fascinated with his typewriter (p. 121). In another essay he writes about the time he bought a typewriter and was surprised to hear the salesman explain that there is a world of difference between a Remington and an Underwood (p. 127).

68. For previous analyses of *Chinatown Family* (hereafter *CF*), see Shirley Geok-Lin Lim, "Twelve Asian American Writers: In Search of Self-Definition," *MELUS* 13.1–2 (1986), p. 59; Sau-ling C. Wong and Jeffrey J. Santa Ana, "Gender and Sexuality in Asian American Literature," *Signs* 25.1 (1999), p. 196; C. Lok Chua, "Introduction," in *CF*, p. xv; Cyrus R. K. Patell, "Emergent Literatures," *The Cambridge History of American Literature, Volume 7: Prose Writing 1940–1990*, ed. Sacvan Bercovitch (Cambridge: Cambridge University Press, 1999), p. 645; and Katherine A. Karle, "Flamingos and Bison: Balance in *Chinatown Family*," *MELUS* 15.2 (1988), p. 93.

69. See David Nye, *American Technological Sublime* (Cambridge, MA: The MIT Press, 1994), p. xiv. See also Leo Marx, *The Machine in the Garden* (New York: Oxford University Press. 2000), p. 219.

70. Ibid., pp. 40, 48. On "El" as another name for "Yahweh" (preserved in Hebrew names such as Israel and Ishmael), see Karen Armstrong, *A History of God: The 4,000-Year Quest of Judaism, Christianity, and Islam* (New York: Random House, 1994), pp. 14–15.

71. The classic argument on the alphabet as a "technology" is Walter Ong's 1982 study, *Orality and Literacy* (New York: Routledge, 2012), pp. 80–91, but he was in many ways repackaging arguments made by Marshall McLuhan in *Understanding Media*, pp. 81–105. What might be called McLuhan's "alphabeterminism" is placed in an explicitly East/West context by his student, Robert K. Logan's overly generalist study titled *The Alphabet Effect: The Impact of the Phonetic Alphabet on the Development of Western Civilization* (New York: St. Martin's Press, 1986). One could perhaps argue that Lin was in some ways anticipating already these conversations in *CF*.

72. For example, Freddie says things like, "Amelican children don't study. Dey play all day" (*CF*, p. 59); "Dey are in Amelican school" (*CF*, p. 106); and "De Amelicans like me. I have a good position" (*CF*, p. 111).

73. Lin, *CF*, pp. 73, 149. Lin may have gotten the idea for this passage from Lewis Mumford, who reported that for him and his wife, "walks over the Bridge, at all times of the day, from one end or the other, were our favorite modes of recreation"; see Mumford,

Findings and Keepings (New York: Harcourt Brace Jovanovich, 1975), p. 215. The classic myth-and-symbol study on the bridge as an emblem of American technological progress is Trachtenberg's *Brooklyn Bridge: Fact and Symbol* (Chicago: University of Chicago Press, 1965); see especially pp. 143–166.

74. "ITC," p. 60. A Chinese-language DVD showing footage of Lin's daughter typing (with remarkable ease) on the machine can be purchased from the Lin Yutang house in Taiwan; *Liang Jiao Ta Dong Xi: Lin Yutang Xinglu Shengya* (Straddling East and West: Lin Yutang's Traveling Career), Starwin Music Company, Taipei, Tawian, 2009; see especially the scene at 1:02:20–1:02:40.

75. It is helpful to note here that in the Chinese translation of *Chinatown Family* (唐人街), the phrase "flashed all three lights" is translated with the word 打亮 (*dǎliàng*), literally "to strike a light," with 打 (*dǎ*) being the same character used in the word 打字 (*dǎzě*), which is literally "to strike a character," meaning "to *type*" (*CF*, p. 220).

76. On Mumford as a founding figure in American studies, see Gene Wise, " 'Paradigm Dramas' in American Studies: A Cultural and Institutional History of the Movement," *Locating American Studies* (Baltimore, MD: Johns Hopkins University Press, 1999), p. 171; the "humanist" phrase is Malcolm Cowley's, quoted in Donald L. Miller, *Lewis Mumford: A Life* (New York: Grove Press, 2002), p. xvii. Some of Mumford's most important studies on technology and modern life include *The Golden Day* (1925), *Technics and Civilization* (1934), *The Culture of Cities* (1938), *The Condition of Man* (1944), *Art and Technics* (1952), *The Myth of the Machine*, two volumes (1967, 1970), and *The Urban Prospect* (1968). Lin Yutang himself wrote that Mumford's *Technics and Civilization* (1934) addressed "the most important problem confronting man in the modern age" (quoted in *The Writings of Clarence S. Stein: Architect of the Planned Community* [Baltimore, MD: Johns Hopkins University Press, 1998], p. 382). On Mumford's friendship with Lin, see *The Letters of Lewis Mumford and Frederic J. Osborn* (New York: Praeger Publishers, 1971), p. 483. The Mumford letters at the Van Pelt library at the University of Pennsylvania also contain a letter from Lin to Mumford (delivered by Aline McMahon Stein) thanking him for the copy of *Faith For Living* (1940).

77. *Art and Technics* (New York: Columbia University Press, 1952), p. 11; emphasis added, hereafter cited as *AT*.

78. Ibid., p. 14. Perhaps not surprisingly, in this search for *technê* Mumford would occasionally turn to Asia. See, for example, *Mumford on Modern Art in the 1930s*, ed. Robert Wotjowicz (Berkeley: University of California Press, 2007), pp. 208, 224; Mumford, *Interpretations and Forecasts: 1922–1972* (New York: Harvest Books, 1973), p. 283; and Mumford, *AT*, p. 155.

79. On these questions more specifically, see Janet Biehl, *Rethinking Ecofeminist Politics* (Cambridge, MA: South End Press, 1991).

80. Michel Foucault, *The Order of Things; An Archaeology of the Human Sciences* (New York: Vintage, 1994), p. xv; emphasis added, hereafter cited as *OT*.

Chapter 6: The Chinese Parrot

1. Technically, the first appearance of Charlie Chan was in Biggers's *The House without a Key* (Indianapolis: Bobbs-Merrill, 1925), but he does not actually show up in the story until nearly a quarter of the way through the novel, and does not play as central a role as he would in subsequent Biggers novels.

2. Earl Derr Biggers, *Five Complete Novels* (New York: Avenel Books, 1988), p. 187.

3. By "ghostless," I mean here that if we accept the terms of Gilbert Ryle's famous critique of Cartesian dualism in his 1949 polemic, *The Concept of Mind* (succinctly rearticulated in Koestler's *The Ghost in the Machine* [New York: Macmillan, 1967]), the parrot is a haunting apparition precisely because it reproduces speech without the ghostly/soulful presence of human consciousness. See Gilbert Ryle, *The Concept of Mind* (Chicago: University of Chicago Press, 2002), pp. 49–50.

4. René Descartes, *Discourse on Method and The Meditations*, trans. F. E. Sutcliffe (New York: Penguin, 1968), pp. 74–75.

5. Ernest Fenollosa, The Nature of Fine Art," *Lotos* 9 (March 1896), pp. 672–673.

6. As Simon Critchley has argued, parrots are "surely the most unnerving of animals because of their uncanny ability to imitate that which is meant to pick us out as a species: language. Comic echo of the human, holding up a ridiculing mirror to our faces, the parrot is the most critical beast of all the field" (Simon Critchley, *On Humour* [New York: Routledge, 2002], p. 38). Paul Carter similarly observes, "Parrots defy classification not by coming in all shapes and sizes, but because they are chromatically mutable, promiscuously social, verbally equivocal and intellectually enigmatic" (Paul Carter, *Parrot* [London: Reaktion Books, 2006], p. 34; hereafter cited as *P*).

7. The most impressive case for an argument against the notion of parrots as "mindless mimics" is found in Irene M. Pepperberg's "Studies to Determine the Intelligence of African Grey Parrots," *Proceedings of the International Aviculturalists Society* (January 11–15, 1995), available at http://clas.mq.edu.au/animal_communication/pepperberg.pdf. However, as Carter observes, "Pepperberg's experimental situation proves mainly that her experiments work. They work because of a strange untested assumption, which is that Alex [her parrot] will mimic his trainers *knowingly*, that he will internalize what they do, and identify it with his own desire, in this way learning to behave in a non-mimetic, self-motivated way" (*P*, p. 154; emphasis in original).

8. Additional images and clips referenced in this chapter can be viewed on my personal website at www.rjohnwilliams.wordpress.com. On Léger's use of parrots, see Museum of Modern Art, New York, *Fernand Léger* (New York: Museum of Modern Art, 2002), pp. 50, 145–146, 226, and 233.

9. *P*, p. 74. See also the website www.movieparrot.com, which collects "the best and worst lines from cinema."

10. See "USB Parrot: Encourages Piracy," at Tech-Fresh.net: http://www.techfresh.net /usb-parrot-encourages-piracy/.

11. It is hardly surprising that Andy Warhol would be similarly fascinated with parrots, as evidenced in "Parrot," part of his Toy Series (1983). See *Andy Warhol, 1928–1987* (New York: Prestel Publishing, 1993), p. 103. The techno-romantic Walt Whitman also saw something beautiful in the mechanical reproducibility of the parrot: "I have probably not been afraid of careless touches from the first—and am not now—nor of parrot-like repetitions—nor of platitudes and the commonplace. Perhaps I am too democratic for such avoidances" (Walt Whitman, *Complete Poetry and Collected Prose* [New York: Library of America, 1982], p. 637).

12. An in-depth study of "woman and parrot" paintings is well beyond the scope of this chapter, but it is worth mentioning a few important contributions merely to demonstrate the historical and geographical breadth of the genre, which begins in earnest in the early seventeenth century and continues on into the present: see paintings by Quiringh Gerritsz van Brekelenkam (1622–1669), Jan Havickszoon Steen (1626–1679), Pieter de Hooch (1629–1684), Frans van Mieris the Elder (1635–1681), Rosalba Carriera (1675–1757), Giovanni Battista Tiepolo (1696–1770), Jean-Honoré Fragonard (1732–1806), Eugène Delacroix (1798–1863), Charles Louis Bazin (1802–1859), Valentine Cameron Prinsep (1838–1904), Paul Cézanne (1839–1906), Pierre–Auguste Renoir (1841–1919), William Sergeant Kendall (1869–1938), Viktor Rafael (1900–1981), Salvador Dalí (1904–1989), Frida Kahlo (1907–1954), and Fernando Botero (b. 1932). The "woman and parrot" genre is also present throughout the early decades of Western photography; for more on this and other representations of the parrot in Western art, see Richard Verdi, *The Parrot in Art: From Dürer to Elizabeth Butterworth* (New York: Scala Publishers, 2007).

13. Quoted in Arden Reed, *Manet, Flaubert, and the Emergence of Modernism: Blurring Genre Boundaries* (Cambridge: Cambridge University Press, 2003), p. 34. As Reed argues, "It is not inconsequential that the *Jeune dame* represents a parrot, speaking creature par

excellence, because the bird's presence already turns the *Jeane dame* into a 'talking picture'" (p. 15).

14. As Reed notes, Courbet's own stated goal in *Woman with a Parrot* was not to "represent the customs, the ideas, the appearance of my own era according to my own ideas," as he had declared in his realist manifesto of 1855; rather, in preparing for this painting, he suddenly foreswore allegiance to realism, producing "a highly readable picture by invoking one of the most potent of narrative lures: erotic fantasy" (ibid., p. 35).

15. Carter's study of cultural "parrotics" puns wildly (and wonderfully) on *polly*, noting the parrot's qualities in the context of polymorphism, polysemia, polyglossia, typol[l]ogy, and polyphonicity, among others. He also notes, "the Polyamory group, which promotes 'loving multiple people simultaneously,' has adopted the parrot as its mascot" (*P*, p. 85). For Carter, "the essence of the ur-parrot is doubleness" (p. 44).

16. Bruce Thomas Boehrer, *Parrot Culture: Our 2500-Year-Long Fascination with the World's Most Talkative Bird* (Philadelphia: University of Pennsylvania Press, 2004), p. 54.

17. Ibid., p. x.

18. See Barry Till, *Shin Hanga: The New Print Movement in Japan* (Petaluma, CA: Pomegranate Communications, 2007), pp. 5–27.

19. Carter's book tracks "the ramifying web of parrot associations, as parrot circulates in the collective imaginary," pausing to note an entire "flock of literary parrots whose powers of imitation expose human 'parrots'" (*P*, 50). See also Julia Courtney and Paula James, *The Role of the Parrot in Selected Texts from Ovid to Jean Rhys* (Lewiston, NY: Edwin Mellen Press, 2006).

20. Biggers, *Five Complete Novels*, p. 271.

21. The website www.imdb.com lists fifty-eight "Charlie Chan" films, eight "Mr. Moto" films, and seven "Mr. Wong" films (all appearing between 1927 and 1949), and thirty-nine television episodes of "The New Adventures of Charlie Chan" (running from 1957–1958).

22. Quoted in Ken Hanke, *Charlie Chan at the Movies: History, Filmography, and Criticism* (London: McFarland & Company, Inc., 1989), p. xv.

23. Ibid.

24. Jon L. Breen, "Charlie Chan: The Case of the Reviled Detective," *Mystery Scene* 82 (2003), p. 27. Film scholar Brian Taves has similarly characterized the Chan movies as "a fundamental reversal in Hollywood's treatment of Oriental characters" (Brian Taves, "The B Film: Hollywood's Other Half," *Grand Design: Hollywood as a Modern Business Enterprise, 1930–1939*, ed. TinoBalio [Berkeley: University of California Press, 1996], p. 336).

25. Breen, "Charlie Chan," p. 31. Also in this vein, Yunte Huang's more recent study (*Charlie Chan: The Untold Story of the Honorable Detective and His Rendezvous with American History* [New York: W. W. Norton & Co., 2011]) blends personal narrative and pop history, offering a more international perspective on the character's broad appeal. Huang's book has been enormously successful—so much so that, according to some sources, Wayne Wang has agreed to direct a film based on it, with Jack Nicholson playing the part of Warner Oland; see Jeff Yang, "If Sherlock Holmes Can Come Back, Why Not Charlie Chan?" *Wall Street Journal: Speakeasy* blog, 19 December 2011: http://blogs.wsj.com/speakeasy /2011/12/19/if-sherlock-holmes-can-come-back-why-not-charlie-chan/.

26. See Frank Chin, "Interview: Roland Winters," *Amerasia* 2 (1973), p. 1. In a recent broadcast on NPR's "On Point" (August 27, 2011) Chin angrily labeled Yunte Huang's attempt to recuperate the Charlie Chan character "crap," and a blatant refusal to acknowledge the Chinese people's own myths and self-characterizations. Chin's reaction is not surprising, given the fact that Huang is offering Chan fans precisely what Chin most despises: an Asian scholar complicating the stereotypical portrayal of "Orientals" with defenses of the detective's less-than-masculine persona.

27. Chin, "Interview," p. 17.

28. Quoted in Breen, "Charlie Chan," p. 26.

29. William Wu, *The Yellow Peril: Chinese Americans in Fiction, 1850–1940* (North Haven, CT: Archon Books, 1982), p. 175.

30. Ibid., p. 182.

31. Sheng-mei Ma, *The Deathly Embrace: Orientalism and Asian American Identity* (Minneapolis: University of Minnesota Press, 2000), p. 13; see also Yunte Huang, *Transpacific Displacement: Ethnography, Translation, and Intertextual Travel in Twentieth-Century American Literature* (Berkeley: University of California Press, 2002), p. 118.

32. Charles Rzepka, "Race, Region, Rule: Genre and the Case of Charlie Chan," *PMLA* 122.5 (2007), p. 1465; hereafter cited as *RRR*. The phrase "Ching Chong Chinaman" has its origins in early twentieth-century American popular culture, as a rhyme for jumping rope; see Huang, *Charlie Chan: The Untold Story*, pp. 117–119.

33. Xiao-huang Yin, *Chinese American Literature since the 1850s* (Urbana, IL: University of Illinois Press, 2000), p. 154.

34. The effort to draw a line between the self-reflexive, defamiliarizing Chan in literature and the stereotypical, mongrelized Chan in film (what Rzepka sees as difference between the literary Chan of "rule subversion" and the Hollywoodized "parade-balloon version") is problematic not only because many of these same stereotype-defying scenes make their way into films (the tension between Chinese pidgin and Charlie's more elegant English, for instance, shows up in both *Charlie Chan in Paris* [1935], and *Charlie Chan at the Race Track* [1936]), but also because Biggers's novels were themselves already engaged in—and were developed for the express purposes of—Hollywood cinematic production. For example, when Chan observes in the novel, "You understand parrot does not invent talk. Merely repeats what others have remarked," one is very quickly reminded that this is also the job description of an actor in the cinema (*Five Complete Novels*, p. 187). Indeed, it is shortly after encountering the Chinese-speaking parrot that Chan meets a young Hollywood location scout who invites him to observe a film production team at work on location in southern California, to which Chan replies, "I have unlimited yearning to see movies in throes of being born" (p. 257). After several pages of describing the various activities of the Hollywood production team, Biggers tells us that, "Near at hand, Ah Kim hovered, all eyes for these queer antics of the white men," and it is at this point that Chan coyly sidesteps the director's invitation to get behind the camera (p. 261). Readers of Biggers's novel, in other words, would have clearly understood not only that the Oriental detective has bested his white counterparts on the police force, but also that Biggers's character has done so with an eye toward becoming a *cinematic* character. In fact, it turns out in the novel that Chan could not have solved the case without the setting of the Hollywood production lot, which ultimately provides the context for Chan to discover the real culprit—who has himself been acting the part of someone else.

35. This is not to say that these actors did not find ways of self-reflexively satirizing the racialized characters they played in these films, but there can be little doubt that the African American characters who show up in the various Chan movies are, to borrow Rzepka's phrase, "diminished figures." For more on African Americans in these films see Donald Bogle, *Toms, Coons, Mulattoes, Mammies, and Bucks: An Interpretive History of Blacks in American Films* (New York: Bantam, 1974), pp. 55–58, 103–104.

36. Recent scholarship on African American audience reception has complicated a number of seemingly obvious assumptions about forms such as "blackface" and "yellowface"; see, for example, Charles Musser, "Why Did Negroes Love Al Jolson and *The Jazz Singer*? Melodrama, Blackface, and Cosmopolitan Theatrical Culture" *Film History* 23.2 (2011), pp. 196–222.

37. My approach here is indebted to Rey Chow's *The Protestant Ethnic and the Spirit of Capitalism* (New York: Columbia University Press, 2002), which offers a critique of Jacques Derrida's poststructuralist intervention in Western metaphysics. According to Chow, in Derrida's turn toward Chinese orthography as the site of some inherently "other," nonphonocentric tradition, he offers both a repackaging of a very familiar stereotype and a

highly self-reflexive critique of the West: "Derrida's approach is noteworthy not because he challenges the stereotype but because he stops at its boundary, hails it as a familiar sight/site ('Ah, such inscrutable Chinese!'), and then redirects his gaze steadfastly at the West, in which things acquire a new significance as a result of this hailing of the other" (p. 65). Such a process is remarkably close to what I will argue is happening in the Oriental detective films of the 1930s and 1940s. Having "hailed the other," the technocultures of the West take on an entirely new significance.

38. *Rockefeller Foundation Review* (1943) as cited by Max Horkheimer and Theodor W. Adorno, *Dialectic of Enlightenment*, trans. Edmund Jephcott (Stanford, CA: Stanford University Press, 2002), p. 258; emphasis added. The most succinct articulation of Frankfurt School suspicion of technology is Herbert Marcuse's *One-Dimensional Man* (Boston, MA: Beacon Press, 1964).

39. Herbert Marcuse, *Reason and Revolution* (London: Oxford University Press, 1941), p. 256.

40. See Theodore Adorno, *The Culture Industry* (New York: Routledge, 1991), p. 172.

41. On the perceived role of technology (referred to here as "a great disturber") in the economic crisis of the 1930s, see "Technological Trends and National Policy," *Science* 86 (July 23, 1937), pp. 69–71. For a fascinating film documentary on these themes, see Civic Films, Inc.'s *The City* (1939), exhibited as part of the New York World's Fair, and narrated by Lewis Mumford.

42. "The use of mechanical reproductions in broadcasting programs without announcing their source was condemned as 'a fraud upon the listening public' by Radio Commissioner La Fount today, who added that 'unless this situation is remedied broadcasting programs will rapidly deteriorate in this country,'" "Hits at Phonograph in Radio Programs," *New York Times* (August 15, 1929). La Fount's argument led to new federal legislation; see "Mechanical Music Must Be So Noted," *New York Times* (December 7, 1929); "Radio Ruling Made on Phonograph Use," *New York Times* (December 28, 1929); "Music and Machinery," *New York Times* (September 12, 1931); "Programs That Whirl on Disks," *New York Times* (October 19, 1930); La Fount's legislation, however, was overturned just two years later; see "Ban on Records Is Lifted," *New York Times* (January 24, 1932). It is worth noting that this particular legislation was also due to the efforts of musicians' unions who were losing jobs because of the new broadcast technologies: see Mark Coleman, *Playback: From the Victrola to MP3: 100 Years of Music, Machines, and Money* (New York: Da Capo Press, 2005), p. 39; and Eric Arnesen, *Encyclopedia of U.S. Labor and Working-Class History, Volume 1* (New York: Routledge, 2007), p. 1080.

43. "Ban on Records Is Lifted." For more on the various cultures of Western technological anxiety, see Lewis Mumford, *Technics and Civilization* (New York: Harcourt, Brace & World, 1934); Jacques Ellul, *The Technological Society* (New York: Vintage Books, 1967). The 1930s also saw the publication of Aldous Huxley's techno-dystopic *Brave New World*, the technological catastrophe of the Hindenburg, and, in the words of one *Harper's* magazine essayist, congested highways that "injured the beauty of the country," which, he argued, only reflected the slapdash cacophony of communications technologies that had caused "deplorable changes . . . in social intercourse"; see Floyd H. Allport, "This Coming Era of Leisure," *Harper's* (November 1931), pp. 641–652.

44. Matt Novak has called this development "The Robot Panic of the Great Depression"; see http://www.slate.com/slideshows/technology/the-robot-panic-of-the-great-depression .html. As Novak notes, "In 1930 the American Federation of Musicians spent more than $500,000 to fight the advance of 'robot music'—prerecordings on records—with the Music Defense League. They ran a series of ads in newspapers across the United States and Canada that featured illustrations of robots."

45. Bennet Lincoln, "Is Man Doomed by the Machine Age?" *Modern Mechanics and Inventions* (March 1931), pp. 50–55.

46. Bruce Catton, "Editorial," *Sandusky Star Journal* (September 28, 1932).

47. Ken Hanke sees the centrality of this "techno-trick" as the unique contribution of director H. Bruce "Lucky" Humberstone, who directed a number of Chan films in the 1930s: "Humberstone was absolutely awestruck by mechanics, inventions, and scientific gadgets on an improbably 'Mr. Wizard' level. All of his Chan outings contain at least one scene where the action stops dead for an enlightening scientific demonstration" (*Charlie Chan at the Movies*, p. 74). However, although Hanke may be right that Humberstone accelerated the narrative role of these techno-tricks in the Chan genre, he does not seem to notice that they were very consistently present before Humberstone's Chan films, and that they would continue to appear for years after. Rush Glick, who runs a Charlie Chan fan site online (and appeared in many of the DVD special features of the recent rereleases of the Chan series), has also published a small article acknowledging some of the technological sophistication seen in the films; see "Charlie Chan at the Technological Cutting Edge," *Circuit* (a publication of the Computer Museum of America) 2.4 (Fall 2003), p. 3.

48. Ronald R. Thomas, *Detective Fiction and the Rise of Forensic Science* (Cambridge, MA: Cambridge University Press, 1999), p. 3.

49. Arthur Conan Doyle, *Adventures of Sherlock Holmes* (New York: Harper & Brothers, Franklin Square, 1892), p. 3.

50. See Thomas, *Detective Fiction*, p. 43.

51. Ibid., 14. Critics of detective fiction have argued that detective plots evidence a kind of Althusserian "interpellation" such that a hegemonic encoding of the technocultural regime is inevitably mapped onto readers. Dennis Porter, for instance, sees the detective genre as inherently conservative, "a literature of reassurance and conformism" (Dennis Porter, *The Pursuit of Crime: Art and Ideology in Detective Fiction* [New Haven, CT: Yale University Press, 1981], p. 220). Franco Moretti has argued that the genre's tendency to isolate guilt serves a similarly conservative purpose: "Detective fiction . . . exists expressly to dispel the doubt that guilt might be impersonal, and therefore collective and social" (*Signs Taken for Wonders: On the Sociology of Literary Terms* [New York: Verso, 1983], p. 135). Defenders of the genre, such as Marshall McLuhan, have argued that what is so admirable about the detective figure (as opposed to the bureaucratic figure of the "cop") is his autonomous "integrity," which McLuhan sees as offering a model for uncovering the hidden mechanisms of the culture industry (Marshall McLuhan, "Footprints in the Sands of Crime," *Sewanee Review* (1946), p. 627). For a succinct introduction to the politics of detective fiction more generally, see Charles Rzepka, *Detective Fiction* (New York: Polity, 2005), pp. 9–31.

52. The first of these is from *Charlie Chan in Shanghai* (1932), the second from *Charlie Chan at the Olympics* (1937), and the third from *Charlie Chan on Broadway* (1937).

53. See *Chanograms: The Aphorisms of Charlie Chan*, DVD (Twentieth Century-Fox, 2007).

54. The classic text on this approach is David Bordwell, Janet Staiger, and Kristen Thompson's *The Classical Hollywood Cinema* (New York: Routledge, 1988). See also Tino Balio, *Grand Design: Hollywood as a Modern Business Enterprise* (Berkeley: University of California Press, 1996); Ethan Mordden, *Hollywood Studios* (New York: Knopf, 1988); and David Gomery's *The Hollywood Studio System: A History* (London: BFI, 2005).

55. Brian Taves, "The B Film: Hollywood's Other Half," *Grand Design: Hollywood as a Modern Business Enterprise, 1930–1939*, ed. Tino Balio (Berkeley: University of California Press, 1996), p. 313. As Leo Braudy has argued, "No part of the film experience has been more consistently cited as a barrier to serious critical interest than the existence of forms and conventions, whether in such details as the stereotyped character, the familiar setting, and the happy ending, or in those films that share common characteristics—westerns, musicals, detective films, horror films, escape films, spy films—in short, what have been called *genre* films" (Leo Braudy, *World in a Frame: What We See in Films* (New York: Doubleday, 1977), p. 663; emphasis in original.

56. Taves, "The B Film," p. 313.

57. Braudy, *World in a Frame*, p. 313.

58. Quoted in Bosley Crowther, "How Doth the Busy Little 'B,'" *New York Times* (January 2, 1938).

59. Taves notes, "Within the limits of the B form, resourceful filmmakers . . . were sometimes allowed to be more creative than in A's. . . . The B's, especially at the majors, could become an artistic endeavor, while avoiding the budgetary excesses that doomed the A endeavors of a Josef von Sternberg or Orson Welles" ("The B Film," p. 337). Hye Seung Chung has also argued that "in addition to unusual visual flourishes, less conventional subject matter and characterizations could pass relatively unscathed in low-budget B pictures, perhaps none more so than in the Oriental detective films theatrically released in the 1930s and 1940s" (Hye Seung Chung, *Hollywood Asian: Philip Ahn and the Politics of Cross-Ethnic Performance* (Philadelphia: Temple University Press, 2006), pp. 67–68).

60. Quoted in Taves, "The B Film," p. 55.

61. Jerome Christensen, "Studio Authorship, Corporate Art," *Auteurs and Authorship: A Film Reader*, ed. Keith Grant (Malden, MA: Blackwell Publishing, 2008), p. 168; see also Christensen's brilliant, more expansive study *America's Corporate Art: The Studio Authorship of Hollywood Motion Pictures* (Stanford, CA: Stanford University Press, 2011). Thomas Schatz's *The Genius of the System: Hollywood Filmmaking in the Studio Era* (New York: Pantheon, 1988) offers a more traditional approach with themes similar to Christensen's.

62. Christensen, "Studio Authorship, Corporate Art," p. 168.

63. Ibid., p. 171.

64. Sometimes the Chan and Moto films would even blend together, as when Oland died, and Fox had already filmed substantial portions of *Charlie Chan at Ringside*. Rewriting the plot as a Moto film, Fox found a reason for Chan's "Number One Son," Lee, to be working with Moto (taking a "detective class" from him at the college), and released the film as *Mr. Moto's Gamble* (1938). As a Japanese detective, Mr. Moto was bound to end with the beginning of World War II, and the last Mr. Moto film at Fox was *Mr. Moto's Last Warning* (1939), preceded by *Thank You, Mr. Moto* (1937), *Think Fast, Mr. Moto* (1937), *Mr. Moto Takes a Chance* (1938), *Mysterious Mr. Moto* (1938), *Mr. Moto's Gamble* (1938), *Mr. Moto Takes a Vacation* (1939), and *Mr. Moto in Danger Island* (1939).

65. The character was originally introduced by Hugh Wiley in *Collier's Magazine* in 1934, the year after Earl Derr Biggers's death. When Monogram purchased the rights to Wiley's "Mr. Wong" series, it was not in fact the first time that Mr. Wong would make it to the screen, as Victory Pictures had been quietly incorporating a "Mr. Wong, San Francisco detective," into their Bela Lugosi vehicle *Shadow of Chinatown* (1936). The character is minor, and is never fully identified as "James Lee Wong," which perhaps would allow Victory Pictures to capitalize on Wiley's introduction of the Wong detective name, without actually buying the rights from him.

66. "Mr. Wong in Chinatown," *New York Times* (July 31, 1939).

67. The five Mr. Wong films with Boris Karloff at Monogram Studios were *Mr. Wong, Detective* (1938), *The Mystery of Mr. Wong* (1939), *Mr. Wong in Chinatown* (1939), *The Fatal Hour* (1940), and *Doomed to Die* (1940). A sixth Mr. Wong film in the series at Monogram, *Phantom of Chinatown* (1940), starred Keye Luke as the Chinese detective, and is sometimes incorrectly labeled as the only Hollywood film of the period to have an Asian detective played by an Asian actor. (In fact, the first three Charlie Chan pictures had Asian actors, and Sessue Hayakawa played a very heroic Chinese detective in Paramount's Fu Manchu film *Daughter of the Dragon* in 1931.)

68. Krystyn Moon, *Yellowface: Creating the Chinese in American Popular Music and Performance, 1850s–1920s* (New Brunswick, NJ: Rutgers University Press, 2005), pp. 1–9.

69. Ibid., p. 1.

70. There are many studies of the characterization of cinema as an Orientalized "ideographic" medium. See, for example, Miriam Hansen, *Babel and Babylon: Spectatorship in American Silent Film* (Cambridge, MA: Harvard University Press, 1991); Tom

Conley, *Film Hieroglyphs* (Minneapolis: University of Minnesota Press. 2006); Christopher Bush, *Ideographic Modernism: China, Writing, Media* (New York: Oxford University Press, 2010); R. John Williams, "Global English Ideography and the Dissolve Translation in Hollywood Film," *Cultural Critique* 72 (2009), pp. 89–136; *Visions of the East: Orientalism in Film*, ed. Matthew Bernstein and Gaylyn Studlar (New Brunswick, NJ: Rutgers University Press, 1997).

71. See Vachel Lindsay, *The Art of the Moving Picture* (New York: Macmillan & Co., 1916), p. 226; Sergei Eisenstein, "Beyond the Shot [The Cinematographic Principle and the Ideogram]," *Film Theory and Criticism 6th Edition*, ed. Leo Braudy and Marshall Cohen (New York: Oxford University Press, 2004), pp. 13–22; Jean Mitry, *The Aesthetics and Psychology of the Cinema* (Bloomington: Indiana University Press, 2000), pp. 13–14. For an interesting take on the chronologically earlier Chinatown films, see Ruth Mayer, "The Glittering Machine of Modernity: The Chinatown in American Silent Film," *Modernism/modernity* 16.4 (2009), pp. 661–684.

72. Consider the degree to which Carter's description of the parrot's classificatory ambiguity coincides with cultural field of Grauman's theater: "Parrots . . . are chromatically mutable, promiscuously social, verbally equivocal and intellectually enigmatic" (*P*, p. 34).

73. See David Karnes, "The Glamorous Crowd: Hollywood Movie Premiers between the Wars," *American Quarterly* 38.4 (1986), p. 557.

74. Theodore Adorno, *Quasi Una Fantasia* (New York: Verso, 1998), p. 109; emphasis added.

75. It is tempting to speculate that Benjamin would have thoroughly enjoyed Robert B. Stone's novel *Damascus Gate* in which an American expatriate journalist in Jerusalem remembers his father taking his mother on a trip to Los Angeles, where she meets members of the Frankfurt School, including Adorno: " 'She thought Theodor Adorno was the guy who played Charlie Chan in the movies. . . . She asked him, 'Does it hurt when they do you up Chinese?' " Adorno is described as thoroughly perplexed by the conversation. See Robert B. Stone, *Damascus Gate* (New York: Houghton Mifflin Books, 1998), p. 126.

76. Walter Benjamin, "The Work of Art in the Age of Its Technological Reproducibility," *The Work of Art in the Age of Its Technological Reproducibility and Other Writings on Media* (Cambridge, MA: Harvard University Press, 2008), p. 33. For a discussion of the different versions of Benjamin's essay, see Miriam Bratu Hansen, "Room-for-Play: Benjamin's Gamble with Cinema," *October* 109 (2004), pp. 3–45.

77. Benjamin, "Work of Art," p. 36.

78. Ibid., p. 24.

79. Walter Benjamin, "Chinese Paintings at the Bibliothéque Nationale," *The Work of Art in the Age of Its Technological Reproducibility and Other Writings on Media* (Cambridge, MA: Harvard University Press, 2008), p. 257.

80. Ibid., p. 259. For a fascinating discussion of Benjamin's views on Chinese aesthetics, see Christopher Bush, *Ideographic Modernism: China, Writing, Media* (New York: Oxford University Press, 2010), pp. 103–121.

81. Rey Chow's masterful discussion of the modern understanding of stereotyping and ethnicity offers an important parallel for this argument: "Rather than viewing stereotypes as problems in cognitive psychology—defined typically as mental structures or reflections—involving intergroup relations, I am primarily concerned with their function as a representational device, a possible tactic of aesthetic and political intervention in situations in which the deployment of stereotypes by dominant political or cultural discourses has long been a fact. I believe it is only by considering stereotyping as an objective, normative practice that is regularly adopted for collective purposes of control or management, or even for purposes of epistemological experimentation and radicalism, and not merely as a subjective, devious state of mind that we can begin to assess its aesthetic-cum-

political relevance. To that extent, it may be more useful to return to the original coinage of the word than to adhere to its more contemporary, popular psychological usage: stereotypes are thought-provoking precisely because they are forms of representing (human beings) that involve, as in the case of printing, a deliberate process of *duplication*, a process that, when cast in literary language, may be seen as the equivalent of *imitation*. If stereotypes are, as they are often characterized to be, artificial, exaggerated, and reductive, such qualities must be judged against the background of (the mechanics of) representational duplication or imitation" (*Protestant Ethnic*, p. 54; emphasis in original). The first scholar to have unabashedly articulated this inevitability was Fredric Jameson, who famously claimed, "The relations between groups are always stereotypical insofar as they must always involve collective abstractions of the other group, no matter how sanitized, no matter how liberally censored and imbued with respect" (Jameson, "On Cultural Studies," in *The Identity in Question*, ed. John Rajchman [New York: Routledge, 1995], p. 274). Rey Chow finds Jameson's position here refreshing because it characterizes stereotyping as a matter of "the outer edge of one group brushing against that of an-other . . . an encounter between surfaces rather than interiors," and thus not something that can be remedied by simply suggesting that "everyone is entitled to her own stereo-types of herself, which others should simply adopt for general use" (*Protestant Ethnic*, p. 57). Put simply, when one understands that stereotyping is not simply a question of prejudiced and internalized duplicity, but rather of cross-cultural *duplicability*, we are forced to confront the very nature of representation itself: "Insofar as stereotypes are generalizations that seek to encapsulate reality in particular forms, they are not essentially different from the artificial or constructed makeup of all representations. Where stereo-types differ is in the obviousness and exaggeration of their reductive mode—the un-abashed nature of their mechanicity and repetitiveness" (p. 58). But, as Chow's arguments indicate, this difference should make stereotypes more interesting in cross-cultural studies rather than less. The real potential and danger in stereotypes, in other words, is that they openly straddle the realms of formula and originality, when, as Chow argues, "for reasons of propriety, they ought to be kept separate" (ibid.).

82. *P*, p. 8.

83. *P*, p. 171.

84. For a fascinating discussion of the philosophical and cultural effects of the signature, see Loren Glass, *Literary Celebrity in the Modern United States, 1880–1980* (New York: NYU Press, 2004), p. 42; and Jacques Derrida, "Signature Event Context," in his *Limited Inc.* (Evanston, IL: Northwestern University Press, 1988), pp. 1–24.

Chapter 7: *Technê*-Zen and the Spiritual Quality of Global Capitalism

1. Robert Pirsig, *Zen and the Art of Motorcycle Maintenance* (New York, 2005); hereafter cited as *ZMM* (in the quotations that follow in this chapter, all italicized words in *ZMM* are in the original unless otherwise indicated). A number of scholars have identified 1973–1974 as a pivotal moment in a worldwide transition to more network-saturated and informational modes of capitalism. See, for example, Manuel Castells, *The Rise of Network Society, Second Edition* (Malden, MA: John Wiley & Sons Ltd., 2010), p. 18; Frederic Jameson, *Postmodernism, or, The Cultural Logic of Late Capitalism* (Durham, NC: Duke University Press, 1991), p. xx; David Harvey, *The Condition of Postmodernity* (Malden, MA: Wiley-Blackwell, 1990), p. 189; Edward W. Soja, *Postmodern Geographies: The Reassertion of Space in Critical Social Theory* (New York: Verso, 1989), p. 160; and Luc Boltanski and Eve Chiapello, *The New Spirit of Capitalism*, trans. Gregory Elliott (New York: Verso, 2005), pp. 184–185.

2. W. T. Lhamon, Jr., "A Fine Fiction," review of *ZMM* in *New Republic* (June 29, 1974), p. 25.

3. "The book is inspired. . . . A detailed technical treatise on the tools, on the routines, on the metaphysics of a specialized skill; the legend of a great hunt after identity, after the salvation of mind and soul out of obsession, the hunter being hunted; a fiction repeatedly

interrupted by, enmeshed with, a lengthy meditation on the ironic and tragic singularities of American man—the analogies with *Moby-Dick* are patent. Robert Pirsig invites the prodigious comparison" (George Steiner, "Uneasy Rider," review of *ZMM* in *New Yorker* [April 15, 1974], p. 150).

4. Quoted in Pirsig, "Introduction to the Twenty-fifth Anniversary Edition," *ZMM*, p. xi.

5. Morris Dickstein, *Gates of Eden: American Culture in the Sixties* (New York: Basic Books, 1977), pp. 274–275. Ed Zuckerman similarly noted, *"Zen and the Art of Motorcycle Maintenance* is a calculated rebuttal of the anti-technological bias . . . that . . . peaked during the 1960s, when anti-technologism became a tenet of the counter-culture" (Ed Zuckerman, "Zen and the Art of Sailboat Maintenance: At Sea with Robert Pirsig," *Mother Jones Magazine* 2 [May 1977], p. 58).

6. Theodore Roszak, *The Making of a Counter Culture: Reflections on the Technocratic Society and Its Youthful Opposition* (Berkeley: University of California Press, 1968), p. 4; hereafter cited as *MCC*.

7. See Jacques Ellul, *The Technological Society* (New York: Vintage Books, 1964), pp. 3–11.

8. Herbert Marcuse, *One-Dimensional Man: Studies in the Ideology of Advanced Industrial Society* (Boston: Beacon Press, 1964), p. 22.

9. Lewis Mumford, *The Myth of the Machine* (New York: Harcourt, 1967), p. 194.

10. Van Meter Ames, "Current Western Interest in Zen," *Philosophy East and West* 10 (April–July 1960), p. 25. For contemporary 1960s accounts of the "Zen boom," see Aishin Imeada, *Japanese Zen: Volume 14 of Bulletin of the International Society for Educational Information* (Charlottesville, VA: University of Virginia Press, 1965), pp. 6–9; Philip Kapleau, "Report from a Zen Monastery, 'All Is One, One Is None, None Is All,'" *New York Times* (March 6, 1966), p. SM114; Paul Wienpahl, *The Matter of Zen: A Brief Account of Zazen* (New York: NYU Press, 1964), p. 100; International Institute for the Study of Religions, "Reminiscences of Religion in Postwar Japan," *Contemporary Religions in Japan* 7.3 (September 1966), p. 265; Horace Neill McFarland, *The Rush Hour of the Gods: A Study of New Religious Movements in Japan* (New York: Macmillan & Co., 1967), p. 29; and Heinrich Dumoulin, *A History of Zen Buddhism* (New York: Beacon Press, 1969), p. v. For more recent accounts, see Kenneth Kraft, *Zen, Tradition and Transition* (New York: Grove Press, 1994), p. 199; Peter N. Gregory, "Describing the Elephant," *Religion and American Culture* 11.2 (Summer 2001), p. 236; Charles S. Prebish, *Westward Dharma: Buddhism beyond Asia* (Berkeley: University of California Press, 2002), p. 110; Richard Hughes Seager, *Buddhism in America* (New York: Columbia University Press, 2000), p. 40.

11. Ames, "Current Western Interest," p. 25.

12. Stephen Mahoney, "The Prevalence of Zen," *Nation* (November 1, 1958), pp. 311–315.

13. The contributions of these and many other Buddhists during the 1970s are mapped out by Seager, *Buddhism in America*, pp. 249–265. See also Philip Kapleau, *Zen: Dawn in the West* (Norwell, MA: Anchor Press, 1979), p. 109; Chögyam Trungpa, *The Collected Works of Chögyam Trungpa*, 8 vols. (Boston: Shambhala, 2004), 8:224–226; and Thich Nhat Hanh, *Zen Keys* (New York: Harmony, 1974), especially the chapter "Spirituality versus Technology," pp. 160–163. It may also be worth pointing out that Charles Reich's antitechnocratic volume *The Greening of America* (New York: Bantam Books, 1970) never even mentions Eastern mysticism and yet was frequently characterized as advocating a Zen approach. See reviews of *The Greening of America* by Reich, *Life Magazine* (December 4, 1970), p. 10, and Philip Nobile, *The Con III Controversy: The Critics Look at "The Greening of America"* (New York: Pocket Books, 1971), pp. 55, 63, 81.

14. Charles S. Prebish, *American Buddhism* (North Scituate, MA: Duxbury Press, 1979), p. 47.

15. Theodore Roszak, *From Satori to Silicon Valley: San Francisco and the American Counterculture* (San Francisco: Don't Call It Frisco Press, 1986), pp. 15, 16.

16. The most impressive articulation of this continuity is Fred Turner, *From Counter-culture to Cyberculture: Stewart Brand, the Whole Earth Network, and the Rise of Digital*

Utopianism (Chicago: University of Chicago Press, 2006), which extends and amplifies a number of arguments begun by the later Roszak, Mark Taylor, Andrew Kirk, Mark Dery, Erik Davis, Thomas Streeter, and others. As Turner argues, it was not just that the counterculture was heterogeneous enough to encompass a certain technophilic segment. What the "New Communalists" of the 1960s were appropriating from the architects of cold war technocracy (systems thinking, cybernetics, and various other forms of military-industrial computationalism) was an already-institutionalized-yet-fundamentally-new form of networking and collaborative technology. The counterculture, in other words, was less of a break with cold war research (at least those forms developed at the Rad Labs at MIT and the Macy Conferences on cybernetics) than it was an adaptation of some of its most central and transformative ideologies. Alan Liu, for example, in his volume *The Laws of Cool*, argues, the "counterculture—precisely because it was from the first an uncanny incorporation of both technological rationality and its discontents—took root *within* corporate culture to prepare the ground for the next, 'revolutionary' industrial paradigm." Alan Liu, *The Laws of Cool: Knowledge Work and the Culture of Information* (Chicago: University of Chicago Press, 2004), p. 137. See also Mark Taylor, *The Moment of Complexity: Emerging Network Culture* (Chicago: University of Chicago Press, 2001); Andrew Kirk, "Machines of Loving Grace: Alternative Technology, Environment, and the Counterculture," *Imagine Nation: The American Counterculture of the 1960s and 1970s*, ed. Peter Braunstein and Michael William Doyle (New York: Routledge, 2002), p. 373; Mark Dery, *Escape Velocity: Cyberculture at the End of the Century* (New York: Grove Press, 1997), p. 29; Erik Davis, *TechGnosis: Myth, Magic, and Mysticism in the Age of Information* (New York: Three Rivers Press, 2004), pp. 179–181; Thomas Streeter, *The Net Effect: Romanticism, Capitalism, and the Internet* (New York: NYU Press, 2011); Steven Levy, *Hackers: Heroes of the Computer Revolution* (New York: O'Reilly Media, 1994); Julie Stephen, *Anti-Disciplinary Protest: Sixties Radicalism and Postmodernism* (New York: Cambridge University Press, 1998), pp. 73–95; and Richard Barbrook and Andy Cameron, "The Californian Ideology," *Alamut: Bastion of Peace and Information*, http://www.alamut.com/subj/ideologies/pessimism/califIdeo_I.html.

17. Alan W. Watts, *The Way of Zen* (New York: Pantheon, 1957), pp. ix, 49. Watts never actually cites Norbert Wiener in *The Way of Zen*, but there are a number of passages in it that were lifted, sometimes word for word, from Wiener's *Cybernetics*. Compare, for example, Watt's description of the "feedback" process of a home thermostat (Watts, *Way of Zen*, p. 136) to the description of the same process in Norbert Wiener, *Cybernetics, or Control and Communication in the Animal and the Machine* (Cambridge, MA: MIT Press, [1948] 1965), p. 115.

18. For definitions of computationalism, see David Golumbia, *The Cultural Logic of Computation* (Cambridge, MA: Harvard University Press, 2009), p. 7, and Jaron Lanier, *You Are Not a Gadget: A Manifesto* (New York: Knopf, 2010), p. 153.

19. Clips and other media from this chapter can be viewed on my personal website at rjohnwilliams.wordpress.com/.

20. Beginning in the 1950s, many writers were already denouncing the burgeoning influence of computationalist "grids" in American culture (in everything from housing plans to military-industrial research, from corporate organization to advertising). Take, for example, the illustrations of the new "grids" of depth psychology techniques in advertising, designed to induce "new patterns of mass buying." See *Life Magazine* (July 21, 1957), p. 84; and Vance Packard, *The Hidden Persuaders* (New York: David Mckay Co., 1957). Similar critiques emerged in William Whyte's 1956 study of the grid-like bureaucratization of American culture in *The Organization Man* (New York: Simon and Schuster, 1956); C. Wright Mills's lament in *The Power Elite* (New York: Oxford University Press, 1956), that, in America, "a vast rural continent has been turned into a great industrial grid," p. 99; and in Malvina Reynolds's 1962 song "Little Boxes," which satirized the banal, grid-like patterns of postwar suburban housing tracts and life plans. Indeed, by the time Watts arrived on the scene with his critique of *māyā* in the early 1960s, many Americans were

already suspicious that the military-industrial complex had begun to rely too heavily on what Phillip F. Schewe has called the "gridness of the grid" (Phillip F. Schewe, *The Grid: A Journey Through the Heart of Our Electrified World* [Washington, DC: Joseph Henry Press, 2007], p. 5).

21. Wiener, *Cybernetics*, p. 5.

22. Freeman Dyson has explained the development of cybernetics in precisely these terms: "To maximize the chance of destroying the airplane, the control system must take into account *the multitude of wiggly paths* that the airplane might follow" (Freeman Dyson, *The Scientist as Rebel* [New York: New York Review of Books, 2006], p. 257; emphasis added).

23. Wiener, *Cybernetics*, p. 26.

24. These meetings have been described by a number of scholars, persuasively I think, as the origins of what has come to be known as the computationalist theory of the mind (S. G. Shanker, David Golumbia), the advent of the posthuman (N. Katherine Hayles), and the generative origins of the Internet (David Mindell and others). Shanker actually sees Wiener's cybernetics as initially resistant to such full-scale computationalism, but notes that it was rather quickly "co-opted by cognitive psychologists and neurophysiologists" (S. G. Shanker, "AI at the Crossroads," in *The Question of Artificial Intelligence*, ed. Brian P. Bloomfield [New York: Methuen, 1987], p. 32). Golumbia similarly credits Wiener with resisting full-blown computationalism, even as he set the stage for its eventual hegemony; see Golumbia, *Cultural Logic of Computation*, pp. 89–92. See also N. Katherine Hayles, *How We Became Posthuman: Virtual Bodies in Cybernetics, Literature, and Informatics* (Chicago: University of Chicago Press, 1999), pp. 50–112; David A. Mindell, *Between Human and Machine: Feedback, Control, and Computing before Cybernetics* (Baltimore, MD: Johns Hopkins University Press, 2002), p. 4; and Streeter, *Net Effect*, pp. 30–34.

25. Richard Brautigan, "All Watched Over by Machines of Loving Grace" (1967), *The Last Whole Earth Catalog*, ed. Stewart Brand (Menlo Park, CA: Portola Institute, 1971), p. 240. See Turner, *From Counterculture to Cyberculture*, pp. 38–39; and Levy, *Hackers*, pp. 176–177. Along with Gary Snyder, Brautigan shared an apartment in the mid-1950s with Zen poet Philip Whalen and was deeply involved in "Beat Zen." Edward Foster has argued that Brautigan's entire career was marked by a conscious effort to embody a "Zen vision," citing Brautigan's participation in a special event of the ninety-fourth annual Modern Language Association convention in 1979 on the topic of "Zen and Contemporary Poetry," with fellow panelists Snyder, Lucien Stark, and Whalen (Edward Halsey Foster, *Richard Brautigan* [Boston: Twayne, 1983], p. 24). Later works such as *Sombrero Fallout: A Japanese Novel* (1976) and *The Tokyo Montana Express* (1980) are perhaps the most direct articulations of Brautigan's Zen philosophy, but it would not be unreasonable to claim that all of his novels are consciously crafted celebrations of episodic, *koan*-like Zen discourse.

26. Gary Snyder, *Earth House Hold: Technical Notes and Queries to Fellow Dharma Revolutionaries* (New York: New Directions, 1969), pp. 4, 92.

27. On Fritjof Capra at Esalen, see Jeffrey J. Kripal, *Esalen: America and the Religion of No Religion* (Chicago: University of Chicago Press, 2007), pp. 302–307. David Kaiser's *How the Hippies Saved Physics: Science Counterculture, and the Quantum Revival* (New York: W. W. Norton & Company, 2011) offers a compelling account of the role of Eastern mysticism in the revival of quantum physics during the 1960s and 1970s, and particularly the role of the Fundamental Fysiks Group in San Francisco (of which Capra's book was an important offshoot); see the chapter titled (of course) "Zen and the Art of Textbook Publishing," pp. 149–165. On Gregory Bateson, see Walter Truett Anderson, *The Upstart Spring: Esalen and the American Awakening* (Reading, MA: Addison Wesley, 1983), pp. 319–320. Eric Davis, who in an excellent study on the commensurate discourses of technology and Gnostic mysticism, offers a brief summary of Bateson's ideas, and then comments, "if all this strikes you rather like cybernetic Zen, you have definitely been keeping your eye on the ball" (Davis, *TechGnosis*, p. 152); see also Joanna Macy, *Mutual*

Causality in Buddhism and General Systems Theory: The Dharma of Natural Systems (Albany, NY: SUNY Press, 1991), which posits specific connections between Zen and cybernetics. On Brand's Eastern mysticism, see John Brockman, *Digerati: Encounters with the Cyber Elite* (San Francisco: Hardwired, 1996), pp. 19–28.

28. As the Author's Note to *ZMM* states, "What follows is based on actual occurrences. Although much has been changed for rhetorical purposes, it must be regarded in its essence as fact" (p. viii). The next sentence of the Author's Note acts as a sort of disclaimer: "However, it should in no way be associated with that great body of factual information relating to orthodox Zen Buddhist practice. It's not very factual on motorcycles either" (p. viii). The key word here is "orthodox." Pirsig has quite a bit to say on Zen Buddhist practice, if not of the "orthodox" type. The final sentence, I think, is offered entirely tongue-in-cheek. As many a motorcycle and *ZMM* enthusiast will explain, the book is very factual on motorcycles.

29. This is yet another measure of how much *ZMM* is a self-consciously post-counterculturalist text; the motorcycle is not a bus. Pirsig had no patience for the Merry Pranksters.

30. Several scholars have identified the similarity of Pirsig's classic–romantic divide with C. P. Snow's characterization of *The Two Cultures* (New York: Cambridge University Press, 1959). However, as we shall see in the conclusion, F. S. C. Northrop's "epistemic correlate" in *The Meeting of East and West* (1946) was a more direct influence (Northrop was also a member of the Macy Conferences); see *ZMM*, p. 122.

31. The notion that schizophrenia was simply an anguished (but ultimately sane and therapeutic) response to a "mad" world gained psychiatric credibility in R. D. Laing's *The Divided Self* (1969), a notion dramatized vividly a few years earlier in Ken Kesey's *One Flew Over the Cuckoo's Nest* (1962).

32. The Greek name "Phaedrus" actually means "bright," "beaming," or "joyous." See James H. Nichols, Jr., translator, *Plato's Phaedrus* (Ithaca, NY: Cornell University Press), p. 35.

33. George Kimball Plochmann, *Richard McKeon: A Study* (Chicago: University of Chicago Press, 1990), p. 1. As Wayne Booth, one of McKeon's other famous students would recall, "for some of his students, the punches were destructive, and for some, like the angry Robert Pirsig who attacked McKeon as 'The Professor' in *Zen and the Art of Motorcycle Maintenance*, the destruction was felt as deliberate. My own view is that McKeon never intended to destroy the arguer, only the fallacious argument or reading. His profound probing did, however, produce some personal tragedies" (Wayne C. Booth, *The Essential Wayne Booth*, ed. Walter Jost [Chicago: University of Chicago Press, 2006], p. 342 n. 3).

34. The text in question is appropriately Plato's *Phaedrus*, which deals with questions of rhetoric, love, and the origins of written language.

35. John Poulakos, for instance, argues that Heidegger's notion of the "possible" is consistent with "Sophistical rhetoric." See "Rhetoric, the Sophists, and the Possible," *Communication Monographs* 51 (1984), pp. 215–226. Other scholars have argued, more persuasively I think, that Heidegger identified less with the Sophists than with other pre-Socratics. Victor J. Vitanza, for example, observes, "Heidegger in his deconstruction of Plato and Aristotle does not, in his own thinking, replace them with the Sophists. He could not because he associates the Sophists with the withdrawal of Being. If Heidegger identifies with anyone, it is a few so-called pre-Socratics but especially Socrates himself, who he says stood in the storm of the withdrawing of Being" (Victor J. Vitanza, *Negation, Subjectivity, and the History of Rhetoric* [Albany, NY: SUNY Press, 1997], p. 24. See also Jacques Derrida, "Jacques Derrida on Rhetoric and Composition: A Conversation," interview by Gary A. Olson, *Journal of Advanced Composition* 10 (Winter 1990), pp. 1–21; Stanley Fish, *Doing What Comes Naturally: Change, Rhetoric, and the Practice of Theory in Literary and Legal Studies* (Durham, NC: Duke University Press, 1989), pp. 479–481;

Richard Rorty, *Philosophy and the Mirror of Nature* (Princeton, NJ: Princeton University Press, 1979), pp. 155–164; Wayne C. Booth, *Rhetoric of Rhetoric: The Quest for Effective Communication* (Malden, MA: Blackwell, 2004), pp. 55–84; and Susan Jarratt, *Rereading the Sophists: Classical Rhetoric Reconfigured* (Carbondale, IL: Southern Illinois University Press, 1991). See Fish on Pirsig's phenomenological holism in "Fathers, Sons, and Motorcycles," *New York Times Online* (June 14, 2009), opinionator.blogs.nytimes.com/2009/06/14/fathers-sons-and-motorcycles/.

36. For an interesting reading of Pirsig's Metaphysics of Quality as a synthetic "field model," see Hayles, *The Cosmic Web: Scientific Field Models and Literary Strategies in the Twentieth Century* (Ithaca, NY: Cornell University Press, 1984), pp. 63–84.

37. Richard H. Rodino, "Irony and Earnestness in Robert Pirsig's *Zen and the Art of Motorcycle Maintenance*," *Critique: Studies in Modern Fiction* 22 (1980), pp. 21–31; and "The Matrix of Journeys in *Zen and the Art of Motorcycle Maintenance*," *Journal of Narrative Technique* 11 (1981), pp. 53–63.

38. Ronald L. DiSanto and Thomas J. Steele, *Guidebook to "Zen and the Art of Motorcycle Maintenance"* (New York: William Morrow and Company, Inc., 1990), p. 28.

39. Tony Wagner notes the narrator's lack of modesty and compassion, as well as his unapologetic commitment to isolation. See Tony Wagner, "A Second Look at Motorcycle Maintenance and Zen," review of *ZMM* in *Humanist* 36 (September–October 1976), pp. 45–46.

40. Motorcycle enthusiasts generally love the book, and hundreds of Pirsig fans retrace his motorcycle route on their own motorcycles every year, aided now by downloadable GPS coordinates of Pirsig's major stopping points. Journalist Mark Richardson has recorded one such pilgrimage in *Zen and Now: On the Trail of Robert Pirsig and the Art of Motorcycle Maintenance* (New York: Random House, 2008). Pirsig's follow-up book, *Lila*, has not been nearly as successful and is generally appreciated by only the most devoted fans. Discussions of both *ZMM* and *Lila* can be found at www.moq.org (MOQ is an abbreviation for Metaphysics of Quality). See also *Lila's Child: An Inquiry into Quality*, compiled by Dan Glover (Bloomington, IN: AuthorHouse Publishing, 2003). Another fan site, www.robertpirsig.org, is run by Anthony McWatt, who has actually earned an entire PhD in Pirsig's Metaphysics of Quality from the University of Liverpool.

41. There is a long tradition in English-language biblical discourse of writing (and pronouncing) the word "atonement" as a hyphenated three-word compound, so as to emphasize the unificatory qualities of Christ's expiation (wherein we become "at-one" with god); see Bill Bryson, *Mother Tongue* (New York: Perennial), p. 97. The god in this case is different, but the fantasy of spiritualized unity at its core is similar.

42. See also Michael Hardt and Antonio Negri, *Empire* (Cambridge, MA: Harvard University Press, 1999), pp. 280–303; Boltanski and Chiapello, *New Spirit of Capitalism*; and Alan Liu, *The Laws of Cool: Knowledge Work and the Culture of Information* (Chicago: University of Chicago Press, 2004), hereafter cited as *LC*.

43. John Micklethwait and Adrian Wooldridge, *The Witch Doctors: Making Sense of the Management Gurus* (New York: Times Books, 1996), p. 18.

44. See *The Information Technology Revolution*, ed. Tom Forester (Cambridge, MA: MIT Press, 1986), where the United States versus Japan is a dominant theme of the essays.

45. Rafael Aguayo, *Dr. Deming: The American Who Taught the Japanese about Quality* (New York: Simon and Schuster, 1990). He is widely known as the "founding father of the quality movement" (John Beckford, *Quality: A Critical Introduction* [New York: Routledge, 1998], p. 65).

46. See Aguayo, *Dr. Deming*, p. 6.

47. The influence of the Bell Telephone Laboratories on the development of cybernetics and other systems theories has been well documented. See Wiener, *Cybernetics*, pp. 4, 10, 60, 67; Mindell, *Between Human and Machine*, pp. 105–137; and Daniel Bell, *The Social Sciences since the Second World War* (New Brunswick, NJ: Transaction Books, 1981), p. 31.

Deming also corresponded frequently with John von Neumann; see John von Neumann, *John Von Neumann: Selected Letters*, ed. Miklós Rédei (Providence, RI: American Mathematical Society, 2005), pp. 95–96. Deming's theories were similarly influential in the development of Stafford Beer's "organizational cybernetics" (Beckford, *Quality*, p. 171); see Art Kleiner, *The Age of Heretics: A History of the Radical Thinkers Who Reinvented Corporate Management* (San Francisco: Jossey Bass, 2008), p. 288.

48. See W. Edwards Deming, *Out of the Crisis* (Cambridge, MA: MIT Center for Advanced Engineering Study, 1982), pp. 167–247, and *The New Economics for Industry, Government, Education* (Cambridge, MA: MIT Center for Advanced Engineering Study, 1994), p. 139; Michael E. Milakovich, *Improving Service Quality in the Global Economy: Achieving High Performance in Public and Private Sectors* (Boca Raton, FL: Auerbach Publications, 2006), p. 53; Aguayo, *Dr. Deming*, pp. 19–50; and Micklethwait and Wooldridge, *Witch Doctors*, pp. 237–257. See also the report issued by members of the MIT International Motor Vehicle Program: *The Machine That Changed the World: The Story of Lean Production*, ed. James P. Womack, Daniel T. Jones, and Daniel Roos (New York: HarperPerennial, 1990), and Kleiner, *The Age of Heretics*, pp. 288–297.

49. Nor has it been lost on Pirsig's fans; see Glover, *Lila's Child*, p. 419. See also John Douglas, review of *ZMM* in *Academy of Management Review* 1 (July 1976), pp. 134–135.

50. See Micklethwait and Wooldridge, *Witch Doctors*, p. 16.

51. See Peter F. Drucker, "Management's New Paradigms," *Alfred P. Sloan: Critical Evaluations in Business and Management*, ed. John C. Wood and Michael C. Wood, 2 vols. (New York: Routledge, 2003), 2:275.

52. Douglas McGregor, *The Human Side of Enterprise* (New York: McGraw Hill, 1960), p. 48.

53. See Kleiner, *The Age of Heretics*, pp. 19–84. Perhaps not surprisingly, McGregor's insights were almost immediately incorporated into a grid structure; see Robert R. Blake and Jane Mouton, *Corporate Excellence through Grid Organization Development: A Systems Approach* (Houston, TX: Gulf Publishing, 1968), pp. 14–16.

54. Brian A. Victoria, *Zen at War* (Lanham, MD: Rowman & Littlefield, 2006), p. 182; hereafter cited as *Z*.

55. Masahiro Mori's study was actually published in two volumes: *Bukkyō nyūmon* (Tokyo: Kosei Shuppansha, 1974) and *Shingan* (Tokyo: Kosei Shuppansha, 1976); the English translation combined the two volumes as Masahiro Mori, *The Buddha in the Robot*, translated by Charles S. Terry (Tokyo: Kosei Publishing Co., 1981).

56. Mori, *The Buddha in the Robot*, p. 51. Regarding his encounter with Norbert Wiener's *Cybernetics* as a young student, Mori writes, "My own encounter with [Wiener's book] determined the future course of my life's work. Owing to its influence, I shifted to [the study of] automated control. Presently I became a member of the Society of Automatic control" (p. 17). Mori also offers precisely the same house-and-thermostat illustration that Alan Watts borrowed from Wiener (see note 17 above) to describe what he sees as expressly Zen-like cybernetic systems (p. 168).

57. Ibid., p. 57. Mori has become famous in the United States more recently for an earlier article he wrote in 1970 on what he called the "uncanny valley" (that "place" or moment, in the spectrum of robot anthropomorphic appearance, when the robot suddenly becomes too closely human and the response is—instead of empathy—revulsion or fear). I would suggest, however, that this recent, nearly exclusive attention to Mori's "uncanny valley" notion—an academic argument that when it was published hardly entered the critical discourse at all in either Japan or the United States—radically skews the historical picture of Mori's influence in Japan, which, for most of his career was in the area of industrial automation rather than in the more specialized field of robotic anthropomorphism. For more on Mori's "uncanny valley" argument, see Lydia H. Liu, *The Freudian Robot: Digital Media and the Future of the Unconscious* (Chicago: University of Chicago Press, 2010), pp. 224–227; and Minsoo Kang, *Sublime Dreams of Living Machines: The*

Automaton in the European Imagination (Cambridge, MA: Harvard University Press, 2011), pp. 47–49.

58. Mori's chapter on "Quality not Quantity," pp. 78–88. For his description of the relative material forms of cosmic flux in the human body, see pp. 26–27; in the robot, see pp. 28–29. Rob Wilson nicely summarizes Mori's sense of Buddhist flux in the context of a "cyborgian future" for the "Asia/Pacific" region of transnational production; see *Reimagining the American Pacific: From South Pacific to Bamboo Ridge and Beyond* (Durham, NC: Duke University Press, 2000), pp. 14–15.

59. Mori, *The Buddha in the Robot*, p. 13.

60. For more on the Mukta Institute, see Frederick L. Schodt, *Inside the Robot Kingdom: Japan Mechatronics, and the Coming Robotopia* (New York: Kodansha International/USA, 1988), pp. 206–211; and Tessa Morris-Suzuki, "Fuzzy Logic: Science, Technology and Postmodernity in Japan," in *Japanese Encounters with Postmodernity*, ed. Yoshio Sugimoto and Johan P. Arnason (New York: Routledge, 2010), p. 122.

61. Schodt, *Inside the Robot Kingdom*, p. 209.

62. Ibid., p. 209; for more on Honda's transformation in the 1970s see James Brian Quinn, *Intelligent Enterprise: A Knowledge and Service Based Paradigm for Industry* (New York: Free Press, 1992), pp. 56–58.

63. William Ouchi, *Theory Z: How American Business Can Meet the Japanese Challenge* (New York: Addison Wesley, 1981), pp. 83, 82. See also Gregory A. Daneke, *Systemic Choices: Nonlinear Dynamics and Practical Management* (Ann Arbor, MI: University of Michigan Press, 2002), p. 135.

64. Richard Pascale and Anthony Athos, *The Art of Japanese Management: Applications for American Executives* (New York: Simon and Schuster, 1981), pp. 98, 99. Hajime Karatsu, one of Japan's "quality control gurus," would later echo these statements when invited by the Pentagon to speak to a group of officials in the United States on Japan's "secrets" for its new technological successes: "Engineers in the United States have a worldview colored by dualism, and they tend to see things in terms of 'black' or 'white,' 'yes' or 'no.' But industrial production is a battle with error; if a design differs from its specifications it won't work the way it should. On the [factory] floor, therefore, the 'gray area' is very important. There is no single truth, but many" (qtd in Schodt, *Inside the Robot Kingdom*, p. 206).

65. Pascale and Athos, *The Art of Japanese Management*, p. 112. See also Julian Gresser, *Partners in Prosperity: Strategic Industries for the United States and Japan* (New York: McGraw-Hill, 1984).

66. See Micklethwait and Wooldridge, *Witch Doctors*, pp. 6, 80–86; Sandford Borins, "Corporate Prophets," *Globe and Mail* (April 12, 1991), p. A16; Miles Maguire, "Fathoming Deming's Ideas on Quality," *Washington Times* (March 14, 1991), p. C2; Michael McKinney "Employing New Thinking in Turbulent Times," *Leading Blog* (October 8, 2008), www.leadershipnow.com/leadingblog/2008/10/employing_new_thinking_in_turb.html; and Thomas Frank, *The Conquest of Cool: Business Culture, Counterculture, and the Rise of Hip Consumerism* (Chicago: University of Chicago Press, 1997), p. 54.

67. Thomas Peters and Robert Waterman, *In Search of Excellence: Lessons from America's Best-Run Companies* (New York: Harper and Row, 1982), pp. 37–38. For a trenchant analysis of this passage in Peters and Waterman's book, see Hugh Willmot, "Strength Is Ignorance; Slavery Is Freedom: Managing Culture in Modern Organizations," *Journal of Management Studies* 30 (July 1993), p. 544.

68. Thomas Peters and Nancy Austin, *A Passion for Excellence: The Leadership Difference* (New York: Random House, 1985), p. 130.

69. Jenny Turner, "Far from the Last Tycoon," *Guardian* (July 19, 1994), p. T14.

70. Micklethwait and Wooldridge, *Witch Doctors*, p. 63. Drucker has also been dubbed the "dean of U.S. management theory" (*LC*, p. 17).

71. See Magnus Ramage and Karen Shipp, *Systems Thinkers* (London: Springer, 2009), p. 120.

72. Quoted in Gay Hendricks and Kate Ludeman, "How to Be a Corporate Mystic," *Yoga Journal* (December 1997), p. 76.

73. See Jeffrey S. Young and William L. Simon, *iCon: Steve Jobs, the Greatest Second Act in the History of Business* (Hoboken, NJ: Wiley, 2005), pp. 31–33; Walter Isaacson, *Steve Jobs* (New York: Simon & Schuster, 2011), pp. 34–36, 48–50, 128, 262, 564, and 570.

74. I am retaining the traditional spelling of *Yijing* here both for homonymic effect and because it is how Jobs himself would have encountered the title of the text in the 1970s. Regarding the lawsuit, Apple paid $100 million to Creative in a settlement over allegations that it stole patents for its mp3 player design. See "Apple and Creative Announce Broad Settlement Ending Legal Disputes between the Companies," www.apple.com/pr/library /2006/aug/23settlement.html. For more on Jobs's "Zen aesthetic," see Carmine Gallo, *The Presentation Secrets of Steve Jobs* (New York: McGraw Hill, 2010), pp. 87–104; Garr Reynolds, *Presentation Zen* (Berkeley: New Riders, 2008), pp. 171–118, 217–219, 267–271; and *Presentation Zen Design* (Berkeley: New Riders, 2010), pp. 22–23, 64.

75. Caleb Melby, *The Zen of Steve Jobs* (Hoboken, NJ: John Wiley & Sons, 2012).

76. Michael Green, *Zen and the Art of the Macintosh: Discoveries on the Path to Computer Enlightenment* (San Francisco: Running Press, 1986), p. 140.

77. See Karen Southwick, *Everyone Else Must Fail: The Unvarnished Truth about Oracle and Larry Ellison* (New York: Crown Business, 2003), and Davis, *The Visionary State* (San Francisco: Chronicle Books, 2006), pp. 172–173.

78. ZENworks, press release, 1998; it also touted "Desktop Enlightenment." Novell's official statement on ZENworks compatibility with Microsoft speaks of "paravirtualization, or enlightenment" by way of "using full virtualization" (Microsoft and Novell Corporations, "Novell and Microsoft: Building Bridges" [October 2008], p. 3, www.moreinterop.com/ download.aspx?filePath=/upload/MediaFiles/Files/PDFs/Collaboration%20Roadmap %20White%20Paper %20English.pdf). See also Elizabeth Montalbano, "Novell, Microsoft Provide Virtualization Roadmap," *InfoWorld* (February 12, 2007), www.infoworld.com /t/platforms/novell-microsoft-provide -virtualization-roadmap-488. For more on "ZENworks Enlightenment," see Mark Schouls, "ZENworks Enlightenment," *Everything Zenworks* (March 11, 2005), drzenworks.blogspot.com.

79. For these and other examples see Noah Shachtman, "Enlightenment Engineers," *Wired* 21.7 (July 2013), pp. 120–128; the entire special issue on "Buddhism and Technology" in *Tricycle: The Buddhist Review* 22.4 (Summer 2013), especially pp. 54–67; and Ajit V. Jaokar, *Meditation in the Age of Facebook and Twitter: From Shamanism to Transhumanism* (London: futuretext, 2012); see also the website http://www.buddhistgeeks.com/ which hosts annual seminars in major cities throughout the United States, celebrating the virtues of *technê*-Zen.

80. See "Valley Zen: Jim Barnett, Founder Chairman CEO of Turn, Inc., on Zen and Simplicity," http://www.youtube.com/watch?v=GzSq_xhVWHw.

81. "Valley Zen: Bill Draper, Draper Richards," http://www.youtube.com/watch ?v=hpWFcWRvcHE.

82. www.drue.net/corporate-art-commissions.htm. Some of Kataoka's art was even launched into space as part of Richard Garriot's $30 million "space tourism." See Valley Zen Blog, "Drue's Art in the First In-Space Art Exhibit on Richard Garriott's Space Mission," www.valleyzen.com/2008/10/17/drues-art-in-the-first-in-space-art-exhibit-on -richard-garriotts-space-mission/.

83. Dave Shea and Molly E. Holzschlag, *The Zen of CSS Design: Visual Enlightenment for the Web* (Berkeley: Peachpit Press, 2005), p. 2; hereafter cited as *CSS*.

84. "CSS Zen Garden," www.csszengarden.com; emphasis in original. The irony is that behind the scenes at CSS Zen Garden, such CSS coding is not always as straightforward as it seems, as designers often have to develop difficult work-around code lines in order to

have their designs work in tandem with the prescribed HTML (I am indebted to Jeremy Douglass for this insight).

85. For more on the supposed commensurability of Internet technologies and Zen Buddhism, see Philip Toshio Sudo, *Zen Computer* (New York: Simon and Schuster, 2001), and Charles S. Prebish, *Luminous Passage: The Practice and Study of Buddhism in America* (Berkeley: University of California Press, 1999), pp. 203–232.

86. See J. P. Telotte, *The Mouse Machine* (Chicago: University of Illinois Press, 2008), p. 141; hereafter cited as *MM*.

87. See Peter Sorensen, "Tronic Imagery," *Cinefex* 8 (1982), pp. 4–35; and *MM*, pp. 150–151. In an online interview, Bernie Macbird, cowriter of *Tron* (1982), remembers drawing inspiration for the film from Homebrew Computer Club figures like Ted Nelson (author of *Computer Lib* [1974], and director of the original hyperlink project, appropriately named *Xanadu*), Alan Kay, the Stanford AI project, and Xeroc PARC; see http://www .mediamikes.com/2011/09/interview-with-trons-bonnie-macbird/.

88. See http://zenpeacemakers.org/2010/12/video-jeff-bridges-on-zen-influence-in-tron/. Dozens of reviews have drawn attention to the Zen element in *Tron Legacy* (2012). See, for example, http://www.denofgeek.com/movies/719654/the_james_clayton_column_tron _philosophy.html. Bernie Glassman and Jeff Bridges later co-wrote a book reflecting on some of these themes; see *The Dude and the Zen Master* (New York: Blue Rider Press, 2013).

89. Slavoj Žižek, "The Prospects of Radical Politics Today," *The Universal Exception*, ed. Rex Butler and Scott Stephens (New York: Continuum, 2006), p. 253. Less controversially, David Weir's *American Orient: Imagining the East from the Colonial Era through the Twentieth Century* (Boston: University of Massachusetts Press, 2011) offers a fine summary of the overlapping tendencies in American Buddhism and postmodern consumerism, arguing that Zen has been streamlined for the "mantra of the market," and that "not much is left" of Eastern philosophy in American culture "as a political, moral, or aesthetic alternative" (p. 256). However, as I have been arguing in this chapter, it was precisely that alterity that (from the very beginning) allowed Zen Buddhism to become so central to global capitalism.

90. Slavoj Žižek, "Forward to the Second Edition," *For They Know Not What They Do: Enjoyment as a Political Factor* (New York: Verso, 2008), p. xliii.

91. In the anti-Festschrift that is *The Truth of Žižek*, co-editor Paul Bowman cites Žižek's claim on the new "Taoist ethic" and then argues, we have "merely to ask is Žižek's argument *correct*? At times it seems persuasive, but on what model of causality is it premised, and is this model or paradigm *sound*? Does it *think* and *analyze* everything, or does it rely on any unthought or even obscurantist supplements?" (Paul Bowman, "The Tao of Žižek," *The Truth of Žižek*, ed. Paul Bowman and Richard Stamp [New York: Continuum, 2007], p. 35; emphasis in original). The implication here that Žižek's inability to "think and analyze everything" (everything!) somehow already discounts the truth of his assertion seems a bit unfair. In fact, we have merely to notice that Bowman's subsequent argument attacks not the accuracy of Žižek's claim but rather the discursive coherence of Žižek's rhetorical strategy—a much easier target to be sure. In fact, Bowman seems to have recently backtracked from the question of whether or not Žižek is "correct." In the republication of his essay Bowman's sentence reads, this time, we have "merely to ask: is Žižek's argument *coherent*?" (Paul Bowman, *Deconstructing Popular Culture* [New York: Palgrave Macmillan, 2008], p. 138; emphasis in original). In fairness to Bowman, however, one could point out that Žižek's critique of Zen is somewhat shallow, relying on the strength of only a few texts. Also, as Ananda Abeysekara has argued, part of Žižek's incoherence stems from his puzzling (perhaps even quasi-Orientalist) insistence that Christianity offers a viable alternative to the Daoist spirit of postmodern capitalism, as though Christianity has not been similarly adaptive. See Ananda Abeysekara, *The Politics of Postsecular: Mourning Secular Futures* (New York: Columbia University Press, 2008),

p. 74; and William E. Connolly, *Capitalism and Christianity, American Style* (Durham, NC: Duke University Press, 2008).

92. It is worth pointing out that Pirsig didn't invent the phrase but was borrowing it from Eugen Herrigel, *Zen in the Art of Archery*, trans. R. F. C. Hull (New York: Pantheon, 1953), and D. T. Suzuki, "Zen and the Art of Tea I," *Zen and Japanese Culture* (Princeton, NJ: Princeton University Press, 1970), pp. 269–290. It is doubtful, however, that the phrase would have made such an impact on the language without Pirsig's contribution.

93. Joseph A. Grundfest, "Zen and the Art of Securities Regulation," *Journal of Applied Corporate Finance* 5 (Winter 1993), p. 5.

94. Bill Readings, *The University in Ruins* (Cambridge, MA: Harvard University Press, 1996), p. 14.

95. See, for example, *Engaged Buddhism in the West*, ed. Christopher S. Queen (Somerville, MA: Wisdom Publications, 2000), pp. 17–25; Derek Wall, *Babylon and Beyond: The Economics of Anti-Capitalist, Anti-Globalist, and Radical Green Movements* (London: Pluto Press, 2005), p. 191; and Simon P. James, *Zen Buddhism and Environmental Ethics* (Burlington, VT: Ashgate Publishing, 2004), p. 125.

96. The historian behind Stewart's archival brilliance is Adam Chodikoff, *The Daily Show*'s chief researcher. It's Chodikoff's impressive memory and ability to mine the media archive that allows the show, as it did recently on June 16, 2010, when President Barack Obama called for a long-term strategy in the search for alternative energies, to provide clips of Richard Nixon, Gerald Ford, Jimmy Carter, Ronald Reagan, George H. W. Bush, Bill Clinton, and George W. Bush calling for, in essence, the same plan (but with a decreasing ambition that is both startling and frightening).

Chapter 8: The Meeting of East and West

1. This account of the song is from the founder of the Hull House, Jane Addams's *Twenty Years at Hull-House: With Autobiographical Notes* (New York: Macmillan & Co., 1912), p. 377.

2. Frank Lloyd Wright, "The Art and Craft of the Machine" (1901), *The Essential Frank Lloyd Wright: Critical Writings on Architecture*, ed. Bruce Brooks Pfeiffer (Princeton: Princeton University Press, 2008), pp. 23–33; subsequent citations are to this edition hereafter cited as "ACM."

3. The English translation Wright would most likely have had access to was Victor Hugo, *Notre-Dame, Vol. I* (New York: George Routledge & Sons, 1891), p. 131; hereafter cited as *ND*.

4. *ND*, p. 242.

5. "ACM," p. 25; emphasis added. Wright would repeat this misreading, in dozens of settings, over several decades of his career; see, for example, Frank Lloyd Wright, *Frank Lloyd Wright: Collected Writings*, ed. Bruce Brooks Pfeiffer (New York: Rizzoli, 1994) (hereafter cited as *CW* followed by volume number), *CW1*, p. 152; *CW2*, pp. 42–47; *CW3*, pp. 56, 63, 236, 296; *CW4*, p. 287, pp. 335–337; *CW5*, pp. 46–47, 56, 158, 165–167, 204, 347.

6. See Bruce Brooks Pfeiffer's introduction to Wright's talk in Wright, *The Essential Frank Lloyd Wright*, p. 58.

7. Any comprehensive reading of *CW* will reveal how saturated this theme was in his discourse. See, for example, *CW1*, pp. 28, 58–72, 98, 107, 127, 194, 211–213, 215, 227, 230–231, 243, 257, 260, 264, 275, 282–283, 288–289, 292, 296–297, 304, 306, 309, 325–327, 330, 334, 337, 341, 345; *CW2*, pp. 23, 89, 98; *CW3*, pp. 19–20, 42, 57–58, 84, 115, 119, 124, 133, 142, 150, 168, 170, 190, 234, 334; *CW4*, pp. 29, 143, 326, 336; *CW5*, pp. 27, 48, 57, 61, 68, 89, 137, 153, 159, 235, 241, 256.

8. What I want to stress here is that these twin concerns—typically considered in stark isolation in Wright studies, almost as though they were the driving tenets of two entirely different architects—were, in Wright's mind, part of a single overarching aesthetic philosophy.

9. In addition to various references to the influence of Japanese art on Frank Lloyd Wright in hundreds of biographies and critical studies, three entire monographs have been devoted exclusively to the subject: Kevin Nute's *Frank Lloyd Wright and Japan* (New York: Van Nostrando Reinhold, 1993), hereafter cited as *FLWJ*, and Julia Meech's *Frank Lloyd Wright and the Art of Japan: The Architect's Other Passion* (New York: Japan Society and Harry N. Abrams, Inc., Publishers, 2001), hereafter cited as *FLWAJ*; *Frank Lloyd Wright's Fifty Views of Japan*, ed. Melanie Birk (San Francisco: Pomegranate Artbooks, 1996). Each of these is an impressive array of visual connections between the architect and the art of Japan, giving the lie to Wright's occasional claims to absolute originality in his work and ideas.

10. *FLWAJ*, p. 16.

11. *FLWAJ*, p. 30. Nute makes the most of Wright's debt to Fenollosa, describing him as "the missing link" in understanding Wright's aesthetic theories; see Kevin Nute, "Frank Lloyd Wright and Japanese Art: The Missing Link," *Architectural History* 34 (1991), pp. 224–230; and *FLWJ*, pp. 20–27.

12. *FLWJ*, p. 59.

13. Ibid., pp. 48–72.

14. For a facsimile of the volume, see *The House Beautiful: A Book Designed by Frank Lloyd Wright* (Petaluma, CA: Pomegranate Press, 2006). Wright specifically cites Okakura's *Book of Tea* in his understanding of interior space; see *CW5*, p. 127.

15. *FLWAJ*, pp. 35–37; Mary Jane Hamilton, *Frank Lloyd Wright and the Book Arts* (Madison, WI: University of Wisconsin-Madison Libraries, Inc., 1993), pp. 59–61; and Penny Fowler, *Frank Lloyd Wright: Graphic Artist* (San Francisco: Pomegranate Artbooks, 2002), pp. 17–20. For more on Wright's tendency to reproduce Japanese print forms in his photography, see Jack Quinan's stunning essay, "Wright the Photographer," in *Frank Lloyd Wright's Fifty Views of Japan*, ed. Melanie Birk (San Francisco: Pomegranate Artbooks, 1996), pp. 73–88.

16. Having seen Lewis Mumford's fondness for Asia-as-*technê* in chapter 6, one can conclude it was something of this quality in Wright's work that Mumford so admired (at least until World War II, when Wright would grow increasingly vocal about his fondness for fascism); see Lewis Mumford, *The Brown Decades: A Study of the Arts in America, 1865–1895* (New York: Harcourt, Brace and Company, 1931), p. 77; *Technics and Civilization* (New York: Harcourt, Inc., 1934), pp. 347–348; and *Art and Technics* (New York: Columbia University Press, 1952), pp. 126–127.

17. *CW1*, p. 122; Wright, *An Autobiography* (New York: Duell, Sloan and Pearce, 1943), p. 194. Wright would often repeat this idea in his talks with apprentices at Taliesin, noting, "when I saw that print and I saw the elimination of the insignificant and simplicity of vision, together with the sense of rhythm and the importance of design, I began to see nature in a totally different way," and that the Japanese Print has therefore "been of fundamental value in the development of what we call modern art" (quoted in *FLWAJ*, pp. 21, 23).

18. For further references to Hokusai's methods in Wright's writings, see *CW1*, pp. 104–105, 118–119; *CW5*, pp. 71–72, and Wright, *Autobiography*, pp. 206, 528.

19. On the mandala form in Wright's work, see Anthony Alofsin, *Frank Lloyd Wright: The Lost Years, 1910–1922, A Study of Influence* (Chicago: University of Chicago Press, 1993), pp. 212–220.

20. The presence of these mandala forms was one of the few overtly "Japanese" elements Wright worked into the Imperial Hotel, which ended up looking strikingly traditional (its axial layout seems almost straight out of the Beaux Arts) in its overall structure. For an analysis of how the mandala-style pattern dominated many of Wright's atrium-type structures, see Paul Laseau and James Tice, *Frank Lloyd Wright: Between Principles and Form* (New York: Van Nostrand Reinhold, 1992), pp. 117–137.

21. In a study of California's "spiritual landscape," Erik Davis points to a Mandala-shaped house ("influenced by Frank Lloyd Wright") designed by Roger Somers and which Alan Watts used as a library; see Erik Davis, *The Visionary State: A Journey through California's Spiritual Landscape* (San Francisco: Chronicle Books, 2006), pp. 157–159.

22. One should also mention here the implied influence of George Ivanovich Gurdjieff, whose "enneagram" mandala may have also exercised some influence on Wright, although, as Roger Friedland and Harold Zellman have compellingly shown, any such influence would have been refracted through Wright's own competitive, egocentric inclinations to guru status. See Roger Friedland and Harold Zellman, *The Fellowship: The Untold Story of Frank Lloyd Wright and the Taliesin Fellowship* (New York: Harper Perennial, 2006), chs. 21–22. Gurdjieff himself offers a fascinating adaptation of Asia-as-*technê* in portraying the body as a "machine" that must be transcended so as to access greater spiritual powers; see Erik Davis, *TechGnosis: Myth, Magic, and Mysticism in the Age of Information* (New York: Harmony Books, 2004), pp. 159–163.

23. A number of works have shown that the Taliesin fellowship was a veritable cult of Asia-as-*technê*. It was not unusual at Taliesin to work all morning, have a Japanese print party in the afternoon, and watch machine-themed films like René Clair's *À Nous la Liberté* (1931) or Chaplin's *Modern Times* (1936) in the evening. See *"At Taliesin": Newspaper Columns by Frank Lloyd Wright and the Taliesin Fellowship, 1934–1937*, ed. Randolph C. Henning (Carbondale, IL: Southern Illinois University Press, 1992), pp. 70, 111, 164, 210.

24. Published originally in *Architectural Forum* (January 1951); see *CW5*, p. 29.

25. While it might appear, at first, that Gehry's architectural spectacles are too "busy" and engaged in global capital branding to fall under the rubric of a contemplative, austere "Zen," there are nonetheless various characterizations of it as such (and as we saw in the last chapter, such an assimilation should not really surprise us); see Jacquelyn Baas and Mary Jane Jacob, *Buddha Mind in Contemporary Art* (Berkeley: University of California Press, 2004), pp. 224–226. For a compelling alternate take, see Hal Foster, *Design and Crime (And Other Diatribes)* (New York: Verso, 2002), pp. 35, 41.

26. See Paul Werner, *Museum Inc: Inside the Global Art World* (Chicago: Prickly Paradigm Press, 2005), p. 31.

27. See especially Werner, *Museum Inc.*, pp. 1–45; and Jed Perl, *Eyewitness: Reports from an Art World in Crisis* (New York: Basic Books, 2000), p. 28. The "Art of the Motorcycle" exhibit made the rounds at the various Guggenheim museums between 1998 and 2001 (including New York, Bilbao, and Las Vegas), as well as a time at the Field Museum of Natural History in Chicago. For the most complete catalog, see *The Art of the Motorcycle* (Las Vegas, NV: Guggenheim Las Vegas, 2001).

28. See Thomas Krens, "Preface" to *The Art of the Motorcycle*, p. 15.

29. Frank Lloyd Wright, "Prefabrication," *House and Home* (April 1958), also in *CW5*, p. 236; emphasis in original.

30. F. S. C. Northrop, *The Meeting of East and West: An Inquiry concerning World Understanding* (New York: Macmillan & Co., 1946); hereafter cited as *MEW*.

31. *Arrive without Travelling*, a video recording of Robert Pirsig's visit to Liverpool during July 2005.

32. See Ordway Tead's review in *Saturday Review of Literature*, as well as glowing reviews in the *New York Times Book Review*, the *Chicago Sun Book Week*, and the *New York Sun*; Pitirim A. Sorokin of the Department of Social Relations at Harvard University noted, "I am making the book a required reading for graduate and undergraduate students in my courses" (cited in promotional material for *MEW*, Sterling Memorial Library, Yale University, Northrop Archives, MS 627, box 43, folder 975). Some of the book's highest praise came in *Time* magazine, which noted, "What he has to say embraces so many facts with such assurance, and is so radical and so constructive, that his book make well influence history, as he seriously proposes that it should" (*Time* [August 12, 1946]). The

book also received wide international praise, with reviews in *La Nacion* (Buenos Aires) and *El Comercio* (Lima).

33. No lengthy biography of Northrop has been written, but details of his life can be found in *Presidential Addresses of the American Philosophical Association, 1951–1960*, ed. Richard T. Hull (New York: Prometheus Books, 2006), pp. 123–126; *Doctor Henry Skilton and His Descendants*, ed. John Davis Skilton (New Haven, CT: Press of S. Z. Field, 1921), p. 372; Lorena Barboza, "Forgotten Philosopher," *Kansas State Collegian* (March 6, 2002); Dagobert D. Runes, "F. S. C. Northrop," *Who's Who in Philosophy* (New York: Philosophical Library, 1942), p. 195.

34. F. S. C. Northrop, "Body and Mind," originally published as part of the proceedings of the *Symposium on Mind and Body of the Association for Research in Nervous and Mental Disease* 11 (December 1938), pp. 99–104, and reprinted in F. S. C. Northrop, *The Logic of the Sciences and the Humanities* (New York: Macmillan & Co., 1947), p. 195; hereafter cited as *LSH*.

35. F. S. C. Northrop, "The Possible Concepts by Intuition and Concepts by Postulation as a Basic Terminology for Comparative Philosophy," in *LSH*, pp. 82–83; emphasis in original. Northrop would return to this example so frequently in his career; to list every instance would entail a near total Northrop bibliography after 1938; it is perhaps sufficient to see its prevalence in the same collection of essays (*LSH*, pp. 102–103, 144, 172, 193).

36. Or, in Northrop's language, "That factor of anything which is denoted by a concept by intuition we shall call the aesthetic component of reality, or reality in its aesthetic aspect; that designated by a concept by postulation, the theoretic component, or reality in its postulated or theoretical aspect" (*LSH*, p. 171). Or again, "Since the immediately apprehended is so inescapably aesthetic in its nature, it seems appropriate to call the immediately apprehended continuum *the aesthetic continuum*. The mathematically defined continued, since it is inferred theoretically from the aesthetic continuum, is appropriately called *the theoretic continuum*" (*LSH*, p. 48; emphasis in original).

37. Ibid., p. 175.

38. Northrop's contribution to the published account of the conference was titled "The Possible Concept by Intuition and Concepts by Postulation as a Basic Terminology for Comparative Philosophy" (*LSH*, pp. 77–101).

39. Northrop, Letter to Junjiro Takakuso, July 12, 1941, Northrop Archives, MS 627, box 8, folder 210.

40. *MEW*, pp. 3, 163. Northrop further subsumes all dilemmas within the modern West (democracy vs. communism, Latin vs. Anglican, medieval vs. modern) as governed by precisely the same intuitional/postulational dynamic, and therefore solvable according to similar modes of synthesis.

41. As Lawrence Chisholm notes in his biography of Fenollosa, "Northrop does not use Fenollosa's term 'fusion,' but the drift of his argument in *The Meeting of East and West* (1946) has marked parallels with Fenollosa's earlier vision" (*Fenollosa: The Far East and American Culture* [New Haven, CT: Yale University Press, p. 241]). To my knowledge, Northrop would never acknowledge the uncanny (suspicious?) similarity between his use of "Blue" in differentiating the aesthetic vs. theoretic components of apprehended reality, and Ezra Pound's gloss of Fenollosa on the color "Red" to convey something similar; see Ezra Pound, *ABC of Reading* (New York: New Directions, 1934), pp. 19–22. Northrop's use of the color "blue" may also be a nod to his teacher Alfred North Whitehead's explanation of the Newtonian difference between the "sense-awareness" of the "Cambridge blue" in a flannel coat as a color and the actual "material object" in which blue is perceived; see Alfred North Whitehead, *The Concept of Nature* (Cambridge: Cambridge University Press, 1920), pp. 151–152.

42. *MEW*, p. iv. On O'Keeffe's debt to both Dow and Fenollosa, see Sharyn Rohlfsen Udall, *Carr, O'Keeffe, Kahlo: Places of Their Own* (New Haven, CT: Yale University Press, 2000), pp. 130–134; and Elizabeth Hutton Turner, *Georgia O'Keeffe: The Poetry of Things, Part 3* (New Haven, CT: Yale University Press, 1999), pp. 2–18.

43. On recent studies that do not mention his cybernetics participation, see Haun Saussy's *Great Walls of Discourse* (Cambridge, MA: Harvard University Asia Center, 2001), pp. 104–108, and Robert W. Smid's *Methodologies of Comparative Philosophy* (Albany, NY: SUNY Press, 2009), pp. 41–78. Katherine Hayles, *How We Became Posthuman* (Chicago: University of Chicago Press, 1999), relegates Northrop to a footnote, citing him only as an example of "How quickly the equation between man and machine proliferated into social theory," but ignores his contribution to the conversations themselves (p. 302). Flo Conway and Jim Siegelman's *Dark Hero of the Information Age: In Search of Norbert Wiener, the Father of Cybernetics* (New York: Basic Books, 2005) otherwise stellar account of the cybernetics group never once mentions Northrop. The one exception to this neglect is Steve J. Heims's admirable study *The Cybernetics Group* (Cambridge, MA: MIT Press, 1991), pp. 262–269.

44. In terms of mapping Northrop's influence, it will be useful to remember that in the decade following the publication of *The Meeting of East and West*, Northrop became something of an academic celebrity. In 1951, for instance, he was invited by James Michener to participate in the "International Conference on Asian Problems" held at the International Center in New York, and only a few years later he spoke on "The Nature of Modern Technology" at the behest of the South-East Asia Treaty Organization (SEATO) in Bangkok. In addition to a steady stream of academic articles on law, comparative philosophy, and the social sciences, he also began publishing in mainstream magazines like *Life* and *Time* (typically with articles like "The Mind of Asia"). Organizations such as General Electric and the RAND Corporation regularly sought his advice and sent him reports of their ongoing work. He exercised an enormous influence over the ongoing series of East-West Philosophers' Conferences in Hawai'i, and was made an honorary charter member of the American Buddhist Academy; all of these details are documented in the Northrop Archives, MS 627.

45. Conway and Siegelman, *Dark Hero of the Information Age*, pp. 136–137;

46. Ibid.

47. Norbert Wiener, *Cybernetics: Or Control and Communication in the Animal and the Machine* (Cambridge, MA: MIT Press, 1948), pp. 13–14.

48. *Bulletin of Mathematical Biophysics* 5 (1943), pp. 115–133; also *DH*, pp. 132–135; see also Christof Teuscher, *Turing's Connectionism: An Investigation of Neural Network Architectures* (London: Springer, 2002), pp. 130–131; and B. J. Copeland, *The Essential Turing* (New York: Oxford University Press, 2004), p. 350.

49. Norbert Wiener, *I Am a Mathematician: The Later Life of a Prodigy* (Cambridge, MA: MIT Press, 1966), p. 269.

50. Warren S. McCulloch, "Memo to the Members of the Conference on Teleological Mechanisms – Oct. 23 & 24, 1947," p. 3; Northrop's annotated copy in Northrop Archives, MS 627, box 5, folder 143.

51. McCulloch, "Memo," p. 3. One of the more fascinating, untold stories of the cybernetics group was that Northrop invited Wiener to contribute a chapter in his edited volume on *Ideological Differences and World Order: Studies in the Philosophy and Science of the World's Cultures* (New Haven, CT: Yale University Press, 1949). But what Wiener wrote was ultimately not prescriptive enough for Northrop's tastes. As Northrop wrote to McCulloch, "The paper which I wanted from Wiener was *not* a paper indicating what is likely to happen." What he wanted was a paper that "asks what *should* happen and act wisely. . . . The real truth of the matter is that you and Wiener are demoralized on this situation in considerable part because neither you nor Wiener has been doing your job, which is not merely to find the scientifically correct conceptions of human beings and nature but to convey these conceptions and bring out their social implications" (Letter dated May 29, 1947, Northrop Archives, MS 627, box 5, folders 141–142; emphasis in original). Wiener eventually agreed that his contribution would not suit Northrop's volume, and it ultimately became the basis for his most popular work, *The Human Use of Human Beings* (Boston: Houghton Mifflin, 1950).

52. F. S. C. Northrop, "The Neurological and Behavioristic Psychological Basis of the Ordering of Society by Means of Ideas," *Science* 107 (April 23, 1948), p. 413; it is perhaps an indication of how cutting edge these ideas were that Turing's name in the quoted passage is misspelled as "Thuring" (surely the only time that's happened in *Science*). Northrop would expand this article (and spell Turing's name correctly) in *Ideological Differences*, pp. 407–428.

53. See George Dyson, *Turing's Cathedral: The Origins of the Digital Universe* (New York: Pantheon, 2012), pp. 103–105. For a fascinating study on Leibniz and the *Yijing* and its influence on the cybernetic moment, see Lydia H. Liu, *The Freudian Robot: Digital Media and the Future of the Unconscious* (Chicago: University of Chicago Press, 2010), pp. 153–200; and Davis, *TechGnosis*, pp. 381–382.

54. I am thinking here of the moment in Kurt Vonnegut's *Player Piano* (New York: The Dial Press, 2006) when the "Shah of Bratpuhr," an emissary from the East, is shown the West's "EPICAC" machine, bows before it and attempts to engage in some kind of spiritual connection with it. When the Shah fails to make any connection and seems puzzled by it, the Western scientists scoff at the ridiculousness of the attempt. But in Vonnegut's mind, the joke is on the scientists, since the only communicative noise that EPICAC makes in the failed communication attempt with the Shah (a mechanical, whirring "*Did, dit, Mmmmm*" [p. 121]) returns when the main engineer's wife responds to his protestations of love:

> "Mmmmm?" said Anita. "Mmmmmmm?"
> "Anita—"
> "Mmm?"
> "Anita, I love you." (p. 136)

The implied critique here being that at least the Shah recognized he was talking with a machine. The Western engineers have no idea that their entire utopian vision has turned everyone into machine-like slaves.

55. See Francis H. Cook, *Hua-yen Buddhism: The Jewel Net of Indra* (University Park: Penn State University Press, 1977), pp. 2–3; emphasis in original.

56. See Davis, *TechGnosis*, p. 380.

57. We saw dozens of examples of this in the last chapter, but it is worth pointing here to Jessica E. Vascellaro's article "Digerati Get Connected to Their Spiritual Side," in the *Wall Street Journal* (February 9, 2012), where we learn that "In Silicon Valley, some of the most popular networking events this season [are] conferences devoted to spiritual topics such as mindfulness, compassion and the teachings of Buddhism," which "are becoming increasingly popular among the digerati." One conference, for instance, "Wisdom 2.0," allowed "employees from Cisco Systems, Inc., Google Inc., Twitter Inc., and Zynga Inc. [to] gather alongside spiritual figures like Eckart Tolle, the author of the popular self-help book 'The Power of Now.'" Talks included "Ancient Wisdom and Modern Life" by Ebay Inc. founder Pierre Omidyar. As Erik Davis has explained, Buddhist "mindfulness" is "a *technê*, neither a philosophy nor a passive trance but an active practice of propping and witnessing experience"; see *TechGnosis*, p. 379.

58. William Gibson, *Neuromancer* (New York: Ace Hardcover, 2004), p. 69.

59. Ibid., p. 70; emphasis added. For more on the "high-tech Orientalism" of Gibson's novel, see Wendy Hui Kyong Chun, *Control and Freedom: Power and Paranoia in the Age of Fiber Optics* (Cambridge, MA: MIT Press, 2006), pp. 171–195; and Lisa Nakamura, *Cybertypes: Race, Ethnicity, and Identity on the Internet* (New York: Routledge, 2002), pp. 61–75.

60. See Carl Jung, "A Study in the Process of Individuation," in *The Archetypes and the Collective Unconscious* (Princeton: Princeton University Press, 1959), p. 352; see also the entire section "Concerning Mandala Symbolism," in the same volume, pp. 355–384.

61. Jung, "Study in the Process," pp. 324, 350.

62. See an example of these videos at Wang's blog, "Kwanon-Z (ver. 2)": http://blog
.naver.com/PostList.nhn?from=postList&blogId=ultraz1&categoryNo=1¤tPage=20.

63. Kim Ji-woon, the writer and director of the South Korean film *Doomsday Book*
(2012), seems to have drawn direct inspiration from Wang's "Z" Buddha machines. Much
more could be said about this provocative film—not the least of which is that the aesthetics
of the "enlightened" robot in the futurist story are dictated by a massive corporation titled
"UR" (an obvious pun on "you are"), thus calling into question the very nature of human-
ity, corporations (as persons), and machines.

64. Im Sung Hoon, "Source of Z," at Wang's blog: http://blog.naver.com/PostList.nhn?
from=postList&blogId=ultraz1&categoryNo=1¤tPage=26. I am indebted to Seo Hee
Im for the translation from Korean.

Appendix A: Japanese Edition Books Published in the 1890s

1. Sources for this list include several trade publications from the 1890s including the
Publisher's Weekly (published in New York by collective publishers), the *Book Buyer*
(published in New York by Charles Scribner's Sons and providing a venue for several other
publishers' catalogs as well), the *Bookman* (published in New York by Dodd, Mead & Co.),
American Book-Lore Quarterly (published in Milwaukee, Wisconsin), the *Library Journal*
(the official organ of the American Library Association), the *Literary News*, the *Literary Era*,
and a number of annual catalogs such as the *American Catalogue*, the *Publishers' Trade List
Annual*, the *Annual Literary Index*, and the *Retail Catalogue of Standard and Holiday Books*.
The list in this appendix is not intended to be exhaustive, but a sampling of the type of
books published in "Japanese editions" during the 1890s. Binding in the advertised
"Japanese style" could mean that the book was printed on double leaves (i.e., with its folds
unopened at the edges and with interior pages blank). Japanese paper or *washi* was
typically thin, silky, waterleaf paper that was wonderful for proofs, woodcuts, and
etchings, but did not allow for erasures of even the lightest marks (doing so, as many
collectors have discovered, leaves a permanent abrasion on the paper). Sometimes called
simply "Japan paper" in advertisements, *washi* was thought to allow for more clarity, detail,
and uniform ink impressions; see, for example, the discussion of engraving and Japanese
paper in the contemporary *Johnson's Universal Encyclopedia, Vol. III* (New York: A. J.
Johnson, 1894), p. 146. Beginning artists and designers were also taught that "Japan paper
yields beautiful proofs, by reason of its warm, mellow tone and fine surface"; see Frederick
Keppel, *What Etchings Are: A Manual of Elementary Information for Beginners* (New York:
Frederick Keppel & Co., 1890), p. 6.

Appendix B: Chronology of Futurism/Vorticism in London, 1913–1915

1. See Richard Cork, *Vorticism and Abstract Art in the First Machine Age, Volume 1*
(Berkeley: University of California Press, 1976), p. 105; hereafter cited as *VAA1*.

2. For the overlapping details of Futurism and Vorticism, I am indebted to Marjorie
Perloff's chronology in *The Futurist Moment* (Chicago: University of Chicago Press, 2003),
pp. 172–174.

3. Zhaoming Qian, *Orientalism and Modernism*, pp. 24–25.

4. "Futurism," *Poetry and Drama* 3 (September 1913), p. 262.

5. *VAA1*, pp. 99–100.

6. Marinetti, "Il Teatro di Varietà, *Daily Mail* (November 21, 1913).

7. Milton A. Cohen, *Movement, Manifesto, Meleé: The Modernist Group, 1910–1914*
(Oxford, UK: Lexington Books, 2004), pp. 281–282; hereafter cited as *MMM*.

8. *New Freewoman* (December 1, 1913), p. 226.

9. T. E. Hulme, "Mr. Epstein and the Critics," *New Age* 14.8 (December 25, 1913),
p. 251.

10. T. E. Hulme, "Modern Art and Its Philosophy," *The Collected Writings of T.E. Hulme*,
ed. by Karen Csengeri (Oxford: Clarendon Press, 1994), pp. 268–285.

11. Ezra Pound, *Selected Letters of Ezra Pound*, ed. D.D. Paige (New York: New Directions, 1971), p. 36.

12. *New Age* 15.1 (May 7, 1914), pp. 16–17; and *New Age* 15.11 (July 16, 1914), p. 255.

13. Cohen, *MMM*, p. 216.

14. A. R. Orage [under the pseudonym R. H. C.], "Readers and Writers," *New Age* 15.19 (September 10, 1914), p. 449.

15. Reed Way Dasenbrock, ed., "Pound and the Visual Arts," *Cambridge Companion to Ezra Pound* (Cambridge: Cambridge University Press, 2006), p. 9; hereafter cited as "PVA."

16. "PVA," p. 27.

17. John Triboulet, "Pastiche. Euphemism; or, What You Will," *New Age* 16.16 (February 1915), p. 434.

18. Pound, *Selected Letters*, p. 61.

Appendix C: Ezra Pound 1910–1912 vs. Ezra Pound 1914–1915

1. On Pound's initial fascination with Bridges, see Perloff, *The Futurist Moment*, p. 165.

2. As Pound argues in *BLAST1*, "CURSE the flabby sky that can manufacture no snow, but can only drop the sea on us in a drizzle like a poem by Mr. Robert Bridges" (p. 12).

3. Ezra Pound, "The Wisdom of Poetry," *Forum* (April 1912), pp. 497–501.

4. Cecilia Tichi's analysis of Pound's debt to Maxim is relevant here; see Cecilia Tichi, *Shifting Gears: Technology, Literature, Culture in Modernist America* (Chapel Hill: University of North Carolina Press, 1987) pp. 93–95. However, Tichi does not account for the vehemence of Pound's initial review of Maxim's book in 1910, noting only that "Pound never adequately acknowledged his debt to the eccentric theorist, but his ideas on efficiency in language were evidently nourished by Maxim's statement . . . that language itself was an elegant, efficient machine" (p. 95).

5. *BLAST2*, p. 86; It is worth noting here that Pound could have certainly said the same thing of Fenollosa.

6. Ezra Pound, *The Spirit of Romance* (New York: New Directions, 1952), p. 22. I am indebted to Perloff for drawing attention to this bland, scholarly passage; see Perloff, *The Futurist Moment*, p. 178.

7. *BLAST1*, p. 45. Perloff's analysis is useful here: "BLAST and Gaudier-Brzeska represent a turning point for Pound, the working out of an aesthetic that was to transform the formal, strophic free verse he and his fellow Imagists were writing in the 1910s—a free verse based on the *vers-libre* of the French Symbolists—into the assemblage of 'verse' and 'prose' that we find in the *Cantos*" (*FM*, p. 163).

8. Ezra Pound, "Tagore's Poems," *Poetry* 1.3 (December 1912), p. 93.

9. Ezra Pound, "Edward Wadsworth, Vorticist: An Authorized Appreciation by Ezra Pound," *Egoist* (August 15, 1914), pp. 306–307.

Index

Ackley, Roy O., "My Master, the Machine,"
51–52
Adams, Henry, 252n121
Adorno, Theodor, 155, 170, 292n75
Aesthetic movement, 246n28
African Americans, 154, 288n35
Allen, Sue, 248n55
alphabet: criticisms of, 137, 138, 140; cultural
influence of, 284n71; ideographs vs., 103;
Lin's Chinese, 135, 136. *See also* Chinese
ideographs
amanuenses, 129
American Railway Union, 48
American studies, 130, 131, 147
Ames, Van Meter, 176
analytic reason, 95, 96, 99
Antheil, George, 274n137, 274n141; *Ballet
Mécanique*, 118, 275n141 (*see also* Léger,
Fernand: *Ballet Mécanique*)
antimodernism: antitechnological attitude
and, 51, 53; concept of, 242n23; of Hei-
degger, 130, 133; Pound and, 100, 113, 267n64
Apple, 194, 216
Arbisser, Micah Efram, 278n4
Archimedes, 3
architecture, 199–209
Aristotle, 3
Armstrong, Margaret, 250n79
Arnold, Edwin, *Japonica*, 31
arrows, graphic, 95, 96
art: machines and mechanization champi-
oned by, 110–26; mechanization contrasted
with, 1, 5–6, 10–12, 21, 26, 90–93, 95–96,
155; science vs., 91–92, 210; and synthesis,
95–100, 97
art education, 25, 94, 265n29
Art Nouveau, 41, 246n28
The Art of the Motorcycle (exhibition), 208–9
Arts and Crafts movement, 20, 109, 111, 203,
246n28, 250n77
Ashbee, Charles, 246n28
Asia-as-*technê*, 6–8; as alternative to Ameri-
can culture, 15; book publishing and,
20–44; Chicago World's Fair and, 13–15;
cinema-as-*technê* and, 169–70; computers
and, 194–95, 215–16; consumer goods and,
15–19; defined, 1; Fenollosa and, 87–91,
94–95, 98, 100–101, 212; Lin and, 131,
132–33, 136, 140, 145, 212; London and,
71–79; mandalas and, 216–18; and moder-
nity, 131–32; Northrop and, 209–15;
Okakura and, 36–42; Oriental detective
genre and, 156, 160–61, 163; Orientalism
vs., 131–32; tea ceremony as, 40–42;
therapeutic effects of, 19, 29–30, 199;
Wright and, 199–209, 305n22; Yeto and,
31–36. See also *technê*-Zen
Asian aesthetics. *See* Chinese art; Eastern
aesthetics; Japanese art and aesthetics
Asian-American studies, 130, 131
Asian/Pacific peoples, London's portrayals of,
48–49, 60–71, 76–78, 84
Asian studies, 130, 131
Athos, Anthony, 192
"The Audience—'Turn on the Biograph'"
(*Cleveland Leader*), 62, *63*
Auerbach, Jonathan, 52, 56

Bagua design, 98–99, *99*, 266n53
Barnet, Jim, 194–95
Bateson, Gregory, 180
Beeching, Wilfred A., 138
being, technological understanding of, 6–7, 218
Bell Telephone Labs, 180
Benjamin, Walter, 149; "The Work of Art in
the Age of Its Technological Reproducibil-
ity," 171
Beveridge, Albert, *The Russian Advance*, 61
B films, 161, 163, 168
Bigelow, William Sturgis, 37, 252n121,
253n125
Biggers, Earl Derr, 152, 153–54, 288n34; *The
Chinese Parrot*, 149, 151–52; *The House
without a Key*, 285n1
Binyon, Laurence, 101–2; *The Flight of the
Dragon*, 101–2; *Painting in the Far East*, 101

Chung SaiYat Po (newspaper), 142
cinema-as-*technê*, 169–70
Cleveland Leader (newspaper), 62
Cobden-Sanderson, T. J., 246n28
Coburn, Alvin Langdon, 276n149
Cole, Jean Lee, 28
collective unconscious, 80, 216
Collier's Magazine, 35
computationalism, 296n24
computers: Asia-as-*technê* and, 194–95, 215–16; minds and, 213–16
concave mirrors, 3
Confucianism, 106, 108, 124
Congress of Art Instruction, Chicago World's Fair (1893), 10, 11, 86, 90
Cook, Francis, 215
corporations: and Eastern thought, 188–98, 227–28; Japanese, 189–91
Cos Cob art colony, 31–32, 32
counterculture, 174–80, 192, 294n16
Courbet, Gustave, *Woman with a Parrot*, 151
Courtney, Julia, 151
Couture, Thomas, 21
Creative Worldwide, 194
Creeley, Robert, 127–28
Critchley, Simon, 286n6
CSS-based design, 195
Cubism, 108–10
culture industry, 170
Cutler, Thomas, *A Grammar of Japanese Ornament*, 27, 249n59
cybernetics, 177, 179–81, 189–90, 212–14, 295n17, 299n56
cyberspace, 215–16

The Daily Show with Jon Stewart (television show), 198, 303n96
Daoism, 7, 89, 100
Dasenbrock, Reed Way, 109, 272n111
Davis, Richard Harding, 28, 60
Dead Men Tell (film), 167–68, 169
Debs, Eugene V., 48
deconstruction, 35
Decorative Design, 26, 41
De Leon, Daniel, 51
Delta Air Lines, 208
Deming, W. Edwards, 189–90
democracy, print technology and, 23–24
department stores, 15–16, 16, 17, 18–19, 253n140
depression (1893), 47
Derrida, Jacques, 186, 288n37
Descartes, René, 149

desire, 18–19
Des Moines Register (newspaper), 62
detective fiction: ideological underpinnings of, 290n51; technology in, 160. *See also* Oriental detective genre
dharmachakra (wheel of the law), 98
Dickens, Charles, 20
Dickstein, Morris, 174
Dictionary Index System, 135–36, 136
Disney, Walt, 195, 196
Docks of New Orleans (film), 168, 170
Doomsday Book (film), 309n63
Dow, Arthur Wesley, 25–26, 87, 91, 94–95, 212, 253n137, 265n29; *Composition*, 25–26, 92, 93, 94; cover and sample pages from *The Lotos*, 93
Doyle, Arthur Conan, 160
Draper, Bill, 194–95
Dreiser, Theodore, 18–19, 245n21
Dresser, Christopher, 246n28
Dreyfus, Hubert, 6–7
Drucker, Peter F., 193
Dürer, Albrecht, 11; woodcut showing perspective machine, 2

Eastern aesthetics and way of life: bookbinding and, 24–27; enthusiasm for, 21, 31; and machine culture, 205; mechanization contrasted with, 4, 11–14, 26, 29–30, 39–40, 86–87, 99–102, 132–33, 136, 176; purity of, 6; redemptive character of, 1, 4, 6, 7, 12, 132, 176, 179–80, 205; West in comparison to, 13, 90, 103–5, 132, 136–37, 199–219; world as depicted within, 4. *See also* Asia-as-*technê*; Chinese art; Japanese art and aesthetics
Eastern mysticism, 176–77, 179–80
Eaton, Edith (pseudonym: Sui Sin Far), 251n92
Eaton, Winnifred (pseudonym: Onoto Watanna), 28–32; *Daughters of Nijo*, 29; *Heart of Hyacinth*, 31; *A Japanese Blossom*, 30, 30; *A Japanese Nightingale*, 31; "The Wrench of Chance," 29–30
e-books, 42–44
Eisenstein, Sergei, 170
Eliot, T. S., 108
Ellison, Larry, 194
Ellul, Jacques, 175
Ely, Richard T., 52
Emerson, Ralph Waldo, 20
Enlightenment, 155
Eperjesi, John, 48, 50, 78

Jung, Carl, 45, 79–84, 216; *Psychology of the Unconscious*, 79–80, 261n118; *The Red Book*, 82

just-in-time manufacturing, 189

Kalauaikoʻolau, 77

Kapor, Mitch, 194

Karatani, Kojin, 245n22

Karloff, Boris, 163, 168, 291n67

Kataoka, Drue, 194–95

Kennan, George, 60

Kerouac, Jack, 180, 283n53; *Dharma Bums*, 176

Kesey, Ken, 180; *One Flew Over the Cuckoo's Nest*, 297n31

Ketcham, William H., 94

Kim, Elaine, 131

Kim, Thomas W., 19, 31

Kim Ji-woon, 309n63

Kipling, Rudyard, 199

Kittler, Friedrich, 282n48

Kiyokichi Sano, 31

Klein, Lucas, 106

Kleiner, Art, 191

Korea, Jack London and, 60–69, *66*

Krens, Thomas, 208–9

Kuki, Shuzo, 37

Kushner, Don, 196

Labor, Earle, 73, 261n121

La Farge, John, 21, 95, 252n121

Lamaist Vajry-Mandala, *83*

language: Fenollosa on Eastern vs. Western, 103–5, *106*; parrot speech in relation to, 149–51; typewriters and, 130, 135–36, 140, 278n4. *See also* Chinese ideographs

Laotse, 133, 145

late capitalism, and *technê*-Zen, 188–98

Lears, Jackson, 242n23

Lee Tung Foo, 163, 165–68, *167*, 173

Léger, Fernand, 118; *Ballet Mécanique*, 150, *150* (*see also* Antheil, George: *Ballet Mécanique*)

Leibniz, Gottfried Wilhelm, 215

Leonardo da Vinci, 11, 206–7, 265n29; *Draftsman Drawing an Armillary Sphere Using a Perspective Machine*, *2*

Leong, Karen, 132

Lewis, Sinclair, 255n19

Lewis, Wyndham, 109–16; *Timon of Athens*, *110*

Lhamon, W. T., Jr., 174

Lindsay, Vachel, 170

linear perspective, *2*, 3–5, *5*, 239n6

Lin Taiyi (Lin Yutang's daughter), 129, 140–42

Lin Yutang, 8, 129–48; and Asia-as-*technê*, 131, 132–33, 136, 140, 145, 212, 279n18; *Between Tears and Laughter*, 132, 137; *Chinatown Family*, 130–31, 143–47, 153, 278n12; and Chinese ideographs, 135–36, 280n27, 280n30, 283n52; education and work experience of, 133–34, 281n41; *The Importance of Living*, 130, 132; influence of, 130; and mechanization, 132–47; misinterpretations of, 130–31, 143; *My Country and My People*, 130, 136–37; typewriter invented by, 129–30, 133–43, *141*, 145–48, 278n4, 283n60

Lisberger, Steve, 196

Liu, Alan, 193, 198

Liu, Shi-yee, 134–35

London, Charmian, 72, 79

London, Jack, 8, 45–85, 216; "The Apostate," 52–54, 73, 78; *The Call of the Wild*, 57; and China, 64–65; complexity of, 48–50; *The Cruise of the Snark*, 73–74, 75, 76, 79; "A Curious Fragment," 58; experiences of, 45–48, 54–56, 73; "Getting into Print," 56; global vision of, 50–51, 69–71, 85; "Goliah," 69–71; and Hawai'i, 71–72, 74, 79–79, 84–85, 260n105; health problems of, 79; *The Iron Heel*, 58–60, 72, 78; and Japan, 60–71; and Jung, 79–84, 261n118; *The Kempton-Wace Letters*, 57; "Koolau the Leper," 77–79; and Korea, 60–69, *66*; Korean refugees photographed by, 67, *68*; "The Language of the Tribe," 85; and machines, 46–47, 51–60, 69–71, 76–79; *Martin Eden*, 56; "On the Makaloa Mat," 76–77, 79; *People of the Abyss*, 53, 78; photojournalism of, 60–71, 259n85; portrayals of Asian/Pacific peoples by, 48–49, 60–71, 76–78, 84; "The Question of the Maximum," 57; and race, 48–49, 59–71, 77–81, 84–85, 260n102, 262n135; "The Red One," 81–84; "Revolution," 50, 57, 59, 72, 255n18, 255n19; *The Road*, 54–55, *55*, 76; "The Run Across," 73; search for *technê* by, 48, 58, 71–76, 79–80, 85; *The Sea Wolf*, 57; self projected by, 52, 55–56; and socialism, 49–50, 57–60, 71–73, 79, 255n19; "Story of a Typhoon off the Coast of Japan," 73; "The Unparalleled Invasion," 259n85; *War of the Classes*, 71; *White Fang*, 57; on work and working conditions, 52–53; and writing/publishing, 50, 52, 56, 257n52, 259n93; "The Yellow Peril," 64–65

London, John, 47

Long, John Luther, 32

Longfellow, Henry Wadsworth, 249n59; *The Song of Hiawatha*, 25
Lorre, Peter, 163
Los Angeles Times (newspaper), 62
The Lotos (journal), 91, 93
Lotus 1-2-3, 194
Lowell, Percival, 22, 38
Luddism, 6, 174–75
Luke, Keye, 152, 291n67
Lye, Colleen, 48, 50, 59–60

māyā, 177–79, 182–83, 195–96, 208, 295n20
MacArthur, Douglas, 189
MacCarthy, Desmond, 109
MacDonald, Michael, 140
machines and mechanization: analytic reason and, 95; antimodernism and, 51, 53; anxiety over, 9–10, 48–49, 87, 88; art contrasted with, 1, 5–6, 10–12, 21, 26, 86, 90–93, 95–96, 155; artistic embrace of, 110–26; Asian aesthetics and, 205; and book publishing, 22–24; in Chicago World's Fair, 9–10, 13; Chinese ideographs and, 88; critiques of, 9–10, 39–40, 52–59, 99–100, 109–10, 132–33, 147–48, 199–200; Eastern way of life contrasted with, 4, 11–14, 26, 29–30, 39–40, 86–87, 99–102, 132–33, 136, 176; Fenollosa and, 86–87, 99–100, 126–27; Japan and, 90, 279n18; Japanese army and, 60–64, 70; Jung and, 80; Lin and, 132–47; Lin Yutang's typewriter and, 129–30, 133–43; London and, 46–47, 51–60, 69–71, 76–79; the nervous system and, 213–16; Olson and, 127–28; Pound and, 88, 101, 108, 111–26, 275n142; socialism and, 51–52, 57–59; typewriters, 133, 142, 147–48; Vorticism and, 272n111; White Disaster and, 39–40; Wright and, 200–206. *See also* technology
MacKaye, James, 256n30
Macy Conferences on Cybernetics, 179, 212–14
magic eye, in Chinese typewriter, 146, *146*
Mahoney, Stephen, 176
management theory, 192–93, 225–28
mandalas, 82–84, *83*, 98, *206*, *207*, 216–18, 304n20, 305n22
Manet, Édouard: *Olympia*, 151; *Young Lady in 1866*, 151
Marcuse, Herbert, 155, 175
Marinetti, F. T., 86, 111–14, 117–18
Marx, Karl, 51
Masheck, Joseph, 25
mathematical ideographs, 117–18

McCulloch, Warren, 213–14
McGregor, Douglas, 190, 192
McKeon, Richard, 186–87
McKinsey & Company, 192
McLuhan, Marshall, 8, 130, 135, 290n51
Meggs, Philip, 248n46
Mencius, 133
Mergenthaler Linotype Company, 141–42
Merleau-Ponty, Maurice, 186
Merry Pranksters, 180, 297n29
Miller, J. Hillis, 35
Miller, L. W., 10
mimetic representation, 10, 26, 92, 265n29
mind, 213–16
Mitry, Jean, 170
Miyake, Akiko, 106
modernism, 7
modernist naturalism, 51
modernity: Asia-as-*technê* and, 131–32; China and, 132–38, 280n31; Oriental themes as sign of, 31
mon (crests), 25, 27, 41, 203, *203*
Monogram Pictures Corporation, 163–65, 168, 291n65, 291n67
montage, 170
Moon, Krystyn R., 165
Moore, Aimee Osborne, 11
Moore, Charles A., 210
Moreland, Mantan, 154, 168
Moretti, Franco, 290n51
Mori, Kainan, 98
Mori, Masahiro, 174, 191–92, 299n56, 299n57; *The Buddha in the Robot*, 191
Morley, David, 241n19
Moronobu, 22
Morris, William, 110, 200, 246n28
Morse, Alice C., 247n42
Morse, Edward, 13, 21, 37
motorcycles, 180–83, 196, 208–9
Mr. Moto films, 163, 291n64
Mr. Moto's Gamble (film), 291n64
Mr. Wong, Detective (film), 163–65, *164*, *166*
Mr. Wong films, 163–65, 168, 291n65, 291n67
Mudie, Leonard, 168
Mullaney, Tom, 278n4
Mumford, Lewis, 147–48, 176; *Art and Technics*, 147; *Technics and Civilization*, 155
Murphy, Dudley, 118

Nam June Paik, 180
National Asian American Telecommunication Association, 153

Twachtman, John H., 31
Twain, Mark, 28
Twentieth Century-Fox, 161, 163, 167–68
Twitter, 194
Tyler, Christopher, 239n5
Tyler, Sidney, 60
typewriters: ascendance of, 129; Chinese, 129–30, 133–43, 134, 145–48, 278n4, 280n36, 281n38, 283n60; and gender, 138–39, 282n48; Heidegger on, 133, 279n26; invention of, 281n39; Kerouac and, 283n53; and language, 130, 135–36, 140, 278n4; and mechanization, 133, 142, 147–48; and modernity, 130; Olson and, 128; uses of, 129, 140; as a whim, 135

ukiyo-e prints, 20, 31, 151
uncanny valley, 299n57
unconscious, 80, 216
University of Chicago, 186–87
USB Parrot, 150–51, 150

Van Eyck, Jan, 2–3, 239n6; The Arnolfini Portrait, 3
Van Gogh, Vincent, 246n28
vanishing point, 5
Velasquez, Diego, 3, 239n6
Victoria, Brian, 191
Victory Pictures, 291n65
Virant, Christiaan, 216
Vonnegut, Kurt, 215, 308n54
Von Neumann, John, 214, 215
Vorticism, 88, 108, 111, 113–18, 125, 222–23, 272n111

Wadsworth, Edward, 273n129; Vorticist drawing, 115
Waller, Greg, 60
Walsh, Richard, 136, 140, 278n12
Walt Disney Studios, 195–96
Wang Hui, The Kangxi Emperor's Southern Inspection, 4, 240n13
Wang Zi Won, 8, 216–18; Buddha_Z in the Steel Lotus, 217; Kwanon_Z, 217, 218; Pensive Mechanical Bodhisattva, 217
Warhol, Andy, 286n11
Warner, Michael, 23
Waterman, Bob, In Search of Excellence, 192–93
Watts, Alan, 177–79, 182, 208; Eastern Wisdom and Modern Life, 177, 178; The Way of Zen, 176, 295n17

Weale, B. L. Putnam, 60
Werner, Paul, 208
Wershler-Henry, Darren, 135, 142
Western art, technological influences in, 1–4, 10–12, 110–26, 239n6
Whalen, Philip, 180
Whalen, Philip: "Vision of the Bodhisattvas," 176
White Disaster, 39–40
Whitehead, Alfred North, 210; Principia Mathematica, 213
Whitman, Sarah Wyman, 19, 21–25, 28, 32, 41, 86, 95, 203, 246n32; cover for The Song of Hiawatha, 25; cover for The Soul of the Far East, 25
Whitman, Walt, 145, 286n11
Whittier, John G., Snow Bound, 27–28
Wiener, Norbert, 179, 189, 213–14, 296n24, 299n56, 307n51; Cybernetics, 295n17
Wiley, Hugh, 291n65
Wilhelm, Richard, 176
Wilson, Rob, 78
Winona Assembly, 94
Winters, Roland, 153, 168
Wm. H. Zinn Department Store, 17
Wong, Anna May, 132
Woolf, Virginia, 109, 270n87
World's Columbian Exposition (Chicago, 1893), 9–10, 13–15, 14, 22, 37, 45–47, 46, 86–87, 90
World War I, 114
World War II, 127, 140, 163, 179, 191
Wright, Frank Lloyd, 8, 199–209, 304n9; "The Art and Craft of the Machine," 199–201, 205–6; designs by, 202, 203–4, 206; Guggenheim Museum, New York City, 206, 207–9; House and temple for the Unity Church, 204; Imperial Hotel, Tokyo, 206, 207, 304n20; The Japanese Print, 204, 205; Perspective of dwelling for Victor Metzger, 204; "Studio Buddha" and Buddhist objects in studio of, 208; Thomas P. Hardy House, 204
Wu, William, 153
Wurtzel, Sol, 161

Xiao-huang Yin, 154
Xu Yang, The Qianlong Emperor's Southern Inspection Tour, 240n13

Yale University, 49–50, 213, 255n15
Yeats, William Butler, 100
Yellow Peril, 39, 49, 153

Yeto, Genjiro, 20, 31–36, *32*, 252n117; "Annual Review of the Tokio Garrison by the Mikado, January 8, 1904," 36, *36*; illustration for Hearn's "Fireflies," 34; "Off to the War!," 35–36, *36*

Yijing, 98–99, *99*, 176, 215

Young, Victor Sen, 168

Zen Buddhism: and computers, 194–95; in corporate culture, 189–98, 227–28; counterculture and, 176–80; and global capitalism, 197; popularity of, 176; therapeutic value of, 179; *Zen and the Art of Motorcycle Maintenance* and, 180–89. *See also techné*-Zen

The Zen of CSS Design (book), 195

The Zen of Steve Jobs (graphic novel), 194

ZENworks, 194

Zhang Jian, 216

Zhaoming Qian, 102

Žižek, Slavoj, 197, 302n91

"Zen and the Art of," 198, 208, 229–37